For Robert and Eric

Art in an Age of Bonapartism, 1800–1815

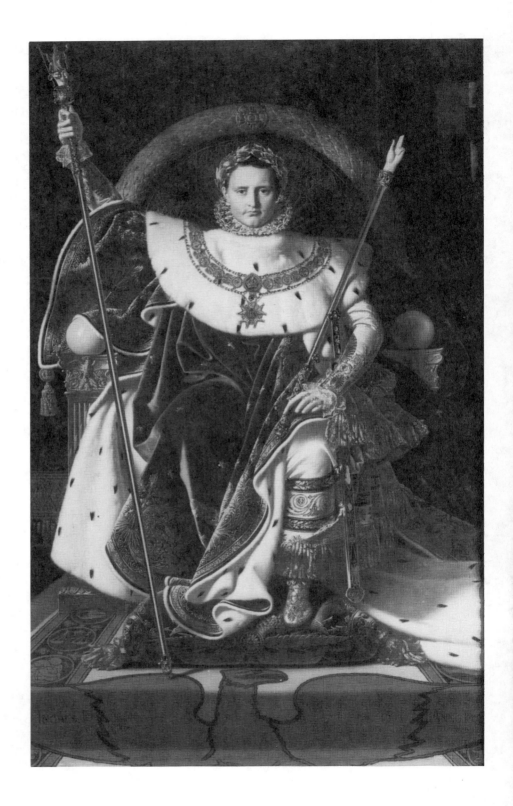

A SOCIAL HISTORY OF MODERN ART
Volume 2

Art in an Age of
Bonapartism
1800–1815

Albert Boime

 The University of Chicago Press
Chicago and London

ALBERT BOIME is professor of art history at the University of
California, Los Angeles.

Publication of this book has been aided by a grant from the
John Simon Guggenheim Memorial Foundation.

The University of Chicago Press, Chicago 60637
The University of Chicago Press, Ltd., London

99 98 97 96 95 94 93 92 91 90 5 4 3 2 1

Library of Congress Cataloging-in-Publication Data

Boime, Albert.
 Art in an age of Bonapartism, 1800–1815 / Albert Boime.
 p. cm. — (A Social history of modern art : v. 2)
 1. Art, European. 2. Art, Modern—19th century—Eu-
rope. 3. Romanticism in art—Europe. 4. Napoleon I, Em-
peror of the French, 1769–1821—Influence. 5. Art and soci-
ety—Europe.
I. Title. II. Series: Boime, Albert. Social history of modern
art : v. 2.
N6757.B56 1990 89-20201
709'.03'4—dc20 CIP
ISBN 0-226-06335-6 (alk. paper)

Photo credits appear on page 689.

⊗The paper used in this publication meets the minimum re-
quirements of the American National Standard for Information
Sciences—Permanence of Paper for Printed Library Materials,
ANSI Z39.48–1984.

Contents

Illustrations ix

Introduction xxi

I *The Adversaries*

1 The Napoleonic Era (1800–15) 3

2 The Iconography of Napoleon 35

3 English Art in the Napoleonic Era 97

4 France and Spain 199

II *The Downtrodden and their Regeneration*

5 Napoleon's Invasion of Prussia and the Rise of German Romantic Nationalism 315

6 The Political Foundations of the German Romantic Pioneers and Their Patrons 357

7 Patrons of the New Movement 385

8 Philipp Otto Runge 411

9 Caspar David Friedrich 511

10 Napoleon in Italy 637

Notes 657

Index 691

Illustrations

1.1 Title page for *Description de l'Egypte* 2

1.2 Frontispiece for *Description de l'Egypte* 6

1.3 Anonymous, *Napoleon Restoring the Institutional Basis of the Jewish Religion* 9

1.4 Vendôme Column 12

1.5 Arc de Triomphe de l'Etoile 13

1.6 Plate 2 of *Histoire naturelle* 14

1.7 Plate 61 of *Histoire naturelle* 15

1.8 Alexandre-Evariste Fragonard, *Volta's Experiment at the Institute* 16

1.9 Alexandre-Denis Abel de Pujol, *Lycurgus Presenting the Heir to the Throne* 18

1.10 Medal of the baptism of the king of Rome 18

1.11 Sèvres table of the imperial palaces 19

1.12 *Oath of the Horatii* clock 20

1.13 Jean-Baptiste Isabey, *Napoleon and Oberkampf* 22

1.14 Plate 20, fig. 1, *The Sphinx near the Pyramids* 22

1.15 Plate 50, fig. 1, *Entrance to Luxor* 23

1.16 Plate 116, *Detail of Emblematic Friezes from Various Egyptian Temples* 24

1.17 *The Sphinx near the Pyramids*, Sèvres Egyptian service 24

1.18 *Entrance to Luxor*, Sèvres Egyptian service 25

1.19 Benjamin Zix, *Allegory of Denon* 25

1.20 John Vanderlyn, *The Death of Jane McCrea* 27

1.21 Antoine-Jean Gros, *The Battle of Nazareth* 29

1.22 John Vanderlyn, *Marius amid the Ruins of Carthage* 31

2.1 Antoine-Jean Gros, *Bonaparte at Arcole* 34

2.2 Guillon Le Thière, *The Preliminary Peace Treaty of Leoben* 36

2.3 Jacques-Louis David, *Napoleon Crossing the Saint Bernard* 39

2.4 Charles Thévenin, *Passage of the French Army across Saint Bernard* 42

2.5 *Passage of the French Army across Saint Bernard* 42

2.6 Jacques-Louis David, *Distribution of the Eagles* 44

2.7 Jacques-Louis David, *Distribution of the Eagles* 46

2.8 Louis-Léopold Boilly, *Departure of the Conscripts in 1807* 48

2.9 Louis-Léopold Boilly, *Reading of the Bulletin of the Grand Army* 48

2.10 Antoine-Jean Gros, *Portrait of the First Consul* 49

2.11 Jean-Auguste-Dominique Ingres, *Napoleon I on the Imperial Throne* 50

2.12 Jean-Auguste Dominique Ingres, *Oedipus and the Sphinx* 51

2.13 Engraving after Jean-Auguste-Dominique Ingres, *Napoleon on the Pont de Kehl* 51

2.14 Jan van Eyck, Ghent altarpiece 52

2.15 Jacques-Louis David, *Napoleon in His Study* 53

2.16 Elisabeth Harvey, *Malvina Mourning Oscar* 56

2.17 Constance Charpentier, *Melancholy* 57

2.18 Jeanne-Elisabeth Chaudet, *Young Girl Mourning for Her Dead Pigeon* 58

2.19 Anonymous, *La machine infernale* 60

2.20 François Gérard, *Ossian Evoking the Shades with His Harp on the Banks of the Lora* 61

2.21 Anne-Louis Girodet-Trioson, *The Ghosts of French Heroes, Killed in the Service of Their Country* 62

2.22 Jean-Auguste Dominique Ingres, *Dream of Ossian* 67

2.23 Jean-Auguste-Dominique Ingres, *Romulus, Conqueror of Acron* 68

2.24 Jean-Pierre Franque, *Allegory of the Condition of France before the Return from Egypt* 70

2.25 Pierre-Paul Prud'hon, *Divine Justice and Vengeance Pursuing Crime* 73

2.26 Pierre-Paul Prud'hon, *Divine Justice and Vengeance Pursuing Crime* 74

2.27 Allegorical frontispiece of P. Manuel's *Police dévoilée* 75

2.28 Anne-Louis Girodet-Trioson, *Funeral of Atala* 78

2.29 Michelangelo, *Deposition* 82

2.30 Antoine-Jean Gros, *Napoleon in the Pesthouse at Jaffa* 84

2.31 Pierre-Narcisse Guérin, *Napoleon Pardoning the Rebels at Cairo* 87

2.32 Benjamin West, *Death on the Pale Horse* 88

2.33 Jean-Pierre Saint-Ours, *Earthquake in Greece* 89

2.34 Johann Michael Voltz, *Earthquake* 90

2.35 Anne-Louis Girodet-Trioson, *Scène de Déluge* 93

2.36 Anonymous caricature, *Without You I Would Have Perished* 95

3.1 David Wilkie, *Village Politicians* 96

3.2 Joseph Mallord William Turner, *The Battle of Trafalgar as Seen from the Mizen Starboard Shrouds of the Victory* 104

3.3 Benjamin West, *Death of Nelson* 107

3.4 Joseph Mallord William Turner, *London* 108

3.5 Joseph Mallord William Turner, *Snowstorm: Hannibal and His Army Crossing the Alps* 111

3.6 Joseph Mallord William Turner, *The Fall of an Avalanche in the Grisons* 116

3.7 Joseph Mallord William Turner, *Interior of an Iron Foundry* 119

3.8 Joseph Mallord William Turner, *Limekiln at Coalbrookdale* 120

3.9 Philip James de Loutherbourg, *Coalbrookdale by Night* 121

3.10 George Robertson, *Iron Works at Nant-y-glo* 122

3.11 John Martin, *Sadak in Search of the Waters of Oblivion* 123

3.12 Joseph Mallord William Turner, *Fonthill Abbey at Sunset* 131

3.13 Claude Lorrain, *Landscape with Cattle and Peasants (Pastoral Landscape)* 131

3.14 Joseph Mallord William Turner, *The Fifth Plague of Egypt* 132

3.15 Joseph Mallord William Turner, *Fonthill House* 139

3.16 Joseph Mallord William Turner, *Chapter-House, Salisbury* 140

3.17 Joseph Mallord William Turner, *Tom Tower, Christ Church, Oxford* 140

3.18 Joseph Mallord William Turner, *Cockermouth Castle* 141

3.19 Joseph Mallord William Turner, *Raby Castle, the Seat of the Earl of Darlington* 141

3.20 Joseph Mallord William Turner, *Tabley, the Seat of Sir J. F. Leicester, Bart.: Windy Day* 150

3.21 Richard Wilson, *Tabley House* 150

3.22 Humphrey Repton, *Sundridge Park* 151

3.23 Joseph Mallord William Turner, *Lowther Castle, Westmoreland, the Seat of the Earl of Lonsdale: Mid-Day* 152

3.24 Joseph Mallord William Turner, *Petworth, Sussex, the Seat of the Earl of Egremont: Dewy Morning* 153

3.25 Joseph Mallord William Turner, *Somer-hilll, near Tunbridge, the Seat of W. F. Woodgate, Esq.* 156

3.26 John Constable, *Golding Constable's Kitchen Garden* 162

3.27 John Constable, *Golding Constable's Kitchen Garden* 164

3.28 John Constable, frontispiece mezzotint for *Various Subjects of Landscape, Characteristic of English Scenery* 165

3.29 John Constable, *Golding Constable's House at East Bergholt: Birthplace of the Painter* 166

3.30 John Constable, *East Bergholt House* 167

3.31 John Constable, *Cloud Study* 170

3.32 John Constable, *Flatford Mill from the Lock* 171

3.33 John Constable, *Flatford Mill* 171

3.34 John Constable, *Landscape with Double Rainbow* 172

3.35 Luke Howard, engraving of cloud formations 173

3.36 John Constable, *Landscape: Ploughing Scene in Suffolk* 174

3.37 John Constable, *Old Hall, East Bergholt* 175

3.38 John Constable, *View of Dedham* 177

3.39 John Constable, *Dedham from Langham* 182

3.40 John Constable, *View of Dedham* 183

3.41 Pierre-Henri de Valenciennes, cloud studies 187

3.42 John Constable, *Dedham from Langham* 189

3.43 John Constable, *His Majesty's Ship Victory, Capt. E. Harvey, in the Memorable Battle of Trafalgar, between Two French Ships of the Line* 191

4.1 Jacques-Louis David, *The Coronation* 198

4.2 James Gillray, caricature of the coronation procession 202

4.3 Louis-Léopold Boilly, *The Crowd Standing before David's Painting of the Coronation* 203

4.4 Jean-Auguste-Dominique Ingres, *Jupiter and Thétis* 206

4.5 John Flaxman, *Jupiter and Thétis* 207

4.6 Medallion of Jupiter-Napoleon 207

4.7 Pauline Auzou, *The Arrival of Her Majesty the Empress in the Reception Room of the Palace of Compiègne* 208

4.8 Pauline Auzou, *Her Majesty the Empress, Before Her Marriage, at the Moment of Taking Leave of Her Family* 209

4.9 Francisco Goya y Lucientes, *The Third of May, 1808* 211

4.10 Francisco Goya y Lucientes, *Carlos IV and His Family* 213

4.11 Manuel Tolsa, *Carlos IV* 215

4.12 Francisco Goya y Lucientes, *The Injured Mason* 220

4.13 Francisco Goya y Lucientes, *The Crockery Vendor* 221

4.14 Francisco Goya y Lucientes, *Dance on the Banks of the River Manzanares* 223

4.15 Francisco Goya y Lucientes, *Kite Flying* 224

4.16 Francisco Goya y Lucientes, *Ballgame* 224

4.17 Francisco Goya y Lucientes, *Blindman's Bluff* 224

4.18 Francisco Goya y Lucientes, *The Straw Manikin* 225

4.19 Francisco Goya y Lucientes, *The Meadow of San Isidro* 226

4.20 Francisco Goya y Lucientes, *The Wedding* 227

4.21 Antoine Watteau, *Embarkation for Cythère* 228

4.22 Francisco Goya y Lucientes, *Conde de Cabarrús* 230

4.23 Francisco Goya y Lucientes, *Manuel Osorio de Zuñiga* 231

4.24 Francisco Goya y Lucientes, *Conde Floridablanca y Goya* 232

4.25 Francisco Goya y Lucientes, *Carlos III in Hunting Dress* 233

4.26 Francisco Goya y Lucientes, *Sebastian Martínez y Perez* 234

4.27 Francisco Goya y Lucientes, *Asylum* 236

4.28 Francisco Goya y Lucientes, *Gaspar Melchor de Jovellanos* 238

4.29 Francisco Goya y Lucientes, *Juan Antonio Meléndez Valdés* 242

4.30 Francisco Goya y Lucientes, *Agriculture* 243

4.31 Francisco Goya y Lucientes, *Industry* 245

4.32 Francisco Goya y Lucientes, *Commerce* 246

4.33 Francisco Goya y Lucientes, *For Being of Jewish Ancestry* 252

4.34 Francisco Goya y Lucientes, *Condesa-duquesa de Benavente* 255

4.35 Francisco Goya y Lucientes, *San Francisco de Borja Exorcising an Evil Spirit from an Impenitent Dying Man* 256

4.36 Henry Fuseli, *Nightmare* 257

4.37 Francisco Goya y Lucientes, *Witches in Flight* 258

4.38 Francisco Goya y Lucientes, *The Bewitched by Force* 259

4.39 Francisco Goya y Lucientes, *The Witches Sabbath* 261

4.40 Francisco Goya y Lucientes, *Capricho 43, The Sleep of Reason Produces Monsters* 269

4.41 Francisco Goya y Lucientes, *Capricho 2, They Pronounce Their Yes and Stretch Out Their Hand to the First Comer* 279

4.42 Francisco Goya y Lucientes, *Capricho 80, Now Is the Time* 280

4.43 Francisco Goya y Lucientes, *Capricho 14, What a Sacrifice!* 281

4.44 Francisco Goya y Lucientes, *Capricho 42, You Who Cannot Do it* 284

4.45 Anonymous, *I've Got to Hope I'll Be Done Soon* 285

4.46 Francisco Goya y Lucientes, *Capricho 39, As Far Back as His Grandfather* 286

4.47 Francisco Goya y Lucientes, *Capricho 45, There Are Many to Suck* 287

4.48 Francisco Goya y Lucientes, *Capricho, 52, Look What a Tailor Can Do!* 288

4.49 Francisco Goya y Lucientes, *Capricho 50, The Chinchilla Rats* 289

4.50 Francisco Goya y Lucientes, *Capricho, 23, That Dust* 290

4.51 Francisco Goya y Lucientes, *Capricho 24, There Was No Remedy* 291

4.52 Francisco Goya y Lucientes, *Manuel Godoy* 291

4.53 Francisco Goya y Lucientes, *Naked Maja* 292

4.54 Francisco Goya y Lucientes, *Clothed Maja* 292

4.55 Francisco Goya y Lucientes, *The Second of May 1808 in Puerta del Sol* 296

4.56 Antoine-Jean Gros, *Capitulation of Madrid, 4 December 1808* 301

4.57 Francisco Goya y Lucientes, *Allegory of the City of Madrid* 302

4.58 Francisco Goya y Lucientes, *The Giant* 304

4.59 Francisco Goya y Lucientes, *The Forge* 305

4.60 Francisco Goya y Lucientes, *The Water Carrier* 306

4.61 Francisco Goya y Lucientes, *The Knife Grinder* 306

4.62 Francisco Goya y Lucientes, *Desastre 26, One Can't Look* 308

4.63 Francisco Goya y Lucientes, *Desastre 38, Barbarians!* 309

4.64 Francisco Goya y Lucientes, *Desastre 39, Heroic Exploits! Against the Dead!* 309

4.65 Francisco Goya y Lucientes, *Desastre 5, And They Fight like Wild Beasts* 310

4.66 Francisco Goya y Lucientes, *Desastre 2, With or without Reason* 311

4.67 Francisco Goya y Lucientes, *Desastre 3, The Same* 311

4.68 Francisco Goya y Lucientes, *Desastre 7, What Courage!* 312

5.1 Antoine-Jean Gros, *Napoleon on the Battlefield of Eylau, 1807* 314

7.1 Karl Friedrich Schinkel, *Cathedral among the Trees* 384

7.2 Karl Friedrich Schinkel, *Evening* 404

7.3 Karl Friedrich Schinkel, *Morning* 405

7.4 Karl Friedrich Schinkel, *Gothic Cathedral by the Water* 406

7.5 Karl Friedrich Schinkel, *Medieval City on a River* 407

8.1 Johann Gottfried Quistorp, vignette for Gotthard Ludwig Kosegarten's *Melancholien* 410

8.2 Jens Juel, *Portrait of Mme de Prangins in Her Park* 421

8.3 Jens Juel, *Portrait of Horace-Bénédict de Saussure* 421

8.4 Nicolai Abildgaard, *Achilles among the Daughters of Lykomedes* 422

8.5 Philipp Otto Runge, copy of plate 17, vol. 2, *Peintures des vases antiques de la collection de son excellence M. le chevalier Hamilton* 422

8.6 Plate 17 of Hamilton's *Vases antiques* 423

8.7 Philipp Otto Runge, copy of plates 27 and 61 of Hamiltons' *Vases antiques* 423

8.8 Plate 27 of Hamiltons' *Vases antiques* 424

8.9 Plate 61 of Hamilton's *Vases antiques* 424

8.10 Philipp Otto Runge, *Head of Meleager* 424

8.11 Philipp Otto Runge, *The Effect of the Comic and Tragic Masks* 425

8.12 Philipp Otto Runge, *The Nightingale's Lesson* 425

8.13 Philipp Otto Runge, *The Triumph of Amor* 425

8.14 Philipp Otto Runge, figure of Creation in *Farbenkugel* 431

8.15 Philipp Otto Runge, diagram of color symbolism in *Farbenkugel* 431

8.16 Diagram in Runge's *Farbenkugel* 432

8.17 Diagram in *Annalen der Physik* 432

8.18 Philipp Otto Runge, *Achilles and Skamandros* 438

8.19 John Flaxman, *Achilles Contending with the Rivers* 438

8.20 Philipp Otto Runge, *The Return of the Sons* 446

8.21 Philipp Otto Runge, *The Birth of Fingal: His Father Comhal Killed in a Duel* 448

8.22 Albrecht Dürer, *The Resurrection* 449

8.23 Philipp Otto Runge, *Fingal with Raised Spear* 450

8.24 John Flaxman, *Beatific Image* 450

8.25 Philipp Otto Runge, *Ossian* 451

8.26 Philipp Otto Runge, *Oscar* 452

8.27 Philipp Otto Runge, *The Source and the Poet* 453

8.28 Philipp Otto Runge, *The Mother at the Source* 453

8.29 Philipp Otto Runge, *Rest on the Flight to Egypt* 457

8.30 Philipp Otto Runge, study for *Rest on the Flight to Egypt* 458

8.31 Philipp Otto Runge, *We Three* 460

8.32 Philipp Otto Runge, *The Hülsenbeck Children* 461

8.33 Title page of Lorenz Oken's *Zeugung* 464

8.34 Philipp Otto Runge, *The Artist's Parents*, detail 466

8.35 Philipp Otto Runge, *The Artist's Parents*, detail 467

8.36 Philipp Otto Runge, preliminary sketch for *The Artist's Parents* 467

8.37 Philipp Otto Runge, *Louise Perthes* 468

8.38 Popular image of the Jungfernsteig, looking north 468

8.39 View of Jungfernsteig, looking south 469

8.40 Photograph of the Lombardsbrücke and windmill 469

8.41 Photograph of the Lombardsbrücke after the fire of 1842 469

8.42 Philipp Otto Runge, *Arion's Sea Journey* 470

8.43 Philipp Otto Runge, *Nightingale's Bower* 471

8.44 Philipp Otto Runge, *The Joys of the Hunt* 472

8.45 Carolus Linnaeus, *Hernandia*, plate 23, *Hortus Cliffortianus* 473

8.46 Carolus Linnaeus, *Cliffortia*, plate 32, *Hortus Cliffortianus* 474

8.47 Jan Wandelaar, frontispiece for Linnaeus's *Hortus Cliffortianus* 475

8.48 Philipp Otto Runge, study of cress 476

8.49 Philipp Otto Runge, leaves and blossoms of cress 476

8.50 Philipp Otto Runge, *Cornflower* 477

8.51 Engraving of *Amaryllis* from Erasmus Darwin's *The Botanic Garden* 478

8.52 Philipp Otto Runge, *Amaryllis formosissima* 479

8.53 Philipp Otto Runge, *Morning* 481

8.54 Philipp Otto Runge, *Evening* 483

8.55 Philipp Otto Runge, *Night* 484

8.56 Philipp Otto Runge, *Day,* or *Noon* 485

8.57 Philipp Otto Runge, *Morning* (small version) 487

8.58 Philipp Otto Runge, *Morning* (large version) 487

8.59 Frontispiece for Gotthard Ludwig Kosegarten's *Legenden* 494

8.60 German lodge jewels, plate 30 of R. F. Gould's *History of Freemasonry* 495

8.61 Berlin lodge medal, Plate 25 of Gould's *History of Freemasonry* 496

8.62 Frankfurt lodge jewel, plate 28 of Gould's *History of Freemasonry* 496

8.63 Philipp Otto Runge, *Vivat 1801* 497

8.64 Hamburg lodge medal, plate 2 of Gould's *History of Freemasonry* 497

8.65 Karl Friedrich Shinkel, *Die Zauberflöte* 498

8.66 Philipp Otto Runge, *New Year's Card* 501

8.67 Philipp Otto Runge, *The Fatherland's Fall* 502

8.68 Philipp Otto Runge, *Plight of the Fatherland* 503

8.69 Philipp Otto Runge, *Plight of the Fatherland* 504

8.70 Carolus Linnaeus, *Folia simplicia*, plate 1 of *Philosophia botanica* 505

8.71 Carolus Linnaeus, *Folia determinata*, plate 3 of *Philosophia botanica* 506

8.72 Carolus Linnaeus, *Partes flores,* plate 7 of *Philosophia botanica* 507

8.73 Philipp Otto Runge, *Saint Peter on the Waves* 507

9.1 Caspar David Friedrich, drawing of male figure from academic copybook 510

9.2 Model from Johann David Preissler's *Die durch Theorie erfundene Practic* 513

9.3 Caspar David Friedrich, *Male Nude* 514

9.4 Jens Juel, *The Little Belt, Seen from a Height near Middelfart* 515

9.5 Jens Juel, *View of Hindsgavl* 516

9.6 Jens Juel, *A Thunderstorm Brewing behind a Farmhouse in Zealand* 516

9.7 Caspar David Friedrich, *Emilie's Spring* 518

9.8 Caspar David Friedrich, *Landscape with Pavilion* 518

9.9 Bernardo Bellotto, *The Old Market, Dresden, from Schlosstrasse* 519

9.10 Bernard Bellotto, *Dresden from Right Bank of the Elbe, before the Augustsbrücke* 520

9.11 Bernardo Bellotto, *The Old Fortifications of Dresden* 520

9.12 Caspar David Friedrich, *Greifswald Marketplace* 521

9.13 Bernardo Bellotto, *Marketplace of Pirna* 521

9.14 Adrian Zingg, *Landscape near Tharandt* 522

9.15 Caspar David Friedrich, studies of plants 523

9.16 Caspar David Friedrich, studies of plants 523

9.17 Caspar David Friedrich, *Farmhouses at the Foot of a Mountain* 524

9.18 Caspar David Friedrich, pencil and ink drawing for *Farmhouses at the Foot of a Mountain* 524

9.19 Caspar David Friedrich, *Rocky Crag with Caves and Masonry* 525

9.20 Caspar David Friedrich, *Schloss Kriebstein* 526

9.21 Caspar David Friedrich, *Manor House near Loschwitz Overlooking Elbe Valley* 526

9.22 Caspar David Friedrich, *Glass Factory in Döhlen* 527

9.23 Title page of Gotthard Ludwig Kosegarten's *Poesieen* 530

9.24 Caspar David Friedrich, *Stubbenkammer* 530

9.25 Caspar David Friedrich, *Prospect from Rugard towards Jasmund* 531

9.26 Caspar David Friedrich, *Königsstuhl* 531

9.27 Caspar David Friedrich, *View of Arkona with Shipwreck* 532

9.28 Caspar David Friedrich, *View of Arkona with Rising Moon and Fishnets* 532

9.29 Caspar David Friedrich, *View of Arkona with Sunrise* 533

9.30 Caspar David Friedrich, *View of Arkona with Rising Moon* 533

9.31 Title page of Gotthard Ludwig Kosegarten's second volume of *Poesieen* 534

9.32 Caspar David Friedrich, *Spring* 535

9.33 Caspar David Friedrich, *Summer* 536

9.34 Caspar David Friedrich, *Autumn,* or *Evening* 536

9.35 Caspar David Friedrich, *Winter* 538

9.36 Caspar David Friedrich, *Die Räuber,* act 1, scene 2 540

9.37 Caspar David Friedrich, *Die Räuber,* act 5, scene 7 541

9.38 Philipp Otto Runge, illustration for Ludwig Tieck's *Minnelieder* 542

9.39 Caspar David Friedrich, *Traveler at the Milestone* 542

9.40 Caspar David Friedrich, *Woman with Spider's Web between Bare Trees* 543

9.41 Albrecht Dürer, *Melancholia I* 543

9.42 Caspar David Friedrich, *Woman with a Raven on a Precipice* 544

9.43 Set of mechanical wings in *Annalen der Physik* 545

9.44 Caspar David Friedrich, *Boy Sleeping on a Grave* 546

9.45 Caspar David Friedrich, *Landscape with Sunrise* 560

9.46 Caspar David Friedrich, *Mountain Landscape* 561

9.47 Caspar David Friedrich, *Procession at Sunrise* 563

9.48 Caspar David Friedrich, *Morning Fog in the Mountains* 564

9.49 Caspar David Friedrich, Tetschen altarpiece 565

9.50 Detail of plate 30, R. F. Gould's *History of Freemasonry* 580

9.51 Caspar David Friedrich, *Monk by the Sea* 581

9.52 Caspar David Friedrich, *Monk by the Sea,* detail 582

9.53 Caspar David Friedrich, *Self-Portrait* 583

9.54 Map of Rügen 592

9.55 Photograph of Arkona 592

9.56 Beaufort wind scale, number 5 593

9.57 Photograph of early morning fracto-stratus clouds over the Pacific Palisades, California 594

9.58 Caspar David Friedrich, *Seashore with Fisherman* 594

9.59 Caspar David Friedrich, *Abbey in the Oakwood* 601

9.60 Caspar David Friedrich, *Landscape with a Rainbow* 604

9.61 Caspar David Friedrich, *Mountain with a Rainbow* 605

9.62 Caspar David Friedrich, *Morning in the Riesengebirge* 607

9.63 Caspar David Friedrich, *Landscape in the Riesengebirge* 610

9.64 Caspar David Friedrich, *View from the Terrace of the Erdmannsdorf Estate* 614

9.65 Caspar David Friedrich, *Cross in the Mountains* 621

9.66 Caspar David Friedrich, Gothic monument of type promoted by Karl Friedrich Schinkel 622

9.67 Caspar David Friedrich, *Gravestone with Knight's Helmet* 623

9.68 Caspar David Friedrich, *Old Heroes' Graves* 624

9.69 Georg Friedrich Kersting, *At the Advance Post* 626

9.70 Caspar David Friedrich, *Cave with Tomb* 626

9.71 Caspar David Friedrich, *The Chasseur in the Woods* 627

9.72 Théodore Géricault, *Wounded Cuirassier Leaving the Field of Battle* 628

9.73 Théodore Géricault, *Charging Chasseur* 629

9.74 Caspar David Friedrich, *The Cross on the Baltic Sea* 629

9.75 Caspar David Friedrich, *Traveler above the Fog* 633

10.1 Antonio Canova, *Napoleon as Mars* 636

10.2 Antonio Canova, *Pauline Borghese as Venus Victrix* 641

10.3 Giacomo Spalla, *Battle of Jena* 644

10.4 Giacomo Spalla, *Coronation* 645

10.5 Giacomo Spalla, *Battle of Eylau* 645

10.6 Andrea Appiani, fresco celebrating Napoleon's victories 646

10.7 Andrea Appiani, *The Triumph of Jupiter-Napoleon, Dominating the World* 647

10.8 Pietro Benvenuti, *The Oath of the Saxons to Napoleon after the Battle of Jena* 649

10.9 Vincenzo Camuccini, *Charlemagne Summoning Italian and German Scholars to Found the University of Paris* 652

10.10 Vincenzo Camuccini, *Ptolemy II Philadelphus among Scholars Brought to the Library of Alexandria* 653

Introduction

This volume continues the social history of art through the period of the first Napoleon, roughly 1800–1815. I call it *Art in an Age of Bonapartism*. Engels's celebrated observation that the course of European history would have been no different if Napoleon had never lived is theoretically correct, or, at the very least, one that I would not wish to dispute. Ten years of unceasing upheavals and conflict, of the enormous drain on human lives, of skewed priorities and continued economic injustice, of just plain taut nerves and disillusionment, gave rise to a situation begging for a symbolic savior. Indeed, military leaders were the only national heroes in this demoralized epoch. For this reason I have refrained from entitling this work "Art in an Age of Napoleon," which might conjure up the machismo shades of Great Men past. It is not the person—after all, if it had not been the Corsican who arrived Johnny-on-the-spot then the dominant elite would have found another daring adventurer—but the ideological system fostered during the period of his power that I wish to emphasize in using the term "Bonapartism."

At the same time, it is necessary to get beyond the sign comprising the signifier "Napoleon" and its tyrannical signified. Certain of his institutional and social reforms proved durable enough to survive his demise for over a century. Not only domestically, but externally, he spread his ambitious programs to encompass the Continent. His destruction of the remnants of feudalism in the nations he occupied set contradictory forces of change in motion, for nationalism, liberalism, and reaction alike were generated by his presence. But we have to divest ourselves of the historical and visual clichés still clinging to the Napoleonic myth to glimpse the wider signification of his contribution.

Napoleon enjoyed a singular advantage in his rise to power. The new type of polity, the new kind of warfare, a national army, and the mobilization of an entire people were ready beforehand. The structure put in place by the Revolution supplied him with the most advanced mechanism to combat his vastly outmoded European antagonists. He fought a series of anciens régimes—atrophied empires, corrupt oligarchies, benevolent despotisms, and divided societies—still encumbered with the fossilizations of bygone eras. His claim to the legacy of the Revolution rested on precisely this hostility to old regimes everywhere, and he had to keep on fighting them to maintain his authority. His enemies hesitated until the end to imitate the French system, to call their peoples into partnerships with them for the purpose of overthrowing the Evil Empire; they knew that this would entail a tradeoff that would push them closer to Jacobinism, ultimately unleashing a monster that would endanger their own position.

Napoleon, however, benefiting from the clearing operations of the French Revolution, could reconstruct on a far larger scale than all previous rulers and thus more easily justify his authoritarian measures. Dedicated republicans and diehard ultraroyalists were never reconciled to his regime, but his eclecticism, effective propaganda, and charismatic personality won over a sizable segment of a divided France. Above all, his consolidation of bourgeois dominance permitted him to build an orderly, hierarchical society to counteract the most progressive of revolutionary social reforms. Under Bonaparte local elections, which the Revolution had engendered, were virtually eliminated. Officials were appointed, severely limiting local autonomy and self-government. His defense of the equality of opportunity unfolded only within the perimeters of his master plan. He used the state's vast appointive powers to confer status on regional dignitaries recruited from among the prosperous landowners and middle class, and he associated the new-rich with his regime under a brilliant patronage system.

Napoleon helped consolidate bourgeois hegemony in more practical ways. His government issued compulsory labor I.D. cards to give employers control over their worker's movements, while labor associations and strikes were expressly forbidden. Leading bankers—predominantly Protestant and non-noble prior to Napoleon—realized their long-standing ambition to have a national bank chartered under their control and at the same time enjoyed the

credit power derived from its affiliation with the state. Under Bonaparte, elite secondary schools known as *lycées* were founded to produce high-level administrators and officers. These were in turn united with a centralized academic system which dominated French education deep into our own time, with a huge bureaucracy put in place to regulate educational affairs down to the smallest detail of curriculum. Napoleon dreamed of a complete control over the shaping of French youth—male youth, of course, for he had no interest in the education of women.

Another durable legal codification covered social relations and property rights. Napoleon participated in the discussions and drafting of the Civil Code, renamed the *Code Napoléon* in 1807, which guaranteed fundamental departures from the practices of the ancien régime. Feudal aristocracy and the property relations deriving from it were abolished, and all male citizens could now exercise unambiguous contractual ownership. The code established the right to choose one's occupation, to be treated equally before the law, and to enjoy religious freedom. Liberals throughout Europe admired this document, and it often made them receptive to his invading armies.

At the same time, it confirmed the sanctity of private property and of patriarchal family life. Property rights were not balanced by anything resembling a right to subsistence. It undid revolutionary legislation that established the civil liberties of women and children and restored the father's absolute authority in the family. The code declared that a wife owes absolute obedience to her husband, and it deprived her of property and judicial rights granted her during the Revolution. Napoleon's famous acknowledgment of divorce applied only to the husband. Penal codes and criminal procedures also rolled back revolutionary progress; the rights of defendants and the role of juries were both curtailed.

Police-state methods under Napoleon were perhaps worse than during the ancien régime and crushed genuine political activity and debate in French life. The large police ministry he inherited from the Directory was placed under the control of Joseph Fouché, an unscrupulous ex-Jacobin, who was charged with eliminating organized opposition and dissent. Newspapers were reduced in number and drastically censored; the freedom of the press spawned by the Revolution was replaced by government-managed news and sophisticated campaigns of propaganda and disinformation. The activities of the presumed opponents of

the regime were monitored by a secret network of police spies.

Opposition was reduced to clandestine plotting or passive resistance in such forms as desertion from the army. Not coincidentally, the Napoleonic period fostered the growth of secret societies abroad, based more or less on the Masonic model, which encouraged the nascent nationalist feelings of occupied peoples. At home, several conspiracies formed, but they became less of a threat than a useful tool for Napoleon to exploit in justifying political repression. Nevertheless, the machinery was set in place for an underground political opposition that would perfect itself during the Restoration and be the bane of Metternich's police.

Bonaparte's actions in the religious domain were designed to promote stability at home and curry favor abroad. An agreement with the church would dissociate Catholicism from royalism and undercut the counterrevolution, pacify the Vendée, and reassure the bourgeoisie and well-to-do peasants who had bought the nationalized lands of the church. The Catholic world had stigmatized the Revolution as atheistic, and Napoleon concluded that concessions to Catholic sentiment could be made if they were carefully controlled by the state. He proceeded to negotiate the famous Concordat of 1801 with Pope Pius VII, which recognized Catholicism as "the religion of the great majority of the citizens" (not, as the pope hoped, as the "established" or "dominant" religion) while also protecting the freedom of conscience and worship for other cults. Bishops were again instituted by the pope, but they were nominated by the First Consul. Primary education was more or less turned over to the clergy, but clerical salaries would be paid by the state. Napoleon intended to fill the clerical ranks with a view to retaining their allegiance through self-interest and persuaded them to produce loyal citizens. He was more concerned with developing faithful subjects than faithful Christians. To this end he managed to sustain one major revolutionary change but only with some hard bargaining: lands confiscated from the church and sold during the Revolution were to be retained by their purchasers.

Napoleon's economic policies were connected above all to his encouragement of industry, using exhibitions, special orders, honors for inventors, and sometimes even concessions in the form of buildings or advances. His knowledge that England's machinery gave his enemy a decided advantage spurred his own efforts in behalf of technical progress. He aided Douglas to set up a factory in Paris to

produce machinery for the woolen industry, and invited open competition for several inventions, such as a light steam engine in 1807 and a flax-spinning loom in 1810. He promoted schools of arts and crafts, opened mining schools to compete with Werner's at Freiberg, resurrected the Gobelins dyeing school (soon to become famous for the experiments of Chevreul), added a practical course to the Conservatoire des arts et métiers, and encouraged the use of new procedures and tools. His scheme for a united Europe set him to developing the road and canal system to knit together the national markets and link them to the vassal countries.

Napoleon's hegemony and reconstitution of the state and of national life profoundly affected European culture. He was determined to play the role of a Maecenas, recalling from his readings into history that every great ruler had his or her *siècle*. Inevitably he politicized the annual Salon so that it became a channel for official propaganda: the title page of the catalogue for the 1808 exhibition, which opened on 14 October, included the commemorative phrase "Second Anniversary of the Battle of Jena." In 1804 he established the decennial prizes for art which were awarded for the first time in 1810. He aimed to control literary and visual practice through censorship, the academies, and the French Academy at Rome. He exercised authority over theaters by limiting their numbers and assigning to each one a particular style of play or musical category to perform. His obsession with prestige was translated into major attractions and improvements carried out in Paris, where he built the Bourse and the Vendôme Column, undertook the construction of the Arc de Triomphe, and planned a Temple de Gloire to build up the Napoleonic legend. He clearly felt at ease in promoting the arts, particularly architecture, since he bought and built on a grand scale.

With the advent of Napoleon the neoclassical hero takes over the central slot traditionally reserved for the monarch and the theme of collectivist action (still apparent in David's *Sabines*) moves over to make room for the dominant loner. The Napoleonic hero is not of royal or noble descent, but is elevated to the status of monarch through insertion in the conventional visual sign system. Thus the preservation of the semiotics of kingly representation preserved the visual configuration of the social hierarchy while at the same time suggesting that commoners could aspire to the apex of the pyramid. The promise of freedom and

equality of opportunity within an orderly, hierarchical society is the basic subtext of David's *Coronation of Napoleon*. Who could deny that Napoleon's artists helped create the powerful secular myth of the common man rising to greatness on the basis of sheer personal talent?

Yet a regime achieving power through usurpation could not depend on convention alone to preserve itself. Just as Napoleon had to wage and win wars to sustain actual power, so he had to mobilize, manipulate, and marshal imagery of every stamp to maintain control of the crosscurrents of the hegemonic process. The originality of much imagery in this period inheres in just this element of tentativeness, hence the unexpected bursts of fantasy and escapism on to a grid of documentary realism. The ideological disguise of the contradiction of domestic repression and foreign "liberation" penetrated to the very roots of contemporary culture, giving rise to bizarre pictorial combinations of naturalism and wild exaggeration. The catastrophic consequences of the Napoleonic era—there were nearly a half million French casualties alone—had to be realistically confronted up to a point and transcended by the propaganda machine. This juggling act explains in part the hybridized imagery of these years.

Not the least of the mythmakers was Beethoven, who dedicated his *Eroica* Symphony (1804) to Napoleon as the heir of the French Revolution and then revoked the dedication after hearing of the proclamation of the empire. It is no coincidence that the movement we call romanticism coalesces in Europe during the period of Napoleonic hegemony. The young German thinkers were rapidly impelled by the French invasions and their own self-interests to a return to the medieval past. Their denunciation of classicism became the basis of their counterrevolutionary position. Compared to those of the French artists, their protagonists were more consistently displaced from the center and their themes dealt increasingly with the fragment, the folktale, and legend which decentered the hero and spoke to collective anxieties and national feelings.

The idea of a popular uprising against the Great Satan was inseparable from the literary idealization of the primitive German warrior under the command of Hermann in the middle of primeval forests, defying the Roman legions who were the instruments of despotism, and of the revolt of William Tell and the German Swiss, which Schiller's masterpiece added to the national heritage in 1805. But it had its immediate roots in the example of the revolt in

Spain, which raised excitement to a fever pitch everywhere Napoleon's enemies agitated. From July 1808 onwards European newspapers, pamphlets, and speeches proclaimed the insurrection, and it had the tacit approval of the various governments. Its complex origins enabled it to win the approval of all parties: the nobility saw the Spaniards as faithful subjects, the republicans as free people rising up against their oppressors, and the politicians as good citizens who had hastened to the side of the regular army. It was precisely this multifarious interpretation that permitted Goya to choose the theme of *The Third of May, 1808* as a celebratory statement for the return of the vicious Fernando VII six years after the event.

The decentering of the hero countered self-centered despotism, and the parallel political responses of nationalism ran head-on with its formidable foe. Even at home patriotism gave the nation an awareness of its own long-term interests and eventually worked against Napoleon's personal power. Externally, nationalism, fused with religious zeal to build popular resistance to afflict the invader and to expel his presence. The Spanish constitution of 1812 was the result of renewal of Spanish political life generated by the need to resist him. It was to set the example of European liberalism during the Restoration years. Writers and artists in occupied lands deployed their skills as a counterforce to the Napoleonic myth of invincibility. And it is precisely this interplay of cultural and political forces that comprises the subject of the second volume of this series. Napoleon's attempt to bring all parties under the imperial aegis to create the new social hierarchy expressed itself culturally as the heroic center rent by a gaping wound. Abroad, his attempts at control and territorial rearrangements concentrated culture through the funnel of nationalism and set in motion the forces that toppled him. Yet despite the fact that he had instituted the most rigorous despotism, it was in his name that the constitutional reign of the Bourbons and the kings of the Holy Alliance would be opposed.

I *The Adversaries*

DESCRIPTION
DE L'ÉGYPTE,

OU

RECUEIL

DES OBSERVATIONS ET DES RECHERCHES

QUI ONT ÉTÉ FAITES EN ÉGYPTE

PENDANT L'EXPÉDITION DE L'ARMÉE FRANÇAISE,

PUBLIÉ

PAR LES ORDRES DE SA MAJESTÉ L'EMPEREUR

NAPOLÉON LE GRAND.

———

ANTIQUITÉS, PLANCHES.

TOME PREMIER.

A PARIS,

DE L'IMPRIMERIE IMPÉRIALE.

M. DCCC. IX.

1 The Napoleonic Era (1800–1815)

Napoleon was born at Ajaccio, Corsica, on 15 August 1769—the year the French completed the subjection of the island. Ironically, an insurrection on Corsica had all but wrested the tiny nation from Genoa, whose sovereignty it had endured for centuries, when France moved in to frustrate the drive for independence. This occurred during the Seven Years' War, when Genoa threw its support behind France in return for aid in its contest with Corsica. Not unlike the later alien intrusions of the United States and the Soviet Union into the affairs of tiny nations beleaguered by rebellion, on the pretext of preserving their presumed spheres of interest, France soon shouldered the complete burden of the contest and secured the island for itself. The Corsicans went right on fighting the French just as they fought the Genoans, until they succumbed in the spring of 1769. Napoleon's birth coincided with the end of insurrection and annexation of a small nation to a larger political entity. Thus his entire career may be seen as the recapitulation of the conditions of his first few months of infancy.

His father, Carlo Buonaparte, was an attorney who made peace with the French invaders and rose to high office in the administration of Corsica. His mother, Maria Letizia (née Ramolino), governed the large household (eight of thirteen children survived infancy) with a firm hand and maneuvered to insure that the elder sons were educated in French institutions at the king's expense. Through the influence of the French governor of the island, she and Carlo secured for Napoleon a charity scholarship at Brienne, one of the twelve royal schools founded in 1776 by Saint-Germain, Louis XVI's minister of war, to prepare the sons of nobles for a military career.

Here the die was cast for him to be a soldier, a die forged

in the wreckage of the same Seven Years' War that cost Corsica its independence. The bitter defeat sustained by France gave rise to the reorganization of the army in the hopes of a future contest with England. The new military manuals emphasized the need for tighter discipline and zealousness to regenerate the French state. Louis XVI intensified his father's program under the impact of the American revolution, and schools like Brienne subjected its preadolescent pupils to a monastic routine lasting eight hours a day. Napoleon's demonstrated aptitude for mathematics eventually led to his nomination in 1784, in a patent signed by Louis XVI, to a place at the Ecole militaire in Paris.

The same year Jacques-Louis David painted the *Oath of the Horatii*. The theme of the oath binding the sons to the father, and by extension to the "fatherland," required the representation of the uncompromising discipline and obedience advocated by the French state to reorganize the army and regenerate the state. The watchword *vaincre ou mourir* (conquer or die) became the formula of both the military manual and the new patriots. Thus the shaping forces in French national life converged on the careers of two of the epoch's most prominent figures, leaders in their respective domains. The Revolution, which succeeded in mobilizing the masses through the model of discipline advocated by the crown, catapulted both into celebrity status and made it possible for the two of them to come together during the aftermath.

Their parallel interest in Plutarch, Livy, and especially Rousseau predisposed them early on to a liberal ideology, and their sense of social inferiority urged them to direct action. Both became associated with the Jacobins, which got them into trouble during the reaction that followed the fall and execution of the Robespierre faction in July 1794 (*thermidor*). Eventually they were cleared and made their peace with the government of the Directory. Napoleon was appointed head of the Army of the Interior, and in March 1796, following his marriage to Joséphine de Beauharnais, he assumed command of the Army of Italy. It was during the Directory that David first attempted to paint Bonaparte, a portrait (never completed) planned to show the general holding the Treaty of Campo Formio (18 October 1797) which gave him authority over virtually the whole of the Italian peninsula.

Napoleon's success in the first Italian campaign gave him an aura of antique heroism and won him great popularity

in the French capital. The prestige of his victories and the money that flowed from his military plundering gave him the whip hand over the government. His treaties and annexation plans were ratified, and by the end of the campaign he barely troubled to disguise his contempt for the Directory and his ambition to seize power in France. He remarked to his entourage, "Do you suppose that I gain victories [in Italy] to increase the glory of the lawyers in the Directory?"[1]

With the support of the foreign minister, Charles-Maurice de Talleyrand—who advocated a new policy of colonialism—Bonaparte persuaded the government to switch its plans from an invasion of England to an expedition to Egypt. Napoleon hoped that by conquering Egypt he could gain a foothold through which to get at the English in India and add to his stature. On 12 April 1798 Napoleon was ordered to seize Egypt to assure "the free and exclusive possession of the Red Sea" and also to explore the possibility of a canal to link it with the Mediterranean.

The fleet sailed in May, but Talleyrand wrongly estimated the intentions of the Turks, and a coalition of Turkey, Russia, England, and Austria succeeded in keeping France out of the Levant. Admiral Nelson's victory over the French fleet at Aboukir was decisive in bringing about this coalition, and the Directory withdrew its ambitions to colonize Egypt. Napoleon left secretly for Paris in August 1799, leaving orders, if no help came, to negotiate with Turkey for evacuation. The terms accepted by his successor, Kléber, however, were nullified by renewed fighting; on Kléber's death, General Menou, who had embraced Islam, capitulated to the British.

Perhaps the Egyptian episode is more important for demonstrating a significant aspect of Napoleon's tactics, what may be called his "cultural imperialism." He made use of the new organization of the academies, now known as the Institut, as an instrument for transmuting French ethnographic and archaeological studies into cultural hegemony. As a member of the Institut himself, he took with him to Egypt in 1798 an entire staff of scientific camp followers—geologists, mineralogists, archaeologists, cartographers, naturalists—headed by Monge, Dolomieu, Berthollet, and Geoffroy Saint-Hilaire. Upon arrival they organized themselves into the Institute of Cairo, which still exists. It was during this period that the Rosetta stone was discovered and its hieroglyphs deciphered by Champollion; the science of Egyptology which this group

1.2 Frontispiece for *Description de l'Egypte*, 1809.

bequeathed to history exemplifies the contribution of nineteenth-century intellectuals to the colonializing process.

Although the Egyptian expedition was stopped dead in its political and military tracks, its role in the Napoleonic legend became a central preoccupation of the propaganda machine. The scientific results of the expedition were inscribed in a massive series of volumes published between 1809 and 1828—a testament to imperial might as weighty as the Arc de Triomphe and the pomp of the *Sacre*.[2] Despite the pretense of the *Description de l'Egypte* to scientific accuracy and thoroughness, its ideological motivation shows through vividly in its remarkable title page and frontispiece (figs. 1.1–2). The frontispiece reveals a plunging perspectival view of Egypt seen through an imaginary temple doorway that embraces all the principal monuments, analogous to the kind of visual cultural appropriation we have seen in the fanciful galleries of Gian Paolo Panini stocked with the treasures of Roman antiquity (see vol. 1, *Art in an Age of Revolution*).

The topmost frieze of the portal depicts Napoleon in the guise of a Roman conqueror driving his chariot in pursuit of enemy Mamelukes, while a personification of the Nile contemplates his actions. The lower frieze has as its focal point the Napoleonic monogram, haloed by a crown and encircled with a serpent biting its tail. Moving in from both sides are the diverse Egyptian peoples paying homage to the Bonapartist symbol. The frontispiece illustrates one of the main themes of the preface, that Egypt's historical role was "to attract the attention of illustrious princes who rule the destinies of nations."[3] Here the great thinkers of antiquity went to study science, religion, and the law, and here Pompey, Caesar, Mark Antony, and Augustus decided among them "the fate of Rome and that of the entire world."

The preface of the monumental imperial production underlines the place of Egypt in world history, knowledge, and commerce. Yet the once great kingdom had long sunk into barbarism and was badly managed by the evil Ottoman empire. Thus the French expedition is justified as a "liberation" rather than as a "conquest." Led by its intrepid "hero," France has restored to Egypt its ancient glory and brought it up-to-date in the light of modern civilization. At the same time, France has demonstrated its own immense historical role by helping to realize Egypt's destiny. The preface concludes by a call to the artists, writers, scien-

tists, and historians to perpetuate the memory of Napoleon, to unite to "preserve his immortal traits, and transmit the brilliance of his triumphs to posterity." [4]

The Directory had no broad political foundations: it had to rely on that part of the bourgeoisie to whom the Revolution had brought some position of wealth through confiscated lands or war contracts. This had led to rampant corruption among the political leaders, which in turn generated divisions and threats from the Left and the Right. Bonaparte, though still believed to be in Egypt, landed unexpectedly at Fréjus on 9 October 1799. His defeats had not yet been revealed, and he was welcomed as a savior. Arriving in Paris five days later, he joined a conspiracy by several members of the Directory to participate in a coup that would restore order and put a new constitution in force. Seeing their offer as the gateway to power such as he already held in Italy and Egypt, Bonaparte stormed in on the flimsiest of pretexts to break up the Council of Five Hundred, while the deputies escaped out of the windows. The government was now disrupted, and a provisional administration made up of two directors and Bonaparte, known as consuls, was established. From the start, the Consulate assumed full power with Bonaparte as First Consul.

The apparently unbroken success of Bonaparte's career was the key to the political stability under the Consulate— a stability that promised to restore order at home and peace abroad. Napoleon relied on gifted people, such as mathematicians, scientists, jurists, rather than on professional bureaucrats. But the control imposed on France was strictly military: the Constitution of the Year 8 (24 December 1799) contained no declaration or guarantee of the Rights of Man, no mention of liberty, equality, or fraternity. But it reassured the new ruling class that the previous sales of national lands were irrevocable.

The First Consul was invested with vast legislative and executive powers. He alone could initiate laws and nominate ministers, generals, civil servants, magistrates, and members of the Council of State. Universal suffrage was restored, but steps were taken to render the concept absurd: electoral colleges composed of wealthy citizens elected for life selected the candidates; from these the senate made its choice. The legislative body was to pass or reject bills without debate; but it hardly ever rejected any.

The most significant and far-reaching of the Consulate's innovations was its administrative work: at the top, the Council of State played a decisive role. It was formed by

Bonaparte from the "men of talent" whom he particularly valued. The great step taken was to put people nominated by the government and subject to dismissal, at the head of the country's eighty-three regional *départements* and of the new urban divisions known as the *arrondissements*. These *préfets* and *sous-préfets* contributed to the centralization of the administrative apparatus. Under the Consulate and the Empire as well, the police—abetted by underground agents—was all-powerful and omnipresent. At the same time, special tribunals multiplied, arbitrary assets were numerous, and internments in state prisons by administrative action recalled the practices of the ancien régime.

The army received special attention. Napoleon ordered designs for special uniforms and did much to elevate the prestige of the troops. Broadly speaking, the army remained as the Convention and Directory had shaped it: recruiting by conscription (but allowing provision of substitutes), mixing young conscripts with veterans, and offering chances to the middle classes of promotion to the highest ranks. Napoleon smoothed the road to commissions for the bourgeoisie by creating the Ecole spéciale militaire de Saint-Cyr for training infantry officers, while the increasingly militarized Ecole polytechnique supplied officers well schooled in mathematics and science for the artillery and engineers. Both schools were given the highest priority by Napoleon.

The gigantic administrative reorganization, involving state appointments to a large number of well-paid posts, gave Bonaparte the opening for a work of reconciliation. Wanting as wide a political base as possible, Bonaparte looked for support from the Right as well as from the Left, and his most successful method of winning sympathy was to appoint people from all sections of the political world to the new posts that were opening. He also opened wide the door to the émigrés, a majority of whom now came home.

Napoleon wanted to shape the state of French society in a permanent way as a reaction to the schisms that had been dividing France since the 1790s, and to facilitate administrative control. The foundations of his new plan were the Civil Code and Concordat. Bonaparte felt that the people needed a religion, and he himself wanted the support of Rome, a rapprochement that was favored by historical circumstances. Pope Pius VII assumed the papal throne almost at the same time that Bonaparte became First Consul, and he kept abreast of Napoleon's rise to temporal power. Negotiations started in September 1800 and ended the fol-

lowing year with the signing of the Concordat. The law of 8 April 1802 which promulgated the Concordat contained a number of regulations that severely limited the freedom of the church. By it, Napoleon hoped to check ultramontane encroachment and to reassert the political Gallicanism of the old regime. Communication between the French clergy and Rome was restricted, and a chain of control was forged which ran from the government through the episcopate to the lower clergy, many of whom were now removable from their posts at the will of their bishop. The pay of the clergy was also now in the hands of the state, thus assuring a large measure of control in the secular domain. Napoleon used the Concordat for his own purposes, to lend religious sanction to his authority and inculcate the people through the clergy. The Protestant and Jewish institutions were also brought under control. The rabbinate was organized according to regions, like the *préfets*.

Anxious to regulate the Jewish religion as every other institution in his state, Napoleon revived the ancient body of the Great Sanhedrin in exchange for official recognition of Judaism and legal equality. While in some ways a strikingly modern appreciation of that community of interests linking emancipated and nonemancipated Jews of the Diaspora, in actuality Napoleon's reforms aimed at controlling the Jewish group and pressing it into the service of the state. Napoleon demanded of the Sanhedrin convoked in 1807 that its members state unequivocally whether there was anything in their religion that prevented Jews from being patriotic citizens, paying taxes, and serving in the

1.3 Anonymous, *Napoleon Restoring the Institutional Basis of the Jewish Religion,* 1806. Bibliothèque de la Ville de Paris, Paris.

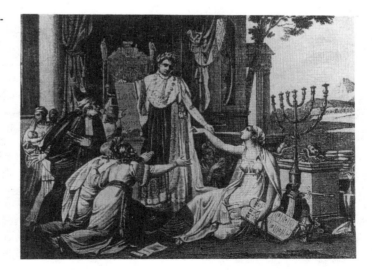

imperial armies. The official line was represented in a print of 1806 depicting Bonaparte as the New Moses restoring Judaism to its ancient status (fig. 1.3). The emperor supports the Ten Commandments with his right hand, while Jewish men and women genuflect before him in gratitude, reminiscent of the pyramidal compositions of black people abasing themselves before white emancipators. In both cases, the imagery sets up a social hierarchy treating the ethnic minority as subordinate and unified in devotion and concealing the positive actions of various factions in achieving their own emancipation.

The other achievement of Napoleon in this period was the Civil Code. The *Code Napoléon* was promulgated on 21 March 1804. It enshrined the great achievements of the Revolution: individual freedom, freedom of work, freedom of conscience, and the secular character of the state. As for equality, the code proclaimed all men equal before the law, at the same time safeguarding acquired wealth: its articles were largely devoted to defining, preserving, and protecting property, especially landed property. It had very little to say, however, about wages or salaries; on the pretext of a laissez-faire program it gave complete freedom to the employers. It even infringed equality of rights by stating that only the employer's testimony should be accepted in wage disputes. The code also ignored equality when it came to women. Although divorce was permitted, the legal rights of women were extremely restricted compared with those of men. Finally, slavery was reintroduced in the colonies (some of which were then in open rebellion). Like the Concordat, the Civil Code was a compromise between the old regime and the Revolution.

At this moment, Napoleon had insured peace by his great victories in Italy (Marengo, 14 June 1800) and in Germany (Hohenlinden, 3 December 1800); he succeeded in signing peace treaties with Austria at Lunéville in February 1801 and with England at Amiens on 27 March 1802. For the first time in ten years, Europe was at peace. But Bonaparte's ambition to rival Great Britain industrially and commercially led to renewed hostilities between the two countries. French cotton was doing well; imports of raw cotton had risen from 4,770,000 kilograms in 1789 to 11,000,000 in 1803–1804. Competitive awards were offered to inventors of new machines. To protect this growing industry and to prevent an outflow of gold which could hamper the new Bank of France, Napoleon, to the great disappointment of the British, imposed high protective tariffs.

Thus, a France that included Belgium and stretched as far as the Rhine closed its doors to British goods. As England could no longer benefit from prizes captured at sea, peace was less profitable for its trade than war.

The reopening of war against England in May 1803 revived royalist activities with which Bonaparte dealt harshly. The execution of the duc d'Enghien under trumped-up circumstances in March 1804 brought about a widespread reaction against the First Consul. Several plots were hatched against him; one he escaped by the narrowest margin when an "infernal machine" exploded as his carriage passed. The renewal of war inspired fresh conspiracies in which royalists and Jacobins joined forces with the aid of the officials of the British government.

In the wake of plot and counterplot (often fabricated by Napoleon's police) the senate offered the First Consul the imperial crown. The French people were asked to express their opinion in a referendum of 1804 which gave Napoleon a majority. The constitution now read like a political jigsaw puzzle as it was amended to declare that the government of the Republic "is now entrusted to an emperor, Napoleon Bonaparte, first consul, emperor of the French." The republic now had an emperor. Napoleon's powers were reinforced, the three assemblies became even less independent, and the influence of the Council of State was weakened.

More importantly, the imperial title was declared hereditary to Napoleon's descendants. Princely titles were revived for members of his family, and in 1808 a new imperial nobility was created. The court of the new emperor was organized on as magnificent a scale as the state. The etiquette and decorum of the ancien régime was restored; Napoleon now became infatuated with the pomp of ancient monarchical ceremony. Formal dress rehearsals were instituted, beginning with the coronation. Napoleon wanted to be crowned by the pope with more pageantry than the Bourbons. Pius VII hesitated, but his concern about the still fragile Concordat led him to finally accept the invitation to come to Paris. The ceremony took place in Notre-Dame on 2 December 1804. Like Charlemagne before him, the emperor took the crown from the pope's hands and set it himself upon his head.

Such measures hardly endeared him to the republicans, and further alienated the royalists. Napoleon shored up his political position by elaborating the propaganda techniques developed by the Revolution's leaders. Books that attacked

the rule of France were prohibited, censorship of the press became stricter, and the total number of newspapers was reduced. No political article could be printed unless it was copied from the official *Moniteur*. The theater was rigorously supervised, and Napoleon expressly forbade the staging of subjects with "times too near the present." When it came to painting, however, he preferred "national"—that is, Napoleonic—subjects to classical ones.

Napoleon especially looked to the visual arts for self-glorification.[5] His reason for accelerating the building of the Louvre is as good as any to explain his promotion of the arts; it was necessary for him, given his relatively ambiguous position among the rulers of Europe, to possess a grander palace than other sovereigns. By extension he had to keep on dazzling his own subjects to stay in place. He envisioned his projected Temple de Gloire as "a political monument" destined to influence "the national conditions of the day."[6]

What one associates with the costly objects of this period is their sheer weight and bulk, evident in the furniture and accessories as well as in architectural fantasies like the Arc de Triomphe and the Vendôme Column. The Vendôme Column was erected in 1810 by Jacques Gondouin and Jean-Baptiste Lepère to commemorate the campaign of 1805 when the Grande Armée defeated the joint Russian and Austrian forces at Austerlitz (fig. 1.4).[7] Crowning the column was an effigy of Bonaparte himself as a Roman emperor—a motif the sculptor Chaudet imposed on the reluctant Napoleon as the most appropriate avatar for a monument modeled after Trajan's Column in Rome. The new caesar held the globe of the world in his left hand, surmounted by an allegorical personification of Victory. The bronze used for the narrative band of battle scenes was taken from the cannons captured during the campaign of 1805. The shifting political circumstances during the emperor's reign disposed him early on to alter the original scheme: for a moment he hoped to enter into an alliance with Czar Alexander and even marry a Russian grand duchess, and the imagery of smashing French victories over Russian troops then seemed inappropriate. He ordered that scenes showing the French defeating the Russians be removed, but the strong protest lodged by his officers, whose honor they claimed would be compromised, forced him to back off from the proposed change. (Fortunately for him, since he wound up marrying the Austrian Marie-Louise).

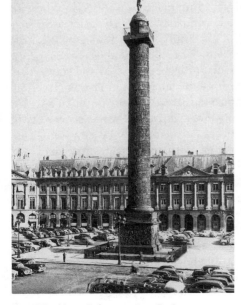

1.4 Vendôme Column, 1810. Paris.

1.5 Arc de Triomphe de l'Etoile, 1806–1836. Paris.

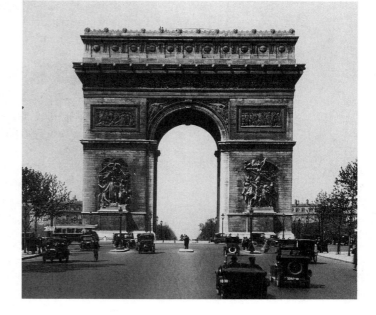

Napoleon admired the motif of the Roman triumphal arch, and during his regime the Arc du Carrousel (1806–1808)—another memorial to Austerlitz—and especially the colossal Arc de Triomphe de l'Etoile served as reminders that neoclassicism had divorced the Republic and married the Imperium (fig. 1.5). Designed by Jean-François-Thérèse Chalgrin in 1806, but completed only under the July Monarchy, it was meant to also celebrate the Grande Armée. Its massive proportions aimed at intimidating the population with Bonaparte's awesome power. The choice of location related to its heroic prospect from the Tuileries Palace, the symbolic center of France. Its placement at the Etoile (the threshold between Paris and Neuilly), an important entrance to the city and a spacious site frequented by promenaders, guaranteed a commanding and imposing presence near the "heart" of Paris, Saint-Germain, Saint-Cloud, and Versailles. But the arch had to be abandoned in a incomplete state in 1814—leaving the astonished Bourbons to contemplate the horrific monumental pile of masonry at the top of the Champs-Elysées.[8]

Napoleon aimed to impress by building higher, more massively, and more ornately than his predecessors. This required the kind of regimentation of bodies that only an emperor could command: just as he mustered the largest French army in history, so he had at his beck and call an

army of craftspersons, artists, and architects. With one army he acquired territory and wealth, with the other he acquired the means to express them.

Napoleon and Scientific Developments

Napoleon's success derived in part from his ability to employ existing technological innovations in the domestic and military spheres. He was proud of being a member of the Institut and had close relations with the leading French scientists, whom he frequently consulted on technical points. It is true that he dropped the military observation balloon unit that had first been used at the battle of Fleurus (1794); but at one point he drew up plans for invading England with a balloon corps. In 1802 he instructed Marmont, his weapons expert, to redesign the field artillery.

French science dominated Europe during the Napoleonic period. It was fostered by the revival of the academies in republican guise as the Institut national de France in 1795 which discharged the responsibility of the state for patronage of science, arts, and letters. Formerly conceived as embellishments of the monarchy, they now functioned as handmaids of civic welfare under the ministry of public education. The Institut consisted of three classes, science coming first in precedence with sixty resident members, moral and political science next with thirty-six, and literature and fine arts third with forty-eight. The classes resumed the functions of the old academy: to serve the science, literary, and art communities as a mecca for ambition and the guardian of standards, and the state as high court of technical resort.

The law of 25 October 1795, which founded the Institut at the summit, had as its main objective a system of universal education. An Ecole centrale would furnish secondary education in each department. These schools, forerunners of *lycée* and *gymnasium* alike, actually began work under the Directory. Science was the staple, taught for its practical importance in the affairs of a nation busy with conquest, commerce, and industry. The favorite subjects were drafting, mathematics, physics, chemistry, and natural history. We may recall how Napoleon expanded this program into conquered territories such as Egypt; the remarkable plates from the record of that expedition confirms the role of scientific knowledge in his schemes of domination (figs. 1.6–7).

The Conservatoire des arts et métiers was inaugurated

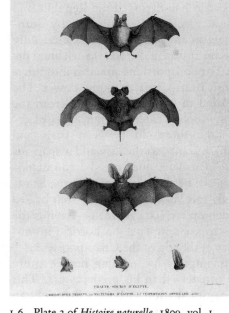

1.6 Plate 2 of *Histoire naturelle,* 1809, vol. 1, from *Description de l'Egypte.*

1.7 Plate 61 of *Histoire naturelle*, 1817, vol. 2, from *Description de l'Egypte*.

during the Directory, designed to house objects of technical value expropriated from enemies of the people. It built around this nucleus the first national museum of science and technology, and offered technical courses for tradespeople and artisans, including a special drawing school for young apprentices. The great institute of technology, energetically promoted by Napoleon, was the Ecole polytechnique, which became the nursery and model for all later engineering schools. It opened at the end of 1794 and succeeded mainly because it was supported by the professionals drawn from the former school of engineering at Mézières. There was now a scientific community to mobilize for war, able to handle supply, ordnance, communications, gunpowder, and fortifications.

The Polytechnique became a channel by which bourgeois idealism could manifest itself, the mainstream for conveying scientific culture in the nineteenth century. The school was paramilitary with an elite chosen by competitive examination. The course required four years of intensive scientific and mathematical preparation. Most of the major French mathematicians and scientists graduated from the school, including the engineers who joined with Saint-Simon to realize his utopian world of technology and public regeneration, and who under Napoleon III would construct railways and canals. In the class of 1814 was Auguste Comte, whose system of positivism became the most influential modern philosophy of science.

Napoleonic France equipped itself with a modern set of scientific institutions. When in 1804 Alexander von Hum-

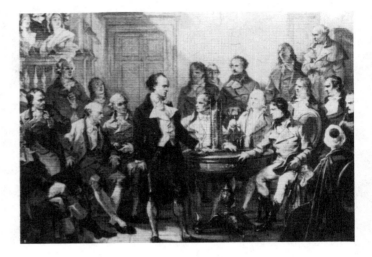

boldt returned from four years in the jungles and mountain regions of Latin America, it was to Paris that he brought his collections and his specimens, gathered during his pioneering geographical, botanical, and anthropological exploration.[9] There he displayed his findings to the members of the Institut. In 1801 Alessandro Volta was called to France to demonstrate for that same august body the electric current from a voltaic pile, the ancestor of all batteries.[10] On 7 November Volta began reading his famous memoir, "On the Identity of the Electrical Fluid with the Galvanic Fluid"—that is, current and static electricity. Galvani had claimed that the muscular convulsions of a frog's leg that occurred when he applied two different metals in contact with the frog's muscles were due to the electricity contained in the animal's nerves. Volta disagreed, claiming that it was not animal electricity that caused the convulsions but electricity produced by the contact between the two metals. Humboldt himself participated in the debate; he carried out thousands of electrical experiments on animals and plants and published the results in 1797. However, his failure to differentiate purely physiological and strictly electrical phenomena made his work obsolete once Volta performed his demonstrations. Volta himself wrote during this period that he succeeded in convincing all the doubting French physicists and chemists of the "identity of Galvanic fluid and electricity." At any rate, Napoleon witnessed Volta's experiments, attending the 7 November session and two later ones at the Institut (fig. 1.8). Napoleon awarded a gold medal to Volta and in his honor established an annual prize for the person whose experiments and dis-

coveries contributed to Galvanism "something comparable to that made by Franklin and Volta." His patronage of the scientists resulted in Volta's ennoblement in Italy, attesting to the First Consul's close identification, for both practical and symbolic purposes, with scientific innovators.

Napoleon threw himself with similar vigor into public works programs and the arts. The canal system begun under the Consulate and partially completed at the close of the Empire as planned on a vast scale and so well designed that it constituted the main design of France's internal navigation right through the nineteenth century. Prisoners of war were organized into "working companies," providing manual labor at next to no expense. The organization was directed by engineers from the Polytechnique and the Ecole des ponts et chaussées. The imperial palaces in the suburbs of Paris were restored and enlarged. In Paris the completion of the Louvre and the clearing of the Tuileries formed part of a general plan that aimed at making Paris *the* metropolis in Europe. Fabulous works of art, looted from conquered countries, poured in to enrich the Musée Napoléon at the Louvre.

He carefully cultivated scientists, writers, painters, sculptors, architects, decorative artists, and musicians to induce them to participate in Napoleonic image making. The Bonapartist regime offered a special decennial prize under the heading of "paintings representing an honorable subject for the national character," which inevitably glorified Napoleon's image. Decreed in 1806 and awarded for the first time in 1810, Napoleon's competition provided the occasion for documenting in a favorable mode a wide range of subjects, from the exotic landscape of colonized peoples to scenes of contemporary military, political, and scientific events.[11] This range is seen in the constellation of decennial prizes awarded to scholars, scientists, and artists such as Laplace, Berthollet, Cuvier, Montgolfier, David, and Girodet. The ancient academies had long since vanished before the new republican organism in which arts, sciences, and letters were amalgamated into the vast Institut de France. As First Consul, Napoleon reorganized the Institut in January 1803 and granted the fine arts, heretofore merged with the division of literature, independent class status. A *secrétaire perpétuel* and twenty-eight members, ten of whom were painters, constituted the new organization. One group, heretofore excluded, was added: that of the engravers, who now formed a special section. Napoleon needed engravers to produce the medals and awards he

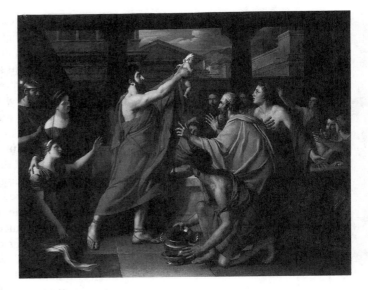

1.9 Alexandre-Denis Abel de Pujol, *Lycurgus Presenting the Heir to the Throne,* Prix de Rome of 1811. Ecole nationale supérieure des Beaux-Arts, Paris.

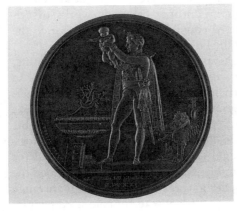

1.10 Medal of the baptism of the King of Rome, 1811. Rogers Fund, 1977. The Metropolitan Museum of Art, New York.

used to win over personnel, as well as to execute the precious materials for courtly pomp, and the three new members—Bervic, Dumarest, and Jeuffroy—were called upon to meet this demand.

Since its foundation in 1795 the Institut had been installed in the Louvre, where it occupied the space formerly reserved to the old royal academies. Napoleon, as emperor, decreed the foundation of a separate building for the corps in the Collège des quatres nations. The architect Vaudoyer was commissioned to transform the chapel into conference halls. Taking his cue from Louis XIV and Colbert, Napoleon took a special interest in the academy at Rome as a means of controlling art practice. He enacted the shift of the academy to its definitive location at the spacious and sumptuous Villa Médici on the Pincio in 1803. The Villa Médici belonged to the duke of Tuscany, son of the Austrian emperor; when Napoleon transformed the duchy of Tuscany into the kingdom of Etruria by the Treaty of Lunéville, authority was transferred to the young duke of Parma, to whom the Villa Médici now passed. Since Napoleon was the virtual ruler of Italy he ordered the new king to arrange the transfer of the property to the French nation. His influence and control extended right into the hallowed sanctuary of the academy's competition for the Prix de Rome, as is evident in the case of the 1811 contest. Not since the time of Louis XIV had the institution been subject to such direct pressure as in the contest of 1811, which presented as its subject *Lycurgus Presenting the Heir to*

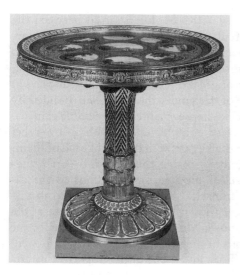

1.11 Sèvres table of the imperial palaces, 1811–1824. Private collection.

the *Throne* (fig. 1.9). Assigned one month after the birth of Napoleon's son, who was named the future king of Rome, it clearly derived from the dynastic ambitions of the current emperor. This is demonstrated by the fact that a contemporary medal struck especially to commemorate the baptism of the king of Rome shows Napoleon holding up his child exactly as Lycurgus does in the winning Prix de Rome entry (fig. 1.10).[12]

Napoleon's effigy was diffused throughout the empire; busts were mass-produced at Carrara, where workshops organized by his sister Elisa produced up to five hundred a year. Silk hangings produced at Lyons for the imperial palace at Meudon were brocaded with symbols of war, the arts, sciences, and trade. The Gobelins tapestry works made screens and portieres (door hangings) representing the *Arms of the First French Empire,* the *Genius of Science and Art,* and the *Genius of Commerce and Agriculture.* Napoleon ordered all kinds of porcelain objects from Sèvres, including a special dinner service with representations of his military campaigns, imperial residences, and favorite horses. He also commissioned porcelain tables whose tops represented views of the various imperial palaces, scenes from recent military triumphs, and individual members of the imperial family. Thus Napoleon exploited the decorative arts to advertise his political supremacy and to cast him as the legitimate heir to the old royal domains.[13]

These unique circular tables made of Sèvres hardpaste porcelain mounted with gilt bronze formed a coherent part of his propaganda campaign. One of the most ambitious objects was the table of the imperial palaces—representing the various imperial residences in nine roundels (fig. 1.11).[14] The central scene shows a view of the Tuileries and is larger and more prominent than the other medallions, thus setting off the symbolic center of France. Although not carried out, the painted decoration on the top of the table was originally designed to further include views of Napoleon's foreign estates which he had appropriated from the local nobility. Here landscape was brought into conjunction with the decorative arts to display the extent of imperial holdings, and by extension the range of the emperor's power.

The circular shape of the tables lent itself to cosmic projections and signified the Napoleonic universe. The table of the marshals, painted by the official miniaturist Jean-Baptiste Isabey, shows a portrait of the emperor from which radiate thirteen golden rays, each bearing the name

of one of his military victories. Interspersed between the rays are thirteen circular medallions with portraits of marshals of the empire and generals of the Grande Armée who distinguished themselves at Austerlitz. A third table, known as the table of great leaders of antiquity, displays at the center a profile of Alexander the Great, surrounded by twelve heads of ancient heroes painted to resemble cameos. The twelve heroes are complemented with a low-relief frieze which recounts a key event in the life of each of them. They include Hannibal crossing the Alps and Pericles rebuilding Athens—clear metaphorical allusions to the career of Napoleon himself.[15] These two tables, commissioned in 1806, were shown by order of Napoleon at the Salon of 1812, an unusual display more appropriate for the industrial exhibitions of the period but perfectly consistent with the propagandistic intentions of the imperial fine arts program during the fateful year the emperor invaded Russia.[16]

That Napoleon's tables were featured in the Salon and other public exhibitions suggests that the decorative arts shared the ideological stage with the fine arts. His success in imposing his outlook on the visual media in good measure is evident in the easily recognizable "Empire style" which is his cultural legacy. It is a heavy-handed, self-conscious style meant to dazzle by its luxurious materials and exacting craftsmanship. In this sense, it reverts to the decorative aims of the first-generation neoclassicists,

1.12 *Oath of the Horatii* clock, c. 1810–1815. Royal Pavilion, Brighton.

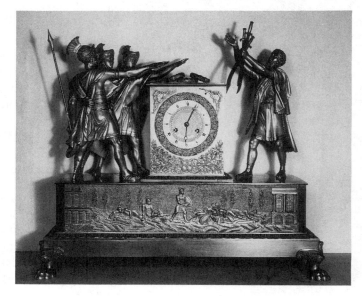

whose patrons similarly project a sense of authority in the realm of both politics and culture. A striking example of this reversion is an Empire clock decorated with gilt bronze statuettes of the male figures in David's *Oath of the Horatii* (fig. 1.12).[17] Divorced from its original context where it stood for unwavering commitment to a patriotic ideal, it is now no more than an ornamental accessory in a decorative grab bag. It is the decorative complement to authority without the energy and conviction that informed the original.

It is during Napoleon's reign that the Industrial Revolution (which by then had radically transformed the conditions of production and labor in England) began to be felt in France. The application of machinery to manufactures, commenced prior to the establishment of the Continental system, continued to develop under the imperial regime, simultaneously hindered and promoted by it—hindered because relations with the most active industrial center had been disrupted, promoted because France's manufacturers were encouraged to produce the commodities no longer available from Great Britain. On the positive side, Napoleon successfully promoted an effective alliance between scientists, entrepreneurs, and manufacturers. The founding of the *Société d'encouragement des industries nationales* (modeled after the English Society for the Encouragement of Arts, Manufactures, and Commerce) in 1802 grouped together under the leadership of the chemist Chaptal representatives of mechanics, chemistry, economics, agriculture, and commerce. By its propaganda, its experiments, its loans, and its prizes it stimulated the scientific progress of industry. One incentive was the industrial exhibitions inaugurated under the Consulate, and culminating in 1806 with the national exposition celebrating the French victories at Austerlitz on the Esplanade des Invalides (the Veterans' Hospital). Nearly fifteen hundred exhibitors were represented in the exposition of 1806, especially noted for the displays of the Alsatian textile manufacturers and calico printmakers.

One of the winners of the gold medal at the exposition was the Bavarian-born Christophe-Philippe Oberkampf, who opened the first cotton manufactory in France and gained an international reputation for his calico prints. The same year the emperor bestowed on Oberkampf the cross of the Légion d'honneur, an event commemorated by Isabey (fig. 1.13). Isabey, who documented more than one

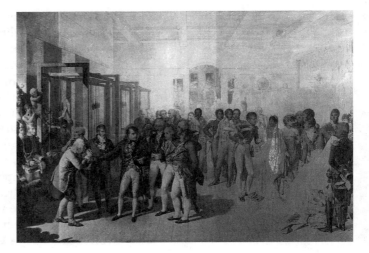

1.13 Jean-Baptiste Isabey, *Napoleon and Oberkampf,* 1806, drawing. Musée national du château de Versailles.

1.14 Plate 20, fig. 1, *The Sphinx near the Pyramids,* in Vivant Denon, *Voyages dans la basse et la haute Egypte, pendant les campagnes du général Bonaparte,* Paris, 1802.

imperial visit to French manufacturers, sketched the dramatic encounter to provide Salon critics with the basis for ballyhoo. Chaussard, for example, observed in connection with his critique that the emperor whizzed through the workshops and stations, which he judged "with an experienced eye." When he and the empress left the firm, it was visible to all that their kindness had made a indelible impression on the minds and hearts "of useful men [*hommes utiles*], simple and hardworking," whose work and effort had been stimulated by their august presence.[18]

Until Oberkampf's entrance into French industrial life calicoes were imported from England, Switzerland, and Germany; these were costly in the first instance but made even more prohibitive by the exorbitant tariff demanded by the French government to protect French hemp, linen, and even silk producers. Oberkampf successfully countered stiff resistance from his rivals and developed a vast manufacturing center at Jouy-en-Josas near Versailles. He drained the swamps surrounding his factories and built cottages for his army of one thousand laborers. During the time of the Continental blockade, Oberkampf dominated the European markets to the detriment of English cotton goods manufacturers. Oberkampf exemplified the emperor's highest hopes for the blockade, and it was for this that Napoleon rewarded him with the Légion d'honneur. Napoleon personally visited the entrepreneur at Jouy on 20 June 1806 to bestow the award and uttered these legendary words of praise: "Here in your workshops we are waging the best and surest war on the enemy! At least it doesn't cost my people one drop of blood."[19] The Napoleonic system

regimented economic activity in behalf of conquest and amply rewarded its ablest participants.

The mathematician Monge, one of the founders of the Ecole polytechnique, presided in 1806 over the jury awarding the prizes to the inventors and manufacturers, demonstrating the close ties of science and industry in Napoleonic France. An even more spectacular case of a scientist making the transition to industrialist was that of the zoologist, geologist, and mineralogist Alexandre Brongniart, who was appointed to the directorship of the imperial porcelain manufactures at Sèvres in 1800. Brongniart made the customary Alpine trek in the company of Dolomieu, a Vulcanist geologist who would participate in Bonaparte's Egyptian expedition in 1798, and wrote treatises on reptiles, monkeys, and mineralogy with special application to the industrial arts. The close interaction of geology and fossil study with industrial processes like mining and ceramics suggests the common ground between scientist, entrepreneur, and artists in this period. As a mining engineer, Brongniart composed an official report on the coal mines at Le Creusot, and on another occasion studied different processes for making faience. Like his hero from Saxony, Werner, he taught mineralogy from a Neptunist perspective at a state mining school, and influenced a generation that would become the captains of industry during the July Monarchy and the Second Empire.

Brongniart's ambitions predisposed him to accept the directorship of Sèvres and to contribute to the Napoleonic image building. Bonaparte wanted to restore the state industry to its prerevolutionary status, which, like that of the Gobelins tapestry works, had considerably declined during the Revolution. An army of workers and designers was regimented at the regenerated state porcelain works to provide the appropriate Bonapartist decor. The new direction is seen in the example of an Egyptian service based on designs executed during Napoleon's expedition and reproduced in Vivant Denon's exquisite two-volume record of the expedition in 1802 (figs. 1.14–18).[20] Brongniart also inaugurated a series of official visits by Napoleon to the factories to inspire the troops, a ritual depicted by Isabey in the drawing of the Oberkampf calico printworks.

Brongniart worked closely with Denon, Percier, Fontaine, and Chaudet to produce the imperial vases or interior decorations, and he commissioned an equestrian portrait of the emperor from Carle Vernet to be reproduced on porcelain. His taste in art leaned in the direction of neoclassi-

1.15 Plate 50, fig. 1, *Entrance to Luxor,* in Denon's *Voyages*.

cism, and his guide was David, his sister's teacher. He aimed to make his porcelain products the equal of painting on canvas, and he often used as his models the work of David and his disciples. The highly polished drawing and sharp contours, and the solid and uniform tones of his designers contributed to the formation of the "Empire style." But pomp and florid opulence became the order of the day,

1.16 Plate 116, *Detail of Emblematic Friezes from Various Egyptian Temples,* in Denon's *Voyages.*

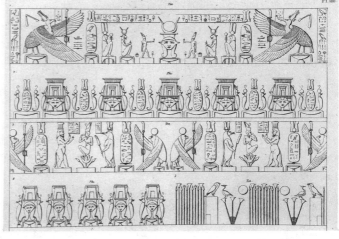

1.17 *The Sphinx near the Pyramids,* 1811, Sèvres Egyptian Service. Victoria and Albert Museum, London.

expressed in the use of rich substances and ornamentation contrary to the taste of the revolutionary epoch. Napoleonic power took as its inevitable visual and symbolic complement the look of luxury previously associated with the Old Regime.

Denon

Dominique-Vivant Denon (1747–1825), trained as an engraver, stood at the head of the vast machine for pictorial propaganda. A wonderful allegorical drawing by Benjamin Zix demonstrates Vivant Denon's central position in the Beaux-Arts complex. He is shown seated at his desk surrounded by a miniaturized version of the Napoleonic sign system (fig. 1.19).[21] This includes a piece of stationery with the letterhead "Directeur du Musée de Napoléon," his two-volume masterwork on the Egyptian expedition, a scaled-down version of the Vendôme Column, and other monuments erected in Paris for the emperor, including busts, statues, and coinage with his effigy—the entire range of Denon's official activities summed up in this drawing. Napoleon appointed him director general of museums in 1802, which began a period of intense activity in the realm of the fine arts. It was he who managed the reorganization of the Louvre (renaming it the Musée Napoléon) and added to it the works being looted from abroad, presided over the Salons, and watched over the imperial factories. The hundreds of projects under consideration for the embellishment of Paris, the triumphal avenues and arches, splendid monuments, bridges, promenades, and statuary, required an army of painters, sculptors, and architects. Napoleon's revamping of the Beaux-Arts system and the energetic activities of Denon became the envy of the Western cultural elite.

A preview of this cultural transformation was available during the summer of 1802; the recent Peace of Amiens between France and England produced a great influx of tourists, especially British and American visitors. Their attention was concentrated mainly on the masterpieces brought back from Italy and housed in the Louvre. Thus this museum became the main Parisian attraction, the center of Napoleon's power as expressed in culture. The sense of energy, growth, and expansion appealed to entrepreneurial-minded Yankees such as Joel Barlow, a real estate salesman and poet, and his partner Robert Fulton, a painter who had studied with Benjamin West but had a greater talent for in-

1.18 *Entrance to Luxor,* 1811, Sèvres Egyptian service. Victoria and Albert Museum, London.

1.19 Benjamin Zix, *Allegory of Denon,* 1811, drawing. Cabinet des dessins, Musée du Louvre, Paris.

vention. Barlow and Fulton had been licensed under the Directory to open a panorama which continued to prosper during the early years of the Consulate. Fulton also tried to sell Bonaparte on the idea of a torpedo boat that could attack enemy vessels below the water. Bonaparte set up a commission to examine the device, but the ministers of war and the navy rejected the project.

Denon played host to the international community, including Barlow, Fulton, and Benjamin West. West exhibited his *Death on the Pale Horse* at the Salon of 1802, and Denon himself accompanied him through the Louvre on his visit to the capital. The ceremonial visit of the First Consul to the exhibitions required that artists stand next to their works, in case Bonaparte deigned to notice their entry and asked to meet the painter. Bonaparte was sufficiently impressed with West's picture to invite the painter to join the official procession as it made the rounds. West exulted in what he perceived as Bonaparte's love for the arts, as Denon informed him of the governmental projects to reform the teaching of the fine arts and to give direction to French and international culture. The choice works of European museums that military conquests had dragged back to the Louvre were not on view as trophies of the defeated, but represented part of a plan of centralization to facilitate the public accessibility to treasures that properly belonged to all humanity. West, still president of the Royal Academy, was bowled over by the French efforts and contrasted them favorably to English indifference to the arts. He hosted a banquet for Denon, as well as for curators at the Louvre and several painters, including David. The publicity attending this event and West's obvious admiration for Bonaparte did not endear him to the Tories, especially when hostilities broke out again between France and England. But the French sang his praises, and Bonaparte appointed him a foreign associate of the newly reconstituted class of Beaux-Arts in the Institut.

Vanderlyn

Thus the Napoleonic military conquests and cultural renovations surrounded the First Consul with an aura of international prestige. When the Salon of 1800 opened on 1 September (15 *fructidor* of year 8 of the revolutionary calendar), the Consulate was in full force and Napoleon ensconced as virtual dictator. John Vanderlyn, a twenty-five-year-old painter from Kingston, New York, became in 1800 the first

American painter to exhibit in the Salon. His ambition was fired by the position of Paris in world culture, and he eagerly sought the prestige associated with its cultural institutions. He was represented by two portraits, one showing himself garbed in the latest French fashion. France had become the mecca for the cosmopolitan American as well as European.[22]

Vanderlyn in fact was something of a Francophile during a period of tense relations between the United States and France. As elsewhere in the world, Americans were turned off by the execution of the king in 1793, and by 1797 the two nations hovered dangerously on the brink of war. Indeed, they did engage in an undeclared naval war that created havoc for American shipping interests in 1798 and 1799. Vanderlyn at that moment was studying in Paris with the master François-André Vincent, a favorite of the revolutionary and Napoleonic epochs who in 1800 had been commissioned by Lucien Bonaparte, then minister of the interior, to paint the Battle of the Pyramids—the battle that gave Egypt to the French.

It was the generous aid and advice of Vanderlyn's benefactor Aaron Burr that prompted the young artist to study in Paris in 1796. At a time when most young American painters went to London, Vanderlyn's move was unprecedented and most probably was bound up with his pro-French, anti-British patron. Burr not only admired French culture but also wanted his government to approach more closely the republican form of France than the royal style followed by Washington. Vanderlyn similarly espoused the French cause, his sympathies leaning toward republicanism and France. Additionally, Vanderlyn always felt a deep antipathy for the British who, during the American War for Independence, had burned his native city of Kingston when he was a child. The memory of this trauma haunted his youth.

It was in the Salon of 1804—the first year that the *livret* read "Musée Napoléon"—that Vanderlyn exhibited his astonishing work, *A Young Woman Slaughtered by Two Savages in the Service of the English during the American War* (fig. 1.20). Known more commonly today as *The Death of Jane McCrea*, its original intention has all but been lost with the passage of time. The painter carefully chose his theme to appeal to Napoleonic France and thus assure the picture a privileged space in the Salon.[23] No case more dramatically demonstrates the way in which artistic activity was affected by the raw data of politics.

1.20 John Vanderlyn, *The Death of Jane McCrea*, 1804. Wadsworth Atheneum, Hartford.

The subject refers to the an incident that occurred in New York state on the eve of the Battle of Saratoga, a crucial battle that turned the tide of the war in favor of the Patriots.[24] General Burgoyne, the cultivated and brilliant English general, had encouraged as his allies the Mohawk tribe, the most easterly of the Iroquois Five Nations. Burgoyne offered compensation to the native Americans for prisoners and allowed for scalps only if the victims had been killed by fire in a fair fight. While both George III and his ministry ordered Burgoyne's alliance with the Indians, it was to prove his undoing. A young woman named Jane McCrea was kidnapped by a band of marauding Mohawks and tomahawked and scalped. As a result of the incident, the American general Gates was able to exploit it to turn New York residents against the British. Many Americans who had been neutral now sided with the Patriots, and even the numerous local Tories refused to help Burgoyne, who required their help for forage and food for his troops. News of the tragedy spread like wildfire; almost the whole of northern New York turned against Burgoyne and went over to the Patriots' side. In addition, his own stringent management of the native Americans forced them to desert him as well.

Much of the original incident is shrouded in mystery. It was believed that McCrea's lover, a Loyalist officer, hired a group of Indians to escort her to the British camp, where they were to be married by the British chaplain. Then becoming anxious, he sent another team; these two groups encountered one another and began to quarrel over which should get the reward, and in the process McCrea was shot and killed. Still another historian, backed up by oral reports, believed that Americans skirmishing with the Indians accidentally killed McCrea with a stray bullet. The most thorough account, however, suggested that she was removed from a house where she had been hiding with others and killed during a quarrel between rival Indian groups.

The history had been obscured no doubt because of the consequences of the event and its implications for political and military purposes. Burgoyne could not afford to let this sully his campaign, while it was in the Americans' favor to take advantage of it to undermine the British position. In the end, the event was fictionalized and romanticized by a Frenchman whose sympathies were with the Americans. Michel-René Hilliard d'Auberteuil's *Miss McCrea: Roman historique* (Philadelphia, 1784) built up the story of the bride-to-be dressed up in her wedding finery

on the way to her lover, and it was this version that seized the public's imagination in France and elsewhere. Vanderlyn depicted the scene as imagined in these sensational terms: McCrea on her knees and screaming in terror while her two murderers pull her hair back and raise their tomahawk in the act of scalping her. The faces of her tormentors have an unrelenting cruelty, bent exclusively on their fiendish task. Vanderlyn's composition is a complicated machine of intersecting planes that convey a mechanical and ineluctable motion to the task being performed. The bodies of the murderers are shown in all their angularity which reinforces the mechanical model, which only McCrea, with her swirling clothing, the rounded curves of her body, and terror-stricken expression, relieves. Her hand, open and vulnerable, recalls that of Brutus's wife in David's *Brutus* (vol. 1) or the defeated Muslims in Gros's *Battle of the Pyramids*. Vanderlyn dramatizes the scene and activates it by the Indian at the right, who rushes in to grab McCrea, and the sadistic expression with gleaming eye and exposed teeth bestializes him. Vanderlyn emphasizes the contrast between the powerful, muscular bodies of the murderers and the sole, helpless person of their victim.

No doubt this scene of Indian violence answered to the government's colonial policies and its justification: the representation of non-Western peoples in contemporary official painting frequently depicted Africans and Muslims in startlingly similar terms, as in Gros's unfinished *Battle of Nazareth* (fig. 1.21). Napoleon was often shown as granting clemency to his defeated enemies, trying to bring home

1.21 Antoine-Jean Gros, *The Battle of Nazareth*, 1801. Musée des Beaux-Art, Nantes.

to the French public the idea of a Bonapartist extension of French civilization to barbarian cultures. Vanderlyn's painting, however, gratified the official taste to an even greater degree by his anti-British sentiment.

Not only did the title make this abundantly clear, but the catalogue entry also made it known that the literary source for the picture was Joel Barlow's anti-English, ultra-patriotic American epic poem, the *Columbiad* of 1807. Barlow's account of the Jane McCrea incident not only makes her a symbol of American suffering under British aggression but establishes unequivocally that the Indians were paid mercenaries of the English government, which incited them to their horrible deed:

> the scalps by British gold are paid;
> A long-hair'd scalp adorns that heavenly head;
> And comes the sacred spoil from friend or foe,
> No marks distinguish and no man can know.
> With calculating pause and demon grin,
> They seize her hands and thro her face divine
> Drive the descending ax . . . [25]

Barlow, a close friend of Robert Fulton, was then living in France as an honorary French citizen for his support of the Revolution. He and Fulton were involved in all kinds of theatrical and real estate schemes, and the *Columbiad* was one of these projects for which he originally commissioned Vanderlyn to do the illustrations. Barlow's chauvinistic work was aimed directly at the American public, and its anti-British tone had the advantage of also gaining the sympathy of Napoleonic France. Barlow was a popular figure in imperial France; the panorama that he and Fulton organized left a permanent impress on the Parisian landscape as the Passage des Panoramas.

Vanderlyn's greatest French success was his *Caius Marius amid the Ruins of Carthage* (fig. 1.22). Vanderlyn shows Marius, a Roman general and politician of the first century B.C., brooding in exile, seething with revenge and awaiting his opportunity to return to Rome. Marius had been in many ways a remarkable leader; he was the first Roman who demonstrated the political support that a successful general could derive from the votes of his army veterans. He reformed the military organization and overhauled equipment, and revolutionized recruitment practices by opening the ranks of the army to the underclasses. He was elected consul seven times, but his political alliances and methods earned him bitter enemies who finally managed

to depose him. He was forced to seek refuge in Carthage for a time, and when he returned to power he engaged in a vindictive massacre of his former opponents.

Vanderlyn wanted to convey Marius as an example of "the mutability of Fortune" and by so doing "gain a reputation." In other words, Vanderlyn wanted to "make his fortune" by exposing the capriciousness of ambition—a contradiction that would haunt him in his later years when his unsuccessful ventures caused him to rail against the vulgarity and avariciousness of American society. But he saw his opportunity in Napoleonic France to do a project which "was capable of showing in two great instances the instability of human grandeur—a city in ruins and a fallen general. I endeavored to express in the countenance of Marius the bitterness of disappointed ambitions mixed with the meditation of revenge."[26] At a time when cities throughout Europe were prey to the force of Bonapartist power and fallen

1.22 John Vanderlyn, *Caius Marius amid the Ruins of Carthage,* 1807. M. H. De Young Memorial Museum, San Francisco.

generals were commonplace, Vanderlyn's work had a distinctly contemporary message. Vanderlyn made the general face outward at the spectator and enlarged the figure to colossal proportions—anticlassical tendencies in keeping with the experimental methods of David's students. For these reasons the work was a great success at the Salon of 1808, despite the fact that it had as rivals Gros's *Battle of Eylau,* Girodet's *Atala,* and David's *Coronation.* As was his custom, Napoleon made a promenade through the Salon with the empress Joséphine and his official entourage while the painters stood by their pictures like soldiers undergoing inspection. Napoleon indicated his approval of the *Marius* and awarded Vanderlyn one of the gold medals.

As an American in Paris, Vanderlyn's painting has cross-cultural and cross-historical significations. Napoleon surely admired it for its didacticism; he knew his classical history, and Marius posed a lesson from which he could well profit. Napoleon knew only too well the example of a general mingling in politics, and he did his best to make his senior officers loyal. He ennobled many of his best generals, and showered them with honors and estates—considering these part of the price he had to pay to keep them out of politics and to induce them to identify their fortunes with his own. He wrote to Joseph in 1808 that his "intention is to make the generals so rich that I shall never hear of them dishonoring by cupidity the most noble profession, and attract the contempt of the soldiers." [27]

Vanderlyn's picture had a much more explicit reference to his generous benefactor, Aaron Burr, who fit the paradigm of the fallen general. Arrested for treason in March 1807, Burr was acquitted in September of that year and went into exile. The exact nature of Burr's project is still not fully known, but its general outlines included a plan to invade Mexico, foment a secession movement in the disaffected southwestern states, and found an empire on the Napoleonic model with New Orleans as its capital. Burr in a sense planned a coup that the American elite would gladly have supported in their own interests: in 1806 America disputed its boundaries with Spain, and Jefferson himself planned to war with Spain but hesitated to do so without the sanction of France. Indeed, part of the dispute had to do with the newly acquired Louisiana Territory, which Jefferson had purchased from Napoleon in 1803. But Napoleon had since entered into an alliance with Spain and warned that, in any American attack on Spain, France would rally to its defense. Jefferson thereupon abandoned

the idea, a decision viewed in negative terms by several of his colleagues. Burr's project was no more than an acting out of popular expansionist aspirations, but Jefferson's zeal to destroy him politically led to the charges of treason. Since no treasonable act had as yet been committed, the jury rejected the circumstantial evidence as insufficient and acquitted Burr.

Burr was now, however, finished politically, and in June 1808 he sailed for England ostensibly to raise support for his schemes in Mexico. Bonaparte's own design on Spain that year provoked England's support of the deposed Spanish regime, and Burr's plan was no longer viable. During the ensuing years Burr spent much of his time in European exile, sometimes under assumed names. It is possible that he made the trip to Paris to see his protégé's *Marius* at the 1808 Salon—a figure with whom he would have closely identified. On the eve of his trial for treason he wrote his daughter Theodosia, "Was there in Greece or Rome a man of virtue and independence, and supposed to possess great talents, who was not the object of vindictive and unrelenting persecution?"[28]

Thus Napoleonic France was a powerful magnet drawing to itself the ambitious, the opportunistic, and the adventuristic whose model was the emperor himself. Their flattery he exploited for his own ends, and their successes— and failures—often depended on the degree to which their work served his interest. His unusual combination of charisma, talent, and temporal power overawed both his opponents and his followers, and enabled the emperor to fight his wars for eleven years and stave off the dissenting sector of French opinion.

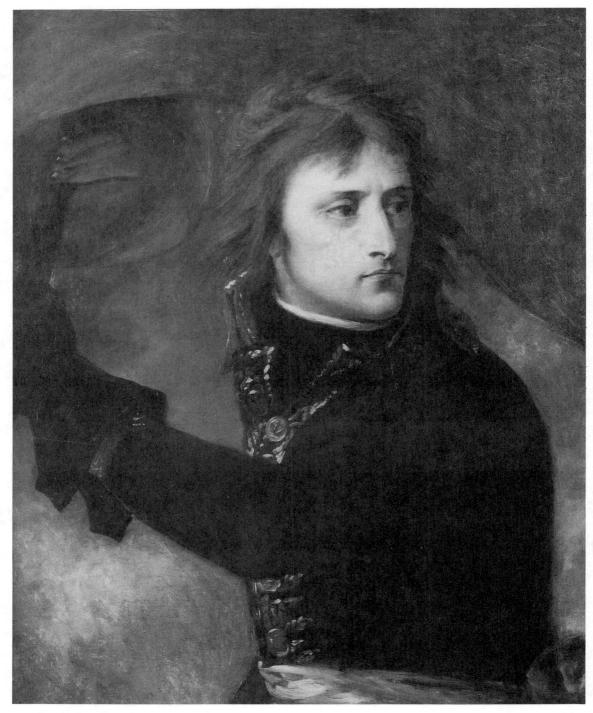

2.1 Antoine-Jean Gros, *Bonaparte at Arcole,*
1796, sketch. Musée du Louvre, Paris.

2 The Iconography of Napoleon

Gros's early portrait of the dashing young commander in chief raising the standard on the bridge of Arcola has something tentative and indecisive about it; Bonaparte's tight-lipped expression as he twists his head towards his army signifies his condemnation of the troops for not responding to his call in this crucial and costly campaign in Lombardy in 1796 (fig. 2.1). Gros had been with Napoleon at the battle of Arcola and witnessed the murderous fire of the Croatians that pinned down the French and kept them from boldly following their leader.

French artists played a cunning game with Napoleon's cultural demands, dutiful in recentering the hero but careful also not to omit the impact of the enemy other. The artists of the Bonapartist era had experienced too much historical change within their young lifetimes to blithely ignore the consequences of political action. Yes, they were subject to, as much as purveyors of, the propaganda that rationalized the content and purpose of war for the masses of French people, but the decades of upheaval between 1789 and 1814 furnished the dramatic examples of historically conditioned existence—of history that affects daily survival and immediate preoccupations.

This ambivalence is displayed in Guillon Le Thière's *The Preliminary Peace Treaty at Leoben,* a work widely praised in the Salon of 1806, portraying a conspicuously cheeky Bonaparte dismissing the position of his Austrian adversaries (fig. 2.2). Commissioned for the Corps législatif, it might well have been a representation of Napoleon confronting his domestic opposition as well. Leoben, Austria, less than one hundred miles from Vienna, served as the site for the signing of the preliminaries of the Treaty of Campo Formio by Austria and the French republic on 18 April 1797.

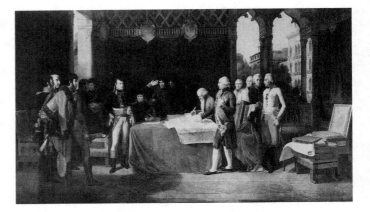

2.2 Guillon Le Thière, *The Preliminary Peace Treaty of Leoben,* 1806. Musée national du château de Versailles.

The treaty dictated the fate of the Italian peninsula, represented in the large map of Italy on the table in the center of the composition.

Fresh from victory at Rivoli and the Treaty of Tolentino by which the pope ceded Bologna, Ferrara, and the Romagna to the French, Napoleon brazenly invaded Austria at great peril to himself and his troops. He was playing a dangerous game in hostile territory, and he knew it. After minor triumphs at Neumarkt and Unzmarkt and within striking distance of Vienna, he abruptly proposed armistice and peace terms to Erzherzog Karl von Österreich, the Austrian field marshal. Bonaparte bluffed his way through this affair, although he enjoyed the advantage of a terrified populace in the Austrian capital. There was notable opposition to his offer, however, from the Austrian chancellor, Franz de Paula de Thugut, who had helped organize the first coalition against the French revolutionary government. But Austria's allies, England and Russia, were preoccupied with internal problems at the time, and Thugut resigned himself to opening negotiations with Napoleon.

Bonaparte himself represented France, already dictating the terms to the Directory. His behavior was disdainful to the Austrian envoys, and when the latter declared in one of their articles that they recognized the French republic, the French general interrupted them to demand that this article be stricken from the record. "France has no need of being recognized," Napoleon stated, gesturing heavenward, "she is like the sun on the horizon, and those who do not see it are blind." And he continued, "The French people are masters of their fate; they have made a Republic; perhaps tomorrow they will establish an aristocracy, the day after, a

monarchy. That is their inevitable own right: the form of their government is strictly their own affair."[1]

Le Thière depicts Napoleon at the hub of French and European politics, as true in 1806 as it was in 1797. Chaussard interpreted Napoleon's gesture as one that addressed the crowd, seemingly saying, "If we are not in agreement on some point, I am continuing my march, and in this direction is the path to victory."[2] Chaussard appreciated the manner in which the French protagonists of the painting were disposed and the visible discomfort of the Austrians seeing Napoleon as effective at the conference table as on the battlefield, thus embodying "the interests and the glory of the French nation."

At the same time, however, Le Thière locates Napoleon well to the left of center, and his position is sustained by the formidable bloc of French officers standing behind him. Without this formal and narrative backup, Napoleon would cut a weak figure in the composition. This is especially evident in the pyramidal shape of General Murat, standing tall in the left foreground and literally providing Bonaparte with pictorial as well as moral support. Yet even within the French camp there are awkwardnesses revealing disagreements and fear. Guillon Le Thière self-consciously represents Napoleon using intimidation to persuade the Austrians to conclude the preliminaries of peace before they realize the weakness of his position. His speedy terms ultimately cost him dearly in granting his adversaries a foothold in the Venetian territories, which led to further war. Austria secretly coveted Venice, heretofore a neutral state, and happily surrendered the Milanese in exchange. So while appearing to dictate peace as he menaced the Austrian capital, Napoleon concluded a bargain favorable to the enemy; additionally, he increased the commitments of the French government in Italy and destroyed any hope of a quick return to normality in the peninsula.

The new realism of the Bonapartist period is seen in the account of Barras, the wily Jacobin turned director, who interrupted his memoirs of the Revolution with a reference to the bloody battle at Eylau, free-associating from there to a comparison of the marquis de Sade and Napoleon. For him the butchery at Eylau smacked of the philosophy of de Sade, but on an order of magnitude undreamed of by the aristocratic profligate. Barras then recounts the anecdote of one of the Italian directors of the Roman republic, the physician Camillo Corona, who sought exile in Paris after the Directory fell. Corona visited the Salon of 1808 and was so

struck by the view of David's *Coronation of Napoleon* and Gros's *Battlefield of Eylau* hanging face to face that he exclaimed in outrage, "Coronation and Slaughter! That's the story of his life!" [3]

While Barras had plenty of axes to grind and exaggerated as all writers of memoirs do, this anecdote holds up under scrutiny because it belongs to a wider field of discourse that embraced a consensus of criticism permissible under the Napoleonic regime. The catalogue description of Gros's painting itself did not shirk from the tragic consequences of the event: it observed that the emperor surveying the aftermath of the battle was "filled with horror at the sight of the spectacle," and this text is followed through in the image, with the entire foreground covered with the dead and wounded (see fig. 5.1). Although the statement made certain that the audience understood that, at the time Napoleon passed in review, "the French troops were bivouacking on the field of battle"—that is, they were the self-proclaimed victors of this internecine destruction—it could not deny what the foreign press had reported to its readership and what had been leaked to the French public earlier that year. Even the government's attempt to contain the damage by underestimating the loss of troops backfired because the conservative body count was bad enough. But what is important here is the evidence that the historical progression and understanding since the Revolution could no longer sustain the supersensible image of the invincible ruler of the ancien régime or the overinflated idealism of the Revolution.

The Battle of Eylau was perhaps a turning point, along with the Spanish insurrection that same year, that revealed huge chinks in the Napoleonic armor; plenty of paint and ink was spilled previously in the effort to mythologize the "Little Corporal" and even to adorn him with divine attributes. For the first time the unprivileged strata of French society experienced France as their own country, as their self-created fatherland which now demonstrated its superiority to the privileged strata of outmoded feudal societies. This invested Napoleon with a mythic component for which there existed only an outmoded symbolism and which was bound to clash with the innovative restructuring of the social order. The demand for a new realism to accommodate the new data of experience and the desire to retain the mythic components of tradition stamp the Napoleonic imagery with its hybridized tension.

Napoleon and David

One way to map this development is to examine the Bonapartist activity of one of Napoleon's favorite artists, Jacques-Louis David (1748–1825). To marshal visual practice Napoleon summoned David, then perhaps the most celebrated painter in France. David was ultimately appointed first painter to the emperor at the end of 1804, the equivalent of the royal position under the old regime. The artist was to receive enormous sums for his official commissions: for example, 52,000 francs for the *Distribution of the Eagles* and 65,000 francs for the *Coronation*—extraordinary when we learn that a well-paid artisan then received about a franc a day! At this moment, David was already a prosperous landowner who identified himself with the bourgeois supporters of Napoleon. Having escaped the Terror with his life, he had thrown in with the Directory and even designed a flamboyant costume for the directors, which Barras especially wore with pleasure. His *Sabines* project, which spanned the duration of the Directory, gave visual form to its ideological claim to restore peace and harmony within the republic and had for its own agenda a speculative venture wholly consistent with those who profited most from the short-lived government. But by the end of 1799, David shared the widespread feeling of his peers that scandal-rocked France was without adequate leadership, civil or military (Napoleon was still in Egypt) and welcomed Bonaparte's coup d'état of *brumaire,* which carried the general to supreme civil power.[4]

Impressed, like everyone else in his social milieu, with Bonaparte's talents and utterly frightened of him, David openly proclaimed him as his new hero. David's earliest work for Napoleon is frankly propagandistic, starting with the *Napoleon Crossing the Saint Bernard* executed in the years 1800–1801 (fig. 2.3). The work was commissioned for the library of the Hôtel des Invalides, the veterans' hospital which at that time was undergoing extensive refurbishing to transform it into a monument to Napoleon's army. David's painting depicts the dramatic moment of the traversal of the Alpine pass of Saint Bernard foreshadowing the First Consul's decisive victory over the Austrians at Marengo in June 1800. On 14 May the first French columns climbed the pass, pulling behind them the cannon in sledges made of hollowed logs, and by 22 May the maneuver was completed. The Austrians, surprised and cut off from the rear,

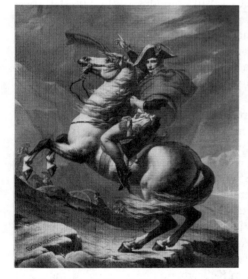

2.3 Jacques-Louis David, *Napoleon Crossing the Saint Bernard,* 1801. Kunsthistorisches Museum, Vienna. Replica of original at Musée national du château de Versailles.

fell back on the village of Marengo, where they were finally routed the following month.

David depicts Napoleon, who himself suggested the idea, on a rearing horse directing the operation across the difficult passage. The forelegs of the rearing animal point to a large slab of rock in the mountainside in which the name of Bonaparte is carved neatly in capital letters just above the more crudely rendered names of his predecessors who similarly mastered the treacherous Alpine crossings, Hannibal and Karolus Magnus (Charlemagne). David's image recalls the earlier equestrian portrait of Count Potocki (vol. 1), except that the "Corsican upstart" is compared to imperial geniuses of the past, proving that in the present age brains and talent count for more than birth and privilege. The myth of Napoleon as the embodiment of the revolutionary credo had already been energetically shaped by David in contemporary cultural practice.

The representation of the event, however, has been manipulated to slant history in Napoleon's favor. Bonaparte actually crossed the Saint Bernard with the rear guard on a mule led by a peasant from Bourg-Saint-Pierre. The image of the hero spurring the troops on by pointing to some distant summit would indicate total mastery; in fact, the campaign came close to being a total wipeout for the French as a result of the First Consul's blunders. While military historians still dispute the actual facts (notably edited by Napoleon in his dispatches from the front), Napoleon himself declared on 15 June that the battle appeared hopeless, but at the last minute a sudden reversal saved his army. It seems that, through faulty intelligence about the state of bridges over the Bormida River, he ordered two divisions under Desaix and Lapoype to the south and north to trap the Austrians, when the enemy suddenly emerged before Napoleon and the now outnumbered French in an open plain. By the time Desaix returned, Napoleon's troops had been overrun and were wildly retreating. Eyewitness accounts of Napoleon's reaction at this moment contradicted the image of the indomitable hero; he sat by the roadside in nervous tension, flicking with his riding whip the dust cloud raised by his stampeding troops. Desaix, however, managed to spearhead a counterattack and, with some courageous behavior from Kellermann's heavy cavalry, managed to beat back the Austrians. Napoleon never did do justice to Desaix, killed in this battle, and took full credit for the victory. This special talent for self-advertisement forged David's portrayal into Napoleon's ideal self-image. As

Laurette Junot rhapsodized, "The index of his powerful hand extended to [Saint Bernard's] icy summits, and the obstacles disappeared."[5]

David nevertheless tried to retain a firm foothold on reality. In the middle distance we see the French columns slogging up the pass, pulling behind them the cannon in improvised sledges, and revealing some of the difficulties and hardships of this arduous undertaking. He painstakingly reproduced the uniform Napoleon wore at Marengo right down to the seams on the breeches, and he ingeniously showed the raised hand of the First Consul without a glove in contrast to the other holding the reins, which gives an irregular cast to the scene.

Ironically, it was Carlos IV of Spain who commissioned from David the first version of the picture. Bonaparte immediately ordered copies of it, and in September 1801 the painter exhibited two versions, one for the king of Spain and the other for the First Consul. Since Marengo, French supremacy on the Continent received recognition from France's neighbors. Napoleon's acquisition of Tuscany put pressure on Spain's Italian possessions and gave him diplomatic leverage with the Spanish court. After the battle of Marengo he succeeded in driving out of office in Madrid a ministry hostile to France. This helped reinstate the ambitious Godoy, the "Prince of Peace," who supported French interests. Napoleon gained his object on 1 October 1800 through the treaty of San Ildefonso, confirmed by the treaty of Lunéville in February 1801, in which Spain declared itself ready to cede Parma and its dependency Elba to France, to give up Louisiana, and even to constrain Portugal to break its alliance with England and close its ports to British ships. A Spanish army led by Godoy and reinforced by a French auxiliary corps invaded Portugal and forced the Portuguese king to sign a treaty closing his harbors to England and requiring him to pay France a large indemnity. Given this French pressure on Spain, which was exploited by Godoy for his own self-aggrandizement, we may well imagine that Carlos IV ordered the painting of Napoleon at this propitious moment to ingratiate himself with the First Consul. One other piece of confirming evidence is the Spanish king's gift of sixteen horses to Napoleon in 1800, including a fiery Arabian steed named El Jornalero that may be the one ridden by the French ruler in David's picture.[6]

David began the work in the final days of 1800, a period marked by the notorious assassination attempt on Napo-

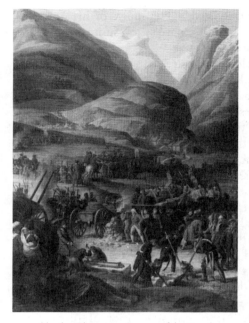

2.4 Charles Thévenin, *Passage of the French Army across Saint Bernard, Commanded by His Majesty the Emperor, the 28 Floréal Year 8 of the Republic,* 1806. Musée national du château de Versailles.

leon's life by the explosion of the *machine infernale.*[7] The crude homemade explosive device went off prematurely, and thus Bonaparte's life was spared. David's charging equestrian is thus the *héros éternel* thwarting the *machine infernale,* rising phoenixlike out of the Alpine snow and ice, intrepid and indestructible. David's historical distortion pits Napoleon against the elements of wind and snow, with the general's cloak swirling around him like a magical force impelling him forward. Chaussard observed that the windswept cloak seemed to take "the form of the wings of an eagle, an ingenious idea."[8]

We can get some idea of the role David's picture played in shaping Bonapartist propaganda, by looking at another text of Chaussard that interprets for the audience of the Salon of 1806 a later version of Napoleon crossing the Saint Bernard. This was Charles Thévenin's *Passage of the French Army across Saint Bernard, Commanded by His Majesty the Emperor, the 28 Floréal Year 8 of the Republic* (fig. 2.4). It is far more consistent with popular engravings of the event which visually focused less on the personality of Napoleon than on the conception of the landscape as obstacle to be overcome (fig. 2.5). Thévenin's work, while still locating Bonaparte in the center of the work, shows him surrounded by his general staff, gesturing them forward towards "the peak of the crossing . . . the goal of their labors and the pathway to glory." Chaussard sees the miracle of Caesar and Hannibal repeated in contemporary terms and even "surpassed." And he continued in the same eulogistic mode: "Very well! a hero, far above all those of antiquity

2.5 *Passage of the French Army across Saint Bernard,* 1800, engraving. Cabinet des estampes, Bibliothèque Nationale, Paris.

by the scale of his plans, the profundity of his combinations, has dared to attempt this crossing and confront every danger; his comrades-in-arms, electrified by his genius, excited by his courage, follow him joyfully; they have overcome every obstacle; under such a chief nothing is impossible to Frenchmen."[9] Reading backward from 1806, Chaussard praises the French troops who brave every climactic change from the burning heat of the desert to the frozen wastes of the north. The lesson of Saint Bernard is its eloquent testimony to the capacity of the Napoleonic soldier to "triumph over every imaginable obstacle, to ward off the very elements, and, in a word, to transcend nature itself."

Here both the painter and the critic base their narrative on the David, taking its original idea as the point of departure for a secondary interpretation that depended on a congelation of the initial encoding into blatant propaganda. It was purchased by the government and served a very special role in attempting to persuade its viewers of the "reality" of Napoleon's seemingly "miraculous" exploits. Drawing liberally upon the lengthy catalogue introduction, Chaussard picks up on the authentic topographical features scrupulously rendered by Thévenin. The painter not only made sketches directly at the site, but he included a variety of local human and landscape motifs, including Saint Bernard dogs, the hospice and cabins for weary pilgrims, a sutler with two exhausted and frostbitten children, as well as a graveyard for those who perish in the mountain.

The catalogue entry stresses Thévenin's "great exactitude" in the rendering of the mountain and its panoramic geographical setting, the upper third of the valley leading to the hospice and just contiguous with the region of the Valais. This geological specificity was informed by both the artist's own sketches and those of geographers assigned to the expedition, and points further to Napoleon's own interest with this science and the special place he made for geologists and geographers on his military incursions. Naturally, they were indispensable to his success in the field, but often he commissioned veteran geologists who carried on their own independent research. The special interest in Alpine geology in this period as a model for understanding the origin of rock formations could be exploited to add a "scientific" veneer to the military venture.

David's imprint of Napoleon's name in a rock outcropping literally "fossilizes" the event and forms the factual counterpart to the falsified action of the protagonist. Here

the authentic-looking inorganic environment camouflages the purposefully erroneous projection of the organic bodies. This conceptual dualism had to be retained in order to juggle the various metamorphoses of Bonaparte, from general to First Consul, and from First Consul to emperor—a series of avatars that corresponded as well to the contradictory stages of the political evolution from republic to authoritarian government, a process belied by the preservation of the name of the republic in official documents. (This is seen in the catalogue entry for Thévenin's picture in 1806 which has the "emperor" leading the troops of the "republic" across Saint Bernard.) The transmittal of "truth" took place in the peripheries of civil, military, and cultural life, in areas that barely affected the falsified center.

Distribution of the Eagles

No more striking example exists of this conceptual dualism than David's *Distribution of the Eagles,* a painting of an event that occurred three days after the coronation, which the artist also represented as part of a formidable package of imperial iconography (fig. 2.6). (The *Coronation* will be discussed in a later section.) The ceremonies were organized by Percier and Fontaine and took place on a huge grandstand set up against the facade of the Ecole militaire at the Champ-de-Mars. This was a tribute to all branches of the army wherein the regimental commanders took an oath to the emperor to defend to the death their standards mounted with eagles and stay on "the road to victory." According to the program, the emperor said, "Soldiers, here are your flags; these Eagles will be your rallying point; they

2.6 Jacques-Louis David, *Distribution of the Eagles,* 1810. Musée national du château de Versailles.

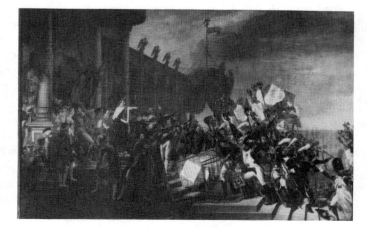

will be wherever your emperor deems them necessary to protect his throne and his people. You will swear to guard them with your life." At this point, the colonels holding the eagles were to raise them in the air and shout in unison, "We swear!" The oath was then repeated by all the military and civil deputations to the sound of artillery salvos, and the solemnities ended with the return of the eagles to their respective regiments.

David's role as depicter-in-residence was spelled out two years later with Austerlitz in mind: "Never was an oath better kept. What a variety of stances and expressions! There never was a finer subject for a painting. How it fires the painter's imagination! It is the forerunner of the immortal battles which marked the anniversary of His Majesty's coronation. Posterity looking at this painting will be astonished and marvel, "what an emperor!" [10] It should be recalled that this production was David's third representation of an oath, each portraying a critical stage in recent French history and inevitably referring back and forth to each other. (This is most obvious in both the preparations and final design of *Distribution of the Eagles,* which depend on motifs derived from its two predecessors.) What is critical in David's statement is the obvious appeal of the oath motif and its objective realization for him in material history. My earlier volume, *Art in an Age of Revolution,* showed how the *Oath of the Horatii,* a prerevolutionary work, and *Oath of the Tennis Court,* a revolutionary work, folded into each other; David himself encouraged the connection by exhibiting them together. I need not rehearse the arguments here, except to point out that both represented oaths sworn in behalf of the unity of the reformed state newly expanded to embrace an heretofore excluded citizenry. Thus the oath in these works connoted patriotic commitment to the principle of the commonwealth rather than of the anointed ruler. The *Horatii* contains a military subtext ostensibly derived from antiquity but actually based upon the new discipline promoted by the French army after the Seven Years' War, whereas the *Tennis Court* applied that standard to forge a highly disciplined and committed civil body capable of taking control of the political apparatus. In the later work the fraternal oath binding the initiates has been transmogrified into contemporary life, signifying that present reality had caught up with ideality. The final oath picture maintains reality as the exciting cause, but it subverts the "national" priorities of Rousseau's social contract to align itself with the narrower inclusive model of the old

regime. And it does so by rejecting the allegorical model of antiquity as a token example for the present and deliberately forefronting it in modern military life in imitation of the old Roman standard-bearers.

The series of oath pictures may be seen as the coding of key developments in the history of the Revolution and its culmination in Napoleonic authoritarianism. The ancient Roman republican model served as a standard for the moderns, authentically realized in the *Tennis Court* oath, but the collapse of the Revolution paved the way for a despotic figure swollen with the blood of military and foreign conquest indispensable for the retention of his hold over the French people. As under the old regime, obedience and loyalty were sworn to the sovereign. It is by no means fortuitous that the last and final oath was both contemporary and almost exclusively military; the *vaincre ou mourir* implied in the *Horatii* was literally written into the Napoleonic ceremony of the eagles and symbolically demonstrated the ascendance of the military over the civil domain and the force of arms over collective expression. The civil pride of French nationalism won during the Revolution had been displaced onto pride in battlefield glory, and the welfare of the French citizenry taken as a whole became subordinated to the prestige of the troops. Symbolically this was further represented by shifting the ancient paradigm from the republic to the empire.

David completed a major drawing in December 1808 for the emperor's approval (fig. 2.7). Between that time and the initial completion of the definitive tableau in October 1810 Napoleon requested two basic changes: he asked

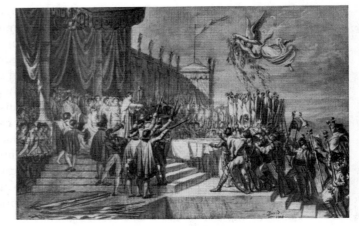

2.7 Jacques-Louis David, *Distribution of the Eagles*, 1808, drawing. Cabinet des dessins, Musée du Louvre, Paris.

that David eliminate an allegorical personification depicted in the sky above the flags, and at the last minute ordered that the portrait of Empress Joséphine be removed, since he had by then been divorced and remarried to Marie-Louise of Austria. Here in a nutshell are the perimeters of Bonapartist visual and historical "truth." The winged Victory hovering in the air and strewing laurel leaves on the flags was for Napoleon an outmoded form of representation that clashed with his sense of the "true" and the "new." The picture was less an allegory of the state than an ideological commentary on the power of Napoleon, who needed no help from idealized entities. Yet his sense of realism could not extend to the historical past which he was in the process of manipulating to justify and legitimize his hold on power. Joséphine, who had actually been present at the event, had to go because her presence belied his claim to dynastic succession now embodied by Marie-Louise. Joséphine no longer had a historical place in Bonapartist ideology, and the documentary record had to be falsified. This entailed eliminating her ladies-in-waiting as well and replacing them with a group of ambassadors, including Mohammed Said-Heled of the Ottoman empire, who looks upon the occasion with an obvious irritation. It was hardly secret that Napoleon had planned an eastern expedition and the partition of the Ottoman empire that would involve France, Russia, and Austria. Austria's desire to share in the spoils was one of the motivations for Franz I's gift of his daughter to Bonaparte. David (who was not present at the ceremony) himself went to great lengths to document the event with precision, but wound up being "complicit" in the historical manipulation. Indeed, David had his own agenda in reconstructing the ceremony: at the top of the pyramid of military corps we see the conspicuous display of the flags of the Twelfth and Ninth regiments, which were commanded by sons-in-law of David.

This family pride in the opportunity for participation in the Napoleonic machine represents the more popular side of the epoch. Bourgeois artists like Louis Boilly encouraged their sons to attend the Bonapartist military academies where they were certain to get a sound general education. The same year that David sketched his composition for *Distribution of the Eagles,* Boilly submitted several Napoleonic subjects to the Salon in the hopes of gaining a commission or sale. One was the *Departure of the Conscripts in 1807* and another, the grandiose *Reading of the Bulletin of the Grand Army* (figs. 2.8–9). Despite the insatiable appe-

2.8 Louis-Léopold Boilly, *Departure of the Conscripts in 1807*, 1808. Musée Carnavalet, Paris.

tite for human sacrifice brought on by interminable wars, many of Boilly's recruits can still muster a sense of heroism and adventure. It is symptomatic of the period, however, given the numerous cases of desertion and even rebellion in the military, that at least one critic called the mood of zealousness "unnatural."[11] Indeed, despite Boilly's attempt to ingratiate himself with the regime in 1808 there are enough contradictory elements in the work to indicate the painter's ambivalence. At the far right of the composition, a blind man led by his dog obviously "sees" more clearly than the silly conscripts, while the majordomo energetically raising his baton hardly gets the response from the parade of recruits commensurate with his gesture.

The other work depicts the interior of an artisanal

2.9 Louis-Léopold Boilly, *Reading of the Bulletin of the Grand Army*, 1808. The St. Louis Art Museum.

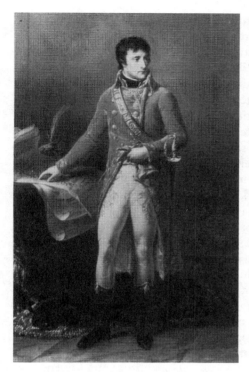

2.10 Antoine-Jean Gros, *Portrait of the First Consul,* 1802. Musée National de la Légion d'honneur, Paris.

household in which several generations follow on a map of Europe the march of the imperial armies.[12] The reason for their intense absorption is not merely their patriotic duty but the absence of a son, who is at the front. The "XII Bulletin" in the grandfather's hand refers to the German campaign, celebrated at the Salon of 1808. In the background, a mother nurses her infant beneath Canova's bust of Napoleon as First Consul, while in the center the grandfather and his son—the woman's husband—argue the location of the troops. Nearby a young woman, possibly the betrothed of the man at the front, listens intently, neglecting both her knitting and the attentions of a would-be suitor. In the foreground children's war games are disrupted by a feuding dog and cat. Despite the visible strain on family life caused by Napoleon's military ventures, the work endorses the patriarchal family structure, unified under the emperor's aegis. Rarely represented in Naploeonic salons, this depiction of the working class acknowledges the heavy sacrifices made by this group during the bloody years 1807–8.

Napoleonic Effigies

The various avatars of Bonaparte constitute another means of mapping the political transformations. The profile of the leader became synonymous with the state, and the kinds of information processed and communicated in the portraiture at a given time provide an index to the ideological developments. Gros's portrait of the First Consul became the prototype for the official type, and replicas and variants were distributed for display in institutional spaces (fig. 2.10). This version, dated year 10, was completed sometime after the Peace of Amiens on 25 March 1802. Young Bonaparte is shown with his body facing the viewer, his head turned three-quarters to the right, and his right hand pointing to a list of treaties that have been enacted under his general- and consulship. More precisely, his index finger strikes "Lunéville," the site of a peace treaty of February 1801 which gave France German territories on the left bank of the Rhine, Belgium, Luxembourg, and control of nearly all of Italy. It symbolized the complete failure of the Second Coalition to stop Bonaparte, and it momentarily isolated England. The way was now open for a truce with that country on terms favorable to the French. The last name on the list is "Amiens," where the signatures were exchanged in March 1802. The First Consul's action is decisive; his feet stand far apart, his left arm is bent at almost a right

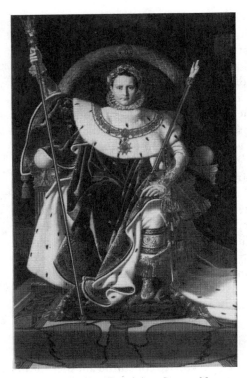

2.11 Jean-Auguste-Dominique Ingres, *Napoleon I on the Imperial Throne*, 1806. Musée de l'armée, Hôtel des Invalides, Paris.

angle as his left hand grasps a pair of gloves, and his right arm thrusts towards the table. These signifiers communicate a telling gesture to an unseen visitor in his interior space. He forcefully drives home the point that Lunéville was the precondition for Amiens, although his own motivation for the latter was his need to buy time to complete the work of political organization in the annexed territories. It is this military competence and capacity for strategic planning that Gros conveys: an energetic leader who makes his point effectively and acts decisively. The empty room and simple uniform convey a Spartan quality more in keeping with revolutionary imagery than with the imperial pomp of the next phase.

The most impressive example of the later stage is Ingres's portrait, *Napoleon I on the Imperial Throne* (fig. 2.11). A student of David, Ingres (1780–1867) early placed his brilliant gifts at the service of the emperor. One of Ingres's most telling examples in this regard is his *Oedipus and the Sphinx* originally done in 1808 as a proof of progress that every Prix de Rome laureate was obliged to send regularly to Paris (fig. 2.12).[13] The hero's encounter with the sphinx reenacts the symbolic confrontation between good and evil, intelligence and guile. The hybrid bestiality and malevolent expression of the Sphinx is reinforced by the human debris of its victims. Ingres carefully confines these negative allusions to the periphery or to the shadows, allowing the elegant and well-proportioned figure of Oedipus to dominate the scene. Imagine the hero in a cowboy hat and white suit and you will grasp Ingres's intention. Oedipus is both taut and relaxed, ready to draw his trusty javelins should sly old Sphinx engage in foul play while he works out the riddle.

The source of Oedipus's youthful confidence and swagger derives from Ingres's identification with Bonaparte, seen most vividly in the artist's design for *Napoleon on the Pont de Kehl* (fig. 2.13). The scene depicts the emperor on the threshold of the Rhine, an allegory of his plan for a confederation of Germanic states adjacent to the river. Ratified in July 1806, the plan was meant to dissolve the Holy Roman Empire. Napoleon's shield carries the no-nonsense inscription "reddition ou destruction" (surrender or destruction) and displays the menacing image of the Napoleonic eagle crushing the double-headed Hapsburg eagle in its talons (an allusion to Austerlitz). The following year, on 9 July 1807, Napoleon signed the Treaty of Tilsit with Czar Alexander, who he completely charmed and won over. The

terms of the treaty included France's acquisition of the Ionian Isles—the collective name for the seven Greek islands—with the result that France now controlled major territories associated with classical antiquity.

Ingres's awe of Bonaparte—or, at least, his calculated vision of awe—manifests itself in his 1806 *Napoleon I on the Imperial Throne,* which projects the emperor as a transcendental being on a celestial throne. His attempt to join the effigy of Bonaparte to an image of eternal authority has elements of both the eerie and the grotesque. The emperor is shown in his coronation robes and carrying all the trappings of dynastic rule: the imperial regalia, the scepter of Charles V, and the hand of justice and the sword of Charlemagne. Ingres's image corresponds to the hierarchical order Napoleon imposed on French society to counteract the excessive individualism of revolutionary social reforms. He reasserted the authority of the state and reaffirmed the social dominance of the middle class. While removing the Old Regime's obstacles to civil equality, Napoleon imposed a system to assure himself virtually unchecked power. Indeed, it was the Corps législatif which commissioned this image—owning up to its lack of independence and total subservience to Napoleon.

To convey a sense of omnipotence, omniscience, and omnipresence, Ingres drew from classical as well as Christian sources. The emperor's frontal pose derived from an engraved Roman gem representing Jupiter and published in the *Recueil* of the comte de Caylus (vol. 1, 1762, plate 46). At the same time, the rigid symmetry and heavy draping

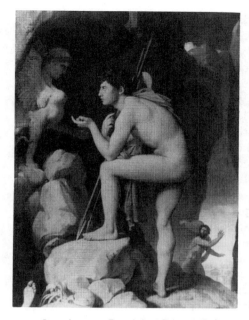

2.12 Jean-Auguste-Dominique Ingres, *Oedipus and the Sphinx,* 1808. Musée du Louvre, Paris.

2.13 Engraving after Jean-Auguste-Dominique Ingres, *Napoleon on the Pont de Kehl,* 1806. Cabinet des estampes, Bibliothèque Nationale, Paris.

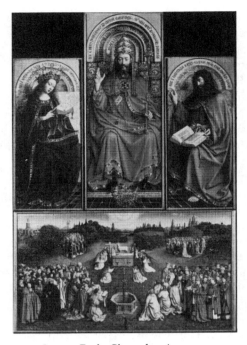

2.14 Jan van Eyck, Ghent altarpiece, 1432, tempera and oil on panel. Saint Bavo, Ghent.

recalls Jan van Eyck's image of God the Father at the top of his Ghent altarpiece, exhibited in Paris as part of the war booty during the years 1799 to 1816 (fig. 2.14). A great admirer of van Eyck, Ingres could not have made the point of Napoleon's unquestioned power more explicitly.

The allusion to van Eyck's altarpiece carries still another reference to Napoleon's imperial ambitions. The emperor hoped to make Paris the art center of the Grand Empire as well as its political capital. Napoleon considered looted art treasures of the enemy to be legitimate trophies of war and, therefore, rightful possessions. Such masterpieces were carefully gathered in the Louvre or sent to provincial museums. Art appropriations were included in peace treaties to give these transfers the semblance of legality. In addition, Napoleon proclaimed himself savior of oppressed countries whose annexation to the new political body made Paris their mutual capital. Thus he had a practical as well as moral pretext for enriching the national treasures and preserving the defeated country's cultural heritage.

Napoleon, who believed in the destiny of his "star," is accompanied in Ingres's picture by an astrological forecast of his rise to power. The carpeted step, covered at the base of the throne with the imperial eagle, is fringed with medallions of the zodiacal signs. At the left of the picture are the signs of Scorpio, Libra, and Virgo, while at the opposite side we can make out Pisces and Taurus. Scorpio (23 October–21 November), lying at the base of the throne and mirrored in the gilt socle, clearly alludes to the coup of 18 *brumaire* (9 November) which brought Napoleon to power, while Taurus must allude to the moment when he was proclaimed emperor (18 May 1804). Thus Napoleon's unearthly image is accompanied by an astrological chart affirming that his fate was indeed written "in the stars."[14] Here the Corps législatif and Ingres combined to mask the emperor's despotism and rule by force.

Ingres's astonishing deification of the emperor, however, suffered a backlash. Chaussard condemned it as an attempt "to push art back at least four centuries," and he stated that his negative impressions "agreed with those of the crowd."[15] The bizarre effects and pictorial complexities turned people away discontented. Yet Chaussard's frustration with the picture had more to do with its failure to produce *his* ideal of the emperor than with a "bad" painting per se. As he stated, "The character of a great man—that heroic physiognomy, his mobility of expression, that pro-

fundity of genius, those lightning gleams of inspiration—did this not offer sufficient difficulty to surmount?" In short, Ingres's attempt to deify Napoleon fell back on an archaicizing, "Gothic" model out of keeping with the modern Napoleonic state. For the closed-circuit world of the reactionary Corps législatif and the subservient painter the approach was entirely appropriate, but its unchecked foray into absolutist and theological sources ran smack into the residual republican components of the imperial system and exposed the contradictions of the regime.

Perhaps the most well-known avatar was the one commissioned by Alexander Douglas, heir of an illustrious Scotch family (fig. 2.15). It was commissioned in 1810 and completed two years later, right in the middle of the war with England. Why the marquis of Hamilton ordered the flattering image of the emperor remains open to speculation, but there are a few clues in the historical record. He considered himself the true heir to the throne of Scotland, and identified with powerful rulers. His will ordered that he be embalmed, buried in an ancient Egyptian sarcophagus, and interred in a colossal mausoleum. His evident admiration for Napoleon is seen in the fact that his extensive art collection included busts, miniatures, intaglios, and Sèvres vases with images of Bonaparte and his family. Lord Douglas was a loyal member of the Whig party, whose oppositional strategy called for attestations to Napoleon's invincibility on land, thus indirectly arguing for peace rather than for intervention.[16]

The full-length portrait of Napoleon represents him in the blue uniform of a colonel of the Grenadiers of the Foot Guard, in the act of leaving his study where he has passed the night at work, as indicated by the candles, which have burnt low and are flickering, and by a clock, which registers 4:13 A.M. The emperor did in fact work long hours and go with little sleep. David explained his painting to Alexandre Lenoir: his hero had been up all night drafting the *Code Napoléon* (shown rolled up on the table at the right) and has been so absorbed in his activity that he does not notice it is dawn until the clock strikes four. Then, without a moment of rest, he rises to put on the imperial sword on the sofa to the right and review the troops. When the work was submitted to the emperor before being dispatched to Scotland, Napoleon responded with pleasure, "You have indeed caught me this time, David. At night I work for the welfare of my subjects; in the daytime for their glory."[17]

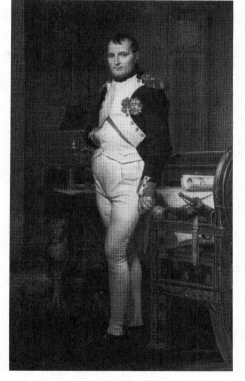

2.15 Jacques-Louis David, *Napoleon in His Study,* 1812. Samuel H. Kress Collection, National Gallery of Art, Washington, D.C.

The effectiveness of this basically flattering political allegory in 1812 lies in its capacity to allow for unflattering features. Napoleon seems to stand before us without physical idealization, his hair thinning, his body stooping and thickening around the waist, his cheeks puffy and pasty. He is no longer the dashing First Consul of Gros's portrayal. At the same time, Napoleon, with his characteristic right hand tucked into his jacket, dominates the picture space articulated by a series of parallel vertical lines. The sofa that he has just pushed aside in rising forms a powerful diagonal that now seems to pin him against the table. He is hemmed in by the furnishings of his study which also lock him into his work. Napoleon is literally a prisoner of his domestic obligations, which make him neglect his troops.

Thus by 1812 Napoleon is portrayed as less the decisive warrior than the compassionate statesman. He is assigned a "nighttime" slot, that is, in behalf of his subjects, with good reason: by 1811 the Continental system was beginning to disintegrate and war with Russia appeared inevitable. This called for a more humanized version of the emperor, which answered to both the ideology of the parliamentary opposition in England and the reality of the weakening military position of France. David makes use of allegory and metonymy to convey the legislative side of Napoleon, but in this later phase the proportion of "reality" to "ideology" has been reversed from what it had been during the time of the crossing of the Alps. The idealization is no longer centered in the body of the hero, but in the arrangement of objects that orders that body and gives it meaning.

Napoleon and the Ossianic Literature

David's distorted projection of Napoleon crossing the Saint Bernard pits the hero against the elements of wind and snow. The meteorological effects and icy heroism convey an Ossianic touch that points to another layer of Napoleon's self-flattery. Even Ingres's chilling portrait reminded one critic of the cold white light of "moonbeams." It may be recalled that the Ossianic epic had been pieced together from fragments and linked in a fictionalized structure by James MacPherson, who reached an audience of conservative Scots as a symbol of Scottish nationalism. The Ossianic saga told in mournful verse of the battles of Fingal, a glorious king, and the woes of Ossian, his son, who was

left old and blind to lament the friends and memories of his youth. The passionate melancholy of Ossian's songs evoked the nostalgia of the aristocracy for older hierarchical structures unthreatened by dissenting voices and republicanism. In addition to Scot aristocrats, Lord North, the abbé Cesarotti—whose Italian translation was the one read by Napoleon—and Chateaubriand represented the kind of conservative mind to whom MacPherson's writings appealed.

Hugh Blair's introduction to the *Works of Ossian* indicated why. He claimed that the ancient Celts enjoyed a government that "was a mixture of aristocracy and monarchy," typical of the form wherever the Druids predominated. The legislative power was entirely in the hands of the Druids, and it "was by their authority that the tribes were united, in times of the greatest danger, under one head." The heroes of the Ossianic songs "carried their notions of martial honour to an extravagant pitch," needing no assist from gods as in the Homeric sagas.[18]

The Celtic peoples preserved the exploits of their king in song transmitted to posterity by the bards. His heroic actions were magnified, and the populace was dazzled by their propaganda. These are ideas that would have had a profound appeal for Napoleon; the warrior nation and its heroes were the Celtic equivalent of the Homeric epic but were cast into a text that was more accessible for the moderns. The Ossianic tales are gloomy and suffused in mist; the moon is a recurrent motif. The figures lack substance and move like shadowy ghosts through the fogbound landscape, appropriate to the lugubrious mood. The poems are related by Ossian the narrator, singing the saga of his fallen friends and his son Oscar, but especially of his father Fingal, the main protagonist of the cycle. Ossian tells these tales in the company of Malvina, his only companion, the betrothed of his son Oscar. Fingal rules over the kingdom of Morven, and his rival is Starno of Lochlin, whose warriors are the traditional enemies of Morven. Napoleon's fascination for the Ossianic sage is bound up with his own self-romanticization which sustained him in the face of the destruction he did so much to bring about.

Napoleon's passage of the Saint Bernard was already linked with Ossianic deeds the year David completed his picture: the poet Creuze de Lesser read his flattering *Vers sur la mythologie d'Ossian* at a gathering in 1801 in honor of the First Consul. It begins by dismissing the antique heroes:

Farewell to the fables of yesteryear,
The gods of the Greeks and Trojans!
Hail in their place the heroes of the clouds
In their aerial palaces!
.

Their souls descend to converse
With earthly heroes.

And slightly later:

When across the towering Bernard
Victorious Bonaparte
Dared to make a passage
We saw the soul of Hannibal
Applaud his young rival
While leaning on a cloud.[19]

Napoleon's infatuation with the Celtic warriors was already known at the end of the century, and by 1800 it was publicized through his portrait medallion of the bard hanging in the First Consul's library at Malmaison.[20] Several of his conversations were recorded in which Ossian figured as a prime subject; every time he met a Scot he invariably asked, "Do you know the works of Ossian?" He took advantage of contacts with German and Scandinavian diplomats to discuss their views of Ossian, and he entertained Cesarotti like visiting royalty. Given this pronounced trait of self-identification, it is no wonder that the Napoleonic years are pervaded by poetic and visual allusions to the Ossianic songs.

Beyond the mere personal attachment to Ossian, however, lies a calculated exploitation of the sagas for political purposes. Napoleon founded a Celtic Academy which tried to make a case for a Gallic Ossian, tying the bard to the Bretons who descended from the Celts. In this way he hoped to whip up nationalist and patriotic enthusiasm against the English, who claimed the Ossianic legacy as their own. There were other reasons for the Napoleonic cultivation of the songs: their melancholic evocation of fallen heroes answered to the mood of the French people during a period of almost uninterrupted warfare and domestic repression.

The clue to this state of mind is clearly indicated in the paintings of mourning women, often done by female artists. In 1806 Elisabeth Harvey exhibited *Malvina Mourning Oscar*, depicting the lover of Ossian's son lamenting his death at the hands of the traitorous Cairbar (fig. 2.16). Based on the song of Croma, the picture shows Malvina

2.16 Elisabeth Harvey, *Malvina Mourning Oscar*, Salon of 1806. Musée national du château de Versailles.

responding with a plaintive cry to a vision of her lover: "Thou dwellest in the soul of Malvina, son of mighty Ossian . . . I was a lovely tree, in thy presence, Oscar, with all my branches round me; but thy death came like a blast from the desert and laid my green head low."[21] She recalls how her friends tried to console her with "the harp of joy"; but she was inconsolable, much as thousands of actual people suffering the loss of loved ones during the Napoleonic wars. Fanciful as the theme was, Harvey rendered the landscape with topographical exactitude and tried to make the legendary domain as persuasive as possible. Indeed, it bothered Chaussard that the fog was not sufficiently in evidence.

One of the most popular of the women painters of the Napoleonic years was Constance Charpentier (née Blondelu), who studied privately under several masters including David and Gérard.[22] She exhibited frequently at the Salon between 1795 and 1819, specializing in genre scenes depicting well-to-do women. One of her most moving contributions was *Melancholy,* which exhibited at the Salon of 1801 and portrayed a woman in a state of despondency in a landscape that clearly contained many memories of her loved one (fig. 2.17).

Themes of melancholy and lamentation became commonplace in the late eighteenth and early nineteenth centuries and usually focus on single women. The revolutions and wars of the period devastated the male population,

2.18 Jeanne-Elisabeth Chaudet, *Young Girl Mourning for Her Dead Pigeon,* 1808. Musée d'Arras.

making widowhood a major problem requiring special legislation and institutional facilities. Many of these themes were produced by women and displaced onto the past or treated in allegorical guise. Henriette Lorimier's *Jeanne de Navarre,* exhibited in 1806, depicts the eponymous heroine guiding her son to the tomb she has erected for her husband Jean IV, duc de Bretagne, surnamed Le Conquerant, who perished in battle in 1399. Jeanne recounts the virtues and unfortunate events in the life of her husband, forming a model of inspiration for her son. The appeal of this theme to the Salon audience is shown in the response of the critic Chaussard, who interrupted his description of the picture to recall the pervasive presence of widowhood and parental loss in the midst of the Napoleonic wars. Noting that family tragedies brought about by the national struggles always move the Salon bystander, he declared, "Show me therefore any mother, father, spouse, or child who would not be affected by such tragedies? They become in some way our own, by reflexive identification and a turning inward on ourselves."[23] If the image of the doleful woman at the tomb or in the woods became something of a cliché, this should not obscure the actuality of loss and tragedy that afflicted female survivors. Furthermore, this imagery actually helped shape feminine gestures and behavior into a kind of anestheticized melancholy which became an erotic symbol for males searching for a certain dreamy, passive, and utterly exploitable human being.

A related image of the period is Jeanne-Elisabeth Chaudet's *Jeune fille pleurant son pigeon mort* (Young girl mourning for her dead pigeon), shown at the Salon of 1808 (fig. 2.18).[24] The work depicts a young woman kneeling on the floor and cradling with deep tenderness her precious pet. She looks heavenward with a poignant look that questions the fate of her dead bird. It is clear that the bird is a metaphor for the tragic loss of human lives, since the proverbial *pigeon mort* had the double sense of the vulnerable person. The white pigeon could also be seen as a stricken dove. Finally, during the Napoleon wars great use were made of carrier pigeons for the transferring of messages. Thus it is likely that the woman's grief over the animal has the larger sense of lamentation over the loss of human life in the ongoing warfare waged by Napoleon.

Ironically, Chaudet's husband was Antoine-Denis Chaudet, one of Napoleon's favorite sculptors. In addition to several busts of the emperor, it was Chaudet who executed

the colossal statue of Napoleon in Roman costume for the Vendôme Column, that capital work of Bonapartist propaganda. While he was building up a macho image of the ruler, his wife was making a modest but powerfully insightful statement about the effects of male dominance and aggressiveness.

Thus at great personal sacrifice the French followed Napoleon's dreams of glory for the nation. He could not establish himself in the sense of a French king; there had to be military campaigns for him to maintain his place. The regime finally broke down as France became worn out; it grew tired of the sacrifice of its youth on the battlefield. Napoleon's imperialism could endure only as long as he could appear as the champion of the Revolution. The enemies of France were undertaking to set up the old order again—the divine right of kings, the right of the church in its medieval claim—and Napoleon defeated them one after another. It wasn't that Bonaparte was interested in establishing a democracy, but that he fought those who were determined to wipe out the last vestiges of the Revolution. Napoleon's great strengths were his capacity for introducing order, security, into the state; his military genius in defeating the enemies of France; and the attendant power over all the armies of Europe—the ability to stand as a dominant power on the Continent.

If the armies of Napoleon had crushed the enemies of the Revolution, they had not established its principles in the French state. They had established another empire, the Napoleonic empire. There was a definite sense of defeat among the popular classes after the failure to organize a society on the basis of liberty, equality, and fraternity. It is this combination of contradictory circumstances, of a sense of glory and a sense of defeat and failure, that created a climate receptive to the Ossianic poetry. The melancholy mood of the Ossianic poems, the lunar quality, the vague, misty settings, the heroic, unreflective actions, and the fatalistic philosophy fit the mind-set of French society during the peak years of the Napoleonic regime. The Ossianic heroes may have occupied "aerial places" and cloudy, celestial domains, but their geographical and chronological proximity made them more accessible than the heroes of Greece and Rome, and their pantheistic and pessimistic view of life prevented a sentimental gloss on their actual experience. Celtic warriors, like Conan the Barbarian, were fierce, virtuous, guilt-free, and unconcerned with history except to

LA MACHINE INFERNALE.

guard the memory of ancestral exploits. Bonaparte's own notion of immortality related to the memory of victorious battles; everything except the military triumphs and martyrs would be filtered out. Thus the eerie Ossianic sagas literally mystified the domestic repression, the sacrifice of a nation's youth, and the destruction wreaked on neighboring countries.

It is no coincidence that the first major French painting based on MacPherson's poems was Paul Duqueylar's *Ossian Singing a Funeral Hymn,* which exhibited at the Salon of 1800.[25] Duqueylar was associated with the rebellious group of David's students known as the Barbus, the model for Bohemian sectarianism in the nineteenth century. The Barbus took their cue from Maurice Quay, whose obsession for Ossian brought him to the attention of the First Consul.[26] Duqueylar's stark landscape, its color and lighting, struck the art critics as somewhat bizarre, but the Barbus claimed the work as their own. Ironically, however, its immediate inspiration derived from Bonaparte.

In 1800, planning to make the Malmaison his summer residence, Napoleon commissioned his favorite architects Fontaine and Percier to restore and decorate it. They in turn gave David's students Gérard and Girodet, and three others commissions for six pictures suitable for Bonaparte's residence. The plans called for political subjects, but a series of landscapes depicting Bonaparte's Italian campaigns did not please the First Consul. Girodet's first subject was an allegorical representation of the well-known

machine infernale attempt on Napoleon's life (fig. 2.19). He depicted a Hercules-Napoleon destroying a fire-breathing monster, but this idea was also rejected. Thus both explicit documentary and neoclassic approaches were rejected.

Gérard had begun an Ossianic subject under the direction of Fontaine and Percier, *Ossian Evoking the Shades with His Harp on the Banks of the Lora* (fig. 2.20). It emphasizes the key function of the blind bard in singing of the heroic exploits of his companions in arms. Ossian consoles himself with the memories of his son Oscar and his daughter-in-law Malvina, seen embracing on the left, his parents Fingal and Roscrana, on the right, as various other warriors and bards gather in the moonlit clouds around him. In the background is seen the aerial palace of Selma, Ossian's birthplace. The lunar lighting adds an eerie touch to the ancestral phantoms.

It is no coincidence that the original version was given as a gift to Jean-Baptiste Bernadotte, a hero of the French army who was designated Swedish crown prince and heir to the throne on 21 August 1810. Bernadotte personally testified to the popularity of the new folklore when he named his son Oscar after Ossian's offspring. The ideal of virtuous action of antiquity has been replaced by a Celtic ideal of action for its own sake. As a Frenchman becoming a naturalized Swedish citizen, Bernadotte may have considered it suitable to display an image of Nordic mythology. The fact that Fingal was the bitter enemy of the king of Lochlin (Scandinavia) made little difference; the appeal of Ossian cut across geographical and ideological bounds and lent itself to a variety of political purposes.

Gérard's painting, with its array of the Ossianic cast of characters, set the backdrop of its complement by Anne-Louis Girodet-Trioson (1767–1824), which directly links the folklore to Napoleonic propaganda. It is a most perplexing and ambiguous picture which attempts to marry the Ossianic heroes to Napoleon's fallen officers who meet in the "aerial" realm evoked by MacPherson's songs. Girodet makes topical allusions to current political events but deliberately keeps the documentary vague, in tune with Napoleonic aspirations. Girodet dedicated his picture to the First Consul, and his letters to Napoleon in this period are filled with exaggerated homage. He noted that Napoleon's taste for Ossian has revealed to the artist its "secret" meaning, and that the originality of the visual conception was meant to match the First Consul's "new" glory. The complete description of Girodet's picture is as fantastic as

2.20 François Gérard, *Ossian Evoking the Shades with His Harp on the Banks of the Lora*, 1801. Hamburger Kunsthalle.

2.21 Anne-Louis Girodet-Trioson, *The Ghosts of French Heroes, Killed in the Service of Their Country, Led by Victory, Arrive to Live in the Aerial Elysium Where the Ghosts of Ossian and His Valiant Warriors Gather to Render to Them in Their Voyage of Immortality and Glory a Festival of Peace and of Friendship,* exhibited 1802. Musée National du Château, Rueil-Malmaison.

the imagery: *The Ghosts of French Heroes, Killed in the Service of Their Country, Led by Victory, Arrive to Live in the Aerial Elysium Where the Ghosts of Ossian and His Valiant Warriors Gather to Render to Them in Their Voyage of Immortality and Glory a Festival of Peace and of Friendship* (fig. 2.21).[27]

These two groups constitute the main interest of the composition, the center of which focuses on Ossian and General Desaix, who embrace. "All these heroes admire the French heroes." Ossian, the bard of Morven (MacPherson's name for the highland areas in northwestern Scotland), leads the Celtic contingent as he leans on his upside-down spear. Just to his right Kléber extends a hand to Fingal and with the other helps Desaix support a trophy captured during the Egyptian campaign. Next comes Caffarelli-Dufalga, who carries a broken standard captured from the Turks. In addition to the several French officers lost during the Revolution, there are representatives of the grenadiers, sappers, dragoons, chasseurs, hussars, and cannoneers, all identified by their uniforms.

The figure of Victory hovers above the central group; with her left hand she presents to the Celtic warriors a caduceus, symbol of peace. In the other hand she holds aloft a sheaf of palm, laurel, and olive leaves, pointing to the "glorious conquests" of the French armies. Above this sheaf is a cock, symbol of France. With an outstretched wing it offers shelter to a dove who had been on the point of being ravished by an eagle, which now flies off at the left.

The Ossianic figures include those receptive to the arrival of the French and those who react negatively to it. Behind and to the left of Ossian is his son Oscar and his father Fingal, who wears a helmet topped with a giant eagle's wing. Fingal clasps Kléber's hand. The maids of Morven welcome the French with flowers, music, and even drinks in cups made from seashells. But the traditional enemy of Morven, the warriors of Lochlin, do not share the general enthusiasm for the French soldiers. Starno, king of Lochlin, at the lower left, is enraged by his daughter's enthusiastic greeting of the French and grabs her by the hair. He is on the verge of slaying her when a French dragoon arrives in time to rescue her. Meanwhile, allies of Starno signal bellicose actions by striking the shield of one of the warriors of Morven with the hilt of a sword and whistling "seditiously."

This abstruse allegory of the political and diplomatic situation in 1801 is submerged in the lunar and meteorological light of MacPherson's tales. The festival of peace in the Ossianic realm contains a direct allusion to the numerous events organized throughout France on the occasion of the peace treaty signed on 9 February 1801 at Lunéville by France, Austria, and other Continental powers.[28] The Continental peace established by this treaty was enthusiastically greeted by all except the English, who continued hostilities. Contemporary patriotic poetry celebrated Napoleon as a hero who established peace through victories and vanquished but did not humiliate his adversaries. Thus the French march triumphantly under the allegorical personification of Victory, topped by the Gallic cock who has chased the Austrian eagle and gives refuge to the dove of peace. The bellicose gestures of the warriors from Lochlin symbolically refer to England's refusal to sign the treaty and its wish to remain at war with France. England was thereupon accused by the French press of attempting to arm the enemies of France and to impede the peace negotiations. It was in England's best interests to keep the war alive. Ironically, however, by the time Girodet finished the picture the Treaty of Amiens was signed (25 March 1802), which proclaimed general peace with all the powers including England. Girodet's allegory was anachronistic at the time of the Salon later that year.

But if the topical political allusions were outdated, the Ossianic context still carried a contemporary meaning for the reigning elite of the period. One of Girodet's friends, noting the encounter between Kléber and Fingal, described that the most poetic idea of the *Ossian* was the rendering of Kléber as friend of Fingal: "it gives a real sense of the character of this brave soldier." The identification of the shades of French military heroes of the Revolution with the Ossianic heroes was a common device in contemporary patriotic poems. Esménard presented a poem to the First Consul celebrating the peace treaty at Lunéville in 1801, which expressly associated French warriors lost on the battlefield with the Ossianic heroes: ". . . in the midst of the skies battered by storms, / Like the shades of the heroes depicted by Ossian, / Their bellicose spirits fly on the clouds, / And follow our flags."[29]

Girodet's correspondence to Napoleon stated that the picture aimed at an "apotheosis" of the dead heroes France now laments as a kind of consolation for the country's sac-

rifice. The reception by the ancient Scot warriors or Caledonians testifies to the high value and deep affection that French people feel for their own heroes. And in his description of the tableau Girodet noted that the most important trait of the Caledonians was courage (*bravoure*); the bravest warriors were the most revered and their deeds transmitted to posterity by the bards. The ancient Celts did not maltreat conquered enemies and protected their oppressed and defenseless neighbors. The dragoon who rushes in to defend Agandecca, the daughter of King Starno, slays Fingal's enemy with a "sword of honor" awarded him by the First Consul. This motif is complemented by the allegorical union of the Gallic cock and the dove that it has just rescued from the Hapsburg eagle in the upper level of the picture.

The blending of the Ossianic and Napoleonic in the attempt to justify the human sacrifices necessary for the Lunéville peace treaty demonstrates the political meaning of MacPherson's sagas for Napoleonic France. Girodet's own mixture of fantasy and fact is the appropriate expression for the ideological role of Ossian. Just as neoclassicism raised the death of General Wolfe to a transcendental level, so Ossian now functioned to lend an air of mystery and enchantment to the sordid realities of Napoleon's imperialism.

Girodet and Contemporary Science

Both the Gérard and Girodet pictures depict the Ossianic characters as if they were made of "crystal"—David's description of Girodet's figures. They are illuminated by lunar and meteoric light, significant meteorological auxiliaries to MacPherson's tales.[30] The melancholy evocation of ancestral phantoms of heroes lost in battle finds its appropriate mood in the moonlit setting—the moon of magic and science combined. Girodet's description of his painting includes several references to brilliant shooting stars and meteors, attesting not only to his familiarity with the MacPherson poems, but to his awareness of recent meteorological investigation linking meteors with electrical phenomena. Bertholon's study, *De l'électricité des météores*, was widely read in France and England, and we know that Girodet himself was fascinated by electricity.[31] In this he shared the fascination of his patron, the First Consul, who in 1801 hosted Alessandro Volta at the Institut to witness his experiments with a pile battery and to hear his obser-

vations on Galvanism. In addition, the science of crystallography was developing in that period under the stimulus of the research of Rome de L'Isle, who observed the electrical effects of the mineral tourmaline, which accumulated an electric charge when rubbed.[32] Hence electricity was associated with meteorology and crystallography, two sciences linked with Girodet's Ossianic painting.

Here again Girodet assimilated characteristics associated with the English experimentalists. The spectral lighting moved him close to Fuseli, while Flaxman's influence is evident in the female figures greeting the French. The flashing meteors and shooting stars both heighten the irrationality of the scene and attest to the empirical investigations of contemporary science. Significantly, Girodet showed his *Sleep of Endymion* at the same Salon as the *Ossian,* thus confirming the scientific links in their relationship to each other.

Napoleon's lavish endowment of scientific institutions made Paris the science center of the world. In the fields of mathematics, physics, and natural science in particular, an international roster of outstanding talents actively collaborated in scientific projects. The spirit of innovation invigorated all areas of cultural life; artists like Gérard and scientists like the chemist Berthollet maintained salons where an intellectual elite mixed and exchanged ideas. A key figure in the dissemination of science among the art community was the Prussian naturalist, Alexander von Humboldt (1769–1859), who regularly participated in both the Berthollet and Gérard salons. Humboldt had already met Gérard in 1795 when the artist painted his portrait, and three years later he met David and more of the master's students. It is certain that he met Girodet around this time, whose *Endymion* he knew and admired. Humboldt and Girodet had several mutual friends including Gérard, the surgeon Dominique-Jean Larrey, and the psychologist and philosopher Pierre Cabanis.

Two of Humboldt's major interests were mineralogy and electricity. He worked for the Prussian Department of Mines and had been schooled by Abraham Gottlob Werner at Freiberg. Werner stood at the head of the Neptunist school of geology, which believed that the formation of rocks was due to sedimentation; opposing the Neptunists were the Vulcanists, led by James Hutton, who claimed that volcanic activity was the source of rock formations.[33] Humboldt would have received a thorough training in mineralogy and geology at the School of Mines in Frei-

berg. Additionally, Humboldt carried out a series of experiments inspired by Galvani's study of so-called animal electricity. Humboldt made thousands of experiments on animals, plants, and even on his own body, arriving at conclusions that lay between the work of Galvani and Volta. He came close to inventing the first electric battery and was disappointed to learn that Volta—whose experiments rendered those of Humboldt obsolete—beat him to it.

More important for Girodet, Humboldt was fascinated with meteors as electrical phenomena. He was the first to observe with instruments the great meteor showers of 1799, and his observations were the starting point of research into the nature and periodicity of meteors. Later, he also compiled data with Sir William Herschel in connection with paths of comets, multiple stars, and planetary movements. Powered by an electrical force, meteors move with planetary speed and proceed from outer space into the earth's atmosphere, where they become luminous. At this point, meteors often let fall fiery, stony matter in the form of a shower. Humboldt believed that the periodic meteoric streams formed a close revolving ring at the time of the meteor falls. Girodet's *Ossian* is illuminated in the upper region by a shower of shooting stars and meteors which bathe the scene in a phosphorescent glow and give the figures the quality of transparent "crystal."

Girodet was fascinated by novel lighting effects and, like the English, derived his interest from the experiments of contemporary scientists. Humboldt studied lighting in connection with his mining activities. As an inspector of mines, he made experiments on firedamp and designed safety lamps. His lamps were used in the mining regions under his jurisdiction until they were superseded by Sir Humphry Davy's design. Ironically, one of the officers depicted in the *Ossian,* General Desaix, was interested in chemistry and heard of Humboldt's safety lamp. When they met during Desaix's invasion of Württemberg in 1796, Desaix inquired about Humboldt's invention. He was so taken with the scientist's ideas that he invited him to an ascent in the balloon Desaix used for reconnaissance.

Napoleon was personally interested in lighting for both civil and military use and encouraged innovation in this area. He subsidized Argand's lamp manufactory at Paris, and encouraged the efforts of the pioneer of gas lighting, Philippe Lebon.[34] An engineer attached to the Service des ponts et chausées (department of civil engineering), Lebon had already experimented with distillation of gas from

wood, which he believed could be applied to lighting, heating, and the inflation of balloons. In an effort to convince the French government of the advantages of applying gas to public buildings, Lebon moved to Paris in 1798 and began conducting experiments on a large scale. He took out a patent the following year for new ways of employing gas for heating and lighting, with an extension dated 1801. Indeed, the first public exhibition of gas for lighting and heating took place in Paris, in October 1801, at the Hôtel Seignelay. The gas was generated by the destructive distillation of wood in two "thermolamps" (his own term). One thermolamp warmed and lighted the interior of the house; the other lighted the garden with flames designed to make fantastic visual shapes. A fountain in a grotto spouted flame instead of water. The exhibition was continued at weekly intervals for some months and was widely advertised in the press. Lighting by gas thus came to be regarded as a practical possibility. While the principles were known and produced in the laboratory, Lebon demonstrated their practical application. Among the visitors to Lebon's demonstration was Gregory Watt, James Watt's second son, who managed to get to France although Britain and France were still technically at war. He sent a report on Lebon's work to his brother James, which helped promote the similar experiments of William Murdoch, who worked for Boulton and Watt's celebrated Soho Foundry. When the Soho Foundry was illuminated to celebrate the Peace of Amiens the following year, the decorations included some gas illumination.

Ossianic themes then pervading the French art and literary scene profoundly affected art production. Critics in 1802 were disturbed by certain aspects of Girodet's picture; one critic noted the cold white light which reminded him of "moonbeams." Napoleon occupies an aerial realm akin to the Nordic heroes who receive Napoleon's fallen officers. A few years later, not surprisingly, Ingres painted an Ossianic subject for Napoleon (fig. 2.22). This was one of two commissions for the emperor's projected triumphal entry into Rome. When Bonaparte replaced the pope in the Palazzo del Quirinale, it was the literal embodiment of what Ingres could only suggest in his effigy for the Corps législatif. Destined to decorate the ceiling of Napoleon's bedroom, the picture represents the *Dream of Ossian*.

Ingres's two commissions were awarded him by General Sextus-Alexandre-François Miollis, who had been appointed governor of Rome and the papal states during the

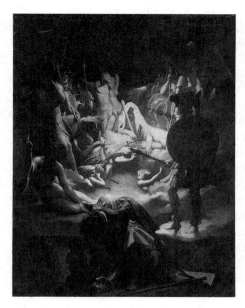

2.22 Jean-Auguste-Dominique Ingres, *Dream of Ossian*, 1811. Musée Ingres, Montauban.

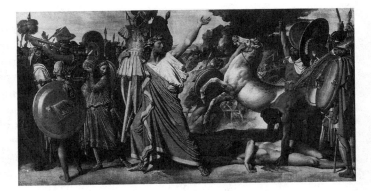

French occupation of the Eternal City in 1808. Miollis carried out the Napoleonic measures against Pius VII and laid the plans for the emperor's reception. This encompassed the redecoration of the ex-papal palace with a didactic and propagandistic program prefiguring the Napoleonic empire. He shared his chief's dual love for Plutarch and Ossian, and also ordered Ingres (as one of several of hired painters for his program, including Duqueylar) to do a *Romulus, Conqueror of Acron* for one of the empress's salons in the Palazzo del Quirinale (fig. 2.23).[35] Acron, king of the Caeninensians, was killed by Romulus, who bestowed his weapons and trophies upon Jupiter. Laurel-wreathed Romulus is clearly a persona for Bonaparte, whose accomplishments are equated with those of the founder of ancient Rome's military and political institutions. Indeed, surveying the crumbling state system of Europe in this period, Napoleon imagined that it could be replaced with a supranational empire, ruled from Paris and Rome and based on the *Code Napoléon*. As in the case of Count Bernadotte, it is a French officer who grasps the connection between Ossian and the grandiose imperial strategy. While Girodet blends the Ossianic, the antique, and the modern in a wild synthesis, Miollis conceived his scheme in distinct but complementary modes. Romulus-Napoleon, the conquering hero, leaves in his wake the dead of his own and his enemy's countries, and these must now be mourned in the form of the phantom reveries of the bard of Morven.

These two works were bridged by the figure of a warrior brandishing a shield at the right in both pictures. Ingres himself posed before a mirror for this figure, and while it was a late addition in the *Ossian*, it conveys a sense of the artist as a warrior in the service of the emperor. Ingres's painting is based on the French translation of the last

paragraph of the song, "The War of Inis-thona," where Ossian declaims,

And ye shall have your fame, O sons of streamy Morven.—My soul is often brightened with the song; and I remember the companions of my youth.—But sleep descends with the sound of the harp; and pleasant dreams begin to rise. Ye sons of the chace [sic] stand far distant, nor disturb my rest. The bard of other times converses now with his fathers, the chiefs of the days of old.— Sons of the chace, stand far distant; disturb not the dreams of Ossian.[36]

Above the sleeping Ossian we see the ghosts of heroes and lovers cavorting in moonlit clouds. At the right, his son Oscar stands poised to combat an adversary, while on the left his dead wife Everallin reaches out to him from the other world. In *Fingal,* Everallin appeared to Ossian in a vision imploring him to save their son Oscar, engaged in battle with the warriors of Lochlin. Reigning in the center of the apparition is a snow-covered king, holding a scepter like the enthroned Napoleon; this is Annir, king of Inis-thona, who fought alongside Fingal. The entire poem interweaves the heroic actions of Ossian's allies with those of Oscar. Fingal admonishes Oscar to battle "like the roaring storm" and never allow strangers to say "feeble are the sons of Morven!" Oscar combats the ferocious Cormalo and defeats him in battle; when, on his return, he raises his enemy's sword, a thousand youths admire it, and Ossian beams with pride as he settles into his reveries: "They look with wonder on my son; and admire the strength of his arm. They mark the joy of his father's eyes; they long for an equal fame."[37]

The simple exhortation of the Caledonians to their sons and brothers to win "fame" on the field of battle and commit themselves to the glory of Morven corresponded to Napoleon's own propaganda appeals to the French public. Considering the date of Ingres's commission (1812), it seems certain that the emphasis of the picture on Ossian's familial relationships and special concern for Oscar allude to the birth of Napoleon's son, the king of Rome born to Marie-Louise on 25 October 1811.

Popular Identification of Napoleon with Ossian

The total identification of Napoleonic and Ossianic themes is clearly seen in a work exhibited at the Salon of 1810,

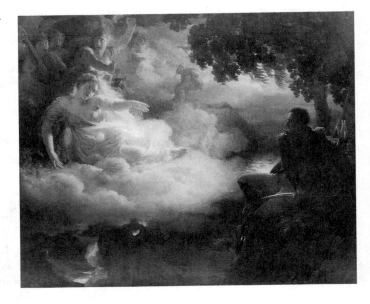

Jean-Pierre Franque's *Allegory of the condition of France before the Return from Egypt* (fig. 2.24).[38] Franque and his twin brother, Joseph-Boniface, allied themselves with the Barbus in David's atelier and thoroughly assimilated the preference for Ossian. The theme of this work is a vision of Bonaparte at the end of the Egyptian campaign, before the coup of 18 brumaire, and is represented in the Ossianic mode. A ghostly personification of France, menaced on all sides by emblematic enemies wielding daggers (Crime, Blind Fury, Fanaticism, etc.), entreats Bonaparte to return from the land of the palms and pyramids to save the nation from the corrupt government of the Directory. Although by 1810 Napoleon's debacle in Egypt and his abandonment of the army had been disclosed, Franque's picture declares that his decision was prompted by his perceptive response to the country's need in a time of crisis. The inscription on the overturned Altar of Law in the cloud reads, "France, suffering under an unhappy government, summons from the bosom of Egypt the hero on whom her destiny depends." Moreover, in 1810 the hated British—against whom the Egyptian campaign had been undertaken—inflicted heavy losses on the French in the West Indies, and the picture essentially appeals to the French people to affirm its support of the emperor, who alone could repel France's enemies and assure its continued dominance on the Continent.

Clearly influenced by Gérard's *Ossian,* Franque's picture

preserves the split-level arrangement of dreamer and dream; but the latter substitutes Bonaparte for Ossian while the phosphorescent allegories in the moonlit clouds replace the apparitions of the bard's ancestors and friends. Critics praised the intense lighting effects and immediately identified it with the "airborne Caledonians" of Gérard and Girodet; one observed "a mass of fluid, in which I seem to see ghosts"—evoking a molten process associated with glassmaking or volcanic material.[39] Here again the originality of Napoleonic conception in the context of Mac-Pherson's poems is related to industrial and scientific phenomena. At any rate, Franque's painting demonstrated the close association of Bonapartism and Ossianism, proving that the presence of one could immediately conjure up allusions to the other.

As in the work of Gérard, Franque, and Girodet, Ingres's Ossianic ghosts resemble glassy, crystalline forms penetrated by lunar light. The hard, brittle surface recalls the work of Joseph Wright of Derby, who similarly combined a highly polished execution with unusual effects of illumination. Ingres's contact with the English school, however, was mainly through Flaxman—an artist he particularly admired. He owned copies of Flaxman's *Iliad* and *Odyssey* illustrations, and several of his paintings from around the time of the *Ossian* incorporate figural suggestions borrowed from the English sculptor. Flaxman's spare outlines appealed deeply to Ingres, who learned to manipulate them for expressive ends. The eerie Ossianic apparitions owe part of their impalpable quality to Flaxman's linear style. Finally, Ingres's bleak, craggy landscape and crystalline forms may invoke the geological ideas of James Hutton, a Scot who developed a popular theory of the crystallization of fluid matter thrown up by volcanic upheaval. Thus during the time Britain became the leading manufacturing country in the world, English writers, artists, and scientists associated with the Industrial Revolution exercised a profound influence on the culture of the Continent. Napoleon's personal scientific and industrial concerns kept the door open for these contacts despite the wartime conflict with Great Britain.

The Moon Motif

The Ossianic, moonlit scene and its association with France in upheaval appeared often during the Napoleonic epoch. The moon is conjoined with violence (even when

self-inflicted as in Gros's *Sappho* or accidentally as in Broc's *Death of Hyacinth*—both exhibited in the Salon of 1801) as evidence of the catastrophic changes in the social order. The moon heralds the new in the scientific realm, but also points to a lack of rational control in the social and political domains. Napoleon's repressive policies consolidated middle-class dominance and patriarchy while penal codes and criminal procedures rolled back revolutionary libertarianism. The resulting social stability was the product of an overcentralized, rigid institutional structure which left the poor, the worker, the woman, and the child in a precarious relationship to the state. Lunar violence pointed to this layer of society unable to directly share in the bounty of the empire and necessarily held in check by a rigid authoritarianism.

Pierre-Paul Prud'hon

One of the most dramatic images of this association was painted by Pierre-Paul Prud'hon (1758–1823). The gifted son of a stonecutter, Prud'hon was early encouraged by the local aristocracy of his native Dijon. While he enthusiastically supported the first phase of the Revolution, he withdrew from the Parisian scene during the second phase and took refuge in the Franche-Comté. During the Directory he fell in with the officials, financiers, and war contractors who ran the government. He quickly switched his allegiance to Napoleon after the coup of 18 *brumaire* and enjoyed the First Consul's confidence and support. In this he was abetted by the patronage of Napoleon's docile *préfet* of the Seine, Comte Frochot, who hailed from Dijon and opened the doors to high society for his compatriot.[40] Prud'hon's early devotion to the First Consul is exemplified in his drawing of the *Triumph of Bonaparte,* which exhibited at the Salon of 1801: it depicts Napoleon entering Paris in a triumphal chariot, standing between personifications of Victory and Peace and leading a train of personages representing the arts and sciences. From this time forward Prud'hon was showered with official commissions, ranging from portraits of the Bonaparte family and letterheads for stationery of government departments to designs for large-scale celebrations given by the City of Paris, such as the coronation, the Treaty of Tilsit, and Napoleon's second marriage, with Marie-Louise. Prud'hon, like Frochot, became an obedient servant whose patrons exerted a major

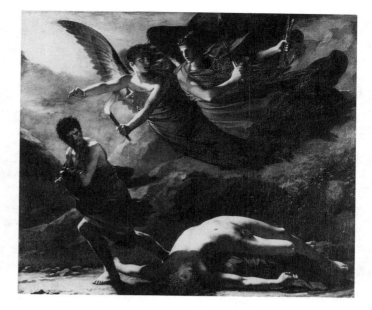

impact on his production. His soft, hazy style of painting, quite unlike David's, suited the Ossianic and sensual side of Napoleonic culture.

Prud'hon's *Divine Justice and Vengeance Pursuing Crime* captivated the middle-class public at the Salon of 1808 and eventually won for him the chevalier de la Légion d'honneur (fig. 2.25). A municipal commission arranged by Frochot, the work was destined to adorn the criminal court at the Palais de Justice.[41] It was meant to replace the traditional image of the crucified Christ with a theme more in keeping with Napoleonic justice. The first sketches were executed in 1804—the year Napoleon was proclaimed emperor. The subject is a scene of horror and retribution: a male figure personifying Crime, under the cover of darkness, has slain his victim and stolen his purse. The victim was an innocent youth, reminiscent of David's *Barra;* some contemporaries also thought of Cain and Abel when they viewed the work. As the murderer flees the scene of the crime, Divine Justice and Vengeance (or Nemesis), the agent of Public Justice, pursue him overhead and are about to swoop down upon him. Vengeance carries a torch and reveals the criminal for Justice, who holds the proverbial scales in one hand and a sword in the other with which to strike the absconding felon. The entire action unfolds against a bleak, Ossianic backdrop of craggy rocks lit by

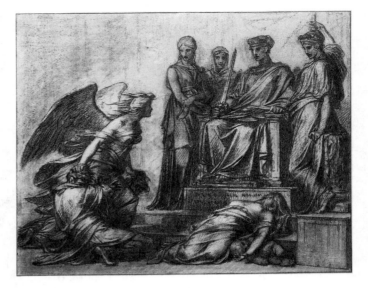

2.26 Pierre-Paul Prud'hon, *Divine Justice and Vengeance Pursuing Crime,* c. 1804, drawing. Cabinet des dessins, Musée du Louvre, Paris.

the torch and a brilliant full moon shining between heavy cloud layers. The double light of the moon and torch lends an eerie effect to the austere landscape.

Earlier projects for this work were even harsher in their message: a victim was shown bloodied with a dagger in his breast, a mother and child lie dead at the feet of Justice, and Vengeance, represented with the wings of a vulture, ferociously drags the criminals by the hair before the tribunal (fig. 2.26).[42] Napoleonic justice is here equated with eye-for-an-eye retaliation. Under the new regime, police-state methods completed what constitutional change began: the drastic suppression in French life of open political activity that could be designated as "criminal." Inheriting a large police ministry from the Directory, Napoleon placed it under the control of a former terrorist, Joseph Fouché, directing him to eliminate organized opposition and dissent. All presumed opponents were placed under surveillance by police spies. The aim was to escalate the punitive response to all criminal activity and ultimately wrest submission from all suspects, political and civil alike.

It is ironic that one of the major pictorial sources for Prud'hon's idea derived from a revolutionary tract exposing the corruption and graft of the police of the ancien régime (fig. 2.27). Pierre Manuel's radical *La police dévoilée* carried an allegorical frontispiece of an assassin, under the cover of night, throwing off a mask that concealed the head of Despotism and about to plunge a dagger into the breast of an innocent sleeper chained to a post, while overhead

Truth lifts the cloud of darkness and holds aloft a torch to illuminate the malevolent machinations of the police.[43]

The horror of Prud'hon's picture is heightened by the nocturnal hour and moonlit environment. The presence of the moon suggests both the scientific investigations of the period and the irrational components of Napoleon's foreign and domestic policies. Contemplation of the vast possibilities of science is brought into juxtaposition with its nemesis. This dialectical interaction is most striking in the regime of Napoleon, which exploited technology and science for imperialistic ends.

Prud'hon's picture points to the paranoidal mentality of the regime. The project began during a time of conspiratorial fears and stepped-up police activities. Bonaparte's secret police force uncovered—as well as fabricated—a series of royalist plots, and in this context the young duc d'Enghien was executed as a deterrent to royalist conspirators. He was shot after a mock trial on 21 March 1804 at 2:30 A.M.—a scene that would be vividly reenacted in the minds of European moderates. The senate immediately drew up a proposal for a "high Court or National Jury" to deal with the recent plots in order to safeguard the existing system of government. At the same time, a move was made to promote the First Consul to emperor so that he could "complete his work." The epitome of "law and order" was now being pushed one notch higher to insure stability for the favored classes. The increased activities of the police—including their own contribution to the "plots"—were used as a pretext to consolidate Napoleon's position and pave the way for his imperial regime. A trial of royal conspirators was widely publicized during the period when a plebiscite was ordered to sanction the new constitution. The chief of the conspiracy, Cadoual, declared in prison, "We have done more than we hoped to do; we meant to give France a king, and we have given her an emperor."[44]

Thereafter, Bonaparte revived some of the arbitrary police administrators of the Old Regime: the prefect of police and the lieutenant general of police were given vast powers; judges were no longer elected as under the Consulate, but appointed by the government for life. Special tribunals multiplied, arbitrary arrests were numerous, and interments in state prisons by administrative action further recalled the Old Regime and even the Bastille. The working classes were subject to strict police supervision; the law of 12 April 1803 obliged workers to provide themselves with "passports" supplied by local police that gave employers

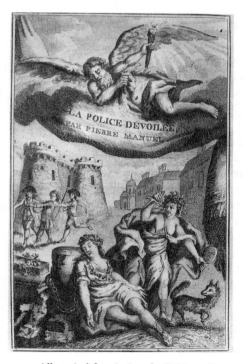

2.27 Allegorical frontispiece for P. Manuel's *Police dévoilée*, vol. 1.

control over their workers' movements. Trade unions and strikes were entirely prohibited, and dissident laborers were treated as derelicts.

While the Revolution implemented and extended reforms of criminal procedure initiated under Louis XVI, Bonaparte claimed that current disorders in the social realm required him to reverse this direction. In January 1801 special criminal tribunals were established, exempt from the restraint of jury or appeal. They denied prisoners time to prepare a defense, deprived them of objecting to judges and of being released on bail. Since the court was relieved of having to explain the grounds of its judgment, there existed no guarantee that the judgment would be reached by any secure rational process at all. Additionally, as the right to appeal was denied, there could be no redress in the event of caprice, bias, or injustice.

Later in the year a commission was appointed to draw up a criminal code comprised of both penal law and criminal procedure. Its first draft came before the Council of State on 22 May 1804 and was debated in the ensuing weeks. From the outset Napoleon revealed his conservative disposition in urging the formation of great legal bodies "above private fears and consideration, that . . . may cause the guilty to turn pale and communicate their energy to the prosecution. It is necessary to organize the prosecution of crime. At present there is no such thing." [45] Debate was terminated at the end of the year and not resumed until 1808, thus spanning the period of the development of Prud'hon's picture.

Napoleon again emphasized the necessity of coercing criminal elements, and in the final Code of Criminal Procedure all the guarantees of 1789 are gone. But Napoleon's imperialism weighed heavily at this moment and it passed almost without discussion. The severe penal code started with capital punishment and life imprisonment, which had been resolved at the earlier discussions in 1804. It further included laws of confiscation (concerning the guilty's possessions) and branding, and in the case of parricide the prisoner was to lose a hand before the death penalty. Penal servitude for life was assigned to those who organized groups against persons or property or who fomented rebellion. Target, one of the authors of the penal laws, had to declare somewhat apologetically that punishment "is certainly not vengeance," and that it was more important that crimes be prevented than that guilty people should suffer. In fact, it was said of those who compiled the Penal Code that "they

were far less concerned with devising means of repression sufficient for public safety, than with compensating the horror of crime by the horror of punishment."[46]

Thus Prud'hon's terrifying painting, with its violent images of murder and retribution, reenacts the harsh spirit of the Penal Code with whose development it coincided. The legal system is drastically condensed into an effective allegory consisting of Alleged Criminal, Victim, Judge, and Executioner. The allegory, like the Napoleonic system of justice, reduces further to the lynch law—the cruel reprisals of imperial France against its antisocial elements at the height of Bonaparte's power.

The moonlit image is also associated with Napoleon's actions in the religious sphere which were designed to promote stability at home and popularity abroad. By 1800 revolutionary policy amounted to a halfhearted secularism, with Catholicism tolerated but barred from an active public role. The orthodox Catholic world stigmatized the entire Revolution as antichurch. Napoleon judged that major concessions to Catholic sentiment were in order, provided they would be carefully controlled by the state. He proceeded to negotiate an agreement with Pope Pius VII, the Concordat of 1801, acknowledging Catholicism as the "preferred" religion of France. The church was now permitted to operate in full public view; indeed primary education would be more or less turned over to the clergy, and clerical salaries would be paid by the state.

The balance of church–state relations was firmly fixed in the state's favor, for it was Napoleon's intention to use the clergy as a major prop of the new regime. With priests now responsible to the government, the pulpit and the primary school became instruments of social control, to be used, as the imperial catechism put it, "to bind the religious conscience of the people to the august person of the emperor." Napoleon summarized his approach to religion in his remark that the clergy would serve as his moral prefects. Eventually devout Catholics feared this highly national version of church organization and Pius renounced the Concordat—to which Napoleon responded by removing the pontiff to France and keeping him under house arrest.

Girodet's *Atala*

The lunar motif is associated with this ambivalent attitude to religion with its combination of revivalism and materialism. This is strikingly seen in Girodet's *Atala,* based on a

2.28 Anne-Louis Girodet-Trioson, *Funeral of Atala,* exhibited 1808. Musée du Louvre, Paris.

novel by François-René Chateaubriand published in April 1801 (fig. 2.28).[47] *Atala* was in fact an excerpt from a larger study of Christianity as literary and artistic inspiration, published as a kind of trial balloon to test the public climate for ideas that were amplified the following year. With its sensational blend of religion, eroticism, and exoticism, *Atala* achieved a major success among the French literary critics and the reading public. Between 1801 and 1805 there were eleven editions, and the novel's protagonists, Chactas and Atala, were widely represented in popular imagery and the applied arts.

The story centered on the love adventure of two native Americans ("savages") against an imaginary background of North American wilderness. Chateaubriand effectively synthesized Old World fantasies about the New World and evangelical religious fervor. The banks of the Mississippi, the deserts of Kentucky, and the forests of Louisiana were strewn with blue herons, green flamingos, bears getting drunk on grapes, and slithering alligators; the flora and fauna of the most disparate regions were transposed to create an incredibly vivid, almost psychedelic, image of the wilderness. Moonlight pervades the novel: Chactas, old and blind, recounts the story of Atala by the brilliant light of the moon; the lunar calendar is used to mark the key scenes; the moon illuminates the dark forest as the two protagonists make their escape; and in the funeral climax the

moon shone "like a white Vestal who came to cry on her companion's coffin."

The plot can be told very rapidly. Captured by an enemy tribe, Chactas is condemned to death. Atala, a maiden of the enemy tribe, falls in love with Chactas and helps him escape. Together they wander in the forest, where their love deepens. They finally come upon a mission run by Father Aubry, where the benefits of Christian civilization are being taught the Indians. Chactas now believes his joy will be eternal. All hopes are dashed, however, when Atala poisons herself. We learn that at her birth, her mother, a Christian convert, had so feared for the child's life that she swore an oath of virginity for Atala. Fearing that her mother would be damned if she married Chactas, Atala took the poison.

Chateaubriand

Génie de christianisme (Genius of Christianity), the larger work from which *Atala* was excerpted, may be understood as a reaction against the sceptical philosophy of the eighteenth century and the deistic outlook of the Revolution. Its author urged a revival of religious fervor among French society, stressing the emotional and aesthetic components of Catholic ritual and symbolism. Chateaubriand admonished readers to reject rationalist arguments about the existence of God and to follow an intuitive, emotional impulse. His writing blends a kind of pagan revelry with Catholic dogma, and in this sense Atala, with its combination of devout duty and myriad temptations, exemplifies his attitude. The *Génie* is a full-scale apology for Christianity, designed to demonstrate the inherent superiority of Catholic religion as a source of moral and artistic inspiration.

At the same time, Chateaubriand's work was immensely political and came out at the right psychological moment. Conservatives spearheaded a revival of Christianity to which the masses of French society warmly responded. Bonaparte himself indicated in various ways that he might be favorable to such a revival. He regarded Catholicism as a fundamental principle of order. As he stated before an assembly of priests in Milan in 1800, "It is religion alone . . . that gives to the State a firm and durable support."[48] Here he simply recognized that the anticlericalism of the Revolution only temporarily dampened the religious beliefs of the French populace. Indeed, an "underground" religious

movement was closely allied with émigré bishops of the ancien régime. Largely as a practical measure, then, Bonaparte found it necessary to reestablish official Catholicism with a hierarchy loyal to him. This was the background of Napoleon's Concordat with the pope, which was signed in April 1801—the same month in which *Atala* appeared. Chateaubriand had been quick to perceive this opportunity to establish himself as a leading Catholic apologist.

Almost the exact contemporary of Napoleon (who was a year younger), Chateaubriand was born into an old and noble family in Brittany. Like Girodet he emigrated during the early stage of the Revolution, choosing, however, to take his chances in the New World rather than the Old. His voyage to America provided him with the background material for some of his most stirring literary accounts and helped shape the European vision of North American wilderness. Chateaubriand returned to France in 1792 and joined the army in exile of the counterrevolutionary emigrants, making his way to London the following year where the émigrés were being warmly received and even subsidized by the English government. During his London exile, Chateaubriand's brother and sister-in-law were executed by the Jacobins, and his mother, sister, and wife were confined to prison.

In September 1797 the royalist and Catholic party in London was reinforced by another exile, the literary critic Louis de Fontanes, an early friend of Chateaubriand and his family. This contact proved to be fortuitous for Chateaubriand when Fontanes worked his way into the Bonapartist circle, serving as speech writer for Napoleon and the editor of the revamped *Mercure de France,* now a Bonapartist journal. A former monarchist, Fontanes now sought to restore the Roman church to its previous status and to attach to the service of the consul a clergy whose prestige, despite the Revolution, remained enormous. And from the very first number of the *Mercure de France* he began promoting the cause of Chateaubriand's *Atala* and bestowing advance praise on the *Génie de christianisme.*

With the advent of Napoleon the return of the émigrés accelerated. While a "blacklist" existed, the laws pertaining to the emigrants were allowed to lapse, and many returned under assumed names. Chateaubriand was among those who came home with a new identity in 1800. The success of *Atala* won him influential friends in Napoleon's own family, and his name was removed from the roster of blacklisted émigrés. Napoleon's enthusiasm for both *Atala* and

the *Génie* is shown by his naming their author secretary of the French embassy in Rome and later appointing him to a diplomatic post in Valais, now one of the federated cantons of Switzerland. But on hearing of the execution of the duc d'Enghien, Chateaubriand resigned his post in protest. Thereafter, secretly hoping for a restoration of the Bourbon monarchy, he played a cat-and-mouse game with the emperor.

In 1807 Chateaubriand took over the editorship of the *Mercure de France* and seized the occasion to attack the despotism of the government. The emperor retaliated by withdrawing the journal from Chateaubriand's control, installing censors and writers of his own choice. Only the intercession of Fontanes prevented a worse fate for Chateaubriand. It was during this period that Girodet's friendship with the author reached its high point; he painted Chateaubriand's portrait in 1809, and the year before he exhibited his *Funeral of Atala* at the Salon. Chateaubriand himself thanked the artist for his "admirable painting" of *Atala* in his *Les martyres,* published in 1809. Certainly Girodet sought some of the eminence attached to Chateaubriand's book, while at the same time his effort rekindled Napoleon's earlier appreciation for Chateaubriand's contribution as a defense of his work in reestablishing the church in France.

As stated previously, the book tells the unhappy love story of two Indians separated by religion. Chactas is a member of the Natchez tribe, Atala is a half caste, the illegitimate daughter of a native American Christian-convert mother and a Spanish *hidalgo* named Lopez, owner of a plantation in Florida. The story unfolds through the narrative of Chactas in old age, now blind and led by a young girl, "like Malvina guiding Ossian on the rocks of Morven." Chateaubriand's fascination for the Ossianic epic, which he discovered in England, filters through much of the narrative in the moonlit scenes and the primitive conditions of the New World. In a sense, *Atala* "christianizes" MacPherson's pagan sagas.

There are many contradictory features in the story; while seemingly glorifying purity and abstinence, the author builds up a highly charged situation inviting passion and sensuality. He plays with the "noble savage" theme, but Atala has a Spanish father, who happened to have raised Chactas as a boy (thus hinting also at incest) and indoctrinated him into Western and Christian attitudes. Indeed, Atala even has golden hair and alabaster skin, so transpar-

ent that the pale-blue veins can be seen. Thus Chateaubriand's "noble savages" had a head start in their progress toward redemption and salvation. The real native Americans are put to work on Father Aubry's farm and exploited. Here the symbolic association of missionary and indigenous work force is consistent with the outlook of both Chateaubriand and Girodet, who espoused the already age-old colonialist rationale for exploiting native peoples. Christian redemption and social repression could be seen as necessarily linked in the "civilizing" process.

Girodet's choice of scene for his picture of *Atala* incarnates the contradictions of the novel. He selected the moment of the protagonist's entombment to maximize pathos and drama, departing somewhat from Chateaubriand's description of this particular scene in combining the two passages of the burial in the grotto and the nocturnal mourning of Chactas and Father Aubry over Atala's body. The cross on the hill, marking the cemetery of the mission Indians, is silhouetted by the unseen moon. Lunar light also picks out the beatific head of Atala, the cross of ebony she clasps, and the spade on the ground, which symbolizes the Passion and echoes the cross on the hillside. Chactas embraces the legs of his beloved before lowering her into the grave, while Father Aubry gently lowers the top half of her body. The image synthesizes aspects of the *Pietà,* lamentation and deposition, thus striking home repeatedly with the Christian message of the original source. An ardent admirer of Michelangelo, Girodet used the sculptor's self-portrait of the late *Deposition* as the model for the monk—especially appropriate for the theme as well as individual motif (fig. 2.29). Despite the sentimental overkill, however, Girodet's sinuous compositional curve uniting the three figures, the icy-smooth flesh of the heroine, her exposed shoulders, and the care given to the outlines of the nipples of her breasts demonstrates to what extent Girodet captured the erotic component of Chateaubriand's evangelizing Christianity. At the same time, the reference to the native American cemetery highlights the intention of the author to exemplify Christian redemption and conversion at the point of death. Chactas's resistance to Christian religion is overcome only when he is broken in spirit like the native Americans working on the mission farm.

The collaboration of Chateaubriand and Girodet was of mutual benefit to each artist's effort and also proved instrumental in the rise of anticlassical approaches. Girodet's rejection of the vigorous classicism of his teacher David in

2.29 Michelangelo, *Deposition,* 1550–1555, marble. Museo dell'Opere del Duomo, Florence.

the *Sleep of Endymion* and *Atala* parallels Chateaubriand's message in *Génie,* that the elements of Christianity are just as capable of serving as a stimulus to literary and artistic activity as the classics, and may even surpass the classics in being based on revealed truth. Thus the revival of Catholic prestige at the time of Napoleon contributed to undermining the remnant of revolutionary classicism and promoted its romantic antithesis.

Science and the Marvels of God and Nature

Aiding this transformation was the advance of science, also manifest in both Chateaubriand and Girodet. Chateaubriand's *Génie* identifies the marvels of nature with the grandeur of God: he invokes the immensity of space with its moon and glittering stars as evidence of infinity and the Divine Being. The moonlit forest near Niagara Falls, the sight of the stars overhead at sea, a fiery sunset, all gave him a sense of his smallness and proved for him the existence of God. He describes the flora and fauna of the American wilderness with equal intensity and empirical investigation. Similarly, Girodet went out of his way to translate Chateaubriand's celestial, geological, and botanical descriptions, seen in the accurate transcription of the ivy, the lianas, and the sensitive plants. It is known, for example, that he visited the Paris botanical garden (Jardin des Plantes) to study American flora. The exotic, greenhouse effect of *Atala* relates to the scientific investigations of Girodet and Chateaubriand and their application in behalf of a vision remote from the austere solemnity of both classicism and the traditional religious subject.

Medical science was no less subject to ideological considerations. Perhaps the most impressive and highly publicized painting of the 1804 Salon was Gros's *Bonaparte, Commander in Chief of the Army of the Orient, at the Moment He Touched a Pestilential Tumor in the Hospital of Jaffa* (fig. 2.30).[49] The feverish plague that broke out at the beginning of the campaign in Syria grew worse after the siege of Jaffa, just south of what is now Tel Aviv. Panic spread among the troops, and a plan was formulated to try to convince the soldiers that the disease was not contagious and could be avoided by preventive means. To raise the morale of the men Napoleon made a visit to the provisional hospital set up in a mosque.[50] Accompanied by his chief of staff and the army's physician in chief, Desgenettes, Napoleon fearlessly entered the makeshift hospital and made bodily contact

with the victims. The Salon entry states that Desgenettes did not want Bonaparte to prolong his visit, and Gros shows this in the picture by making Desgenettes looking furtively to his left while motioning his chief with his left hand that it is time to go. Even one of the victims, an officer kneeling in front of Bonaparte, tries to prevent him from touching the lanced bubo of the armpit. Napoleon, however, insisted on staying and offering words of consolation and the "healing touch" to inspire courage. Napoleon ordered some of the buboes to be lanced so that he could touch them and demonstrate that there were no grounds for fearing contagion. At the right of the picture, an Ottoman surgeon makes ready to open a tumor under another patient's armpit. Gros shows Napoleon calm amid terror, bestowing a divine touch akin to the Christian saints and kings who healed by touching. The catalogue entry expressly stated that Napoleon's act of unprecedented courage has since been emulated by others, that it stands as an example of his benevolence.

Not unexpectedly, the catalogue mixed a kernel of truth with a great deal of propaganda. On 25 July 1798 Bonaparte crossed the Nile and took possession of an undefended Cairo, but his joy was short lived; on 1 August Nelson had sailed into the shallows of Aboukir Bay and destroyed the French fleet. The morale of the French troops was at its lowest level after the news of the Battle of the Nile reached Cairo. In addition, a plague developed whose symptoms were a ferocious fever with carbuncles or bu-

2.30 Antoine-Jean Gros, *Napoleon in the Pesthouse at Jaffa,* 1804. Musée du Louvre, Paris.

boes developing in the groin and armpits. The plague was particularly devastating in Alexandria, where several naval officers had died. The disease now became rampant in the army; the medical officers tried to cover up suggestions of a plague, hurriedly removing the bodies of the victims, burning their clothes and personal effects, and fumigating the rooms where they were isolated. Dominique-Jean Larrey, the surgeon in chief, was convinced of the existence of a plague but told only Desgenettes of his fears.[51]

Ideas about the nature of plague were utterly confused, although official policy at the start of the campaign in Egypt was to ignore it and hope it would go away. It was while Larrey and Desgenettes were busily sweeping the facts under the carpet that Bonaparte announced the French army's exodus through Syria. It was during this campaign that the expedition experienced the horrors that attended their assault and sacking of Jaffa. The number of wounded was so great that Larrey set up an improvised hospital in a huge mosque. Evidence of the plague immediately appeared, and this time Larry reported it to his commander in chief. The military machine was in serious danger of coming to a grinding halt from plague alone. Larrey knew the disease to be contagious, but morale had to be sustained. What the men had to believe they were suffering from, said Bonaparte, was a well-recognized but noncontagious disease: "fever of the buboes," a disease that in some strange way affected those who lacked courage or whose spirit was weak. Larrey accepted this at first, but gradually became vigorously opposed to the idea. Desgenettes, by all accounts, also believed in the contagiousness of plague but proclaimed the opposite. He squared his conscience by having the troops live in bivouacs outside the town, ordering them not to wear Turkish clothing, and burning everything, including uniforms, he judged to be contaminated—a move that infuriated quartermasters.

Yet still the number of cases increased, particularly among the wounded. On 11 March Bonaparte acted to counter the panic of his terror-stricken troops, visiting the mosque that Desgenettes had converted into a plague hospital and spending an hour and a half chatting with the sick and their attendants. At one stage he helped to move a corpse whose tattered clothing was soaked with pus from the buboes. Desgenettes was on tenterhooks and tried to get Bonaparte to leave. The commander replied, "But I only do my duty, am I not the General-in-Chief?"[52] When he visited the hospital for the wounded, where plague was

also strife, he was quickly hustled through by Larrey. But these visits served their purpose in raising the tottering morale of his men.

Jaffa had been reached on 3 March and after four days' siege was captured by assault. The horrors of the surrender, culminating in the cold-blooded murder of twenty-four hundred of the garrison, are well known. It was also at Jaffa that the much-discussed, and often-denied, order is said to have been given by Bonaparte for the poisoning of the incurably sick who could not be evacuated, and who if left alive would be supposedly tortured and murdered by the Turks. Bonaparte had suggested that opium might be administered if Desgenettes so decided, an assertion that Napoleon repeatedly denied.

The idea, however, was circulated by Napoleon's enemies, as Chateaubriand made clear during the first Bourbon restoration in 1814. Serving now the cause of the Bourbons, Chateaubriand noted how skillfully Napoleon used artists, especially as evidenced by Gros's picture of the plague house. He wrote that "Bonaparte poisoned the plague victims of Jaffa: a picture was made depicting him touching, by an abundance of courage and humanity these same plague victims . . . This is not how Saint Louis healed the diseased; his royal hands were motivated by a deeply felt religious conviction." [53]

Chateaubriand, nevertheless, put his finger on the image Gros wanted to project, that of a ruler endowed with the divine power to heal the sick and suffering. Napoleon's presence is a healing one, he shares the power with Saint Louis and other kings who have exercised the thaumaturgical ability possessed through the state of kings legitimated by divine right. While Napoleon was then only a general, his new status in 1804 as founder of an hereditary empire is projected in the picture. It is a picture that justified his elevation to emperor and rationalized his authority.

Gros's picture associates the legend of the divine touch of kings with Bonaparte and grants him the status of a savior. Similarly, Pierre-Narcisse Guérin's *Napoleon Pardoning the Rebels at Cairo* invokes the clemency associated by great rulers of the past (fig. 2.31). The scene shows the aftermath of a revolt of Mamelukes who fell on the French in Cairo with savage ferocity on 21 October 1798. The French troops quickly brought the situation under control—a slaughter that effectively crushed further thought of rebellion in Egypt. Two days later Napoleon pardoned the remnant of the decimated rebels. Since 12,500 Egyptians had

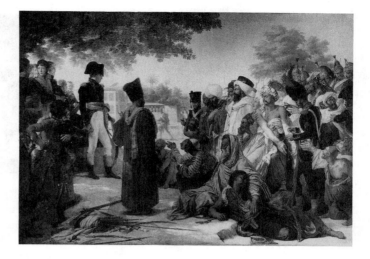

perished, this act of clemency for a handful of prisoners has been blown up way out of proportion to its significance.

The reason for this was the growing criticism of Napoleon's treatment of prisoners, exemplified by his ruthless conduct at Jaffa. A large part of the Egyptian garrison had surrendered to the French on the condition that their lives be spared. Bonaparte, however—despite the opposition of his generals—refused to ratify this agreement and ordered the twenty-four hundred prisoners killed. News of this massacre alarmed domestic and foreign observers, and Guérin's painting, which received maximum publicity at the 1808 Salon, was meant to counteract the reports of his battlefield conduct. Guérin opposes the majestic and dignified posture of Napoleon with the childlike and subservient attitudes of his black and Arab prisoners, mediated by the interpreter who stands between the two parties with his back to the spectator. Typically, a Napoleonic lackey has fictionalized the contrast between a civilized European colonizer and the ignorant and barbaric peoples to whom he has come to save from themselves.

Natural Catastrophe and Social Upheaval

Paris was all aglow for the Salon of 1802; opening five months after the Treaty of Amiens, the exhibition was seen by an influx of foreign visitors who poured into the city during the brief respite from war between March 1802 and May 1803. For the first time in over a decade, the English were able to travel to France, and this included a number of

painters like Turner, Fuseli, and West who were eager to see the latest developments in French culture. Benjamin West, as president of the Royal Academy, was feted by the Parisian art community. West showed his sketch of *Death on the Pale Horse* at the Salon of 1802 (fig. 2.32), and the following year he was elected a corresponding foreign member of the Institut national.

West's picture was based on the book of Revelation, chapter 6, verses 7 and 8, having to do with the opening of the fourth seal: "And I looked, and behold a pale horse: and his name that sat on him was Death, and Hell followed with him. And power was given unto them over the fourth part of the earth, to kill with sword, and with hunger, and with death, and with the beasts of the earth." The idea of a holocaust is central to West's depiction, as stated in his account of 1808: "This subject is to express the triumph of Death over all things . . . Its object is to express universal desolation; to depict all the methods by which a world may be destroyed."[54] West's aim ignored the traditional emphasis on the wild horsemen of the apocalypse, but rather stressed the ravages "over the fourth part of the earth"—an appropriate allusion to the Napoleonic destruction in continental Europe. He achieves his effect through natural calamity as well as allegorical—earthquake, lightning, darkening sky, and volcanic clouds combine to maximize the sense of terror.

West had been developing this concept off and on for many years, starting from around 1783, and related works were exhibited in 1784, 1796, and 1802. One sketch was dated 1783 and retouched in 1803, suggesting that these dates—although distant by several years—have something in common. Indeed, when we look at the years of activity on the work we see that the various versions come just after the American revolution, at the height of the Continental

wars and the lull in the Napoleonic wars—periods of pro-
longed mourning for the devastation to life and property.
West adopted the biblical allegory to represent the human
destruction of the period, and for this he abandoned his
neoclassical format to achieve a startling image of death and
destruction.

The Swiss painter, Jean-Pierre Saint-Ours (1752–1809),
who studied under Vien in Paris and won the Prix de Rome
in 1780, began working in the neoclassical mode with a
number of placid scenes of ancient Greece.[55] Returning to
his native city Geneva in 1792, he tried to resume his his-
torical bent but found that the progress of the Revolution
overturned the class who bought historical painting, and he
tried to earn his living doing portraits. By 1799 (according
to his own admission) he was so disillusioned by the course
of political events that he embarked on a series of variations
on the theme of an *Earthquake in Greece* (fig. 2.33). While
his first version was painted in 1799, the larger and more
elaborate picture reproduced here was finished in 1806.
Both pictures focus on a terrified family fleeing the scene of
a Greek temple crashing into ruins. The collapsing edifice
was clearly a metaphor for both the failure of classical civi-
lization and the ruin of the neoclassical ideal.

A contemporary popular print by the Bavarian artist Jo-
hann Michael Voltz entitled *Earthquake* (Das Erdbeben) sets
out in a modern urban context the theme that Saint-Ours
transmuted into Salon art (fig. 2.34). Families flee after
being displaced by their fallen buildings, while in the dis-

2.33 Jean-Pierre Saint-Ours, *Earthquake in
Greece*, 1806. Musée des Beaux Arts, Geneva.

2.34 Johann Michael Voltz, *Earthquake*, c. 1810, etching. Staatliches Kupferstichkabinett und Sammlung der Zeichnungen, Greiz.

tant background an erupting volcano discharges its debris into the sky. The panic-stricken citizenry attest to the impact of the Napoleonic juggernaut that marked the countryside with refugees, a machine that Voltz experienced and later opposed during the Wars of Liberation.

From the time Saint-Ours returned to Switzerland the country was a site of constant French invasion, as we have already seen in Napoleon's crossing of the Saint Bernard Pass. Swiss hospitality accorded to the émigrés and the presence of Swiss Guards in the service of Louis XVI early provided the French with a pretext for invading. When in 1797 France's finances were exhausted, General Bonaparte looked to Switzerland for deliverance. Diplomatic agents were dispatched to incite the inhabitants to rebellion, and Bonaparte stepped in ostensibly to "mediate" the situation. Federal territory was dismembered as Napoleon annexed the three Grisons provinces of Valtellina, Chiavenna, and Bormio, winning over the peasant populace by promising freedom from feudal servitude and the bonds of subjection. His promises, like the trumpeters of Jericho, brought the old Confederation crashing to the ground. On 5 March 1798 French troops entered Berne, the first time foreign troops had ever set foot on the soil of the republic. While not the capital of Switzerland, Berne was its key stronghold, and its loss brought about the collapse of the rest of the Confederation. Geneva, which had its own revolution in 1792 under the protection of the French, was now obliged to conclude under threat a union with their neigh-

bor. Napoleon's Act of Mediation of 19 February 1803 kept the country dependent on France and in a permanent state of weakness; harsh taxes were exacted from the cantons and towns, and Berne's treasures were confiscated. Swiss mercenaries were impressed into the Napoleonic armies. Between the years 1803 and 1814 Switzerland became a veritable satellite of France, its unity profoundly rocked and divided by internal factions.

The Geologists

During a period of political stability in Switzerland the country was the site of two prominent schools of geological thought—James Hutton and the Vulcanists, who believed that all rocks and mountains were created by volcanic upheaval, and Abraham Gottlob Werner and the Neptunists, who believed that rocks precipitated out of a primordial liquid. The Neptunists enjoyed more popular appeal, as their theories tended to confirm the biblical account of the Flood. However, "catastrophists" believed that the world came into existence through violent upheavals, a theory that at the turn of the century greatly stimulated artists and scientists (and that is being revived in the present day). For example, Leopold von Buch, considered by Humboldt to be the foremost geologist of the time, thought that the erratic boulders found high on the Jura had been hurled like cannonballs by the sudden upheaval of a neighboring mountain range. Thus in the popular imagination theories of geological catastrophe paralleled actual political catastrophe. The Swiss naturalist, Horace-Bénédict de Saussure, whose *Voyages dans les Alpes* was widely cited by both Vulcanists and Neptunists, experienced calamity in his personal life, losing his fortune during revolutionary upheavals in Geneva and dying in 1799, a ruined man.[56] Saussure had crossed the Alps fourteen times by eight different passages and claimed in his first volume of *Voyages* that it was "especially the study of mountains that facilitates the progress of theory about the globe."[57] Evidence submerged in the plains and valleys, he said, is presented with startling clarity in the upheaved rocks, sections, jutting strata, and mountain fissures. While Saussure followed the precepts of Werner and the Neptunists, he was fascinated with the cataclysmic suddenness of volcanoes and, with Sir William Hamilton, made a study of Vesuvius.

Jean André Deluc was another Genevan who helped

found the study of geology. He praised Saussure's work as the foundation of all sound geology, and made inferences from Saussure's Alpine observations about a primal deluge, which he used in support of the biblical account. He first stated his Neptunist position in a series of letters addressed to the queen of England in 1779. Deluc also analyzed the origins of volcanoes and earthquakes, making observations on Mounts Vesuvius and Aetna based in part on the work of Hamilton. His famous *Letters on the Physical History of the Earth, Addressed to Professor Blumenbach,* originally appeared in the *British Critic* in the 1790s and were translated into French in 1798, while his *Elementary Treatise on Geology* was published in both French and English in 1809.[58]

Déodat Guy Silvain Tancrede Gratet de Dolomieu was a French geological pioneer who like Saussure devoted himself to amassing observations in the mountains, making the Alps and the Pyrénées his base of operations.[59] He was perhaps most knowledgeable about the history of earthquakes and volcanoes, publishing a *Mémoire sur les tremblements de terre de la Calabre.* Dolomieu was the most widely respected geologist in France at the end of the eighteenth century and was selected by Napoleon to accompany him on his expedition to Egypt. So it was that geologists were themselves inevitably caught up in the play of power politics as they spun their catastrophic theories on the origins of the earth's surface.

Saint-Ours's depiction of a family caught in an earthquake makes artistic reference to the impact of the Revolution and its aftermath, using geological symbols. The terrified husband and wife carrying their infant child struggle to maintain their foothold while treading on a collapsed building. Lightning illuminates the dark sky, and the earth's surface is rent by fissures and clefts. It is the destruction of civilization and the old order, using the English sense of the sublime along with the prevailing scientific mentality. Hutton's *Theory of the Earth,* which appeared in 1795 and embodied the Vulcanist point of view, would have provided Saint-Ours with a plethora of earthquake stories and themes.

Girodet's *Scène de déluge*

Close in spirit to the work of Saint-Ours is Girodet's *Scène de déluge,* executed in almost the same period as the larger version of *Earthquake in Greece,* 1802 to 1806 (fig. 2.35). Girodet similarly portrays a family in extremis, caught in

2.35 Anne-Louis Girodet-Trioson, *Scène de Déluge,* Salon of 1806. Musée du Louvre, Paris.

the torrential floodwaters of a swollen mountain lake during a fierce storm. The fainting mother, with one child in her arms and another clutching her hair and shoulder, is kept from falling into the raging abyss by her husband's tenuous grasp of her wrist. With his other hand, her husband has seized the bending branch of a tree, while an old man is balanced on his back. It is a scene of awesome suspense, and one that can only end in tragedy. The expression of utter terror on these faces suggest Girodet's deep interest in Lavater's popular *Essays on Physiognomy* (English tr. 1789), which posited a close connection between the face and the peculiarities of personal character.[60] The psychological moment is also heightened by the influence of Michelangelo's cataclysmic *Last Judgment* and by the Miltonic vision of the gigantesque and the terrible, as embodied in Fuseli's illustrations for *Paradise Lost,* which had been recently published in a new edition by De Rouveray in 1802.

As in his previous works, Girodet is scrupulous about background accessories; *Scène de déluge* depicts an indeterminate rocky landscape with a stormy sky of thunder, lightning, and rain: everything conduces to the power of the natural forces. If Saint-Ours took his cue from Hutton and the Vulcanists, Girodet demonstrates his interest in Abraham Gottlob Werner and the rival Neptunist school, who proposed that all geological phenomena resulted from a series of inundations, hence the aqueous origin of rocks and mountains. Girodet's understanding of Werner's theories may have come from Humboldt himself, who had studied under Werner at the Freiberg School of Mines. Werner's principal theory (which taught that "in the beginning" all the solids of the earth's present crust were dissolved in the heated waters of a universal sea) coincided with the biblical narrative of the Flood and was even more popular than Huttonian speculation. Werner affirmed that all rocks had been formed by precipitation from this sea as the waters cooled, and that mountains were gigantic crystals, not upheaved masses. Girodet's elemental image of the flood and the bleak landscape may have been informed by this hypothesis.

While there were numerous precedents for the theme of the deluge, Girodet's works fits into a time when the taste for disaster pictures like floods, shipwrecks, volcanic eruptions, earthquakes, and avalanches reached its peak. Scenes of disaster recur often in the literature of Girodet's heroes MacPherson, Salomon Gessner, Bernardin de Saint-Pierre,

and Chateaubriand, while such scenes proliferated at the Salon during the late years of the Revolution and the Napoleonic period. Girodet, moreover, rejected attempts to interpret his work from a biblical perspective; he claimed that he used the term "deluge" to describe a "convulsion of nature, such as, for example, the picture which could be seen during the disaster which recently occurred in Switzerland."[61] Thus Girodet insisted that the subject was a cataclysm of nature similar to that which took place at Goldau, Switzerland, late in 1806. While the setting of Girodet's picture defies precise localization, in the artist's mind the event took place in a mountainous region similar to Switzerland.

As in the case of Saint-Ours, the work also carried an allusion to the cataclysmic changes of the period. Girodet seemed to attack selfishness among the individuals of the family: the old man clings desperately to a bag of gold, and one of the children clings to his mother's hair without concern for her fate. Girodet's close-up concentration on the fate of a single family and their struggle for survival exemplifies the impact on contemporary vicissitudes for French society. As he himself explained, "I thought to find in this concept the idea of a parallel, which seemed significant to me, between physical and moral nature. How many people who, placed on the reefs of the world and in the midst of social storms, entrust, like this family, their salvation and their fortune only to rotten supports!"[62] Here we have a specific parallel drawn by the artist himself between the natural catastrophe and the social upheaval, between the meteorological storm and the "social storm." The current political upheaval engenders a purely personal and selfish response, far removed from the self-sacrifice and patriotism of the Davidian heroes in the service of their country. Girodet's people do not foment change but are affected by it.

Here Girodet, analogous to Prud'hon and his master David, deliberately subverts the revolutionary impulse and betrays the cynicism of the Napoleonic epoch. This is vividly demonstrated by comparing his picture with a popular caricature of the Revolution that clearly informed it (fig. 2.36). In the caricature, which celebrates the heroes of 14 July 1789, monarchical France, personified by a woman in dire stress, is rescued from raging floodwaters by members of the Third Estate, grabbing her arms while tottering on the edge of a rocky precipice. She says to her saviors, "Without you I would have perished." Girodet has literally

2.36 Anonymous caricature, *Without You I Would Have Perished,* c. 1791, etching. Department of Prints and Drawings, Library of Congress, Washington, D.C.

deprived the event of its positive political content and transformed the theme of ordinary people's active participation in the political process into a tale of helpless victims tossed to and fro by the political tides.

Girodet's concentration on passion in the context of violent circumstances anticipates features of the romantic school, already announced in the work of the conservative Fuseli, who profoundly influenced Girodet's conceptual process. Girodet's expression of emotion is also linked to the religious revival articulated in Chateaubriand's work, which appealed by its evocation of feeling and sense of action. Both Chateaubriand and Girodet attempted to arouse emotion through images of catastrophe, relying on actual conditions in Napoleonic Europe to provide the dynamic backdrop to their appeal. Thus Girodet's romanticism was a state of mind shaped by the historical circumstances at the end of the eighteenth and beginning of the nineteenth century. Fear and religious feeling were mingled in an era when authentic political activity was suppressed in favor of personal authority. Girodet's work not only speaks to these political tensions but rationalizes authority by warning of worse consequences attendant upon its absence. The association of his image with the biblical account of Noah in the minds of the critics attested to the work's subliminal message. Napoleon did in fact imply that "sans lui, le déluge."

3.1　David Wilkie, *Village Politicians*, 1806. Private Collection, Scotland.

3 English Art in the Napoleonic Era

Following the renewed outbreak of hostilities between France and England in May 1803, there was almost uninterrupted war between the two belligerents through Waterloo. Public opinion both in France and England generally opposed war, but government propaganda in the two countries had prepared their respective audiences to perceive their antagonist as inimical to survival. Great Britain warned the people persistently (despite intelligence reports declaring the contrary) of imminent French invasion, while in France the English were blamed by both the Right and the Left for financing domestic terrorism. For Napoleon victory over the British required the destruction of British commerce, on which England was believed to be dependent. These considerations lent the Anglo-French conflict a stubbornness unique in the Napoleonic period. Indeed, the parallel with the ancient Rome-Carthage struggle gave rise to a classical paradigm for both rivals to European supremacy.

In both countries the rural and urban poor suffered the brunt of these propaganda campaigns. The English government's direct taxation for the purpose of financing the war crushed the impoverished of town and village, and the hardships incurred by the Continental blockade pushed the working classes to food rioting and machine smashing. In monetary terms the British carried by far the heaviest load during the war, which cost them at least three or four times as much as it did the French. The French suffered the loss of their youth to the vast Napoleonic military machine, but the same machine swallowed up the unemployed and financed itself to a large extent at the expense of the conquered foreigners upon whom it imposed levies of materials and cash.

English art and letters expressed the disruption of these years in escapist forms that often displaced onto rural life and landscape the fears and anxieties of the moment. David Wilkie, the influential genre painter from Scotland, typically painted scenes of villagers and hard-pressed people in a caricatured style for a mainly upper-class clientele. His popular *Village Politicians* (fig. 3.1), which was shown at the Royal Academy exhibition of 1806, elicited this response from his father, the Reverend David Wilkie: "The subject of your picture must be regarded as a fortunate one: political disputes and cabals are still popular in our villages among the lower classes."[1] The work satirizes the rustic participants, comically registering their response to the political and social conditions that impoverish them, and trivializing their gestures and expressions. Wilkie's special contribution to privileged culture in this period consisted in the muting and transformation of underclass threat. His kind of pathetic in-joke for the social elite (it was painted for the third earl of Mansfield) served to make more tractable and even to neutralize (on canvas as well as on administrative documents) the unruly troublemakers of town and village.

The dislocations and political divisions of the period raised the specter of actual homelessness, and engendered a self-conscious awareness of the fragility of the social structure and its potential collapse. The ruthless repression of these years reflected the fright of the landowning class, who even felt it too dangerous to leave the troops hired to maintain order billeted on the people. For the first time in British history barracks appeared all over northern England to isolate the soldiery from a discontented populace. Possession of the land became paramount in the thought of the dominant elite, and manifested itself culturally in the metaphorical uses of landscape. This concern coincided with the increasing evidence of the ability of people to harness physical forces and control the environment.

Samuel Taylor Coleridge

The first generation of English romantics, that of Blake, Wordsworth, and Coleridge, had been wholly Jacobin, but by the time of the Napoleonic wars they had become conservative and Tory. Coleridge's case is especially fascinating, and provides a curious parallel to the catastrophic-minded Girodet. The work of the English writer was

similarly steeped in the sciences of meteorology and astronomy, with emphasis on the moon motif. The poems of Ossian exerted an enormous influence on his early thought, with one work entitled *Imitated from Ossian* (1794) and *The Complaint of Ninathoma* from around the same period. Beginning with his youthful sonnet, *To the Autumnal Moon,* Coleridge (1772–1834) showed a lifelong preoccupation with the moon, most often associated in his mind with hope and regeneration.

Coleridge reveals in his work the philosophy of pantheism, the mingling of God in nature as a substitute for orthodox religion—a philosophical constant in the wake of the French Revolution and one that pervades Western landscape throughout the nineteenth century. It is a riposte to both the political revolution and the economic, since the commingling of the Divine and the Material reflects the growing confidence of society to transform nature and to control it. God in nature is a metaphor for the "machine in nature," or the "machine in the garden," as Leo Marx has referred to it in the context of the locomotive.

Coleridge's nightmarish *Rime of the Ancient Mariner* (1797–1798), written during his developing opposition to the French Revolution, fuses his pantheism with a negative blast at those who would usurp nature's prerogatives. Like Blake, he opposed industrial applications to warfare, but he recognized industry's progressive side and adapted it to poetry. He likened the steam engine to "a giant with one idea," and after viewing a cluster of furnaces in Birmingham in 1812, he observed their "columns of flame instead of Smoke from their chimneys, the extremity of the column disporting itself in projected Balls and eggs of Fire."[2] Coleridge was fascinated by lights, chemical illumination, firelight, the supernatural quiet and awful red that burned in the charmed water of the *Ancient Mariner*. All this is understandable when we recall that Coleridge was subsidized by Josiah Wedgwood's son, a second-generation captain of industry who paid him an annuity of 150 pounds.[3]

Meteorological references abound in the tale, with the moon in various guises performing the role of leitmotif. The killing of the albatross, a crime against nature, leads to nature's revenge and the pursuit of the crew by a spirit, one of the invisible inhabitants of this planet. The metaphors of waves all "a-flame" from the "broad bright Sun" and the ghost-like ship which they sight on the horizon, then the "horned moon with one bright star," are symbolic of

the disabling of the crew who drop "one after one, by the star-dogged Moon." At one point the ancient mariner cries,

I closed my lids, and kept them close,
And the balls like pulses beat;
For the sky and the sea, and the sea and the sky
Lay like a load on my weary eye,
And the dead were at my feet.[4]

In his loneliness he shifts his attention to the moon and the stars moving in their indigenous ether, as if in their natural homes and native country. When finally "the rain poured down from one black cloud"—thus terminating the drought—"the Moon was at its edge." The light of the moon also reveals God's marine creatures, moving "in tracks of shining white" and "every track/Was a flash of golden fire." The meteorological events compound, with the sky becoming more tumultuous, till "Beneath the lightning and the Moon/The dead men gave a groan." As the ship enters the harbor in a brilliant moonlit calm, the angelic spirits leave the bodies of the dead sailors.

Coleridge thus reveals the same obsession with lunar light effects as the painters, and sets them in an incredible marinescape whose magnitude is all-encompassing, but whose message is to teach reverence for all things in nature. This respect for nature occurs at the moment when individuals felt able to control the earth more than at any other time in its history. The pantheism of Coleridge is a metaphor for the ability to enjoin nature to human artifice, as in the case where the sky and the sea are objectified, thingified and therefore subject to manipulation. The pantheism is in fact a means of reducing the idea of infinity to a finitude of all things, real and imagined.

These allusions were transferred to the realm of politics when in 1798 the French government suppressed the Swiss cantons, which to Coleridge meant that revolution and republicanism were turning out to be tyranny. *France: An Ode* was Coleridge's poetic statement of this change:

Forgive me, Freedom! O forgive those dreams!
I hear thy voice, I hear thy loud lament,
From bleak Helvetia's icy caverns sent—
I hear thy groans upon her blood-stained streams!
Heroes, that for your peaceful country perished,
And ye that, fleeing, spot your mountain-snows
With bleeding wounds; forgive me, that I cherished
One thought that ever blessed your cruel foes![5]

The poem is a compendium of nature symbols; Coleridge calls upon the clouds, ocean waves, woods, sun, sky, and moon—"everything that is and will be free!"—to bear witness to his own sincere love of liberty.

Fears in Solitude, written the same year "during the alarm of an invasion," reaffirms his solidarity with the English people and his love of country expressed in topographical metaphors.

O native Britain! O my Mother Isle!
How shouldst thou prove aught else but dear and holy
To me, who from thy lakes and mountain-hills,
Thy clouds, thy quiet dales, thy rocks and seas,
Have drunk in all my intellectual life,
All sweet sensations, all ennobling thoughts,
All adoration of the God in nature,
Whatever makes this mortal spirit feel
The joy and greatness of its future being?
There lives nor form nor feeling in my soul
Unborrowed from my country. O divine
And beauteous island! thou has been my sole
And most magnificent temple, in the which
I walk with awe, and sing my stately songs,
Loving the God that made me![6]

Later, when Napoleon's invasion plans were thwarted, Coleridge exalted that the emperor's army lay encamped on the French coast "like wolves braying at the moon." While he at first perceived Napoleon as a heroic figure who could restore order to France, after the rupture of the Peace of Amiens in 1803 Coleridge saw him as a tyrant committed only to personal self-aggrandizement. By 1809 he could claim that the emperor's main strength lay in his "splendid robes and gaudy trappings" which dazzle and blind the people's imagination. He styled him "a Wretch and a Monster," the "enemy of the human race." He was outraged by Napoleon's treatment of the Swiss, Tyrolese, and Spanish peoples; and finally, he detested him for his uncontrollable urge to decimate England at the cost of the French people and of the Christian middle class: "But that in order to gratify his rage against one country, he made light of the ruin of his own subjects; that to undermine the resource of one enemy, he would reduce the Continent of Europe to a state of barbarism, and by the remorseless suspension of the commercial system, destroy the principal source of civilization, and abolish a middle class throughout Christendom; for this, Sir, I declared him the common enemy of mankind!"[7]

Bonapartism and the English School

It was Napoleon's success on the battlefield against France's enemies that allowed him a free hand domestically. His success on the battlefield transformed him from a general of the Revolution to an imperial conqueror of the Continent. Bonaparte's occupation of Switzerland, Germany, Spain, and other lands set contradictory forces of change in motion, for nationalism, liberalism, and reaction alike were unleashed by his presence. Only England stood between Napoleon and his hegemonic ambitions; Admiral Nelson's victory over the French navy at the Battle of Trafalgar in October 1805 ensured the security of the British Isles for the remainder of the Napoleonic era. Since Britain could not be reasonably invaded, Napoleon's objective was to destroy its influence by means of economic warfare.

The emperor sought to close the Continent to English trade, to stop Britain's exports and ruin its credit. He reasoned that lack of markets for its manufactured goods would lead to bankruptcy, and at the same time overproduction would cause unemployment and social unrest. Meanwhile, French advantages in Continental markets would naturally increase with the diminishing of British competition. Accordingly, Napoleon mounted his so-called Continental system prohibiting English trade with all French allies and all commerce by neutrals carrying English products. This meant preventing all ships coming from British ports from landing in Europe, and impounding all goods coming from or belonging to the British Isles.

Great Britain was certainly hurt by the Continental system. Its gold reserves dwindled, and internal divisions did erupt in 1811, a year of widespread unemployment and rioting. France in turn was adversely affected by England's counterblockade, which cut the country off from raw materials and British finished goods, always extremely popular on the Continent. The weak link in the system was smuggling, which in turn drove Napoleon to more drastic policies and menacing rhetoric. Given his impact on a war-weary England, it is not surprising to find in that country as well parallels to French artists like Girodet.

Joseph Mallord William Turner

The most important of these was Joseph Mallord William Turner (1775–1851). Like most English people, Turner was profoundly caught up by the Napoleonic wars, which he

watched very closely from the start. He wrote several verses in 1811 expressing patriotic anger at the Continental blockade, and several of his pictures record key events in the Anglo-French conflict. His first exhibited oil painting based on a contemporary event was *Battle of the Nile, at 10 O'clock when the L'Orient Blew Up, from the Station of the Gun Boats between the Battery and Castle of Aboukir*.[8] Shown at the Royal Academy in 1799, this work (whose whereabouts is presently unknown) demonstrates how quickly Turner responded to Bonaparte's designs against Britain's colonial interests, including the all-important approaches to India. The naval action, which took place during the night of 1 August 1798 between Admiral Nelson's fleet and a French fleet anchored in Aboukir Bay, turned Napoleon's mission into a debacle. In a skillful maneuver, Nelson concentrated his attack on a portion of the French fleet exposed to a high wind, making it impossible for the leeward vessels to render any assistance. He thus managed to destroy almost all the French ships in order, culminating with the flagship *L'Orient*.

Turner displayed his picture with a quotation from book 6 of Milton's *Paradise Lost* that amplifies the Miltonic and Dantesque associations of Fuseli, Blake, and Flaxman with modern warfare and technology:

> Immediate in a flame,
> But soon obscured with smoke, all heav'n appear'd
> From these deep-throated engines belch'd whose roar
> Imbowel'd with outrageous noise the air,
> And all her entrails tore, disgorging foul
> Their devilish glut, chain'd thunderbolts and hail
> Of iron globes.

Turner does not precisely identify Satan with Napoleon but rather employs the literary allusions to convey generally the vast magnitude and scope of the conflict.

Three years later, he used an Ossianic song from *Fingal: An Epic Poem* to allude to the Anglo-French naval wars: he sent to the 1802 exhibition a work entitled *Ben Lomond Mountain, Scotland: The Traveller: Vide Ossian's "War of Caros,"* referring to the site of a showdown between King Caros—a Roman usurper who attacked Britain by sea—and Oscar, the son of Ossian. Caros was called in the poem "the king of ships" for his victorious naval engagements, but he is subdued on land by Oscar.[9] In the English sign system Ossian became the indigenous Celtic-British hero staving off the Romantic-French assaults. Given the artist's early

response to the Anglo–French maritime rivalry, it was inevitable that he would depict the real-life Battle of Trafalgar in which Nelson again masterminded the defeat of a French fleet, definitively breaking the naval power of France and putting an end to Napoleon's visions of colonial conquest. A contemporary described the work as "a British epic picture," pointing to both its novel attempt to digest the whole of a naval encounter on a single canvas and its patriotic testimony to a great triumph for Britain's organization.

Turner and the Battle of Trafalgar

First executed and exhibited in his personal gallery less than a year after the event, Turner's *The Battle of Trafalgar, as Seen from the Mizen Starboard Shrouds of the Victory* testified to his patriotic commentary on the progress of the Napoleonic wars (fig. 3.2).[10] Just as the Battle of the Nile thwarted Napoleon's dreams of conquest in India, the outcome of the Battle of Trafalgar eliminated the emperor's chances for a successful invasion of Britain.[11] Napoleon intended to invade England between 1803 and 1805. In the spring of 1804, Napoleon issued instructions to Admiral Latouche-Treville, commander of the Toulon squadron, for a combined operation of the fleet with large barge-flotillas for the transportation of armed personnel. Latouche-Treville was shown how to elude Nelson's blockade in the Mediterranean and ordered to join Admiral Villeneuve's Rochefort squadron and enter the English Channel. Latouche-Treville, however, died in August 1804, and

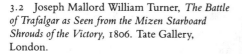

3.2 Joseph Mallord William Turner, *The Battle of Trafalgar as Seen from the Mizen Starboard Shrouds of the Victory*, 1806. Tate Gallery, London.

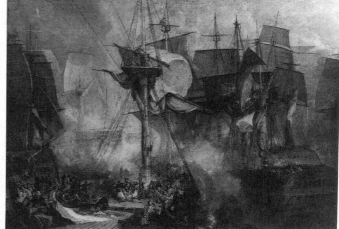

the plan had to be shelved indefinitely. Then an alliance with Spain, which placed the Spanish fleet at Napoleon's disposal, rekindled his prospects for invasion. Unable to penetrate the Channel, a fleet of French and Spanish vessels under the command of Villeneuve sailed to confront Nelson at Cape Trafalgar on 21 October 1805. Villeneuve's ships formed a long line, bent at an obtuse angle, the ends inclining inwards to the approaching English fleet. At the head of two British columns sailed Admiral Nelson in the *Victory* and Collingwood in the *Royal Sovereign*. Nelson signaled to prepare to anchor and then made the last appeal of his life, "England expects that every man will do his duty." The English won the battle, and their predominance of the sea was now undisputed. But during the course of the encounter, Nelson was struck by a bullet. His last words were "God and my country." While there was a tremendous cost of lives on both sides, news of the loss of Nelson overshadowed the grief of individual families. Nelson's ardent nationalism and close identification with the glory of the navy endeared him to the English masses and made of the event a tragically memorable occasion.

The Battle of Trafalgar also represented England's technological supremacy and exemplified Nelson's scientific use of his weapons; Britain's advanced methods in producing coke-smelted iron obtained from the blast furnace made possible the casting of superior cannon, in particular for the Royal Navy. The combination of English iron production and Nelson's ability to use his cannon for raking fire contributed to their victory.

Turner's *Battle of Trafalgar*, with its glimpse of the fallen Nelson being carried down from quarterdeck and its accurate depiction of the vessels, embraces what in the public mind would have been the salient features of the event. The painter concentrated on the mizen starboard shrouds (ropes that help support the masts) of Nelson's ship *Victory*, projecting it from an angle like a wedge penetrating the space of the French ship *Redoubtable* and the Spanish *Bucentaur* and *Santissima Trinidad*. This corresponds to the actual point where Nelson broke through the line of the Franco-Spanish fleet, accompanied by the *Temeraire*, which is seen behind the mast of the *Victory*. Nelson has been struck by a bullet from a rifleman in the mizen yard of the *Redoubtable*, and we see also Nelson's midshipman who shot the rifleman preparing to fire. Meanwhile, the *Victory* is discharging its starboard guns into the hull of the *Redoubtable*.

It is clear that Turner aimed for journalistic accuracy in

depicting this topical event. He made a special trip to sketch the *Victory* as it entered the Medway and later made a number of detailed studies aboard the ship when it was anchored off Sheerness in late December.[12] Above all, he tried to capture a panoramic sweep of the naval encounter and bring the spectator close up to the actual engagement. The assumed position of the observer inevitably draws her into the action metaphorically as a direct participant, a characteristic of Turner's mature landscape work. To dramatize his scenes and break down distance between image and beholder, Turner employed all kinds of ingenious pictorial devices such as vortex movements and scant foreground transitions. His compositions are panoramic and engulfing and push the gaze toward the center; in the *Battle of Trafalgar* these qualities reinforce the sense of Nelson's overpowering tactics and concentration of fire.

West's *Lord Nelson*

Turner's work may be compared with Benjamin West's version of the event, focusing on the fallen Nelson. The doyen of Anglo-American history painting, hero of the picture of the *Death of General Wolfe*, did not fail to capture the opportunity to do another apotheosis. Following the victory at Trafalgar, the death of Lord Nelson inspired the same outpouring of public emotion evoked by Wolfe's death at Quebec a half-century earlier, and West capitalized on the moment. He actually began the work at the instigation of the engraver James Heath, and the two contracted as partners in the reproduction and distribution of an engraving after the picture. This was meant to be a companion to Woolett's engraving of the *Wolfe*.

West was to paint several versions of Nelson's death, indicating a lack of confidence about his approach. It is the first that interests me here: now at the Walker Art Gallery in Liverpool, it was designed to be a grand-style drama with all the compositional devices of his earlier works (fig. 3.3). The admiral lies on the deck of his ship surrounded by an entourage of officers and seamen in the very kind of dramatic finale that West had earlier engineered for the *Wolfe*. Again, West is more concerned with the portraits of the living, those alive when he painted the picture and hired out for the engraving. Everyone appears to be maneuvering for position, while Nelson himself counts for nothing except as the pretext for bringing the others together.

As in the *Wolfe*, West manipulated both the site and the

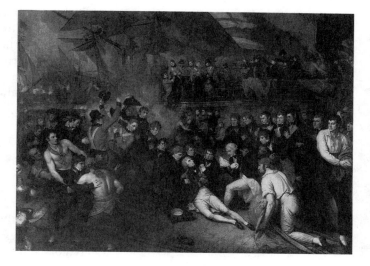

people actually present. Nelson's final moments unfolded
in the claustrophobic quarters of the belly of the ship, but
West moved the scene to the crowded open deck. While he
gathered a multitude of details from sailors he personally
interviewed, his desire for a heroic memorial overshad-
owed his commitment to verisimilitude. As he told Joseph
Farington,

Wolfe must not die like a common Soldier under a Bush; neither
should Nelson be represented dying in the gloomy hold of a Ship,
like a sick man in a Prison Hole.—to move the mind there should
be a spectacle presented to raise & warm the mind, & all shd. be
proportioned to the highest idea conceived of the Hero. No Boy,
sd. West, wd. be animated by a representation of Nelson dying
like an ordinary man, His feelings must be roused & his mind
inflamed by a scene great & extraordinary.[13]

Of course, West also meant a scene of such great effect that
it could not fail to capture the public's attention—and
pocketbooks.

West's dissatisfaction with this scheme, however, shows
in his final attempts to do a neoclassical apotheosis. His de-
sign of 1807 for a proposed monument to Lord Nelson was
meant to frame a painting depicting the admiral's body, in
classical garb, being transported to heaven by Britannia,
Neptune, and a whole host of flying putti and angels. Gods
of sea and land, reminiscent of Barry's glorification of Em-
pire, leap around the admiral's body. Then followed a more
accurate attempt to memorialize Lord Nelson in his quar-
ters, attended by only a few of his officers. Veering back

and forth between epic painting and documentary realism, he demonstrated that he could no longer maintain the neoclassical posture that had served him earlier. Dreams of British empire were clouded over by the powerful image of Napoleon, and the times called for a style of high tragedy and catastrophe more easily assimilated to landscape. It is in this sense that Turner spoke more readily to the elite of his generation.[14]

Turner's Patrons

Turner's patriotic images were enthusiastically endorsed and purchased by England's wealthiest art patrons. Typical of these was Walter Ramsden Fawkes of Hawksworth, Yorkshire. Fawkes acquired a major collection of Turner's watercolors and oils which he hung in his seat at Farnley Hall and in his elegant townhouse on Grosvenor Square in London. A major landed proprietor with both agricultural and industrial interests, he was renowned for his scientific farming and cattle breeding. His shipments of cattle to domestic markets developed into a large-scale enterprise. He helped found the Otley Agricultural Society and produced some of the finest shorthorn cattle in the world. Fawkes was also a Whig liberal on domestic issues and supported the abolitionist movement. As M.P. for the county of York during the period 1806–1807, he helped Wilberforce pass his measure outlawing slave traffic. He approved of liberty in moderation and despised despotism because he valued

3.4 Joseph Mallord William Turner, *London,* 1809. Tate Gallery, London.

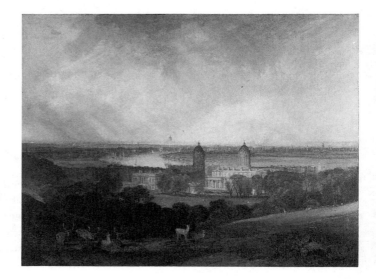

his freedom of action and believed that private property flourished best under a liberal regime.

During the early years of the Napoleonic wars, Fawkes took the government's side on all major foreign policy decisions, but gradually the economic hardships of the Continental blockade and popular dissent forced him to modify his position. His initial patriotism is expressed in the work he purchased from Turner. Probably the first oil he brought from the artist was *The Victory Returning from Trafalgar*, a scene of Nelson's flagship bearing the admiral's body on board, shown from three heroic positions. Three years later Fawkes acquired the splendid view of *London*, exhibited at the Royal Academy in 1809, focusing on the famous building complex at Greenwich on the south bank of the Thames (fig. 3.4). The artist assumed a lofty vantage point to embrace the wider vista of the bustling commercial activity and at the same time to show deer grazing peacefully in the foreground. In this he identified with the landscape attitude of James Thomson, the patriotic poet whose commanding view in *The Seasons* is associated with nationalist sentiment: "Meantime you gain the height, from whose fair brow / The bursting prospect spreads immense around." And in his later poem, *Liberty*, where the goddess of liberty is synonymous with British liberty and he traces the history of the idea "down to her excellent establishment in Great Britain," Thomson rhapsodizes:

Turning to the south,
The whispering zephyrs sigh'd at my delay.
 Here, with the shifted vision, burst my joy:—
"O the dear prospect! O majestic view!
See Britain's Empire! lo, the watery vast
Wide waves, diffusing the cerulean plain." [15]

Turner's scene deliberately shows the city unperturbed by war and offering a bulwark to a world beset by hostilities, a Thomsonian view expressed in the painter's own verses accompanying the exhibition catalogue:

Where burthen's Thames reflects the crowded sail,
Commercial care and busy toil prevail,
Whose murky veil, aspiring to the skies,
Obscures thy beauty, and thy form denies,
Save where thy spires pierce the doubtful air,
As gleams of hope amidst a world of care.

In this case, the "gleams of hope" piercing "the doubtful air" are embodied by the monumental twin domes of the

Greenwich Naval Hospital, designed by Sir Christopher Wren. In 1694 William and Mary instructed Wren to transform a declining former residence of Henry VIII into a naval hospital, commemorating the decisive naval victory of the English over the French at La Hogue (1692). Turner clearly made an association between the origins of the naval hospital and the recent Battle of Trafalgar—highly appropriate since it not only referred to an analogous victory over the French but also, at the time he painted it, the hospital was housing pensioners who had fought in the Battle of Trafalgar.

But the tranquility of *London* proved to be the proverbial calm preceding the storm. As Napoleon's Continental blockade began to take its toll on the English economy, Turner had to find other metaphors to convey the state of things. This period coincides with Fawkes's growing disillusionment with the king's policies: in May 1812 he called for a restoration of the Constitution, "which has [been] so long and loudly extolled in theory, and so strangely perverted in practice." He condemned the inadequate representation of the Commons in Parliament, and its tendency to ally itself to royal despotism. He attacked the vast waste of national resources on war with Napoleon, and declared a state of crisis. He perceived the nation on "the brink of the frightful precipice," with insurrection and corruption on the verge of pushing it over. Throughout the Napoleonic period, moreover, Turner produced a series of pictures based on themes of disaster in both realist and allegorical categories. Reading like a veritable inventory of what might be called the "geological and meteorological sublime," it comprises storm wreck, biblical plague, avalanche, volcanic eruption, and the inevitable deluge. As in the case of Saint-Ours and Girodet, the natural catastrophe became a complex and finely honed metaphor for social and spiritual crisis. Unlike those artists, however, Turner did not emphasize the plight of a few individuals in the context of natural disaster, but tried to embrace an entire environment and its impact on whole populations. The magnitude of his projection springs in part from his training as a landscapist, but it issues primarily from his response to advanced industrialism in England, with all its attendant scientific and technological changes. Turner's capacity for the panoramic embrace derives from his experience as a Londoner growing up with a sense of participation in a vast commercial empire. Hence he consistently draws the observer into the whirling rhythms of his com-

positions, into a primary focus of elemental violence which makes us identify with his own sense of social and political turmoil.

Turner's Hannibal in a Snowstorm

Turner's *Snowstorm: Hannibal and His Army Crossing the Alps*, exhibited at the Royal Academy in 1812, synthesizes the geological interest in the Alpine regions,[16] the anxieties over a Napoleonic invasion, and unrest at home through a dynamic stylistic approach made possible by the pioneer forms of English industrialism (fig. 3.5).[17] Based on a storm he witnessed over the Yorkshire hills, it was exactly the kind of complex image that appealed to Turner and justified his claim to the rank of history painter despite the dominance of the landscape. Although the historical event is depicted with observed geological and meteorological data, it is projected from a superhuman perspective. I call this the *managerial prospect*, referring to the nineteenth-century artist's intention and capacity to orchestrate a variety of observed and imaginary phenomena on a vast scale and encompass an entire landscape that he or she could not have witnessed directly or simultaneously in its totality.

It may be recalled that Hannibal was a Carthaginian general committed to a lifetime struggle against Rome. In an audacious maneuver, he and his army crossed the Alps with elephants, surmounting fifteen days of hazardous climate and terrain. He conquered what is now Piedmont, ravaged Apulia and Campania, and then settled with his troops in the city of Capua, which had defected from the Italic Confederacy to join the victorious Hannibal. Here the Cartha-

3.5 Joseph Mallord William Turner, *Snowstorm: Hannibal and His Army Crossing the Alps*, 1811–1812. Tate Gallery, London.

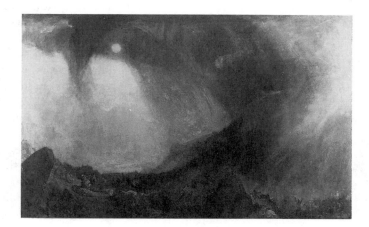

ginians, their strength weakened by their enormous ordeal, settled in to spend the winter of 216–215 B.C. It proved to be a turning point in the invasion, since Hannibal's reluctance to push towards Rome undercut his momentum.

While Turner's picture shows Hannibal atop an elephant jeering at the elements way off in the middle distance, the verses that accompany the 1812 catalogue entry reveal the demise rather than the victory:

Craft, Treachery, and Fraud—Salassian force,
Hung on the fainting rear! then Plunder seiz'd
The victor and the captive,—Saguntum's spoil,
Alike, became their prey; still the Chief advanc'd,
Look'd on the sun with hope;—low, broad, and wan;
While the fierce archer of the downward year
Stains Italy's blanch'd barrier with storms.
In vain each pass, ensanguin'd deep with dead,
Or rocky fragments, wide destruction roll'd;
Still on Campania's fertile plains—he thought,
But the loud breeze sob'd, "Capua's joys beware!"

The central theme of the verses is the prediction that, after all the valiant suffering, the Carthaginian will traverse the mountains only to descend onto the affluent cities of the plain and get mired in the corruption.

Turner's early biographer, Thornbury, claimed somewhat cautiously that in Turner's mind there seemed always to be a "dim notion of some analogy between Carthage and England." [18] It was indeed common at the time to compare the imperial and commercial rivalry of Rome and Carthage with the contemporary struggle between England and France. Earlier in his reign, George III could find aspects of both empires to bolster his self-image. Napoleon's coronation in 1804, however, preempted an exclusive identification with Rome, although the English ideal of imperium lingered on throughout the nineteenth century.

Closer to home, it should be recalled that the British Isles had been subjugated by the Romans for almost five hundred years. Julius Caesar invaded in 55 B.C., and his descendant Claudius repeated the action in A.D. 43. The Romans invaded Yorkshire in 51, and York became the military and civil capital of the country under Roman rule. The area was densely populated by Romans, whose remains still dotted the region at the time Turner painted the picture. Eventually, the Saxons, Angles, and Jutes crossed the Channel to conquer the Romans and imposed their layers of customs and political and social institutions onto the Ro-

man framework. Thus English conquest over the Roman invader was written into the British schoolboy's basic text.

Turner would have been affected by the knowledge that the most spirited opposition to Napoleon occurred in states with major mountainous barriers: the Swiss and Tyrolese Alps and the Spanish Pyrénées. In late 1809 a delegation of Tyrolese came to London to request support against Napoleon's invasion of their Alps; they aroused strong popular sympathy. In 1808 the English were impressed by the resistance of the people of Cartagena in southeastern Spain against the attempts of the French navy to blockade their port. Since Cartagena was founded by the Carthaginians, who first named it Carthago Nova or New Carthage, it is likely that the symbolism of the Rome-Carthage encounter was updated in response to the event. Both England and France established blockades of Cartagena at one time or another during the Peninsular wars.

Turner's later works unequivocally linked Carthage with France, identifying with the ultimate conquerors of the ancient North African empire. His *Dido Building Carthage; or, the Rise of the Carthaginian Empire*, exhibited in 1815, shows the foundation of the "war-loving" and "aggressive" state (the reference accompanying the exhibition entry, which was quoted from book 1 of Virgil's *Aeneid*) that would become the future rival of Rome. Two years later Turner depicted the result of that rivalry in the companion picture, *The Decline of the Carthaginian Empire*, whose full title spells out the terms of Rome's subjugation of Carthage. Moreover, the final phrase of the title—"the Enervated Carthaginians, in Their Anxiety for Peace, Consented to Give up even Their Arms and Their Children"—unmistakably alludes to the terms imposed on France by Great Britain and its allies following Waterloo.

Given this scenario, it would appear that *Hannibal Crossing the Alps* expresses renewed English anxieties about a Napoleonic invasion. During a trip to Paris in 1802, when the Treaty of Amiens permitted a respite in the hostilities between France and Great Britain, Turner visited David's studio and saw his picture of *Napoleon Crossing the Saint Bernard*. Additionally, it was generally believed that Hannibal himself crossed somewhere between Little Saint Bernard Pass and the Col de Genèvre. It did not require David's inscription of Hannibal's name on the rocks of his painting to ensure the association with Bonaparte. Furthermore, at the time Hannibal engaged in this maneuver he

had yielded all control of the sea. The traditional maritime advantages of the Carthaginians were now transferred to the Romans, who then controlled the sea. Hannibal, like Napoleon after 1805, had no supporting navy. Finally, it could not have escaped Turner's notice that Napoleon's son, born in 1811 and named the king of Rome, epitomized Napoleon's hegemonic annexation of the papal states.[19]

Yet it is still possible that Turner's French-Carthage association was soft until the encounter with David's painting, and the traditional identification of Great Britain and Carthage still had a grip on his imagination. This would make the *Hannibal* a much more problematical picture than is usually presumed and make the Napoleonic symbolism less mechanical in its connection with the historical circumstances. An attempt to understand the image as an outcome of Turner's shared concern for an England tottering on the brink of catastrophe requires some further historical analysis of the crisis provoked by the domestic turmoil.

Under the pressure of Bonaparte's Continental blockade, the years 1811–1812 proved to be a tumultuous period for English society. By 1810 the oppressive taxes on commodities created a glut of colonial products, which had been piling up in English ports. A wave of bankruptcies pointed to a severe economic crisis, already exacerbated by the unemployment caused by bad harvests in the preceding two years. At the same time, Napoleon succeeded in embroiling England with the United States. He offered a compromise on his blockade if the English rescinded their Orders in Council that in effect reverse the blockade: they required all neutral ships to be furnished with a trading license in an English port, thus intervening in all trade between neutrals and most European ports so that a total naval war involving neutrals grew out of the Continental system. President Madison attempted without success to persuade the English government to revoke the orders and imposed an American embargo on the belligerents. Meanwhile, tensions reached the boiling point as the English seized American ships, searching them for deserters or impressing American seamen presumed to be English. The United States finally declared war on England in June 1812—when *Hannibal* was exhibiting at the Royal Academy.

At home, internal strife had erupted in 1811, a year of widespread unemployment and rioting. The high prices and scarcity provoked the Luddite revolts—a name given to organized bands of English striking workers who de-

stroyed machinery.[20] The machine-breaking riots began toward the end of 1811 in Nottingham and ultimately spread into Yorkshire, Lancashire, Derbyshire, and Leicestershire. Fueled by the terrible pressure of the transition from handicraft to machinery in the textile trades, the distress caused to those workers dismissed or to those whose wages were reduced due to competition, and the general scarcity pushed the unemployed to desperation. While the Luddites—usually masked and operating at night—left people unharmed, they were shot by the military and ruthlessly suppressed. Harsh legislation and judicial reprisal all but destroyed the Luddite organization, but this fierce confrontation between the owners of the means of production and those whose labor produced the goods gave rise to a new class consciousness. In the next two decades, the Luddite revolts would become a symbolic rallying point for English laborers, who organized the first independent working-class movement.

It is probably not coincidental that one of the immediate sources of inspiration for the *Hannibal* was suggested by a thunderstorm over the Yorkshire Hills, seen from the terrace of Farnley Hall in Yorkshire, the seat of Turner's patron Walter Fawkes. As Turner and his patron's son watched the storm, the painter exclaimed that "in two years you will see this again, and call it Hannibal crossing the Alps."[21] While this event occurred in 1810, already the storm clouds of mutiny were gathering in the Midlands; between the conception and the finished work the correlation between weather-made and human-made destruction would become apparent.

Thus chaos on the domestic front is alluded to in the form of a violent snowstorm whirling around the dim sun. Driving rain and huge fallen boulders dramatize the event, while the swirling forces almost transform the picture into one vast whirlpool. These highlight the foreground scene of Carthaginian troops plundering, raping, and killing the Alpine people and of the Alpine horns signaling a reprisal. Hence, the theme of mutiny and internal division follows in the tracks of Hannibal, and reinforces its allusion to national politics. The picture's subtext points to the self-destructive components of English culture during the Napoleonic wars, with England-Carthage literally invading itself and making the ultimate task of Napoleon a lot easier.

The landscape achieved its effect in the mind of Turner's peers by a combination of moral and physical elements seemingly out of control. Here Turner invoked the elemen-

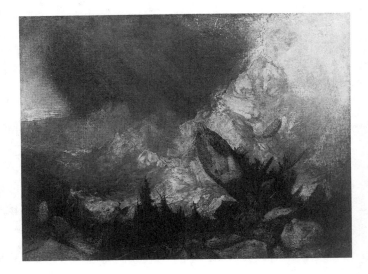

tal forces of the Alpine region, an area becoming increasingly fascinating for artists as well as geologists. In 1810 Turner exhibited *The Fall of an Avalanche in the Grisons,* focusing on an enormous boulder about to crush a little cabin below (fig. 3.6). Turner traveled in Switzerland in 1802 and may have visited the Grisons, a canton in the northeast. In December 1808 a disastrous avalanche occurred at Selva in the Grisons, in which twenty-five people were killed in one cottage alone. But the natural catastrophe shown in Turner's picture is inseparable from political events of like impact: on 15 October 1809 the Vienna Peace Treaty gave Napoleon the title of "mediator of Switzerland"—official recognition of his suzerainty over the Helvetic Confederation—and the fief of Razuns, in the Grisons, which belonged to the emperor of Austria. Like an avalanche, the Napoleonic steamroller seemed unstoppable.

Turner and the Poet James Thomson

James Thomson's section on winter in *The Seasons* embodies ideas that may have affected the conception of *Hannibal.* The poet's winter muse sallies forth from the "frigid zone" to oppress other parts of the globe:

Here Winter holds his unrejoicing court;
And through his airy hall the loud misrule
Of driving tempest is for ever heard:
Here the grim tyrant meditates his wrath;
Here arms the winds with all-subduing frost;

Moulds his fierce hail, and treasures up his snows,
With which he now oppresses half the globe.

But wintry time passes into the "unbounded Spring" of
eternity:

Ye good distressed!
Ye noble few! who here unbending stand
Beneath life's pressure, yet bear up awhile,
And what your bounded view, which only saw
A little part, deem'd evil, is no more:
The storms of Wintry Time will quickly pass,
And one unbounded Spring encircle all.

Thomson's *Seasons* consistently merges meteorological,
geographical, and geological allusions with his panegyric
on the beloved homeland. *Autumn*, for example, begins
with a section on the blessings of industry and commerce
as civilizing forces, while *Summer* culminates with a cele-
bration of "Happy Britannia." Like Thomson's poetry,
Turner's landscapes are rich with scientific allusion to the
power, glory, and influence of England.

Turner and Geology

Indeed, it was in the context of modern geology that Tur-
ner expressed his visual ideas about the world. Both Nep-
tunists and Vulcanists considered mountains the key to the
field, since mountains permitted glimpses into sections of
the earth's surface, its fissures and strata that were so diffi-
cult to examine in the uniform planes of the flatlands. Saus-
sure's *Voyages dans les Alpes* was widely quoted for its de-
tailed analysis of rocks, while the Huttonian James Hall
tried to demonstrate that the architecture of river valleys
and inland basins throughout the globe was formed by a
cataclysmic torrent that had flowed high and deep over the
Alps. But if the observations by Swiss geologists were cen-
tral to the hypotheses of the new science, the discipline
took off in England, where the first national geological so-
ciety was founded in 1807.[23] *Transactions of the Geological
Society*, first published in 1811, became a clearinghouse for
the claims of the two contending schools and their interna-
tional partisans.

We know that Turner owned volume 1 of the *Transac-
tions*, in which a Swiss geologist named Berger compared
the rock structure of the Alps to the mountains of Corn-
wall.[24] Berger declared that Saussure's analysis of the Al-
pine terrain was applicable to the Cornwall mountains.

There could be found great quantities of detached granite blocks that formed mountains or that were scattered over their borders. This was a phenomenon found in the Alps and in the English counties of Cornwall and Devonshire. Not surprisingly, we find that Turner undertook a major tour of Cornwall and Devon in late summer of 1811 in connection with a major series of topographical engravings. It is likely that some of the rocky piles of *Hannibal* were sketched during his travels to these regions, while others were based on the Jurassic formations in Yorkshire.

One contributor to *Transactions* was John MacCulloch, a celebrated member of the Geological Society who became Turner's friend.[25] An ardent patriot and Scot chauvinist, MacCulloch prepared the first geological map of Scotland, and his article "On Staffa," in volume 2 of the *Transactions*, may have contributed to Turner's later painting of *Staffa, Fingal's Cave*.[26] MacCulloch was something of an eclectic, borrowing from both Hutton and Werner, neither one of whom he wholly respected. While he wrote on the Alps and relied on Saussure, MacCulloch felt that England furnished more extensive opportunities for geological research than any other country in the world. Except for volcanoes "and little more," Great Britain contained every known geological fact. MacCulloch's chauvinism was complemented by his devotion to English mercantilism and militarism: he was commissioned by the Board of Ordinance to study what kinds of rocks could be most safely used in powder mills, and he dedicated his book, *A Geological Classification of Rocks* (1821), to the board of directors of the East India Company. His analyses of such minerals as coal and limestone always emphasized their commercial possibilities. He spent the last years of his life trying to prove scientifically that God governs the physical universe as well as the moral one.

In fact, MacCulloch regarded the ultimate purpose of science to be the positive demonstration of God's association with His works. His beliefs were founded on his geological theories of the earth, and in this sense resembled Turner's landscape approach, which similarly fused moral theme with the data of hard geological and meteorological fact. MacCulloch himself was a gifted landscapist and illustrated his own writings. He felt that all aspiring geologists should be able to draw and that "practice and facility in landscape are indispensable."[27]

Turner's own involvement with geology related to his interest in the substructure of the landscape and the rocky

outcroppings that hinted at the formations that lay hidden below the ground. Turner's fascination with the influence of geology on the visible surface was inseparable from his attachment to the English landscape. We have already seen that contemporary geologists found analogies between parts of Britain and Switzerland, and we know that Turner incorporated certain geological structures and rock formations of Yorkshire into his Alpine scene. Fawkes was fascinated by the Alps and encouraged Turner's visit to Switzerland in 1802. Of the forty watercolors related to the tour, over half hung at one time at Farnley Hall. Fawkes also commissioned a series of twenty watercolors: ten Yorkshire subjects and ten Alpine—attesting once again to the indigenous source of inspiration for the Hannibal picture.[28]

Yorkshire's geology was also essential to its industrial expansion and a factor in regional unrest during the Napoleonic wars. Turner further resembled MacCulloch and his fellow geologists in sharing their interest in geological applications to industry and commerce. This interest was decisive for his mature visual production: such early studies as the *Interior of an Iron Foundry*, with its central luminous glow, anticipate the visionary themes in which the industrial motif is transformed into an apocalyptic explosion (fig. 3.7). Already near the turn of the century, he expressed this link between geology and art in his painting *Limekiln at Coalbrookdale* (fig. 3.8). Crushed limestone was calcinated in kilns to produce lime which, as MacCulloch noted, had many commercial uses. By 1800 most English

3.7 Joseph Mallord William Turner, *Interior of an Iron Foundry*, c. 1797, watercolor, Sketchbook TB33-B. Tate Gallery, London.

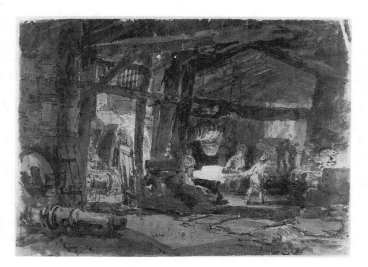

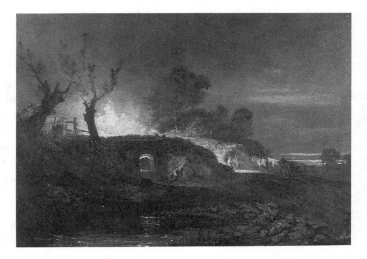

3.8 Joseph Mallord William Turner, *Limekiln at Coalbrookdale,* c. 1797, panel. Paul Mellon Collection, Yale Center for British Art, New Haven.

villages and large farms had their own limekilns. Lime was used for making cement and building stone, and to correct soil acidity and promote crop production. Above all, lime was used for fluxing purposes in smelting pig iron with coke.

It may be recalled that Coalbrookdale, in Shropshire, was famous for its iron works and played a major role in development of the Industrial Revolution.[29] It was here that Abraham Darby succeeded in smelting iron ore with coke instead of charcoal. Coalbrookdale's products were shipped down the Severn River by barge to Bristol and thence all over England and the rest of the world. It was to facilitate the shipping and transportation of their goods that the Darbys erected the first iron bridge in order to span the river. The bridge was designed by the architect Thomas Farnolls Pritchard and cast in Abraham Darby III's Coalbrookdale furnaces. When it opened in 1780 it quickly became a symbol of British technological prowess: a special engraving was commissioned by the Coalbrookdale Company in 1782 and dedicated to George III. In many ways, the bridge was used to distract people from the more unfavorable aspects of Coalbrookdale's industrialized landscape.

However, the most popular method of showing off Coalbrookdale "in a good light" was to paint it after dark. The awesome impression of its blazing furnaces and roaring blasts at night divested the industrialized landscape of its squalid aspects. The intrepid traveler Arthur Young wrote about his visit to Coalbrookdale in 1776:

Coalbrook Dale itself is a very romantic spot, it is a winding glen between two immense hills which break into various forms, and all thickly covered with wood, forming the most beautiful sheets of hanging wood. Indeed too beautiful to be much in unison with that variety of horrors art has spread at the bottom: the noise of the forges, mills, &c. with all their vast machinery, the flames bursting from the furnaces with the burning of the coal and the smoak of the lime kilns, are altogether sublime, and would unite well with craggy and bare rocks, like St. Vincent's at Bristol.[30]

One visual equivalent of such observations is Philip James de Loutherbourg's *Coalbrookdale by Night* of 1801, which glorifies the glowing industrial wasteland (fig. 3.9).[31] The fiery light and billowing clouds of smoke silhouette and monumentalize the factory complex at the left and direct the gaze away from the rubbish heap of metal castings and scrap in the foreground. Another is George Robertson's *Iron Works at Nant-y-glo* (fig. 3.10) which, reminiscent of Joseph Wright of Derby's Arkwright cotton mill at night, sets the industrial buildings in a moonlit setting. In this case, however, the full moon does not shine in a clear country sky but is glimpsed through the haze of grime and pollution. The association of the moon with the industrial site continues to trade in on Ossianic convention and the Burkean sublime, but now reveals the emerging industrial townscape and its "horrific" features. The air of lunar mystery has diminished in proportion to its revelation of the seamy side of the Industrial Revolution.

Turner drew on the moonlit motif in connection with his seascapes, connecting it with English commerce and trade. While *Limekiln at Coalbrookdale* follows this pattern,

3.9 Philip James de Loutherbourg, *Coalbrookdale by Night,* 1801. Trustees of the Science Museum, London.

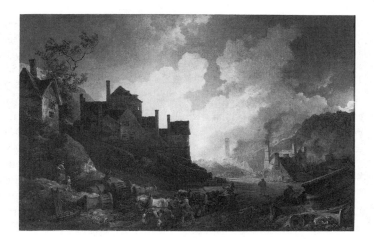

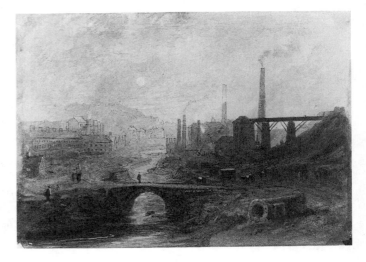

3.10 George Robertson, *Iron Works at Nant-y-glo*, c. 1788. Welsh Industrial and Maritime Museum, Cardiff.

the moon's presence is only indirectly seen through glimmering streaks of light in the night sky. Limekilns were essential to Coalbrookdale's iron production, and a major use of the Iron Bridge was to bring in the much-needed limestone for the smelting process. Like de Loutherbourg and Robertson, Turner delights in the contrast of the industrial glare with the night effect, but unlike them he stresses the peacefulness and beauty of the pastoral setting. His smoking kiln illuminates the countryside but is not allowed to obtrude upon it.

During the Napoleonic wars, Turner's landscapes became more dynamic; while not always concerned with industrial subjects, they correspond increasingly to the enterprising application of manufacturing techniques to solve the problems caused by the Continental blockade. The blockade encouraged adventurous agriculture, including the use of machinery, with the aim of becoming self-sufficient in wheat production. Almost all of Turner's major patrons in this period were landowners who applied the latest geological, agricultural, and industrial ideas in the exploitation of their land. In addition to Fawkes, Lord Egremont, Sir John Fleming Leicester (first baron de Tabley), and William Beckford vastly improved their estates during this period and belonged to agricultural societies. Turner's novel landscape approaches and audacious lighting and paint techniques were a testament of his identification with affluent bourgeois and aristocratic patrons.

John Martin

The close link between the explosive way of structuring space and the effects of war and industry is seen in a younger contemporary of Turner's whose work created almost as great a sensation as the *Hannibal* in the same exhibition of 1812.[32] John Martin's *Sadak in Search of the Waters of Oblivion* recalls both the catastrophic images of Girodet and the panoramic violence of Turner (fig 3.11). It projects an unprecedented scale, pitting a single puny mortal against a colossal mountain range, falling torrents of water, with wild flashes of lightning and volcanic explosions giving off a searing effect of heat. From the pool in the center gigantic cataracts descend, and between them, desperately struggling to climb a rocky ledge, is the diminutive figure of Sadak—an ant in the face of eternity. What makes the work so remarkable is its persuasive combination of science and fantasy: while the scale seems beyond terrestrial experience, the attention given to geological and meteorological phenomena is that of the knowledgeable observer. The fiery atmosphere is reminiscent of the scenes of smelting plants by de Loutherbourg and Robertson—the effect of the whole achieved as much through the natural formations as by the possibilities opened by the new technology. The work is a clear example of the catastrophic view of earthly creation intimately related to Hutton's Vulcanist theories, but, as in the case of Turner, the ability to visualize these forces derives from the social convulsions caused by Napoleon and the expansion of the industrial sector with its correlative ideals of mass production and distribution.

Raised in Newcastle upon Tyne, a center of coal and lead mining, Martin (1789–1854) developed his imagination against the background of the new industrial townscape. It was an environment that encouraged invention, and both John and his brother William made notable scientific contributions. As early as 1805 William invented a fan ventilator for mines, for which John sketched the plans. John also conceptualized and sketched the idea for hauling coal by rail. Both brothers were familiar with the work of the physicist Sir Humphry Davy, who in 1816 announced to the Newcastle miners the discovery of his famous safety lamp. Davy extended the investigation of Volta, constructing a series of batteries in various combinations and finally constructing an example of two thousand cells with which

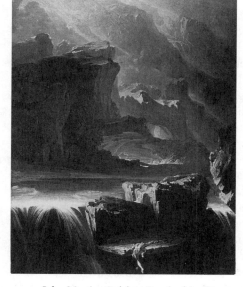

3.11 John Martin, *Sadak in Search of the Waters of Oblivian*, 1812. Southampton City Art Gallery, England.

he produced a bright light from points of carbon—the prototype of the modern arc lamp. Davy's experiments brought him to the attention of the mine owners and reformists worried about the series of explosions in the mining region of Newcastle. However, William Martin had perfected his own safety lamp as early as 1813; when later tested by mine workers it was judged superior to Davy's. John Martin himself submitted a paper to the Select Committee on Accidents in Mines in 1835 entitled "Mr. John Martin's Safety-Lamp, being a suggested improvement on Mr. William Martin's Safety-Lamp."[33] Two other papers that he submitted to the committee dealt with the ventilation in coal mines and an analysis of the causes of mine explosions. But by this time John perceived himself almost as much as a civil engineer as an artist: he projected designs for the Thames Embankment, purification of the London water supply, and a new sewerage system.[34]

Like Turner, Martin revealed a deep interest in the natural sciences, especially geology and its everyday applications. He developed close ties with well-known naturalists and geologists like Georges Cuvier, a French pioneer of comparative anatomy whose writings (starting from 1812) formed the scientific basis of catastrophism, and Gideon Mantell, discoverer of the iguanodon and author of the *Wonders of Geology* (1838). While these relationships occurred later in his career, Martin's background in the mining region of Newcastle and early employment in the ceramic industry no doubt encouraged his involvement with geology. He worked for a glass and china painter in London in 1806, and when this business failed three years later, he entered the employ of William Collins, who owned a famous glass and china factory near Temple Bar. Here for a time he was quite successful, but eventually the resentment of envious fellow workers forced him to quit and do freelance work.

The impact of the Napoleonic wars was always close to home: his brother Jonathan had himself gone to London to seek his fortune, but fell into the clutches of a press gang who made him serve as a seaman in the campaigns against Napoleon. Thus when John requested to leave for London, his family tried to detain him, fearing he would meet a similar fate. William belonged to the Northumberland Militia that stood by in the event of a Napoleonic invasion. Later, when John sold a work for a handsome price, he claimed to have felt as great as "Wellington must have felt in conquering Bonaparte."[35] Finally, in 1820 he exhibited at the Royal

Academy a design for a national monument commemorating the Battle of Waterloo.

Sadak in Search of the Waters of Oblivion works a synthesis of Vulcanism and Neptunism into a general doctrine of geological cataclysm. The scouring torrents of water in combination with the explosive volcanic activity appeared to Martin's contemporaries like a visualization of earth's cosmic origins. This in turn should be understood as an analogy of the convulsions produced in English society by the impact of Bonaparte. In the original story of Sadak the hero's peaceful life in the country with his family is violently disrupted by the tyrannical ambitions of the sultan Amurath. The sultan envies Sadak's family harmony, and his gardens, though "wild and regular" (i.e., the English style), offered pleasures superior to the "splendid pageants of the Ottoman Court." The sultan secretly covets Sadak's wife, Kalasrade, and abducts her. In an attempt to forestall Amurath's passion, Kalasrade suggests that he obtain a vial of liquid from the waters of oblivion to help her forget memories of the past. Hoping to break her steadfast devotion to her husband, the sultan tricks Sadak into searching for the waters of oblivion on an island dominated by a huge mountain whose summit reaches beyond the clouds and where an uncommon volcano belches liquid fire. The author's description is both Ossianic and geological and abounds in allusions to meteors, earthquakes, raging waterfalls, and other convulsive natural phenomena.

When Sadak at last completes his assignment and returns to Amurath's palace, the sultan grabs the vial and swallows the fatal contents—realizing too late that oblivion meant death not forgetfulness. Martin's painting emphasizes Sadak's extravagant adventure in a fantastic environment, but, in the sense that it shows the dangers besetting the hero and his family in a time of great crisis, it greatly resembles Girodet's *Deluge*. Closer to Turner, however, he could amplify the sense of crisis by enlarging the pictorial space to give tangible evidence of the threatening conditions and the helplessness of the individual. It is noteworthy that the eighteenth-century illustrations for the tale neither portray the scene of Sadak scaling the heights of the volcano nor show any interest in the singular topography of the island. Rather, they show more concern for the close-up interaction of the various characters. Thus Martin's novel approach to the story documents the dual impact of the Industrial Revolution and the Napoleonic wars on English art in general, and on landscape in particular.

The subject was taken from one of the *Tales of the Genii; or, the Delightful Lessons of Horam, the Son of Asmar*, first published in book form in 1762 as the translations from the Persian of a Sir Charles Morell, "Ambassador from the British Settlement in India to the Great Mogul."[36] In the end, however, it turned out that the book was another hoax like the Ossianic poems—written by one James Ridley, who cast the tales in the style of the Persian storytellers. Morell-Ridley begins the book by claiming to have been "chiefly conversant in trade" with little appetite for what he terms "the religious doctrines of pagans." By chance he meets Horam, whose tales he had read, and as Horam recounts his adventures the two debate the virtues of Christianity and Islam.

Sold in his youth to an English merchant, Horam disclaimed English preachments of faith and declared that "traffic is the prophet of the Europeans, and wealth is their Allah."[37] Horam eventually gained his independence and devoted himself to the study of mathematical sciences. He was fascinated by Newton, with whom he "held such converse as the inhabitants of the east are said to hold with the genii of mankind. I saw him bring down the moon from the realms of night to influence and actuate the tides of the sea . . . he marked the courses of the stars with his wand, and reduced eccentric orbs to the obedience of his system. He caught the swift-flying light, and divided its rays."[38] Under this inspiration, Horam advanced himself to the position of court astronomer and scientist to the Mogul in Bengal, where he began to assemble his didactic tales.

Most of these stories concern merchants and commerce, clearly indicating the influence of the colonialist ideal of the British Empire. Ridley dedicated the book to "His Royal Highness George, Prince of Wales," hoping that the prince would approve of the attempt to promote the cause of "morality." During the Seven Years' War when England and France were struggling for world empire, the English established themselves in India, where the wealth and enterprise of the English traders were the envy of other European nations and the Moguls as well. The English traders ruled Bengal, the delta of the Ganges, the richest and most fertile of all the Indian provinces. Its rice, sugar, and silk and the products of its weavers were popular in European markets. When Surajah Dowlah seized the settlers of Fort William and forced them into the Black Hole of Calcutta (a small prison), where many of them died, Great Britain dispatched troops and cannons to impose its full power. On

23 June 1757 the English East India Company was able to put a mogul of its own choice on the throne of Bengal, and thus began the rule of the English in India. Ridley's tales of Horam, the ex-slave of an English trader, unfolds a series of fantastic images of wealth and topography which glorify the exotic possessions of Great Britain in India.

What's more, the interest of Horam in Newton also suggests that non-Westerners elevate themselves through contact with Western civilization and science, despite the fact that Arab knowledge of mathematics and science antedated that of European colonization by several centuries. Even more interesting for our study is the commingling of science, trade, and colonialism with the exotic settings and fantastic images of the *Arabian Nights*. Expansion of colonial interests in India through the settlements of the East India Company stimulated major scientific and geological expeditions: it may be recalled that MacCulloch dedicated his *Geological Classification of Rocks* to the company's board of directors. Moreover, Napoleon's own expedition to Egypt, meant to exert pressures against English possessions in India, deployed scientists and scholars as well as troops to aid in his takeover. Hence *Sadak* was an ideal subject for Martin in his bid for success in the London art world. William Manning, a governor of the Bank of England and an M.P., purchased the work and opened the way to Martin's dazzling career as a painter of large-scale disasters and the boundless scope of ancient Empires.

William Beckford as Art Patron

One of Martin's later patrons was William Beckford, a landowner and writer of Oriental tales whose literary fantasies were matched by prodigious achievements in the real world.[39] Also a major benefactor of de Loutherbourg and Turner, Beckford commissioned Martin to execute the designs for the engravings of Fonthill Abbey, his remarkable country seat. Beckford's father, twice lord mayor of London, was one of the richest persons in England, and his mother, also an accomplished individual, descended from the old aristocracy. The family fortune derived from vast sugar estates in Jamaica and the West Indies, which William had to oversee periodically. From childhood his imagination was stimulated with visions of English overlords exploiting hordes of slaves in the accumulation of immense wealth. His parents deliberately inculcated him with the vanity of wealth and power, hoping thereby to maximize

his material aspirations. It is not surprising to find that he nourished his adolescent daydreams with readings of the *Arabian Nights* and Ridley's *Tales of the Genii*. Later, he carried these fantasies into his adult experience: when he moved to a house in London in March 1782, he spoke of his "caravans" from Fonthill laden with furniture, and he was flattered by his neighbor in Portman Square, the countess of Home (who also had immense possessions in Jamaica), who looked upon him "as a West Indian potentate."

Like most upper-class youths of the period, Beckford was also stimulated by his reading of MacPherson's *Ossian*, whose ghostly beings, gloomy landscape descriptions, and pseudoscientific allusions fused with his grandiose visions of the East. When he was sent to Switzerland to complete his education in 1777, Beckford's encounter with Alpine scenery meshed with his mental image of the Ossianic landscapes. This experience helped bring out his literary talent; he began his first important manuscript—now called *The Vision*—which opens with a description of the moon's illumination of rugged Alpine cliffs. Thereafter, the moon becomes his symbol for imagination, irrationality, and the utopian promises held out by science. In the story, the lunar orb is a magnetic force that lures the narrator-author through an Ossianic world in his quest for knowledge. He is led through a series of natural marvels including searing flames, eddying whirlpools, and a subterranean realm where he comes upon crystalline caverns, grottoes, labyrinthine passages, and golden landscapes of groves, island, and lakes.

For the details of his story he drew upon his training in Switzerland under distinguished naturalists, geologists, and astronomers. In Geneva, he became the friend of Saussure and studied natural sciences in the laboratory of M. d'Espinasse, a former tutor of young George III. He investigated electrical phenomena and learned to use a telescope—the start of his lifelong interest in astronomy. Hence his descriptions of the moon, meteorological events, and exotic topography in his early writing were based on the scientific knowledge he acquired from those who were making major contributions to contemporary natural science.

The Vision is also significant for Beckford as a forerunner of his famous Oriental tale *Vathek*, a Near Eastern extravaganza compounded of ideas from MacPherson's *Ossian*, Ridley's *Tales of the Genii*, and the *Arabian Nights*. The

hero is a caliph of vast fortune and ambition who uses his wealth and authority to indulge a taste for excess. He builds five sumptuous palaces to gratify each of his senses, and his Faustian passion to master all knowledge—even "sciences that did not exist"—impels him to construct an immense tower of fifteen hundred stairs to "penetrate the secrets of the heavens."[40] From his pinnacle he gazes rapturously at the moon and studies the positions of the stars and planets. When he surveys the world below he is filled with a sense of grandeur and dominance, a feeling only momentarily deflated when he looks up again and sees the celestial bodies still beyond his grasp.

Everything about Vathek is large scale; he owns a dazzling art collection, surrounds himself with an army of slaves, male and female, and keeps eunuchs and dwarfs for his entertainment and personal needs. Passages describing architectural settings are Miltonic and Dantesque in their proportions: Vathek and his mistress Nouronihar approach a site that, though roofed with a vaulted ceiling, was so spacious and lofty that at first they took it for "an immeasurable plain." Ultimately, they enter the Halls of Eblis in which endless caverns are divided by thousands of massive columns into stately halls "all without bounds or limit," diminishing into a vanishing point "radiant as the sun."

There is no doubt that the story of the over-indulged and vastly wealthy young caliph abandoning himself to the pursuit of sensual pleasure and worldly knowledge was based on Beckford's own experience and fantasies. A Christmas party he organized at Fonthill in 1781 provided the immediate stimulus to the writing of *Vathek*, executed under the influence of "all that passed at Fonthill during this voluptuous festival." He had hired de Loutherbourg to arrange the lighting and scenic effects which inspired the description of the fantastic Halls of Eblis. Among the guests was Samuel Henley, who transcribed Beckford's tale, edited it, and prepared it for the press. Henley was headmaster at the East India College, which emphasized Oriental studies and helped prepare upper-class youth for service in the colonial administration. Beckford must have had his own colonial interests in mind when he makes Vathek call for "the Koran and sugar" while reciting his prayers.

Perhaps Beckford came closest to his hero in the construction of a massive neo-Gothic abbey for his seat at Fonthill. Begun at the end of 1796, its completion spanned the period of the Napoleonic wars. In the center of this

building an octagonal chamber was erected—the loftiest space in any private dwelling in the world—rising to a height of 128 feet, while above this octagon, crowning the whole edifice and dominating the countryside, rose a great tower measuring 275 feet high. This eminence represented a real-life attempt to actualize the fantasy of Vathek's tower of fifteen hundred stairs. As the buildings stood on the topmost point of the estate, the upper views gave an impression of limitless distance and heightened the sense of total control of the outer world. Near the octagonal interior Beckford located two large drawing rooms which he crowded with his unique art collection and costly furniture. Like Vathek, too, he had at his beck and call a troop of servants, including a dwarf named Piero.

Fonthill Abbey was the central feature in a monumental plan to transform the 519 acres of natural landscape that belonged to the estate. Throughout the Napoleonic period Beckford organized his extensive property, planting a million trees, both timber and fruit-bearing, laying out broad avenues, opening vistas, cutting paths in the dense woods, and creating a twenty-seven-mile ride encircling the entire estate to provide for the scenic points of view. He often took personal charge of the hundreds of laborers who even worked at night by torchlight to realize his vision of a "picturesque garden composition."

This need to subjugate the terrain—both in terms of the drastic reorganization of the grounds and the commanding edifice—is tied to fantasies of power generated by real power in the world. Beckford called his property his "plantations," as if by extension they were part of his colonial domain. This capacity to dominate persons and land lies behind Beckford's fascination with landscape painting. As it shall be made clear, the innovations of landscapists like de Loutherbourg, Turner, Martin, and Constable were encouraged by landowning aristocrats like Beckford who expressed their fantasies derived from property through the new landscape forms. It is not surprising to learn that Beckford spent most of his spare time in this period working out his lines of descent, or that the main decorative schemes of Fonthill Abbey illustrated the noble families from which Beckford claimed descent. The eastern wing was designed to commemorate his descent from all the baronial signatories of the Magna Carta of whom many descendants still lived at the time of the erection of the abbey. Naturally, the Napoleonic wars infused Beckford's obsession with patriotic feelings: already by December 1800

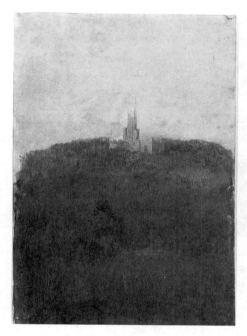

3.12 Joseph Mallord William Turner, *Fonthill Abbey at Sunset*, 1799, watercolor, Fonthill Sketchbook 57. Tate Gallery, London.

Beckford was hosting Lord Nelson, then the hero of the Nile, with a lavish ceremonious welcome in the incomplete building. Upon Nelson's arrival, the band struck up "Rule, Britannia," and the day's proceedings closed with the playing of "God Save the King."

In view of Beckford's vast expenditures for art and decoration it is understandable that his patronage was something to be sought after, and he often received letters from people anxious to be allowed to share in the embellishment of Fonthill. Sculptors, painters, and landscape gardeners all offered their services. But the clearest indication of his taste is his choice of de Loutherbourg, Turner, and Martin to either decorate or design landscapes featuring his own seat of Fonthill Abbey. Turner stayed at Fonthill for three weeks in 1799, and during this time he prepared a series of studies for five watercolors of the abbey set in the remote distance of the surrounding countryside. One study anticipates Turner's later works in locating the mansion on a curving horizon near the center of a circular movement formed by the densely foliated foreground planes, the clouds, and the light and dark pattern (fig. 3.12). The building itself is almost entirely suffused by sunlight, an effect he gained from studying the works by the seventeenth-century French master, Claude Lorrain, that were recently acquired by Beckford.[41] Claude was a favorite of the British ruling class, who used his Italianate landscapes with classical ruins as models for their rolling gardens and estates. Claude himself celebrated a mercantile world in his port scenes, while his rural evocations almost always indicate the hand

3.13 Claude Lorrain, *Landscape with Cattle and Peasants*, 1629. George W. Elkins Collection, Philadelphia Museum of Art, Philadelphia.

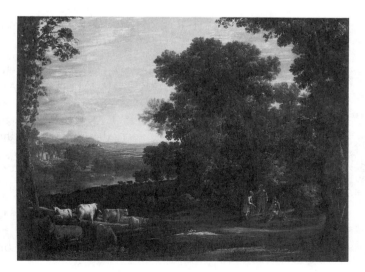

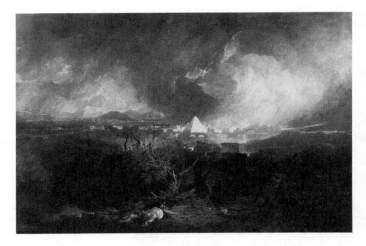

3.14 Joseph Mallord William Turner, *The Fifth Plague of Egypt*, exhibited 1800. Indianapolis Museum of Art.

of the villa architect and gardener. His work invariably shows a shepherd and shepherdess winding their way with their herd or flock on a carefully arranged path leading us through the composition (fig. 3.13). Claude's figures, which his contemporaries claimed were painted by others and which he himself claimed to give away for "free," play a critical function in guiding the eye and setting out the perimeters of aristocratic control. Turner's *Men with Horses Crossing a River* (ca. 1806–1807, Tate Gallery, London) discloses this compositional precept as a device to transform property into a visual pastorale. In addition, Claude's mature use of dazzling sunlight to bind together his various landscape devices captivated Turner and set the standard for his lighting techniques. Above all, however, it must be emphasized that the major impetus to Turner's novel effects was the personal taste and ideological needs of his benefactors.

In the same period Turner executed for Beckford his first major history picture, *The Fifth Plague of Egypt,* exhibited at the Royal Academy in 1800 (fig. 3.14).[42] The following quotation from Exodus 9:23 accompanied the work: "And Moses stretched forth his hands toward heaven, and the Lord sent thunder and hail, and the fire ran along the ground." Curiously, both the title and the quotation were incorrect: the picture represents the seventh plague, that of hail and fire, and not the fifth, which was the murrain (like hoof-and-mouth disease) of cattle, and in the Bible the verse states that Moses stretched forth his rod and not his hands. Whatever the reasons for these errors, Beckford and Turner chose the one plague that related to meteorological

phenomena which, as we have seen, had such a fundamental appeal to painters in this period. As in the case of *Hannibal,* Turner used storm effects he observed in the countryside—confirmed by the anomalous glimpse of a slice of English topography in the far distance. As rain and hail sweep down on the land, ominous flashes of lightning dart across the raging sky and illuminate the central pyramid and the dying people and animals in the foreground. Once again, Turner deployed his central motif—in this case the brightly lit pyramid—in the center of a vortex. It is likely that he drew his immediate inspiration from verses in James Thomson's *The Seasons,* an epic nature poem interspersed with patriotic allusions to Great Britain and its famous citizens:

> Down comes a deluge of sonorous hail,
> Or prone-descending rain. Wide-rent, the clouds
> Pour a whole flood; and yet its flame unquench'd
> The unconquerable Lightning struggled through,
> Ragged and fierce, or in red whirling balls,
> And fires the mountains with redoubled rage.
> Black from the stroke, above, the smouldering Pine
> Stands a sad shatter'd trunk; and, stretch'd below,
> A lifeless group the blasted Cattle lie.[43]

Turner worshipped the chauvinist Thomson, whose "Rule, Britannia" was sung by every English schoolboy. Thomson's influence on *The Fifth Plague* may be understood in the context of Turner's patriotic statement about the aftermath of the encounter between Admiral Nelson and Napoleon's fleet in the bay of Aboukir. *The Fifth Plague* was actually begin in 1799, the year in which Turner exhibited his *Battle of the Nile.* Turner now cast the disastrous Napoleonic campaign into a biblical guise, showing Moses as an Anglophile prophet wreaking vengeance on the land of the pharaohs, where Napoleon had the temerity to address his troops before the battle of Cairo: "Soldiers, forty centuries look down upon you from the summit of the pyramids." But the French subjugation of Egypt lasted for only a brief period: the French were besieged in 1799 by terrible climactic conditions, pestilence, murderous assaults from the English and the Turks, almost as if they were being visited by the series of biblical plagues. While the French occupation of Egypt dragged on for two more miserable years, their untenable position was made apparent during the fateful year of 1799.

The commission, for which Beckford paid the young

artist the astonishing sum of 150 guineas (one guinea = app. $10.50 at present), takes on fresh meaning when we recall that in 1800—the year in which the picture exhibited at the Royal Academy—the patron played host to Admiral Nelson in a dazzling ceremony at the still incompleted Fonthill Abbey. The occasion celebrated Nelson's victory of the Nile, and arrangements had been made for all the people in the area to play their part in the welcome given to him. The Fonthill volunteers turned out to give an air of military pageantry to his reception, and their band of thirty performers, specially selected by Beckford himself, greeted Nelson with Thomson's "Rule, Britannia," the well-known refrain of which is "Rule, Britannia, rule the waves, / Britons never will be slaves." Hence *The Fifth Plague,* already in Beckford's possession by April 1800, equates Moses with Nelson, who tells Pharaoh-Napoleon, "Let my people go."

At the same time, Turner's panoramic vision, which centers on the pyramid lit by lightning flashes, may be seen as the analogue to Beckford's vast family estate at the center of which stood an equally massive, equally exotic structure. As in Turner's watercolors of Fonthill Abbey, the circular swirl of the composition has as its target a dominating architectural feature. Beckford employed hundreds of workers to erect his neo-Gothic fantasy, especially during the feverish period of 1799–1800 when building went on without intermission night and day. In his ability to command men and land he even reminded himself of ancient despots. Beckford's extensive landholdings remind us that a few thousand landlords controlled over half the land in Great Britain. It is a short step from this to an understanding of contemporary fantasies about dominance over all nature. The other side of the catastrophic visions so prevalent in the period is the attempt to give tangible embodiment to uncontrollable forces and therefore to govern them. To a large extent this was accomplished in reality by adventurous agricultural techniques and the use of machinery. Moses' power to control the forces of nature to bring about a desired effect expresses the landowner's wish to maximize the land potential for profit during all seasons of the year. At Fonthill, dominance over both landscape and the law of gravity required the complex operations of a factory. Beckford himself referred to the operations as the "Wheels of a great Machine," including the erection of a new village of temporary cottages near the estate gates to accommodate the great influx of workers. It may not be coincidental that

John Ruskin, the famous Victorian critic who championed Turner, noted that the pyramids in *The Fifth Plague* "look like brick kilns, and the fire running along the ground like the burning of manure."[44]

Turner and the Aesthetics of Property

Turner's fundamental landscape development unfolded in the context of his patrons' desire for visualizations glorifying both their complex relations to property and historical or regional sites bearing upon their ancestry. English landscape painting in general emerged as an offshoot of topographical drawing or images of real estate and the self identified with ownership and property.[45] Originally, topographical drawing had been considered as a kind of adjunct to military mapmaking and surveying, and this practice was still influential in Turner's youth. Turner's early friends included William Alexander, William Delamotte, and W. F. Wells, all of whom taught landscape and topographical drafting to army cadets. Later, topographical drawing referred to maps decorated in the margins with local historical sites and well-known estates; from this it developed into the equivalent of the postcard or snapshot, ordered by patrons who wanted the portrait of places at home or abroad (and often of themselves in those places) to exemplify their social status. In 1774 Josiah Wedgwood's talent for flattering the vanity of aristocratic clients induced Catherine the Great of Russia to commission a ceramic tea service of 952 pieces, each of which carried a different English view. Among these were the stately homes of the aristocracy. The London exhibition of the tea service prior to its shipment to Saint Petersburg stimulated some fresh thoughts on the relationship of landscape to topographical, bird's-eye views.

During Turner's youth, the rage for illustrated topographical works provided employment for aspiring artists. The speculations of the print publishers enlarged the print-buying public, while the demand for local history further amplified the market. Turner began by copying topographical watercolors of Paul Sandby—who began his career as a military draftsman—which were displayed in the Turner barbershop and sold for one to three shillings. The watercolor medium, closely connected to the expanding market for topographical art, became a distinctly English specialty. Sandby meant his work to be cheap and attractive to buyers, and went beyond the sparse tints of his predeces-

sors. Watercolor effects, most brilliant when executed rapidly, were the answer and hence became increasingly popular. Turner's father, anxious to exploit his son's commercial potential, pushed him to devote full time to watercolor copies, allowing him to take to the fields when only eleven or twelve years old to sketch old towers and steeples, churches, and miscellaneous views which he then displayed in his shop window. The earliest works attributed to Turner are the watercolor tints on engravings in a copy of Boswell's *Antiquities of England and Wales* (1786), for which he received a fee of twopence each. He applied strong effects of lighting and weather, and broad, richly colored washes to enliven the rather dull images.

Turner attended the drawing school in St. Martin's Lane, where Sandby taught, and at the same time colored prints for a printseller named John Raphael Smith in the same street. Through Smith he encountered Thomas Girtin, two months older than Turner, who also made a living coloring prints. Both also worked closely with local topographic draftspersons (known as "geographic artists") and touched up architects' drawings by adding skies and backgrounds. Turner's father then sent the budding artist to Thomas Malton, an architectural draftsman and master of perspective, who kept a school at his home in Long Acre. By this time, Turner was making a good living embellishing architectural designs, and his father took a healthy cut of the profits. Several architects in the period employed the boy to wash in blue skies, while Malton taught him to put in backgrounds to architectural drawings. Even in this period Turner regarded his work as a business, and looking back at his rivalry with Girtin, who died at twenty-seven, he told a colleague, "Had Tom lived I should have starved."[46]

Another lucrative source of income for Turner was the topographical view that could be reproduced as an engraving. These were popular both as periodical illustrations and in the form of luxurious folios comprising a series of prints grouped under such titles as *Picturesque Views of the Antiquities of England and Wales* and *Select Views of Gentlemen's Seats*. Although Turner began this work in his youth, he practiced it throughout his life and, to a large extent, owed his wealth and reputation to the vast number of his works that were circulated in reproduction, both as separate prints or as engravings in book and magazine form.

Turner's extraordinary output had to do with his practice of making sketching tours for patrons, going on his first when he was sixteen. These early sketches did not

cover his costs, and he was forced to develop a broader, quicker technique to increase his production and make a profit on the tours. Thus it may be said that his "masterly" technical approach was conditioned by the economic necessity of making ends meet. This evolution was facilitated by his contact with Dr. Thomas Monro in the 1790s, who hired him to draw in his house in the Adelphi complex during the evenings. Monro, an unscrupulous physician who treated the mentally ill, had been one of the physicians to George III and practiced at the Bethlehem Hospital. One of his patients was the landscapist John Robert Cozens, a protégé of Beckford who had accompanied the patron on a tour through Italy and Switzerland. Monro had no expectation of Cozen's recovery and gained possession of a number of his incomplete drawings and compositions. These he had loosely copied and then completed by aspiring artists like Turner and Girtin, who worked from 6:00 P.M. to 10:00 P.M. each evening.

Monro's curious arrangement and his relationship with his young employees has not been adequately investigated.[47] It has been claimed that the "Monro School" was run out of generosity, the good doctor encouraging young artists by giving them paid assignments. He eventually allowed Turner three shillings and sixpence each night, but the elder Turner had complained bitterly when his son was executing drawings for Monro "for half a crown." It is not certain whether the raise of one shilling was due to his father's agency, but it seems unlikely that the father would have complained about his son's wages if he were indeed a student in a "benevolent academy." Rather, it appears that the venal Monro exploited his draftsmen for monetary gain, a possibility evident in the division of labor. Girtin and Turner, for example, worked as a team, with the former drawing in the outlines and the latter washing in the effects. This is not a sound pedagogical approach, but it makes sense if we see Monro's evening arrangement as a kind of drawing "manufactory." The copies of Girtin and Turner, or more correctly, variations of drawings and views, possess a drama of lighting, a richly colored surface, and lively handling that is often strikingly different from the originals.[48] Thus Cozen's precise style was not the aim of the copies but rather a point of departure in the way of providing motifs.

Another case of the specialization of labor in the workshop related to Monro's assigning of topographical drawings executed with the aid of a camera obscura to his artists

to develop lighting, color, and meteorological effects. Monro's friend, Thomas Hearne, whose *Antiquities of Great Britain* was illustrated with plates based on camera obscura designs, provided him with outline sketches that were traced by the students and elaborated with color and wash effects. These embellished studies could have facilitated the engraver's task. We may conclude that Monro was not only collecting these reproductions but also profiting from the copying and execution of topographical views, colored prints, and facsimiles of old and new master drawings in his private collection. Not surprisingly, Monro was closely associated with John Raphael Smith, the printseller and engraver who first employed Girtin and Turner in a similar capacity and distributed prints of Cozen's landscapes.[49]

The Influence of Commercial Topography on Turner's Technique

Turner's involvement in topographic recording and its dissemination influenced his novel techniques. At Monro's, he learned to develop an approach consonant with the division of labor in the factory and the notion that "time is money." When joined with his businesslike attitude toward art, we find that Turner was a true child of the Industrial Revolution. His original methods were aimed at a particular market and kept pace with the changing taste. He scratched and scraped, took out lights from masses of color with bread, used palette knives, repeated washings to achieve a variegated texture, stippled, and flung paint all in order to produce rapidly and at the same time attain novel and brilliant effects. His mature development reflected the transference of these audacious techniques learned from his topographical practice to the domain of "high art." this transition was made possible by wealthy patrons who wanted unique presentations of their country seats. Ruskin observed among his hero's early sketches a large number of "gentlemen's seats."[50] These included the transcription of Beckford's Fonthill House for William Angus's album entitled *The Seats of the Nobility and Gentry in Great Britain and Wales,* which praised the estate as "one of the grandest Masses of Wood and Forest Scenery in *England*"(fig. 3.15).[51] The painter dressed up topographical views in poetic and "historical" guise, dramatizing the landscape with meteorological and lighting effects normally reserved for history painting. His experience as an architectural draftsman and view sketcher developed in him a strong sense for schematic,

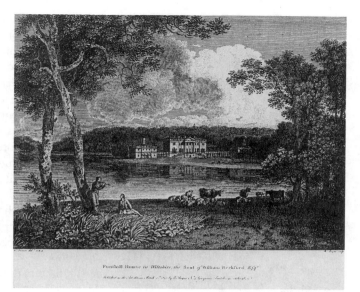

3.15 Joseph Mallord William Turner, *Fonthill House*, 1800. Etching in W. Argus's *The Seats of the Nobility and Gentry in Great Britain and Wales*, 1787–1811, plate 50.

non-naturalistic color masses, briskly rendered in diagonal slashes, and dramatic illumination. By transforming topography into "high art," Turner extended the frontier of art production. But he accomplished this at the behest of patrons who perceived in his exaggerated distances, soaring heights, and audacious techniques the equivalent of their extended ambitions and privileged possibilities.

These connections guaranteed the painter rapid progress in his career. He entered the classes of the Royal Academy as a precocious fourteen-year-old in 1789, exhibited his first work, a watercolor, at the academy in 1790, and nine years later when he was made associate of the academy, became the youngest artist ever elected to that institution. The same year (1799) he received commissions from William Beckford, the duke of Bridgewater, Sir Richard Colt Hoare, and John Angerstein of Lloyd's of London, who generously paid Turner forty guineas more than he asked for a drawing.

The Great Landowning Patrons

It may be recalled from volume 1 that Francis Egerton, the third and last duke of Bridgewater, had amassed his fortune from coal mines at Worsley, Lancashire, and from his canals which ran from Worsley to Manchester and from Manchester to Liverpool. He was both a major landowner and an industrial entrepreneur. He also used his wealth to

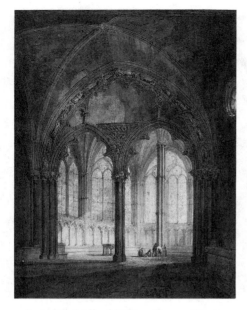

3.16 Joseph Mallord William Turner, *Chapter-House, Salisbury*, 1801, pencil and watercolor. Victoria and Albert Museum, London.

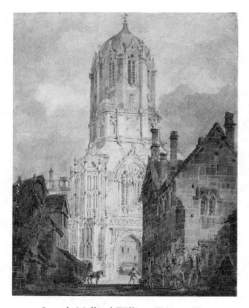

3.17 Joseph Mallord William Turner, *Tom Tower, Christ Church, Oxford*, c. 1793, pencil and watercolor. British Museum, London.

collect and invest in art; with two partners he purchased the Orleans collection—one of the finest in the world—put up for sale in London in 1798. The syndicate bought the collection for 50,000 pounds, kept the best of the pieces, and sole the remainder for 70,000 pounds. Among the works kept by the duke was *A Rising Gale,* painted by the Dutch seventeenth-century artist Willem van der Velde the younger. Dutch art, with its perennial high market rating, as well as its Protestant and seafaring associations, was a favorite of the English aristocracy. But the duke of Bridgewater's special interest in canals and dependence on maritime trade provided an added rationale for his taste. Turner, who resided in the duke's mansion in 1799, was commissioned by him to paint a companion piece to van der Velde's picture, *Dutch Boats in a Gale: Fishermen Endeavoring to Put Their Fish on Board.* Known also as *The Bridgewater Seapiece,* it flatters the patron's taste by using one of his favorite old-master works as the springboard for a contemporary painting. Turner created a pictorial drama by showing the impact of the meteorological elements of wind and water on human beings who must earn a precarious living coping with these elements.

Sir Richard Colt Hoare, the historian of Wiltshire, descended from a prominent banking family ruled by his grandfather Henry Hoare, one of the major collectors of neoclassic art.[52] Sir Richard shared the historicist interests of many recently ennobled persons eager to demonstrate their links with older established families. He spent much of his time tracing the pedigrees and memoirs of the Hoare line, and developed a deep interest in the history and antiquities of the region of his country seat at Stourbridge, Wiltshire, publishing the *Ancient History of North and South Wiltshire.* He commissioned Turner to execute eight large watercolor views of Salisbury Cathedral in the county seat of Wiltshire (fig. 3.16). Here we see also an early manifestation of the nostalgia for the Gothic so eminent among painters traditionally characterized as "romantic." This nostalgia rears its head in the context of the dual revolution: the Industrial Revolution brought on a wave of nostalgia for the handicraft system of the Middle Ages, while the French wars and the internal dissent they fomented gave rise to memories of a healthy, harmonious, and stable medieval society. Turner's delight in the carved tracery and the shadowy, lofty interiors imparted to these watercolors a touch of the sublime.

It was precisely through contemporary aesthetic cate-

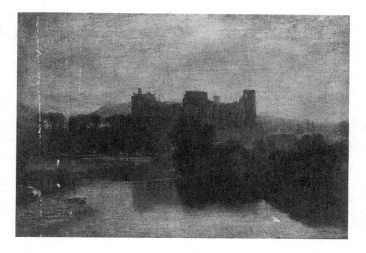

3.18 Joseph Mallord William Turner, *Cockermouth Castle,* exhibited 1810. HM Treasury and the National Trust (Lord Egremont Collection), Petworth House, Sussex.

gories like William Gilpin's "the picturesque" and Edmund Burke's "sublime" that Turner could reach his patrons.[53] The eighteenth-century concept of the picturesque related to the idea that nature copies art, that the capacity to discover a site in nature worthy of the subject of a picture was the mark of the enlightened artist and connoisseur. Such an experience supposedly uplifted one's soul—that is, the soul of the trained observer. For Turner and his patrons this meant translating topographical drawing, especially of regional sites, into the realm of fine art. The highest level of this transformation took the form of the sublime, a category dealing with a larger magnitude of phenomena and often associated with awesome, astonishing, or dangerous events in real life. When this mood or state was converted

3.19 Joseph Mallord William Turner, *Raby Castle, the Seat of the Earl of Darlington,* exhibited 1818. Walters Art Gallery, Baltimore.

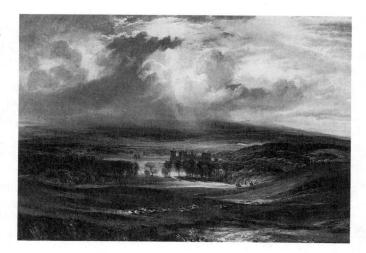

into a pictorial image and displayed in a danger-free zone, the spectator could derive pleasure from it. Turner's progress in topographical views demonstrates his transition from the picturesque views of quaint villages, ruins, and castles to sublime views of cathedrals and country seats (figs. 3.17–19).

Turner and the Concept of the Picturesque

Turner's approach was nourished by theories of landscape gardening founded on the notion of the picturesque. This category of aesthetic appreciation formed part of upper-class British taste and was treated according to specific rules of composition that insured varied and broken surfaces and dramatic use of chiaroscuro. The standard of upper-class taste was mainly concerned with landscape, ultimately derived from the practice of landscape gardening for the rolling estates of the wealthiest 5 percent of the population.

The great landowners dominated Parliament during Turner's youth; the House of Lords exercised a far more controlling influence than in the present and consisted almost exclusively of the landowning peers. They dominated even the House of Commons, since members of the lower house were often relatives of the peers and frequently their elections were financed or rigged by the aristocracy. Landownership formed a kind of pyramid, spreading out from the nobility and contracting to the smallest yeoman farmer. Although the largest proprietors were not a totally closed social class, only the most able and ambitious were ever permitted to break in on the established circles of the aristocracy.

Their taste in landscape—represented and actual—traced the trajectory of economic, political, and social change. Following the Seven Years' War, such prominent neoclassical collectors as Edwin Lascelles of Harewood House (who made his fortune in Barbados), Henry Hoare, and Thomas Coke II of Holkham employed the ingenious landscape gardener, Lancelot ("Capability") Brown, to design their estates as real-time versions of the classicizing landscapes of Claude Lorrain and Nicolas Poussin as backdrops for their mansions and collections. William Mason's poem, *The English Garden,* first published in 1772, admonishes the devotees of the Grand Tour to register the Italian scenes that inspired Claude and whisk them "back to Britain; there give local form / To each Idea, and if Nature lend

/ Materials fit of torrent, rock, and shade, / Produce new Tivolis."[54] They attempted to recreate the Italianate scenery of Claude on English soil, and it was inevitable that they would encourage homegrown artists to rival the seventeenth-century French master. By the end of the century, Lascelles' descendant and the younger generation of great landowners were commissioning Turner to record their country seats in a style contradictory of the Brown approach, which organized the landscape on a central unity whose focal point was the house itself. Brown's improved version of the English countryside, which eliminated unsightly blemishes and emphasized attractive features, eventually gave way to the picturesque model, which insisted on the indigenous site with its rough edges and broken silhouettes.

The writer most closely identified with the idea of the picturesque is William Gilpin, who made it the heart and soul of his aesthetic doctrine and elaborated it throughout his lifetime.[55] Gilpin was ordained an Anglican priest in 1748, and his concept of the picturesque carries with it moral and didactic significations for the upper classes, whose taste it decisively affected. The picturesque is more than a category of aesthetics, it represents a frame of mind open to the changing nature of the countryside and especially its nonsmooth, irregular features, which place it outside the realm of the conventionalized beautiful. Nor is it a subcategory of the Burkean sublime, which influenced it but which it attempts to rival; images of the terrifying and the painful are embraced in the pleasures of seeking, anticipating, discovering, and recording the unknown and unexpected. The picturesque was a kind of beauty appropriate for a pictorial rendition of nature, but in this Catch-22 formulation it is clear that Gilpin's ideas of what was appropriate for a picture were classbound and timebound. The picturesque actually consisted of an amalgam of his personal preferences for roughness, ruggedness of texture, singularity, variety, irregularity, and chiaroscuro.

While it might seem from this preference that Gilpin allowed for the rough-and-ready world of everyday life, his preferred aesthetic qualities actually derived from a disdain for the "modern" whose commonality contradicted his notion of the picturesque. He rejected figures in modern costume because they introduced a note of vulgarity; in a letter of 20 December 1791 Gilpin confessed that he hated "all *vulgarity* of form," including contemporary fashion, modern utensils, and all familiar things.[56] For him painting was

"a kind of poetry" that excluded vulgarisms. The seeker of the picturesque finds it in inanimate objects as well as in humans and animals, but he would exclude the "appendages of tillage" and "dressed-out" figures. Indeed, in grand scenes "the peasant cannot be admitted, if he be employed in the low occupations of his profession: the spade, the scythe, and the rake are all excluded."[57] In this sense, moral and picturesque ideas contradict each other; from a moral perspective cultivation is pleasing, but to the "picturesque eye" it is disgusting. This is true also of figures actually engaged in work: "In a moral view, the industrious mechanic is a more pleasing object than the loitering peasant. But in a picturesque light, it is otherwise. The arts of industry are rejected; and even idleness, if I may so speak, adds dignity to a character. Thus the lazy cowherd resting on his pole; or the peasant lolling on a rock, may be allowed in the grandest scenes; while the laborious mechanic, with his implements of labour, would be repulsed."[58] But if he allowed indolent workers under certain conditions, that is, those types whose importance derived "merely from not mixing with low, mechanic arts," Gilpin argued that they were at best "only *picturesque appendages*." They were essentially of a negative nature, used only to embellish a scene that is unaffected, one way or another, by their presence.[59]

Gilpin's perspective is that of the dilettante writing for an audience of "gentleman-artists." Returning to London after his "picturesque" tour of northern England, he came face to face with

all those disgusting ideas, with which it's [*sic*] great avenues abound—brick-kilns steaming with offensive smoke—sewers and ditches sweating with filth—heaps of collected soil, and stinks of every denomination—clouds of dust, rising and vanishing, from agitated wheels, pursuing each other in rapid motion—or taking stationary possession of the road, by becoming the atmosphere of some cumbersome, slow-moving waggon—villages without rural ideas—trees and hedgerows without a tinge of green—and fields and meadows without pasturage; in which lowing bullocks are crowded together, waiting for the shambles; or cows penned, like hogs, to feed on grains.—It was an agreeable relief to get through this succession of noisome objects, which did violence to the senses by turns: and to leave behind us *the busy hum of men*.[60]

In this remarkable passage of the influential writer we see the profound connection between his social views and his philosophy of the picturesque. The picturesque states in

visual terms the ideal of social relations projected by the elite landowners and their acolytes. Work is proscribed from this world, though the proprietors live off it, and when the landless laborers are depicted their existence has to be shown almost as idyllic as those of the landed elite. Toilsome work and drudgery must be masked to conceal the reality of the material existence in the countryside, that real leisure was exclusively reserved for the landowners and implied total freedom from having to work for a living and the unlimited opportunity to travel through the countryside searching for picturesque views.

Gilpin's sermons for his humble parishioners castigated idleness and stressed the need for hard work, but in his aesthetic system he distinguished between the moral and the picturesque.[61] Art was primarily an upper-class pursuit that aimed at eliminating the trivial and vulgar—the signs of the everyday world proclaiming alterations of the economic structure and the transition from a rural society to an urban one. Gilpin's discussion of the vagaries of landscape change due to times of day and weather is followed immediately by one about the barbarities of human intervention, "inclosures—canals—quarries—buildings—and above all, from the growth, or destruction, of timber."[62] He moaned the fact that the history of the past he recorded in his sketches is no longer representative of the present. He even referred to the woods belonging to Lord Egremont (the father of Turner's patron) as an example of the destructiveness to the landscape; the proprietor allowed the timber merchant to lay the whole flat, which prevented fresh growth. It was especially the market-oriented agriculture that disturbed Gilpin and motivated him to flee its effects.[63]

Gilpin's understanding of the picturesque is fraught with contradiction betraying his anxiety about rural change. Despite his insistence on the links between the picturesque and the natural peculiarities of the site, the "gentleman-artist" has the right, nay the duty, to transform it in conformation with the rules spelled out by Gilpin. For example, a marvellously picturesque scene of water, rising ground, and woody banks may be marred by the presence of a castle whose regular towers and turrets display no variety of line. The artist should then introduce only a part of the castle near the corner of the picture, and cut down a section of the woods on the opposite bank of the river. Gilpin had no difficulty in identifying the artist with the landed proprietor, for he stated that just as wood in fact is periodically cut

down, so the artist has the liberty to eliminate trees for his scene of the picturesque and occasionally "plant a tree or two on the foreground." He justified this "liberty" through the observation that nature excels art in every category except for composition, "the life of scenery." Thus the landscapist "may certainly break an ill-formed hillock; and shovel the earth about him, as he pleases, without offence. He may pull up a piece of awkward paling—he may throw down a cottage—he may even turn the course of a road, or a river, a few yards on this side, or that." [64]

The art of constructing castles in landscape, and of adapting landscape to castles, is rarely demonstrated in actuality. Ruins are infinitely preferable, and if need be the artist should make "ruin" of the edifice to enhance its picturesque relevance. When discussing Tintern Abbey (part of the estate of the duke of Beaufort), Gilpin praised the site as well as the "noble ruin," but noted that the gable ends "hurt the eye with their regularity; and disgust it by the vulgarity of their shape." He suggested that the judicious use of a mallet to fracture some of them would be of service, particularly those of the cross aisles, "which are both disagreeable in themselves, and confound the perspective." [65] Born in a castle himself, Gilpin fantasizes about the feudal world of "merrie Olde England" that can be evoked nostalgically only under prescribed conditions.

The landscapist of the picturesque functions analogously to the landed proprietor who alters his grounds in conjunction with a landscape architect. Even Brown's aim was to forge a landscape that would "be exactly fit for the owner, the Poet, and the Painter." [66] He often planted a belt of trees around the perimeter of his client's parks to insure that all the land visible from the house belonged to the owner's domain. This act of screening the outside world out of existence is analogous to the escapist fantasies of Gilpin, whose ideas caught hold toward the end of the century. Thanks in good measure to his writings the educated classes were able to distinguish conceptually between the aesthetic and the economic aspects of property, but the great landlords had no intentions of devoting a major section of their acreage to a purely visual design. By invoking the idea of the picturesque they could maintain the irregularities of their natural surroundings at reasonable cost and even allow herds of deer and sheep to wander in the parks. This way the park could display both the taste of the owner and his good sense.

The picturesque came into common use only after Gil-

pin published the second edition of his *Observations on the River Wye, and Several Parts of South Wales, etc., Relative Chiefly to Picturesque Beauty* in 1789 and his popular *Three Essays,* printed three years later. These works stressed the term as the denotation of a specific visual quality linked with nature in an unkempt state, incorporating such unseemly natural objects as gnarled tree trunks, craggy rock formations, and swirling waters. They influenced two Herefordshire squires who owned extensive estates in close proximity to each other: Richard Payne Knight of Downton Castle, and his neighbor Uvedale Price of Foxley. Both were wealthy collectors and erudite minds who organized their estates in the picturesque mode. Their ideal landscape presented not only a natural but a wild and rugged aspect, such as would appeal to a painter. In 1794 Knight published a didactic poem entitled *The Landscape* (dedicated to Price), which set forth his ideas on the picturesque and condemned the tradition of Brown, while Price published his *Essays on the Picturesque,* which acknowledged the profound influence of Gilpin on his thought. The following year, Humphrey Repton, a middle-of-the-road landscape architect, published his *Sketches and Hints on Landscape Gardening* and dedicated it to George III. Repton, often hired by successful merchants who wished to emulate the neoclassical tradition, created a paper war by defending Brown, a defense he elaborated upon in his later *Inquiry into the Changes of Taste in Landscape Gardening* (1806).

Politics entered into this debate, with Repton sympathetic to the Tories and Knight and Price committed to the Whigs. Both Knight, an M.P. who represented Ludlow from 1784 to 1806, and Price were intimate friends of Fox and other leading Whigs. Their simultaneous attachment to the picturesque and opposition to the fashionable laying out of grounds may not be separated from their moderately liberal views. The domestic impact of the French Revolution raised basic questions about the nature of despotism and dissent, spreading alarm throughout the ranks of the dominant elite, who grew particularly frantic when the French peasantry began to burn their lord's châteaux and divide up the manorial lands. Tactically, the Tories and Whigs differed on how to meet the threat of the Revolution, but the Whigs at least insisted on the right of the French people to manage their own house. The picturesque, with its tame realism, was the cultural complement of Whiggish liberalism: it allowed for the unkempt character of the world which could no longer be maintained ide-

ologically as neat, smooth, and tidy, and even conveyed the sense of a native freedom through the rugged qualities of the untamed shrub and "savage pride" of the ancient forests. Indeed, Knight's poem of 1794 expressly associates the tyrannical control of the Brownian landscaping with royal metaphors such as "kings of yew [an evergreen shaped into geometric forms]" and "prim despots," while the natural countryside is the place "Where ev'ry shaggy shrub and spreading tree / Proclaim'd the seat of native liberty."

But Knight did not wish to relinquish control, only to exchange one kind of control for another:

May oft the place of nat'ral rocks supply,
And frame the verdant picture to the eye;
Or, closing round the solitary seat,
Charm with the simple scene of calm retreat.

Landscape gardening and landscape painting represented in a systemic way the ideology of possession and property. Both the actual shaping of the land and the two-dimensional representation of the shaped landscape pointed to the capacity of the landowner to exercise control over the countryside. This is why even some Tories came to identify with the picturesque; it appealed to their sense of change and allowed them a way to look "up-to-date" without giving up symbolic as well as actual domination.

This prerogative further manifested itself in the patriotic attachment to English land, whether "shaven" and "shorn" or left in its native state. All the landscape architects and upholders of the picturesque defended their point of view as the expression of their unwavering devotion to British soil. Gilpin declared that English landscape exceeds "most countries in the *variety* of its picturesque beauties"; although Switzerland, Germany, and other countries might surpass it in some specialized category, on the whole "it exceeds them all." Its peculiar, unrivalled advantage is its intermixture of wood and cultivation, created by the division of property by hedges. It is true that this combination appears unsightly close up, but "when all these regular forms are softened by distance—when hedge-row trees begin to unite, and lengthen into streaks along the horizon—when farm-houses, and ordinary buildings lose all their vulgarity of shape, and are scattered about, in formless spots, through the several parts of a distance—it is inconceivable what richness, and beauty, this mass of deformity, when melted together, adds to the landscape."[67] That this

love of British landscape could be linked to more chauvinistic sentiments is seen in Gilpin's record of a voyage along the coasts of Hampshire, Sussex, and Kent. Sailing up Portsmouth Bay in the first-rate vessel *Britannia* filled Gilpin's thoughts with visions "of the grandeur of Britain," and the sight of "so many of those vast machines, whose thunder had so often shaken every part of the globe," inspired him to list the ships and their victories.[68] Finally, in his poem "On Landscape Painting," published in *Three Essays,* Gilpin uses as an analogy for his notion of balance in pictorial design the "balance of power" England wields in world affairs:

> So when Europe's sons
> Sound the alarm of war; some potent hand
> (Now thine again my Albion) poises true
> The scale of empire; curbs each rival pow'r;
> And checks each lawless tyrant's wild career.[69]

Thus when Gilpin writes that "the province of the picturesque eye is to survey nature" and comprehend "an extensive tract at each sweep," we know that his aesthetic formulations are solidly grounded in private property rights and the political power that sustains them.

Turner's first patrons were readers of Gilpin, who describes their estates on his many tours: among them, Edwin Lascelles, Sir John Leicester, Sir James Lowther, and Lord Egremont. Turner's early patronage derived from the landowning aristocracy, who requested him to make topographical drawings, watercolors, and oils in the picturesque and sublime modes that enhanced specific places they visited or panoramic views of their residences. Already in 1799 Joseph Farington, the painter-diarist close to Turner and Constable, noted that "there is a sort of Landscape *Portrait* Painting by which a good deal of money is got, viz.: painting views of houses &c but where the picture will only be purchased for its intrinsic merit few will be found to command an income."[70] During the Napoleonic wars Turner continued to paint the real estate portrait, most notably the pair of pictures for Sir John Fleming Leicester, first baron de Tabley. Sir John, a close friend of Fawkes and Sir Richard Colt Hoare, was a Tory and an ardent nationalist who early offered his services to the crown when it was rumored that Bonaparte threatened to invade the country. Sir John raised a regiment of cavalry for the home defense called the King's Regiment of Cheshire Yeoman Cavalry. He translated his patriotism into the realm of art as

well, determining to promote the English school of painting. In 1805–1806 he helped found, with other aristocratic patrons, the British Institution for the Encouragement of British Art and held annual exhibitions of both old masters and current English works, with the stated goal of encouraging younger artists by providing an alternative exhibition space.[71] At the same time, it became a showcase for displaying old-master pictures in the sponsors' private collections and the latest works of their protégés. It also served to validate the taste of the founders, who were searching for new talent to convey their changing self-image. Turner

3.20 Joseph Mallord William Turner, *Tabley, the Seat of Sir J. F. Leicester, Bart.: Windy Day*, 1808. Tabley Collection, Victoria University of Manchester.

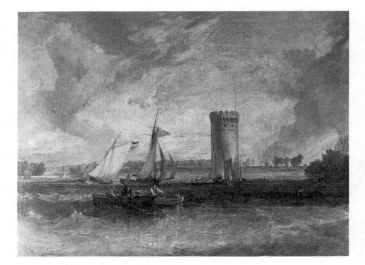

3.21 Richard Wilson, *Tabley House*, c. 1768. Private Collection.

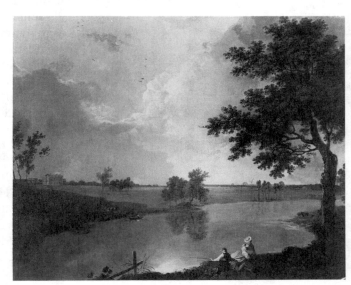

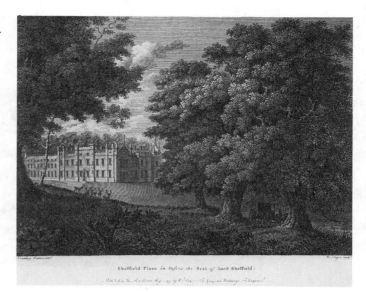

Sheffield Place *in Sussex, the Seat of* Lord Sheffield.

exhibited two oils at the opening show in 1806, and two years later the British Institution proudly displayed his *Battle of Trafalgar*.

Turner stayed at Tabley in Cheshire in the summer of 1808 to paint *Tabley, the Seat of Sir J. F. Leicester, Bart.: Windy Day* (fig. 3.20) and a companion piece for his patron, who already owned half a dozen pictures by the artist.[72] Tabley House was painted by a number of other artists besides Turner, notably Richard Wilson some forty years earlier (fig. 3.21).[73] A comparison of these two approaches to real estate portraiture conveys a sense of Turner's innovations. Wilson adopted a panoramic scheme but carefully guided the vista to the mansion with diagonals formed by the lawn leading to the house and the large tree in the right foreground functioning also as a scenic prop setting off fore- from background. While Wilson manages to capture the vast holdings of Sir John's great-grandfather, the placid calm and perspectival control differs only in degree from conventional eighteenth-century landscape. This approach visually complemented the Brownian organization of an estate, which focused on the solitary mansion house, thus arousing Knight's bitter denunciation of the "improver's desolating hand." The image of the lonely mansion surrounded by "shaven lawns" is seen in the plates of William Angus's *Seats of the Nobility and Gentry in Great Britain and Wales*, for which Turner supplied a drawing (figs. 3.22, 3.15).

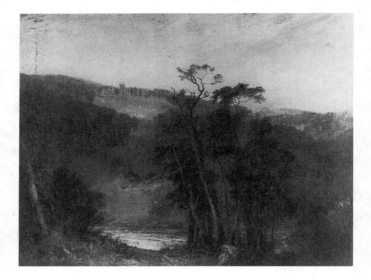

3.23 Joseph Mallord William Turner, *Lowther Castle, Westmoreland, the Seat of the Earl of Lonsdale: Mid-Day,* 1810. Private collection, England.

Turner's version of Tabley House, however, dispenses with traditional planar progression for regulating distance and seems to be entirely unconcerned with the house in the remote background. His point of reference is the old tower set off in the middle distance, and as in the *Bridgewater Seapiece,* the action of wind and water on several fishing boats. These crafts tilt and point to the isolated yet commanding tower, whose dominating presence is further accentuated by the clouds swirling around it. Pictorially, the house is placed at right angles to the tower and, although set back in the deep background, seems almost to be a structural outgrowth of it. As in the connection between Salisbury Cathedral and Sir Richard Colt Hoare, the crenellated tower here represents a stable element of tradition that functions as a buttress for the residence. Thus everything in the picture literally revolves around the looming structure. No wonder that one contemporary critic was struck "by the novelty of its effect," and another noted that what in anyone else's hands would have been "mere topography" here "assumed a highly poetical character." [74]

The success of this picture is in the Royal Academy exhibition of 1809 brought further orders for real estate portraits from the second earl of Lonsdale and the third earl of Egremont. William Lowther was created earl of Lonsdale on 7 April 1807, and the following year tore down the old residence of Lowther Hall and began building the "majestic pile" known as Lowther Castle. Next he launched into official life as junior lord of the admiralty. It is evident that he

wished to mark his social advances with a painting of his country seat, so recently secured. Turner painted two views of *Lowther Castle* from different positions and at two different times of day.[75] *Lowther Castle, Westmoreland, the Seat of the Earl of Lonsdale: Mid-Day,* exhibited in 1810, depicts the castle on top of a steeply graded slope, while at the bottom of the hill a clump of trees violently shoots up from the near foreground, dividing the lower half in two and reaching towards the still-unfinished residence (fig. 3.23). Again the normal perspectival controls have been abandoned, and the drama of the image almost totally overshadows the subject of the picture.

The Earl of Egremont

In that same exhibition, Turner showed *Petworth, Sussex, the Seat of the Earl of Egremont: Dewy Morning* (fig. 3.24). Sir George O'Brien Wyndham, third earl of Egremont, had begun his career as a Whig, but by the time Turner met him he had become more conservative, especially on domestic issues like Catholic emancipation. Lord Egremont had bought his first work from Turner the year he was elected to the academy, the first in a long series of exchanges which brought Turner into the intimate orbit of one of the largest landowners in England. He had a seat on the Board of Agriculture and was an eminently successful farmer and stockbreeder and a leader in experimental agriculture. His interests were vast, and one of the most spectacular sights

3.24 Joseph Mallord William Turner, *Petworth, Sussex, the Seat of the Earl of Egremont: Dewy Morning,* exhibited 1810. HM Treasury and the National Trust (Lord Egremont Collection), Petworth House, Sussex.

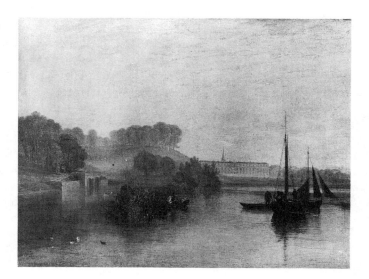

at his funeral was a procession of his four hundred laborers, who wore a special work uniform for the occasion.

According to Arthur Young, Lord Egremont established a reputation for his husbandry and land use.[76] He made various kinds of improvements and innovations at Petworth and introduced them into the neighboring region. He was loud in his commendation of *Dactylis glomerata,* or cocksfoot grass, considered valuable as a pasture grass in light soils because it thrived on cold, wet lands where oxen could never graze before. Young, however, also noted Egremont's conservative posture in opposing a reformer's suggestion to distribute land to the poor in 1801.

Turner's patrons were successful farmers, a class that did well during the Napoleonic wars. Especially before the Continental blockade, the increase in their wealth had been enormous. The vast accumulation of capital, as well as the increase of population in this period, told upon the land and forced agriculture into a feverish and abnormal prosperity. Wheat rose to famine prices, and the value of land rose in proportion to the price of wheat. Enclosures went on with prodigious rapidity; the income of every landowner was doubled, while farmers like Lord Egremont were able to introduce improvements into the processes of agriculture that changed the character of the countryside.

But if the increase of wealth among this class was great, its distribution was partial. During the fifteen years that preceded Waterloo, the population increased from ten to thirteen millions, and this rapid increase suppressed wages, which should have advanced in degree with the jump in the national wealth. At the same time, the introduction of machinery worked hardship on the cottage industry and impoverished the families who relied upon it for support. While labor was thus displaced from normal outlets (and driven to the Luddite revolts) and the rate of wages kept down at an artificially low figure by the jump in the population, the rise of the price of wheat, which brought wealth to the landowner, the farmer, the merchant, and the manufacturer, brought famine and death to the poor.

Lord Egremont's profits from these years enabled him to form a major art collection, most of which consisted of direct commissions from living artists. He enjoyed the work of innovative artists who, like himself, experimented with new techniques. It is curious to note a parallel in Lord Egremont's later shift to the industrial sector with Turner's

late subject matter, marking a transition in the artist's patronage from the landowning aristocracy to the captains of industry. In 1809, however, Lord Egremont's achievements lay in his agrarian experiments, and he wanted culture to complement his self-image as well as to glorify his achievements. Accordingly, he ordered from Turner portraits of his seat at Petworth and also another prize property, *Cockermouth Castle,* (fig. 3.18) both of which were exhibited in 1810. Turner's *Petworth* is located snugly in the landscape, set off by the river and a hill that partly conceals it; a morning mist obscures the scene and is exploited to transform a mere likeness of a house into a radiant presence at one with, and enriched by, the benign light effect. Gilpin praised the unique moisture and vapory heaviness of the English atmosphere which obscured distances with a *haziness,* thus throwing "over the face of landscape that harmonizing tint, which blends the whole into unity and repose."[77] This effect also transforms the laboring boatmen into decorous accessories adding to the serenity of the view like the ducks in the foreground. An unearthly stillness pervades the scene; the dawning light gradually discloses Lord Egremont's elegant residence amid the agrarian paradise. Lord Egremont's actual working of the land and the hired laborers who carried out his experiments are transformed into a poetic evocation of primitive Arcadia. Turner's role was to glorify private ownership of the land as a reflection of power and prestige—not as in traditional landscape views that often conjoined the patron and his family to the estate view, but in a novel, panoramic vista projecting the vast range and potential of the property. Turner disposed all the elements—boatmen with their fishing craft, hill with grazing sheep, and the dawning sky—in an orbital path around the Petworth house, leaving no doubt as to the force governing the multifarious operations of the estate.

Turner achieved the light effect in this work by using a white ground throughout and attaining the feeling of a high key. He learned to do this from his experiments with watercolor, where he used the white paper economically to lighten tones or provide highlights in topographical views by allowing it to show through transparent washes. The transference of these experiments to his finished oil struck the critics as original, especially his attempt to achieve atmospheric clarity and pellucidity without the customary foil of dark and otherwise contrasting objects. Thus Turner's patrons profoundly affected his novel style, accepting

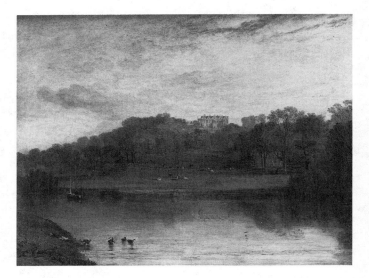

3.25 Joseph Mallord William Turner, *Somer-hill, near Tunbridge, the Seat of W. F. Woodgate, Esq.*, exhibited 1811. National Gallery of Scotland, Edinburgh.

and encouraging his evocation of a mood or his orchestration of a drama which raised their estate portraits to the level of history painting.

Turner's *Somer-Hill, near Tunbridge, the Seat of W. F. Woodgate, Esq.*, exhibited at the Royal Academy in 1811, epitomizes his revolutionizing of the topographical tradition during the Napoleonic wars (fig. 3.25).[78] He takes us through a blissful dreamworld, across a wide lake replete with dinghies and bobbing ducks, up a graded slope on which cattle graze, and finally to the splendid house on the summit. Turner has made the mansion the culminating point of the composition, but insures that it is reached only after a gradual manipulation of the eye through a series of alternating bands of light and shadow. This not only imparts a sense of the magnitude of the domain, but tends to glorify the house like some unattainable ancient cathedral or castle. In Turner's hands, the topographical view-cum-landscape apotheosizes private property and, by inference, the landowning class. Even the sky, dramatically streaked with the brilliant orange light of sunrise, associates this privileged body with the dawning and promise of a new era.

No single social or cultural expression bears more tellingly on the history of the period than this type of landscape portrayal: the impact of the dual revolution on landed property and agriculture was the most catastrophic phenomenon of the period. Neither the political nor the industrial revolution could neglect land, which all leaders agreed

to be the precondition of rapid economic development. Through the process of enclosures—the rearrangement of formerly common or open fields into private land units—accelerated at the end of the eighteenth century by systematic use of acts of Parliament, a relative handful of commercially minded landlords came to monopolize the land. They farmed predominantly for the market, and accumulated capital for use in the more modern sectors of the economy.

This class, including precapitalist landlords who attuned themselves to the industrial bourgeoisie, required a new type of imagery to represent their outlook. The solemn, topographical view had become trite and overformalized, and the presence of genre elements or even the owners and their families delimited in a real physical sense the scope of the material environment and, worse, tended to conventionalize it. While these hardy innovators continued to find in the landscape a combination of naturalness and extension that satisfied their self-perception, they wanted an approach that lifted their estate out of the banal topographical tradition while at the same time offered a heightened degree of modernity and verisimilitude. Turner responded, gradually working his way through the traditional methods to an understanding of how he could make the landscape a vehicle for the surging economic, industrial, and catastrophic changes experienced by his privileged clientele. Thus he could invest scenes of their property with the same effects he had used for imaginative and historical landscapes and, conversely, join aspects of his patrons' estates or familiar English countryside to his poetic or history paintings.

Turner's disciple and faithful supporter, Augustus W. Callcott, claimed in 1812 that "novelty is the essence of art," and it is certain that he was giving voice to the master's ideas.[79] Turner's innovative and bold effects often gave his works an "unfinished" appearance which opponents attributed to his early training in watercolor. His "sketchy" technique, however, which resembled raw materials undergoing transformation, was admired by his affluent patrons nurtured on the writings of Gilpin. Gilpin, it may be recalled, encouraged the "gentleman-artist" to take up the practice of landscape sketching, which was attainable even by "a man of business." He admonished his elite readership not to attempt complex art forms but rather to become proficient in an "inferior branch, than a bungler in a superior." He gently conceded that fine execution was hardly to

be expected but suggested that the peculiar virtues of the sketch outweigh this consideration, and in the quick jot, "you may please others by conveying your ideas more distinctly in an ordinary sketch, than in the best language."[80] Thus the sketch has its own intrinsic charm, absent in finished works, and lends itself to an English landscape blissfully veiled by a hazy atmosphere.

Turner's abbreviated methods and rapid execution emerged fairly early, as we have seen, and related to economic necessity. Later, he experimented with a variety of media and grounds to achieve novel effects. In the post-Napoleonic phase, his style became increasingly visionary, more than ever tied to industrial developments. I shall analyze these works in the next volume. For now it is important to realize that the basis of Turner's original artistic impulses as established during the Napoleonic wars. Such dramatic effects as iridescent, vaporous dawns, blazing sunsets, volcanic action, and the fury of storms and avalanches were ideally suited to his experimental methods. As a consequence, he developed an almost brutal handling of pigment and bold scumbling applied with the palette knife. Already in 1806 critics complained that his works smacked of the "trowel."

Experiments with light and color, closely related to Turner's technical evolution, were stimulated by C. O'Brien's treatise on fabric printing, *British Manufacturer's Companion and Callico Printer's Assistant* (1795). The growth of the cotton industry and the specialized areas it spawned, such as the calico printing firms, brought fierce competition for attractive designs and patterns requiring a scientific appreciation of color theory and optics. Turner's lifelong interest in these sciences reminds us again of how closely his style was tied to the Industrial Revolution.

Fiercely competitive, Turner's interest in novel light effects was also related to his desire to excel Claude, the seventeenth-century French landscapist whose sunset effects appealed to the English aristocracy in the eighteenth century. He also tried to "outshine" his contemporaries by exploiting the "Varnishing Days" at the Royal Academy. This was a privilege of the members of the academy, who were allowed to "touch up" and varnish their pictures just prior to the opening of the annual exhibition. Turner took advantage of the procedure, not only to finish incomplete work, but to heighten or tone down an effect, depending on how it looked next to his competitors. Later, his use of large brushes and rapid execution during the Varnishing

Days prompted cartoonists to picture him using a mop on his pictures.

Turner the Entrepreneur

But if critics and colleagues were not so amused by this behavior, Turner's patrons loved him and made his fortune. By 1810 Turner had a stockbroker and was a landholder himself: he had purchased land at Richmond for 400 pounds, and at Lee Common, Bucks, for 102 pounds, and now bought a house at Queen Anne's Street West, with a gallery adjoining his other place on 64 Varley Street, and began carrying out the plans for a country house at Twickenham. He also owned one or more boats with which he sailed on the Thames, and possessed a horse and gig. Finally, he employed several servants to run his households. Turner had now come into his own as an entrepreneur-artist, "a self-made man," and one who identified easily with the outlook of his patrons.[81]

This prestigious backing eventually endeared him to publishers of travel albums and picturesque views. He executed watercolors for illustrations for the popular topographical books, catering to a market promoting British scenery while the Continent was closed to travelers by the Napoleonic blockade. As early as 1811, he began gathering material for forty illustrations commissioned by W. B. Cooke for *Picturesque Views of the Southern Coast of England,* the first volume of which appeared in 1814. Turner was paid for each drawing and received a share of the profits. His close attention to commercial affairs helped him in his negotiations, but eventually he broke with Cooke over payment for his work. The painter felt underpaid when he noted the success of the publications, and asked for a substantial increase for later drawings contracted for previously. Clearly, Turner drove a hard bargain; but his frank approach to money matters may be understood in the context of his identification with the commercial aspirations of those who profited most from the Napoleonic wars.

John Constable

John Constable (1776–1837) was Turner's almost exact contemporary, and he also made profound contributions to nineteenth-century landscape painting.[82] The fact that they emerged in the same generation suggests the impact of identical historical forces on their thought. Ironically, how-

ever, the two were most often unfriendly rivals and painted in seemingly diametrically opposed styles. Instead of threatening scenes of vast cataracts, steep mountain ranges, violent storms, and infinitely extending views, Constable depicted the more placid and intimate aspects of the English countryside. Constable found Turner's *Hannibal* "so ambiguous as to be scarcely intelligible in many parts," although he admitted that on the whole it was "novel and affecting."[83] While Turner exercised his imagination to project breathtaking glimpses of nature, Constable dutifully and faithfully painted the landscape of his home and surroundings. In this sense, Constable may seem to be an anomaly among the group of artists previously mentioned, a lone exception studiously avoiding the upheavals and social transformations in favor of the repose of the open field and the continuity of life expressed in quiet passages of rural activity. Yet Constable represents another phase of the reaction to social upheavals at home and abroad, and must be viewed as the dialectic partner of Turner; indeed the two artists taken together provide a rare glimpse into the fullness of a certain historical period. Constable was much more overtly political than any of his biographers are willing to admit; and his closest friend and patron, John Fisher, expressed the apocalyptic note when he defined 1789 as the year "the volcano burst."[84]

While Constable was born in extremely well-to-do circumstances and never knew the money-grubbing practices of Turner's household, he lacked the drive that Turner's unstable family life seems to have engendered. Elected associate of the Royal Academy in 1819 when he was already forty-three years old and had been exhibiting at the academy for seventeen years, Constable never attained Turner's early recognition, nor did he ever enjoy the kind of influential clientele Turner managed to secure from the outset. Yet Constable never wanted for patrons and had an immense success abroad, especially in France, where his work appealed to a younger generation of landscapists and even history painters. Constable's English patrons, however, differed fundamentally from those of Turner: they were less wealthy, more conservative, and above all, more regionally based. They were the country gentry and their professional suppliants, whose outlook was determined by the exploitation and protection of property. Their political activity was confined primarily to local government, and they supported the Church of England. In short, like Constable himself, they were rural Tories who declaimed the advan-

tages of village over town life and saw in their farms or estates the ideal of social harmony and stability. Constable worked not only for this class at home, but for its equivalent abroad after 1815: during the Restoration his pastoral scenes appealed to the new French conservatives.

Constable was born at East Bergholt, Suffolk, in the Stour River valley, the son of Golding Constable and his wife Ann (née Watts). Golding was essentially a miller, but he grew his wheat and owned his own sloops and barges for river trade. He inherited from his uncle, Abram Constable, a prosperous corn factory in London and not only money, property, and business assets, but a water mill at Flatford on the River Stour, a wharf and dry dock, a granary, and kilns. Later, he added another water mill at Dedham, which he ran on behalf of a local consortium, and a windmill at East Bergholt. As one of the Commissioners of River Stour Navigation, he had the obligation to keep the canal locks in order and to clear the water of obstructions, in return for which he could charge tolls on the shipping of commodities. Ann Constable also came from a well-to-do family, her father being a successful cooper; thus the Constables gained a solid position in the business and cultural life of their region. By 1774, two years before John was born, they were sufficiently well off to make the social transition to the gentry. They bought a sizable property at East Bergholt, becoming one of the biggest landholders in the area and pillars of the community.

Suffolk County farmers prided themselves on their efficient techniques, crop rotation schemes, and enclosures. Enclosure, as we have already learned, meant the abolition of the ancient open-field system of cultivation, and this facilitated the adoption of more efficient methods of production and the full cultivation of common pastures which had often been overstocked and poorly maintained. Additionally, many enclosures were made to bring under cultivation wastelands like marshes and moors. In Suffolk there was great regional pride in the efficiency of land use and its profit.

Constable's father owned a farm of nearly one hundred acres around the village, and grew food for the family as well as for the market. Like the larger landowners, he profited from the inflation of agricultural prices during the Napoleonic wars. Moreover, since the family fortune was tied to the rising price of bread, they did exceedingly well during the wars. Nothing is more revealing of the father's situation than Constable's depiction of *Golding Constable's*

Kitchen Garden, painted in 1815 (fig. 3.26). It was done from an upper window of the family house in East Bergholt—an unusual topographical approach in that it reverses the traditional view centering on the country seat or residence. Here the extent of one's private property is projected from one's own home, a distinctly privileged vantage point that gives the viewer a sense of being "lord of the domain." Constable's view embraces the family farm backing onto the garden, its neat patchwork of meadows and arable fields now enjoying a bumper harvest, the windmill near the horizon, and houses of the village off to the right. The property is tidy and well kept, carefully divided and enclosed by fencing, hedging, and rows of trees. Land use here was maximally efficient, recalling that enclosures proliferated to improve the light lands through crop rotation.

Constable's Regionalism

Constable's scene emphasizes the arrangement of the land during a singularly blissful moment when all the elements of nature seem of one accord. His outlook could be defined as "georgic," the gentry's model of Virgilian propriety based on a vision of a harmonious rural society capable of informing and ordering the whole of civil society. Poets like William Cowper and Robert Bloomfield and painters like Constable and James Ward cast their landscape in the Virgilian mode and therefore rationalized the gentrified way of life. Constable's view of the local geography clearly expresses a well-ordered community, one that is especially productive and harmonious—not the turbulent panorama of Turner's portraits, but a finite territory sharply defined

by human structures like the windmill and fences and natural barriers. Constable is most concerned with capturing readily identifiable smaller land divisions belonging to his social group in East Bergholt and its environs. In this he was forced to defy Gilpin, whose writings he collected and to whom he was otherwise indebted for his preference for striking chiaroscuro, rough textures, and "the endless varieties of Nature." But Constable's provincialism (here meant in the geographical as well as attitudinal sense) overrode Gilpin's strictures on showing areas under cultivation. Gilpin addressed the great landowners, while Constable's clientele represented the squirearchy.

This conservative regionalism is further expressed in the depiction of labor, in which Constable again deviates from Gilpin's line. Gilpin rejected the "industrious mechanic" for a lack of picturesqueness while extolling the "lazy cowherd" and "loitering peasant," but Constable's emphasis on the cultivated grounds of his neighbors could not allow for so severe a stricture on the labor of tenants and landless workers who worked in close proximity to the regional proprietor. Constable's landscapes would have appeared bizarre without the presence of industrious mechanics. But he qualified this presence by accepting Gilpin's advice on the subordination of "alien" objects to the broader lines of the composition. Constable's *Kitchen Garden* is typical of his depiction of workers in the field: they are diminutive, located well below the horizon, and seem almost "camouflaged" amid the foliage and crops, recalling the "hidden" objects in puzzle pictures. This is even more immediately evident in the preliminary drawing for the *Kitchen Garden,* where the absence of color in clothing and of flesh tones barely distinguishes the human from the nonhuman environment (fig. 3.27). Constable deliberately positioned his workers in inconspicuous locations or hid them among the landscape features, giving the minuscule people near the barn and irrigation canal and in the garden the appearance of those figurines in an architect's model, thrown in to indicate scale. In both cases, they represent just another set of objects in the visual field rather than fundaments of the world they constructed.

While the enterprise and self-interest of Constable's class produced a hardheaded realism, it was realism based on the ideology of that class. Accordingly, labor could not be ignored, but it could be downplayed and made innocuous. As we shall see in other works, Constable's figures are "token" laborers who stand in a very tenuous position vis-à-

3.27 John Constable, *Golding Constable's Kitchen Garden*, c. 1812–1814, drawing. Victoria and Albert Museum, London.

vis the soil they work. The social classes are clearly distinguished, the gentry referred to through their real estate holdings and the rural proletariat shown safely at work and too few in number to constitute a threat to the stability of "Constable's country."

Constable's preoccupation with the "correct" placement of rural people is shown in an account given by Leslie. This ex-plowman from Constable's neighborhood, who became head porter and occasional model at the Royal Academy, always vouched for the accuracy of the farming operations and social relations depicted in Constable's landscapes. He especially admired one work—ultimately poorly received—which depicted a team of reapers and mowers in Suffolk County led by "the lord," a term designating the leading man. By accurately portraying the relations of the lord to the rest, Constable was essentially asserting his own family's role in Suffolk as "landlord" and hence his place in the social hierarchy.

The artist's highly personal view of his father's property projected from the house in which he was born is central to a further understanding of his work. He used the house as the frontispiece of a mezzotint (a method of engraving) series reproducing his paintings, published in 1830–1833 under the title *Various Subjects of Landscape, Characteristic of English Scenery* (fig. 3.28). Thus he took his own home— the point from which he often painted views in all directions—as a "characteristic" example of the native landscape, transposing the personal to the national level of consciousness. But even here he could not forbear quoting from a travel guide referring to the house as one of several

notable residences in and around East Bergholt, which gave the place "an appearance far superior to that of most villages."[85] That Constable and his family perceived their village in nationalist terms is clear from an exchange between John and his sister Mary, who, at the time, was negotiating the purchase of a piece of property at East Bergholt. She wrote to him, "A small portion *of England in East Bergholt,* I trust, would prove a *harmless link* of worldly pleasure."[86] Of course they objected to the sale of land to Whigs and even worse creatures, for only the region's conservatives, with whom Constable and Mary identified, deserved to own the local scenery.

In *Pride and Prejudice* Darcy states as evidence of Elizabeth's need to stay close to family that for her, "Anything beyond the very neighborhood of Longbourn . . . would appear far." There is a remarkable parallel between Constable's stable, confining world and that of his contemporary Jane Austen (1775–1817). The daughter of country clergy, she took her subjects from the careers of that class and its gentrified patrons. Like Constable, she was a Tory whose attachment to her native village (Steventon, north Hampshire) implied a similar critique of large-town corruption and carried chauvinisticx and conservative attitudes about her native country. She shuns the poor and the laboring classes who are relegated to the shadows of her gentrified world as in the ccase of the mute gardeners in *Pride and Prejudice* (1813) and *Mansfield Park* (1814). Out-

3.28 John Constable, frontispiece mezzotint for *Various Subjects of Landscape, Characteristic of English Scenery,* 1830–1833.

3.29 John Constable, *Golding Constable's House at East Bergholt: Birthplace of the Painter,* c. 1810–1811. Victoria and Albert Museum, London.

wardly, her characters rarely concern themselves with the burning ideological issues of the day, preoccupied as they are with cultivating their own gardens. But this is a deliberate strategy that is often betrayed by the very intensity of her protagonists' concerns with their trivial pursuits. If she retreats from the political conflicts, it is from the desire to hold fast to what is near at hand.

Throughout her fiction, estates figure prominently not only as settings but as clues to the character and social outlook of their owners. In *Pride and Prejudice* the balanced vista of nature and artifice at Pemberley valorizes the good sense and decency of Darcy, while in *Mansfield Park* the wholesale improvements suggested by Crawford for Sotherton Court and Thornton Lacey betray his social irresponsibility and discordant nature. In this sense, the estate stands in for the state, wherein the organicist and gradualist approach is taken as preferable to radical change. Thus, for Austen and Constable, the rural village and country estate embody those values essential to the stability of English political, social, and religious institutions. As against the forces of disintegration operating from the Continent, they offer the individual the maximum amount of freedom within an ordered framework.

Always at the center of Constable's patriotic attachment was the paternal mansion that he celebrated in several sketches (figs. 3.29–30).[87] He could even choose an uncharacteristic panoramic treatment to indicate by way of contrast with its surroundings the prominence of the house in the landscape. This projection of a worldview from the family home, front and back, is key to grasping Constable's relations with his human and nonhuman environ-

ment. He identifies with the father's commanding position, but at the same time works through his oedipal conflicts by displacing them onto the landscape and mastering this land through his painting. He obeys the parental injunction to *"earn money,"* but rejects the business outlet proffered by his father in favor of visual domination through art.[88]

The assurance with which Constable vaunted his family property as characteristic of English landscape was born in part from the prosperity generated by the Napoleonic wars. Yet he deliberately avoided all references to internal or external events in his work, maintaining the serenity and harmony of his familiar environment which he claimed to have associated with his earliest childhood. As late as 1812, when Turner and Martin were responding in dramatic visual form to foreign and domestic upheavals, Constable could write how much he preferred "Bergholt and the vicinity of our own house to almost any other."[89] Clearly, Constable developed an obsession with the surroundings of his native region: he admired his neighbor Willy Lott, whose house and farm on the edge of the River Stour he painted over and over again, for having lived more then eighty years in one place without having spent four whole days away from it; and whereas most landscapists of the period were itinerant and made topographical tours, during the Napoleonic years Constable concentrated on scenery around the family home.[90]

It should be recalled that his was a tightly knit family, the classical type of extended grouping, with most of the members remaining in close proximity to one another. While Constable's birthright was more advantageous than Turner's, his life was more conservative and provincial.

3.30 John Constable, *East Bergholt House,* c. 1810. Tate Gallery, London.

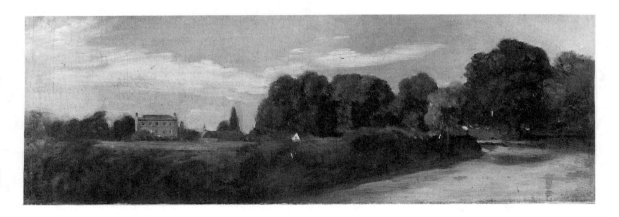

The patriarchal figures who governed his existence were rigid and pretentious in their claims to solid living. Constable's family did not approve of his choice of career, a choice that also hampered his selection of a wife. Making pictures was certainly not the proper occupation for a Constable.

Life began traumatically for Constable; he barely survived childbirth, a fact his family made him aware of very early in childhood. His sense of the tenuousness of existence must relate to his obsessive attachment to the things of his home environment. When he was only seven, Constable was sent to a boarding school at Lavenham where the students were flogged unmercifully. As a result, he seems to have suffered from separation anxiety most of his life, an anxiety that underlies his choice of subject matter in painting. In a revealing letter to Fisher of 23 October 1821, he emphasizes that he paints his "own places best"—those places associated with his "careless boyhood."[91]

Although this reference is often used to show Constable's modern attitude toward landscape, in fact it is clear that his identification with painting and feeling are tied to childhood associations. It suggests a fantasized realm of calm and security afforded by his native village. "I had often thought of pictures of them [i.e., scenes of the River Stour] before I ever touched a pencil," he said. In other words, childhood images were already fixed in his mind before he actually painted them. Setting aside the most obvious infantile sexual and scatological associations in his love of "the sound of water escaping from mill-dams, etc., willows, old rotten planks, slimy posts, and brickwork," it is clear that those scenes were visualized with the aid of the most hackneyed of picturesque recipes.

Paradoxically, however, to realize these childhood fantasies Constable was compelled to depict the land and its benchmarks faithfully and repeatedly to insure the "boyhood" connection. He could not recover the landscape itself, although he could falsify the social relations between proprietor and worker. Hence his oft-repeated phrase of 1802, "there is room enough for a natural painture," expressed his resolution to ignore nature seen through the imagination of the past and "return to Bergholt, where I shall endeavour to get a pure and unaffected manner of representing the scenes that may employ me." Thus he would achieve a "truth" that alone could "have just claims on posterity."[92]

Constable's model was Gilbert White, the naturalist (and

close friend of Jane Austen's family) whose *Natural History of Selborne* (1789) displayed an obsessive attachment to the ecology of his village in Hampshire. Fisher wrote Constable that the book "is in your own way of close natural observation," and Constable replied that "the mind and feeling" that produced the work is one that he had "always envied." [93] White's observations of the flora and fauna and meteorological phenomena, and his weather summaries and forecasts for the years 1768 and 1792, demonstrate a similar zeal for unadorned inventory that Constable strives for in his recordings: "There is a steep abrupt pasture field, interspersed with furze, close to the back of this village, well known by the name of the Short Lithe, consisting of a rocky dry soil, and inclining to the afternoon sun. This spot abounds with the *Gryllus campestris;* which, though frequent in these parts, is by no means a common insect in many other counties." [94] And again like Constable, White distributes his remarks on the rural poor at the tail ends of sections or in the form of asides, sometimes even using the same terminology he uses for the "brute" world. His village "abounds" with poor rural workers, "hordes of gypsies" infest the south and west of England, and the "faunist" who visits Ireland will be especially fascinated by the "wild natives" and their "sordid way of life." [95]

Their claim to truth here may be clarified by an example from the realm of modern mass communication. No one would deny the conservative ideological bias of most popular television, regulated and governed by the pressures of advertisers and major shareholders. This control extends to the way in which the news is reported, especially in terms of selection, time allotted, and the amount of detail covered. There is one exception, however, and that is the weather report. Here satellite information, maps, and meteorological data provide a relatively precise and accurate accounting of all the information available at the moment of the report. This is the most objective section of newscasting; but while it convinces us of its veracity and affects our action, it leaves us as ignorant of the world as we were prior to the newscast. Now the truth of White and Constable may be likened to the weather report, which yields precise data about climate and topography but precious little about the actual state of the world. It is "truthful" in its own narrow sphere and apparently safe from ideological intrusion. It maintains its objectivity at the risk of moving beyond "a circle of a few hundred yards at Flatford, very near Bergholt." [96]

Constable's Meteorological Forecasts

Constable's actual concern for the weather is well known, a natural interest of a miller's son. His father intended him to follow in his footsteps, and young Constable participated at various stages of his life in his father's trade. In 1808 he registered a complaint on his father's behalf about the state of the Stour River at Flatford with the Suffolk County Commissioners of River Stour Navigation. He studied at first hand the machinery of water mills and windmills, one of which he sketched as early as 1792. At the same time, his attention was very much drawn to the appearance of the sky, since cloud formations foretold the wind conditions. Typical of persons who live off the land and rely on nature for the operation of machinery, Constable developed an obsession with clouds. His well-known series of oil sketches of clouds exemplify the transference of this obsession to the realm of art: these hastily executed oils are almost all annotated with the date, time of day (one of cumulus clouds is precisely timed at 5:05 P.M.), direction of the wind, and other weather conditions (fig. 3.31).[97] Although they date from 1821–1822, he made cloud sketches very early on, either as notes for more ambitious works or as studies for general knowledge. Clouds play a fundamental role in his earliest paintings and the typical cumulus found in the East Anglian summer sky are most conspicuous in his scenes of Flatford lock and the mill (figs. 3.32–

3.31 John Constable, *Cloud Study,* 1822, 5:05 o'clock, evening. City Art Gallery, Birmingham.

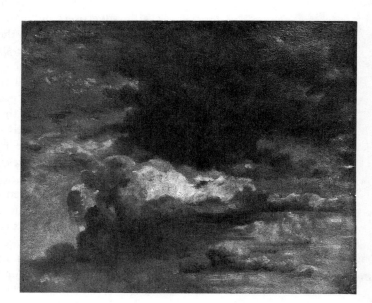

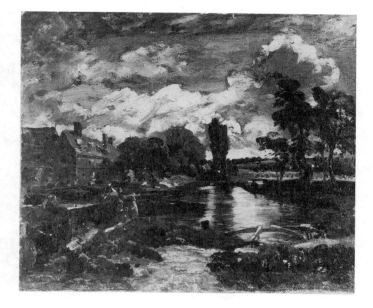

3.32 John Constable, *Flatford Mill from the Lock,* 1811. Tate Gallery, London.

33). In his *Landscape with a Double Rainbow* of 28 July 1812, Constable shows the flat base of a cumulonimbus cloud and a sunlit foreground—all consistent with the meteorological conditions, except that he erred in the order of colors of the secondary bow, which appears in reverse order from the primary, with red on the inside (fig. 3.34). Information about the wind and rain was important for canal users; droughts were disastrous for the locks, which required

3.33 John Constable, *Flatford Mill,* 1816–1817. Tate Gallery, London.

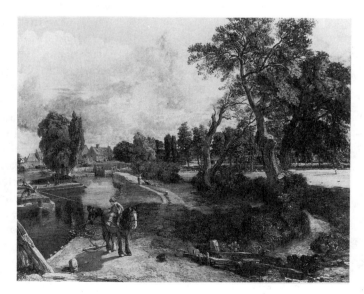

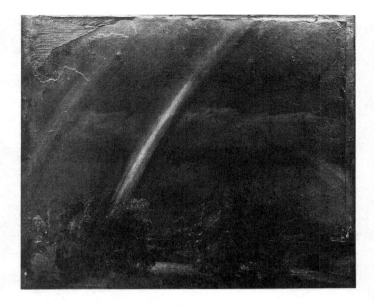

3.34 John Constable, *Landscape with Double Rainbow,* 1812. Victoria and Albert Museum, London.

abundant water, and collecting the runoff in heavy rains prevented floods and helped irrigate the land adjacent to the banks of the canal. Thus unlike Girodet, Martin, and Turner, who studied meteorology for the sake of their painting, Constable's involvement with the science arose from its practical applications to his father's trade and preceded his professional ambitions in the art field.

Constable also kept up with the latest findings in meteorology. He labeled the cloud formations in his sky studies with Latin-name classifications like *cirrus* and *cumulus.* These were first introduced in Luke Howard's papers "On the Modifications of Clouds," published in the *Philosophical Magazine* in 1803.[98] Howard applied the system Linnaeus pioneered in botany to establish a nomenclature for the observations of "the weather-wise mariner or husbandman" who was dependent on them for his survival. Now considered one of the founders of modern meteorology, Howard began his essay by noting that the increasing attention to the new science had stimulated his interest in "the study of the various appearances of water suspended in the atmosphere." He concluded from his researches that clouds are as good "visible indications" of atmospheric activity as is "the countenance of the state of a person's mind or body."[99] Significantly, Howard published engraved plates of the cloud formations which greatly resemble Constable's sky studies (fig. 3.35).

Howard and Constable—almost exact contempora-

ries—are an interesting study in contrasts. Unlike Constable, Howard came from the prosperous urban manufacturing class; his father was a manufacturer of iron and tin goods, specializing in the production of Argand lamps.[100] Howard in turn became an outstanding chemist and a partner in a chemical firm manufacturing refined products for the textile industry and for druggists. Thus he participated directly in the Industrial Revolution of which his meteorological studies are an outgrowth. While both were moralists and condemned idleness, profanity, and strong liquor, Howard was a zealous supporter of the abolitionist movement and engaged in several philanthropic actions outside his own country. Constable was much more the narrow provincial, self-involved or family-involved. Both turned to the science of meteorology to clarify their relationship to the world, but whereas Howard used it to help promote the wider interests of those who bought his goods or produced his raw materials, Constable's interests were limited to expediting the family business complex and using it to paint a "climate" free from the grime and pollution of the Industrial Revolution and the social relations these implied.

Constable also profited from Thomas Ignatius Maria Forster's *Researches about Atmospheric Phaenomena,* first published in 1813. An astronomer by profession, Forster came to meteorology by way of his exploration of lunar, solar, and meteoric effects on terrestrial phenomena, as well as on patterns of human behavior. His preface stressed the utility of meteorology for mariners and husbandmen in enabling them "to foresee and predict . . . the approaching changes of the weather." Its knowledge would "contribute to general safety, and to the improvement of the conveniences of life."[101] Forster was heavily dependent on Howard's definitions as set forth in the *Philosophical Magazine,* but he also recognized the contributions of foreign meteorologists and geologists like Bertholon, Saussure, and Deluc. He shared their larger interest in electrical causes of atmospheric activity, and even credited Napoleon for encouraging this interest.

The work of Forster and Howard (amplified in his *Climate of London,* published during the years 1818–1820) constituted the high point of English meteorology in the Napoleonic period, and both were familiar to Constable. They helped sharpen his perceptions of cloud structures and stimulated him to define them more systematically. His cloud formations evolve from the conventional signifiers of Claudesque examples into the scientific renderings

3.35 Luke Howard, engraving of cloud formations in *Philosophical Magazine,* 1803, vol. 17, plate 6.

3.36 John Constable, *Landscape: Ploughing Scene in Suffolk,* exhibited 1814. Later replica, Paul Mellon Collection, Yale Center for British Art, New Haven.

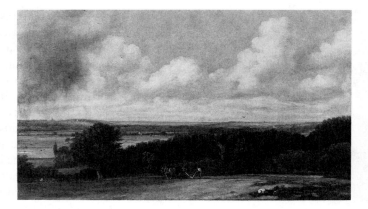

of East Anglian skies. In addition to their contribution to his thinking, they may have been instrumental in leading him to the work of the poet John Bloomfield, whose *The Farmer's Boy* inspired a number of artists in 1800.[102] Bloomfield was a homespun Thomson, dividing his work into the seasons but focusing more microscopically on a particular person in a particular place—in this case, Suffolk County. Seen from the perspective of a prosperous and educated farmer's son, Bloomfield's firsthand reporting of rural life appealed above all to the gentry, who identified themselves with his nostalgia for a bucolic past and his moralizing posture on rural labor. Thus it is not surprising to find that Constable quoted a couplet from Bloomfield's long poem for his exhibition of *Landscape: Ploughing Scene in Suffolk* in the Royal Academy in 1814 (fig. 3.36). Earlier both Forster and Howard quoted a passage from Bloomfield's section on *Winter* that poetically describes the cirrocumulus clouds, more frequently seen in summer when they are a prognostic of warm and dry weather:

For yet above these wafted clouds are seen
(In a remoter sky, still more serene,)
Others, detached in ranges through the air,
Spotless as snow, and countless as they're fair;
Scatter'd immensely wide from east to west,
The beauteous' semblance of a Flock at rest.
These, to the raptur'd mind, aloud proclaim
Their MIGHTY SHEPHERD's everlasting name.

Constable actually incorporated cirrocumulus clouds into his composition (more sharply defined in the later replica reproduced here), but the couplet he quoted was from the section on spring referring to the plowman and not to the weather: "But, unassisted through each toilsome day, /

With smiling brow the Plowman cleaves his way." [103] Constable's use of this quotation indicates that his meteorological accuracy was meant to serve as the backdrop for a statement on rural labor.

For Constable's class, the plowman symbolized rural progress, the ideal of the industrious skilled worker who nevertheless exuded cheerfulness and contentment, secure in the knowledge that his earthly efforts would be rewarded with a spiritual recompense. On the larger farms, the head plowman was considered a "farm servant" whose knowledge was valued and whose duties made it essential for him to be always available. Plowmen were generally hired and paid by the year and received room and board in addition to wages. They were considered superior in both skill and living conditions to the day laborers, who lived out in cottages and whose livelihood was much more precarious. And when there were grievances with the employer, the head plowman was often called in to mediate the dispute.

Constable's landscape, with its exacting rendition of the skies and land, depicts the countryside as skillfully farmed, fertile, and socially stable. He took the view from the park of Peter Godfrey, the squire of East Bergholt and a major proprietor, whose country seat at Old Hall Constable had painted in 1801 (fig. 3.37). [104] This youthful work imitates the conventional type of topographical view, making no pretense to the compositional stagecraft of Turner; it is, in short, a classical real estate portrait. As he matured and his patrons prospered during the Napoleonic wars, Constable found his way to a more personal approach. He projected a psychological as well as physical sense of his patrons' prop-

3.37 John Constable, *Old Hall, East Bergholt,* 1801. Private collection.

erty from their estate seat or home, laying out the magnitude of their position in the community and the extent to which the stability of the surrounding area was owing to their careful organization and improvements. By adopting the privileged vantage point of the proprietor, moreover, he could still retain the specificity and identity of the land he knew so intimately. His view of the *Landscape: Ploughing Scene* is a high one, not only embracing Godfrey's farm, but looking across the Stour River valley to the Langham hills. Yet this is not the awesome panoramic sweep of Turner: the valley is spotted with familiar benchmarks and surveyed from the perspective of eminent geographical, social and psychological "standing" in the community that enables Constable to confidently assert a kind of visual proprietorship over the land.

The high viewpoint, as in *Golding Constable's Kitchen Garden,* also insures that the central plowman is subordinated to the main lines of the landscape. His action follows a prescribed path along the slow, sloping diagonal of the hill and trees, not simply because he cuts a straight furrow, but because he is also stuck in a social "rut." Not surprisingly, the less conspicuous plowman on the lower level is moving at a right angle to the other, following the line of the horizon. Their dual movement appears incredibly mechanical, obeying the dictates of the land and its social organization. The chief plowman is actually graphically mechanized by an ingenious zigzag design which—starting with the horses whose legs echo the V-shape frame of the plow—regulates his action. According to the Bloomfield couplet, both plowmen should be toiling with a "smiling" and not a "sweaty" brow; here the biblical condemnation is transformed into an affirmation of the values of the rural hierarchy whose blessings—if not its profits—are bestowed on those at the bottom. Curiously, however, there is no overt indication of any kind of expression in the painted figures. They are particularly inexpressive and cheerless, automatic drudges without thought or feeling. In this sense, Constable painted faithfully what he actually felt, but rationalized, or perhaps apologized for, his perceptions on behalf of his class. He later expressed this process in the form of an aesthetic paradox: "*I never saw an ugly thing in my life;* for let the form of an object be what it may,—light, shade, and perspective will always make it beautiful."[105] Simultaneously, we know that he preferred painting landscape to people, that he despised the "rabble," and on a trip to Brighton Beach could express utter con-

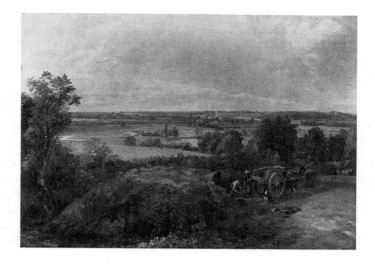

tempt for "rotten fish & those hideous amphibious animals, the old bathing women, whose language, both in oaths & voice, resembles men—all are mixed up together in endless & indecent confusion."[106] Now the industrious plowmen, contrasted with the lazy "cur" (but whose loyalty they manifest) who naps in the right foreground, are divested of their real-life vulgarity by their subordination to the character of the landscape. Of course, there is always the flip side in reality of the aesthetic fantasy—as Bloomfield himself acknowledged concerning the loyal sheepdog:

E'en so the MASTIFF, or the meaner Cur,
At time will from the paths of duty err,
(A pattern of fidelity by day;
By night a *murderer*, lurking for his prey;)[107]

But for the time being, at least in Constable's picture, the two laborers toil alone and keep to the "straight and narrow," seemingly incapable of troubling the order and harmony of their rural environment.

A similar example of this aspect of the artist's mentality may be seen in his *View of Dedham*, also painted in 1814 (fig. 3.38). *View of Dedham* was commissioned by Thomas Fitzhugh, a rich landlord from Denbighshire, for his bride-to-be Philadelphia Godfrey, daughter of Squire Godfrey of Old Hall, East Bergholt. Once again, Constable assumed a point of view from the park fencing of Old Hall, this time shifting slightly to survey the valley across the Dedham. Just right of center in the middleground we glimpse the spire of Dedham parish church, a landmark that recurs regularly in Constable's work. It has both a material and spir-

itual function in his work, serving to identify the region and to "moralize" the landscape. It is certain that local surveyors used the lofty tower at the west end as a triangulation station. Most sightings were taken from the western towers of churches. Since Dedham parish was bounded by the Stour, which formed the Essex County boundary, this would have made the church a key surveying point. In analogous fashion, Constable fixed on it as a familiar benchmark on his landscape grid.

In the foreground, two men dig manure from a dunghill and load it on a cart to be carried downfield for the plowmen to work into the soil. Although manure processing might strike the contemporary urbanite as an unfit subject for a wedding picture, our modern cultural biases should not prevent us from understanding a solid respect for horseshit. In fact, Bloomfield poeticized manure in several sections of *Farmer's Boy,* intimating a bright future for the properly prepared ground: "The rich manure that drenching winter made, / Which pil'd near home, grows green with many a weed / A promis'd nutriment for Autumn seed." Thus a rich harvest is assured, a glorious promise and Christian blessing for the newlyweds.

Kirwan's Fertile Activities

The use of manure constituted a basic section of all agricultural treatises in the eighteenth century and was closely linked to scientific farming. Perhaps the most important contribution to the study of manure was made by Richard Kirwan, the indefatigable president of the Royal Irish Academy and a gifted mineralogist, chemist, geologist, and meteorologist who promoted the application of science to industry.[108] Kirwan paved the way for a theory of winds and published a major piece on the subject in the *Philosophical Magazine* of 1803. His voice was heard in almost all areas of scientific investigation at the turn of the century, and it is certain that Constable knew his work.

In 1796 Kirwan published what proved to be an enormously popular manual on manure: *The Manures Most Advantageously Applicable to the Various Sorts of Soils and the Causes of Their Beneficial Effect in Each Particular Instance.* He began his study with a definition of agriculture as "the art of making the earth produce the largest crop of useful vegetables at the smallest expense." Manure, he claimed, is that substance or operation by which a soil is improved to the point "of producing corn, legumens, and the most useful

grasses." Kirwan insisted that effective application of manure depended upon the latest scientific knowledge, especially chemical analysis. He noted that the average country farmer could hardly be expected to have this kind of information at his disposal, hence it was incumbent upon "country gentlemen" to test soil samples so that they "could enlighten and encourage their more ignorant and diffident neighbors." Many of the rural gentry might develop a real taste for such occupation, which would not only fill "the many vacant hours and days which the solitude of a country life must frequently leave them, but are moreover sweetened by the pleasing recollection that of all others they tend most directly to the general happiness of mankind." [109] Hence, working with manure could mark the scientific awareness and social status of its user.

In Constable's picture, the pile of manure heaped up in the right-hand corner is as much an indication of the proprietor's social position as the point of view and the extent of land under his jurisdiction. Kirwan defined this category of fertilizer as "farm yard dung consisting of various vegetables, straw, weeds, leaves and fern impregnated with animal matter which should be piled up in heaps." Its use should be gauged by the type of soil and the amount of moisture available in any particular environment. Kirwan warned that little could be expected from agricultural societies "who do not unite chemistry and meteorology with their principal object." [110] For both Constable and his patron, such knowledge lay at the basis of their own agricultural success, and the orderly progression of the landscape levels and the pride of place given to the manure pile point to their contributions to the improvements of the area and "to the general happiness of mankind."

Knowledge of soils, especially, presupposed familiarity with mineralogy and geology. Constable claimed late in life that it was the study of geology, more than any other, that satisfied his mind. [111] The close connection between these sciences and landownership was a major factor in the development of the Industrial Revolution; English landlords invested their capital accumulated from farming in commercial and industrial activity. In some cases, such as the mining of coal, the establishment of an ironworks, or the quarrying of building stone, the investment was just as legitimate a part of estate exploitation as the letting of land to tenant-farmers. While generally the entrepreneurial activities of landowners were limited to the mineral exploitation of their estates, some cast their net more widely and

took a lead in the general development of the district in their vicinity. Their growth induced them to consider cheaper and more reliable forms of inland transport. Starting with the duke of Bridgewater, it was the landowning class that fostered the canal age. On a much more modest scale, Constable's father helped improve the inland water transport by developing the canal system on the Stour River. He certainly capitalized on the river trade, building his own barges and shipping coal and wheat. Geology, of course, was central to the construction and improvement of canal systems.

Geologists like Hutton and Kirwan were major proprietors themselves and used their specialized knowledge to improve their estates. What's more, they tended to uphold the values of the countryside where they carried out their geological explorations. Deluc, the Swiss geologist who settled in England and whose authority was invoked by Hutton, Kirwan, Howard, and Forster, addressed a series of letters to the queen of England in 1779, setting out his theoretical connections between geology and biblical narrative and, at the same time, squeezing in his observations on the moral advantages of rural life. The keynote of happiness among villagers is their "simplicity," and happiness would be more permanent for all if sought in the country. Similarly, Saussure's excursions in the Alps led him to idealize Alpine villagers as the happiest and friendliest people in the world.

Whitehurst: Geology and Real Estate

This condescending attitude toward their rustic inferiors marks the gentrified geologist as well as the painter of rural life. It could even enter the theoretical domain as well. While the "happy" laboring classes and the evolution of the earth's surface may seem too far removed from each other to admit of a logical connection, they were in fact connected in a popular geological treatise published in 1778 by John Whitehurst, *An Inquiry into the Original State and Formation of the Earth*. A friend of Kirwan and Wright of Derby, Whitehurst belonged to the famous scientific club that promoted the alliance of science and technology, the Lunar Society, whose members and affiliates Josiah Wedgwood, Matthew Boulton, Erasmus Darwin, and Joseph Priestley subscribed to the book. In addition, the duke of Newcastle, who owned extensive mining interests, purchased five copies. Whitehurst was both scientist and me-

chanical engineer, and his treatise had both a theoretical and practical side. He began with a cosmic, big bang theory of the universe and culminated with discrete subdivisions of the earth's surface privately owned. For his examples of the earth's stratification he drew on the environment of his native Derbyshire, insisting that the science of "subterraneous geography" is fundamental not just for speculative contemplation but for its immediate application in locating coal and limestone "in the lower regions of the earth."[112] Whitehurst observed that geologists pay more attention to natural history than to mining, and he intended to correct this by representing the strata in sections to aid miners in achieving more efficacious results.

While the practical application of natural history in general, and geology in particular, was hardly novel, Whitehurst went further in seeking in geology an understanding of the rise of private property. Early in his discussion he established the finitude of the earth, which came into existence in a fluid state and could not have existed from eternity "as some persons have imagined." He concluded from its finiteness that the earth was open to particular divisions, exploitation, and ownership. This process developed gradually after the earth began to cool, when there emerged a "great increase of terrestrial surface, contraction of the sea, and equal changes in the temperature and seasons of the year." This period could be likened to the golden age celebrated by Rousseau, when the "calls of human nature were satisfied without art or labour; neither were there any storms or tempests, jealousies or fears amongst men to invade their repose; but they slept in perfect security on the ever verdant turf."

As soon as mountains and continents emerged from the deep, however, the years divided themselves into spring and summer, autumn and winter. At that point, earth's products could be obtained only by art and labor: "It then became necessary for men to *sow* and *cultivate the earth;* also to lay up for winter's store, and to protect themselves from the influences of the seasons. Thus commenced *property;* for he that sowed, would expect to *reap* the *fruits* of this labour; and *he* who *built a house,* would expect to enjoy it."[113] Necessity thus gave birth to property, and abolished that equality and harmony that prevailed among the people at the beginnings of the world. But if Whitehurst seemed to lament this transition, he straightway added, "For experience shows, that men who are born in rude and savage climates are naturally of a ferocious disposition: and that a

fertile soil, which leaves nothing to wish for, softens their manners and inclines them to humanity." This contradiction indicates Whitehurst's celebration of the rural, pastoral life, at the apex of which was the noble landlord who epitomized the highest ideal of civilized "humanity." While geological and meteorological conditions no longer allowed for a "golden age," the closest thing to it would be along the lines of "Constable's country." For in the end, landscapist and geologist alike looked upon the earth's surface as so many strata of real estate and potential wealth.

Constable's share in the control of the land he painted was actual; his privileged social position gained him access to terrain otherwise strictly forbidden to trespassers and poachers. But he controlled it pictorially as well through the innovative landscape developments of his time. He rejected the thought that his work resulted from "poetic aspiration," but regarded it as a pursuit *legitimate, scientific and mechanical.* In part this expressed his desire to rationalize his choice of profession in bourgeois terms and satisfy the demands of his parents that he "earn money." At the same time, he identified his approach with the latest scientific investigations in geology, meteorology, and astronomy. "Painting is a science, and should be pursued as an enquiry into the laws of nature," he declared. "Why, then, may not landscape painting be considered as a branch of natural philosophy, of which pictures are but the experiments?"[114] Following Gilpin,[115] Constable perceived the landscape directly through the medium of the study and sketch. His quickly executed jottings of cloud and other

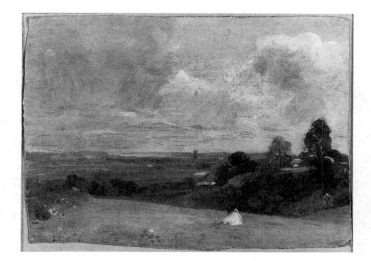

3.39 John Constable, *Dedham from Langham,* 1812, oil on canvas laid on board. Tate Gallery, London.

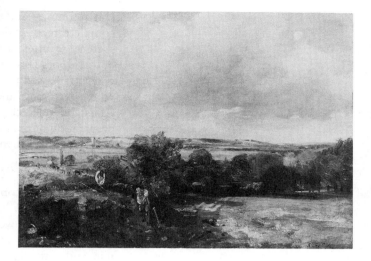

3.40 John Constable, *View of Dedham*, 1814, oil sketch. Leeds City Art Galleries, Leeds.

atmospheric phenomena coincide with the writings of Howard, Kirwan, and Forster but also reflect his awareness of trends in London and on the Continent.

Constable's attempt to record atmospheric effects on the spot had to be shorthand, and his studies often show the spontaneous character of the sketch. He wrote Dunthorne in 1814 that he now determined "to finish a small picture on the spot for everyone I intend to make in future."[116] His *Barges at Flatford Lock,* painted circa 1810–1812, explored an overcast moment with breathless speed, fixing on the sky effect and the reflections in the water, while another oil sketch from the same period, *Dedham from Langham,* caught the rolling clouds seemingly in transit (fig. 3.39). While we might expect to see a fluid technique in sketches, Constable often transferred this quality to his final work, where there are passages left in a rough state or that have a freshly painted look. In this way he preserved the atmospheric effect that he could capture only at breakneck speed. Fuseli claimed that looking at Constable's work made him long for his coat and umbrella, while others railed at Constable's "snow." Here they were not considering the outdoor studies, but the feel of the studies left in the definitive project produced indoors.

This may be seen in a comparison between the sketch of *View of Dedham* (fig. 3.40) and the final version, previously discussed (fig. 3.38). Strictly speaking, a sketch for a composition differs from a study; studies are often used to inform the more complete sketch, which represents a later stage in the artistic process. Studies, moreover, retain a cer-

tain autonomy and can stand alone without reference to a complete picture. In the case of landscape the study and sketch are often indistinguishable, both being produced out-of-doors in a single sitting. (As we shall see, much of what has passed for modern painting simply collapsed the whole sketching-finishing process into a single operation). Constable's sketch actually traces an earlier phase in the preparation of the field for sowing wheat; the manure heap is much larger than in the final picture, and a harvest is shown in an adjoining field. It captures faithfully an earlier moment in time, along with its specific meteorological conditions. The completed version follows closely the layout of the sketch, but obeys faithfully the passage of time and the changing weather picture. All the same, the vitality of the brushwork in the sketch is preserved in the manure pile, and in the foliage and soil of the foreground.

During the period of neoclassicism, the problem of sketch and finish emerged as a polemic about the "ethics" of aesthetics. Finishing and careful outline meant, for people like David and Blake, honest labor and integrity, while virtuoso brushwork stood for fudging, idleness, and courtly elegance. The impact of the Industrial Revolution and the rise of landscape challenged this view by emphasizing the need for special effects not subject to scrupulous polish. The expression of one's own personality as a virtue of self and class, and the need to distinguish oneself in the marketplace, further encouraged experiments with sketches. Constable remarked, "When I sit down to make a sketch from nature, the first thing I try to do is, *to forget that I have ever seen a picture.*" [117] Traditionally, the sketch procedure promoted this disposition through its association with the first instinctive movement of the mind— hence, the most personal state of artistic creation. This made sketching accessible to the amateur as well as to the professional, to the "gentleman-artist" and the "business man."

The landscapist was permitted more leeway in a final picture than the history painter, and could leave brush traces to create a textural effect where the character of the terrain or the general effect warranted it. The general effect was the arrangement of light and dark that stood for the actual lighting conditions. While both landscapists and history painters made sketches, the latter spent more time working from the imagination and in the studio, and the former worked mainly out-of-doors. Landscapists profited directly from the industrial and scientific revolution which,

with its own novel effects and influence on the environment, heightened the awareness of material techniques and expanded the artist's pictorial possibilities. Both Turner and Constable were accused of "incompleteness," but they took their cue from modern developments and satisfied their respective patrons. It is clear, however, that they held different aims. Turner tried to intensify the drama of everyday life in line with his urban sense of the unfolding historical and industrial developments, while Constable understated it in favor of a local, rural enclave.

Pierre-Henri de Valenciennes and the Aesthetics of Landscape

We may trace the theoretical rationale for Constable's approach to the French landscapist Pierre-Henri de Valenciennes (1750–1819), who laid great stress on the importance of sketching out-of-doors in the countryside.[118] Perhaps the most celebrated French landscape painter of the period, his book of 1800, *Elémens de la perspective pratique,* enjoyed international popularity.[119] It influenced the thought of several generations of French landscapists including Corot and the impressionists. Like Turner, Valenciennes was the son of a hairdresser, but his father was master wig maker of Toulouse, who serviced the local gentry and used the aristocratic *de* before his last name. Through contact with his father's aristocratic clientele, Valenciennes received encouragement and patronage; his turn to landscape was in part a tribute to their capacity to voyage widely and own rolling estates and gardens. He prospered and, through inheritance and speculation, acquired sizable landholdings himself. It is understandable that he perceived as his audience "people of taste."

While Valenciennes preferred historical landscape (scenes in which historical personages were represented but subordinated to their surroundings), he was open to a variety of approaches and media. He felt that landscapists, even more than history painters, should be familiar with chemistry, physics, natural history, and geography, since their task was to translate the whole of nature. He told his readers to study clouds and their effects, storms, and volcanoes, whose eruptions produce an "inconceivable variety of tones." He discussed stage design and delighted in the possibilities of the panorama—a developing public entertainment housed in a rotunda that allowed a view of an ex-

tended area in the form of a monumental horizontal painting. His excitement over its breathtaking illusionism no doubt influenced his student Pierre Prévost, who became a pioneer in the field along with the Americans Robert Fulton and John Vanderlyn. It was a novelty that appealed to such diverse practitioners as Robert Fulton, John Vanderlyn, Karl Schinkel, and John Constable.

Valenciennes's own rationale for choosing a career in landscape indicates a privileged but surprisingly modern attitude: "love of the countryside, a desire to contemplate nature to my heart's content, and above all a fervid ambition to portray it with truth and accuracy—these are the motives that governed my choice of profession, guided by travels and led me to visit and study almost all the gardens in the environs of Rome and Paris."[120] Implicit in Valenciennes's experience in his admiration for the private estates of the European elite, which he used as the backdrops for his historical pictures. Throughout his lifetime he also painted various views of the European countryside, exhibited in the Salons with his more studied landscapes. His practice taught him to formulate in a systematic way the use of the *étude* as a reference for more complete work.

The object of the outdoor study was to render nature directly without attempting the detailed finish reserved for tableaux. These studies had to be made hastily because the conditions of the moment could never again be repeated. The landscapist needed to concentrate on the principal tones of the sky and earth and water and forget the rest. For the historical or still-life painter working indoors, objects were generally uniformly lit throughout the day, and one had the luxury of finishing all necessary details carefully. But landscape painters were confronted with a different situation: they had to paint the constantly shifting light of the sun. If the landscapist persisted in painting a single view throughout the day, the final result would be absurd: the background lighting would reflect the light of the sunrise; the middleground the light of high noon; and the foreground the light of the sunset. Valenciennes therefore advised students to start their studies with the sky for the background tone and work progressively toward the foreground. This way everything would follow from the principal tone. This, however, does not permit detail, "for all studies from Nature should be done within two hours at the outside, and if your effect is a sunrise or a sunset, you should not take more than half an hour."[121]

The study differed from the composition sketch, although both concentrated on compositional harmony: the *étude* was an investigation of natural effects, which meant that the final work was not an act of creation as in history painting or its subdivisions, but an arrangement resulting from the preliminary work of the studies. Given the importance that Valenciennes attached to the sky, it is not surprising that many of his ideas were comparable to the most advanced of the period. He bade the neophyte forego stereotyped stage props, like the large tree in one corner of the foreground, which only encumber the sky, and emphasized the appreciation of meteorological phenomena. He made a series of cloud studies in the 1780s, anticipating the later examples of Constable, who no doubt knew Valenciennes' book (fig. 3.41). In a letter of 23 October 1821, Constable refers to his "skying" (a pun on the practice of the hanging committee of the Royal Academy to place works adjudged inferior high above eye level) and continues, "That landscape painter who does not make his skies a very material part of his composition, neglects to avail himself of one of his greatest aids." And he elaborates, "It will be difficult to name a class of Landscape in which the sky is not the *key note,* the *standard of* 'Scale,' and the chief '*Organ of sentiment*' . . . The sky is the '*source of light*' in nature—and governs every thing; even our common observations on the weather of every day, are suggested by them [sic] but it does not occur to us."[122]

In this same letter Constable, acknowledging his correspondent's description of the scenery of a fishing excursion, makes his famous declaration: "But I should paint my

own places best—Painting is with me but another word for feeling. I associate 'my careless boyhood' to all that lies on the banks of the *Stour.*" Constable equates the sky, both as a meteorological phenomenon and as the key to "sentiment," with his boyhood scenes and his present professional activity. It was his way of maintaining control, and it meant preserving the texture of his memories and the lighting conditions of the moment.

In his *English Landscape Scenery* Constable reiterated the discourse of the picturesque: "In some of these subjects of landscape an attempt has been made to arrest the more abrupt and transient appearances of the CHIAR'OSCURO IN NATURE: to shew its effect in the most striking manner, to give "to one brief moment caught from fleeting time," a lasting and sober existence, and to render permanent many of those splendid but evanescent Exhibitions, which are ever occurring in the changes of external Nature."[123] At the same time, the aim of his series was "to increase the interest for, and promote the study of, the Rural Scenery of England with all its endearing associations."[124] On this account, the sketch clearly had as its immediate goal the aestheticizing of local scenery and by extension the glorification of the state as an example of "Pastoral Beauty." Constable's landscape production was his means of ratifying the provincialism of his social milieu.

Constable's sketches of precise meteorological data which communicate a specific set of light conditions in time and space have yet another significant facet. As early as 1802 he recognized that "there is room enough for a natural painture," implying that he found a unique niche for himself among contemporary artists. The change in his perception may be seen in contrasting the stereotypical estate portrait of Old Hall, (fig. 3.37) painted in 1801, with the *Dedham from Langham,* painted the following year (fig. 3.42). The familiar landmarks of Dedham Cathedral and the winding Stour River are conspicuously depicted in the later composition, heralding his mature direction. Nevertheless, lingering reminiscences of the past remain: he deployed the tedious scenic trees at the right, the clouds are entirely nondescript, and the winding river culminates at the cathedral planted squarely in the middle of the composition. Not quite "natural" yet. He continued to do a variety of scenes, moreover, including a series of landscapes from the Lake District during the years 1807–1808. But so

many others were doing the same thing that he hardly received notice at the Royal Academy exhibitions. Meanwhile, his family began to pressure him to produce a saleable commodity, and he realized that to convince them he needed to make a hit as an original painter. He began in 1808 to systematically sketch Stour valley scenes, accelerating his shift from the picturesque to a more natural look. He focused exclusively on his native region, exhibiting local views in the exhibitions of 1810 and 1811. By (May 1812) he could write, "I have succeeded most with my native scenes . . . I have now very distinctly marked out a path for myself, and I am desirous of pursuing it uninterruptedly."[125]

Both Turner and Constable desired to be original above all and avoid "mannerisms" or clichés. While certain academicians could not accept the sacrifices they made in the

3.42 John Constable, *Dedham from Langham,* 1802. Victoria and Albert Museum, London.

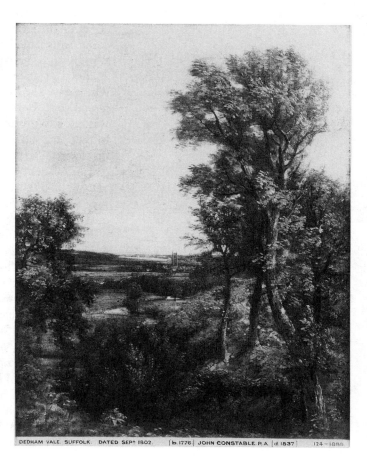

DEDHAM VALE. SUFFOLK. DATED SEPr 1802. [b. 1776.] JOHN CONSTABLE. R.A. [d 1837] 124~1888

interests of "lightness and freshness," Turner's early admittance to the Royal Academy and Constable's independent means allowed them to pursue their art unhindered. Defying the older convention of highly finished works, they threw their lot in with the impulsive "sketchers." Constable actually referred to his pictures as his children whom he hated to "abandon." It is clear that he longed to recover the world of his childhood and to convey that childhood wonder. Traditionally, sketches were categorized with the spontaneous activity of children—considered crucial first steps in the creative process but still requiring mature reflection and polishing. Hence Constable's need for originality in the context of his early associations is ultimately linked to his sketch experiments.

Constable and Bonapartism

Constable's work struck a responsive chord among his social peers in East Anglia (the larger geographical territory comprising the counties of Norfolk and Suffolk). The expression of native scenery during the Napoleonic period assumed a patriotic character, and the increased demand for wheat gave the local gentry a heightened sense of their regional contribution. Constable himself participated in the war effort with his own version of the Battle of Trafalgar. In 1806, the same year that Turner exhibited his *Trafalgar* at his own gallery, Constable showed a watercolor in the Royal Academy of *His Majesty's Ship Victory, Capt. E. Harvey, in the Memorable Battle of Trafalgar, between Two French Ships of the Line* (fig. 3.43). Constable had previously sketched the *Victory* in 1803, fascinated by its size and number of guns, but the subject of 1806 was immediately inspired by an account of the battle by a Suffolk sailor who had served on Nelson's ship. Constable's chauvinism is also shown in his loathing for the French painter David, whom he claimed was inspired by three sources, "*the scaffold, the hospital, and a bawdy house,*" and who produced a school that gave rise to "stern and heartless petrifications of men and women." [126]

Naturally, the opposition to Napoleon united all the English, but Constable turned to comforting farm scenes untouched by the drama of war or changing social relations, maintaining the illusion of a happy Suffolk (read "Britannia") impervious to invasion or popular revolution. Yet after 1810 relations between landowner, tenant-farmer, and

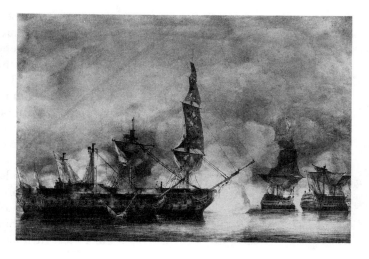

3.43 John Constable, *His Majesty's Ship Victory, Capt. E. Harvey, in the Memorable Battle of Trafalgar, between Two French Ships of the Line,* 1806. Victoria and Albert Museum, London.

laborer became strained, and riotous assemblies and petitions for redress were not unusual. The jump in the rural population and the increasing consolidation of farms brought a high rate of pauperization and landlessness, while the growing surplus of day laborers forced wages downward. The slack winter season was worst of all. The Luddite revolts and the downward economic swing inspired a wave of nostalgia among the landowning class and sustained Constable's fictional Arcadia. Though Arnold Hauser considered Constable modern because his figures were displaced from the compositional center, he failed to grasp the class implications of this displacement. Constable downplayed the role of his laborers because of his contempt for the unruly classes and because his particular idea of truth required their subordination to the orderly world of the enclosed land.

Constable's attempt to hold on to childhood impressions was not simply escapist, but an assertion against both internal change and external threat. As late as 1814, he kept a journal of daily walks around East Bergholt, in which he inserted "little scraps of trees, plants, ferns, distances, &c&c."[127] His collection of natural fràgments was a way of preserving the actual environment instead of merely remembering it—of tenaciously guarding the concrete facts of his village. If Turner and Martin appealed to their public by playing on the national anxieties and fears, responding to the tensions of the moment, Constable projected a safe, sane countryside unscathed by "war and rumors of war"—

though even his personal life was undergoing the pressure of a long engagement and opposition from the parents of his fiancée. When he wrote to her in May 1812 about Turner's *Hannibal,* ambiguous and unintelligible but nevertheless "novel and affecting," she replied with an apology for her long silence, and added, "What do you think of accompanying Sadak in his search for the waters of oblivion?"[128] This jesting indicates to what extent Turner and Martin had caught hold of the contemporary imagination. Even Fisher reflected this preoccupation in 1813 when he wrote Constable that his landscape in the Royal Academy exhibition was surpassed only by Turner's *Frosty Morning.* An in an ironic allusion to Napoleon's abortive invasion of Russia, Fisher counseled him not to bemoan this comparison: "You are a great man like Bounaparte [sic] & are only beat by a frost."[129] The strain of maintaining "Constable's country" took its toll on the artist physically and psychologically; he began to suffer in this period from chronic headaches, nervous anxiety, and indigestion.

Ironically, however, Constable's work remains very much a statement about the Industrial Revolution as viewed through the lenses of his class and political attitudes. His obsession with science—especially geology and meteorology—and its application to scientific farming found an appropriate outlet in his "natural" rural scenes. His consistent recording of his father's mills and locks document the central importance of the British system of inland navigation in facilitating the distribution of the agricultural and industrial products fostered by the Industrial Revolution. Constable's canal scenes show his father's locks, which permitted the raising or lowering of the barges from one level of the River Stour to another, and he even depicts the construction of barges at his father's dry dock. The canal system of eighteenth-century and early nineteenth-century Britain provided a greatly improved means of transporting bulk goods, in particular coal, at a time when the pressures of economic growth were rising to unprecedented levels. Secondly, it was a massive exercise in harnessing private initiative and finance. Canal companies were the only joint-stock enterprises widely sanctioned in the early Industrial Revolution. A wide range of people invested in canals, and certainly not just the landowners, but farmers, industrialists, tradespeople, and clergy, professional men living in the vicinity of the line of each scheme. Before the railway age, it was the canals that

introduced the well-off to the marketable share and the chance to invest and earn dividends. While the canal system was most often a response to local and regional needs, the total map of Britain's canals was the map of industrial Britain. Despite Constable's inevitable attempt to blend the canal system into his rustic setting, his glimpses show the integration of his surroundings into the general configuration.

Constable and Wordsworth

Thus Constable and Turner form the poles of English landscape painting during the Napoleonic wars while sharing in the same historical process and its intellectual currents. Both admired Thomson (whose verses Constable also appended to his work), Coleridge, and Wordsworth. Wordsworth and Constable are often paired, and with some justification: in addition to their mutual love of the rustic theme and its richly nuanced landscape textures, they shared Tory ideals, and a fascination for meteorology and geology, and cherished the childhood impression as the most telling form of "truth."[130] Sometime around 1829 Constable copied Wordsworth's famous poem that asserted the primacy of the childhood vision:

My heart leaps up when I behold
 A rainbow in the sky:
So was it when my life began;
So is it now I am a man;
So be it when I shall grow old,
 Or let me die!
The Child is father of the Man;
And I could wish my days to be
Bound each to each by natural piety.[131]

Their interest in the popular sciences is shown in their common attraction to the lunar motif; Constable's early landscapes make use of it, and Wordsworth writes movingly about the moon in his "Night-Piece" (1798) and "With how sad steps, O Moon, thou climb'st the sky" (1806). The poet's "I wandered lonely as a cloud" is well known, but the opening lines in "To a Sky-lark"—"Up with me! up with me into the clouds!"—exhibit a striking affinity with Constable's study of the stratocumulus cloud, which shows birds soaring skyward amid the clouds. Met-

aphors of "mist and rain, and storm and rain" abound in Wordsworth's poetry, and his piece entitled "Written in a Blank Leaf of MacPherson's Ossian" demonstrates that he fully absorbed the meteorological implications of that work as well.

Above all, they were linked by their participation in the social circle of Sir George Howland Beaumont (1753–1827), in whose house they first met.[132] Both poet and painter were variously subsidized by this Tory M.P. and fashionable landscape painter. Beaumont had the classic aristocratic passion for Claude, and arranged parts of his estate at Coleorton Hall, Leicestershire, to resemble the painter's picturesque views. He was also a close friend of Gilpin, whom he admired immensely. His bête noir was Turner, whose crudities and brusqueness offended him. Beaumont's mother, the dowager Lady Beaumont, resided at Dedham, where he made regular visits. Constable's mother obtained for her son an introduction to Sir George, who soon took the young artist under his wing. Beaumont introduced Constable to his Claudes (which marked "an important epoch in his life") and encouraged him in a conservative path, both in politics and (less effectively) in art. He did the same for writers he supported, like Coleridge and Wordsworth; the latter, who began as a republican and supporter of the French Revolution, ended by championing the aristocracy and their privileges. Wordsworth often stayed at Coleorton Hall, and like Turner, projected images of the landscape seen in and around the country seat. Wordsworth himself designed for Lady Beaumont a winter garden enclosed with evergreens. He dedicated the 1815 edition of his poems to Beaumont and, in addition, referred to the patron in such titles of his poetry as "For a Seat in the Groves of Coleorton" and "In a Garden of Sir George Beaumont, Bart." He even used the painted landscapes of Beaumont as the point of departure for poetic rhapsodies. Constable himself considered the picturesque grounds of Sir George as an enchanted "fairy land."[133]

Beyond Beaumont's parks and gardens the landscape was being changed by acts of enclosure. From 1800 onwards, the high prices of the war years made it profitable to bring more marginal land into cultivation. The old pattern of open fields, with grassy cart roads and paths, and strips of cultivation, the commons, and rough areas, became a vast checkerboard of squarish fields enclosed by fences and hedges and crossed by straight, wide roads. Wordsworth already accommodated his poetry to the new

landscape in "Lines Composed a Few Miles above Tintern Abbey":

These hedge-rows, hardly hedge-rows, little
 lines
Of sportive wood run wild: these pastoral
 farms,
Green to the very door; and wreaths of smoke
Sent up, in silence, from among the trees![134]

He went on to make a relevant comparison with a seventeenth-century painting that depicted formal divisions of highly cultivated land, noting that the hedgerows conducted the eye into the depths and created the striking "appearance of immensity." It was in this way that both poet and landscapist joined hands in celebrating private real estate in the guise of landscape. Years later, Constable painted the park setting of the monument Beaumont created at Coleorton to Sir Joshua Reynolds; in the catalogue he quoted the lines inscribed on the monument, which were written by Wordsworth at the request of the patron.

Similarly, the glorification of the land owned by the privileged elite signaled patriotic dedication to English values. When Constable wished to distinguish himself from the Italianate bias of Richard Wilson and Claude, he declared that he "was born to paint a happier land, my own dear old England"; and then he badly quoted[135] two verses from Wordsworth's ode, "On the Morning of the Day Appointed for a General Thanksgiving, January 18, 1816," celebrating Britain's role in the defeat of Napoleon and the ushering in of the Restoration. The original context of his quote follows:

O Britain! dearer far than life is dear,
 If one there be
Of all thy progeny
Who can forget thy prowess, never more
Be that ungrateful Son allowed to hear
The green leaves rustle or thy torrents roar.[136]

We may take these lines to mean the "green leaves" and "torrents" in the woods and gardens of Coleorton Hall.

Wordsworth's Response to Napoleon

Wordworth's political alliances were shaped by the Napoleonic wars. As a liberal and a Whig, he was appalled when

his party began calling for negotiations with Napoleon.[137] Regardless of how he may have felt about the values of the Tory party, it was enough that they were committed to the absolute defeat of Napoleon. While Beaumont's patronage at this time was no doubt another deciding factor in the poet's conversion to Toryism, it remained an ambivalent conversion, and Wordsworth continued his staunch support of abolition and the downtrodden on the Continent.

However, the Spanish uprising against its French invaders was to resolve England's doubts and ambiguities about the necessity of a military counterforce against Napoleon. Perceived by England as a classic showdown between good and evil, the country could experience a rare national unity with Spain against their common enemy, the French.

Wordsworth had closely followed the rise of Napoleon, writing several pieces on the French emperor as well as a series on the Peninsular War involving Spain. As early as October 1803—during the alarm of a French invasion of Britain—he wrote a short poem denouncing Bonaparte:

When, looking on the present face of things,
I see one Man, of men the meanest too!
Raised up to sway the world, to do, undo,
With mighty Nations for his underlings,
The great events with which old story rings
Seem vain and hollow; I find nothing great:
Nothing is left which I can venerate.[138]

By 1810, in his "Indignation of a High-Minded Spaniard," he could extend the metaphor of the colossus overpowering the weak:

We can endure that he should waste our lands,
Despoil our temples, and by sword and flame
Return us to the dust from which we came;
Such food a Tyrant's appetite demands:
And we can brook the thought that by his hands
Spain may be overpowered, and he possess,
For his delight, a solemn wilderness
Where all the brave lie dead. But, when of bands
Which he will break for us he dares to speak,
Of benefits, and of a future day
When our enlightened minds shall bless his sway;
Then, the strained heart of fortitude proves weak;
Our groans, our blushes, our pale cheeks declare
That he has power to inflict what we lack strength to bear.[139]

That same year, news of the opposition from Spanish guerrillas sparked Wordsworth's hope: "Where now?—Their

sword is at the Foe-man's heart; / And thus from year to year his walk they thwart, / And hang like dreams around his guilty bed." [140] Wordsworth's hopes were shared by countless Europeans who now detected for the first time chinks in the Napoleonic armor.

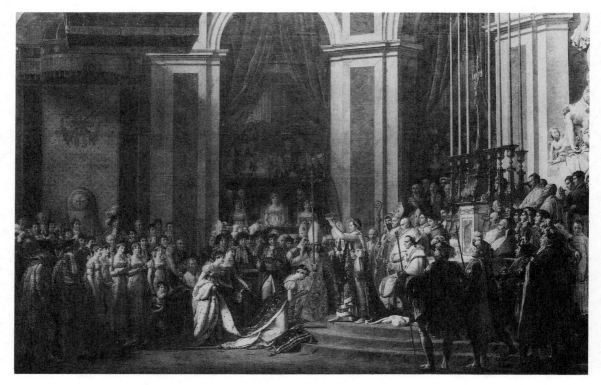

4.1 Jacques-Louis David, *The Coronation,*
1807. Musée du Louvre, Paris.

4 France and Spain

The internal politics of Spain and the French occupation of that country proved to be disastrous for Napoleon's strategy.[1] Originally, the two countries had a common interest in weakening British power in Europe and the colonial world. But their alliance brought only reversals for Spain, including the loss of her Louisiana Territory and (at the Battle of Trafalgar) most of her fleet. Domestically, things were no better. The royal household was the scene of scandal and bitter controversy. Queen Maria Luisa's lover, Manuel Godoy y Alvarez de Faria, had achieved astonishing ascendancy as prime minister with the king's blessing, but his methods angered large segments of the Spanish populace. He also had an enemy in Crown Prince Fernando, who was equally hostile to Godoy's protectors, the king and queen, but he had the trust of the people.

Napoleon looked on the internal situation with contempt and impatience and seized the opportunity to reorganize Spain himself.[2] The feuding King Carlos IV and his son Fernando were tricked, threatened, and bribed into abdicating, one after the other. However, confronted with the prospect of a French occupation, the gradual departure of the remaining members of their royal family, and the ultimate crowning of a Frenchman, the Spanish people rose in rebellion. On 2 May 1808 a furious crowd rioted with primitive weapons against French troops, who responded the following day with brutal reprisals. These bloody events galvanized the uprising into a sustained offensive against the French and pro-French Spaniards. Local notables organized juntas comprising rebel peasants, priests, and monks, and coordinated them with regular Spanish troops.

The troops were generally ineffective against the French,

but their lone victory at Bailén in July 1808 broke the aura of Napoleonic invincibility. The main brunt of professional military operations in what had now become the Peninsular War was sustained by the English under the command of Arthur Wellesley, later duke of Wellington. Meanwhile, thirty thousand Spanish guerrilla fighters harassed French troops, which kept the invaders constantly on edge and led to atrocities and reprisals that in turn escalated the war's bitterness. All told, the juntas, guerrillas, and British held a massive French army of nearly three hundred thousand troops pinned down in Spain and made it impossible for Napoleon to mobilize effectively elsewhere on the Continent. No wonder he referred to the war as his "Spanish ulcer." In addition, the example of resistance in Spain inspired other occupied Europeans to rebel against their French invaders.

If the conflict inspired the British liberal community, it proved a disaster for Spain's liberals. Torn between Napoleon's democratic innovations and the nationalist rebels, they fell into an untenable position between the two. Those who stood with the rebels managed to organize a provisional government in 1812 by convening the ancient parliament, the Cortes, and drafting a liberal constitution. When the French were finally expelled and Fernando VII took the throne, he tore up the constitution of 1812, restored the Inquisition and the power of the priests, revived censorship, and arrested the leading liberals. The main beneficiaries of the Spanish rebellion and the Peninsular War were thus the Spanish reactionaries and the British expeditionary force.

The Spanish painter, Francisco Goya (1746–1828), is one artist whose work attempts to deal with the cataclysmic changes in Spanish society brought about by the Napoleonic wars. Allied with both the court and the Spanish liberals who supported Napoleon's ejection of the corrupt monarchy, his work documents the ambiguities, contradictions, and horrors of these years. But before we can understand his profound contribution we must return momentarily to the French imperial court in formation to gain further insight into the machine that Napoleon forged to overwhelm the whole of Europe.

The *Sacre* and Napoleonic Domination

The Senatus Consultum of 18 May 1804 ordained that "the Imperial succession should thenceforth be vested in the di-

rect issue of Napoleon Bonaparte, natural and legitimate, descending always in the male line, by order of primogeniture, to the perpetual exclusion of females and heirs claiming through female descent." Napoleon's reign as emperor ushered in the machismo of ancient patriarchy, with himself exalted as immutable male authority. The coronation ceremony for the new emperor and empress, which took place on 2 December 1804, was choreographed to project this image. David was called upon to record the event, and it is through the medium of his painting that we gain a sense of Napoleon's power at that moment (fig. 4.1).

A few historical details will put the scene in context.[3] On 7 March 1796, just before leaving for Italy, Napoleon contracted a civil marriage with Joséphine Tascher de la Pagerie. When Pope Pius VII came to France in 1804 for the ceremony of the unction, he refused his blessing to a couple who had only been through a civil marriage. Consequently, on the night of 1 December, in the utmost secrecy, the religious marriage was performed by Cardinal Fesch, Napoleon's uncle and the French ambassador to Rome, with only two witnesses present, Talleyrand and Berthier. On the following day, 2 December 1804, the ceremony of the unction was celebrated at Notre-Dame with memorable pomp. Along the walls were ranged in full-dress costume for the occasion, according to rank, the officials and deputies collectively representing the French nation. The Gothic interior was decorated in an "updated" medievalism by Percier and Fontaine, who masked the interior with cardboard partitions, painted the vaults with stars as in the ancient Bourbon baptisms and marriages, and erected an elaborate tent-shaped vestibule on the outside. The occasion was more remarkable for its splendor than for popular enthusiasm. Napoleon was moving quickly towards the establishment of a system akin to that of the old monarchies. He wanted to be crowned with even more ostentation than the Bourbons, and by the pope himself. Pius VII had hesitated, but his anxiety over the still-tenuous Concordat made him finally accept. During the ceremony, Napoleon, in emulation of Charlemagne, took the crown of the Holy Roman Emperor from the pope's hands and set it on his own head. Next, he set the empress's crown on Joséphine and carefully patted it into place. While seemingly unprecedented and startling, the action was staged in advance and agreed to by the pope.

The entire ceremony was in fact a sham, for no one could have believed Napoleon's power to be hereditary.

Gillray's travesty of the procession goes straight to the heart of the charade, and the legend persisted that the caricature filled Napoleon with rage (fig. 4.2).[4] But if the drama at Notre-Dame fooled no one in this respect, it certainly demonstrated the firm control Napoleon had over Europe and his own country. When it had been suggested that the ceremony go public and take place out-of-doors on the Champs-de-Mars, Napoleon rejected the idea, to demonstrate that the populace no longer dictated policy. But the European elite were dazzled by the spectacle, as reported by the duchesse d'Abrantès: "All the great men of Europe, everyone at all notable in the sciences, the arts and in literature, came to this marvellous ceremony . . . never again shall we see such a *man,* a man who obliterated memories and surpassed expectations."[5] It mattered little that the emperor lost the admiration of inconsequential types like Beethoven, who removed his dedication to Napoleon at the head of his Third Symphony (the *Eroica*) when he learned of the imperial ambitions. It was enough that he captured the imagination of the ruling elites and the Parisian crowd, forcefully brought home by Boilly's picture-in-a-picture tribute, *The Crowd Standing before David's Painting of the Coronation* (fig. 4.3).[6] We know that Boilly himself was dutifully impressed, since he included a family portrait at the right of the picture and tried to ingratiate himself with the regime by a series of Bonapartist themes in 1808.

On 21 December 1804 Napoleon commissioned four pictures from David—proclaimed first painter to the emperor only a week before—to commemorate the coronation ceremonies centered on the *sacre* itself.[7] David had attended the ceremony and made numerous studies for the

4.2 James Gillray, caricature of the coronation procession, 1805. Henry E. Huntington Library and Art Gallery, San Marino, California.

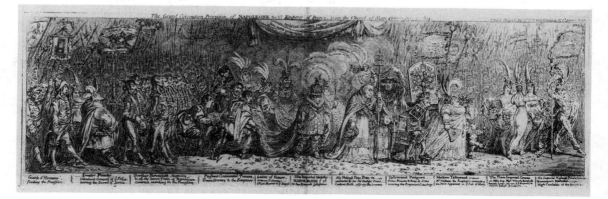

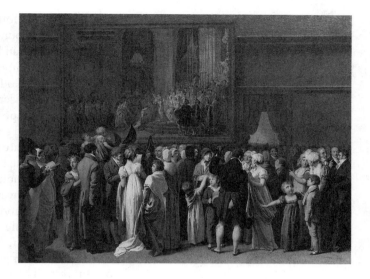

final picture, including portraits of the principal participants. He projected the scene on a gigantic scale (nineteen by thirty feet) and hired a set designer from the Opéra. Together they constructed a three-dimensional maquette of the cathedral interior into which David placed mannequin-type figures to establish proper light and shadow effects.

Problematic though it was, Napoleon wanted to publicize the renewed alliance of throne and altar for the sake of the aristocratic classes, and he certainly knew that religion was indispensable for keeping the underclasses in line. The pageant was designed for maximum glitter: the cardinals and bishops were advised to wear their miters draped with gold, while the magnificence of the embroidered costumes in the styles of Henri III designed by David and Isabey added the sheen of silk, satin velvet, and lace to the spectacle. Even his technique, with complicated glazing, was modeled after the Venetian school to convey the glitzy effect of Veronese's monumental *Wedding Feast at Cana*—part of Bonaparte's booty which set the standard for "imperial" pageantry. All the trappings of Catholic pomp and ritual were included, with the hierarchy of the church looking on. Napoleon nevertheless remained the supreme authority, shown at the point of setting the crown upon the head of the genuflecting Joséphine. In fact, the duchesse d'Abrantès claimed that Joséphine appeared to be praying to Napoleon rather than to God, and the new Sunday school catechism stated authoritatively that the emperor reigned through "the order established by God himself,"

setting out the following question-and-answer exercise: "Why are we bound to love, respect, obedience, loyalty, military service, and taxes ordered for the preservation and defense of the Emperor and his throne?" And the response: "First, because God, who creates Empires and apportions them to His will, set him up as our sovereign and made him the agent of His power and His image on earth. Thus it is that to honor and serve our Emperor is to honor and serve God himself." Naturally, those who are derelict in their imperial duty expose themselves to "eternal damnation." [8]

David's enormous machine, depicting well over a hundred figures, conveys the emperor's capacity to regiment French society and to summon seemingly limitless resources. While originally David planned to show Napoleon crowning himself, his definitive idea in fact magnifies the ruler's position in pointing to his power to bestow the title of empress. The order of the ceremony and rigidly held poses indicate far more than the compositional exigencies of the painter; they exemplify the formality and uniformity of a military procession. The look of tedium and monotony results from Napoleon's power to organize the political and social fabric of France. We have come a long way from the *Oath of the Tennis Court,* with which it may be compared: the enthusiasm and energy of real social change have been supplanted by formalized ritual and the weight of oppressive authority. It is closer in this sense to Trumbull's *Signing of the Declaration of Independence.* Unlike that work, however, where the central motif alludes to a political collectivity, David's picture is dominated by the overwhelming authority of Napoleon, and every object and person portrayed is keyed to this dominant presence.

David depicted himself in the upper box with his family and friends in the Institut, including his ex-master Vien. The artist's look of intense concentration on the central action, as well as the inclusion of Vien, with whom he had had a severe falling out over the Revolution, attests to the fundamental change in his ideological position. He even justified the inclusion of the older artist as a way of rendering homage to the one who had prepared him for "the most important of my works." [9] The diagonal direction of David's gaze carries us past Napoleon to the group of five striking figures in the right foreground, who loop around to embrace the main action and act as a powerful dark *repoussoir.* They were Napoleon's most influential advisers: starting from the end, holding the scepter, is the financial wizard Lebrun; next, holding the Hand of Justice, is the

legal genius Cambacérès; on his right is his military confidant Berthier, followed by the grand chamberlain Talleyrand, who is singled out by his ample cloak. Finally, just above him is Eugène de Beauharnais, Bonaparte's stepson, now a prince of the empire and soon to become viceroy of Italy.

David spotlights further the cream of French society during the empire, Napoleon's brothers and sisters who would soon be appointed to govern subjugated lands. Indeed, the work is basically a "family portrait." While the family had a hard time accepting Joséphine, the emperor's persuasive skills swept all before him, and in David's picture they watch with rapt admiration. His brother Joseph, who threatened to absent himself if Joséphine were crowned empress, is shown in profile at the far left as the mainstay of both the familial hierarchy and the pictorial organization. Next to him on the right is brother Louis, followed by sisters Caroline, Pauline, and Elisa, Louis's wife Hortense (Joséphine's daughter), and Joseph's wife, Julie Clary, and their son. Moving to the center, just behind the empress, is the standing General Murat, husband of Caroline Bonaparte. Directly behind him, seated majestically in the loge, is Napoleon's mother, Letizia Bonaparte, who received the title "Madame Mère." Although actually in Rome at the time of the ceremony, here she is given place of honor and a key formal role as one point of an upturned triangle embracing Joséphine at the opposite end and Napoleon as the vertex. She looks on with maternal self-esteem, a state of mind reflected in Napoleon's whispered remark to Joseph at the ceremony: "If father could only see us now!" [10]

The combination of doting mother and passive wife exemplify the emperor's view of women. Under the empire, the mother had no voice in the control of her children and the father was absolute. He could imprison his child without any writing or judicial formality. Napoleon's Civil Code asserted the authority of the father, and the despotism of the state declared itself in the structure of the family. This paternal dominance is reflected in Bonaparte's statement, "As the head of the family is absolutely at the disposition of the government, so is the family absolutely at the disposition of its head." Indeed, Napoleon despotically ruled over his own family as he ruled over the state.

Accordingly, the civil status of women was systematically depressed. A woman could not be accepted as a witness to the acts of the civil state; as a wife she was subject

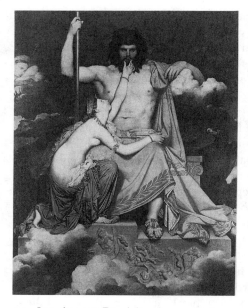

4.4 Jean-Auguste-Dominique Ingres, *Jupiter and Thétis*, 1811. Musée Granet, Aix-en-Provence.

to her husband and had no voice in the administration of their common property. The woman of the Civil Code is represented as nearly mindless, and female lapses from virtue are punished far more severely than those of the male. Napoleon thought that the husband should have the right to control almost every phase of his wife's daily life—when she should go out, who she should see, what she should think.

Not that Napoleon failed to recognize female power when it confronted him. He both feared and respected Anne-Louise-Germaine de Staël (1766–1817), his greatest female antagonist. She threatened him with her skillful political maneuvering and the intellectual influence she wielded over officials in his government, literati, and even members of his own family. He did everything possible to isolate her from his court, exiling her from Paris in 1803. On her side, she resisted his hints to climb aboard the bandwagon and to glorify his regime, on the contrary never losing an opportunity to needle him by her courageous criticism of the oppressive climate he established in France. He seized and destroyed the proofs and plates of her first version of *De l'Allemagne* (On Germany), which set up an idealized image of Germany over and against Napoleonic France. Bonaparte earlier had attacked her novel *Delphine* (1802) for its feminist principle, calling it "antisocial." Actually, she was not so much concerned with equal or legal rights of women (she was a classic moderate liberal who feared "mob rule"), but she advocated a society in which gifted women would not be judged by a different code from males. Here she sharply opposed Napoleon's conventional view of women.

Only on the issue of divorce did they concur. The problem of divorce fascinated Bonaparte; while his views on the subjection of women and the value of family cohesion militated against the idea, he also felt that divorce might serve his own purpose, and that within certain limits it was a social necessity. Eventually, he used his divorce law to dissolve his marriage with Joséphine on the grounds that she failed to produce a Napoleonic heir.

Ingres's painting of *Jupiter and Thétis,* completed in 1811 to fulfill his annual obligations as a pensioner at the French academy at Rome, expresses the heavy male bias of the regime (fig. 4.4).[11] The omnipotent male portrait is set off by the beseeching, diminutive Thétis. That this dramatic contrast of male power and female subservience sprang from a melding of the artist's fantasies and the politics of Napoleon

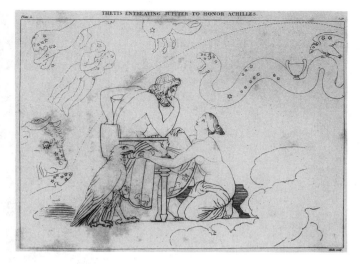

4.5 John Flaxman, *Jupiter and Thétis*, engraving, plate 5 in *The Iliad of Homer*, 1805.

is quickly seen when it is compared with one of its sources, Flaxman's illustration of the same theme, which poses the figures on a more equal plane (fig. 4.5). Not surprisingly, Bonaparte—disappointed in his attempt to produce an heir—divorced Joséphine and remarried in 1810. His new wife was Marie-Louise, daughter of Maria Teresa of the Two Sicilies and Emperor Franz of Austria, who arranged the marriage for strictly political reasons. Napoleon in turn regarded her as a sensual, submissive being charged exclusively with the mission of conceiving a male offspring. She certainly regarded her husband with an admixture of fear and awe. Thétis's entreaties on behalf of her son Achilles may also have suggested a further allusion to Napoleon's son, born on 20 March 1811 and named the king of Rome. Finally, the link between the enthroned Jupiter and Napoleon was inevitably established by their complementary animal totem, the eagle, and carried through in the popular imagery of the period (fig. 4.6).

For a different perspective on the relationship of Marie-Louise and Napoleon we have to turn to the work of Pauline Auzou, a popular female painter of the period. Well known as a teacher, Auzou had trained under Regnault and began her career as a neoclassicist. Typical of such artists during the Napoleonic epoch, she inclined under governmental pressure to the depiction of actual events. Her most important commissions were a pair of pictures portraying the new empress for the Salons of 1810 and 1812. The first, *The Arrival of Her Majesty the Empress in the Reception Room of the Palace of Compiègne,* shows the newlyweds greeted at

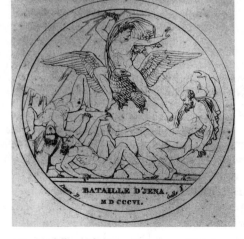

4.6 Medallion of Jupiter-Napoleon, 1806, in C. P. Landon's *Annales de musée,* Salon of 1808, vol. 2.

their honeymoon site by the Bonapartist princesses and ladies-in-waiting, who shower Marie-Louise with bouquets and floral wreaths (fig. 4.7). Auzou makes the empress the dominant figure, while reducing her spouse to the modest position of bystander gazing upon her with complete adoration.

The more important of the two pictures, *Her Majesty the Empress, before Her Marriage, at the Moment of Taking Leave of Her Family, Distributing Her Mother's Diamonds to the Archdukes and Archduchesses Her Brothers and Sisters,* positions Marie-Louise frontally like a pillar of strength and love around which the family affections revolve (fig. 4.8). Her sad mother retires to a dark corner in the background to contemplate the daughter's departure, while the young siblings are too preoccupied with the gifts to register their sister's farewell. Auzou specialized in family drama, typical of a number of women artists who exhibited at the Napoleonic Salons. One example entitled *Departure for the Duel,* exhibited in 1806, centers on a young man leaving in the wee hours of the morning to defend his honor by dueling with a hardened assassin who insulted him. He casts a last look at his sleeping wife and child, knowing that he is heading for certain death and that he will take his family with him to the grave. As the critic Chaussard observed, the family will not be able to support themselves, with the wife "condemned to seduction and the child to poverty." [12]

Auzou's pair of paintings were conceived just after the imperial marriage, concentrating on the good will and af-

fection that would be sorely tested in the next few years. Marie-Louise could never win the hearts of the masses of French people, who loved Joséphine and resented the new intruder, who, like Marie-Antoinette, had descended from the Austrian nobility. She reciprocated by never learning French and maintaining a discreet isolation. But if she never became a popular idol or heroine, she enjoyed deep esteem and affection within courtly and official circles. Auzou ingeniously spotlights Marie-Louise within her familial and courtly domains, the superficial and narrow spectrum of society where she retained dominance and the love of her peers.

But Auzou's vision is the exception. The patriarchal legacy of history has saddled us with the myth of the overarching authority of the emperor. Ingres's wish to project this mythical ideal of male superiority could only be achieved at the expense of the academic norm. Secure in his official backing, he could risk the academy's ire at what they perceived as a fundamental departure from their standards. The academy claimed that Jupiter's head did not conform to the nobility and deific grandeur of the subject, that his torso was grotesquely exaggerated in the upper portion and too narrow where it connected with the shoulders. They further observed that Thétis's head was forced back in an impossible position and that it was difficult to make out which leg was attached to her right thigh. In short, the academy accused the young Ingres of having invented his own "system."

4.8 Pauline Auzou, *Her Majesty the Empress, Before Her Marriage, at the Moment of Taking Leave of Her Family, Distributing Her Mother's Diamonds to the Archdukes and Archduchesses,* Salon of 1812. Musée national du château de Versailles.

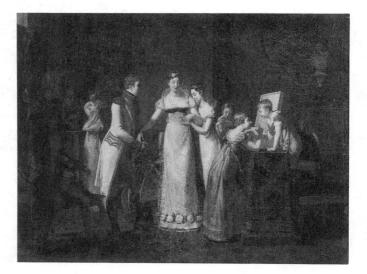

While Ingres steeped himself in classical sources to execute this work, there seems to be no precedent for Jupiter's colossal bulk and hulk. Ingres taught his students to seize the essential character of a model: "When sketching a strong person, do not settle for a half-way resemblance; grasp wholly the Herculean character."[13] His pictorial inflation served imperial propaganda needs even though it collided with the academic ideal still influenced by David's classicism. In many ways, Ingres's *Jupiter* is the mythical counterpart of his *Napoleon I on the Imperial Throne*. The emperor's reign, with its hybrid political and cultural system, ushered in new forms such as practiced by Ingres and Girodet. Ingres's Jupiter is a vulgar, slovenly being with all the grandeur of a man sitting in a steambath—a humanized immortal just as the *Napoleon* was a godlike mortal.

Thus the *Jupiter* amplifies one of the many facets of imperial power incarnated in David's *Coronation*. David recorded with razorlike acuity the impact of the Napoleonic dominion on French life. The capacity to forge this awesome machine depended on social regimentation and tyrannical exploitation of gender, class, and vulnerable neighboring countries. The corollary of domestic repression was oppression of other nations. Napoleon masked his aims, as Wordsworth divined, by posing as the liberator of downtrodden peoples and as an extension of the Revolution. The French masses supported him as long as French arms led to victory; he seemed to stand for popular sovereignty and the defeat of those enemies who would restore the old order. By toppling other regimes and spreading ideas of the Revolution, Napoleon consolidated French power at home and stimulated the rise of nationalism abroad.

Goya and *The Third of May, 1808*

David's picture was completed in November 1807, and the following January Napoleon visited the artist in his studio, where he paid him the highest honor in admitting, "You have understood my thoughts."[14] The *Coronation* was exhibited that summer at the Salon of 1808 together with the *Intervention of the Sabine Women*—another drama of usurpation by force. It was between the interval of the painting's completion and exhibition that Napoleon invaded Spain. By the Treaty of Fontainebleau in October 1807, Spain agreed to assist France against Portugal, whose sea-

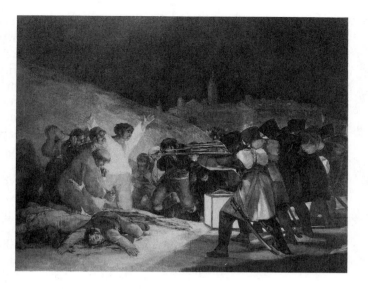

ports the emperor wished to close to British trade. King Carlos IV was lulled into the treaty out of fear and on the condition that Portugal would be divided between Spain and France. Napoleon, however, under the pretext of reinforcing his army in Portugal, began pouring troops into Spain, and by the end of February 1808 his true intentions were revealed. The machine implied in the *Coronation* now began to roll southward, with Napoleon assisted at the controls by brother Joseph, and the generals Murat and Junot (the duc d'Abrantès).

No painting of the period demonstrates more effectively the contradictions of Napoleonic ideology than Francisco Goya's *Third of May, 1808,* painted in 1814 (fig. 4.9).[15] In depicting the systematic execution ordered by Murat of Spanish patriots who had rebelled against the French occupation troops the day before, it is the obverse of the David scene, the brutal reality glossed over by the imperial glitter. The executioners line up in precise, faceless anonymity (Murat was especially concerned with troop discipline to please Napoleon and demonstrate his competence), in striking contrast to the emotional and physical disarray of condemned Spanish prisoners.

The drill stance of the firing squad—now functioning inversely to the meaning of the alignment of David's *Horatii* but dialectically related to it—the precision of modern weaponry and the military discipline, was based on the memory of an actual event that Goya may have even witnessed. At the same time, the artist picks up on another

significant detail that defines the relationship between Napoleonic ascendancy and contemporary technology. The scene is illuminated by an unusually large lantern—at least two feet high—with glass sides. This lamp must have been lit by oil or carbon gas, and it may be recalled that the first public exhibition of gas for lighting and heating took place in Paris in 1801 under the auspices of the then First Consul. Ironically, the Napoleonic wars had interfered with the supply of whale oil and Russian tallow, and as a result of the increased cost of lamp oil and candles, new sources of light were explored. Napoleon also encouraged the industry to find new ways of lighting the front lines to protect his troops against nocturnal attacks.[16] In Goya's picture, the full strength of the powerful lamp is aimed at the victims. The two most brilliant features of the painting are the lamp and the central martyr who confronts his executioners with upraised arms. The direct association between the two is seen by the captive's white and yellow clothing, mirroring the colors of the lamp sides. Goya sought to demonstrate the use of Napoleon's military genius against the people, the application of science and industry for repressive ends. Like his contemporaries in England and France, Goya was fascinated by unusual light effects, and this fascination as well as his incorporation of it in a visual structure are marks of his modernity.

Goya's Portrait of the Royal Family

If Goya's *Third of May, 1808* illustrates a turning point in what the English call the Peninsular War, his earlier picture of *Carlos IV and His Family* catches the inherent weaknesses of the Spanish monarchy (fig. 4.10).[17] As the most significant of his royal commissions as first painter to the king, the family portrait is often cited as an example of the artist's freedom to treat his patron with scorn and still get paid for it. Nothing could be further from the truth: poorly designed and painted without the certainty of his other portraits of the royal family, the picture is no less degrading for the author than for its subjects and thus cannot be read as satire.

At the time Goya painted the royal family he was earning 50,000 tax-free reales annually plus 500 ducats for the maintenance of a carriage (approximately $53,000 in today's currency). His livelihood depended on the royal family, and he could hardly afford to antagonize them. He made careful studies of individual members of the royal

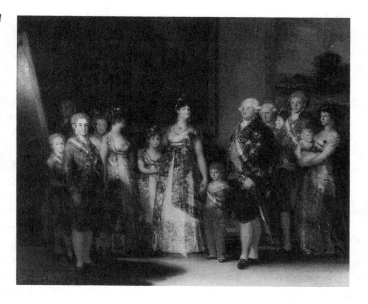

4.10 Francisco Goya y Lucientes, *Carlos IV and His Family*, 1800–1801. Museo Nacional del Prado, Madrid.

household before undertaking the final canvas, and we know from correspondence that the sitters were delighted with the preliminary sketches. In some ways, Goya's subjects look no worse than those of any other domestic group portrait, though his depiction of the royal family is not what would be expected.

Neither the queen nor the king occupies the compositional center or constitutes its main focus. The figures of María Luisa and Carlos IV are separated by the Infante Francisco de Paula Antonio (age 6), rumored to be fathered by the queen's lover and the virtual dictator of the royal machine, Manuel Godoy. The child literally and figuratively comes between the king and queen and prevents them from assuming the psychological focus of the composition. The two are further segregated by the corner of the large picture hanging on the wall behind them. While María Luisa is closest to the physical center, she is set back in the picture, and Carlos IV advances nearer to the frontal picture plane, which somewhat compensates for his off-center position. Carlos is balanced at the far left by the crown prince, the future Fernando VII, who stands ominously in the shadows. Behind him and just to the right, the birdlike visage of the king's elder sister, María Josefa, pokes forward as if making an effort to be seen. There are other disconnecting elements: the bride-to-be of the prince of Asturias (Don Fernando) was conveniently absent (she was described as being excessively ugly) and she is shown facing away from

the viewer; the head of the eldest daughter of Carlos IV is glimpsed in profile at the right; and finally Goya includes a portrait of himself, at his easel in the left background and staring directly at the viewer.

Goya was certainly aware of the compositional disunity of the picture, since the group in the painting on the wall forms a tightly-knit pyramidal structure. In contrast, the royal family sways uneasily in an undulating line gazing off in a number of directions. It is not simply that this is an example of Goya's democratic attitude transforming a ceremonial picture into a casual family portrait (the full regalia of their attire belies this), but that Goya has succeeded in capturing the authentic social relations of the court. The real locus of power, Godoy, who ran the administration with loyal followers, is absent. (Even in actuality Godoy carefully kept to the peripheries of courtly space when the royal family received guests.) The king, profoundly influenced by the queen and content to let the talented Godoy manage affairs of state, has little actual presence in the picture. The queen actively confronts the spectator and cocks her head energetically in contrast to her passive husband. The prince of Asturias, who hated Godoy, is shown alert and waiting in the wings for his opportunity. But there is no dominant, authoritative motif because actual political power issued not from the throne, but from behind it.

Contrast this image of the Spanish royal family with David's *Coronation* and it may be immediately grasped how the two paintings embody the respective social relations of the two regimes. Goya's position as first painter is analogous to that of David's under Napoleon, and both have sufficient status to allow themselves the privilege of including themselves in their pictures. David, however, who had to fight to win a decent place during the ceremony, locates himself in an upper box quite removed from the main action, while Goya assumes a much more fundamental role in the composition and is located on the same plane as the royal family. Naturally, the events are quite unlike, with one a ceremony of unbelievable pageantry and the other occurring in intimate chambers. Nevertheless, for David the locus of power is unmistakable, including his relationship to it, while for Goya it is less certain. The lack of communication among the various members of the Spanish royal family demonstrates a vagueness about courtly position, and a want of energy to assume control. Moreover, it is not surprising to learn that Godoy was a major patron of Goya in this period; Goya painted him as a war hero and

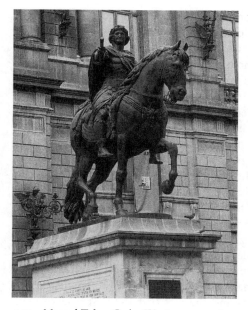

4.11 Manuel Tolsa, *Carlos IV*, 1803, equestrian statue. Secretaria de educación publica de Mejico, Oficina de monumentos coloniales y de la republica, Mexico. Photo by Susan Masuoka

did a number of commissions at his behest, including the celebrated *Majas*. Thus the painter, no less than David, enjoyed a direct contact with the actual seat of authority and in this sense functions as Godoy's alter ego in the background of the portrait.

Tolsa and Carlos IV

Goya's perception of Carlos IV arose from the political realities which the painter experienced close up. Other contemporary portraits of the Spanish monarch are less degrading and help clarify the distinctive historical features of Goya's picture. The most impressive example is by Manuel Tolsa (1757–1816), a sculptor and architect born in Valencia.[18] Like Goya, he held memberships in the Academy of San Carlos in Valencia and the Academy of San Fernando in Madrid. In 1791, however, Tolsa accepted an appointment as director of sculpture in the Academy of San Carlos in Mexico City. Eventually, he became one of New Spain's chief masters, helping to complete the construction and decoration of the Cathedral of Mexico and designing his masterwork, the Palacio de Minería.

In 1796 Tolsa received a commission for an equestrian statue of Carlos IV for the Plaza Mayor in Mexico City—the great plaza in front of the cathedral, now known as El Zocalo (the pedestal) in tribute to the monument. (The work has since been removed and now stands across from the School of Mines.)[19] Completed in 1803, its presentation of the ruler is diametrically opposed to Goya's image (fig. 4.11). Tolsa fashioned *Carlos IV* in the mode of the great equestrian monuments of the past, giving him the air of a regal commander in the field. While we recognize the same round chin, long nose, and tight-lipped mouth (reminiscent of Stuart's portraits of George Washington) we find in the Goya, the resemblance ends there. Tolsa's Carlos IV wears classical armor and a laurel wreath, carries a scepter in a powerful right arm, and is totally in control. Goya's king is portrayed as portly and ungraceful, Tolsa's as authoritative and elegant.

The sculptor's work (nicknamed affectionately in Mexico as "El Caballito") could be idealized in the neoclassic style partly because of Tolsa's remoteness from the Spanish court, and partly because of New Spain's position in the colonial hierarchy. As a Peninsular (a native-born Spaniard), Tolsa enjoyed the advantages of the most privileged social group, an identification seen in his commission for

the School of Mines, an institution founded on the single most important source of income in New Spain. The mineral wealth of the colony more than doubled between 1750 and 1804, while the production of silver alone equalled the total output of the rest of the world. The principal beneficiaries of this wealth and of the viceroy's enlightened despotism were the Peninsulars.

This social advantage was threatened in the 1790s by the French war of 1793–1796 and the British war of 1796–1801, which brought on a plague of financial burdens, privateers, and the interruption of communications with the parent country. Relations between Spain and New Spain grew strained as the colony found itself forced to trade with neutrals and even with the enemy. In addition, the upheavals exacerbated the local struggles for political power between the Creoles (native-born Mexicans of Spanish ancestry) and the Peninsulars. Creoles mainly of the mercantile and professional classes chafed under the Spanish commercial restrictions and the fact that the best government posts usually went to the Spaniards. Creoles began organizing conspiracies in this period, and while they were easily suppressed, they formed the backdrop for large-scale rebellion and the push for independence in the next decade.

Thus at a time when foreign wars, civil strife, and economic crisis rent the social and political fabric of New Spain and disrupted the links with the parent country, Tolsa attempted to impress upon the populace a memorable image of royal authority. It is noteworthy that his conception took the form of a familiar sign of power and prestige, the proverbial "man on horseback." Each of the four sides of the original base contained a circular medallion representing one of the four corners of the globe. Beneath the hooves of the horse is a quiver (belonging to the native people?), recalling the triumphal motif of the Marcus Aurelius on the Capitoline in Rome, which had a horse trampling a bronze barbarian. Tolsa's proud victor was perhaps less authentic than Goya's "corner baker," but it answered to the needs of the reigning classes at a critical juncture of New Spain's history.

Goya's Career up to the Napoleonic Invasion

A review of Goya's career as it unfolded in the context of the main historical developments in Spain leading up to and encompassing the Napoleonic invasion, its reception, and its aftermath will help clarify his visual practice.[20] He was

born in 1746 in the village of Fuendetodos, near Zaragoza in Aragón, when the country was regionally compartmentalized and the natives thought of themselves as Catalan, Castilian, or Aragonese rather than Spanish. The aspiration toward nationalism began in Goya's lifetime and is exemplified by his upwardly mobile career. After his elevation to court painter in Madrid, the capital of Spain became central to his work, while the Puerta del Sol—the heart and nerve-center of Madrid—became the hub of his professional activity. In fact, the Puerta del Sol was the site of the uprising against Napoleon on 2 May 1808 which inspired his pendant to the *Third of May.* Just as Goya's topography sparked nationalistic and patriotic associations for the triumphant return of Fernando VII, so his earlier topographical recordings document his own rise from provincial status to courtly rank as a reward for fealty to king and country.

Previous governments failed to achieve centralized administration in Madrid until the advent of Carlos III in 1759. Extending the policies of his father and elder brother, Carlos III assumed the mantle of "enlightened despot." As such, he launched major social and bureaucratic reforms, espousing the strategy known as "regalism." While the regalists subscribed to conventional Catholic doctrine, they played down the international character of the church and put the state's importance above it. Carlos even attempted to reform the church and improve the quality of the episcopate. In 1787 he and Floridablanca—who headed the royal government—drew up a program to improve teaching methods of the clergy in mathematics, science, and economics, encourage the abolition of superstitions, and help restore the religious orders to their pristine forms.

Carlos wanted Spain to match the progress of other leading nations; although a descendent of the Bourbons and predisposed to French culture, he brought in foreigners from every major European state to achieve his reforms. Italians and Irishmen served in his government, Prussians and Englishmen advised him on military matters, French and Dutch entrepreneurs and craftsmen worked in commerce and industry. His efforts to spread culture in Spain attracted the internationally renowned painters Anton Raphael Mengs and Giovanni Battista Tiepolo to his crusade. Although both were gifted decorators, they stood for opposing stylistic aims. While Mengs was spearheading the new classical revival, Tiepolo represented the last vestige of the Italian baroque-rococo tradition. Be-

tween them, they generated a lively cultural atmosphere at the moment Goya reached adolescence. Indeed, Mengs's rigorous study of the human body and Tiepolo's swash-buckling ceiling techniques (reinforced by the tradition of Velázquez and Rubens) provided the immediate ground-work for Goya's own unique synthesis.

Goya's first commission of true importance, the series of tapestry cartoons for the Royal Tapestry Works of Santa Bárbara, came to him through the intervention of Mengs.[21] This commission eventually helped secure him an appoint-ment to the court in 1786, so that Carlos III and Goya be-came good friends in the last years of the king's life. A ma-jor economic enterprise, the royal tapestry manufactory was modeled after the Gobelins factory established by Louis XIV and Colbert. The factory employed eighty men and women who worked exclusively for the king, making and repairing all the tapestries and carpets for the royal res-idences.[22] That Goya's career should unfold within a craft context is no coincidence. His father was an artisan, a mas-ter gilder who worked for the local churches in and around Zaragoza. Since gilding is a form of painting, the gilder was known as the *pintor de imaginería* or "image painter."[23] The master gilder was generally responsible for decorating the monumental choir screens or *rejas,* and for gilding or coloring sacred furniture and interiors such as altars, pan-els, doors, and ceilings. Thus Goya followed in the foot-steps of his father as a potential master craftsman.

At the age of fourteen, Goya was apprenticed to José Lu-zán, who trained both fine and applied artists. Luzán initi-ated Goya into the copy of prints, the common method of pedagogic indoctrination for artist and artisan. A native of Zaragoza, Luzán had been educated at the expense of the Pignatelli family—the counts of Fuentes who ruled over Goya's hometown of Fuendetodos. Ramón de Pignatelli, a canon of the cathedral of Zaragoza who supported the king's regalist policy, was famous for his encouragement of the economy of Aragón. In 1772 he took over the plans for the Royal Canal in Aragón, and in the next decade he founded the highly active Royal Economic Society in Zar-agoza. His friend and business partner, Don Juan Martín de Goicoechea, founded a spinning factory in Zaragoza, was a fellow member of the Royal Economic Society, and single-handedly financed an industrial drawing school to promote local textile design. Both Pignatelli and Goicoechea helped Goya early in his career, and later, when a successful court painter, he reciprocated by doing their portraits.

Goya depicted both men wearing the cross of a knight of the Order of Carlos III, serving as a reminder that the economic activity they inspired was stimulated by the king's reform policies which aimed at industrial expansion, increased employment, and the unfreezing of commerce. In his desire to step up education in the arts and crafts and spread knowledge of the latest technological advances, Carlos III also encouraged the founding of the popular economic societies known as the Amigos del País (friends of the country).[24] These societies were directly concerned with improving the economy of the country; the first society was the brainchild of a Basque nobleman. The stated purpose of the first Amigos del País was to encourage agriculture, industry, commerce, and the arts and sciences. The king became patron of the society, which now added *Real* (royal) to its title. Provincial nobility were urged to follow the model and open the new associations to all ranks and classes. In 1775 a similar institution was established in Madrid, and thereafter economic societies sprang up in cities throughout Spain. The Sociedad Aragonesa at Zaragoza advanced the education of young females, ran a drawing school, established chairs at the local university in commerce and civil economy, and offered prizes for memoirs and practical achievement in the fields of agriculture, arts, commerce, and natural history. Artisans were invited to participate and improve their knowledge, in an attempt to realize the hopes of the king and his attorney general (*fiscal*) Campomanes for a prosperous artisan class. Carlos III tried to implement this ideal by weakening the guilds (*gremios*), which were exclusive monopolies. In 1777 all *gremios* were ordered to admit craftsmen from other parts of Spain and even Catholic foreigners, and seven years later women were authorized to work at suitable jobs regardless of contrary regulations of the guilds.[25] At the same time, Carlos III wished to remove all social stigma from manual labor; occupations like those of tanner, smith, shoemaker, and carpenter were declared honorable callings for nobles. Thus we see that Goya's work unfolds within the development of major economic and cultural innovations inspired by Carlos III.

This flowering of industry and trade and the arts demonstrated the effectiveness of the convergence of regalism with the reform spirit. The series of tapestry cartoons executed by Goya at this time represent the full spectrum of Spanish life and testify to the nationalism engendered by the king's policies. But he was not unique in this respect;

his mentors and future brothers-in-law, Francisco and Ramón Bayeu, also produced tapestry cartoons depicting a similar range of Spanish life and customs.

During the period 1775–1792, Goya painted a total of sixty-three cartoons for Carlos III and the prince and princess of Asturias (the future king and queen). The cartoons were destined for the royal residences at El Pardo, located fifteen kilometers northwest of Madrid near the River Manzanares, and San Lorenzo de El Escorial, a major complex of monastery, basilica, and palace outside Madrid. Generally designed in broad surface patterns and light tonalities to harmonize with the stuccoed and gilded interiors, the cartoons depict—according to one contemporary French traveler—"an accurate representation of the manners, the diversions, and costume of his native country." [26]

The Injured Mason (fig. 4.12), executed in the period 1786–1787, points to a decree issued by Carlos III in 1778 requiring all scaffolding for royal or public works to be safely constructed to protect the workers from accidents. [27] This legislation was enthusiastically acclaimed by the advanced minds of the day (*ilustrados*) as a model of humanitarian regulation. The theme exemplifies the king's concern for the lot of the craftsman and is highlighted by the conspicuous network of scaffolding that dominates the background. The work may be viewed as a kind of royal propaganda done in the period immediately following Goya's appointment as *pintor del rey* (painter to the king). Goya's long, vertical composition, almost half of which is given over to sky, and its simplified light-and-dark pattern indicates its decorative intent and appreciation of the weavers' requirements.

An earlier cartoon, *The Crockery Vendor* of 1778 for the palace of El Pardo, is still another example of the preoccupation with the crafts (fig. 4.13). A fashionable woman gazes wistfully out of the window of her luxurious coach as it passes through a pottery market (the new prosperity allowed some women to leave home for the theater), while on the ground two middle-class women wearing fancy white lace mantillas, and a coarsely clad old woman, inspect the wares. Here the pottery market becomes a site for an interaction of the classes, whose distinctions are nevertheless well defined. The diverse social positions are united by gender and by their manifest fascination with the potters' products.

Spurred on by the notoriety of Sèvres in France and Wedgwood in England, the crown made sustained efforts

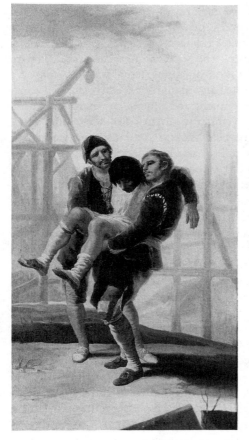

4.12 Francisco Goya y Lucientes, *The Injured Mason*, 1786–1787, tapestry cartoon. Museo Nacional del Prado, Madrid.

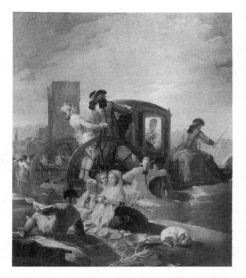

4.13 Francisco Goya y Lucientes, *The Crockery Vendor,* 1778, tapestry cartoon. Museo Nacional del Prado, Madrid.

to revive the Talavera potteries, known for its imitations of Italian majolica and blue oriental china, and even founded a Royal Porcelain Factory in the Buen Retiro Park of Madrid, popularly called the "Fabrica de la china." The factory employed a multitude of workpeople and their families who produced every kind of porcelain, including imitations of Wedgwood's blue jasper ware. Like the Royal Tapestry Works of Santa Bárbara, the object of the Buen Retiro factory was to supply luxury items for the royal residences. Carlos III's liberal minister, the conde de Aranda, a leading *grande* of Aragón and *ilustrado,* owned a major pottery works at Alcora which had an annual output of three hundred thousand objects, while the conde de Floridablanca ordered a full-scale report in 1785 of the famous gilded pottery factory at Manises. In Goya's native region, the potters greatly benefited from the government's involvement in their craft, and Zaragoza became a major center for the production and marketing of earthenware.

Goya's *Crockery Vendor* celebrates the government's ideal of a prosperous and proud artisan class, enunciated in Campomanes's publications of 1774–1775, *Discurso sobre el fomento de la industria popular* and *Discurso sobre la educación popular de los artesanos y su fomento.* Campomanes hoped to put to work all the idle classes of the nation, and to this end urged the cultivation of domestic crafts like pottery (although most of his examples are taken from the textile industry) that would not take people from the small towns and farms. Over and over again he praised the work of the economic societies for their encouragement of the arts and crafts, emphasizing their broad social appeal and representation. He especially lauded the spread of drawing instruction, which he considered "the father of practical trades and without which nothing can flourish." He had warm words for Mengs for his exemplary contribution to the national art, thus uniting the applied and fine arts in a common drive to rehabilitate Spanish commerce and culture.[28] His vision for national growth was a large population, all gainfully employed, and an industry incessantly stimulated in all ways. Goya's cartoon, showing involvement of all classes in the potter's craft (here symbolized by women attracted to domestic articles), conveys the government line in a dazzling pictorial arrangement. One of the kneeling women, in manifest appreciation of the craft, points with her index finger at some element of the design or the potter's stamp.

In addition to the shimmering silk, satin, lace, brocade,

and glazed earthenware, Goya displays his personal sensibility in the curious looks of the protagonists who glance around in every direction. Their attention is not united by absorption in a single event, but seems rather to be diverted by a series of events occurring offstage, including the beholder as one of the foci. This is a characteristic common to several of the tapestry cartoons, a kind of self-conscious behavior motivated by the knowledge that they are being observed. It is this look of self-consciousness that often gives the tapestry designs their "bizarre" quality, a reflection of the painter's own acute sense of self in the goldfish bowl of courtly life.

Majismo versus Afrancesamiento

The 1770s was a period of great faith in the government's capacity to create a highly developed, thriving artisan class. While no such class would appear, the tendency to romanticize one particular group of artisans pervades Goya's series of cartoons executed between 1776 and 1778 for the dining room of the prince and princess of Asturias. Laborers and artisans eyed with suspicion the reform policies of the Frenchified regalists, and expressed their dissatisfaction through exaggerated loyalty to Spanish culture and amusements. This tendency was known as *majismo* and those who affected its style were called *majos* and *majas;* they set themselves in opposition to those who cultivated French fashions, the *afrancesados*. The *majos* let their hair grow long and arranged it with a hairnet, wore long capes, short jackets, and broad-brimmed hats in contrast with the French three-cornered hat, full-skirted coat, and wig paraded by the elegant males forming close intellectual and business ties with France.[29]

Both groups participated in the search for national identity stimulated by the king, but divided along class lines in their expression of it. The new Spanish bourgeois descended from old families of local merchants and guild masters, prospering members of a cosmopolitan world of business venture whose objectives were expansion and profit. The commoners who made it to the top, and the aristocrats who (like Campomanes and Floridablanca, a friend of Marat) served the government, envisioned a modern Spain especially open to French influence. The popular classes, led by one segment of the artisanal labor force, developed their indigenous brand of patriotism. Indeed, the attempt of Squillace, the secretary of state for war and fi-

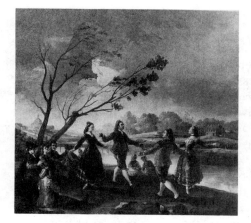

4.14 Francisco Goya y Lucientes, *Dance on the Banks of the River Manzanares*, 1777, tapestry cartoon. Museo Nacional del Prado, Madrid.

nances, to forbid the wearing in Madrid of the long capes and slouch hats—on the ground that they made it easy for criminals to disguise themselves—led to the one violent riot of Carlos III's reign. The injudicious decree had been issued during widespread working-class irritation over the high price of grain and taxes exacted to pay for improved roads and street lamps in Madrid. On 23 March 1766 the secretary's house was sacked and the street lamps were destroyed. The next day Carlos had to accept the demands of a crowd raging outside his palace: removal of the Neapolitan secretary, revocation of the dress code for Madrileños, and a lowering of food prices. Ever after, *majismo* served as an expression of working-class solidarity and showed itself in full force in the 1780s when the government, recognizing the failure to create its ideal artisan class, threw its full support behind large industry. Workers were not protected from the new *fabricantes,* for the polestar of the official economists was not the happiness of the individual but the prosperity of the state.

Goya's cartoons for the dining room of the palace of El Pardo in the late 1770s include such appropriate themes as *The Picnic* and *Dance on the Banks of the River Manzanares,* which introduce the roguish *majos* and *majas* (fig. 4.14). Both scenes take place on the shores of the Manzanares, whose fertilizing stream watered an extensive plain on the western outskirts of Madrid and fed the capital. The location of the Palacio Real (royal palace) and El Pardo along the banks of the Manzanares was as much symbolic as practical. *Dance* indicates a topographical interest in the capital and its environs, an interest that became a hallmark of Goya's mature activity. At the left, on the eastern shore of the river, is the recently completed basilica of San Francisco el Grande with its spectacular dome, and on the right, the opposite shore, is the walled-off royal garden known as the Caso del Campo. This places the scene on the western shore near the Campo del Moro bordering on the Palacio Real. Here two *majos* and *majas* (instantly recognized by their hairnets) dance the popular *seguidilla* with castanets and musical accompaniment, giving a clear identification of *majismo* with the supreme landmarks of church and state.

As we have seen, *majismo* originated among the artisanal classes and represented a sort of counterculture to regalism. In the period of Goya's cartoon, the government was attempting to promote the status of this group, as declared in Campomanes's 1775 publication on the education of the artisan. Campomanes stressed the need for a total indoctri-

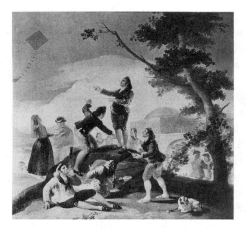

4.15 Francisco Goya y Lucientes, *Kite Flying,* 1777, tapestry cartoon. Museo Nacional del Prado, Madrid.

nation in religion, morals, dress, and language, in addition to information on the latest technological advances and thorough training in design. He was particularly disturbed by what he felt to be the contempt of artisan-*majos* manifested by their dress and behavior. Noting that this group was generally literate, he claimed that they should not be exposed to the "frivolous and capricious" literature of their time, nor should apprentices be allowed to swear or indulge in lascivious gestures. The workshop must guard proper decorum and teach high moral values, Campomanes warned. Above all, if artisans hope to move upward in the social scale they must change their dress and avoid amusements that lead to job absenteeism and family neglect. By his slovenliness, the artisan-*majo* looks like a va-

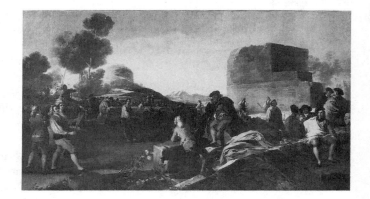

4.16 Francisco Goya y Lucientes, *Ballgame,* 1779, tapestry cartoon. Museo Nacional del Prado, Madrid.

4.17 Francisco Goya y Lucientes, *Blindman's Bluff,* 1788–1789, tapestry cartoon. Museo Nacional del Prado, Madrid.

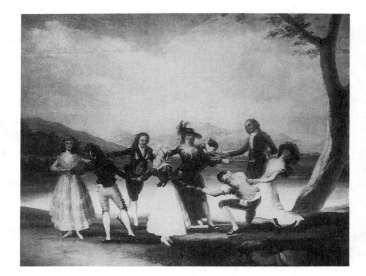

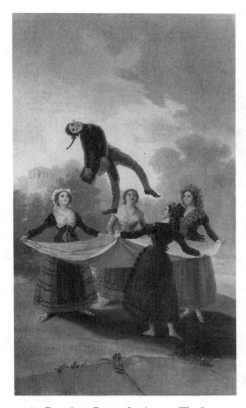

4.18 Francisco Goya y Lucientes, *The Straw Manikin*, 1791–1792, tapestry cartoon. Museo Nacional del Prado, Madrid.

grant or beggar. Besides, the cape was of Moorish origin and therefore not indigenous to Spain. Campomanes advised the use of smocks, caps, and cloaks more in keeping with traditional workmen's clothing and especially condemned the use of hairnets (the *cofia* or *redecilla*) as unsanitary and conducive to indolence. *Majos* and *majas,* he said, no longer comb and arrange their hair, and as a result their heads became vile breeding grounds for lice, mange, and scabies. Finally, artisans must avoid taverns and bullfights; rather, they should engage in healthy diversions on festival days like ballgames, tenpins, swordplay, and target practice.[30]

Campomanes attempted to gently chide the artisan into conforming with the outlook of the *ilustrados.* There was, however, another level to the official discourse on *majismo.* The predilection for popular amusements like bullfighting, flamenco singing, and dances like the *bolero* and *seguidilla* was not exclusively plebeian, and attracted members of the court as well as a major portion of the aristocracy who felt threatened by the reform policies of Carlos III and wanted to cultivate the support of the popular classes. (The court in fact believed that the Squillace riot was instigated by a combination of aristocratic and Jesuit intrigue against the minister's reforms.) The future queen, Maria Luisa, admired the cheekiness of the *majos,* and a number of her friends aped their style, a kind of slumming to breathe fresh air. Gradually, *majismo* was detached from a particular class and assumed symbolic importance as an expression of the "pure Castilian spirit" and thus as an instrument of political and cultural protest.

Significantly, *majismo* did not imply criticism of church or king and could be exploited as a *national* trait. Goya's *majos,* while retaining the "infectious" hairnets, nevertheless perform a traditional dance in the wholesome atmosphere of royal and churchly institutions. Others, like the *Kite Flying* of the same series, the *Ballgame* of 1779, the much later *Blindman's Bluff* (which shows *majos* or those dressed in their costume playing with aristocrats), and *The Straw Manikin* feature *majos* and *majas* engaged in salubrious, harmless sport exactly as Campomanes suggested (figs. 4.15–18). Goya even pokes fun at class and cultural distinctions; in his description of *Kite Flying* he calls one of the background figures a *petimetre*—a distortion of the French *petit maître* that *majos* used derisively to label followers of French fashions, while the straw dummy being tossed in the air by the *majas* is clearly an effigy of the *afran-*

4.19 Francisco Goya y Lucientes, *The Meadow of San Isidro,* 1788. Museo Nacional del Prado, Madrid.

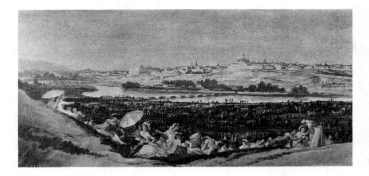

cesado.[31] These themes form part of a conscious program to depict a cross-section of Spanish society thriving under the reign of Carlos III, tolerant of class and cultural differences and living together harmoniously.

Goya descended from the same class as the rising bourgeois and felt most at home with this group, an attitude reflected in his dress, his friendships, and his boast to a friend after being appointed to the court: "Now I am Painter to the King with 15,000 reales!"[32] He belonged to that section of society that welcomed the *luces* or *ilustrados,* where, analogous to the French middle classes, the Enlightenment found its greatest support. At the same time, Goya was caught up by *majismo* and its loyalty to indigenous Spanish customs. There is a tension in his work between popular representation and cosmopolitan views, reflecting the divisions in Spanish society which become increasingly marked after the death of Carlos III in 1788 and the outbreak of the French Revolution in the following year.

While several writers have analyzed the tapestry cartoons as perverse and critical of the dominant society, they in fact correspond closely to the taste and ideals of his royal patrons and are similar to the style of the Bayeus. If the figures often seem strangely stiff and marionette-like, it should be recalled that they were destined to be replicated by the weaver, for whom silhouetted forms were preferable. The stiffness is also a social quality, corresponding to the rigidly formal court of Carlos III. Play and work were regulated to such a degree that the lives of the royal family followed along a predictable and inalterable timetable. Goya's doll-like people project the atmosphere of the hothouse environment. It should be noted, too, that in such a work as *The Straw Manikin,* the "sinister" play with the stuffed *afrancesado* may not be separated from the historical

events of 1791–1792 when the picture was painted. At that moment, scores of émigré French aristocrats were pouring across the border and attempting to stir up Spanish sentiment against the Revolution. Even Floridablanca turned reactionary in this period and tried to control the flow of news coming across the Pyrénées. *Afrancesado* was a label suddenly invested with a new and provocative aura, for those wearing it had to decide for or against the Revolution.

This change in status is most vividly seen in two of his most brilliant tapestry designs, one done in 1788 and the other in 1791–1792 (figs. 4.19–20). The first, *The Meadow of San Isidro,* is a sketch for a tapestry cartoon intended for the bedroom of the infanta in El Pardo, but never executed. It depicts the annual celebration of the feast day of the patron saint of Madrid, which falls on 15 May. Goya noted in a letter to his friend Zapater dated 31 May 1788 that he was in the process of painting his "San Isidro Day," thus making it virtually certain that the scene was based on direct observation of the festivities. We know the exact time and place of Goya's picture, a rich historical as well as visual document of the era. It was the custom on 15 May for all of Madrid to congregate on the right bank of the Manzanares River and participate in the *romerías* (pilgrimage combined with picnic-excursion) and *verbenas* (dancing and games). Goya's festive picknickers establish the occasion, while the panoramic vista of Madrid pinpoints the site still known as the Pradera de San Isidro. The painter depicts with utmost topographical clarity the famous Segovia Bridge designed by Juan de Herrera in the sixteenth century, and leads us to

4.20 Francisco Goya y Lucientes, *The Wedding,* 1791–1792. Museo Nacional del Prado, Madrid.

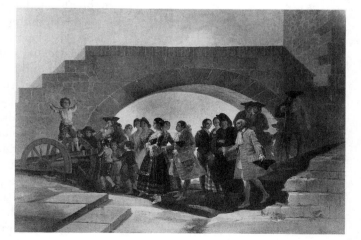

4.21 Antoine Watteau, *Embarkation for Cythère*, 1717–1719. Musée du Louvre, Paris.

the royal palace and the basilica of San Francisco el Grande on the far side of the river—a view that one may confirm by standing on the meadow today.

While *majas* and *majos* mingle freely with aristocratic men and women, Goya's attention was riveted by the French fashions of the *afrancesados*. Even the *majos* have worn the three-cornered hat on top of their hairnets. On this major festival day the tone is set by the elegant, self-confident aristocrats, reminiscent of the noble women and men of the French rococo painter, Antoine Watteau, whose *Embarkation for Cythère* describes a luxurious excursion in a vast landscape suggestive of sensual pleasure (fig. 4.21). While Goya replaces the sensuous, dreamlike atmosphere with a conscious sense of reality, he nonetheless displays an affinity with a painter dear to the sensibility of French Enlightenment thinkers. If Goya's scene does not reveal an ephemeral glimpse of Arcadia, it still conjures up an image of social harmony and festivity, with throngs of friendly people dancing and singing.

Seven months later Carlos III died, and his son ascended the throne as Carlos IV on 21 September 1789, The festivities of the coronation indicate how successfully Floridablanca censored the press and kept the populace ignorant of the French Revolution. During the next two years, however, a broad range of French agents, from itinerant peddlers to large-scale entrepreneurs, began to circulate revolutionary propaganda. Short-lived newspapers were spread, maxims were posted or concealed in manuscripts, paper fans with designs of the fall of the Bastille and poems in favor of religious liberty circulated everywhere. A

Frenchman in one Spanish town sported a waistcoat that pictured a galloping horse with the word *liberté*. Carlos IV reacted by cooling reform activities. Campomanes fell from favor, and the directors of the societies of Amigos del País received instructions to permit no more discussion of questions of political economy.

Goya's *The Wedding* of 1791–1792 (fig. 4.20), executed in this tense period, differs strikingly in mood and content from *The Meadow of San Isidro*. *The Wedding* is characterized by an acerbic, heavily moralistic attitude more closely aligned to the English satirist Hogarth than to the elegant Watteau. The principal figures are in the center: the cruelly caricatured groom and the lovely young bride, who stands alone looking wistful. Behind them follow the sanctimonious father and the self-satisfied priest, while ahead of them friends and the merely curious cast mocking and knowing expressions at one another. It is clear that the bride has been unwillingly sold into the marriage. Significantly, the grotesque groom with his tricorn hat tucked under his arm, the fatuous father, and other male relatives are all elegantly clad in the latest French attire. Since much of the aristocracy and the upper bourgeoisie were pro-French, Goya's satire of cupidity and indifference is explicitly connected with the *afrancesado* associated at the time with the irreligious and revolutionary ideas seeping through the Pyrénées from France.

The Ambiguous Status of the *Afrancesado*

Ironically, Goya's main sympathies lay with the *afrancesados,* whose popularity shifted according to the status of the Spanish and French alliance. During the decade of the 1780s when Goya established himself as one of the leading younger painters in Spain, he became increasingly linked to the reformers close to Carlos III. These reformers were quick to take up with an artist who could give visual form to the currents from abroad they wished to promote in Spain. It is no coincidence that in this period Goya began to disclose those singular and original traits that distinguish his work. The most obvious connection to this group, however, is expressed in his more conventionalized portraits.

Between 1785 and 1788 Goya painted six official portraits for the Bank of San Carlos, founded in 1782 by Francisco Cabarrús, Carlos III's French-born financier. When Spain joined America in its war against Britain, the king

4.22 Francisco Goya y Lucientes, *Conde de Cabarrús*, 1788. Bank of Spain, Madrid.

needed extra revenues to supplement an increase of taxes and loans from the merchant guilds of Madrid and the bishops. Cabarrús won official adoption of a project to issue interest-bearing royal bonds, known as *vales reales*, which would circulate as legal tender. Repeated issues finally forced them off par, and by October 1782 they were being depreciated at 22 percent. To meet this threat to royal credit, Cabarrús was authorized to found the first national bank of Spain with the aim of redeeming the *vales*. They not only recovered their original value but circulated at 1 to 2 percent above par during the years 1786–1792. These last years of Carlos III's reign witnessed an unprecedented flourishing of the Spanish economy; the directors of San Carlos boasted of the industrial and agricultural progress, while the postwar consumer demand in Spain and the colonies spurred on factory owners. This economic expansion favored the growing middle class and the nobles linked to them through business ties, among whom could be numbered Cabarrús and Goya himself, who owned shares in the Bank of San Carlos.

Goya depicted the director of the Banco Nacional de San Carlos as a fashionable *afrancesado,* sporting wig, long full-skirted coat, and three-cornered hat tucked under his left arm (like the groom in *The Wedding*) (fig. 4.22). At the same time, the director is shown as a man of action—feet spread apart, right arm extended and gesturing, eyes looking to the right at some offstage happening.

The count of Altamira was another of the bank's directors. A *grande* of one of the oldest and most distinguished Spanish noble families, he was the lord of vast estates, including the prosperous town of Elche, with 17,300 inhabitants, run by the judges and local officials he appointed. But if the count breathed the rarefied air of the reigning aristocracy, he nevertheless joined with the commoners in support of the king's efforts to rejuvenate Spain's economy. Goya portrays him in a somewhat uneasy pose, seated stiffly at a high table that seems to dwarf him. Altamira's title of director was more honorary than practical, and Goya's portrait reveals him as more an adjunct than a functioning bureaucrat.

Goya's sensitiveness to the relationship of sitter to environment (ultimately disclosing shades of rank and power) is also shown in his masterful portrait of Altamira's youngest son, *Manuel Osorio de Zuñiga* (fig. 4.23). Pampered and sheltered by a system of rigorous formality, the four-year-old child is elegantly wrapped in a large silk sash worn

4.23 Francisco Goya y Lucientes, *Manuel Osorio de Zuñiga*, c. 1788. Metropolitan Museum of Art, New York.

around his waist and a lace collar that seems too large for his tiny bust. He holds the leash of a pet magpie who carries a card in its beak with Goya's signature. Behind him and to the right is a bird cage, while at the left three sinister cats eye the bird with rapt fascination. Although the child with a bird on a leash was a commonplace motif, Goya enlarged upon it symbolically from the perspective of aristocratic childhood. The child projects a sense of helplessness, a vulnerability akin to the bird itself. He is caged in his palatial surroundings, bound by costume and household etiquette, and prey to the grownup world like the bird to the ravenous felines. The situation also amuses Goya, whose card-in-the-beak replaces the bird-in-the-hand: here is early evidence that he could sympathize with the small fry of this world.

Indeed, the same year he painted Altamira's son (c. 1788), Goya began complaining to friends about his dependence on commissioned works (read "portraits"). But he was too eager to please, too intent on rising to the top of Spain's artistic hierarchy and establishing himself as a portraitist of the court. His first major official portrait was of Floridablanca in 1783, and the artist includes himself in the picture in the role of a lackey (fig. 4.24). Floridablanca was the most powerful minister in the court of Carlos III. As diplomat, lawyer, and politician he articulated Carlos III's program of "enlightened despotism" through his cabinet, or *junta de estado,* which welded all bureaucratic activity into a coherent whole. Goya's portrait catches the energy and versatility of the prime minister, who is engaged simultaneously in a meeting with the court architect, in checking plans for the canal project in Aragón, and in sitting for Goya, who shows himself holding up a sketch for Floridablanca's inspection. While both artist and sitter are represented in the attire of the *afrancesado,* Goya presents himself as a subordinate anxiously awaiting his master's response. We know from Goya's correspondence of the period that he hoped the portrait would help him gain entry into Madrid's official circles.

That year Goya also painted the portrait of the family of the Infante Don Luis Antonio de Borbón, his first royal patron. Don Luis was the youngest brother of Carlos III, but after making a morganatic marriage he had to give up his ecclesiastical functions in the court and retire to his country estate. Goya was delighted to receive the commission and visit the estate at Arenas de San Pedro. The composition centers on the wife, Doña María Teresa de Valla-

briga, who is having her hair done and is watched admiringly by her family and servants. Goya depicts himself crouched at his easel in the left foreground in the guise of another domestic attendant.

After his appointment as king's painter in 1786, Goya painted two portraits of Carlos III, an official portrait for the Bank of San Carlos and a more informal example depicting the king in hunting clothes (fig. 4.25). Hunting was one of Carlos III's passions, his one relief from the tedium of kingship, and he indulged in this sport on special grounds attached to his various palaces. Goya previously translated this passion into the subjects of his first series of tapestry cartoons which consisted of eight hunting scenes and one fishing scene. While designed for the dining room of the heir to the throne, they showed perhaps the one diversion shared by father and son. Several contemporary observers noted Carlos IV's obsession with the chase, inherited from his father. Carlos III's favorite hound lies at his feet, bound to him in eternal loyalty like the king's subjects: Goya inscribed "Rey N. Señor" (the king our lord) on the dog's collar.

Goya's portrait coincides with the peak of Carlos III's achievement, and the painter's success followed the rise of the reformers. When the king died and the French Revolution broke out, the spirit of reform in Spain was temporarily halted. With the initiative of Floridablanca, the government took every possible care to prevent the influx of revolutionary ideas into Spain. Floridablanca revived the Inquisition and ordered all private Spanish periodicals suspended early in 1791. Cabarrús was arrested for his liberal leanings, Campomanes was demoted, and Gaspar Melchor de Jovellanos—one of the most capable of Carlos III's officials—was exiled to his native Asturias.

But the rapidly changing political situation in France forced Carlos to modify his position in an effort to save the throne of Louis XVI. He dismissed Floridablanca in February 1792 to convince the French government that he was no longer hostile to the Revolution. There was even a certain admiration for the National Assembly and the French constitution to which Louis swore fidelity in September 1791. Floridablanca's successor, the conde de Aranda, could briefly relax the official attitude toward the Revolution. But when news of the imprisonment of the French royal family reached Spain, Aranda was forced to change his attitude, and the afrancesados again found themselves in a state of crisis. The king's concern for the safety of Louis

4.24 Francisco Goya y Lucientes, *Conde Floridablanca y Goya*, 1783. Bank of Spain, Madrid.

4.25 Francisco Goya y Lucientes, *Carlos III in Hunting Dress*, c. 1786–1788. Duchess of Fernan-Nunez, Madrid.

XVI predisposed him to a policy of neutrality and kept him from joining with Austria and Prussia in their war against France. It was only after Louis XVI's execution in January 1793 that Carlos IV joined the grand coalition and declared war on France. Meanwhile, the injudicious nomination of Manuel Godoy for prime minister in 1792 roused many segments of the Spanish nation against the government.

It cannot be a coincidence that during the years 1792–1793 Goya underwent a profound mental and physical crisis. While the illness left him stone deaf, a friend during this period claimed that Goya's sickness was "entirely in his head." But whatever the explanation for the mysterious seizure that resulted in deafness, there can be no doubt that it was exacerbated by the changing political circumstances. Carlos IV and his queen María Luisa, arriving on the scene at an explosive moment with little practical experience, preferred to pass on the reins of power to the queen's *cortejo,* or male companion, Manuel Godoy. On 15 November 1792 Aranda—who held office for less than a year—was peremptorily dismissed as prime minister, and the public soon learned to its astonishment that his successor was to be the twenty-four-year-old Godoy. Although clearly gifted, his sole claim to this promotion was widely believed to be the protection of María Luisa. Before October 1791 the report had spread as far as France that Godoy and the queen were lovers and that Carlos IV played the willing cuckold. The intimacy of the duque de la Alcudia (Godoy's newly bestowed rank) with the king and queen had scandalized the popular classes of Madrid. The sight of the three of them together had been demoralizing enough, but when the queen's *cortejo* was named prime minister, a major segment of the Spanish population was dismayed. A member of the French embassy in Madrid reported that the period following the appointment of Godoy was the one occasion when he could feel the possibility of revolution in Spain. Even the aristocracy was offended by the elevation of Godoy, while the *ilustrados* complained of the injustice of the situation. At the very moment when Spain was ready to break with France a tide of resentment against their own rulers led some Spaniards to covertly support the French Revolution. Domingo de Iriarte, the brother of one of Goya's close friends and patrons, headed a spy ring to funnel news from Spain and distribute French papers. If it was unfashionable and even dangerous to be an *afrancesado,* it was quite understandable. After war was declared, dissatisfied Spaniards hoped for French victories to bring about

4.26 Francisco Goya y Lucientes, *Sebastian Martínez y Perez,* 1792. Metropolitan Museum of Art, New York.

government change. Regardless of Goya's ideological commitments in this period, he could not forsake his *afrancesado* circle, while at the same time he had to pay court to both the royal couple and Godoy, all three of whom were playing off each other for one reason or another. It was in the context of such social and political instability that Goya suffered a nervous breakdown which brought on his seizure and deafness.

Goya must have been in relatively good health at the end of 1792 when he painted his host, Sebastian Martínez y Pérez, the wealthy merchant of Cadiz (fig. 4.26). Treasurer general of the Council of Finances at Cadiz, Martínez had amassed a personal fortune through trade with Spain's colonies in South America. He owned an exceptional art collection of over three hundred paintings and several thousand prints, including Goya's etching of Velázquez's *Triumph of Bacchus*. His dazzling blue silk coat, white lace jabot, and bright yellow knee breeches with silver buttons and buckles demonstrate the sitter's *bon goût,* impeccably groomed and tailored in the latest French fashion. The colonial commerce of Cadiz attracted an important group of French merchants; in 1772 there were seventy-nine French wholesale houses. The French community greeted the news of the Revolution with joy, and used their club as a storehouse of revolutionary publications. In 1791 the government submitted the French to legal persecution, and large numbers returned to their native country. It is possible that Goya's ties to the court and his concern for his career made him anxious in the home of an *afrancesado* who had business ties to the French community. It may have been this close association that complicated Goya's situation at court at the time of his illness. He had left Madrid without official permission (this was illegal for a court painter), and his prolonged illness would have made his absence conspicuous. Through Martínez, Goya asked Francisco Bayeu to make it appear as if he were still in Madrid and request an official leave to recover from his sickness in Andalusia. Goya was clearly trying to cover up the truth of the situation, a fear that may be traced in part to the volatile situation in France and Spain from December 1792 to March 1793, when the French king was executed and Spain declared war.

The execution of Louis XVI and the Reign of Terror, combined with the bitterness caused by the war between Spain and France, neutralized many Spanish supporters of the French Revolution and virtually destroyed their plans

for changing their own government. On 7 June 1793 a royal order prohibited the insertion in any book or newspaper of "reports favorable or adverse of things pertaining to the kingdom of France." Everything that recalled the Revolution was at once openly despised, and sermons condemned the republic of regicides and atheists. In Madrid women wearing French coiffures in public were forced to let their hair down on the spot, and those with the temerity to wear red liberty caps in the theater were hooted at. All nondomiciled French people were ordered to leave the country, and many of them were physically assaulted. In March 1794 members of the French colony in Valencia were imprisoned for their own safety.

It was precisely during this period that Goya, his personality and work modified by his recent physical trauma, executed a unique series of compositions that attest to the upheaval in Spanish society. They were sent in January 1794 to Bernardo de Iriarte, a well-known *afrancesado* (previously convicted by the Holy Office for blasphemy and heresy), who was then vice-protector of the Academy of San Fernando. Goya's accompanying letter claims that the works were done to keep his mind off his recent sufferings, as well as to defray his medical expenses. Goya emphasized that the compositions allowed for "capricho y invención" (caprice and invention) normally incompatible with commissioned works.[33] His production in the years 1793–1794 was slight, the result of his illness, the political pressure on his *afrancesado* patrons, and general inflationary conditions. Uncertain of his market, he approached Iriarte in the hopes of gaining academic sanction for his new endeavors. Iriarte showed the pictures to the academicians and then sold or entrusted them to the marquis de Villaverde.

If Goya's illness exhausted him financially, it liberated him creatively. He used the term *capricho* to characterize his new series, a word having more in common with the Italian *capriccio* (irregular, a caper) than the English *caprice* (an arbitrary change of mind). He associates it expressly with his imagination "mortified by the contemplation" of his sufferings. The series contains a farrago of themes dominated by violence and tragedy, some of which were seen by the academicians of San Fernando as "various scenes of national pastimes."[34] At that time, they had access only to eleven of fourteen pictures, almost all of which were devoted to the bullfight. Yet several of these center on the savagery associated with the sport: a picador is gored by a bull, a dog is killed in the process of capturing the bull, or

4.27 Francisco Goya y Lucientes, *Asylum (The Madhouse of Saragossa)*, 1793–1794, tinplate. Algur H. Meadows Collection, Meadows Museum, Southern Methodist University, Dallas, Texas.

the bull itself is lanced, killed, and dragged out of the arena. In the other works the dark silhouette of a marionette seller (seen from behind) attracts a crowd of children like a diabolic pied piper, while the *Strolling Players* presents a commedia dell'arte routine making explicit reference to the "unholy trio" of king, queen, and Godoy. While the actor-king stands in his best Bourbon pose, a clown wearing a "liberty bonnet" and a royally clad Columbine bearing a distinct resemblance to María Luisa dance off together while casting knowing glances at the posturing fop. Three other pictures in the series deal with violent shipwreck, brigands plundering a coach and killing its passengers, and a raging fire at night—explosions of light and dark pointing to the uncontrollable in experience.

The final picture in the series, *Asylum Yard with Lunatics,* exemplifies the time of private nightmare and public disorder (fig. 4.27). In the lurid green shadows of the asylum courtyard in Zaragoza, two naked inmates wrestle while their warden beats them with a whip. Around them circulate a cast of unforgettable characters—including some who return the spectator's gaze—expressing themselves with wild gestures and distorted grimaces. While insanity was then only beginning to be considered a disease susceptible to cure by doctors, reformers like Goya's friend Meléndez Valdés wanted to correct the inadequacies in food and health care and to teach basic skills and crafts. According to the French pioneer psychoanalyst, Pinel, who visited the asylum in the 1790s, it was a model institution that permitted the patients to cultivate land, harvest crops, build trellises for vines, and gather olives. This was done under strict surveillance, and the patients were marched off in groups to the field. This mechanical activity promoted "calm and tranquil sleep" and restored their reason.[35]

Goya, however, claims to have directly witnessed his scene, seeing in his native region a mirror image of his own physical, social, and political despair. His impaired motor activity and isolating deafness predisposed him to identify with society's victims. At the same time, his seizure would have brought him face to face with Spain's woeful institutional facilities for the mentally ill whose ranks often included religious heretics and political dissidents hounded by the Inquisition. Here madness becomes pure spectacle, with patients treated as monsters to be shown before an audience. By reducing them to performers—freaks to be stared at—spectators could laugh at them and validate their own sense of "sanity" in the crazy world they inhabited. In

the troubled atmosphere of Spain following the outbreak of the French Revolution, Goya could not have been the only victim of a nervous disorder. It was the "madness" of Spain's social and political contradictions that provided the stuff of Goya's "fantasies."

Godoy and Jovellanos

The political climate changed again the following year. News of French victories in the spring of 1794 added fuel to the discontent over Godoy. Rumors began to circulate that secret clubs of revolutionary sympathizers were hatching a variety of plots. Opposition to the war by students in the universities also began to have an effect on the court's policies. All of these factors induced the Spanish government to make peace with France by the Treaty of Basle in July 1795. The joy and satisfaction with which the news of the peace was received turned somewhat sour when the public learned that Godoy, for his achievement in ending the war, was awarded the title of Príncipe de la Paz (prince of the peace) and a large property to maintain his new status. Normally, only the direct heir of the throne held the title of *príncipe,* so that Godoy was now elevated above all the nobility of Spain. If the popularity of Godoy and the prestige of the king and queen suffered, the treaty did produce a relative calm that was to last until 1798.

During this calm, a hasty rapprochement with the French took place, and the high standing of the *luces* attached to Enlightenment ideals was restored. Goya found himself again in *afrancesado* circles orbiting around the person of Gaspar Melchor de Jovellanos. Jovellanos was a poet, a playwright, a critic, an economist, a statesman, a jurist, and an educator of distinction. When Godoy, in an effort to neutralize domestic discontent by associating himself with the reformist legacy of Carlos III, decided to bring back into favor the *ilustrados* he called upon Jovellanos to become secretary of grace and justice, with control of religious affairs. Bernardo de Iriarte was appointed minister of agriculture, commerce, and overseas relations, and Cabarrús ambassador to France, who in turn recommended Francisco de Saavedra for secretary of finance. Juan Meléndez Valdés, a former protege of Jovellanos in the faculty of the University of Salamanca, became attorney-general of the royal court of Madrid. Finally, Godoy raised to second place in his own ministry of foreign affairs Mariano Luis de Urquijo, a translator of Voltaire who barely escaped the In-

4.28 Francisco Goya y Lucientes, *Gaspar Melchor de Jovellanos*, 1798. Viscountess of Irueste, Madrid.

quisition in 1792. Not since the day of Carlos III had such a galaxy of enlightened individuals been given charge of the destinies of the country. All of them were bound in friendship to Jovellanos, enjoyed the protection of Godoy, and—fortunately for both history and art—sat for Goya.

The most vibrant and complex of Goya's effigies of these *luces* is that of Jovellanos himself (fig. 4.28).[36] It is an intimate glimpse of the thinker in his study: Jovellanos is seated at his ornate neoclassical desk in a meditative pose, with his head leaning on one hand and his bent arm resting on a stack of official papers. The gilded table and gleaming yellow silk upholstery of his chair stand out against a dark background, giving a postmidnight atmosphere. A large bronze statue of the goddess Minerva watches over him like a ghostly apparition, and her right arm extends toward his head in seeming benediction. As the personification of dawn in both the literal and metaphoric sense, she symbolizes here the illuminating and knowledge-giving light of the sky—appropriate to a *luce* whose learning covered many fields. Yet while showing Jovellanos as more a "man of ideas" than a "man of action," the searching expression and slumped figure also suggest a degree of frustration and indecision. It is not fortuitous that one month after Goya received payment for the picture (19 July 1798), Jovellanos was dismissed from office.

Depending on who we read, Jovellanos was a good Catholic, a heretical Jansenist, a Freemason, a revolutionary, a traditionalist, or a middle-of-the-roader.[37] Overall, he may be classified as a moderate progressive who tried to maintain the momentum of Carlos III's policies during the subsequent regime. He was certainly a devout Catholic, but he defended its left wing (the Jansenists) against the right wing (the ultramontanes) and tried to reform the Inquisition. Although of noble descent, he attacked the concept of privilege based on birth as well as the venality and frivolity of the aristocracy. He wrote a famous satire ("On the Faulty Education of the Nobility") that presents a degenerate noble who affects the vulgar elegance of *majismo*.[38] But if he condemns its degeneracy, he does not condemn the concept of nobility. He hardly trusted the popular classes, and all his proposals designed to benefit them were to be carried out by an enlightened minority. Finally, Jovellanos believed in a strong centralized government limited by constitutional rights. He defended the people's right to insurrection under extraordinary circumstances, but at all other times they must accept the full authority of the

king. He was certainly uneasy about the disorderly nature of the popular uprisings of 1808, and his plans for constitutional reform did not allow for yielding to what he called "la manía democrática."

The outstanding expression of his liberal economic principles is his *Informe de la ley agraria* (Report on the agrarian law), published in 1795 and perhaps the most significant work published under Godoy's ministry.[39] In the 1780s Carlos III's government commissioned the Economic Society of Madrid to study various projects for agricultural reform and to recommend a general plan for agrarian legislation. In 1787 the society commissioned Jovellanos to formulate a plan for its report, but over the next few years the vicissitudes of his personal and public life interfered, and the report was not completed until 1794, appearing in print the following year. Jovellanos's doctrines derived in large measure from the French physiocrats who believed that land was the main source of national wealth and that the natural agent of prosperity was private initiative as opposed to government control. He also drew heavily on Adam Smith's *Wealth of Nations,* a work he translated into Spanish.[40]

The belief that the free exercise of private self-interest is the principle stimulus to economic advancement led Jovellanos to attack existing legislation restricting the ownership or use of the land. Because of limited land for peasants common lands should be enclosed, the privilege of entail, both by noble families and the church, is unjust and should be modified, and donations of land to the church (to be held in mortmain) should be prohibited. Although he emphasized a hands-off policy on present church property, the church should be encouraged to voluntarily divest itself of its land by sale or lease for patriotic reasons. The government's role should be confined to spreading knowledge of economics and agricultural science, calling for the participation of the Amigos del País. And it was also the obligation of the government to create improved road and water transport to facilitate the marketing of farm products.

Jovellanos's moderate reforms had the backing of the government, which was then facing an increasingly difficult financial situation caused by the war against France. While it began in a strong financial situation, the expulsion of French entrepreneurs and laborers, the need to recruit from the indigenous work force for the military, and the French invasion soon affected the economy. To finance the war the government made use again of *vales reales,* the

interest-bearing notes that could circulate as legal tender, first used during the American War of Independence. The crown undertook to guarantee payment of interest on the *vales* by levying a tax on income derived from land. Naturally, the church and large landowners balked at this solution, which explains why Godoy supported the publication of the *Informe*. The name of Jovellanos recalled the days of Carlos III, and the book provided the most effective propaganda for the royal policy of imposing the cost of the war on the rural oligarchy. The *Informe* could also justify Godoy's order that the town common lands of the province of Extremadura be distributed to private individuals to enclose and farm—an attempt, with the wartime rise in grain prices, to put more land under cultivation.

The publication encountered stiff opposition from the right wing of the church and the conservative landowning classes. It was denounced to the Inquisition early in 1796. The examiners (*calificadores*) who read it condemned it as anti-ecclesiastical "and conducive to ideas of equality in the ownership of goods and lands." While the Consejo de la Inquisición in July 1797 decided to suspend the case, the inquisitors could never forget Jovellanos's ideas, and they helped to bring about his fall exactly one year later. The moving portrait of Jovellanos by Goya is an image of a melancholic temperament frustrated in its efforts.

Goya's depiction of Jovellanos provides a striking contrast with the official portrait of Floridablanca done over ten years earlier, attesting to the artist's greater self-confidence and psychological insight. There are several traits of self-identification in the picture, including the figural pose which Goya used to portray himself in one of the *Caprichos*. The sitter even holds a note with the dedication "Jovellanos por Goya." The two probably met for the first time in 1780, when both became members of the Academy of San Fernando, and thereafter Jovellanos became a loyal friend and protector. In 1784 Jovellanos commissioned four altarpieces (all now lost) for the Calatrava College, one of four *colegios mayores* in Salamanca recently reorganized by the government. Although originally designed to provide lodging and support for poor students, by the middle of the eighteenth century the *colegios* had become monopolized by second sons of wealthy landholding families. Upon graduating, these aristocratic *colegiales* would leap to high posts in church and government and maintain an old-boy network with the help of Jesuits who dominated the faculties of the *colegios*. Following the expul-

sion of the Jesuits in 1767 and after a long struggle, Carlos III restored the *colegios* to their original purpose as homes for indigent students. The action, in which Jovellanos took part, represented a significant victory for regalism over ultramontanism and also for commoners and lower nobility over the landed aristocracy. The collaboration of Goya, son of an artisan father and *hidalgo* mother, with Jovellanos, reformist scion of the aristocracy, demonstrates the extent to which Carlos III's progressivism intersected with the career of Goya. And when Jovellanos was restored to favor in the mid-1790s, he did his best to obtain royal commissions for Goya, including the landmark fresco decorations for the hermitage of San Antonio de la Florida.

Juan Meléndez Valdés

Goya's relationship with Jovellanos drew him inevitably into the circle of reformers dependent upon the minister's guidance and protection. One of these was the jurist and poet Juan Meléndez Valdés, whose appointment to the chair of the humanities at the University of Salamanca in 1781 was facilitated by Jovellanos's influence. In 1797 he was called to Madrid by Godoy to serve as district attorney (*fiscal*) in the reshuffled administration. The same year he wrote a poem dedicated to Jovellanos, one of several over the decades celebrating his mentor's promotion to the ministry of grace and justice, and published a new edition of his poems which included the famous "El melancólico, a Jovino."[41] "Jovino" was the nickname of Jovellanos, and some of the content of the poem indicates a source for Goya's portrait, painted the following year. One verse reads

When the funeral shade and the mourning
Of the gloomy night envelope the world
In silence and horror, when in peaceful
Repose mortals the delights
Of a calm, healthful dream enjoy;
Your friend alone, bathed in tears,
Keeps vigil, Jovino, and by the uncertain shine
Of a feeble light, in sad laments,
With you alleviates his profound pain.[42]

The mood of the poem with its broodings on life, death, and immortality is captured in the picture, but it is about Meléndez Valdés, not Jovellanos. The poet wrote in the first person in presenting the picture of a despairing person. Unfortunately, some writers have reversed the title of

4.29 Francisco Goya y Lucientes, *Juan Antonio Meléndez Valdés,* 1797. The Bowes Museum, Barnard Castle, Co. Durham, U.K.

the poem to read "A Jovino, el melancólico," which makes it appear as if Meléndez Valdés named his friend "the melancholy one," when in fact it is an autobiographical musing dedicated to a close friend and mentor who could best appreciate it.[43] Meléndez Valdés suffered from bouts of depressive melancholia, and in the poem pours out his frustration and loss of personal initiative. Yet at the end of the poem, despite his sense of fate dragging him down into the abyss, he still longs to share the burdens of his fellow sufferers.

Goya's portrait of Meléndez Valdés in 1797 (carrying the inscription "A Meléndez Valdés su amigo Goya") corresponds to the flavor of the poem (fig. 4.29). The face of the poet is tired, grave, and troubled. He had not yet begun his new job, but we still might expect a positive image of someone looking forward to a rosy future. Despite the backing of Jovellanos and Godoy, the political machinations and nervous functioning of the government show in the world-weary visage of Meléndez Valdés.

Nevertheless, he still longed for a sense of shared community, and this is reflected in his commitment to social change.[44] At the University of Salamanca he led the fight for curricular reform, placing greater emphasis on the natural sciences and philosophy than on theology and jurisprudence. He wanted to use Castilian as well as Latin for term papers and introduce new courses in the social sciences and in vocational and industrial subjects to promote the economy at home and abroad. He joined the Basque branch of the Amigos del País, which was particularly open to the political and economic ideas from across the Pyrénées. No eighteenth-century poet can equal his number of works devoted to social problems: his long poem published in the 1797 publication, "La despidida del anciano" (The farewell of the old man), attacks poverty and the aristocracy and pleads for a redistribution of the land based on the agrarian ideals of Jovellanos. In his work celebrating the promotion of his hero, he writes, "Jovino holds the authority, the sons of Minerva take courage"—thus signaling the central luminary of his constellation and providing Goya with the constituent metaphor of his portrait.[45]

Despite his penchant for reform, however, Meléndez Valdés shared with his mentor a belief in a strong centralized government. As far as he was concerned, all reforms could be achieved within the framework of the existing administration. His pleas for the correction of abuses were not directed to the people themselves, but to the govern-

ment ministers or to the king. Thus it is not surprising to find that he addressed several epistles, humanitarian discourses, and odes to Godoy. Following the Peace of Basle in 1795, Meléndez Valdés immediately wrote to congratulate Godoy, and it was to him that he dedicated his three-volume work of poetry in 1797. In one epistle dedicated to Godoy, containing an oblique attack on the Inquisition, he urged the prince of the peace to use his power to throw off the monster oppressing genius and holy truth. He also addressed his ode entitled "El fanatismo" to Godoy, which the prime minister referred to in his *Memorias*.[46] Godoy took it as an example of the difficulties that his government experienced in its fight against reactionary elements. Meléndez Valdés also wrote in verse praising Godoy's support of the *luces,* exhorting him at one point to "continue his protection of the arts and sciences."[47]

Goya and Godoy

It seems clear that Meléndez Valdés went out of his way to curry favor with Godoy, who in turn encouraged these efforts to win to his side the *afrancesados.* Godoy embodied the very concept of enlightened despotism they preached, while at the same time he had the position and ability to enact major bureaucratic reforms. Just as Meléndez Valdés used his literary talents to gain Godoy's favor, so we find Goya in the same period exercising his abilities on behalf of the prime minister. In 1797 Godoy commissioned Goya to paint four large circular allegories to decorate the library of his palace in Madrid. These four allegories offer a remarkable glimpse into Godoy's program and exemplify his glorified self-image. Their subjects correspond closely to the prime minister's range of accomplishments as outlined in his *Memorias.*

Goya's four works exploit conventional allegorical personifications to represent agriculture, industry, commerce, and science. The first shows Ceres, the goddess of the crops, who is seated in an open field with her feet on a number of farming tools (fig. 4.30). She wears a crown of ears of wheat from the first ripe crop, signifying the multiplication of the seed that was so crucial for human existence. A farmer is looking up at her adoringly, offering a hamper filled with fruits and flowers. Now it may be recalled that one of the major events of Godoy's administration was Jovellanos's publication of the *Informe de la ley agraria.* The presence of the farmer in this intimate space

4.30 Francisco Goya y Lucientes, *Agriculture,* 1797–1800. Museo Nacional del Prado, Madrid.

illustrates Jovellanos's emphasis on redistribution of the land for more and more cultivators, and the encouragement of small cultivators to settle on the land away from the villages. He cherished the ideal of the small, self-sufficient farmer living in virtuous simplicity and moderate well-being. Removed from the clash of passions that motivate townspeople, the farmer would be more forcefully drawn to the land by love and tenderness, and gain "those social and domestic virtues which make for the happiness of families and the true glory of states."[48]

Earlier, Meléndez Valdés had written in "La despedida del anciano" about the abuses in the agricultural realm. He noted that "the poor farmer / Crying over his small harvest of grain / Watches the wheat that a steward of his lord / Takes away from him."[49] Meléndez's zeal for agricultural reform was rooted in his native Extremadura, an agricultural section of Spain, and the fact that he came from a rural family. In his epistle "El filosofo en el campo" (The philosopher in the field) he states his basic premise that farmers are the most necessary people in all Spain. He attacks the rich absentee landlord who disdains the long-suffering farmer, and urges that the riches derived from Spain's possessions be spent to improve the lot of the peasantry rather than wasted at court in frivolous expenditures. Like his mentor Jovellanos, Meléndez Valdés was disgusted by the idleness, corruption, and immorality of the town, making a vivid contrast with the virtues and strengths in the country.

Godoy founded an important Seminary of Agriculture, and in honor of the event Meléndez Valdés dedicated an epistle on the agrarian problem to the prince of the peace. It contains most of the elements of Goya's picture and reaffirms the close connection between Godoy and the *luces* in the 1790s. It begins with an image of "La Madre España" crowned with "golden ears of corn," and identifies Godoy as the "new Triptolemus"—a reference to the ward of Ceres whom she directed to teach the people how to plow, sow, and reap. Meléndez Valdés stresses the need for introduction of more scientific farming methods and the use of "new seeds, new fertilizers and new farm implements." National and colonial prosperity will come with the stimulation of agriculture through irrigation and witness the abundant harvest of grains and "scented fruits." Here he again calls for the breaking up of large, uncultivated estates into small farms for the peasantry and the improvement and extension of cultivable land through government-

4.31 Francisco Goya y Lucientes, *Industry,* 1797–1800. Museo Nacional del Prado, Madrid.

sponsored irrigation projects. He predicts that under the prime minister's enlightened rule the farm worker, "who is instinctively good will now be so by virtue of reason." And he contrasts the honesty, candor, and long suffering patience of the farmer "with the haughtiness of the rich and indolent townsperson."[50]

The spirit of the reform that animated Godoy met with resistance from the oligarchy of the landowners and large tenants who ran the countryside in alliance with the monasteries and cathedral chapters. Logically, it would seem that the peasants and agricultural laborers held the opposite attitude. But the partisans of reform did not find much support in this sector either: the church enjoyed the unquestioned loyalty of the mass of Spaniards, whose world outlook was formed by their local priests or monks. Culturally, the underclasses of the countryside were in the hands of the most backward part of the Spanish church. In their daily life they were also dependent on the wealthy señores, decried by Meléndez Valdés, who lived in Madrid and the large cities on the income their overseers, tenants, or dues-paying peasants provided them. Even if the *luces* could have appealed to the peasants' self-interest, to arouse support for new doctrines among them would be less a task for Ceres and Triptolemus than for Hercules.

Goya's allegory on *Industry* was illustrated by two women seated at their spinning wheels (fig. 4.31). The raw materials of the textile trade—silk, cotton, and wool—related it to agriculture, and it was one of the most progressive industries in the country. The societies of Amigos del País provided active support in its behalf, and Campomanes almost inevitably drew upon it for his examples of domestic manufacture and artisanal life. It was in the promotion of the manufacture of cloth that the government made its most effective inroads on guild restrictions and monopoly. Provision was made for the establishment of schools for spinning in the towns where they would be most profitable, the women were authorized to work at all suitable jobs in the trade despite any contrary regulations of the *gremios*. Women dominated the cotton-cloth industry in Catalonia, which numbered at the end of the century over three thousand establishments and some one hundred thousand workers. It was for the sake of expanding this industry that Carlos III and his minister encouraged the efforts of women by prying open the guilds to allow for more international and gender diversity.

The manufacturers of cotton, silk, and wool made use

4.32 Francisco Goya y Lucientes, *Commerce*, 1797–1800. Museo Nacional del Prado, Madrid.

of the most advanced technology. But Goya's picture shows neither a mechanized workshop nor the typical cottage setting for the "putting-out" system in which spinners and weavers worked in their own homes and were financed by a merchant entrepreneur. The thick walls of the spacious interior, the large hemispherical window and monumental doorway do suggest some kind of institutional building that gathered workers under one roof. During this period, the local economic societies throughout Spain funded workhouses to provide employment for orphans, handicapped persons, and indigent men and women reduced to begging. One outstanding example of these institutions was the new Casa de la Misericordia of Zaragoza completed in 1792. It was another innovation of Don Ramón de Pignatelli organized under the auspices of the Aragonese economic society, designed to take in unemployed men and women to work for local manufactories. Here seven hundred workers spun cotton and wool, wound silk, and wove various cloths, performing several nonmechanized operations that made more efficient distribution to manufacturers than the "putting-out" system. Pignatelli wanted charitable institutions to give sound work for the promotion of industry and the welfare of Spanish citizens. The Casa de la Misericordia was considered one of the many innovations in Goya's hometown that gave the capital of Aragón its forward-looking reputation. Such a work in Godoy's palace would have identified him as a supporter of the economic societies and the heir of Campomanes and Jovellanos.

The allegory on commerce depicts the interior of an oriental trading house (fig. 4.32). On one level it points to the older treaties that Spain granted to the merchants of foreign nations for the establishment of commercial houses in its ports. Foreign merchants were allowed to reside in these ports under the protection of their consuls and had the liberty to form national associations. In Goya's picture the bright light streaming through the open window creates the atmosphere of a Mediterranean port, while the interior projects a sense of infinite calm and stability. In the center foreground the curious white stork—a bird associated with water—symbolizes mutual confidence and support with its cooperative attitude toward its mate and other members of the flock. France was one of the active members in this trade arrangement, and its merchants played an especially large role at Cádiz. It may be recalled that the French business community underwent violent persecu-

tion in the years 1793–1794, and as a result Spain's export trade fell off considerably. Godoy meantime worked for a rapprochement with the French and a more favorable climate for commerce.

On yet another level, the scene of the two men in oriental costume, one wearing a turban, carries specific reference to the anterior history of Spain when it was dominated by the Moriscos. *Ilustrados* like Campomanes and Jovellanos questioned the expulsion of the Moriscos as well as the Jews from Spain, because they were excellent farmers, artisans, and merchants. Even Juan Pablo Forner, a leading apologist for Spanish religion against the godless French *philosophes,* claimed in the late 1780s that it was essential to study the deportation of the Moriscos and Jews. He asked, Was the exile of four million Spaniards in whose hands lay the nation's commerce and agriculture just and necessary or senseless? The doubts raised by the *ilustrados* constituted a slap in the face of the Inquisition, an institution Godoy tried unsuccessfully to curb. Finally, the oriental motif makes a modern point about the expulsion of the French and pleads for tolerance. It implies also a laissez-faire economical principle that understands the various nations as mutually dependent and supportive rather than as rivals to eliminate.

While the fourth allegory, *Science,* was completely repainted at the beginning of this century, the motif and its details probably followed the original since they are consistent with the content of the others in the series. As recorded previously (the work is now lost), an elegant young woman was shown seated at an astrolabe with a large telescope behind her, while in the background an old sage studies a large volume. Thus the iconography focuses on astronomy, totally understandable when it is recalled that Godoy founded the Royal Observatory in 1796 as part of his institute for the Ingenieros cosmografos de estado. Godoy was very proud of this institute and its cultivation of astronomy and the mathematical sciences with their application to geography, navigation, and agriculture. He even ordered that the royal observatory be run on a round-the-clock schedule to close the gap between the state of the discipline in Spain and that of other countries. Next to cosmography and astronomy, Godoy especially encouraged the botanical sciences for their link to agriculture. Generally, under his administration the crown gave special support to advances in higher education. New schools of medicine and other sciences were established, and promising

students were sent abroad, as they had been by Carlos III. Godoy generously distributed stipends to talented individuals who needed to travel for advanced study in their field. Additionally, a great many scientific publications were published in Spain during his rule, including a flood of extracts from foreign journals.

In his memoirs, written in exile in the 1830s, Godoy looked back to his tenure in office and tried to vindicate it by enumerating his accomplishments. He prided himself for having restored the *luces* to favor, and for his promotion of art, industry, and science. While contemporary historians increasingly find documentary evidence to verify Godoy's attempt at self-justification, Goya's series ironically anticipates the *Memorias* in giving visual form to Godoy's projected program.

The Spanish Enlightenment and Witchcraft

The scientific interest of the *luces* naturally carried the seeds of anticlericalism, but this anticlericalism has often been misconstrued as antireligious sentiment. In fact, almost all the "enlightened" minds in Spain revealed a strong attachment to the church and gave it active support. They held the Catholic religion as sacrosanct. The discoveries of science did not conflict with religious sentiment but rather redounded to the glory of God. At the same time, they joined in the fight to reform the organization of the church. Godoy, for example, supported the regalists, or Jansenists, who wanted a simplification of church service, reform of the religious orders, and a more equitable distribution of income among the clergy.

The most fundamental feature of the desire for reform showed itself in the opposition to the Inquisition that embodied the conservative ultramontane spirit.[51] The Inquisition existed independently for the regular clergy in Spain. At its head was the inquisitor general, usually a leading Spanish prelate, who was named by the king. Although it had lost much of its authority during the eighteenth century, it retained extensive powers of censorship, and heresy prosecutions continued through the period. One terrifying group of persons associated with the Inquisition were the *calificadores,* who reviewed reading matter and testimony as to their orthodoxy and propriety. This censoring process was known as "qualifying" (*calificar*). Periodically, an "Index" of all prohibited writings was published, and to own or read books on this list constituted a sin for which one

could be excommunicated. Only the officials of the Inquisition could grant absolution from this sin, and these officials could exact strong penances.

It was this authority to censor that the *ilustrados* could not abide; their scientific interests required publications from France and England that were often prohibited. The "witch hunts" of the Inquisition also served the interests of those jockeying for power, and might be useful in the elimination of rivals. Jovellanos tried to strike at this power by assigning the control of reading material to the administration and the bishops. Visiting the tribunal of Logroño in 1795—historically important for its witch burning—Jovellanos described it as "a magnificent palace to house three clergymen and oppress a few unhappy wretches." An ode by Meléndez Valdés to Godoy that same year urged the overthrow of the monster who was oppressing genius and holy truth.[52]

Since its foundation, the Inquisition had served as an important instrument of social control, underscoring the boundary between acceptable and aberrant behavior. When witchcraft became associated with demonic possession, heresy, and the rejection of God, it fell within the jurisdiction of the Inquisition, and during the seventeenth and eighteenth centuries it passionately investigated those suspected of practicing in the occult. As late as 1780, an old woman from Seville was accused of witchcraft and burned alive for having had intercourse with the devil.

The Enlightenment meanwhile stressed the need for banning dogma as well as magical practices, which often entailed the folkloric tradition. Pierre Bayle's irreverent *Dictionnaire historique et critique* (listed on the Index but read by all the *ilustrados*) was skeptical about witches and sorcerers, Montesquieu noted the connection between witch hunts and political tyranny, and Voltaire wrote flippantly about demonic possession. In Spain the Benedictine scholar, Benito Jerónimo Feijóo y Montenegro (1676–1764), took the lead in exposing mythical notions about the casting of spells and fallacies, in the light of advances in science.[53] His major work, *Teatro crítico universal* (Universal theater of criticism), was published in nine volumes during the period 1726–1740 and went through fifteen editions by 1780. The work is a rich storehouse of magical folklore in which figure hobgoblins, vampires, demons, witches, angels, bleeding crucifixes, moving statues, and miraculous signs of every description. The subject of the occult was a dangerous one in Spain, where the church held the monop-

oly of interpretation of all nonnatural phenomena; for reasons established by the Inquisition, marvels had to be explained as the work of either angels or demons. Unlike England, for example, where many so-called supernatural events could be explained in nontheological terms, Spain maintained that the occult was either a manifestation or perversion of religious doctrine. But Feijóo broke with this conception and insisted on the application of the scientific method to examine both magical belief and false religious miracle.

Feijóo claimed that Spain needed progress in science and that science did not necessarily clash with religion. Against the Spanish scholastics, Feijóo courageously held up the experimental method of the English Francis Bacon and culled his information from primarily French sources. Like the later *afrancesados* who deeply admired him, he united a strong devotion to his faith with a sincere desire to see his country catch up with the rest of Europe. His spirit of skepticism aroused controversy, but his monastic credentials and the patronage of Fernando VI and the young prince (the future Carlos III) protected him from attempts to prohibit his writings. By the end of the century his name had become a national byword, and one critic could write, "Thanks to the immortal Feijóo, spirits no longer trouble our houses, witches have fled our towns, the evil eye does not plague the tender child, and an eclipse does not dismay us."[54]

Of course, it was not true that Feijóo had expelled magical belief from Spain. Small ivory, glass, or stone fists (*manecitas*), with the thumb thrust out between the middle fingers, were still fastened to children's wrists to ward off the evil eye, and even mules and horses had to be secured against the *mal de ojo* with the paw of a mole or a bit of scarlet cloth.[55] Goya's work demonstrates that witches and demons pervaded popular thought long after Feijóo's death, but it is certain that the artist's depiction of them was indebted to the intellectual ferment marked by Feijóo's writing. Indeed, Goya's imagery suggests that he understood even more than Feijóo that the popular interpretations of certain phenomena were the means by which the people objectified subjective states and integrated inexpressible experiences into a workable, everyday system.

Feijóo contended that it was the lower clergy that especially contributed to the fomenting of supernatural belief. He noted that those who wanted to be a power in exorcism could easily persuade themselves that there are people to be

exorcised. In this the parish priests often acted irresponsibly. Once a befuddled doctor handed a patient to the exorcist, it was not uncommon to find that the terrified subject adopted the state of demoniac possession with all its traditional attributes by the power of the priest's suggestion and folk memory. The frightening ceremony of the exorcism itself, with its solemn bell, candle, and Latin incantation, no doubt contributed to the illusion. Feijóo also noted the predisposition of the clergy to interpret incoherent expressions and even mumbling as Latin, a notorious symptom of demoniac possession among the uninstructed.

Such debunking of the clergy inspired the satirical publication by Padre José Francisco de Isla, *La historia del famoso predicador Fray Gerundio de Campazas* (History of the famous preacher Fray Gerundio). A Jesuit, Isla published his famous burlesque of sermonizing rhetoric in 1758, which savaged popular preaching so mercilessly that the book ended up on the Index. The author points out that preachers filled their harangues with allusions to pagan mythology and flowery allegorical interpretations in which moral exhortations were almost entirely neglected. Indeed, the protagonist chooses his vocation because even the most stupid who preach "often make a great deal of money." As a result, the minor clergy had the effect of fostering superstitions within the religion of the people. Through oratory such priests played on the public's credulity, as in the case of the *beata* of Cuenca who convinced the local citizens that her flesh had been converted into the body and blood of Christ and was carried in procession surrounded by tapers and burning incense. While the Inquisition punished the young woman, the basic cause of the fraud was the influence of the local priests and monks. (It should be noted that Feijóo and Isla aimed their barbs at the lower-class clergy for the amusement of the aristocratic prelates who accused many of the sons of peasants and artisans of entering the church only to gain the social prestige of being a friar or priest.)

The world outlook of the peasants was a primitive Christianity, full of miracles and demons, which they inherited from their local priests or monks, men who were hardly more educated than their parishioners and who came from the same ranks. The church enjoyed the unquestioned loyalty of the mass of Spanish people. Devotion to the Catholic religion, carried frequently to excessive exaggeration, was probably the strongest force in Spanish society at the end of the eighteenth century. But popular mys-

ticism also expressed the fervent desire of the underclasses to escape from their immediate miseries and gain some control over their lives. The temptation to establish direct communion with God through the supernatural revealed an affinity to what the Inquisition defined as heresy.

The Inquisition actually reinforced popular magical belief by its intimidation and torture. Feijóo noted that the excessive fear unnerved innocent people and made them confess to acts they never committed. These people often accused others, and whole communities were torn by grief and fear of the supernatural. Indeed, the very handbook on the treatment of witchcraft used by the Inquisitors, *Malleus maleficarum* (The hammer of witches), insisted that witchcraft was real and involved commerce with Satan and the devouring of human children. It actually promoted belief in the very practices it was allegedly fighting. It was no wonder that the so-called conspiracy of the witches' sabbath was likened by a few courageous people to that of the Holy Office. It may not be coincidental that the term *familiar*—used to designate the sinister lay servants of the Inquisition whose identities were never revealed—was applied to the witches' animal agents—cats, bats, and owls. In any event, the Inquisition's theocratic mysticism and fanaticism, embracing a farrago of archaic ritual and ceremony, threatened the progressive movement initiated under the reign of Carlos III.

The sight of the victims wearing on their heads the *coroza,* the cardboard cone decorated with allusions to the alleged crime, and the *sanbenito* tunic of enforced penitence, outraged Goya and his fellow *afrancesados* (fig. 4.33) like Leandro Fernández de Moratín, the popular playwright whose portrait Goya painted in 1799. Yet another protégé of Jovellanos, Moratín was later offered the powerful protection of Godoy, which enabled him to stage his controversial comedies in Madrid. In 1811 Moratín published an edition of an account of an *auto de fe* for sorcery, which originally appeared in 1611. He titled his version, *Auto de Fe Celebrated in the City of Logroño during 7–9 November 1610,* envisioning the famous witch trial as a monstrous farce. A thousand officials took part in the spectacle, and two days were required to read the list of crimes, which included spells against crops and animals, the sucking of infants' blood, and feasting on decaying corpses. Moratín stated in his introduction that he relished the opportunity "to ridicule the extravagant absurdities" that abounded in the tragicomic event.[56]

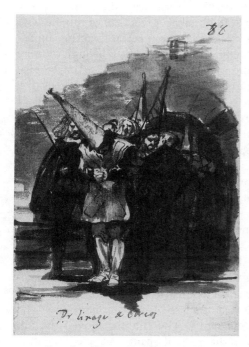

4.33 Francisco Goya y Lucientes, *For Being of Jewish Ancestry,* c. 1814–1823, sepia wash, album C.88 [1324]. Reproduced by courtesy of the Trustees of the British Museum, London.

Moratín's edition appeared during the French occupation, when he worked for the new government as director of the Biblioteca nacional. It was a propitious moment to publish, since Napoleon had abolished the Inquisition by decree on 4 December 1808. This touched off a flood of pent-up resentments in every print medium. But although the book first appeared in 1811, preparation for it began in the 1790s and thus antedated by many years the actual date of publication. There are significant correspondences between several of Goya's images of witches in the late 1790s and the style and details of Moratín's Logroño account.[57] Even more significant for the pro-French *ilustrados* is the fact that during the hostile confrontation between France and Spain in the early 1790s the Inquisition of Logroño took an active role in monitoring French movements and ideas. Charged with watching the provinces bordering southwestern France, the Logroño Inquisition confiscated revolutionary newspapers and radical literature, and warned readers of French journals that if they continued to defy the edicts of the Inquisition they would be considered "criminals of state and of our holy faith." It may also be recalled that Jovellanos described the Logroño tribunal in 1795 as "a magnificent palace to . . . oppress a few unhappy wretches." The *afrancesados* did not miss the connection between the witch hunts of the past and the persecutions of the present.

Goya and the Osuna Family

The most celebrated family identifying with the Enlightenment were the Osunas, one of the oldest and richest of the Spanish nobility.[58] Their Andalusian seat at Osuna boasted a collegiate church and a university, but they were part of a cultured and enlightened minority among the mass of nobility who, while devoted to the Catholic faith and to Spanish tradition, were open-minded and fired by the scientific progress of the day. By their admiration of foreign achievements and the use of their influence to propagate the Enlightenment, these nobles helped bring about liberal innovations under Carlos III and Carlos IV.

The duques de Osuna had spent several years in France and steeped themselves in French culture and fashion. The duke maintained pensioners in France whom he subsidized to perfect their skills or to complete scientific studies. His wife, the condesa-duquesa de Benavente, was president of the women's section of the Royal Economic Society in Ma-

drid and highly knowledgeable in both art and science. Both also admired English letters and science, inspiring their friend Godoy, who accepted the dedication of a Spanish edition of Adam Smith's works in 1794. The Osunas adopted the Enlightenment as a tool to further social and economic reform; following Jovellanos's lead in agrarian reform, they supported the economic societies and stimulated Godoy's schemes for promoting commerce and industry.

Naturally, their enthusiasm for reform was inseparable from their self-interests. The steady inflation in the second half of the eighteenth century caused a revolution in land values and greater stress on agriculture. This in turn stimulated interest in land reform and the economic societies. At the same time, the growth of commercial companies under government approval led to an expansion of trade to the Indies, and to a rise in the import of precious metals from America. The economic boom, which built up to an inflationary climax at the very end of the century, precipitated new social and political developments that revolutionized the attitude of the progressive classes in Spain.

This expansion laid the foundation for cultural and social change. When Spanish nobles read foreign books, it was not only to put on the trappings of foreign culture but because they wished to apply new methods to Spanish economic problems. Works on agriculture, industry, and trade were not only introduced from abroad: they were also drawn up ambitiously and systematically by Spaniards. The bourgeoisie everywhere in Spain identified with the minority of aristocratic liberals, while the common people and the bulk of the aristocracy composed the conservative or traditionalist party. The progressive movement in Spain did not take the form of a popular struggle for liberty, but embodied the aspirations of the *ilustrados* and their aristocratic and bourgeois supporters for a wider economic base.

As bearers of culture and enlightenment, the Osunas gathered innovators in every field at their *tertulia* (a group that met at the same house on a regular basis, roughly equivalent to the French salon). Talk of the new agricultural methods and scientific advancements mingled with the exchange of artistic and literary ideas. Moratín and the Iriartes received the Osunas direct support: Tomás de Iriarte dedicated many of his poems to the duquesa de Osuna, while she constructed a theater for the performance of his plays. The Osuna art collection joined seventeenth-

4.34 Francisco Goya y Lucientes, *Condesa-duquesa de Benavente*, 1785. Bartolome March Severa, Madrid.

century old masters with the works of their favorite contemporary, Goya.

It is no exaggeration to claim that during the years 1785 and 1799 the Osunas were Goya's most generous and enthusiastic patrons. They commissioned or bought from him some thirty works, including individual portraits and compositions, to decorate their home in Madrid, their country estates at La Alameda, and their private chapel in the Cathedral of Valencia. Goya's portrait of the remarkable duquesa in a three-quarter-length view emphasizes the Parisian fashions that singled her out as a *petimetra* (fig. 4.34). Yet the liveliness of her face and the confidence of her bearing are more than equal to the dazzling beribboned and plumed hat and the floral extravaganza of the silk dress. Three years later (1788) he painted the entire Osuna family, this time focusing on the simplicity of their domestic lifestyle. The background is absent of accessories, the duquesa and her children are modestly attired, and the figure of the duque is not heavily laden with the badges of rank and honor awarded him by Carlos III.

The Osunas are central to an understanding of Goya's interpretation of theocratic mysticism and witchcraft.[59] It was a topic of discussion at their *tertulia* and a subject of scientific investigation on the part of their friends. The Osunas respected popular beliefs, but they were also alert to the exploitation of magic and sorcery for political purposes. The second half of the eighteenth century saw the publication of many books attacking belief in witches and sorcery from a rationalistic viewpoint. These rational thinkers inevitably questioned the practices of the Inquisition, which had began to act as a political institution rather than as a prosecutor of heresy. Gradually the aristocrats came to perceive the Inquisition as a barrier to progress in science, industry, and agriculture.

As early as 1788, the duquesa de Osuna commissioned Goya to do two large paintings for the Capilla de San Francisco de Borja in the Cathedral of Valencia, one of which featured preternatural beings. The Spanish saint, a general in the Jesuit order during the sixteenth century, was one of the illustrious ancestors of the duquesa de Osuna. At that time the Society of Jesus in Spain distinguished itself by its liberal ideology and was not yet identified with the Holy Office. Francisco de Borja's publications were even put on the Index, and although he was a Spaniard of unimpeachable Old Christian blood (i.e., of non-Jewish ancestry), he

4.35 Francisco Goya y Lucientes, *San Francisco de Borja Exorcising an Evil Spirit from an Impenitent Dying Man*, 1788. Catedral, Valencia.

allowed *conversos* (converted Jews) in the Jesuit ranks. He stoutly defended this policy against the attacks of members of the Inquisition, noting that they were serving the Lord "for whom there is no distinction between persons, between Greek or Jew, or barbarian and Scythian."

Goya's two subjects show the saint taking leave of his family to enter the Jesuit order (symbolizing the lineage of the Osunas) and, more important for our discussion, *San Francisco de Borja Exorcizing an Evil Spirit from an Impenitent Dying Man* (fig. 4.35). Here we see for the first time in Goya's work the demonic creatures of the supernatural world. The victim, racked in naked torment on his bed, is unable or unwilling to make confession and thus exposes himself to the severity of the penitential law and the threat of everlasting punishment. Grinning devilish beings hover over the bedside impatiently awaiting the soul of the impenitent. The frightened saint holds up in his right hand a small crucifix that miraculously spurts blood towards the dying victim. Through the intercession of the priest Christ reenacts the suffering he underwent to save the sinner from the clutches of Satan and his minions.

Given the Osunas' admiration for French and English innovation, it is not surprising to find that Goya based his composition on the work of the most advanced artists of those two cultures: David and Fuseli. The horizontal composition of the stricken figure on a bed immediately recalls David's *Hector and Andromache,* while the content and several details derive in part from Fuseli's *Nightmare.* Both works were well known through engravings, which the Osunas may even have owned in their extensive print collection. Goya's sinner is no hero, but his expanded chest and taut muscles imitate the pagan Hector, for whom also there can be no celestial reward. The basic disposition of the bed and sprawling foreground figure cut by the vertical line of the curtain come straight out of Fuseli, and as in *Nightmare* the monstrous creatures occupy the inverted V-shape formed by the curtain's folds and shadows (fig. 4.36). Even the vials on the table at the left in Fuseli's composition have been taken over by his Spanish admirer.

Both the sprinkling crucifix and the demons recall the writings of Feijóo, who declared open war on quackery of all kinds, including miracles and visions that he related to superstition. But Feijóo also asserted his unwavering belief in the power of God to intervene miraculously in nature, and in the devil's personal power for evil. He rarely delved into alleged miracles substantiated by the proper episcopal

4.36 Henry Fuseli, *Nightmare*, 1781. The Detroit Institute of Arts.

authorities, or which otherwise had some bearing on church doctrine. Moreover, much of his work was done out of reaction to foreign opinion of Spain as a backwater culture. His zealous inquiries into unauthenticated instances of the miraculous often ignored the distinctions between harmless pretense, folklore, and superstition proper.

The Osuna-Goya version of Francisco de Borja's wondrous experience carefully indicates the saint's profound astonishment and guards respectfully the folk beliefs of his native Valencia. Where compassion and intelligence are rationally combined, the church may be assured a victory over the forces of superstition and evil. Thus the two paintings attest to the Osunas' association with their "enlightened" ancestry and declare that progressive ideas were not incompatible with a strong attachment to religion.

Two years earlier their protégé, Tomás de Iriarte, had been hounded and persecuted by the Inquisition. Iriarte—an ardent Francophile who had been critical of certain "miracles"—was accused of harboring the errors of the "false philosophers" and required to abjure behind closed doors. The complete destruction of the prominent Pablo Antonio de Olavide in 1778 provided evidence that the Inquisition could, when necessary, still make its presence felt. What the Inquisition feared most was the invasion of French philosophy which, as the year 1789 approached, became increasingly widespread.

Nearly a decade later, however, after the *afrancesados* had survived the chilling nightmare brought on by the French

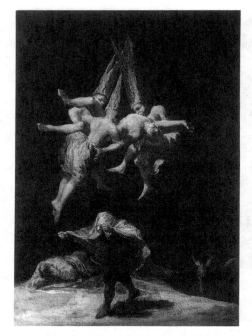

4.37 Francisco Goya y Lucientes, *Witches in Flight,* 1797–1798. Ministerio de la gobernación, Madrid.

Revolution, the Osunas again turned to Goya, this time for a series of paintings exclusively devoted to witchery and the occult. Goya's account of 27 June 1798 records payment for "six compositions of witch subjects." They were probably begun in late 1797 and completed in June 1798 for the decoration of the Osunas' country house, La Alameda, not far from Madrid.

Whereas the *San Francisco de Borja Exorcizing an Evil Spirit* occurred within the framework of the church's interpretation of nonnatural phenomena, Goya's series was openly critical and satirical of such phenomena, shown as independent of the scope of theocratic mysticism. The paintings incorporate the ideas of Feijóo and Isla, and breathe the heady atmosphere of Iriarte, Moratín, and Meléndez Valdés. This new attitude is consistent with the liberal climate stimulated by Godoy in the years when Jovellanos came to power and there was a brief period of intense reformist agitation. Opinions that could only have been expressed previously with a certain restraint were now advanced openly, often in a jocular manner. Jovellanos read books on witchcraft near the end of August 1798, at the very moment of his impending withdrawal from the ministry, and in his diary entry of 24 August he made the following comment on one of them: "Excellent ideas for banishing pointless belief in witches, spells, spirits, diviners, etc." For the Osunas and Jovellanos, a belief in witchcraft expressed an anachronistic and conservative position.

One work in the series makes clear the connection between the fanatical cruelty of the Inquisition and the perpetuation of superstitious fear (fig. 4.37). The *Witches in Flight* depicts three semi-nude male demons, wearing the *corozas,* who carry skyward a terrified nude woman from whom they are about to suck blood. Goya's caps cue us to his intention: not only were the *corozas* required of suspected sorcerers by the Holy Office, but here the *corozas* are cleaved like the miters of bishops. Goya wants us to see the flying witches as diabolical prelates. Below, two horrified witnesses react to the scene in panic, one throwing himself on the ground and covering his ears, while the other flees with his head covered with a blanket. They try to shut out the sight and sound of the ghastly scene they have just encountered, both to escape the awful consequences for themselves and possible incrimination should they survive. The threat of the Inquisition, like that of witchcraft itself, forced society to ignore, or to hide from, the frightful process and allow it to go on without interference.

Perhaps the most popular example of the series is *The Bewitched by Force* (El hechizado por fuerza), based on a famous play by Antonio de Zamora (fig. 4.38). While first performed around the end of the seventeenth century, it thrived throughout the eighteenth century. Moratín's prologue to the comedies in his collected works included a short biography of Zamora; he singled out the *Hechizado por fuerza* for praise, even while pointing out its flaws. Moratín especially admired the older author for his borrowings from "el gran Molière." Zamora's farce in fact resembled the French writer's *Le malade imaginaire* and *Le malade malgré lui,* which also center on the eccentricities of a single individual. Molière's influence on Zamora is especially evident in the characterization of the doctors who attend the monomaniac, Don Claudio. In turn, the Molière-inspired dialogues between Don Claudio and his servant Picatoste anticipate the witty and energetic exchanges between Don Roque and Muñoz in Moratín's famous play of *El viejo y la niña* (The old man and the young girl).

In the town of Osuna Zamora's plays were great favorites, as well as others with similar subjects such as the anonymous comedy, *El diablo predicador* (The devil as preacher). This last was regularly performed in the 1790s by strolling players and continued to captivate public opinion through the Napoleonic occupation.[60] The plot centers on the efforts of Lucifer to halt the spread of the Franciscan order, which interferes with his activities. But the intervention of the Christ child and Michael the archangel forces him to assume the habit of Saint Francis and aid in the support of the very Franciscan convent he tried to subvert. Lucifer succeeds only too well, and then in a passionate exposition of the hardship this imposes on his nature, induces the archangel to permit him to abandon his cowl and resume his hostilities against the Franciscans. The back-and-forth exchange between the devil and the friar suggests a form of latent hostility against the controlling priests and monks. The fact that it is a credulous priest in Zamora's comedy who imagines himself bewitched indicates to what extent the clergy fostered superstition in the ranks of the people. Here Zamora's play may have profoundly affected Isla's *Fray Gerundio.*

The play unfolds the experience of a timorous priest, Don Claudio, who is persuaded that he has been cast under a spell by Luciguela, the slave of Doña Leonor who wants to frighten him into marriage. The key scene is in act 2 when Don Claudio is tricked into thinking that his life will

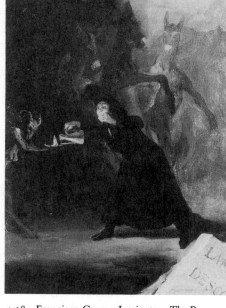

4.38 Francisco Goya y Lucientes, *The Bewitched by Force*, 1797–1798. National Gallery, London.

last only as long as an oil lamp in Luciguela's chamber remains lit. Accompanied by his servant Picatoste, he enters to replenish the lamp, not knowing that Luciguela has prepared several surprises for him, including a revolving statue resembling a ghostly Don Claudio. Large grotesque paintings are displayed to frighten him as he approaches the table on which the night lamp is burning. The sight of colossal donkeys dancing gives him pause as he nervously pours oil into the lamp's receptacle and utters the monologue on which Goya based his painting:

Monstrous lamp,
whose civil light
from me like a candlewick
sucks up life's oil,
I stay in the belief that I shall
conquer your evil influence . . .

The sudden rattling of chains shocks him into dropping the oil can and he cries,

May they have pity on me,
The Deacons and Exorcists,
and the Four Evangelists
Faith, Hope and Charity.[61]

The dialogue is replete with puns; "moco de candil" (candlewick) also means booger and implies the loss of his vital forces, while "chupando" (from *chupar,* "to suck") refers to one of the murderous activities of witches—a theme common to several works in the series and Goya's famous album of *Los caprichos.*

The farcical elements of the scene are contextualized by the word fragments written in large capitals on the prompter's book in the right foreground, "LAM . . . DESCO." These are the prefixes to the first words of Don Claudio's address to the taper, "Lampara descomunal" (monstrous lamp). Goya retains the histrionic quality of the original: Don Claudio, looking ridiculous in his priest's habit and clerical hat, stands petrified. He cups his mouth with one hand and stares in terror as he pours oil into the lamp. The table on which the lamp rests is in the form of a he-goat, one of the earthly avatars of the devil. Behind Don Claudio three monstrous donkeys dance on their hind legs, reminiscent of the wild stallion in Fuseli's *Nightmare.*

The stagy presentation of this scene, as well as another from Zamora's *El burlador de Sevilla* (The seducer of Se-

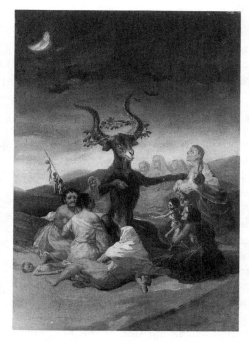

4.39 Francisco Goya y Lucientes, *The Witches Sabbath*, 1797–1798. Museo Lazaro Galdiano, Madrid.

ville), testifies to the involvement of the Osunas in the theater and their patronage of young playwrights. Indeed, almost every work in the series projects a theatrical character, reflecting the taste for popular theater which at that time was appreciated as an expression of the national psychology. One fundamental feature of eighteenth-century theater was the *comedia de magia,* which made use of all the tricks of the stage machinist to beguile the audience with magical illusion. This included novel lighting effects, and it is no coincidence that Goya's characteristically powerful light-and-dark contrasts are early revealed in the nocturnal scenes of this series. The "Goyesque" mood may be understood as an outgrowth of his patrons' taste for the dramaturgical presentations of the supernatural.

The satirical treatment of the priest coincides with the liberal policies of Godoy. In 1797 he passed the first decree of toleration ever known in Spain: his order of 8 September allowed any foreign manufacturer, even if Protestant, to settle in Spain, provided he respected the religion of the country. The only shadow from the past was that Jews were expressly forbidden entry by the decree. But even in this moderate form it indicated the great gulf between the Inquisition and the administration of Godoy.

Perhaps the most unforgettable work in the Osuna series is *The witches' sabbath* (Aquelarre), showing Satan in the form of a billy goat surrounded by a ring of his terrifying witches in a barren landscape (fig. 4.39). The Basque word for a male goat is *akerra,* and to this is added the term for field, *larre,* to get *akelarra* (*aquelarra* is the Castilian equivalent), or the "domain of the he-goat." The Basque accounts of witchcraft abound in references to the *akelarra* and were the main subject of investigation by the Logroño Inquisition in earlier times.

The he-goat's head, with its huge horns, is crowned with a wreath of oak leaves, and he officiates like a priest at a mass or baptism. At this ceremonial presentation of a novice, the neophyte shrieks as she offers Satan her baby for "benediction." In witchcraft, Christian symbols and values are always used in inverted form, and here the goat extends his left hoof towards the child (in Christian ritual the blessing is given with the right hand). The "old-timers" carry the shrunken corpses of babes they have sucked on the end of a stick, or hold up infants reduced to skeletal forms. In church doctrine, the moral accountableness of a human being did not begin until seven years of age, so that

baptized children dying before that age were sent straight to heaven and became angels. Witches therefore sought unbaptized infants to render to the devil, their masters. Goya's scene, with its images of sucked, dehydrated, and deformed children, is an inverted image of Catholic doctrine.

Much of this imagery derives from the Logroño account, which preoccupied Moratín in this period. It may be recalled that Moratín envisioned the notorious witch trial as a tragicomic event which could even be set to music. His cast would include all the characters paraded in the testimonies of the witnesses and the defendants: a he-goat, acolyte devils, witches, dozens of sucked children, a chorus of dogs, toads, and nocturnal familiars like cats, bats, and owls. This in fact constituted the dramatis personae of the *aquelarre* in the Basque country, which became celebrated in the trials at Logroño.

In Goya's evocative presentation bats circle above the bedeviled congregation, while an eerie crescent moon gleams dimly from the nocturnal sky. Here as in Prud'hon the "unearthly" lunar orb reflects the flip side of the Enlightenment's sunny rays, an ironic symbol of the rational and critical inquiry it inspired. The rationalists, who were convinced that scientific progress would extend the domain of the known, still remained curious about the dark side of nature and its place in the new scheme of things. Like Feijóo, they took delight in the name of reason in displaying the whole phantasmagoric array of supernatural phenomena.

At a deeper level of "inversion" Goya's *Witches' Sabbath* is a metaphor for those agencies favoring progress and overturning the Inquisition. The meetings of the royal economic societies were perceived by the conservatives as subversive, and their members as instruments of the devil. In some ways, these organizations are comparable to the English provincial societies that represented the vanguard of progressive thought in their country. We may recall the Lunar Society, who met each month on the Monday nearest to the full moon to foster their common enthusiasm for scientific and industrial progress. In England the infernal character of steam and ironworks gave rise to satanic metaphors and sublunary allusions. Spain's economic difficulties did not allow for this magnitude of projection, but Goya's demonic images demonstrate the intellectual fermentation that exorcised the impediments to progress and facilitated the spread of scientific knowledge.

The English Connection

Goya's association of the moon and witchcraft is a distant echo of Wright of Derby's combination of moon and industry. Nevertheless, it too must be understood in the context of indigenous intellectual advances. The *ilustrados* were deeply indebted for their concepts to the English whose works were mainly known through French translation. Jovellanos, Meléndez Valdés, and the duque de Osuna, however, read the language in the original and were profoundly influenced by English political, scientific, and economic ideas. Sorcery and witchcraft were topics of concern to English scientific thinkers like Erasmus Darwin, a leading member of the Lunar Society. In part 2 of *The Botanic Garden* ("The Loves of the Plants," canto 3), Darwin makes explicit the links between "the mysteries of witchcraft" and its investigations:

Thrice round the grave CIRCAEA prints her tread,
And chaunts the numbers which disturb the dead;
Shakes o'er the holy earth her sable plume,
Waves her dread wand, and strikes the echoing tomb!
—Pale shoot the stars across the troubled night,
The timorous moon withholds her conscious light;
Shrill scream the famish'd bats, and shivering owls,
And loud and long the dog of midnight howls!—
—Then yawns the bursting ground!—*two* imps obscene
Rise on broad wings, and hail the baleful queen;
Each with dire grin salutes the potent wand,
And leads the Sorceress with his sooty hand;
Onward they glide, where sheds the sickly gyew,
O'er many a mouldering bone, its nightly dew;
The ponderous portals of the church unbar.
..

O'er the still choir with hideous laugh they move,
(Fiends yell below, and angels weep above!)
Their impious march to God's high altar bend,
With feet impure the sacred steps ascend;
With wine unbless'd the holy chalice stain,
Assume the mitre, and the cape profane;
To heaven their eyes in mock devotion throw;
And to the cross with horrid mummery bow;
Adjure by mimic rites the power above,
And plight alternate their Satanic love.[62]

Here also the relationship of the sacred and profane is brought into the context of religious subversion, like a black mass or witches' sabbath. It is probably not coincidental that almost immediately afterwards follow the

verses on Fuseli's *Nightmare,* which was reproduced in the edition of 1791. Goya was highly influenced by Fuseli, as well as Hogarth and Flaxman, and was generally open to the English influences emerging during the Industrial Revolution. In plate 61 of his series of satires known as *Los caprichos,* a woman soars through the air with her head swollen with "inflammable gas"—perhaps an allusion to the contributions of Priestley and his colleagues in the Lunar Society.

Los caprichos

It was as the creator of *Los caprichos* that Goya aligned himself with the English and Spanish satirists and first became known in England and France.[63] *Los caprichos* are a series of eighty satirical prints which he drew and etched in the years 1797–1798 and published as an album in 1799. Not surprisingly, the Osunas were among the earliest and most enthusiastic subscribers to the series, purchasing four sets in January 1799 even before they were formally offered for sale. Produced during the same period as the decorations for La Alameda, the subjects of both overlap in the area of witchcraft and anticlericalism. The connection is especially evident in plate 60, *Trials,* where a monumental he-goat presides over the initiation of neophytes as in *The Witches' Sabbath.* In *Los caprichos,* however, the social criticism is more obvious and biting. The artist expands his range to encompass the oppression of the underclasses, brutalized by deadening superstition that hid from them the true nature of their exploitation.

The sale of the series was announced in two Madrid newspapers, but the series was almost immediately withdrawn from the public domain. Nothing more was heard of the venture until 1803, when Goya offered the copperplates and 240 unsold sets of the first edition to Carlos IV. While there is no evidence of formal proceedings against Goya, late in life the painter himself wrote that pressure from the Inquisition forced him to withdraw the prints from circulation. This would not have been the only publication to suffer such a fate in 1799: that year the Inquisition went on a rampage, curtailing the sale of prohibited literature and ruining many booksellers.

The dates of execution and publication of *Los caprichos* encompass a brief scenario of events. Reformist agitation under the liberalized ministry of Godoy reached a peak in

the period 1797–1798. In addition to the numerous *ilustrados* in government whose friendship Goya enjoyed, he had the backing of Godoy in his most politically motivated work to date. In fact, the prince of the peace not only purchased a set of *Los caprichos,* but even took credit in his *Memorias* for the second edition of the etchings in 1803. (Scholars have mistakenly taken several of the plates as slurs against Godoy, yet only no. 56, *Rise and Fall*—a satire on the chaotic rise and fall of his ministry in 1797–1798— may be specifically related to him.)

But by the end of 1798 the liberal climate and support in high places had evaporated: Godoy had resigned his post, Jovellanos and Saavedra were forced to leave the ministry, to be replaced by the *afrancesado* Mariano Luis de Urquijo (next in power to Godoy) and the reactionary José Antonio Caballero, who had worked to overthrow the liberals. Goya may have made certain concessions at this time, since in October 1799 Urquijo (whose portrait he painted the same year) had him appointed as first painter to the king.

The shakeup of the government and the cause of Godoy's retirement at the end of March 1798 had to do with Spain's relations with France. The coup d'état in France of 4 September 1797 (18 *fructidor*) had halted the rightward drift of the Directory and handed over its control to a dictatorship of strong-willed people determined to crush the domestic and foreign threats to the Revolution. It was inevitable that French foreign policy should be affected by the coup, since the royalists' collusion with the enemy was one of its contributory factors. The new government was suspicious of Godoy for not having expelled the French émigrés from Spain. Early in 1798 the directors declared Cabarrús unacceptable as Spanish ambassador to France because of his French citizenship. and they intrigued through their ambassador in Madrid to bring about the dismissal of Godoy. (In May the French government appointed their representative Ferdinand Guillemardet to the ambassadorship; he took back to France a copy of *Los caprichos,* to be discovered at a later date by his godson, Eugène Delacroix.) Rumors also circulated that the prince of the peace had fallen out with the queen, and in fact his correspondence with the royal couple shows that for the next two years his advice on government matters was not asked. On the other hand, Godoy retained all his honors and titles and was allowed open entry to the royal residences. It is possible that he was merely keeping a low profile during the French pressure.

Godoy's retirement left Jovellanos momentarily the best-known figure in the government. Jovellanos was forced to deal with Spain's economic woes and the bitterness of the wealthy class upon whom most of the financial burdens of the war with Britain had been levied. The major landowners reacted by turning to the ultramontanes, whose fight with the Jansenists over the organization of the Church of Spain heightened the new tensions. After the expulsion of the Jesuits, the antagonisms were kept alive by educational and religious reform movements. Jansenist gains within Italy and France also encouraged the liberals during the early years of the reign of Carlos IV, and incited the ultramontanes to drastic action.

As in other matters, Godoy had followed the policy of Carlos III by supporting the Jansenists, who now succeeded in publishing writings favorable to their cause. These writings included the work of the French bishop Grégoire, a progressive given a central role in David's project of the *Oath of the Tennis Court*. Grégoire was in close contact with the condesa de Montijo, a leading figure in Madrid society and a Jansenist sympathizer. Her *tertulias* in the 1790s became gatherings of like-minded supporters, including the Osunas and her dear friend Jovellanos. Goya no doubt participated as well; his portraits of her children in the early years of the nineteenth century suggest familiarity with the family.

During the ministry of Godoy, several halfhearted attempts were made to pare the newly sharpened claws of the Inquisition. In reaction, the Inquisition began persecuting the clergy for Jansenism, and several ultramontane clergymen, led by the archbishop of Seville and the queen's confessor, tried to discredit Godoy by having the Inquisition convict him of atheism and immorality. The leading royal official in their party was Caballero, a member of the council of war, who was married to one of Queen María Luisa's ladies-in-waiting and had an able hand for intrigue. According to Godoy, it was Caballero who helped discredit him with the king and worked to oust the new liberal ministers.

Just before Godoy left office in March 1798 he inadvertently furnished the ultramontane party with a powerful ally. The French invasion of the papal states had threatened the peace of the Spanish ex-Jesuits. They appealed to Carlos for help. A royal order of 29 October 1797 allowed them to return to Spain to live in convents remote from the

populous centers. Upon their return, however, the ex-Jesuits joined other ultramontanes to denounce the condesa de Montijo and Jovellanos to the Inquisition, pressuring the king to bring about the minister's dismissal. In August 1798 Jovellanos suffered severe stomach disorders (many suspected poisoning), an illness that provided the pretext for his dismissal and exile to the Asturias. Caballero now replaced Jovellanos in the court of Carlos IV. During this period, Godoy's successor, Francisco de Saavedra, suffered a severe attack of colic (more rumors of poison), and he was replaced by the next highest official, Urquijo. Those who lamented the departure of Jovellanos turned their hopes on this brash personality, known to detest the Inquisition, which had tried to convict him for a translation of Voltaire. Overnight Caballero and Urquijo, both new to authority, became rivals for control of royal policy. Eventually, however, the ultramontanes successfully discredited Urquijo, and by December 1800 he was dismissed and imprisoned.

Before excitement over the ministerial upheaval died down, the publication of partisan works brought the religious controversy in the press to a climax. On the ultramontane side, an aristocrat arranged for the printing of a translation of an Italian attack on the Synod of Pistoia, whose Jansenist recommendations were widely disseminated. The Jansenists fired back with a reply by Fray Juan Fernández de Rojas, a friend of Jovellanos and Meléndez Valdés, and the two rival pamphlets became the talk of informed circles. One witness claimed that three thousand copies of Rojas's pamphlet were sold in one day. While Urquijo's sympathies were with Rojas, he felt that, to neutralize the religious dispute, both works had to be prohibited. He issued a royal order in January 1799 to collect all copies of the two pamphlets. Thus despite Urquijo's liberal position, the circumstances forced him to censor controversial publications. This explains the sudden withdrawal of Goya's *Caprichos,* works whose creation and bizarre history are inextricably bound to the temper of the years 1797–1799 as to the anticlerical content of several of the etchings and the frequent recurrence of the term "reason" in Goya's commentaries—a favorite verbal weapon in the Enlightenment arsenal. Above all, the history of the epoch in which the series unfolded explains how it was possible for *Los caprichos* to bridge Spanish culture under Carlos IV and the modern epoch.

Meaning of *Capricho*

For Goya's contemporaries, *capricho* was pervasively used by the *ilustrados* to denote something arbitrary, like the English term *caprice,* but also carried the Italian sense of *capriccio,* referring more to a sudden leap of the imagination. Indeed, it is related to *caper,* from the Italian *capro* for "goat," that is, "capering like a goat." In this sense, it implies a deviation from the rules, as in music where *capriccio* signifies a composition or passage in a free, irregular manner. At the same time, the fact that a satanic goat occupies a conspicuous role in both the decorations at La Alameda and in *Los caprichos* links the concept to an exploration of the realms beyond the ken of academic and neoclassical approaches.

Goya's series uses the term in its double sense, subjective and objective: the themes are drawn from his imagination, but they are also statements about the caprices of his contemporaries. In his ad for *Los caprichos* of 6 February 1799 he described the collection as "asuntos caprichosos" (capricious subjects), thus directing attention to their imaginative origin.[64] He goes on to state that the censure of human errors and vices is not exclusively the province of literature but may also be the object of painting, and thus he has chosen themes from among "the multitude of follies and blunders common in every civil society, as well as from the vulgar prejudices and lies sanctioned by custom, ignorance or interest." This amplified use of *capricho* is reasserted in the last sentence of his opening paragraph, when he states that in holding up society's vices for ridicule he is also granted the opportunity to exercise his "fantasy." Here it may be recalled that in his letter of 4 January 1794 to Bernardo de Iriarte, then director of the academy, he discussed his new group of paintings on copper as original ideas, which, as opposed to commissioned projects, allow scope for "capricho y la invención."

Goya also mentioned in the letter to Iriarte that he hoped that their sale might cover the considerable expenses caused by his recent illness. Similarly, he put up the self-consciously original *Caprichos* for sale. His lengthy notice appeared in the *Diario de Madrid,* a highly conservative paper spared Floridablanca's merciless suppression of the press. The series was offered for sale in a perfume and liquor shop at a cost of 320 reales—approximately $40—a hefty sum for that time. Like David in France, Goya saw both the intellectual and market value of art for a clientele seeking cultural innovation. While Goya's art would not

have had investment value for them, it would have complemented their status and sense of achievement. For Goya, it meant another opportunity to break from the dependence on an exclusively aristocratic patronage preoccupied with portraiture. There can be no doubt from the way it was organized that Goya had embarked on what he hoped to be a major commercial venture, exploiting what he felt to be—erroneously as it turned out—a propitious moment.

As he made clear in the ad, the series was neither concerned with exact replication of nature nor with the example of previous masters. He endeavored to communicate "forms and attitudes that so far have existed only in the human mind, obscured and confused by lack of illustration, or excited by the unruliness of the passions." And he concludes that for such an approach he merits not the title of "the servile copyist" but rather that "of inventor." Here is evidence of his intention to create, and get credit for, an original product distributed in the open market. In this as well, Goya demonstrated his modern temperament.

Capricho 43 and the Sleep of Reason

The key to the entire series—and its most spectacular example—is *Capricho 43, The Sleep of Reason Produces Monsters* (fig. 4.40).[65] It shows the artist sleeping at his worktable, surrounded by the nightmarish vision of a disordered and tormented mind. A lynx on the ground and a cat just behind the artist eye him in a way recalling the felines staring at the birds in the portrait of *Manuel Osorio de Zuñiga.* The earliest preparatory drawing indicates the figures in the background as less distinct and more varied; human heads, dogs and even a horse blend into an inchoate mass. In the next stage, a sepia ink drawing dated 1797, the word *Sueño* is written above the picture and carries this legend: "El Autor Sonando" (The author dreaming), followed by "His only intention is to banish prejudicial banalities and to perpetuate with this work of *caprichos* the solid testimony of truth." Goya's personal commentary on the print explains his method for achieving his aim: "Fantasy, abandoned by reason, produces impossible monsters: united with it, it is the mother of the arts and the origin of their marvels."

Goya originally designed the composition as the title page to a series of *Sueños*—his initial idea for what evolved into *Los caprichos*—but as his ideas developed he decided to insert it halfway into the album, where it serves as a kind of

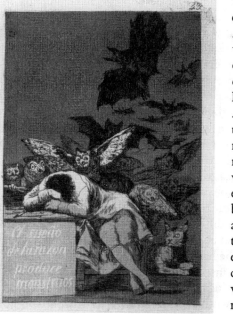

4.40 Francisco Goya y Lucientes, *Capricho 43, The Sleep of Reason Produces Monsters,* 1797–1798, etching and aquatint. Rosenwald Collection, Library of Congress, Washington, D.C.

introduction to a sequence of prints mainly concerned with witchcraft. It is a curious and contradictory image, one pointing to the reformist advances yet assuming a negative perspective. In this it corresponds to the tensions provoked by the Jansenist-ultramontane debates. Religion and superstition were closely intertwined with the whole range of public and private life in Spain, where the law threatened every dissenter with the severest retribution. Hence the need for clandestine expressions of protest that took the guise of black magic. The label "heretic" still carried dangerous consequences, and for all their progressive declarations, the *luces* and their followers rigorously maintained outward respect for the church. This may help explain some of the contradictory features of the series and why there are so many hybrid forms. Like Blake in roughly the same period, Goya's candor and public concern was checked by intolerance exacerbated by the French Revolution. This pressure, although mitigated by Godoy's ministry, encouraged dissembling; but the sinister forms in *Los caprichos* nevertheless correspond to the social and moral realities Goya perceived in the real world.

The grotesque monsters in Goya's etching carry both positive and negative connotations: on the one hand they represent the inventive side of his mental faculties (the owl at the left actually grasps Goya's *porte-crayon* and nudges him to arise and sketch), and on the other they invoke those phenomena that evade reason. The tension between the prescribed picture and original creation, between reason and imagination, parallels the conflict between religion and free thought, as in the case of the controversial *Historia de la vida del hombre,* involving the debate between an ex-Jesuit free-thinker and a Jansenist member of the Inquisition. Written by Lorenzo Hervas y Panduro, the work had its first two volumes confiscated by Floridablanca in 1789 because the prologue outlined social theories that seemed too advanced. Publication resumed with volume 3 in 1794, and after some more difficulties with the censors, the work was finally completed in seven volumes in 1799. The burden of *Historia* is that the best ideas of the Enlightenment on political and social institutions were not incompatible with Catholic beliefs. In dealing with philosophical truth, Hervas claimed he would reject "the errors with which ignorance has monstrously obscured it in favor of the modern experimental method."[66] Science is reason, and the person who reasons best is the wisest. Without it the theological science would be subject not only to errors of ignorance

but also to false devotion and superstition, the ultimate sources of heresy. Hervas's work generated a vitriolic response from the Jansenistic *calificador* of the Inquisition, Joaquin Lorenzo Villanueva. His *Catechismo del estado* (Catechism of the state), published in 1793, argued that the new irreligious ultramontanes tried to set up false distinctions between natural man and spiritual man, concepts that in reality are inseparable. These ultramontanes then mistakenly conclude that one side of the person can act independently of the other, so that revealed religion becomes irrelevant to the scientific and political organization of society. Villaneuva then blamed Jesuits like Hervas for having prepared unwary Catholics for the ideas of the *philosophes,* while Hervas, in his third volume, blamed the Jansenists for the French Revolution. We may see in the complexities of the alignments an indication of Goya's torments: the split between natural and spiritual man is the analogue of the split between reason and imagination. In seeking to unite them, Goya is also indicating a Jansenistic thought process.

Despite the rise of a significant middle class in the second half of the eighteenth century, in Spain this class remained more or less subservient to the dictates of the church. Prevented from the formation of an organized body that could sustain a policy of social enlightenment, Goya and his circle could engage in reformist activities only insofar as the Jansenist-ultramontane conflict opened the way for them. Here is one source of the closeted world of *Los caprichos* and its hybrid forms. In this we see Goya's dilemma: his imagination gave vent to the very horrors both carefully scrutinized and condemned by his enlightened patrons and advisers. Once those "horrors" were judged to be true or false they were transcended as potential for an image. Yet the more Goya reasoned, the less contact he had with that side of his "supernatural" self that alone allowed the imagined image a spontaneous value and guaranteed his creative freedom. This meant surrendering to its immediacy and being totally enveloped by it. Either way, he was menaced with the accusation of heresy.

Once again Goya's work may have been informed by *Botanic Garden,* especially Darwin's metaphorical digression into witchcraft. These emblematic images of bats, owls, and moonlight were a prelude to Darwin's poetic interpretation of Fuseli's *Nightmare,* illustrated in the 1795 edition, in which the physiological basis of nightmares and their relation to sleep were analyzed. While sleep involves

the suspension of all voluntary action, some muscular activity and thought persist as the result of internal stimuli. Thoughts aroused during waking hours continue to resonate in the nervous system and stimulate dreams. But as long as volition is suspended, there can be no active physical or mental challenge to the irrational train of associations. In sleep, whenever the stimuli produce "a painful desire to exert the voluntary motions, it is called the Nightmare or Incubus."[67]

Darwin's Theory of Dreams

Darwin elaborated on his theories of sleep and dreams in *Zoonomia; or, The Laws of Organic Life* (1794–1796), which attempted to set down a general law for both physiology and psychology and which classified the nightmare as a form of mental "disease." While his analysis lacks the full Freudian discovery of the nightmare as a means of working through residual trauma and sensation, Darwin's perceptions seem refreshingly modern, with his exploration of dream time, dream memory, the function of the dream in preserving sleep, and the physiology of the body during the dream state. As Fuseli declared in a much-quoted aphorism, "One of the most unexplored regions of art are dreams."

Darwin's theory of the relationship of dreams to art is found in the sprightly dialogue of "Loves of the Plants," an exchange between the author and his bookseller or poetic allegory and the plastic arts—distinctions that bear upon the links between imagination, reason, and dreams. Since in the plastic arts angels, devils, Death, Time, and other intangibles must be shown visually, only the greatest artist manages to convince the viewer of the reality of the supernatural, which is also the reality of the dream.

Darwin formulated the basis of illusion in dreams: during sleep rational control is arrested and an imaginative train of ideas is set loose unchecked. We cannot perceive the incongruity of this flow of random imagination at the time because in sleep we cannot distinguish between fantasy and reason. Thus the irrational features of dreams arise literally and physiologically from "the sleep of reason," and the most grotesque forms may seem entirely normal.

The artist can present a dreamlike flight of ideation in such a commanding artistic form that we suspend our disbelief. If the phenomenon is short-lived—what Darwin called a state of "reverie"—at least for its duration we do

share the reality of the dream world. The artist has achieved this effect by conscious artifice: "The matter must be interesting for its sublimity, beauty, or novelty; this is the scientific part." Darwin expressly associated pictorial originality and sublimity with a progressive and scientific position, rejecting the simple reproduction of nature as retrograde: "Nature may be seen in the market-place, or at the card-table; but we expect something more than this in the play-house or picture-room. The farther the artist recedes from nature, the greater novelty he is likely to produce; if he rises above nature, he produces the sublime."[68]

Darwin's book, which "enlisted the imagination under the banner of science," corresponds at so many junctures with the statements and commentaries of Goya that there must have been some direct connection. Both Jovellanos and Meléndez Valdés were heavy readers of eighteenth-century English literature. Darwin's writings would have clarified for Goya the relationship between imagination and reason, dream and reality, and they would have rationalized Spain's political and religious contradictions. Goya's deafness, moreover, would have reinforced Darwin's ideas, since the condition cut off a vital source of empirical knowledge and threw Goya into introspection and reverie. The nightmarish quality of Goya's *Capricho 43* testifies to a sense of personal despair in his attempts to maintain the rational mind in the face of subjective experience, as set forth by Darwin.

Fuseli's *Nightmare* and Goya's *Capricho 43*

The relationship of Goya's *Capricho 43* to Fuseli's *Nightmare* (fig. 4.36) is striking: the figure of the tormented artist is analogous to the prostrate woman; the owl on the artist's chest substitutes for the incubus on the woman's. Goya's lynx, with its staring eyes and pointed ears, echoes the macabre horse thrusting through the curtains in Fuseli's painting, while the vivid light-and-dark contrasts achieved through the aquatint technique (an etching process permitting a gradation of tones) recalls the theatrical lighting of the Fuseli. Even more suggestive for comparison, in both works the private space of a sleeping person has been invaded; the events of the external world can no longer be shut out by physical barriers or mental blinders. Thus it is apparent that just as England exported its technical know-how, so the cultural manifestations of those advanced ideas made their way across the Channel; the influence of the In-

dustrial Revolution on English artists could be assimilated in other countries by those most receptive of new ideas. The likes of Campomanes, Jovellanos, and Meléndez Valdés partook freely at the well of English culture, drawing inspiration that nourished the reform spirit at home. This helps explain why, despite obstacles to advanced ideas in his own country, Goya shared with other European artists a distinctly modern quality. Goya's circle was receptive to English science and technology, even while Spain was at war with Britain, its longtime economic rival.

The Literary Sources of *Capricho 43*

The literary sources of *Capricho 43* are central to its meaning. As previously discussed, Meléndez Valdés's "El melancólico, a Jovino" was not meant to be a poetic statement about Jovellanos, but rather was an autobiographical lament dedicated to an understanding friend. Some verses, however, are indeed relevant to the print:

Over its horrid throne raised the obscure
Melancholia, and its mansion had
The watchman's pains, the groans,
The agony, burden, the bitter plaint.
And whatever monster which, in its faustian delirium,
The bewildered reason may miscarry.[69]

While the word "abortar" in the original has sometimes been translated as "beget," the precise meaning here is to "abort," or "miscarry," which matches the negative tone of the passage. In a bewildered state, reason functions not as a clarifying or liberating agent, but becomes the medium through which ideas miscarry and emerge as "monsters." Reason, then, is not taken as an absolute good, but is itself subject to aberrations akin to the disordered imagination.

Another literary influence for Goya was Tomás de Iriarte's translation of Horace's *Ars poetica*. Printed with a dedication to José Cadalso, an intimate friend of Meléndez Valdés and the author of *Noches lugubres* (Lugubrious nights), this was a long poem that was itself influenced by Edward Young's *Night Thoughts* and that corresponds to the gloomy mood of *Capricho 43*:

If by a *capricho* a painter were to unite
To a human face
The neck of a horse, and distribute
To the rest of the body
Parts of various beasts, which he could adorn

With different feathers, so that
The monster whose face
Captured the beauty of a woman
Ended as an enormous and ugly fish;
On seeing such a form,
Could you refrain from laughing, o Pisos?
Well, friends, believe that to this painting
At every point is similar
Those compositions
Whose vain ideas appear
In the dreams of delirious invalids.[70]

Clearly, Iriarte understands *capricho* in a negative sense, as a deviation from standards of acceptable behavior. Conversely, when Goya used the term, even in the course of everyday life, it had the positive idea of liberation. What Iriarte saw as a monstrous deformation, Goya saw as an original construction.

Iriarte developed his ideas in an important essay in response to a malicious attack on his fables by Forner. Forner insisted that no rules are necessary for writing fables except that of whim or caprice, and sets out his own fable, *El asno erudito,* to prove his point. Responding in the form of a letter from a friend (Don Eleuterio) to himself, Iriarte observes that the critic is annoyed with him for having declared himself

against *Gothicism,* or Gothic taste . . . Every educated man knows and abhors that mortal enemy of the arts who is always so bitter and dreadful that when he gains entrance into the republic or the sciences, he banishes good taste, and with it sane reason, sometimes for centuries . . . Disorder is introduced; the laws, with the abolition of the most fundamental, wide, and beneficial, are broken and despised, and only foolish and monstrous *Caprice* [monstruoso *Antojo*] reigns, sustained by idleness and ignorance.[71]

Here Iriarte uses *antojo* instead of *capricho,* but the two words are almost identical in Spanish, and he uses them interchangeably. He declares (*Obras* 6:368) that in the absence of the principles established in *Ars poetica,* "the *capricho* will decide everything." And he retorts to Forner, who accused him of ignoring logic and science, that to the contrary his fables are there to point out the "vices" introduced in these sciences. It is only by following the rules that error can be discovered and ejected.

Iriarte insists that rules of nature—simplicity, measure, and plain common sense—must apply to all writing forms. Without these checks, the result is confusion, chaos, and final defeat. The poet's answer to his own rhetorical ques-

tion, "What would be the nature of a fable not subject to constant rules based on the observation of nature and on the great poets who knew how to imitate it with propriety?" encapsulates all the terms used by Goya for *Capricho 43:* "Un sueño de enfermo delirante, un monstruo, una ficción desatinada; en suma, un *Antojo*" (a dream of a delirious invalid, a monster, a confused fabrication; in sum a *Caprice*).[72] Yet we know that Goya acknowledged *capricho* as fundamental to his creative and commercial aspirations.

Iriarte lays out the conditions for a sane, rational approach to literature and art; his fables distill the essence of Spanish neoclassicism in writing at the end of the eighteenth century. Like a true child of the Enlightenment, Iriarte reaffirms a commitment to order, reason, and truth. If these principles are abandoned, willful caprice follows. But Goya's *Capricho 43* puts it the other way: "Fantasy, abandoned by reason, produces impossible monsters, united with it, it is the mother of the arts." Conversely for Goya, if reason is abandoned by the imagination, it may produce monsters of another kind. Even Hervas allowed for religious and intuitive reasoning if only to understand supernatural phenomena: "The philosopher relying solely on natural reason knows that the human mind frequently fails to think clearly about the things within its realm of knowledge; how then is it possible to think well on supernatural things which are certainly hidden from the light of natural reason and even infinitely beyond its ken?" While Goya retains the didactic intent of neoclassicism, he seeks to expand such a position to make allowance for *capricho* in his system of "truth." This obviously gave rise to a severe mental conflict. Having begun work at the same time on the Osuna decorations, Goya must have glimpsed the paradoxical character of his irrational visions within the framework of reason. Fascination for the occult led to the abandonment of a rationalistic viewpoint, and this development must have been attended by anxiety and self-torture. *The Sleep of Reason* is thus an attempt to justify and work through this turn of events, a manifesto of his struggle and of his new direction.

This doubt about reason itself as the dynamic principle of earthly and heavenly wisdom was fueled by the contemporary Jansenist-ultramontane debates. Except for Hervas, the ultramontanes attacked the concept of material reason as the very source of the Enlightenment "heresy." One of the most popular works in the early 1790s was the Spanish

version of Philippe-Louis Gérard's epistolary novel, *Le comte de Valmont; ou, Les Egaremens de la raison* (the count de Valmont; or, the errors of reason), in which a young nobleman renounces his previous indulgence in incredulity, sex, and materialism in favor of the superior reasons of religion. The Spanish translator wanted the theme to be even more evident from the title page, so he called it *Triumph of the True Religion over the Aberrations of Reason*. Its widespread popularity demonstrated that the peculiar spirit of Enlightenment in Spain did not conflict with religious sentiment. *Le comte de Valmont* critiques that form of reason that raises objections to religion and piles up arguments for not submitting to spiritual principles. This leads to the adoption of the most extravagant opinions and a rapid falling away from "sacred truth." The comte de Valmont distinguishes between truth and reason, and in the end concludes that "reason is insufficient . . . her light feeble, her conclusions erroneous." [73]

Perhaps the climax of Spanish religious apologetics of the decade is the book written in the home of the Revolution by the exiled Pablo Olavide. After having escaped the Inquisition, he underwent a conversion during the revolutionary years and spent much of his time in devotion. He now detested France and wished to return to Spain. As a means to achieve this end, he composed a four-volume work on a theme strikingly similar to the highly successful *Comte de Valmont*, entitled *El Evangelio en triunfo; o, Historia de un filosofo desengañado* (The triumph of the gospel; or, the story of a disillusioned philosopher).

The story also employs the fashionable, long-winded epistolary style, and purports to be the letters of a "false philosopher" who is won back to religion by the sound arguments of a good *padre* and who then proselytizes his former "enlightened" friends. Olavide condemns the new philosophy as nothing but abandonment to atheism, license, and vile passions because "human reason . . . is variable in its ideas, and . . . receives and welcomes all the errors of the imagination." [74] He holds up the example of Voltaire, who, endowed with much imagination and devoured by ambition, led youth astray with his characterization of the most sanctified ideas as "pure superstition," resulting in the most deplorable corruption possible in the world. Olavide went on to predict that if the world continued to propagate "his *caprichos* of incredulity, it will exterminate all governments and reduce nations to disorder and

confusion."[75] Here he expressly identified *capricho* with in-credulity and the errors of reason that deflected people from the path of true religion.

Olavide catered to the prejudices of his audience, and, not surprisingly, *El Evangelio en triunfo* has been likened to Chateaubriand's *Génie de christianisme,* which it preceded by a few years. Like the French author, Olavide judged accurately the temper of his market. First published in 1797–1798, it was the Spanish best-seller of the turn of the century. Carlos IV accepted Olavide's formal petition to return to Spain in 1798 and bestowed upon him all his former honors and a munificent pension.

"Reason" was thus one of the most popular catchwords and concepts of the period, and Goya's use of it in *Los caprichos* made him a participant in the current debates. Religious-minded Spaniards could not have been immune to the critique of reason as the enemy of the church. Until then the religion of the *afrancesados* was not seen as compromised by Enlightenment principles, but the new criticism of the 1790s challenged the irrational. Goya's ambivalent *Capricho 43* was troubled by the climate of attack on reason. It has not been pointed out that the word *sueño* means not only "dream" and "sleep," but also "vision" and "fancy." Thus the caption could be interpreted as "fancies of reason"—the very errors of reason discussed in the Catholic apologetics of the 1790s. Not only the disordered *imagination,* but also the disordered *reason* is capable of generating monsters. If the work was meant to "banish prejudicial banalities and to perpetuate . . . the solid testimony of truth," then reason alone cannot achieve this breakthrough, since the *caprichos* themselves spring directly from it. The underlying intention of this series is to expose the disorders of both reason and imagination and to heal those disorders through a unity of the mind.

The Content of the Other *Caprichos*

For such a work of profound synthesis as *Los caprichos,* Goya had to call upon his friends for advice and ideas. The connection between *Capricho 43* and his portrait of Jovellanos in 1798 (fig. 4.28) demonstrates that the execution of *Caprichos* is intimately linked with the *ilustrado*'s brief ministry. The works are compositionally similar, showing a slumped figure seated at a worktable planted at right angles to the picture plane. Both figures are fashionably dressed in identical costume, and their legs are crossed with the toes

of their shoes pointed outward. The thematic link is also striking: Jovellanos assumes the classic pose of melancholia, a state of inaction and numbness in which ideas are untranslatable into concrete form. Two emblems in the portrait amplify the relationship: the statue of Minerva, goddess of wisdom (often accompanied by an owl), and the head of the he-goat carved into the table almost directly below her. The suspension of reason in Jovellanos, symbolized by the overshadowed statue, gives rise to fantastic creatures.

Jovellanos directly inspired some of *Los caprichos* by his own satires: the caption of number 2, *El sí pronuncian y la mano alargan al primero que llega* (They pronounce their "yes" and stretch out their hand to the first comer), derives from a work published in 1786 in the periodical *El Censor*.[76] Addressed to a certain fictional Arnesto who served as the satirist's confidant, it attacks the vice of adultery and the general corruption of aristocratic women. Jovellanos censures the *cortejo* and the excessive freedom of women, perhaps bearing in mind the exploits of María Luisa. He describes the behavior of one Alcinda, who brings home a gallant while her husband sleeps, and then addresses others who looked upon her as a role model "and without heeding reason and without / weighting their suitors' merits in their hearts, / pronounce their "yes" and stretch out their hand to the first comer!"

This conduct outraged Jovellanos, for while the rich and noble adultress triumphed unpunished, the machinery of justice cruelly chastised

the unhappy victims who are dragged to vice
by poverty and lack of all protection,
the helpless orphan harried without cease
by gold and hunger, or who yields to love
and is seduced by tender flattery.

Jovellanos was interested in equal treatment for all social classes. He sees the individual crime as a result of social as well as individual factors, and so for him the prostitute is society's victim. This facet of his attack on adultery reflects the new social consciousness of Spanish liberals and the trend toward a more humane treatment of all kinds of criminals.

Goya's print shows a young woman wearing a mask—the symbol of deception—arriving at her destination in the company of her grotesque chaperone (fig. 4.41). One Goya commentary makes clear its source: "The ease with which

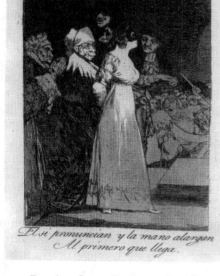

4.41 Francisco Goya y Lucientes, *Capricho 2, They Pronounce Their Yes and Stretch Out Their Hand to the First Comer,* 1797–1798, etching and aquatint. Rosenwald Collection, Library of Congress, Washington, D.C.

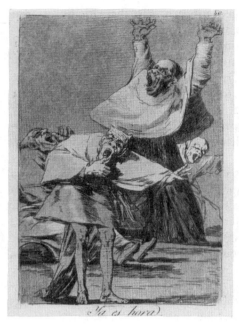

4.42 Francisco Goya y Lucientes, *Capricho* 80, *Now Is the Time*, 1797–1798, etching and aquatint. Rosenwald Collection, National Gallery of Art, Washington, D.C.

many women consent to marry, hoping thereby to enjoy more freedom."[77] Here and elsewhere in the first main group of etchings Goya decries what he sees as the frivolity and venality of relations between the sexes. *Caprichos* 2 to 36 are dominated by themes of secret assignations and prostitution, ranging from playful flirtation to violent abduction and murder. Like Jovellanos, Goya's perception of sexual mores most often centers on the woman who sells her favors. Although Spanish Enlightenment encouraged more freedom for women in the form of moderate emancipation in the workplace and in public, such measures provoked the discomfort of even open-minded males. Men generally suffered few constraints on their own sexual freedom, but they held fast to the comforting ideal of the passive, domestic female. In fact, sexuality was one area where women could make a point about male hypocrisy in the Age of Enlightenment and was a source of the deep fascination among the upper classes for the *maja*'s apparent independence. This sexual tension, as evidenced in the macabre prostitution sequence (*Caprichos* 19–24), which culminates with two Inquisition scenes, produced a climate of suspicion and paranoia among men and women.

Jovellanos's influence is seen also in *Capricho 80*, entitled *Now Is the Time* (fig. 4.42), the last etching of the album, which culminates the second half dominated by the terrifying visions projected in *Capricho 43*. Here satanic monks, stretching and yawning with obscene gestures, make ready to fly off as day is about to break. Goya's commentary notes that until now no one had been able to learn where these nocturnal creatures conceal themselves during the day, and he concludes, "He who would catch a group of goblins in their den, and show them in a cage at 10:00 A.M. in the Puerta del Sol [that is, the most popular square in Madrid] would not need another *mayorazgo*."[78]

Now a *mayorazgo* was private land in entail, a practice that began with the decline of feudalism in order to protect the estates of a noble family from being squandered by a reckless heir. Already in the sixteenth century commoners were permitted to entail their land, especially those who wished to become gentlefolk and perpetuate the family name. By the end of the eighteenth century, nearly half a million Spanish citizens claimed to be nobles on the basis of their *mayorazgos*—a much greater percentage of nobility than in France, with twice the population of Spain. Reformers attacked the concept, however, for it created a large idle class and took Spain's land out of circulation.

As might be expected, no legislation of Carlos III had met greater opposition than his attempt to reform the control of the land. Jovellanos made his land reform scheme the basis of *Informe de la ley agraria,* attacking the privilege of entail and proposing that neither private families nor the church be allowed to receive additional unalienable land. When the *Informe* was denounced to the Inquisition early in 1796, it was condemned for its most important conclusion—that entail was an evil. The malevolent monks in Goya's etching thus signal clerical opposition to the elimination of entail, and the message implies that it is time for a change—time for the agrarian reforms of Jovellanos.

The critical influence of Jovellanos in the first and last narrative image of *Los caprichos* demonstrates the importance of his short-lived ministry for their production. The ideas of him and his protégés are liberally sprinkled throughout the album, which made it something of a collaborative venture. Spanning the entire series is a critique of marriage, especially marriages of convenience contracted without love and for ulterior motives. This is already evident in *Capricho 2,* where it is implied that many women marry to gain their independence. The theme becomes more apparent in *Capricho 14, What a Sacrifice!,* showing a distressed bride-to-be turning away in disgust from her future spouse, a response even shared by her mother (fig. 4.43). Goya's commentary runs, "The bridegroom is not the most desirable, but he is rich, and, at the cost of an unhappy girl's freedom, relief for a hungry family is brought."[79] In keeping with the nightmarish imagery of the concluding section of *Los caprichos,* the theme becomes demonic in number 75, *Is There No One to Untie Us?,* where a man and woman violently struggle with the knots that fasten them to a tree, and a monstrous bespectacled owl hovers above them with a grisly talon planted on the woman's head. Goya slyly comments, "Either I am mistaken, or they are two people who were forced to marry."[80]

One immediately thinks of Hogarth's first plate in his series *Marriage a la Mode,* published much earlier in the century, where an incongruous marriage is being arranged between a wealthy commoner and a titled aristocrat. But Goya's print makes the point much more quickly, and communicates the psychological torment that escaped Hogarth. Goya and his circle admired Hogarth and Hogarth's friend Fielding for their social commentary. Among Goya's circle was Moratín, who similarly sought to unmask the

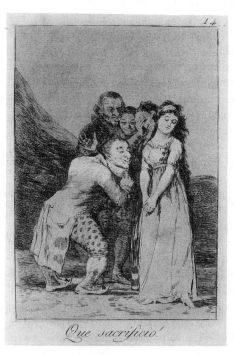

4.43 Francisco Goya y Lucientes, *Capricho* 14, *What a Sacrifice!* 1797–1798, etching and aquatint. Rosenwald Collection, National Gallery of Art, Washington D.C.

vices and follies of his contemporaries. His plays, influenced by the work of Swift and Fielding, dramatized marriages of convenience, the upbringing of children, pedantry, and superstitious belief.

Moratín's *El sí de las niñas* (The yes of the young girls) attacked parental authority and constraint, while *El viejo y la niña* (1796) is a tragicomedy declaring the right of women to a satisfying intellectual and emotional life. Don Roque, a widower of seventy years of age, has recently married Doña Isabel, a girl of nineteen who was pushed into the marriage by a guardian anxious to be rid of her. The guardian broke the attachment of the girl for a childhood sweetheart, Don Juan, by deceiving her into believing that he was betrothed to another. The situation is resolved tragically, with Don Juan sailing for America and Doña Isabel entering a convent.

To Moratín, comedy should possess a moral aim, and spotlight the vices and errors common to society. Good satire has an underlying moral intent. He believed that true virtue resided in actions and not in words; under the guise of piety and devotion "the greatest vices are often concealed." Satire was a genre especially in keeping with the critical spirit of the Enlightenment, and in Spain it had the added advantage of the sly attack. Jovellanos, Meléndez Valdés, Moratín, and Iriarte used satirical means to criticize individuals or institutions. Spanish literature of the time is filled with allegories, fables, and plays in which the characters correspond to real people who have maligned, insulted, or in some way offended the authors. *Caprichos* falls into this category, a visual complement to the writings of the *ilustrados,* which caricatures the old institutions and their contemporary consequences.

But the plebeian form of *Los caprichos,* their gloomy shadings and crude execution, is uniquely Goya's. They have in common the form of the popular *jacaras* sold by hawkers in the street. These street ballads, also known as *romances vulgares,* often glorified criminal escapades, kidnappings, and murders and recounted tales of supposed miracles and fantastic supernatural events which played havoc with church doctrine. Both conservatives and progressives considered such popular literature threatening to society insofar as it seemed to inculcate in the underclasses a disrespect for the law and defiance of authority.

In June 1798 the trial for the street peddlers of *jacaras* came before Meléndez Valdés, then *fiscal* in Madrid. His long-standing involvement in the issues of education and

the upbringing of children predisposed him to make this case a critical test of the ministry formed by Godoy. Meléndez Valdés believed that the *jacaras* in their present state had to be prohibited. He confessed to having avidly read similar doggerel in his boyhood, but claimed that his education helped him overcome possible ill effects. However, he went on, the *populacho* have no such recourse, and do not know how to combat the vices perpetuated in these ballads. Children especially should be protected from their corrupting influence.

Meléndez Valdés took the opportunity to review the Spanish educational system, deciding that there were not nearly enough primary schools and no decent textbooks. Teachers were generally incompetent because the contemptible salary they were paid attracted only mediocre talent. He felt that, pending the development of widespread free public education, the state should try to find a substitute for the street ballads. The same inexpensive format and style should be used, but the content should inculcate social and domestic virtues, love of country and king, while stressing the noble heroism of Old Spain to counteract the corruption of the times. "La despidida del anciano" (The farewell of the ancient one), his long poem of 1797, keenly analyzes the sociological problems of eighteenth-century Spain and urges political reform to save the country. It is perhaps the first proletarian poem in Spanish literature, attacking the system that supports the luxuries of "effeminate men and immoral women" while the poor—especially the peasants—groan under intolerable burdens.

The heart of the Spanish Enlightenment, as in the rest of Europe, was education. Like his mentor Jovellanos, Meléndez Valdés saw education as the means for the material and moral improvement of all classes in society. Those two surely influenced Godoy, who founded a Pestalozzi Institute as early as 1806 to train and educate indigent children. During his brief ministry, Jovellanos's official duties involved educational reform, and he began a pedagogical treatise to submit to the king but could not complete it before 1802. Jovellanos also stresses the duty of schools to inculcate love of country, a desire for peace and public order, "and all the social virtues which form good and generous citizens." The Spain he and Meléndez wished for could only be achieved by education, and they blamed scholasticism for retarding the spread of knowledge.

Interspersed between the main themes of *Los caprichos* are single plates illustrating the miserable effect of bad edu-

cation, which point to the influence of Meléndez Valdés and Jovellanos. In this sense, *Caprichos* has the propagandistic intent of Meléndez Valdés's ideal *jacaras;* they are executed in the vulgar and occasionally obscene style of the street ballads, but they also disclose a didactic message reminiscent of the poet's humanitarian writings. *Caprichos* 3–5 relate their subjects to the faulty rearing of children, setting the stage for the ghastly scenes that follow. *Here Comes the Bogey-Man* shows a parent embracing her two terrified children as a shrouded figure approaches them. The white hood of the anonymous creature, placed directly with his back to the viewer, is etched sharply against a black opaque background and throws a long shadow towards one of the children. "Deadly abuse in early education," reads one commentary. "To bring up a child to fear a bogey-man more than its own father, and force it to be afraid of something that does not exist."[81] Hence superstition crushes the spirit of the child and renders it susceptible to the influences of an exploitative system.

Worse, it teaches children to be duplicitous and to exploit others in turn. In contradiction to the terrified expressions of the children, the mother's face registers agreeable surprise and even adoration. This would suggest that the mother is in fact receiving her lover in a disguise designed to scare away the children and leave the adults free to have sex. It is precisely this kind of gross deception that angered the Benedictine monk Feijóo, for it perpetuated the belief in ghosts and permitted the impostors to take advantage of their frightened victims.

The theme of the anachronistic belief in imaginary beings is carried over into plate 4, *Nurse's Child,* referring to a Spanish proverb: "The nurse's child who is seven years old and is still being breast-fed." The scene depicts an adult in child's clothing, sucking one of his fingers, and tied to a tether pulled by a servant. Hanging from the sash of the overgrown child is a series of protective amulets, including a *manecita.* Goya's gloss on the print makes it clear that parental overindulgence and the nurturing of childish timidity prevent offspring from becoming mature adults, forever expressing obstinacy, arrogance, greed, and slothfulness. The next plate, *Two of a Kind,* shows furtive lovers arranging an illicit rendezvous, while two gossipy crones in the background put it all together. The vices of men and women, says Goya, "come from poor education" (vienen de la mala educación).

In a sequence of etchings (nos. 37–43) dividing the two

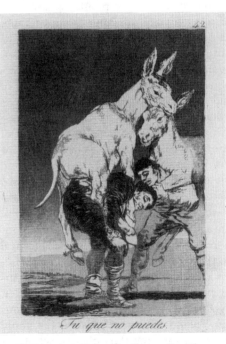

Tu que no puedes.

4.44 Francisco Goya y Lucientes, *Capricho* 42, *You Who Cannot Do it,* 1797–1798, aquatint. Rosenwald Collection, National Gallery of Art, Washington, D.C.

A FAUT ESPERER Q'EU JEU LA FINIRA BEN TOT.
l'auteur en Campagne dp. 1789.

4.45 Anonymous, *I've Got to Hope I'll Be Done Soon,* 1789, etching. Bibliothèque Nationale, Paris.

main sections, Goya has used the fabulist's devise of anthropomorphic animals. *Capricho 37, Could It Be That the Pupil Knows More?,* shows an ass-pedagogue teaching an ass-student the ABCs. The commentary reads, "One doesn't know whether he knows more or less; the truth is that the teacher is the most earnest personage it has been possible to find."[82] This goes right to the heart of Meléndez Valdés's attack on the incompetency of primary-school teachers, with Goya implying that ignorant masters can produce only mediocre pupils. In *Capricho 42, You Who Cannot Do It,* two asses ride on the groaning backs of two laborers, recalling the human-animal reversal in Swift's *Gulliver's Travels* (fig. 4.44). The title is taken from the Spanish proverb, "You who cannot do it, carry me on your shoulders." This is a concise statement about exploitation based on ignorance: unless the laboring classes learn how to apply scientific and technical advances to agriculture and manufactures, they will be forced to remain tools of the reigning elite.

Of course the remedy for this state of affairs needed the kind of drastic reforms proposed by Jovellanos, and it is probably not fortuitous that Goya's print evokes a French revolutionary caricature published around the time of the opening of the Estates-General in May 1789. It alludes to the inequities of the ancien régime by a farm laborer carrying on his back two figures—whose pockets are stuffed with the taxes, tithes, and dues paid by the peasant—representing the nobility and the clergy (fig. 4.45). It was common for Enlightenment reformers to reproach the social structure for the burdensome economic weight charged to the agricultural worker. While the tables were momentarily turned in France, the fresh prints showed the regenerated Third Estate supported by the other two, Goya's worldview could only encompass an upside-down universe in which the most numerous class in society was subject to a parasitical minority.

The Influence of Iriarte's Fables

Goya's sequence of anthropomorphic animals leading up to *The Sleep of Reason* and followed by the thickening witch subjects was influenced by the popular animal fables of Tomás de Iriarte. Indeed, the reputation of Iriarte rested on his *Literary Fables,* which were published in 1782 and widely acclaimed throughout Spain. These were of a satirical nature, and their morals contained references to con-

4.46 Francisco Goya y Lucientes, *Capricho 39, As Far Back as His Grandfather,* 1797–1798, aquatint. Rosenwald Collection, National Gallery of Art, Washington, D.C.

temporary life and individuals. Goya's animal-headed cavaliers, fops, doctors, and pedagogues with heads of asses, monkeys, or bulls, his grandiloquent parrots and bespectacled owls come straight out of the fabulist style of Iriarte. Iriarte's fable (8) *The Ass and the Flute,* illustrates the vagaries of art:

There are donkeys plenty,
Who, without one jot of art,
May, for one, well play a part,
By chance.

The Bear, the Monkey, and the Hog (3) declares the moral,

Authors, who seek nobles' fame,
Mark well the moral of my verse!
That's bad which worthy judges blame;
What bad applaud, is worse.[83]

These recall Goya's *Capricho 38, Bravissimo!,* in which a monkey serenades an ass on a guitar without strings. The ass sits enraptured, while in the background spectators mindlessly applaud. Goya's commentary mocks the pretensions of critics who lack insight: "If ears were enough to understand, there would be nobody more intelligent; but it is to be feared that he may applaud what is not being played."[84]

Capricho 39, As Far Back as His Grandfather (fig. 4.46), is intriguing for the print as well as the preliminary sketch with the pencilled caption, *El asno literato* (The literary ass). Earlier I referred to a polemicist named Forner, who attacked Iriarte's morals for their rebuke of the bizarre and Gothic. Forner cast his arguments in the form of a fable entitled *El asno erudito* (The erudite ass). The similarity of this title to that of Goya's caption on the drawing is so striking that it must have been deliberate. Forner was insanely jealous of Iriarte and seized on his work to catapult himself into the limelight. Goya's donkey turns the satire back on to Forner by calling attention to his pretensions to fame and social prestige.

The final plate also sheds light on the Spanish preoccupation with genealogy, showing the ass studying his genealogical chart: "This poor animal has been driven mad by genealogists and coats-of-arms. *He is not the only one.*"[85] The obsession with genealogy, and with *limpieza de sangre* (purity of blood), had to do with the ineligibility of descendants of Moors and Jews for public office, the principal

colleges and universities, guilds, the higher ranks of the clergy, and, above all, membership in one of the four chief military orders—the condition for becoming an *hidalgo*. It was thus crucial for applicants to any of these institutions to draw up genealogical proofs of the purity of their lineage. The names and residences of parents and grandparents had to be included in the genealogy, and the applicant was disqualified if any signs of impure blood were found. The fact that the social structure was based on a racial and economic exclusivism gave it a particularly retrogressive character in the history of modern Spain.

Capricho 43 immediately follows the series of anthropomorphic asses who satirize the corruption of the aristocracy and the professions. We have seen that Iriarte's academic discourses contributed to the conception of that plate; it is possible that his fable, *The lion and the eagle (26)*, contributed to it as well. The fable recounts the conventional tale of the hybrid bat who is neither bird nor beast and is expelled by the chiefs of the animal kingdom. Iriarte, however, gives it a literary twist:

Bats of authors, who seek
To be two things at once,
Take care lest ye prove
In both—but a dunce!

Goya's plate of "the author dreaming"—synthesizing literary and visual forms—mocks the pretensions of the artist and makes the bat a conspicuous accessory.[86]

Witchcraft and the Inquisition

The foremost instrument of the Spanish ruling classes in maintaining the status quo was the Inquisition. The prosecution of magical practices and belief and the exploitation of the people went hand in hand. *Capricho 45, There Are Many to Suck,* manifests the popular belief (promoted by the *Malleus maleficarum*) that witches sucked and devoured prebaptized children (fig. 4.47). But Goya's commentary amplifies the idea to include the idea of exploitation: "Those who reach eighty years of age suck little children; those under eighteen suck grownups. It seems as if man were born and lived just to be sucked."[87] The term *chupar* contains many nuances including the idea of the "sponger," the individual or institution that lives at the expense of others. The inquisitors actually financed their work with the

4.47 Francisco Goya y Lucientes, *Capricho 45, There Are Many to Suck,* 1797–1798, etching and aquatint. Rosenwald Collection, National Gallery of Art, Washington, D.C.

possessions confiscated from their victims, and it became a popular joke that their search for heretics was really a search for property. The preliminary drawing for *Capricho 13, It's Hot,* showing clerics gulping down their food, carries the caption "Dream of some men who were devouring us." As the anachronistic instrument of racial and religious exclusivism, it was inevitable that the Inquisition lost status during the Enlightenment and be characterized as a leech on the body politic.

The relationship of religious intimidation and the spread of superstition is seen in several of *Los caprichos,* perhaps most obviously in nos. 49 and 52, *Little Monks* and *Look What a Tailor Can Do!.* The first confounds ignorant and gluttonous monks with malevolent sprites, and the second depicts a group of terrified people worshiping a tree draped with a menacing monk's cowl while ghostly goblins hover overhead (fig. 4.48). But the work that pins down the link between fanaticism and superstition is no. 70, *Profession of Faith.* Here two donkey-eared inquisitors wear the symbolic *corozas* of their victims and, with pincers (familiar instruments of torture), hold open a "sacred" book from which acolytes draw the following oath: "Do you swear to obey and respect your masters, as well as those in authority: to sweep attics, to spin tow, to beat timbrels, to howl, to yell, to fly, to cook, to anoint, to suck, to boil, to blow, to fry, each and every time you are so ordered?—I swear—Then, child, now you are a witch. Welcome to the fold."

The Inquisition relied on the clandestine cooperation of the Spanish clergy, who were expected to report any matter that came under its jurisdiction. Its activities were shrouded in darkest secrecy. Those who had any dealings with it—including its victims—had to swear not to reveal what they knew. The Holy Office was especially dependent upon its lay servants, known as "familiars," who acted as a fifth column of informers and spies. To become a familiar was a high honor, and the Inquisition could boast of nobles and titled persons among its familiars. *Capricho 50, The Chinchilla Rats,* alludes to these secret informers of the Inquisition (fig. 4.49). Two men pinioned in sleeveless garments resembling straitjackets and blazoned with heraldry, are being spoon-fed by a sinister blindfolded creature with donkey ears. The ears of the two men are fastened with heavy padlocks, their eyes are shut and their robotic mouths are agape to receive the spoon. The one lying on the ground fingers a rosary in his right hand, while the

4.48 Francisco Goya y Lucientes, *Capricho,* 52, *Look What a Tailor Can Do!* 1797–1798, etching and aquatint. Rosenwald Collection, National Gallery of Art, Washington, D.C.

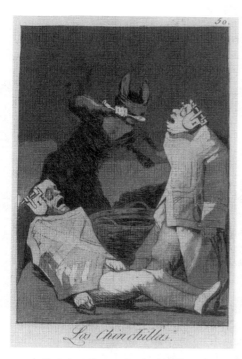

4.49 Francisco Goya y Lucientes, *Capricho 50, The Chincilla Rats,* 1797–1798, etching and aquatint. Rosenwald Collection, National Gallery of Art, Washington, D.C.

other stands girded with a sword. Goya's caption for his preliminary drawing connects the figures to the nobility, but he ingeniously plays on the resemblance of the coats of arms to the symbols on the penitential garment of the Inquisition's victims, known as the *sanbenito.* A close look at the sleeveless garment on the recumbent figure reveals the X-shaped cross of Saint Andrew, which decorated the *sanbenitos.* Goya's commentary makes clear the mindless character of the Inquisition's lackeys: "He who does not listen to anything, nor knows or does anything, belongs to the numerous family of the chinchillas who never have been good for anything."[88] The connection between the sneaking familiars and the chinchillas is evident when we realize that the rodents are furtive creatures who sleep by day and come out at night to hunt for food. The dual allusion to coats of arms and the *sanbenitos* may also relate the theme to a popular comedy of manners by José de Cañizares, *El domine Lucas,* about a family named Chinchilla who were obsessed with their noble ancestors, including a famous servant of the Holy Office.

Caprichos 23 and 24 make a direct attack on the Inquisition. The first, *That Dust (Aquellos polbos),* represents an Inquisitorial trial with the accused seated on a platform wearing the *sanbenito* and the pointed *coroza* (fig. 4.50), and the second, *There Was No Remedy,* shows a woman condemned for harlotry also wearing the *corozo* and led seminude on a donkey through the populace (fig. 4.51). Goya's outrage at the spectacle of *That Dust* makes him utter unexpectedly, "This is wrong!"

In a clear reference to witchcraft, the title *Aquellos polbos* is taken from the Spanish proverb, "Aquellos polbos traen estos lodos" (That dust brought this mud). Popular superstition was rife with tales of the manufacture of powders and ointments used by witches to scatter over crops they wished to ruin or to cause harm to people and animals. Significantly, the *afrancesado* Antonio Puigblanch, whose popular broadside against the Inquisition (*The Inquisition Unmasked*) was published in 1811, not only used the phrase "porción de aquellos polvos" in describing the Logroño witch trial, but referred specifically to Goya's plate in a footnote to a passage detailing the financial advantages that inquisitors derived from prosecuting heretics.[89] Indeed, in 1784 the Inquisition profited considerably from the wealth of an ex-veteran and his female accomplices who were convicted of sorcery for making and distributing a love pow-

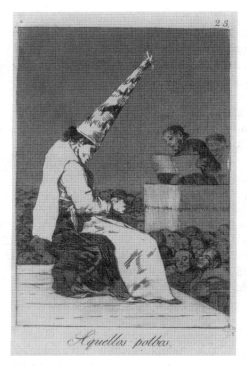

4.50 Francisco Goya y Lucientes, *Capricho, 23, That Dust,* 1797–1798, etching and aquatint. Rosenwald Collection, National Gallery of Art, Washington, D.C.

der. All three were publicly exposed in an *auto de fe* with the *sanbenitos* and *corozas*. The title and the implied second half of *Aquellos polbos* thus point to the symbiotic relationship between witchcraft and the inquisitorial process.

Spain and France 1800–1808

The defeat of the political "Jansenists" in the years 1798–1800 was crowned by the arrest of Jovellanos in March 1801 and his transportation to Majorca, where he was confined until 1808. If the Inquisition gained momentary ascendancy in this period of Carlos IV's administration, it had forfeited the confidence of the *afrancesados* and its days were numbered with the advent of Napoleon. Goya represented the bourgeois movement in Spain that demolished the tribunal's support system and helped sweep away certain barriers confining Spain's repressive society.

Notwithstanding the fact that French political machinations helped bring down Godoy and Urquijo, Godoy's intimacy with the royal pair soon revived, and before the end of 1799 his influence was again felt at the court. Godoy did not take a hand in royal policy, however, until late in 1800, when he stepped in to help pacify the Jansenist-ultramontane controversy. The years out of office had tempered his political outlook. His enlightened policies had failed, and in future he would aim to keep domestic peace by a more centrist position and take his cue for foreign policy from Napoleon. (It is in this period that Carlos commissioned David to paint the grandiose image of Napoleon crossing the Alps.) In 1801 Spain, cooperating with France against Britain, waged a brief and successful war against Portugal. Godoy, invested with the title of *generalísimo* of the armies, commanded the Spanish forces. The Portuguese war—baptized derisively by Spaniards as the "War of the Oranges"—was the last act of the war with Britain. Peace between England, France, and Spain was concluded at Amiens on 27 March 1802. Peace abroad had succeeded peace at home, and if this was what Spain most needed to heal the wounds of the 1790s, it was a peace that was soon overshadowed by the colossal ambitions of Bonaparte.

During these years, Goya's production tapered off, and his outstanding work was done for the royal couple and Godoy. The large group portrait of the family of Carlos IV, with its vague, shifting locus of authority, was complemented by the contemporaneous image of the smugly dominant Godoy—the power behind the throne (fig. 4.52).

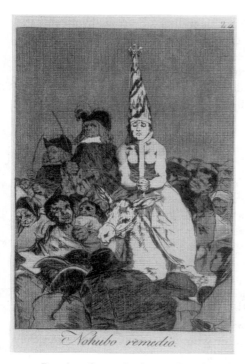

Nohubo remedio.

4.51 Francisco Goya y Lucientes, *Capricho 24, There Was No Remedy*, 1797–1798, etching and aquatint. Rosenwald Collection, National Gallery of Art, Washington, D.C.

It supplies the missing piece to Goya's royal puzzle. In the autumn of 1801 Goya depicted Godoy reclining on cushions in a bivouac near Elvas, Portugal, wearing his well-decorated commander's uniform, saber at his side. Conspicuously draped at the left are two captured Portuguese flags, while in the background his crack cavalry are shown milling about. Godoy's sprawling body dominates the landscape and completely overshadows the aide-de-camp at his side; Goya depicts him reading a letter as if he were on the living-room sofa rather than in a tense battlefield situation. That this was deliberate is clear from the curious positioning of the commander's baton between Godoy's legs. It thrusts upwards nearly on a vertical to almost touch the letter held in Godoy's right hand. It is no coincidence that the Spanish word for baton, *bastón*, is also slang for the erect phallus. Godoy's cocksure expression and the sideward glance of the aide over Godoy's shoulder suggests that the letter is from one of his paramours. Godoy's sexual prowess was well known throughout the kingdom, and it was widely rumored that if one needed a favor from the prince of the peace it was advisable to send a daughter of the household to arrange the negotiations. Thus Godoy's ministerial sofa anticipated the Hollywood "casting couch." Goya playfully indicates that the locus of Godoy's power is in his genitals rather than in his military capacity, cracking a joke in the mode of the *Caprichos* and attesting once again to Goya's insider's status.

Undoubtedly Godoy dictated the attitude and form of presentation himself, suggesting that the *generalísimo* wanted to be shown supremely confident on the battlefield. Goya satisfied his patron by emphasizing his sensuous

4.52 Francisco Goya y Lucientes, *Manuel Godoy*, 1801. Real Academia de Bellas Artes de San Fernando, Madrid.

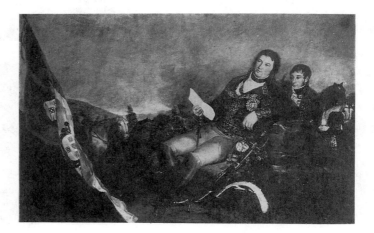

physical presence over his military bearing. Ironically, the posture actually betrays Godoy's inexperience as a professional soldier: he could win the campaign primarily because the tiny Portuguese army was badly equipped and poorly commanded, affording Spain a cheap victory after only four days of fighting a comic-opera war with Portugal.

The Clad and the Unclad

The return of Godoy's authority was manifest in still another domain of activity, captured by Goya in the legendary paintings known as the *Majas,* clothed and unclothed (figs. 4.53–54). These two works were completed for the prince of the peace sometime between 1800 and 1805, and show up in the 1808 inventory of his collection under the title of *Gitanas* (gypsies). While there is nothing to support the popular assertion that the portraits represented the duquesa de Alba, all the indicators suggest the distinct outlook of Godoy. Godoy was famous for the use he made of his position to exploit women sexually, often when they approached him for political favors.

4.53 Francisco Goya y Lucientes, *Naked Maja,* c. 1798–1805. Museo Nacional del Prado, Madrid.

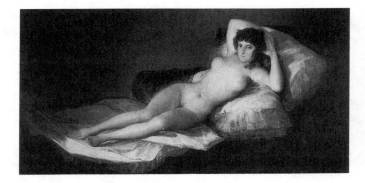

4.54 Francisco Goya y Lucientes, *Clothed Maja,* c. 1798–1805. Museo Nacional del Prado, Madrid.

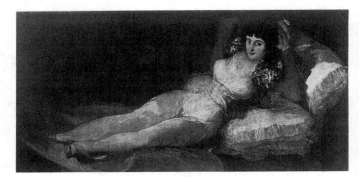

One such petitioner was Pepita Tudo, an Andalusian woman who journeyed with her mother to Madrid to ask Godoy to intervene in a village land dispute. Eventually Tudo became Godoy's mistress and was given titles and privileges at court. (In 1797, when Godoy married the condesa de Chinchón, daughter of the Infante Don Luis Antonio de Borbón, thus making himself a cousin of the king, it was rumored that he spent the dowry to set up Tudo in a residence close to his own.) Based on contemporary images and literary reminiscences, it is most likely that the *Majas* are actually portraits of Pepita Tudo and were destined to hang in the residence Godoy provided her.

Prior to this time the female nude was a rarity in Spanish art, and when it did appear it was shrouded in the trappings of mythology. Velázquez's *Venus and Cupid* (also owned by Godoy) is such a work, with the figure of Venus modestly shown from behind. Goya's *Naked Maja* was the exception, with its life-size scale, direct exposure of the female body, and lack of mythological allusion. The Maja was a woman of the times, confronting the gaze of the observer frankly and without self-consciousness. Her voluptuous body, angled on the bed pillows in the direction of the beholder, expresses neither overt seduction nor invitation, but a profoundly confident sexual presence. Inseparable from the clothed version, the Maja's nakedness implies the removal of the *maja* costume, but her riveting glance belies that her nudity is an act of sexual submission. Rather, the works are a voyeuristic exchange between the woman and the male spectator.

Spanish coquetry in this period was raised to a fine art and enhanced by popular fashions such as the mantilla, seen as a seductive, half-concealing article of clothing, by the transparent fringe of the petticoat known as the *basquina,* and by the play of fans which intrigued male tourists. The tourists were also provoked by the flow of double entendres, obscene songs, loose expressions, and forthright tales of sexual exploits—especially from the *majas,* "whose attitudes have in them a perfect air of effrontery and licentiousness." [90]

The idea to paint clad and unclad pictures of the same model in the same pose was a pun on several levels, and linked to the Spanish (and generally upper-class) obsession with clothing as signs of social rank, culture, and political position. The impetuosity of the *majas* made them a model of behavior for the upper-class women wishing to express their freedom from courtly restraint. Goya's clothed ver-

sion includes the short, sleeveless jacket and brilliant sash of the *maja,* used with the fashionable petticoat worn by the well-to-do. The woman's air of effrontery is connected with the costume, and it is maintained by the nude despite the apparent suggestion of sex. The Maja desires to be the object of sex, not love; she flirts for her own gratification, forcing the spectator to pay homage to her while remaining in control of her body. What Goya portrays here is a woman whose idea of herself seeks confirmation in the scrutiny and desires of the male beholder. She catches the eye of the spectator and holds the gaze with unflinching certainty.

The sexual poise of the woman is identified with the licentious *maja* and the dissolute gypsy, who were dependably available for sex in that church-dominated society. As the Spanish elite required a lineage free from the taint of Jewish, Moorish, or gypsy blood, Goya and Godoy seem to be suggesting that beneath the female costume there is neither Jew nor Greek, but simply woman as erotic possession.

Such a commission required the powerful backing of the prince of the peace, to overcome the social and religious constraints of the time and allow his political exploitation of women to be brazenly displayed. Nevertheless, the owner of both the woman and the painting was distanced by the self-possessed expression which contradicted the provocative pose. This contradictory character is also implied in the upperclass reconciliation of illicit sexual activity with the minute observance of sacred ritual. Neither sex cared much about preventing scandal, but saw the religious obligations as recompense for their transgressions. The two paintings show this conflict of conscience, although they were later pronounced "obscene" when Goya was called before the restored Inquisition in 1815.

Godoy's influence in this period grew increasingly dependent upon the policies of Napoleon, and he began to look for ways of expanding his personal, as well as the national, power. For a time, England tolerated Spain's alliance with Napoleon so long as Spain did not seriously increase its armaments; but finally in October 1804, on the pretext that there was too much activity in the Spanish dockyards, England seized four ships bound for Cádiz, laden with treasure from the Spanish colonies in South America. The British commander off Ferrol was also ordered to blockade that port. Under pressure from Napoleon, Spain reluctantly declared war on England; this came to a disastrous

end the following year when the Franco-Spanish fleet was demolished at the Battle of Trafalgar.

This defeat set back Napoleon's plans for an invasion of England, and he now developed his plan for a Continental system that would effectively blockade the major European ports against British trade. The English retaliated with an aggressive policy to blockade all ports excluding British trade from receiving vessels from other nation and held that all ships bound for these harbors were subject to seizure unless they had touched at an English port. This pressure motivated Bonaparte to make his move against Spain and especially Portugal, which had not joined his Continental system.

In October 1807 France and Spain agreed to divide Portugal between them; Portugal's reigning House of Baraganza fled from Lisbon and took refuge in Brazil. Godoy was soon to learn that the French alliance had in reality become a French occupation. The annexation of Portugal by French troops under Junot in 1807 was followed by the imposition of French garrisons on Spanish cities in 1808, when Murat took over control of Spain. Differences over court policy led to disagreements between Carlos IV and his son Fernando, who mounted the throne as Fernando VII in March 1808 after Godoy had been displaced and Carlos forced to abdicate. The French command, however, refused to recognize the change of monarch, and the royal family was induced to go to Bayonne, just inside the French frontier, to lay their differences before Napoleon. Once at Bayonne, Carlos and Fernando were in the emperor's power. Bonaparte persuaded Fernando to renounce the crown but immediately had Carlos surrender it to France. Napoleon then chose his brother Joseph as the new king of Spain.

Faced with military occupation, economic distress, the disappearance of their royal family—especially Fernando, upon whom the populace had placed such high hopes— and the crowning of a Frenchman, popular agitation was inevitable. (Price levels had risen by 50 percent in these years, while a laborer's salary rose by only 12.5 percent.) The country focused its resentment on Godoy and pinned their hopes on his enemy Fernando—nicknamed the "Deseado" (the desired one). At first it was thought that Napoleon was backing Fernando, but later the people suspected that Napoleon had kidnapped the crown prince and had entered into a secret pact with Godoy to usurp the throne.

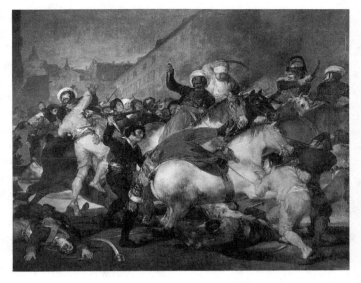

On 2 May 1808 an unanticipated incident sparked an uprising of the *majos* and segments of the peasantry already goaded to anger by anti-French pamphleteering. That day most of the remaining members of the royal family prepared to leave the palace in Madrid for Bayonne. As the carriage transporting the Infante Don Francisco de Paula began to depart, it was noised about that force was being used to get the boy on the road. When an aide-de-camp of Murat appeared, a riot broke out among the crowd gathered to block the road, and the officer was assaulted; Murat lost his head and ordered the grenadiers and the Polish light infantry to clear the approaches to the royal palace. Grapeshot was fired on the crowd, and now the riot against the French troops spread throughout Madrid. French soldiers caught isolated on the streets were murdered by an outraged populace. Thousands of demonstrators gathered in the Puerta del Sol, where they soon confronted a squadron of Mamelukes—Napoleon's crack Muslim troops commanded by General Grouchy—who had joined him during his expedition to Egypt. A violent engagement ensued, which Goya captured in the first of his two pictures painted in 1814, *The Second of May 1808 in Puerta del Sol* (fig. 4.55).

This event became the opening shot of the war of independence, celebrated ever after as the *Dos de Mayo*. Goya worked for topographical accuracy to stress the connection between the historic occasion and the geographical and symbolic center of the city. The action occurs in front of

the post office building (El Correo) and looks eastward (hence the name of the square, "Gate of the Sun") toward the Calle de Alcala, one of the main thoroughfares radiating from the Puerta del Sol. At the sight of the Muslim troops in the service of the "atheistic" French, the demonstrators lashed out at the Mamelukes, dragging them off their horses and stabbing them to death, while the surprised troops retaliated with their daggers and Turkish scimitars. Spanish snipers also fired on the French troops from houses on the adjacent streets. Goya makes the spectator feel like an eyewitness to the brutal killing, emphasizing the unplanned, spontaneous character of the uprising to set the stage for the picture of the systematic repression that follows in *The Third of May* (fig. 4.9). Actually, the French had been prepared for an insurrection for several days; a letter from Napoleon to Murat dated 26 April advises him in the event of a riot to seize ten of the guiltiest agitators and shoot them as an example.[91]

Profoundly concerned by how Napoleon would view his competence, Murat issued orders for the establishment of a military tribunal and the summary execution of all Spaniards captured carrying arms, "especially knives." Most of these executions were carried out during the nights of 2 and 3 May but continued through the next morning in the vicinity of the hill of Príncipe Pío, the site of Goya's picture. At seven o'clock the evening of 2 May, Murat wrote Napoleon that he had already shot thirty of the "rascals" and intended to execute another thirty the following day.[92] Murat decided to set an example by selecting victims from among the artisanal classes and the lower-class clergy who helped organize them. (French troops were fired upon by monks at the monastery of Santa María de Atocha at the southeast edge of the park of El Retiro.) Since the *majos* regularly carried clasp knives (*navajas*) in their sash or pockets, Murat used this costume accessory as a pretext for their arrest. *Majos* also wearing the long cape were subject to harassment and arrest. Just as the *majos* remained loyal to traditional Spanish customs, so they had taken the lead in rebelling against the French invaders.

Goya's painting emphasizes the anonymity of the condemned, and even the capriciousness of their selection. He depicts them in terror and disarray, confusion and despondency, constructing an image of ordinary people dying without heroism and without knowing why they have been singled out for obliteration. Yet Goya's unideal-

ized and unheroic "heroes" are novel characterizations in the history of art and have meaning only in relationship to the particular conditions of the Napoleonic years.

Active resistance to Napoleon was often local, peasant, and clerical: the early provincial uprisings in Spain were led by canons of the church. In Spain and elsewhere nationalism played a major role in mobilizing popular enthusiasm, ironically anticipated in the experience of the French Revolution and Napoleon. Eventually local notables created juntas to organize the rebels—mainly peasants, priests, and monks—and to coordinate them with regular Spanish troops. All told, the juntas, the guerrillas (a word coined at this time), and the Spanish and English (who entered on the side of Spain that summer) pinned down Napoleon's massive army in Spain and made it impossible for him to mobilize fully elsewhere on the Continent. His entanglement in Spain encouraged rebellions in other countries. Thus by the end of the empire, when Goya painted his picture, the role of the "people" began to be celebrated in high art in the form of the Crowd, the Unsung Victim, and the Anonymous Protagonist.

Both the liberal and conservative factions viewed the people as canaille to be used for their own purposes. But Spanish resistance to Napoleon differed somewhat from the general movement of European nationalism, lacking as it did the participation of a strong middle-class component. Fernando's supporters were dominated by conservative priests and monks who nevertheless considered the 2 May insurrection as a "scandalous tumult of the common people." Yet in 1814, when Fernando returned as the new king, official policy flattered the people even while eliminating the few modest reforms undertaken in their behalf by Joseph Bonaparte and the Cortes with its famous Constitution of 1812.

In Goya's *Third of May* the upraised arms of the central victim and even the stigmata on his hands recall the crucified Christ. The identification of this figure as a Christian martyr springs directly from the painter's memories of the actual events and the new political and social conditions of 1814. As seen from the perspective of the ruling elite, the people had risen up out of love for church and king. In fact, the conspicuous presence of the monk or friar at the foot of the central figure lends credence to Napoleon's laconic description of the Spanish front as the "war of the monks." (While only one friar was identified among the victims, an eyewitness account reported that several were executed,

and Murat himself wrote Napoleon on 4 May that two priests had been shot for their "provocations of death against French troops.") The ground beneath the victims was indeed fertilized by "the blood of the faithful."

Yet, to understand this war of a largely unarmed people against one of the mightiest military machines ever known, it should not be seen strictly as a war of national independence. The people, with the collaboration of some clergy, acted promptly to elect leaders, obtain arms, attack property and, in short, engage in genuine social revolution. It is no coincidence that both Murat and Goya chose primarily artisanal types as the target-subjects of their respective demonstrations: though coming from opposing sides, the implications of their choice is similar. With no organized middle class in Spain, the burden of insurrection fell to the least privileged classes. Popular resistance to the French had a strong component of social-revolutionary content. When news of the events in Madrid spread, outbursts against authority broke out all over the country. Guerrilla warfare was a distinct contribution to modern military tactics, with its organization and ideological cohesion.

This movement was finally taken over by the local nobles and clergy who canalized its revolutionary potential to serve their own ends. It is tragic that Murat could execute workers and indigent friars who may not have participated in the revolt; on the other hand, Goya could have portrayed the people in *The Third of May* in a moment of solidarity, but he was too busy "exploiting" them for his art. After the victories of the duke of Wellington's armies and the Spanish partisans, Goya notified the Regency Council—set up pending Fernando's return to power—of "his ardent desire to perpetuate . . . the most notable and heroic actions and scenes of our glorious insurrection against the tyrant of Europe." Along with this request he added a word about his poverty (despite the fact that he had recently inherited a substantial sum upon his wife's death), thereby submitting his body and soul to the government. Goya also knew that his previous association with King Joseph Bonaparte would have to be explained, so that the commission clearly was a way of ingratiating himself with the new king, whose portrait he was to paint several times in 1814. Both pictures, moreover, were thought to have been earmarked for triumphal arches erected to celebrate Fernando VII's return. Thus Goya's portrayal of the victims cringing on their knees was the result of careful deliberation: resistance to Napoleon had gone as far as those now

in power would allow. To show the rebels in heroic solidarity was to imply a continuing threat to the new social order.

King Joseph and the *Afrancesados*

In the years preceding this commission, Goya was closely involved in the political and social sphere of Joseph Bonaparte, the king of Spain between 1808 and 1813. Except for Jovellanos, who finally joined the Junta central in exile, all of the *afrancesados* in Goya's circle supported French rule. These men had been high-minded patriots, yet many of them, including Urquijo, Cabarrús, Moratín, Meléndez Valdés, Iriarte, and Llorente, were appointed to Joseph's government. Although their motives were not strictly unselfish, they also felt that compromise was the best way of meeting the needs of the Spanish people, urging acceptance of Napoleon's puppet government as the only alternative to bloody civil and international war. With the support of these *afrancesados,* the Bonapartes suppressed the Inquisition, abolished feudal rights and privileges, and closed two-thirds of the convents.

Significantly, these *afrancesados* can be identified exactly with the reforming ministries of Carlos III and Carlos IV. They now formed a moderate party between the two extremes of conservatives and left-wing liberals, who were both anti-French. The *afrancesados* stuck with Joseph during the interval between his forced evacuation from Madrid in August 1808 and his return to power in January of the new year (following Napoleon's entrance into Madrid at the head of sixty thousand troops that winter). In December, Goya swore "love and fealty" to King Joseph, like many of the *afrancesados* welcoming the return of the French regime.

Antoine-Jean Gros's View of the Reestablishment of Joseph

The French painter, Antoine-Jean Gros, student of David and a Napoleon devotee, celebrated the reassertion of French military might in Spain for the French public with his *Capitulation of Madrid, 4 December 1808* (fig. 4.56). Exhibited at the Salon of 1810, the painting shows the emperor and his general staff receiving the delegation of the town of Madrid, following the victorious march of the French from the north.[93] While Spanish rebels had held

4.56 Antoine-Jean Gros, *Capitulation of Madrid, 4 December 1808,* 1810. Musée national du château de Versailles.

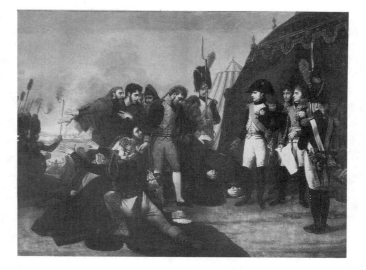

the French at bay in 1808, the British expeditionary force landed in Mondego Bay in August and began a new chapter in the Napoleonic campaign. By September the French were expelled from Portugal, and the English now turned their sights to Spain. Meanwhile, alarmed at the changing tide, King Joseph evacuated Madrid, crossed the Ebro, and fell back to the foot of the Pyrénées. Napoleon intervened, striking against the Anglo-Spanish forces to open the road to Madrid. Joseph then joined his brother, and together they marched triumphantly to Madrid.

Madrid was an open city devoid of any regular defenses, and no garrison except for some holdouts from previous skirmishes with the French. As in the case of 2 May, however, the populace rioted and set up barricades and batteries. But when Napoleon's troops stormed the Buen Retiro heights and forced their way into the Prado (the city's most fashionable promenade), enthusiasm waned, and the town fell on 3 December. The capitulation order was signed the morning of the fourth, and Joseph took up residence in El Pardo. For several weeks Napoleon remained in and around Madrid, dictating laws and projects for the reorganization of Spain. Registers were opened in different parts of the city, and all those who wanted Joseph on the throne again were invited to inscribe their names. Joseph recovered his monarchy in January and appointed *afrancesados* to key government posts.

Gros's painting depicts the events of 3 December, the day following the appearance of French troops on the heights overlooking Madrid from the north. Napoleon

made two offers to the citizens to capitulate, which they immediately rejected, and the emperor began massing his armies in key positions around the capital. He then sent a third offer to the defense junta with an ultimatum to stop all resistance in return for respect for the lives and property of the Madrileños. The junta ordered a cease-fire and sent a delegation led by Don Tomás Morla, who had organized the defense, and the governor of Madrid.[94] In the picture, Morla is seen bowing his head as Napoleon dishes out a tongue-lashing, while monks of various orders, priests, and citizens of all classes prostrate themselves before the emperor and implore his pardon. A *majo* kneeling in the lower left of the work pleads with Napoleon to call off the artillerymen who stand poised to bombard the town.

Meant to serve as a design for a tapestry, Gros's scene exaggerates the subservience of the Spanish and their eagerness to submit. It is a fatuous distortion of actuality, as the French position in Spain was never secure for any appreciable length of time. In this case it was an official attempt to gloss over the fact that the coalition of English, Portuguese, and Spanish armies were beginning to turn the tide, and to justify the deaths of French boys on Spanish soil. As usual, Gros, always close to the events, could not wholly hide the truth: one of the Spanish representatives behind Morla glares in anger, while critics observed the rather unauthoritative pose of the emperor, which suggests uncertainty and tentativeness.[95]

Goya's Apotheosis of Joseph

In February 1810 Goya completed a commission that had previously been assigned to another artist, entitled *Allegory of the City of Madrid* (fig. 4.57), wherein an allegorical personification of the city points proudly to a medallion on which Goya painted a bust-length portrait of Joseph. Overhead, a trumpeting figure signals a triumphant arrival and salvation. Though conceived as a glorification of the French king, the nature of the allegory made it possible to substitute other political messages as one regime followed another (today the medallion reads "Dos de Mayo"). Nevertheless, *Allegory of the City of Madrid* testifies to Goya's official association with the French ruler, who awarded him the Royal Order of Spain in 1811. In this same period Goya executed a number of portraits of the *afrancesados* who supported Joseph's rule. During the remainder of the war, Goya lived in solid bourgeois comfort

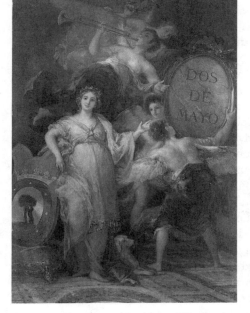

4.57 Francisco Goya y Lucientes, *Allegory of the City of Madrid*, 1810. Ayuntamiento de Madrid.

in a house he had purchased at number 15 Calle del Valverde.

Goya was thriving, but in a web of contradiction—a predicament he shared with many of his friends, especially Meléndez Valdés, whose personal fortunes closely paralleled the flip-flops of government. In April 1808 Meléndez Valdés wrote a patriotic poem, *Alarma espagnola* (Spanish alarm), alerting Spaniards to the duplicity of Napoleon and inciting them to arms against the French. By June the poet felt that resistance was useless and urged Jovellanos to accept the proffered post of minister of interior in the new French administration. Then, after the French had been momentarily set back by their defeat at Bailén and forced to evacuate Madrid, he wrote a second "alarm" addressed to the Spanish troops:

Run, sons of glory,
Run, the trumpet calls you
To save our homes,
Religion and Country.[96]

When Joseph returned the following year, however, Meléndez Valdés was named a high-court magistrate, which provided him entry into the most socially prominent salons. During Joseph's triumphal tour of the provinces in 1810, Meléndez Valdés wrote *Al rey nuestro señor,* in praise of the king's charity. The next year there was an allegorical ode featuring Mother Spain, who addresses the king, describing the horrors of war all about her, the misconceptions of her sons, and her hopes for salvation through the king's efforts. It is the poetic counterpart of Goya's *Allegory of the City of Madrid.*[97] Meléndez Valdés was named by the king a member of the Royal Order of Spain, and his financial picture brightened considerably. Indeed, his fortunes became so intimately linked with Joseph that when the regime fell in 1813 he followed Joseph back to France, where he spent the remainder of his life.

The Fall of Joseph I

By 1812 it was clear to the *afrancesados* that Joseph's government was toppling and could not take root in Spanish soil. Revolutionary juntas were turning up everywhere, and Wellington had won his first major victories. The country was a chaos of guerrillas and juntas. They stung the French troops into madness, an indispensable support for Wellington's troops. The French army, meanwhile, was divided

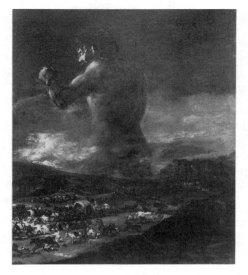

4.58 Francisco Goya y Lucientes, *The Giant,* c. 1808–1812. Museo Nacional del Prado, Madrid.

and weakened by other wars in Prussia and Russia. Moreover, Bonaparte never completely trusted his brother's competence and created military governorships in northern Spain independent of Joseph's administration. Bonaparte's troops in Spain were not receiving their payroll; corruption, pillaging, and atrocities led to a serious deterioration of morale among the ranks. The terrified peasantry was caught between the guerrillas and the French soldiers, who were murdering one another as they ravaged the Spanish countryside.

Goya's remarkable painting known as *The Giant,* which appeared in his inventory of 1812, gives visual embodiment to the convulsions in the countryside, which at the time of the inventory had experienced four years of almost uninterrupted foreign occupation (fig. 4.58). A towering male nude strides across the horizon, dominating a dark cloudy sky, while below him an entire populace is in panic. In both a pictorial and narrative sense, the giant and the terrified peasantry build a dialectical unity: they determine the composition with their vertical-horizontal movements and dramatize the cause-and-effect relationship.

Done in the same period as Ingres's *Jupiter and Thétis,* Goya's work is a metaphorical depiction of the Napoleonic titan gone awry. Where the French painter sees control and regimentation, the Spaniard sees disorder and chaos. The Napoleonic machine has begun to malfunction, and the oppressed are the first to recognize it. Yet Goya's giant, whose back is to the populace, does not directly threaten it; when the painter executed this work he identified with the *afrancesados* who were unable to take definite sides in the Peninsular War. (Goya's ambivalence is further suggested by the evidence of an X-ray showing that the giant originally faced the viewer with his left hand on his hip.[98]) His related aquatint, showing a colossus seated on the horizon under a night sky, looks awkwardly back and upward in bewilderment. But despite this ambivalence he did not hesitate to denounce the atrocities on both sides.[99] The sheer lumbering presence of the mythical giant has disrupted the continuity of existence and rent the fabric of Spanish society.

The theme takes its immediate cue from Shakespeare's Cassius, who compares Caesar to a "colossus" who "doth bestride the narrow world" and Swift's Gulliver and other titanic characters whose powermongering disrupts the lives of an entire nation. An even more symmetrical influence was Burke's *Philosophical Inquiry into the Origin of Our Ideas on the Sublime and Beautiful:*

The large and gigantic, though very compatible with the sublime, is contrary to the beautiful. It is impossible to suppose a giant the object of love. When we let our imagination loose in romance, the ideas we naturally annex to that size are those of tyranny, cruelty, injustice, and everything horrid and abominable. We paint the giant ravaging the country, plundering the innocent traveller, and afterwards gorged with his half-living flesh: such are Polyphemus, Cacus, and others, who make so great a figure in romances and heroic poems.

Both Goya and Meléndez Valdés referred to Napoleon in the abstract as "the tyrant." They echo Wordsworth's passages, cited earlier: "I see one Man, of men the meanest too! / Raised up to sway the world, to do, undo, / With mighty Nations for his underlings." And in 1810 Wordsworth related Napoleon specifically to Spain:

We can endure that he should waste our lands,
Despoil our temples, and by sword and flame
Return us to the dust from which we came;
Such food a Tyrant's appetite demands.

If ideological commitment to one side or another is lacking in *The Giant,* the work does convey Goya's awareness of the overwhelmed populace.

In the interval between *Giant* and *Third of May,* Goya became increasingly sensitive to the plight of working people. Whereas in previous pictures they had been depicted as allegorical types or, in their off-hours, dressed in the colorful *majo* costume, now he observed them directly in the context of their specific kind of occupation. They were no longer trotted out for the amusement of the royal family but, rather, distinguished against a plain background. The sheer physicality of the smiths in *The Forge* does not allow for the beholder's condescension, while the *Water Carrier* and *Knife Grinder* barely pause from their labors to notice the spectator who interrupts them (figs. 4.59–61). These figures hark back to the peasant laborers of the north Italian painter Giacomo Ceruti in their absence of sentimentality and straightforward depiction. But Goya's subjects project a self-confidence lacking in the examples of his eighteenth-century predecessor. They embody the ideals of the societies of Amigos del País and of such reformers as Campomanes, who wanted to give dignity to the popular classes by assuring they were "all usefully employed."

Water carriers and knife grinders were itinerant peddlers in the Spanish streets and roadways. The water carriers sold cool water and carried a large stone pitcher and goblets in a

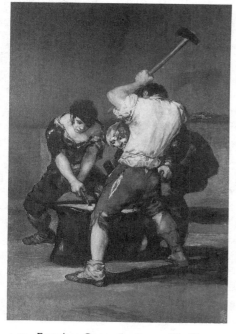

4.59 Francisco Goya y Lucientes, *The Forge,* c. 1812–1816. Copyright the Frick Collection, New York.

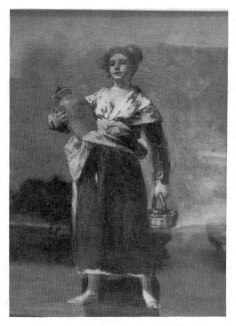

4.60 Francisco Goya y Lucientes, *The Water Carrier*, c. 1808. Budapest Museum, of Fine Art.

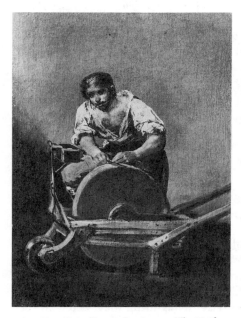

4.61 Francisco Goya y Lucientes, *The Knife Grinder*, c. 1808–1812. Budapest Museum of Fine Art.

basket for the clients. Goya's female vendor seems to be hawking the familiar cry, "Agua fresca! Agua fresquita! Quien beve? Quien quiere? Ahora viene de la fuente?" (Cool water, nice cool water! Who is drinking? Who wants water fresh from the fountain?) Water carrying was dominated by the Gallegos, or Galicians from northwest Spain, a group occupying one of the lowest rungs on the Madrid social ladder. They were the porters and scavengers, and on the stage they served as the butt of innumerable jokes as the slow-witted, good-humored servant. Goya deliberately singled out a representative of the humblest sector of the population and invested her with all the stateliness previously reserved for female saints.

Both the knife grinder and the smiths of *The Forge* point to the guerrilla experience, particularly during the harsh years of famine, terror, and counterterror. Goya's protagonists are shown in action, exposing powerful chests, muscular forearms, and sturdy legs. The robust shoulders of the knife grinder echo the circular grinding stone, while the blacksmiths are caught at the peak of concentration and physical exertion. All are involved in the production and rehabilitation of the implements of war. The traditional Spanish fascination for the sword and the knife—meant to "chip bread and kill a man"—was given a new dimension in the hand-to-hand fighting that characterized the guerrilla wars. Local forges worked overtime to turn out the deadly tool of the guerrilleros known as the *cuchillo,* clasp knifes (*navajas*), and daggers (*punales*), as well as to convert and hone farm implements into weapons of war.

While Spain possessed rich ore deposits everywhere, its iron industry was mired in stagnation and, in terms of extraction and machinery, fell way behind its Continental neighbor to the north. During the late eighteenth and early nineteenth centuries, open-hearth furnaces and the primitive type of forge predominated. The greatest number of ironworkers were concentrated in the Basque province of Guipúzcoa, where the mountains were blessed with iron ore. There the iron was forged into arms, including the conversion of plowshares into swords. Closer to Madrid was the celebrated Fabrica de armas of Madrid, founded by Carlos III and known for its swords and bayonets. Hence the production of blades was a primary function of both private and state ironworks.

Goya's smithies are shown tempering a piece of metal in a state of "cherry heat." A close examination of the shape of this object reveals it to be that of a sword. The ferocious

absorption of the smithies is motivated by the national crisis. Unlike the three principal figures in Joseph Wright of Derby's *Blacksmith Shop* (to whom they bear a resemblance), Goya's forgers do not glorify the national industry (i.e., the early Industrial Revolution) but exemplify the indomitable energy of the Spanish laboring class. Wright's smiths are self-consciously posed in an anecdotal situation, while Goya's triad bear up tautly against a neutral backdrop, with every muscle and nerve concentrated on the task before them.

Los desastres de la guerra

That Goya developed a profound respect for the peasantry and the laborers who joined together in the struggle for liberation is confirmed by his images of male and female workers in the series of engravings entitled *The Disasters of War* (Los desastres de la guerra), drawn and etched during the years 1810–1820. What the Spanish people experienced in that period is vividly recorded in what remains his single most important contribution to international culture, in which for the first time an artist undertook to show the horrors, the close-up reality, of war without allegorical, theatrical, and sentimental embellishment. While not published in his lifetime (the first edition came out in 1863), the initial plates are dated 1810 and entitled "Fatal Consequences of Spain's Bloody War with Bonaparte and Other Trenchant Caprichos" (*caprichos enfaticos*).

The work comprises three main groups: the first two, depicting scenes of war and famine, date from the Napoleonic epoch, while the third (to be considered in the next volume) amplifies the anticlericalism of *Caprichos* and belongs to the period of the reactionary Restoration. The etchings depict the atrocities of both sides during the five-year struggle, and many seem to attest to direct observations. The allusions in titles to the beholder's gaze establishes Goya's attempt to construct a documentary point of reference. *Yo lo vi* (I saw this), he wrote beneath *Desastre 44,* which depicts a panic-stricken population fleeing through the wasted countryside. *No se puede mirar* (one can't look), the caption of *Desastre 26,* is an ironic comment on Goya's credibility as an eyewitness (fig. 4.62). Goya refused to turn away from this brutal execution of defenseless men, women, and children—a reprisal of the French against a civil population that probably served as a model for the *Third of May.* Since the bloody conflict encompassed both

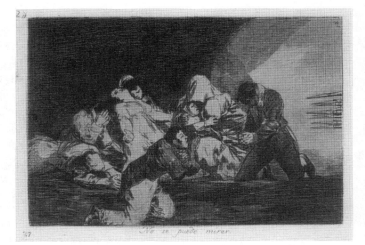

4.62 Francisco Goya y Lucientes, *Desastre 26, One Can't Look,* 1810–1812, etching and lavis. Rosenwald Collection, National Gallery of Art, Washington, D.C.

foreign invasion and civil war, Goya indicts both France and Spain. Because his links with the *afrancesados* prevented him from outright condemnation of the invaders, he vented his fury against the outrages on both sides, against the forces of history that transform traditional values. The Spanish people fought back in self-defense, but in their resistance they themselves committed the most terrible cruelties. Goya's *Desastre 28, Rabble,* depicts the peasantry mutilating the naked corpse of the enemy as it is dragged through the street, while a priest looks on complacently.

Unlike *Los caprichos,* Goya's approach in *Desastres* is documentary and emotional. *Los caprichos* were mediated by a stagelike arrangement and theatrical lighting and, like the plays of Zamora, exhibited creatures ruled by mystical forces. *Los Desastres* have an immediate life-and-death involvement that impels the spectator into the tragic landscape and toward the action. Events are no longer shown in imaginary terms. Reality, although even more shocking and grotesque, has become too compelling to be mystified.

Barbarians! he cries at the sight of soldiers shooting point-blank at the back of a man bound to a tree (fig. 4.63). In other plates uniformed thugs, armed with rifles, bayonets, and swords, impassively mow down the peasantry, hack them to pieces, and impale the torsos on the branches of a tree. *Grande hazana! Con muertos!* (Heroic exploits! Against the dead!) Not until the photographs of the victims of the Nazi Holocaust are there such terrifying scenes of corpses rotting like so much refuse (fig. 4.64). Goya captured the fundamental nature of modern warfare, which was to forsake the traditional formality of opposing troops

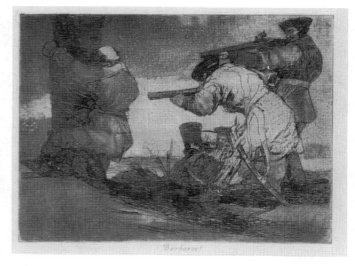

4.63 Francisco Goya y Lucientes, *Desastre 38, Barbarians!* 1812–1815, etching and aquatint. Rosenwald Collection, National Gallery of Art, Washington, D.C.

in designated military zones and emphasize the impact on the civilian population. Since the new mass armies couldn't be maintained by a depot, they existed by requisition, robbery, and plunder, bringing them directly into contact with the people of the country.

Goya's wretched civilians hurl themselves at the enemy with their knives and makeshift weapons: *Desastre 9 They Don't Want To,* shows a French trooper assaulting a young woman while an old crone rushes at him from behind with her raised *cuchillo;* in *Desastre 5, And They Are Wild Beasts*— one of a sequence of early scenes in which women act heroically—a mother holding her child under one arm runs her

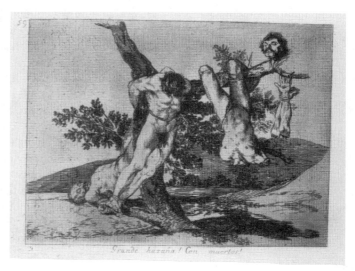

4.64 Francisco Goya y Lucientes, *Desastre 39, Heroic Exploits! Against the Dead!* 1810–1815, etching and lavis. Rosenwald Collection, National Gallery of Art, Washington, D.C.

4.65 Francisco Goya y Lucientes, *Desastre 5, And They Fight like Wild Beasts*, c. 1812–1815, etching and aquatint. Rosenwald Collection, National Gallery of Art, Washington, D.C.

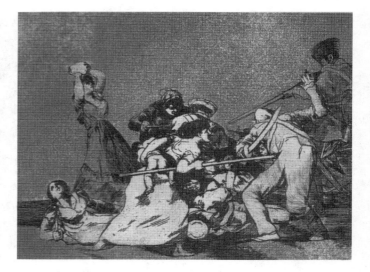

pike through an assaulting soldier with the other, while her wounded comrade on the ground maintains her knife in a ready position (fig. 4.65). The gruesome *Desastre 34, For Having a Clasp Knife,* depicts a renegade priest garrotted by French sympathizers, with the crude weapon hung around his neck as the symbol of his "crime."

Admiration for the intrepid men and women—that is, for the popular resisters—who challenged the Napoleonic machine is shown in the transposition of robust poses from the work site into the field of combat. The knife grinder reappears in *Desastre 2, With or Without Reason* (fig. 4.66), bravely confronting French troops with an improvised spear; the central figure of *The Forge* returns as the ferocious axe-wielding fighter (wearing the same torn breeches and fallen stocking) in the next plate, *The Same* (fig. 4.67); and the self-reliant water carrier has become the heroic maid of Zaragoza igniting the cannon in *Desastre 7, What Courage!* (fig. 4.68). Such committed actions are contrasted with the indifference of the well-to-do in the series on famine, recounting the grisly episodes of 1811–1812 when thousands of Madrileños died of starvation. One of Goya's bitterest indictments of the social order is *Desastre 61, As If They Were of Another Breed,* where a policeman keeps a starving family separate from a fashionable couple. The plate manifests the critical spirit of Goya's friend Meléndez Valdés, whose angry epistle, "El filosofo en el campo," condemns war and imperialism, and rages against the indifference of the rich to those who do the work and fight the battles.

The remainder of *Los desastres* were done after Fernando VII's return to power in March 1814 and the start of the Restoration in Spain. The king quickly moved to annul the democratic Constitution of 1812 ratifid by the Cortes of *liberales* (this was the first use of this term in its current political sense) at Cádiz. Based in large measure on the ideas of Jovellanos and the reforms of Joseph Bonaparte, the constitution abolished seigneurial dues, allowed for the sale of royal domains, and abolished all feudal restrictions on the land. While recognizing Catholicism as the only legitimate religion in Spain, the Cortes (in 1813) declared the Inquisition incompatible with the constitution, but Fernando,

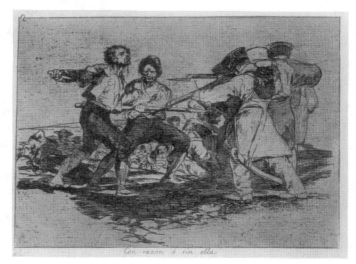

4.66 Francisco Goya y Lucientes, *Desastre 2, With or without Reason,* 1812–1815, etching and lavis. Rosenwald Collection, National Gallery of Art, Washington, D.C.

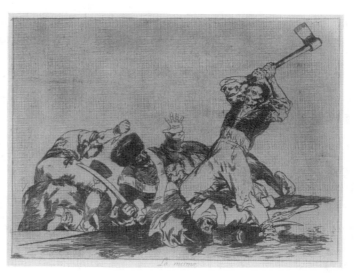

4.67 Francisco Goya y Lucientes, *Desastre 3, The Same,* c. 1810–1815, etching and lavis. Rosenwald Collection, National Gallery of Art, Washington, D.C.

4.68 Francisco Goya y Lucientes, *Desastre 7,
What Courage!* c. 1810–1815, etching and aqua-
tint. Rosenwald Collection, National Gallery of
Art, Washington, D.C.

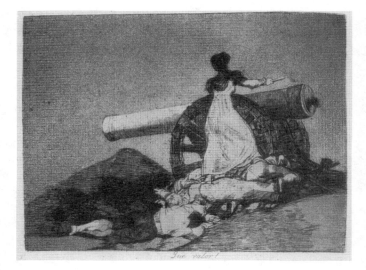

who had returned to power with the backing of Wellington
and the British Expeditionary Forces, abolished the demo-
cratic regime. He filled the key positions in his government
with the *serviles,* the reactionary clerics and nobles who re-
stored their own prewar privileges and established a regime
of unprecedented oppression. Fernando systematically
purged the *afrancesados* and the *liberales,* even while prom-
ising to keep alive the reforms projected by the Cortes of
Cádiz. Absolute monarchy was reinstated and brought
back the terrors of the Inquisition. Fernando's regime now
generated further revolution and counterrevolution which
marked the subsequent history of Spain.

Meanwhile, Goya's conflicting loyalties posed a di-
lemma he never fully resolved. He managed to survive the
problem of his relationship to King Joseph Bonaparte, as
well as his summons to appear before the tribunal of the
Inquisition in 1815 for the *Majas,* which had been declared
"obscene" by the Holy Office. The same year he and his
son are officially listed as "purified" and as reinstated in all
their rights, including salary and pension. During the pe-
riod 1814–1815, he embarked on a series of portraits of Fer-
nando for various official institutions. But the absence of
many of his friends who fled into exile in France, and the
merciless repression that followed the Restoration, made it
clear that his own days in Spain were numbered. The ten
years he spent waiting for the right moment to make his
move to France, Goya devoted to personal projects. These
projects are the final fruits of Goya's disillusionment and
will be discussed in the next volume.

II *The Downtrodden and Their Regeneration*

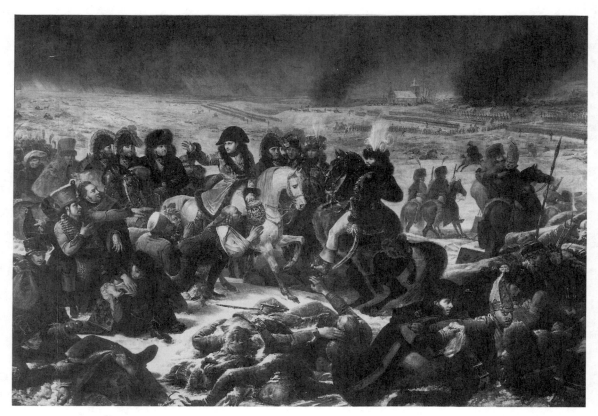

5.1 Antoine-Jean Gros, *Napoleon on the Battle-
field of Eylau, 1807*, 1808. Musée du Louvre,
Paris.

5 Napoleon's Invasion of Prussia and the Rise of German Romantic Nationalism

Goya's two paintings of the Madrid uprising and his *Desastres de la guerra* series are not the only indication of chinks in the Napoleonic armor. Bonaparte's own faithful artist, Gros, could not avoid showing the strains of victory as well as defeat, even in overtly propagandistic images. No matter how extensive Napoleon's efforts in trying to manage the media or the body count to his advantage, he could not explain away a widow's weeds and a mother's grief. The lugubrious mood of the Ossianic themes is now transferred to "subjects uplifting for the national character," including depictions of actual encounters with Napoleon's foes.

One example is Gros's *Napoleon on the Battlefield of Eylau*—painted the year French troops entered Madrid—which shows the emperor visiting the desolate plain of combat strewn with the enemy's dead and wounded the morning after the bloody engagement with the Russians on 8 February 1807 (fig. 5.1).[1] Despite the disastrous consequences of the battle for both sides, a semi-open competition (only twenty-five artists participated) for a depiction of the scene was offered and widely publicized. The program for the contest stated that "the day following the Battle of Eylau, the Emperor, in visiting the battlefield, was filled with horror and compassion at the sight of the spectacle. His Majesty ordered help for the wounded Russians. Moved by the humanity of the conqueror, a young Lithuanian expressed his gratitude with an enthusiastic voice." Since the emperor could not be shown triumphantly, a subject was chosen that venerated the pacific and magnanimous gesture of the emperor. It was strikingly reminiscent of the Château de Choisy program of 1764, which used images of Roman emperors displaying solicitude for the victims of war as a way of exalting Louis XV

in the wake of the French loss of the Seven Years' War. Napoleon's sense of realism, however, encouraged the artist to substitute the contemporary emperor for the ancients without need of the neoclassical trappings.

In July 1806, Napoleon formed the Confederation of the Rhine with himself as protector of the German principalities. He routed the main Prussian army at Jena and Auerstädt on 14 October, and the French troops entered Berlin two weeks later. From Berlin Napoleon proclaimed the blockade of Great Britain and then prepared to meet the Russians who had moved into position to protect East Prussia. The French entered Silesia that winter, then turned northeast to meet the czar's army at Eylau, near Königsberg. The land was open and undulating and snow-covered, abounding in lakes which were frozen so thoroughly that cavalry could cross them. Napoleon with sixty thousand troops attacked eighty thousand Russians and Prussians.

The battle of Eylau was fought in a blinding snowstorm, through nightfall, and became one of the bloodiest military encounters in history. Each side lost a third of their number, and no clear victor emerged. It was the first time Napoleon failed to win decisively in a pitched battle. But the Russians and Prussians (who had to spend the night in the field while the French had control of the town) withdrew from the area, and Napoleon could claim a technical victory. The French remained for a week near Eylau to simulate victory and to expedite the removal of the wounded. Great pains were taken to minimize the French losses; Napoleon feared that an accurate official bulletin would provoke a public outcry, jeopardize recruitment, and demoralize his troops.[2]

The official program for the artist's competition specified the scene as the "day after" the battle—the moment when the emperor visited the enemy's dead and wounded—and carefully avoided acknowledging the tragedy of the engagement for the French, whose wounded were routed east of the Rhine and in some cases in a direction away from the French border. The ingenuity of showing Napoleon comforting the "defeated" enemy suggested a ruler magnanimous enough to demonstrate his compassion for men of the opposing side. As such it was required of the contestants that they include in their work a wounded Lithuanian hussar crying out to Napoleon, "Caesar, you wish that I live; very well! If you heal me, I will serve you as faithfully as I did Alexander." As in Gros's

Pesthouse at Jaffa, the theme of the royal healing touch returns to mask a situation where the "divinely" anointed ruler in reality is shown to be highly fallible.

Gros shows the required hussar at the left of his painting, his knee being bandaged by a medical attendant. Enfolding them in his wide-open arms is Pierre-François Percy, the French army surgeon, as if to verify that Napoleon's orders concerning care of the enemy's wounded are being followed. At the extreme right, the chief surgeon of the Grande Armée, Dominique-Jean Larrey,[3] offers a bandage to a terror-stricken wounded enemy. Thus not only the emperor but his chief medical officers are glorified for their humanitarian concern for their stricken foes. Indeed, the two surgeons established reputations for their disinterested generosity to the wounded on both sides. They were innovators of military medicine, inventing special field ambulances, bonesetting techniques, and novel dressing for wounds. Larrey's inventiveness commended him to the scientific entourage of Girodet, to whom the surgeon would propose the idea of painting a scene of his improvised field hospital in the snow near Eylau.

Despite the presence of these two brilliant surgeons, however, the medical corps blundered with disastrous consequences in this campaign. The supply train with its nurses and attendants, run by private enterprise, lagged far behind at the moment of engagement, and only the officers were available for care of the wounded. Percy, long aware of the deficiencies of the *service de santé,* had been advocating a radical reorganization of the medical corps and resubmitted his proposal in the wake of the battle. Here again Napoleon wanted to dress up the failures—in this case of his medical services—associated with Eylau. But the piteous recollection of Larrey belied the official image: "Amidst what heartrending scenes did we perform our sad but necessary ministry! While I operated on one wounded man I heard from all sides the urgent appeals of others for the same assistance."[4]

Gros's *Napoleon on the Battlefield of Eylau* casts the emperor as a benevolent ruler touched by a scene of suffering casualties, disillusionment, and medical failures. Emphasis is shifted from heroic victory to the wasteland of human destruction. Napoleon himself wrote to Joséphine a week after the battle, "This country is covered with dead and the wounded. It is not a beautiful aspect of war. The soul suffers and is oppressed at the sight of so many victims."[5] The Ossianic dirge for the valorous slain, analogous to Goya's

rude awakening from the "sleep of reason," has been drowned out by the cries of the victims in the blood-stained snow. As in *Los desastres de la guerra,* the reality of dead bodies in a starkly inhospitable countryside mitigated against allegorical niceties. Although Gros labors to transmute Napoleon into a Christian savior, the shocking results of the war (displayed for all to see in the foreground) contradict the emperor's saintly appearance. The sense of Christian salvation is overridden by the actual battle site. The duchesse d'Abrantès noted that the death throes of thirty-eight thousand human beings were "violently forced before the tribunal of their Creator!"[6]

The resulting jumble of the conventional and the real, of artifice and genuine compassion, reveals all the glaring contradictions of Napoleon's grand design. Nevertheless, Gros's "agony in the garden" is an example of the growing use of landscape as a site of encounter between religious and natural forces and their impact on human destiny. The barren, frozen plains speak less of one man's failure than of forces unleashed by tampering with God's grand design. Indeed, it was precisely through landscape that the German romantics gave expression to the spiritual and temporal conflicts set into motion by the Napoleonic encroachment on their land.

By the last decade of the eighteenth century, a major portion of the German educated class had developed a cultural, if not yet political, national consciousness. As has been noted in the discussion of Fuseli and the Sturm und Drang movement in volume 1, middle-class intellectuals achieved notable gains in literature and philosophy. While politically conservative and involved mainly with their own class, the stimulus provided by the work of the intellectuals laid the groundwork for the politicizing of German society during the revolutionary and Napoleonic eras. From 1795, when the Treaty of Basle ceded the left bank of the Rhine to the French revolutionary armies, the national political consciousness gradually unfolded until it led to the rising of Prussia against Bonaparte.

The political vacuum encouraged attempts to turn universities and scholarly forums into instruments of national regeneration. Johann Gottlieb Fichte's famous *Reden an die deutsche Nation* (Addresses to the German nation), a series of popular public lectures delivered in occupied Berlin in 1807–1808, infused German students with an ardor that anticipated Jules Michelet's impact at the Collège de France forty years later. Fichte took an extreme position in this in-

secure period, declaring Germany a nation predestined to lead the world towards the highest ideals. Another important stage in the evolution of German nationalism was the founding of the new University of Berlin in October 1810; under Wilhelm von Humboldt's leadership it was inaugurated with a curriculum designed to spread Prussian influence throughout all Germany and to promote the national consciousness.

As in Spain, however, some Germans viewed the prospect of Napoleonic rule as a mixed blessing: he was warmly received by many who wanted to see an end to feudalism and an extention of bourgeois rights. These liberals hoped for a unified national state in which no one territory would dominate, in which the middle classes would supplant the aristocracy as the dominant social class, and in which all Germans—and only Germans—would be embraced. They knew, however, that such far-reaching changes could not be achieved without a drastic overhaul of the social structure. In short, they preferred Napoleon to revolution.

Germany at this time was divided religiously into a Protestant north and a Catholic south, and was politically fragmented into several hundred sovereign states, some no larger than private estates. The old Holy Roman Empire never corresponded to Germany's national existence, either having included large numbers of non-Germans or excluded large numbers of Germans. But when Napoleon dissolved it in 1806, he eliminated the one remaining symbol of German unity. The sweeping territorial changes brought by his Confederation of the Rhine (now a client realm of France) and successes in the north reduced the number of German states formerly encompassed by the Holy Roman Empire. Over three hundred separate entities and principalities that could be distinguished in the older Germany were reorganized into thirty-nine states. Among these were two new ones: the kingdom of Westphalia, on whose throne Napoleon placed his brother Jérôme; and the grand duchy of Berg, to be ruled by Murat. Bonaparte's ally Saxony was proclaimed a full-scale kingdom, while a new duchy of Warsaw was created out of Prussian Poland.

Thus the sheer physical reshaping of the geographical divisions promoted a collective *self*-consciousness. Unlike Spain, where the church and monarchical institutions exerted a strong influence on the masses, the native institutions were weak and ineffectual, and the impact of the French Revolution and Napoleonic incursion posed a deeper challenge. The German people now had to confront

the problem of self-definition with regard to their past and future. The desire for a unified nation made itself felt over and against the rivalry of the various states to maintain their individual identity.

It was especially the French occupation that provoked the new kind of national feeling. The physical dislocations, the crushing indemnities, the forced billeting of the troops, and confiscation of goods fostered the rise of a negatively induced nationalism. Germany was forced to assume political and social ideas of a revolutionary ideology, ideas that were incompatible with the traditional privileges of the nobility and church. The average citizen was bewildered by these ideas, and while the final result of all this did not make itself felt until much later, it soon became clear that neither the old regime nor the Napoleonic empire could satisfy the altered state of German consciousness.

A fairy tale of the period conveys the pain of Germany's identity crisis. *Peter Schlemihl* by Adelberg von Chamisso is the story of a man who sells his shadow to the devil and can no longer appear openly in society. Condemned to roam the world in magical seven-league boots, he redeems himself by holding on to his soul (resisting the devil's offer to exchange it for the shadow) and devoting the remainder of his life to a study of the natural sciences. Chamisso's story is almost wholly concerned with the drastic dislocation of the individual and the breakdown of the sense of self. The man without a shadow became the metaphor for the split and divided German nation.

During the Napoleonic epoch, artists and writers expressed themselves in a nationalist framework. They gradually abandoned classicism as a "French" style and sought a principle of aesthetics in the medieval world. Liberal artists wandered by default into the camp of conservatives who favored aristocratic control of the newly projected nation-state. Following the victories of the wars of liberation, the aristocracy quickly regained its political influence and sabotaged most of the work of reform.

The Lay of the Land

Two painters whose work dramatically attests to the tensions caused by the Napoleonic upheaval, Runge and Friedrich, could have identified with the story of *Peter Schlemihl,* the man without a shadow. Of German descent, both were born in western Pomerania, a northern territory wrested by Sweden from the Holy Roman Empire during

the Thirty Years' War. (The territory was restored to Germany by the Congress of Vienna in 1815 and now belongs to the DDR.). Though Swedish subjects, they were German patriots, and their impatience with the Swedish and Prussian governments was exacerbated by the failures to counter the French menace.

These artists expressed themselves most powerfully in the category of landscape. This is not surprising given the catastrophic territorial changes occurring in their lifetimes. In German, *landschaft* is both a scenic view and a specific territorial division, like a district or region. The Old English work *landscipe* had similar connotations, but the eighteenth century *landscape* had come to designate a general view of the earth's surface falling within the scope of vision from a single perspective. Undoubtedly, the German use of the term maintained its primal derivation from topographical sketches of military and civil surveyors. This tradition fused with the ideal of cultural unity being forged by the romantic thinkers and provided the basis for more effective action during the Napoleonic period. Runge and Friedrich shared with other German intellectuals a keen awareness of social and political order. Like the writers and philosophers, they delineated sharp oppositions between imagination and social reality, and perhaps viewed the ideal as truer than the actual. Their landscape art took on the attributes of the symbolic and mystical in their effort to make sense of the national calamity. We need to know more about the actual circumstances of property and the national reawakening to grasp some idea of their accomplishment.

The landscape prospects of Runge and Friedrich are extensive, panoramic, and detailed, covering large-scale and smaller divisions of the land. It is paramount in studying their work to understand what had happened to the landed property.[7] As elsewhere prior to the French Revolution, aristocratic life was an elaborate superstructure based on an agrarian economy. The nobility, already enjoying almost exclusive rights to the chief ranks in the government and the military, had the sole privilege of owning landed property. Occasionally one might find a landed proprietor of middle-class origin—a member of a family that had grown rich in the town—but the restrictions placed on the purchase of old feudal estates made the number of such cases comparatively rare. In the northeast almost the whole of the land was in the hands of the Junkers—owners of vast estates which often included sizable villages. The values and traditions of the Junkers set the tone of Prussian public

life. The wealthy merchants who purchased titles emulated these descendants of the medieval knighthood, whose lands were fiefs originally granted for services to some prince or great nobleman. The Junkers could entail their own estates and could exact dues from merchants or craftsmen making use of their land. The tax burden fell chiefly on the farmers and small landowners.

In the west, the peasantry made up over 75 percent of the population and practiced open-field cultivation, the land being laid out in strips with cottages clustered around the churches. (This was the opposite of the English system with its compact, enclosed farms and isolated houses.) Conditions worsened to the east, with peasantry bound to the soil in virtual serfdom in the eastern provinces of Prussia. Peasants owed body and soul to their *Gutsherr,* the lord of the manor. In the land east of the Elbe River, however, as also in Mecklenburg in the north, the large estates were often worked mainly by the landlord himself, partly with the labor of his peasants and partly with paid labor. Here the isolated farm, the *Einzelhof,* was to be found.

When Friedrich Wilhelm III ascended to the throne of Prussia in 1797, the pressures of the French Revolution moved him to initiate a policy aimed at weakening the hold of the nobility over the land and removing the restrictions on trade and industry. The king wanted to extend the reforms to all the peasantry in his dominions, but he was fiercely opposed by the landed aristocracy. Meanwhile, the inroads of the Revolution and Napoleon revealed the helplessness of the old regimes that did not adopt methods patterned on the French model. Thus in October 1804 the king appointed Freiherr vom Stein as his minister of commerce to review the areas of taxation, customs, and manufacture.[8] A knight of the Holy Roman Empire, Stein was attracted to the medieval system of estates, of well-distributed privileges and obligations, of a Christian aristocracy patriotically doing its duty, of self-governing cities, of corporations, churches, and universities administering their property in the common interest. He shared this vision of a "new" medievalism with the leading intellectuals of the day, but he was also a modern pragmatist who believed in the educational and moral function of government. Stein's appreciation of medieval corporative and modern bureaucratic ideas was not contradictory in this period. Many lines of development converged in the trend toward nationalism, including the fascination with the Middle Ages.

Stein began his career in the Prussian mining service, one of the many successful protégés of Werner in Freiberg. He took an active interest in stimulating Prussian manufacturers, particularly those of textiles, in carrying through Friedrich Wilhelm III's land reforms which intensified when the *Code Napoléon* was introduced on the Rhine, an event that sealed the fate of the gentry. Not only in the Rhine, however, but in Baden and the Palatinate the subdivision of property was made compulsory. Church lands were confiscated and secularized and then sold off to wealthy landowners and the well-to-do peasantry. After Prussia's defeat, the old monarchical restraints were swept away, and a powerful group of high officials advocated immediate reforms of the central government and the military, and consideration of the state of the peasantry and agriculture. They were convinced that only drastic political and social changes could make Prussia capable of competing with Napoleonic France.

This new ministry, headed by Stein, included Gerhard Johann David von Scharnhorst, Theodor von Schön, Berthold Georg Niebuhr, and August Wilhelm Anton Neithardt von Gneisenau—all soon to distinguish themselves in the Wars of Liberation. Their mission was summed up by Stein in this autobiographical memoirs: "The chief idea was to arouse a moral, religious and patriotic spirit in the nation, to instill into it again courage, confidence, readiness for every sacrifice on behalf of independence from foreigners and for the national honor, and to seize the first favorable opportunity to begin the bloody and hazardous struggle.[9] Stein, Scharnhorst, and Gneisenau became a triumvirate, deeply inspired by the Spanish uprising of 2 May 1808. While working out their practical reforms—Scharnhorst and Gneisenau revamped the military organization—they secretly formed a party of insurrection and planned for the arming of the nation. Stein, of course, had a profoundly personal motivation for his patriotism: the formation of the Rhine Confederation terminated his independent position, for part of the constitution of the new league granted to the allied German princes the sovereignty over the lands of the imperial knights. Since the dukes of Nassau (Stein's country seat) seized possession of the Freiherr's estates, there was nothing left for him outside Prussia.

Stein's name is directly associated with the abolition of serfdom. By 1807 the government made progress with its plans for the abolition of serfdom on private estates, here-

tofore militantly opposed by a majority of the Junkers. Yet even the Junkers were swept along by the tide of events. The owners of the large estates of East Prussia, which were well suited to new methods of capitalistic exploitation, were making increased use of landless labor. There had been brisk dealing in agricultural estates; many had changed hands, and the older feudal relationship between landowner and peasantry had become increasingly rarer. Many officials in Königsberg, now the seat of the Prussian government, were affected by the ideas of Adam Smith and wanted to encourage free enterprise. They advocated an agreement between landlords and peasants: landlords would be relieved of obligations to peasants in time of need, in return for a renunciation of their claims on their peasants.

Stein approved this scheme and made the emancipation edict of 9 October 1807 apply to all the provinces left to Prussia by the Treaty of Tilsit (arranged between France and Russia). The main decree removed all existing restrictions on the sale of the land, so that landed estates normally reserved for the nobility could now be acquired by the middle-class or peasant purchasers, and conversely, the nobility could now engage in industry and commerce. The net effect of these reforms was to undermine the legal basis of the old class structure, with its sharply distinguished ranks, and turn feudal landlords into capitalist farmers and serfs into hired laborers. This solution was socially the least revolutionary, however, and favored the propertied class. The Junkers retained control of their estates which they had cultivated for the export market with servile labor, but they now operated with peasants separated from their land. They learned that the obligations of a landlord to the peasantry cost them far more than what the services of these peasants had been worth to them.

Stein's emancipation edict and land reforms influenced Swedish Pomerania. One Pomeranian who heartily endorsed Stein's emancipation edict was Ernst Moritz Arndt, a friend of both Friedrich and Runge, who dedicated his book, *Der Bauernstand* (Condition of the farmers) to the aristocrats whose sacrifice made the edict possible. Arndt urged the establishment of a free and powerful German yeomanry as the backbone of the state, the limitation of large estates to one-third of the total land area of Germany, and the direct and separate representation of the yeomanry in a national parliament, and pleaded for harmony between the prospective estates or classes. Seven years earlier Arndt

had written a book advocating the abolition of serfdom in Pomerania and Rügen, *Versuch einer Geschichte der Leibeigenschaft in Pommern und Rügen* (An attempt at a history of serfdom in Pomerania and Rügen).[10] He surveyed serfdom in Germany as a whole and, after tracing the genesis and development of the institution in Swedish Pomerania since the twelfth century, declared the urgency, and outlined the procedure, of reform. The work carried the motto of Emperor Tiberius: "In a free state, tongue and spirit must be free." Arndt himself was of "servile" ancestry, and the work clearly indicated his liberal convictions.

The work provoked much antagonism not only among the German nobility in Pomerania, but also among large numbers of the gentry and great renters, who felt that Arndt was inciting revolution among the peasants.[11] Indeed, a group of angry noblemen and landowners showed the pamphlet to Gustav IV, who in turn sent the work to Baron Hans Henrick von Essen, governor-general of Pomerania and Rügen and the chancellor of the University of Greifswald. The controversy over the book forestalled Gustav IV's own plans for freeing the serfs in Pomerania and Rügen, but the Napoleonic war provided a convenient pretext for reviving the scheme. Following the defeat of the allies at Austerlitz, Gustav wanted to raise a popular army (*Landwehr*) of five thousand troops in Pomerania and Rügen. His dependence on the population induced him to issue an edict in the summer of 1806 abolishing serfdom under certain conditions. The various estates (nobility, burghers, clergy, and peasantry) were assembled at a *Landtag* in Greifswald to discuss the proposed reforms, but the invasion of French troops in October forced them to disband.

The Swedish king introduced changes along the lines of Stein's reforms, such as the *enskifte* system—the right to consolidate and enclose the scattered holdings of the peasants into larger fields. The strip farming and three-field system were now absorbed into the *enskifte* process for more intensive and efficient production.[12] In addition, the crown farms leased by the nobility and burghers were to be cut up, after the leases expired, into several small estates for the habitation of single peasant families. In time they would come into actual possession of the land and be raised to the rank of free peasants. While many of the king's schemes for the reorganization of Pomeranian land tenure remained theory, the abolition of serfdom sent shock waves through the countryside and permanently transfigured the

community, much as Stein's reforms altered the way people perceived the Prussian landscape.

The Anti-Enlightenment and the rise of Romantic Nationalism

Critical cultural events of the Napoleonic epoch occurred in Prussia and Saxony, the most advanced states outside England and France. The initial reception of the Napoleonic incursion related both to Napoleon's personal charisma and to the influence of French ideas among the intellectuals in the decade following the French Revolution. Two major writers who emerged in the late 1790s, Wackenroder and Tieck, stimulated the romantic movement by rejecting the Enlightenment and the classicism that followed in the arts. Undeniably, it was the stimulus received from France that set this agitation in motion. Rousseau's notion of the supremacy of the individual appealed to middle-class intellectuals in Weimar and Jena who felt constrained by the social and political structure of small states and lacked a collective base for bringing about change. The division of German-speaking peoples into numerous states contributed to the evolution of a decentralized mentality known as particularism, which mitigated against the rise of a strong national sentiment. German particularism bred not only national but also social disintegration. Every rank and class was split into different sections; the cleavages between the upper and middle classes ran deeper than in England, Spain, and even France. This adversely affected student life; students in different territories divided into regional fraternities and provoked clashes with one another. The "enlightened" response to the narrowness of particularism took the form of "cosmopolitanism." Those who espoused cosmopolitanism saw themselves as citizens of the world. The Enlightenment, with its emphasis on rationalism and universalism, perfectly suited cosmopolitanism. Thus the romantics rejected Enlightenment rationalism and cosmopolitanism in favor of irrationalism and nationalism. Their task was to overcome the political divisiveness of particularism, the antipatriotism of cosmopolitanism, and the anarchy of individual effort. This could be achieved only through the nationalism stimulated by the Napoleonic occupation. Rousseau's political ideal was a society of free and equal citizens, whereas his German disciple Herder conceived of all history as a striving after a harmonious blending of individual and collective forces.

Rousseau's ideas were embodied in the French Revolution, Herder's in the German nationalism of the Napoleonic phase.

German romanticism—always an inadequate label for the highly composite and diversified literary, artistic, and philosophical movement—coincided in time with the subjection of the German people to Napoleonic rule, the formal dissolution of the Holy Roman Empire, and the Wars of Liberation. What made Madame de Staël's *De l'Allemagne* so politically unpalatable for Bonaparte was precisely her formulation of the opposition between a dynamic, romantic Germany and a static, classic France. While the romantics owed much to such Sturm und Drang writers as Herder, Lavater, Goethe, and Schiller, they developed a perspective in tune with the burgeoning nationalism. The line of demarcation between the two generations was the French Revolution.[13] Except for Goethe, who had always mistrusted the Revolution, most of the old guard greeted it with enthusiasm, only to reject it when the Reign of Terror began. The literary and artistic leaders of the new school—August and Friedrich von Schlegel, Novalis, Tieck, Wackenroder, Schleiermacher, Schelling, Runge, and Friedrich—were still in their adolescence or barely in their twenties when the Revolution rocked the world. While Goethe and Schiller turned their backs on insurgence and disorder, the young standardbearers saw in the events an opportunity for self-realization. They had been primed by their forerunners to evaluate ty-rannicide, popular rebellion, and political freedom in the context of their own sense of destiny. Goethe's *Götz von Berlichingen* (1773) and Schiller's *Die Räuber* (The robbers, 1781), with all their aristocratic posturing and condemnation of the popular classes, nevertheless inspired the middle-class intellectuals of the next generation by their calls to freedom within a medieval and national framework.

The younger generation of intellectuals were not more politically committed or sophisticated than Goethe and Schiller, but they managed to fuse their perspectives with the growing self-consciousness sparked by the French Revolution. The revival of the Middle Ages and celebration of the *Volk* focused their energy into the new nationalism. Their religious sentiments, a fusion of Catholic ritual and pietistic emotionalism, advanced their anti-Enlightenment spirit. Thus the romantic movement embodied the responses of a generation reeling under the impact of the greatest political upheaval of that epoch. Maximilian Klin-

ger's 1776 drama *Sturm und Drang* tells of an adventurer whose excessive vitality and restlessness requires an outlet in revolutionary moments. For the next generation, however, revolution was not a youthful caper but fundamental to their very existence.

German Philosophy

The shift from one generation to the next was prepared textually by the metaphysical speculations of contemporary German philosophers, to whom I now want to turn. The rich philosophical investigations in the second half of the eighteenth century were dominated by the figure of Immanuel Kant (1724–1804). The son of a saddle maker, who espoused pietism, Kant grew up with the perspective of the artisanal class.[14] Of particular significance was the pietist influence in his native Königsberg. Pietism was a religious movement that developed in Germany towards the close of the seventeenth century and represented a return of German Protestantism to the original character of the Lutheran revolt and a reaction to the scholastic orthodoxy in which later Lutheranism took shape.[15] Its roots could be traced to mystical movements such as that of Jakob Böhme and his disciple Johann Georg Gichtel. It assumed great importance after the middle of the eighteenth century when it was taken up by influential thinkers like Lavater, Johann Heinrich Jung-Stilling, and Anna Schlatter. A basic characteristic common to all pietistic leaders was their emphasis on a more evangelical and emotional form of Christianity. Pietism in all its forms and aspects sought to eliminate the wide gulf between the official clergy the lay classes. The regeneration of the Christian church for pietists could come about only through the active involvement of all classes, and all segments of the population were encouraged to study Scripture.

Pietism invested the popular classes with self-respect and thus helped to unify the nation. It spurred the use of vernacular German as opposed to Latin or French, and stressed public education, social welfare, and philanthropy. Pietism was also the one safe form of protest against the noble landowners who were the pillars of Friedrich II's army. As seen by Gottfried Arnold, one of the early leaders of the movement, pietism was completely democratic: "Scholastic theology requires human diligence and research and can be mastered by only a few, namely the

learned; the mystical on the other hand can be reached by all, at all times and in all places."[16] While the orthodox clergy generally disapproved of schooling for lower-class children, the pietists had great influence in the field of elementary education. In Königsberg they opened a school for poor children and made great contributions to popular education which ultimately made possible Kant's training. Although he claimed he misunderstood the masses until he read the writings of Rousseau, he showed his class origin in justifying his democratic convictions: "I should feel myself of far less use than the artisan if I did not believe that my reflections would aid in restoring the rights of humanity."

His famous *Kritik der reinen Vernunft* (Critique of pure reason, 1781), which demonstrated the subjective character of all human knowledge, had a major impact on Tieck and the Schlegels. Kant held that the immediate objects of perception are due partly to external conditions and partly to our own built-in system for perceiving. Earlier, John Locke had proposed that the secondary qualities—colors, smells, sounds, and so forth—are subjective, and do not inhere in the object as it is in itself. Kant went even further to make the *primary* qualities also subjective. He claimed that the causes of sensations belong to a realm inaccessible to the mind, what he termed "things-in-themselves" (*Dinge an sich*) or "noumena," and these comprise the noumenal world as opposed to the phenomenal world of everyday life. What appears to us in ordinary perception—the "phenomenon"—consists of two parts: matter conveyed to us as sense impression or "sensation," and form which orders the sense impressions in certain relations due to our subjective apparatus. The three fundamental forms of all human knowledge—the conceptions of space, time, and causation—are subjective functions of our own intellect through which we see things. We do not see things as they *are*, but only as they *appear* to be.

Thus it is the individual intellect that shapes the raw material of cognition; the individual is the lawgiver. Such a perspective would have seemed to justify the French Revolution; it laid the basis for the romantic crisis later expressed in Tieck's *Die Geschichte des Herrn William Lovell* (1793–1796). Disillusionment with the dual revolution brought with it the attempt to turn the clock back, to recapture the medieval past with its values, its order, its seeming stability. The despair of many German intellectuals and loss of moorings predisposed them to seek solace in the old order; but Kant had posited a more controlling

experience of the intellect, for the world is what we make it. We determine the contours of the world; it is the objectification of thought and language.

The philosopher's *Kritik* of 1781 produced a sort of puzzled dread. Kant seemed to have destroyed all faith. He was then forced to think out his position on moral and religious conduct, and the result was his *Kritik der praktischen Vernunft* (Critique of practical reason), published the year before the French Revolution. Stimulated by Rousseau's idea of the general will, Kant claimed that every individual volition should have a universal character.

Rousseau's doctrine presupposed that people would engage in some political action only to the extent that they put themselves in the place of everyone else in the community and to the extent that they accept the obligations that that act of will carries with it. Kant generalized the political and social position of Rousseau and made it the basis of his moral philosophy. For Kant morality consisted in giving a universal character to every act, which he put in the form of his famous categorical imperative: It is necessary to act in such a way that the grounds of that action could be made into a universal law. For example, take the case of property: to demand possession of one's own property would be to demand that all others should also have possession of their own property. Kant's generalization of Rousseau's principle provided Germans still another philosophical handle for grasping the French Revolution.

Kant's position applied not only to the individual's will in society, but also to the laws of nature. If our intellect is confined to the realm of the senses as the object of its activity, our will extends to embrace the infinite. Life would be unbearable without the conviction that the contingent world of appearances is the manifestation of an eternal, spiritual world. Ideas of God, of moral freedom, of immortality, will always be unproven assumptions to the intellect, but to the will they are fundamental conditions for existence.

True freedom requires obedience to the moral law. This is the central hub of existence. Everything else in this world is subject to doubt and misrepresentation; only the inner promptings of conscience are a direct and unmistakable revelation of the divine. Thus, while Kant demolished what was left of a religious system that saw in God an extraterrestrial or extrahuman sovereign, he replaced it with a belief that reconstructed the divine from the individual's sense of duty. We *feel* ourselves to be moral beings,

and it is this feeling that gives the law of the categorical imperative.

Kant instilled a vivid self-consciousness in speculative philosophy and profoundly affected the outlook of the writers and artists we label "romantic." They took their cue from Kant's critical philosophy and the problematic features of the French Revolution. The romantic idealist started from Kant's postulate of a world of things-in-themselves, not as a postulate of an unknowable realm, but as something directly given in experience.

Fichte

Johann Gottlieb Fichte (1762–1814), Kant's disciple, was the theoretical founder of German nationalism.[17] He translated Kant's universal maxims into local patriotic duties. "To have character and to be a German undoubtedly means the same thing," he proclaimed. On this basis he developed a theory of nationalism that had enormous influence on the intellectuals in the German territories during the French occupation.

In 1806 Napoleon had begun his campaign against Prussia, which almost alone among German states still maintained its independence. When Bonaparte entered Berlin later that year, the Prussian fortresses capitulated one by one. Fichte fled to Kant's native town Königsberg, where he remained for the winter. The Russians came to the aid of the Prussians, fought to a draw at Eylau early, but the next year were defeated at Friedland in June, and made peace with France at Tilsit in July of 1807. It was this treaty that deprived Prussia of much of its territory and forced it to maintain French garrisons, reduce its own army to forty-two thousand troops, and pay a large indemnity to France.

Upon his return to Berlin at the end of August 1807, Fichte found Prussia humiliated by the proud French conquerors. He decided to participate in the work of reform, taking upon himself the task of inspiring the German people to new life by a series of lectures. While he never mentioned Napoleon by name, such a course took courage and determination in the face of the French army of occupation. He was essentially urging his audience to put aside the values imported from France in favor of a uniquely Germanic culture. The French authorities permitted the lectures as a propaganda device to exemplify their own ideals of liberty.

Fichte emphasized the need for an educational system that aimed at training youths of all classes and becoming an instrument of political unity. Fichte presented the idea that originality, "the power of creating new things," is a peculiar trait of the German people. He alluded to German philosophy as an example of the national uniqueness. An intimate connection existed between the individual's originality and national consciousness, which the new education would promote.

Fichte condemned the political conservatism fostered by religion. According to him, religion should be more than the consolation of the oppressed slave. It should actually provide the means to fight against slavery rather than to instill resignation and encourage the meek to look to heaven. The natural impulse of the individual is to find heaven on earth, and to endow daily life with permanence and eternity; to

plant and to cultivate the eternal in the temporal—not merely in an incomprehensive fashion or in a connection with the eternal that seems to mortal eye an impenetrable gulf, but in a fashion visible to the mortal eye itself. What man of noble mind is there who does not want to scatter, by action or thought, a grain of seed for the unending progress in perfection of his race, to fling something new and unprecedented into time, that it may remain there and become the inexhaustible source of new creations?[18]

The noble-minded German will be active and willing to sacrifice all for the nation. Only the permanent is of value, but this permanence is obtained only by the continuous and independent existence of the nation. Those who regard their spiritual life as eternal, but not their material life as equally eternal, may perhaps possess a heavenly fatherland but not one on earth. For the earthly fatherland is to be seen only in the image of eternity—eternity visible and made sensuous—and for this reason they are incapable of loving their fatherland. But to the individual who has inherited a fatherland, "and in whose soul heaven and earth, visible and invisible meet and mingle, and thus, and only thus, create a true and enduring heaven—such a man fights to the last drop of his blood to hand on the precious possession unimpaired to his posterity. The promise of a life here on earth extending beyond the period of life here on earth— that alone it is which can inspire men even unto death for the fatherland."

Fichte's stirring addresses reverberated throughout Germany. They emphasized a new type of national life, one

that had not been expressed previously under the Hohenzollerns. Fichte appealed very vividly to the national sense, as the German people faced a historical situation in which they had to reinvent themselves. It is in defense of a homeland that a nation achieves consciousness; in the face of an external enemy, people identify with one another and converge toward that larger purpose to which Fichte wanted to rouse them. The wars of Friedrich II had been carried out for personal aggrandizement and for the benefit of the aristocracy but were not the expression of a popular movement. Fichte added philosophical wings to the new movement inspired by Stein, Scharnhorst, and Gneisenau, who put forward the idea of universal military service and the recognition that there must be an intelligent and patriotic participation on the part of all sectors in society.

Fichte's address called upon the German people to free themselves from Napoleon. He sought to appeal to their patriotism and intelligence, as well as instill in them a sense of moral obligation. National self-consciousness had come earlier to the English, French, and Spanish, but the Germans achieved it during their encounter with Napoleon, and it was in this context that Fichte publicly presented his romantic philosophy.

Fichte accepted Kant's logic insofar as he said that space and time are facts only for our consciousness, and that things-in-themselves are unknowable. But Fichte went further and denied that there can exist things-in-themselves beyond consciousness. For Fichte, the world existed only insofar as we recognize it as there for us and shape it accordingly. The universe of beings molding and creating the world constitutes the life and embodiment of the one true and infinite Reason, God's will, the Absolute Self, which, while transcending the level of finite personality, uses our very conscious lives and wills as part of its own life. The only real world is the world of conscious activity—the world of society and of national existence—that exists through the embodiment of work; matter is the raw material required to give form, stability, and outline to mental and physical work.

Tieck

Ludwig Tieck (1773–1853), the son of a prosperous rope maker, is an example of the romantic pioneer affected by Kant and Fichte.[19] Under the influence of revolutionary enthusiasm Tieck rejected the egoistic isolation of Sturm and

Drang ideals in favor of developing all his "powers for the common good." But the unexpected change in the character of the Revolution and the war aroused a wave of reaction against the liberal tendencies of the Enlightenment and held up plans for political reforms in Prussia.

Tieck's first accomplished narrative work, *Die Geschichte des Herrn William Lovell* (The story of William Lovell), is a major statement on the evils of Enlightenment thought.[20] It is cast in the epistolary form of Richardson's *Clarissa Harlowe* and Rousseau's *Nouvelle Heloise*. Like Goethe's Werther, Lovell reads passages to his lover from Ossian and writes long letters full of detailed descriptions of his emotions and thoughts as he makes the Grand Tour of the Continent. In Paris he succumbs to a coquette and becomes unfaithful to his betrothed in his native England. In Rome he falls in with a hardened libertine and continues to lapse into decadence. Under the influence of Fichte's philosophy, he tries to justify his conduct. He writes, "Thus my external mind controls the physical, my inner mind the moral world . . . I myself am the only law in all nature, everything obeys this law."[21]

He seduces a young girl, who proceeds to commit suicide by drowning. Upon his return home to England, he finds that his father has died and that his patrimony has fallen into the hands of a deceitful friend. Lovell tries to poison him, but failing that he seduces his sister. Finally, he seeks comfort in solitary communion with nature. Before he can atone for his errors, however, he is shot in a duel by the brother of the girl he had seduced and abandoned.

The hero's continual self-analysis, which only ends in pessimistic resignation, is based on the Enlightenment ideal. In the preface to a second edition of *William Lovell*, Tieck claimed a positive moral and educational aim in this work:

My youth fell in those times when not only in Germany, but in the greater part of the civilized world, the sense for the beautiful, the sublime, and the mysterious seemed to have sunk to sleep or to be dead. A shallow enlightenment, to which the divine appeared as an empty dream, ruled the day; indifference toward religion was called freedom of thought, indifference to country, cosmopolitanism . . . In the struggle against these predominant views, I sought to win myself a quiet place, where nature, art, and faith might again be cultivated; and this endeavor led me to hold up to the opposing party [i.e., the Enlightenment] a picture of their own confusion and spiritual wantonness which would in a measure justify my falling away from it.

Lovell starts out as an enthusiastic admirer of Rousseau and Schiller and shares their belief in a past social ideal. Gradually, he takes a materialistic turn, seeking a theoretical foundation for his immorality. He finds it in a Fichtean response to Kantian transcendentalism: "Everything submits to my caprice; every phenomenon, every act, I can call what it pleases me. The world, animate and inanimate, is suspended by the chains which my mind controls. My whole life is a dream the manifold figures of which are formed according to my will."[22]

Kantian disillusionment is expressed by the hardened libertine, Balder, who asserts that the power of reason, the faculty cherished by the Enlightenment, is no longer capable of grasping absolute laws or things-in-themselves (Kant's *Dinge an sich*), but is restricted to the realm of phenomena. Objective truth is undermined, and the world may appear deceptive to the individual. There is no longer a way of demonstrating the existence of a rational or knowable divine order. Although Kant declared that it is necessary to posit such an order, the characters in the novel distort his ethical intention to justify their conduct.

Fichte's *Wissenschaftslehre* (1798) dispensed with Kant's notion of a "noumenal" world which must be posited for metaphysical thought and moral action but which in fact is not knowable. At the center of Fichte's system is the primeval self, a creative force, absolute and self-justifying. The autonomous ego (*ich*) creates its own subjects (the *nicht-ich*), which include God and the universe. The individual self shapes the world and in the process bridges the transcendental realm. Thus Lovell can conclude, "I am the one supreme law of all nature."[23]

But this leads to painful responsibility, and Lovell feels the need to believe in some externalized and objective principle. When his request to marry is refused by his father on class grounds, he plunges into sensual enjoyment. Later, he takes refuge in the occult, but in his final conversion he turns to religion. Lovell's conversion is stated in terms that anticipate the subjective approach to God urged by Friedrich Schleiermacher: "Our boldest thoughts, our most wanton doubts, after having destroyed everything . . . at last bow before a feeling which makes the wilderness bear fruit again . . . This feeling overthrows doubt as well as certainty . . . It rests satisfied in itself; and the man who has arrived at this point returns to some form of belief, for belief and feeling are the same. Thus even the most reckless freethinker will in the end become religious."[24]

Throughout the novel is a recognition that the abstruse philosophical concepts being bandied about have economic implications. Autonomy is an economic privilege—the prerogative of the rich. The villain of the novel, who leads Lovell to his final degradation, has organized a secret society with the declared aim of promoting democracy but which in fact is an agency designed to reduce members to machines in the service of industrial enterprise. Society is a colossal mechanism in which the human being represents a cog driving another cog, where one exploits and is exploited, dominates and is dominated. Lovell concludes: "The greatest idiot can then use this machine for his own profit, and the more sensible man will regard the whole world as one giant factory in which to install this machine, and activate it for his profit."[25]

Lovell detests the attributes embodied in the machine and longs for the unpredictable and "supernatural." Here the partnership of the Enlightenment with the Industrial Revolution has worked to the detriment of society, and Lovell's critique constitutes an explicit attack on the dual revolution. The philosophical attempt to surmount the negative perception of the dual revolution is represented by Schelling, the *Wunderkind* of German idealist speculation. Tieck introduced Schelling to the writings of Jakob Böhme, whose mystical explanations of existence aided him to get beneath the "outer form" of phenomena. He was geared to discovering the infinite in the finite and producing "the only true system of religion and science."

Schelling

Between 1799 and 1800 Friedrich Wilhelm Joseph Schelling (1775–1854) published his *Erster Entwurf eines Systems der Naturphilosophie* (First sketch of a system of the philosophy of nature) and *System des transzendentalen Idealismus* (System of transcendental idealism).[26] Here the outer world was declared to be the manifestation of spirit; the inner world of the self expressed itself in relation to the external, natural order. Schelling took the point of view of an artist looking out at a landscape. Artists go out into nature to find the very ideas they are trying to bring to consciousness. They also turn to their surrounding society, finding in social relations and in past history those ideas that they seek to express. Schelling therefore conceived of an Absolute Self finding in nature an objective expression, an external expression of the self.

Schelling's position went under the name of *Identitäts-System*, which he first developed in his *Darstellung meines Systems der Philosophie* (Exposition of my system of philosophy) of 1801 and elaborated upon the following year. In 1802 his *Philosophie der Kunst* (Philosophy of art) set out his definitive idea that artistic creation represents the highest synthesis for human intelligence. The laws of nature operate analogously to the laws of subjectivity. To understand the difference between organic and inorganic matter it is necessary to study our own inner consciousness and to examine its various stages leading up from disorganized sensations to clear and organic reason. The forms of matter in the external world are symbolic and analogous to the processes of the inner life. To study nature is to sympathize with nature, to trace the likenesses between the inner life and the magnets, crystals, solar systems—the "living creatures" of the physical world. The genius feels sympathy with these forms of matter and understands that feeling is an indispensable guide to reason. God would be totally inaccessible if we did not share his nature in our emotions. God is only the many-sided and infinite Genius, and romantics could appreciate him because they perceived themselves to be geniuses!

Like Erasmus Darwin, Schelling came to the conclusion that eighteenth-century science had become too haphazard and piecemeal by virtue of its lack of theoretical grounding. Given his contention that philosophy begins with transcendental reflection, science too must begin with a theoretical model—*Naturphilosophie* (natural philosophy)—if it is ever to attain the level of *Naturwissenschaft* (natural science). Schelling had the greatest sympathy for Darwin, probably rooted in his reading of the *Zoonomia*, published in 1794.[27] Here a unified theory of the gradual transformation of all organisms from a single source came to the attention of the young Schelling. In the preface Darwin rejects the mechanical model of the body as an approach to medical practice, and instead suggests that "the whole is one family of one part, [on]this similitude is founded all rational analogy." He then suggested a fourfold classification of organic functions, describing how the symptoms and effects of various illnesses can be understood with reference to these functions of sensation, irritation, association, and volition. *The Botanic Garden* also would have influenced Schelling's holistic approach to philosophy and the sciences. The dynamic character of Hume, Adam Smith, Darwin, and Flaxman showed the impact of

English culture on German intellectuals in this period. Schel-ling was well aware of the Lunar Society, since he referred to the work of Priestley on electricity, as well as to Franklin, Galvani, and Volta.

For Schelling, ego is "simultaneously subjective and objective being." The external world has the same character as the internal world; this is the core of the *Identitäts-System*. The philosophy of nature and the philosophy of consciousness are to be brought together, not by asserting, as Kant did, that reality is a product of consciousness, but by asserting that mind and the objective world have ultimately the same character.

Schelling's dream was to formulate a general theory of all of nature itself, a theory that would unify the natural, life, and social sciences as aspects of a single, interconnected reality. To accomplish this, science would have to be speculative rather then empirical. Empiricism becomes untenable without a clear and absolute separation of subject and object, and without the assumption of real time and space. Instead, if the subject is part of the object through a higher unity, then it is only in understanding the nature of this connection that a proper perspective on scientific knowledge of the world can be achieved. Science, then, must begin with fundamental principles made evident through intellectual intuition: the unity of the ideal and the real, the development of the real out of the structures of the ideal, and the priority of conception over perception.

Schelling saw his philosophy as a kind of religion, "the embodiment of the divine in science, life, and art, and the universal propagation and establishment of the same in the minds and hearts of men." The perception of the unity of science, art, and life implied a unified world now transferred to the realm of the state. Schelling's aim to reveal the divinity and unity of that which "has always been unified and one" could easily be taken for a reference to the new nationalism.

The School of *Naturphilosophie* and Its Relation to National Culture

It is no coincidence that several influential scientists of the time accepted Schelling's mandate to seek interrelations among natural phenomena and to eventually bring about a unity of nature and culture.[28] All were ardent German patriots and included Henrik Steffens (1773–1845), a close friend of the artist Runge and energetic participant in the

Wars of Liberation; Lorenz Oken (1779–1851), who used science as a rallying point for German patriotism and founded organizations to unite the German scientific community behind *Naturphilosophie;* Gotthilf Heinrich von Schubert (1780–1860), a close friend of Friedrich who was raised in the pietist tradition and tried to make *Naturphilosophie* acceptable to the masses; Joseph von Görres (1776–1848), who denounced Napoleonic rule and preached union of Germany under a German emperor, with a national army and free trade within the empire; and Carl Gustav Carus (1789–1869), a much younger follower who fused his love of natural science with devotion to the German landscape, which he expressed in pictures deeply influenced by his friend Caspar David Friedrich.[29]

The Role of Art

The aesthetic standpoint marks the completion of the journey of self-consciousness in Schelling's *System des transzendentalen Idealismus.* Other philosophers such as Hegel found this disagreeable because they thought that only philosophy could represent the highest form of spiritual activity. For Schelling, art represented the essence of intellectual intuition. Schelling's *Philosophie der Kunst* is his attempt to show the connection between art and *Naturphilosophie:* "In the philosophy of art I construe art not as art, as this particular thing, but I construe the Universe in the form of art, and the philosophy of art is the science of All in the form or potency of Art." For example, the fully contemplated form, which the plastic arts produce, is the objective representative prototype (*Urbild*) of organic nature itself. In the total identity of the real and ideal contained in the Absolute—or, what now Schelling begins to speak of as "God"—art and philosophy each play their indispensable roles. Insofar as artists participate in this activity, they do so by an interaction with nature, but simultaneously participate in the universal creative process by producing *symbols* as universals in particular form.

Schelling's philosophy of transcendental idealism begins with a transformation of the Fichtean ego-philosophy, the central principle of which is that one begins not from the object (nature) but from the subject (ego). The problem of transcendental idealism is therefore how, starting from the ego, one is to reach a completely realized world. The philosophy of nature starts from the object and endeavors to see how a subject can arise (i.e., how consciousness can

arise in the world). Earlier, Schelling viewed nature as an evolutionary system, not in the Darwinian sense, but as a system in which nature is a spirit or intelligence forever trying to realize itself. He traced this self-development from matter to the highest stage of consciousness.

In the philosophy of transcendental idealism, the movement is just the reverse: from ego to the world. The ego is at once a productive agent that creates by itself, stage by stage, the objective result, and an intuitive agent that can grasp what it produces by an intellectual intuition. This intuition is a process of deepening awareness so that the ego can follow its own evolution. Philosophy is therefore able to comprehend this process by reflecting on its own activity. Philosophy is a self-conscious recreation of the process of ego. Only those with philosophical insight akin to artistic genius can perform the re-creation.

Schelling's essay, "Über das Verhältnis der bildenden Künste zu der Natur" (On the relationship of the plastic arts to nature), was originally delivered as a lecture before the Royal Academy of Sciences of Munich on 12 October 1807 to celebrate the name day of Ludwig, I crown prince of Bavaria.[30] Flattering the crown prince for his support of the arts and sciences, Schelling indicated to what extent philosophical investigation served the royal interests. He expressed gratitude to "the rulers of the earth" for preserving for us "the peaceful enjoyment of the excellent and beautiful, so that we cannot recollect their good deeds, nor contemplate the general happiness, without being immediately guided to the universally human."

The lecture proved to be an application to art of *Naturphilosophie*. Schelling emphasizes that art is "a connecting link between the soul and nature, and can be understood only as a vital synthesis of both." Art embodies the miracle "by which the finite should be elevated to the infinite, and by which humanity should be deified." The soul is not merely the individualizing principle in humans, but that by which they elevate themselves. It is that by which they are capable of self-sacrifice and "of the contemplation and perception of the being of things, and thus of art." And it is to be distinguished from property and possessions:

The soul is not concerned with matter, nor immediately connected with it, but only with the vital spirit, as the life of things. Although appearing in the body, it is free from the body, the consciousness of which only hovers over it like an ethereal dream, in the most beautiful shapes, by which it is not disturbed. It is no property, it is no possession, nor anything of limits; it knows not,

but is itself knowledge; it is not good, but goodness itself; it is not beautiful, but is beauty in essence.

Loyalty to king and fatherland is a cardinal point of Schelling's lecture, as if great art depends on a favorable climate produced by a mild ruler, "where energy is in voluntary action, where every talent shows itself with joy, because every one is valued at his worth; where subserviency is shame, where the commonplace brings no praise, but where all strive after a high-paced and extraordinary aim." Only "when public life is animated by the same power by which art is elevated" can art expect encouragement from it; for art cannot, without forfeiting its integrity, be influenced by any external consideration. "If the state of art is dependent upon the universal fate of the human mind, with what hope may we contemplate our peculiar fatherland, where a noble governor has given to the understanding freedom, to the spirit wings, and realization to the ideas of philanthropy; while a pure people still preserve the living germs of ancient art, and with them the ancient seats of old German art."

Schelling's high-flown philosophical language was an attempt to mask the political ambiguity in Bavaria, then a vassal state in the French empire. While the crown prince loathed the subservience of his father, Maximilian I Joseph, to the emperor, he himself served in Napoleon's headquarters during the campaign against Prussia. The great debate then raging in the German territories centered on the issue of regional patriotism or particularism versus German nationalism. Schelling's remarks, made in the context of French hegemony, do not make this distinction. His fatherland is Bavaria, and his apologetics gloss the struggle of more reform-minded types who wanted to exchange provincialism and cosmopolitanism for nationalism.

Nationalism and the Philosophers

Nationalism proved to be one of the more durable of the nineteenth-century ideologies, less consistent but more flexible than most and more complicated by encompassing both liberal and reactionary components. It could be invoked in the face of a foreign oppressor, but just as easily manipulated for domestic purposes by rallying those of the dominant group against a minority that was defined as "foreign," that is, alien to the dominant interests. In both cases, however, nationalism was defined negatively as the

common fraternal bond that unites a disparate group against an enemy other. The positive outcome of the wars of nationalism was the temporary suspension of class barriers, a feeling of unity that cut across heretofore exclusive social lines. Deceptive though it may have been in many instances, this national solidarity provided a model for possible cooperation and raised the hopes of the liberals.

France was the first place the broadest masses experienced the sense of nationhood. The Revolution and Napoleonic rule enabled the peasantry and the urban laborer to experience France as their own country, as their personally created father- and motherland. But this awakening of national sensibility was not peculiar to France; the Napoleonic presence everywhere evoked a wave of national feeling, of national resistance to the French occupation and repression, and of enthusiasm for national independence. Generally, these movements were a compound of regenerative and reactionary actions, but in whatever proportion, they touched the experience of the broader populace. The appeal to the national ideal was inseparable from a reexamination of national history and folklore, together with selective memories of the past that put the nation in a heroic and positive light.

Nationalism's profoundest source of appeal is the shared sense of common regional and cultural identity, especially as this identity is expressed in custom, language, and religion. Although such feelings antedated the modern period, they were further stimulated by increased communication, mobility, and the formation of mass armies. And while social groups in earlier epochs experienced these feelings, it was only in the post revolutionary period that they were attached to the nation-state and facilitated the concentration of unprecedented power. Nationalism also played a tactical role in mobilizing energies for modernization, attracting the progressive classes of backward societies aspiring to achieve the prosperity and independence of France and England.

While they varied in content and tactics, nationalist movements not only exploited advanced political thought to hold out promises of reform, economic expansion, and social progress, but they also assimilated many of the advanced cultural trends of the period. Here romanticism, with its rejection of the rationalism and cosmopolitanism of the Enlightenment and the French Revolution, played a critical role. German repudiation of the values imported from France in favor of the indigenous culture in turn influ-

enced French and other intellectuals to look to their own traditions, ethnicity, and dialects as the expression of national greatness.

Nationalism is the cultivation of feeling for the national group and the subordination of the individual to the interest of that group.[31] This subordination may also be read as an experience of solidarity with the group that establishes a bulwark against the sense of hierarchy. It promises to reward the individual by incorporation with the nation and instill a grateful sense of not being treated as the "other"— nation, ethnic affiliation, or race. The nationalist is supremely devoted to the state above all other groups or collectivist ideals.

As in Spain, German nationalism was stimulated by the presence of the Napoleonic machine on its soil. It arose in response to foreign usurpation as well as to the forces within the nation hostile to nationalism—absolutism, and caste—forces whose corruption was manifest in the craven capitulation before the enemy. Absolutism and caste allowed some freedom to the individual within the caste but not on the broad plane of the nation; they interposed allegiances above to those of the nation, and the nationalist demanded that these be abolished. Eventually, those members of the noble classes who opposed nationalism joined the movement and exploited it for their own ends. They knew that without it they could never expel the invader, but once this occurred, they could resume their former hegemony with a minimum of concessions.

As against privilege, however, bourgeois nationalists asserted the right of each person to equal opportunities; as against rights, there should be duties to the nation. The mercenary army commandeered by an elite corps, or the occupying army of another nation-state, would be replaced by a national army staffed by all classes, private education by a national education offered to all members of the state, cosmopolitan or provincial culture by the national culture, private or mercantile economy by a national economy, and private charity by national responsibility. Social rank would not be determined by birth but by meritorious service to the nation.

Nationalism grew at the expense of orthodox Christianity, replacing the latter with belief in a spiritual system of its own. Significantly, nationalism began to emerge after the Enlightenment, and it first expressed itself among the Continental peoples most influenced by the Enlightenment—the French and the Protestants of north and central

Germany. On the surface, nationalism and Christianity share common ideals. Both oppose rugged individualism, preferring a mode of liberty that goes beyond the welfare of the individual. Both preach love, fraternity, self-sacrifice, and devotion to ethnic roots, and seek to unite feeling and reason.

But there is a fundamental difference. Orthodox Christianity places its heaven in the next world; nationalism seeks its heaven on earth in the perfect nation. Christianity preaches resignation, meekness, humility, peace, and forgiveness, while nationalism arouses pride, actions, and often hatred, vengeance, and war. Christianity preaches acceptance of all humanity. The nationalist approves mainly of the members of a single state. God becomes not a deity for all seasons but a god of one nation.

What follows is a series of case studies of leaders in various fields whose nationalist proclivities mediated between the macro complex of culture and the micro realm of day-to-day politics. Their personal motivations varied according to class and personality, but in the end they merged to form a coherent body of opinion with far-reaching influence.

The Example of Fichte

As we have seen, Fichte was the leading intellectual of German nationalism in the period of Napoleon.[32] He arrived at this position gradually under the impact of events. He was born to the artisan class in Saxony, scarcely differentiated from the surrounding peasantry. His precocious gifts attracted the attention of a local Junker who subsidized his early education. His class-hopping made him aware of his family's deprivation, and he grew embarrassed by their social behavior. This may explain his own social eccentricities. His career reveals a series of intense, short-lived friendships followed by intense animosities, of enthusiasm for a place, then growing disgust with the population of that town or city. The same restlessness and dissatisfaction appeared in his writings and, in fact, predisposed him toward cosmopolitanism. Dissatisfaction with his immediate environment led to general dissatisfaction with society. The discrepancy between his birth and position, character and training, hopes and actualities, instilled in him a desire for social transformation consonant with his ideals. It led him to work for a society in which he would be a well-adjusted member. On these grounds he defended Rous-

seau's *Du contrat social* and attacked absolutism, emphasizing that the attainment of cultural freedom necessarily involved the participation of everyone in those affairs that concerned them, including the destruction of absolutism.

In 1795, when Fichte was working on his *Wissenschaftslehre,* the chief exposition of his philosophy, he hoped for a subsidy from the French republic while completing his studies. He informed the French government that the first ideas of his speculative system came to him while he was writing his *Beiträge zur Berichtigung der Urteile des Publikums über die französische Revolution* (Contributions to the rectification of the public's judgment of the French Revolution), published in 1793. In his mind the two were inextricably linked, and momentarily he even contemplated becoming a French citizen. As late as 1799 he tried to gain a position in a proposed German university to be established in the French-controlled town of Mainz. Although the plan for the school did not materialize, these incidents reveal Fichte's cosmopolitanism.

Fichte's cosmopolitanism, however, was challenged by the advent of the Napoleonic empire. He had framed a philosophy grounded in Kantian speculation and the French Revolution, and developed it into an activist philosophy, preaching the necessity of doing and thinking. He had been dismissed from the University of Jena as a result of trumped-up accusations of atheism and sympathy for the French Revolution, and now he had to face the contradiction of his lack of freedom at home and in Napoleonic France.

During the winter of 1804–1805 Fichte delivered the first series of his Berlin lectures. His subject was "Die Grundzüge des gegenwärtigen Zeitalters" (The characteristics of the present age), in which he proposed an interpretation of the past to explain why the philosophy of freedom, set into motion by the French Revolution, was then being rejected. France had embraced the authority of Napoleon, and since Fichte identified his fate with that of the Revolution, he wanted to understand why their common philosophy now faced collapse.

Fichte divided past, present, and future into five epochs: (1) domination of reason by instinct, (2) authority, (3) liberation from blind reason and from blind authority, (4) reason as science, and (5) sanctification of the fully realized state. Fichte identified his own age with the third, as a transitional period of disorder that played into the hands of Napoleon, but that would also lead to his unraveling. There-

after would follow the fourth epoch, the prelude to utopia. Utopia, of course, would be ushered in and dominated by Fiche's own idealistic philosophy, as it alone combined the required unity of thought and action for reform.Indeed, Fichte would rehearse this stage with his *Reden an die deutsche Nation,* a survey of those primal elements out of which the new state may be constructed.

By 1806 Fichte the cosmopolitan had been transformed into Fichte the nationalist. On the eve of the Battle of Jena the philosopher still rejected patriotism for a particular state or nation, but for him cosmopolitanism and nationalism were merging. In *Die Patrioten* (The patriots), a dialogue written before the Jena defeat, Fichte declared, "Cosmopolitanism is the will that the purpose of humanity be really achieved. Patriotism is the will that this purpose be fulfilled in that nation to which we ourselves belong, and that the results spread from it to the whole of humanity . . . Cosmopolitanism must necessarily become patriotism." In the same piece he declared that whereas the distinction between Prussian and German was artificial, the distinction between Germany and other European nations was natural. Germany would usher in the new epoch with knowledge derived from the philosophy of idealism, and spread its new philosophy to the rest of humanity:

The German alone can will this; for he alone can, by means of the possession of this knowledge and of an understanding of the age through it, perceive that this is the next objective of humanity. This objective is the only patriotic one; the German alone can, therefore be a patriot; he alone can for the sake of his nation encompass entire humanity [while] the patriotism of every other nation must be egoistic, narrow and hostile to the rest of mankind.[33]

Jena deepened Fichte's feeling of nationalism. He offered to serve the troops as official orator and teacher (this was refused by the government) and then joined the court and the army in their flight. The collapse of Prussia seemed to him a personal affront, and he identified with the Prussian state. Meanwhile, the government paid him a subsidy while he lived in retreat, and he castigated Wilhelm von Humboldt for hobnobbing with Napoleon. As he wrote to his wife from Königsberg, "It makes a difference in one's conscience and apparently also in one's later success if in troubled times one has openly shown devotion to the good cause." As a matter of fact, he did profit: undoubtedly the episode contributed to his appointment to the University

of Berlin. Meanwhile, he went from joy to gloom as he monitored the battle of Eylau and its aftermath which made his stay at nearby Königsberg untenable.

Fichte returned to Berlin later that year and, determined to make a contribution to the nation, delivered the *Reden an die deutsche Nation* during the winter of 1807–1808. Reduced to their historical and biographical context, the lectures represent Fichte's patriotic plea to the elite to accept his philosophy for the regeneration of the state.

Ernst Moritz Arndt's Nationalism and the Peasantry

Despite the essential conservatism of the peasantry, the nationalists found in the rural folk a paradigm for their propaganda. They claimed that peasants are the purest expression of the national life. Being closest to the soil, and mistrusting change, they preserve the nation's character. Above all, on a small scale, the peasantry offers a pattern of fraternal life essential to nationalism.

Arndt, who hailed from Swedish Pomerania like Runge and Friedrich, was one of the first German nationalists of peasant birth.[34] His father, an emancipated serf, rose quickly to the ranks of the middle class. By means of a rise in agricultural prices he had become a renter of a large estate on the island of Rügen in Swedish Pomerania, including several villages of serfs, and the occupant of a house that had once been the home of an aristocrat. Rügen's real estate and landscape were always inseparable in Arndt's mind. He identified Rügen's varied topography with its inhabitants' property and made it part of a popular cause. This environment also stimulated him to gather local folktales. Although the standards of the Enlightenment required a search for universal meaning in the quaint lore of peasant folk, Arndt's fascination for folktales made him into a cultural anthropologist, folklorist, and historian, close to the thinking of Herder.

As the son of a former serf, Arndt had to work through the insecurity felt by a person jumping class barriers, and his intellectual growth was slow. His sense of identity was forged through wide reading and traveling, through emotional and intellectual adjustment. Even then Arndt never satisfied himself fully in this respect, and his nationalism, like Fichte's, arose in part from this sense of dissatisfaction. As he stated: "When Germany, through its discords, had fallen to nothing, I recognized its true unity."[35]

Arndt studied at the universities of Greifswald and Jena

in the 1790s, and encountered head-on the philosophical approach of Fichte and Schelling. He wrote his mother in December 1796, "I do not know whence I came; I do not know where I am going; but how I go, that I must know." Arndt certainly assimilated Fichte's exhortation to action. Arndt was then committed to monarchism, but despising the aristocracy, the thought of the German princes made him bitter. He maintained that the aristocracy rarely equaled members of other castes in talent and virtue, and blamed it for class antagonisms as well as for serfdom and social misery.

One would have expected such an opponent of the existing form of government to applaud the French Revolution. Arndt did at first sympathize with many of its goals and watched its course with keen interest. But he objected to its excesses, the change of constitutions, the wars of conquest, and the certainty that reason alone could solve the nation's social problems. When Napoleon became emperor, Arndt believed that the progressive gains of the Revolution had been destroyed. He despised Napoleon as the embodiment of blind rationalism, cynicism, and despotism, as one who trampled on the sacred rights of human beings and of society. He especially hated him for defeating the Germans, and for the fact that some Germans became eager subjects of Napoleon.

While Arndt repudiated the French for taking parts of Germany, his anti-French sentiment did not arise out of the desire to exalt Germans. His nationalism derived in part from his ambivalent national heritage. Pomerania, the home of the Arndts, was populated by Germans and governed by Sweden. He belonged to both Germany and Sweden. He did not feel exactly as a Swede, because Sweden lay across the Baltic and spoke an alien language; he could not regard himself as a German, because Pomeranians revered the Swedish king.

Fueling Arndt's nationalism was his condemnation of the age, its culture, and its institutions; his belief in the regeneration of people; and his search for a group to lead in this quest. Arndt had rejected bourgeois culture as uninspired and anemic, and banked on the peasantry to breathe new life into civilization. For him the peasantry resolved his ambivalent loyalties; they represented a primordial social group uncontaminated by the foreign conventions and fashions and ready to serve as the core of the new society.

Arndt believed that Kant had effaced all previous philosophy, leaving the way clear for the creation of a new one.

He wrote in his *Geist der Zeit* of 1806 that the "two worlds are divided, it seems forever, the spiritual one here which the spirit has now forsaken, and the heavenly one above which should light and bless the one below." Arndt obeyed the idealist desire to unite heaven and earth, spirit and matter, to reconcile the ideal and material, to bring into reality the teachings of Fichte and Schelling. His perusal of Schelling's philosophy between 1803 and 1805 confirmed the idea of union between spirit and nature which satisfied his own need for universality and predisposed him momentarily to accept the all-inclusive *Weltseele* (world soul).

Arndt's program to unify subject and object, spirit and matter, was inseparable from his political desire to override class barriers and bring the peasantry into intimacy with state policy. As in typical idealist discourse of the period, the union of seeming opposites could not be achieved by intellect alone, but requiredsensibility and feeling, as well. The capacity for all groups to allow for a more inclusive and representative society was ultimately the product of a nurturing education. This idea he derived from the pietistic-evangelical strain of Protestantism and its interpretation by Friedrich Schleiermacher, whose *Reden an die Religion* (Speeches on religion)—first published in 1799 and reedited in 1806—introduced jaded North German intellectuals to the idea of religion as indispensable to complete human beings. He preached that a fundamental impulse of the mind is to desire to surrender itself to the Inifinite and feel a oneness with the universe. This sense of harmony with the Infinite is the model for national harmony and solidarity of the classes.

In 1805 and the first half of 1806 Arndt thought the Swedes capable of defeating the Napoleonic menace. After the French invaded Pomerania, established control, and threatened to destroy the land, Arndt fled to Sweden. His opposition to Bonaparte and the French had made it risky to remain. He stayed in Sweden until late in 1809, hoping for someone to lead the struggle in Germany. For a person as eager to put his ideas into practice as Arndt, enforced stay—even among a people he knew—became identical with enforced exile. His sense of union with the German folk, the people of his language, was denied. When we also recall that while in Sweden he was separated from his family and relatives, we may imagine the tension he must have felt.

Worst of all, closer intimacy with the Swedes disillusioned him. Devoted to the Swedish king, who hated Na-

poleon and wished war as much as Arndt did, he hoped for the king to lead a crusade for the liberation of Europe. To Arndt's astonishment and sorrow, the Swedes opposed the war against Napoleon and regarded indifferently the fate of Pomerania, not to mention Germany; he realized that the fraternal Nordic feeling was all on his side. When the king began war, first with France, then with Russia and Denmark, his officers opposed it and betrayed their troops in order to undermine their ruler. Arndt felt isolated, lonely, and useless, and when early in 1809 the nobles and the army deposed the king, he was eager to leave Sweden. By that time he had concluded that the Swedes lacked public spirit and courage, and did not think like a nation.

When the French restored Pomerania to Sweden in 1810, Arndt returned to his position at the University of Greifswald and tolerated with mixed feelings the political humiliation of this German province. But he no longer felt at home in the academic and provincial environment. He found Pomerania controlled by particularists and the university full of pro-French professors and students. Even his old friends had turned to Napoleon and did not wish the peaceful atmosphere disturbed. When on the birthday of the Swedish king Arndt proposed to make a speech, his colleagues, objecting to his stirring up political trouble, prevented him from doing so. During October 1810 he requested release from the university and in the course of the next year began a new life of service to the German nation writing political propaganda abroad.

Arndt turned to active German nationalism only after all avenues for realizing his program were closed off. Wherever he went the shadow of Napoleon haunted him. The German people were his last hope for defeating the French. Like his friend Schleiermacher, he made German nationalism his first allegiance and fused his pietism with the struggle for independence. Arndt regarded the Wars of Liberation as holy, with God on the side of the Germans and fighting against the Evil Empire. He advocated the use of every means for destroying Napoleon, including the *Landsturm* in its most exaggerated form. He urged every man, woman, and child to mobilize against the French and to use or destroy every animal, every inanimate object, so that the enemy could not deploy it. If the princes refused to lead the people, the people had to rebel. Condemning cosmopolitanism and particularism as contrary to the divine order of nature, he proclaimed the right and duty of all Germans to unite. Kinship, customs, natural frontiers, and especially

language held them together. By German unity Arndt meant during these years actual political unity with a central head, a constitution, and an efficient government. Up to 1814 he still regarded Austria as the leader of the Germans; but disgusted with Austrian military diffidence and impressed with the renewed Prussian vigor, Arndt transferred his loyalty to Prussia and henceforth agitated in favor of unification under its control. He demanded an emperor or king, and a *Reichstag* for all Germany representing aristocracy, burghers, and peasants and civil liberties for the individual.

Kleist and Aristocratic Nationalism

Heinrich von Kleist (1777–1811) descended from old German nobility with a lineage dating to the year 1176.[36] The future poet was reared in the garrison town of Frankfurt an der Oder, where his father was stationed. A male Prussian aristocrat could follow one of three possible careers: officer in the army, bureaucrat, or lord of an estate. Since the Kleists of Heinrich's branch lacked the material basis for the lives of rural lords, they had usually entered the army. When not quite fifteen years old, Kleist himself went to Potsdam as a member of one of the most exclusive Prussian regiments, advancing in rank at the usual rate. Kleist chafed against military life, however, and in 1799 resigned his post, breaking with the tradition of his family and his caste.

In his distressed state he pondered Kant. The tough assertions of the Königsberg philosopher confirmed his suspicion that the search for absolute truth, for objective knowledge, for a definite plan of life, was futile. As he interpreted Kant's notion of the noumenal realm, "the thought that here below we can know nothing, absolutely nothing of Truth, that that which we call Truth here is something quite different after death and that consequently the effort to gain possessions which will follow us into the grave is quite fruitless and vain—this thought has shaken me in my inmost soul. My only and highest purpose has sunk; I have no other."[37]

Shattered by this reading, Kleist tried to escape his social obligations as well as his romantic entanglements. He went to Paris and then to Switzerland. During this chaotic period two things became clear to Kleist: his wish to write and his attachment to transcendental philosophy. In spite of Kant, he now rejected the idea that absolute assurance was

unattainable, and began reading Ficht and Schelling. While retaining the idea of an absolute, he substituted for the implementation of reason that of the ego. The way to grasp reality was through feeling. He decided to go with Schelling rather than Kant.

Meanwhile, Jena and the French threat were instilling in him a militant nationalism. He wrote his sister, "It would be horrible if this tyrant should establish his empire. Very few people comprehend how ruinous his rule would be. We are the subject peoples of the Romans. The aim is to plunder Europe in order to enrich France."[38] Early in 1807 he and two companions were seized by the French on charges of espionage and sent to prison in France. After his release several months later Kleist settled in Dresden, where together with Adam Müller and two other friends he founded and edited the magazine *Phöbus,* which steered clear of political subjects and devoted itself to literature and art. Like many of his publishing ventures in this period, it petered out after a short time. It was a period of intense literary activity accompanied by high hopes of success, but either the projects failed to materialize or folded quickly due to political pressures.

In August 1808 Kleist wrote his sister of his concern over French censorship in the publishing and theatrical fields. He felt that he could not hope to succeed with his own ventures in Berlin "because there they produce only translations of small French pieces and in Cassel the German theater is abolished and a French one put in its place." And he added wryly, "Who knows whether in a hundred years anyone in this locality will any longer speak German." It is probable that Kleist's sense of being blocked in his writing and publishing in Dresden goaded him to embract nationalism. It was frustration that caused him to identify with the nation-group suffering likewise from the invasion. In the last half of 1808, during the time of the decline of *Phöbus* and his other hopes, he composed the first of his popular nationalist dramas, *Die Hermannsschlacht.* The shift is also evident in the patriotic *Berliner Abendblätter,* which he published in 1810–1811, showing the transformation of a cosmopolitan poet into a poet-patriot. Although it folded under French pressure, its famous review of Friedrich's *Monk by the Sea* assured its historical niche.

Kleist was always short of money and could not earn a living from his writing. He attributed his economic misfortunes to the tight grip of the French over the Prussian state. His frustration grew as he tried unsuccessfully to en-

courage political leaders to assert themselves and rally German patriotism. He wrote in April 1809 to a friend that he wished he had a voice of iron and could sing his poems "to the Germans from the top of the Harz." He felt himself as a kind of Ossian-manqué—a bard who failed to make himself heard—and in 1811 he took his own life.

August Neithardt von Gneisenau and the Military Nationalist

Kleist, Arndt, and Fichte looked for leadership to the universally admired member of the patriotic party, August Neithardt von Gneisenau (1760–1831).[39] He shared their ambiguous social status and obsessive attachment to land, personal and national. Gneisenau's career began with his strange entry into the world. As an infant, he had slipped from his unconscious mother's arms and was found lying in the road by a soldier. He was reared by a poor family and raised like an impoverished peasant. His maternal grandparents finally retrieved him when he was nine years old. Though the grandparents were Catholic, the peasants had drilled him in Luther's catechism, and he continued to worship in Lutheran churches. In addition, the reading of Kant and Fichte helped form his philosophical outlook.

Gneisenau entered the services of a prince who hired his soldiers out to England, and in 1782 he was shipped with his battalion to America. He remained with the military in one post or another, finally landing service in the Prussian army. Gneisenau was much more serious and ambitious than the average Prussian officer. While stationed in Halifax and Quebec, he seized the occasion for learning all that he could about the country and its methods of fighting. He wished particularly to understand how relatively untrained troops could defeat a standing army and discovered that the citizens were inspired by fighting on their own soil for independence. They used the scatter formation, availing themselves of the protection offered by the terrain and fighting not as a mass but as an army of adaptive individuals. He also perceived that, the colonial army lived off the territory, thereby gaining mobility. He received a basic lesson in the methods of warfare appropriate to nationalism, a lesson that the armies of Napoleon reinforced and that the Prussian reformers later tried to implement.

Returned to civilian life, Gneisenau introduced modern methods of agriculture on his estate, obtained through marriage with the daughter of a Silesian noble. But the de-

feat and flight of Prussia haunted Gneisenau with the fear that through the war with Napoleon he and his family might become paupers. He wrote in May 1808 that "the possessor of property will probably be ruined."[40] This forced him to assume the offensive against Napoleon. He was selected as commander of Colberg, one of the few well-protected towns holding out against the French attack in the aftermath of Jena. In striking contrast to the immediate surrender by their commanders of almost all the other fortified towns of Prussia, Gneisenau defended Colberg against superior forces until the Peace of Tilsit stopped the combat. Unlike the previous commander, an aristocrat of the old order, Gneisenau was not constrained by the caste system. He incorporated the burghers of the town in the defense, treated them as social equals, and instilled a common feeling of patriotism in them and the soldiers.

During the Napoleonic occupation Gneisenau shunned Berlin and feared that his family might be taken as hostages. He believed that he was ruined financially. He considered his own estate as an "inn where he was lodged for as long as it pleased God, his creditors and Napoleon."[41] He did not dare emigrate, however, because of his family and property ties.

Gneisenau hoped that through basic reforms Prussia could win the wholehearted support of its own population and gain the adherence of non-Prussian Germans. He wrote the Prussian monarch in 1808 "that the people should be given a fatherland if they are to vigorously defend a fatherland. This was particularly necessary for those other German-speaking peoples who did not formerly live under the Prussian scepter, but desire now to join us in freeing our common German fatherland."

What Gneisenau wanted was a spiritual unity to preserve his own idea of freedom and property. He advocated the incitement of the entire population against the French, and the use of education and religion to serve this end. Gneisenau recommended a type of guerrilla warfare and harassment of the enemy rather than direct battle. He also offered to landowning peasants who fought for independence abolition of dues still attached to the property. Conversely, all those who showed themselves lax or sympathetic to the enemy would have their possessions confiscated, to be distributed among the survivors of those fallen in the service of the fatherland.

Gneisenau's pleas for a national uprising went unheeded, and by 1812 he became so discouraged that he wanted to

retire to his estate. Then the Wars of Liberation broke out. Gneisenau served as chief of staff under Blücher and was primarily responsible for that leader's military victories. Afterward, Gneisenau retired from active duty, disgusted by the results of the Congress of Vienna and by the struggle of the reactionaries against the reformers. Gneisenau, however, did not openly espouse fraternity and equality. Like many liberal-minded members of his class, he wished to siphon off popular discontent by involving the popular classes in public affairs through the creation of a citizen army and to gain their allegiance by freeing them of feudal services attached to their lands. In this way he could exploit the nationalist passions of the German people to secure his own property.

Gneisenau, Fichte, Arndt and Kleist—as motley a crew as the French Jacobins—incarnate the many-sided motivations of the nationalists. Déclassé, blocked in their careers, they invest the land, the source of ownership and identity, with a mystique bordering on animism. Now we may turn to the aesthetic issues to perceive the juncture of the macro realm of nationalism and the micro realm of art production.

6 The Political Foundations of the German Romantic Pioneers and Their Patrons

This and the next chapter set out the ideas of the seminal thinkers and patrons identified with German romanticism, with emphasis on those whose work intersected directly with the visual practice of Runge and Friedrich. Not all these writers are as well known as Tieck and Wackenroder, for example, but the influence of these "lesser lights" on the two painters is incontestable. ("Seminal" here refers in part to the canonical studies of German romanticism, but I try to elaborate on the past literature by greater attention to the political and social content.)

Revolution and German Nationalism

The German nationalism that finally brought about the defeat of Napoleon's armies was first sparked by the French Revolution. Almost all of Germany's intellectuals were inspired by the first stage of the Revolution and saw in it a model for freedom and change in their own spheres. Fichte considered philosophy the intellectual counterpart to the actions of the French revolutionaries. The young Schelling and Hegel, then students of theology at the University of Tübingen, were ready to reeducate the entire middle class in the duchy of Württemberg. Although they later developed their systems along conservative political lines, their youthful dream was to liberate the consciousness of citizens through a new philosophical outlook that would truly make them capable of social, political, and spiritual freedom.[1]

During the eighteenth century, the clerics in Germany were mostly loyal and obedient subjects of the absolute princes. But in Württemberg, the clergy possessed political rights against their sovereign. In this state the political or-

der was based on a charter between the middle classes and the prince, in their common desire to suppress the threat of peasant unrest. The position of people like Hegel and Schelling represented a division in the ranks of the middle classes—between those who accepted enlightened despotism as the only form of government in keeping with the times, and those who advocated substantial change.

Distinguishing themselves sharply from the majority of their peers, the young Swabians believed that their own class constituted a secret enclave held together by common faith in the power of freedom and reason. To describe this spiritual community, Schelling and Hegel used two Christian symbols, the invisible church and the kingdom of God, which bridged the gap bteween the two traditions that were most influential on their thinking: Kantian idealism and Swabian pietism.

For Kant, these symbols were rational constructs within his scheme for a reasoned approach to religion. Moral individuals within the temporal church formed an "invisible church" aiming at the realization of the "kingdom of God on earth." It was the existence of the "noumenal" church that gave meaning to the "phenomenal" or institutional church. But Kant never believed that either the invisible church or the kingdom of God were entities operative in human time or accessible to the human mind.

For the Swabian pietists, on the other hand, both the invisible church and the kingdom of God were concrete historical entities that would be realized in real historical time. The kingdom of God was the real goal of human work in the world. Through the work of the elect, a new republic of reborn Christians would create a utopian society in which justice and freedom reigned. Their position was politically progressive, pointing out the connection between orthodox Christianity and despotism.

Schelling's first book, *Über das Ich,* (On the ego), published in 1795, would "free men from their slavery to objective truth" and convince them that they themselves were the source of all truth and all reality. Once people realized that they shared unrestricted sovereignty over the world, they would unify all knowledge and themselves in obeying laws stemming from human autonomy.

Schelling's invisible church and kingdom of God existed in the recognition that the absolute ego was the first principle of all truth and the ultimate source of all reality. As beings capable of grasping the absolute through "intellectual intuition," people should abolish the mental forms that

limit and structure the world. Schelling's symbols and his pantheistic position brought him in close association with the ideas of the seminal figures in the German romantic movement—Ludwig Tieck and Wilhelm Wackenroder.

Tieck and Wackenroder

Like Schelling, Tieck was carried away by the news of the fall of the Bastille, and his early writings, like his play *Alla-Moddin,* are pervaded with the high-flown rhetoric of 1789. When war broke out in 1792, he still sympathized openly with the enemy and their neoclassic inspiration. In a letter to Wackenroder that year the wrote, "Oh! to be in France! It must be a glorious experience to fight under Dumouriez, to send the slaves flying, and even to fall; for what is life without liberty? I salute the genius of Greece, which I see hovering over Gaul. France is now my thought day and night."[2] The fact that Dumouriez was a leading Jacobin general who defeated the Prussians at Valmy the preceding September conveys an idea of Tieck's lively support for the Revolution. Wackenroder himself shared the enthusiasm for the French experiment, which he maintained even after the execution of the king—a rare exception to his German peers.

German support for the French Revolution subsided as news of the Terror spread. Interest in medievalism at that time is thus associated with both the second stage of the French Revolution and the nationalist response that arises out of it. Since the upheaval was identified with the Enlightenment, medievalism was a riposte to its classical heritage and its revolutionary legacy. When Tieck and Wackenroder made their legendary tour through the Franconian countryside during the summer semester and vacation of 1793, it was to seek out what they felt were their spiritual and national roots. There were still many medieval towns that had barely changed from the Middle Ages, but to most of Wackenroder's contemporaries these towns meant inadequate sewage, vicious odors, and moldering church interiors. Yet Wackenroder exults in the old-world atmosphere of towns like Nuremberg, delighting in the fact that not "a single new building" disturbs the picture. "Thus," he says, "one is completely transported into the olden times and is always expecting to meet a knight or a monk, or a citizen in ancient costume, for modern clothes do not fit at all with the style of the architecture."[3] These images provide the background for the famous opening paragraph of the

Dürer essay in the *Herzensergiessungen eines kunstliebenden Klosterbruders* (1797) in which the nationalistic proclivity is expressed as a love for Nuremberg's "antiquated houses and churches, upon which the permanent trace of our early native art is imprinted!"[4]

In the opening chapter of Tieck's novel *Franz Sternbalds Wanderungen: Eine altdeutsche Geschichte* (Franz Sternbald's excursions: an old-German story, 1798) the hero is a young Nuremberg painter of the sixteenth century who studies first under Dürer, then journeys to the Netherlands to become a disciple of Lucas van Leyden, and finally goes to Italy in search of his aesthetic ideal. Tieck intermingles several charming pictures of German medieval life in the narrative. The patriotic and national allusions begin almost immediately. As he is about to depart from Nuremberg, Franz's close friend and fellow-student in Dürer's workshop asks him if he will remain loyal to his old friend while abroad. Sternbald replies to Sebastian, "I love you and my fatherland and the room in which our master lives, and nature and God. I will always be attached to them, always! See, here, on this oak tree I promise you, here is my hand upon it." The association of fatherland with the ancient patriotic symbol of the oak tree makes the reference much broader than the specific northern Bavarian town. He repeats this nationalist sentiment again when he exclaims, "How lucky I feel inside to be a German."[5]

Later, as Sternbald passes through Strasbourg on his way to Italy, he excitedly exclaims to his companion Bolz that he sees in the distance the minister (cathedral). Bolz replies that the minister "is certainly a work that honors the German!" Sternbald then elaborates on the "magnificence" of the Gothic achievement as a symbol of the "Spirit of Man," of his unity in diversity, of the boldness of his heavenward aspiration and his power of endurance. While here the patriotic note is sounded in general terms, Tieck exaggerated it in his revised version published in 1843. There Bolz goes on to say that the Gothic structures, "which perhaps belong to the Germans alone, must make immortal the name of this people . . . Perhaps we will learn one day that all the splendid buildings of this type in England, Spain and France were erected by German masters." What was scarcely articulated in the 1790s becomes a vividly projected symbol of the united fatherland.

Tieck's *Sternbald* is a fantastic flight into the past, a time-machine episode in which the narrator infuses the experience of the old with his perspective of the new. In the work

of Novalis, *Die Christenheit oder Europa* (Christianity or Europe), published in 1799, there is a wish for a return to the real or imagined unity of the medieval Empire, including a unity of creeds.[6] Novalis wanted to point out the contrast between the aridity of the godless present and the glowing ardor of the Middle Ages, where every aspect of life was inspired by the same enthusiastic faith. The unity of Christendom became the metaphor for a united Germany. His essay attacked the French Enlightenment and accomplished what Chateaubriand did in France with the *Génie de christianisme* three years later. It was instrumental in stimulating a Catholic revival (among German intellectuals) and exerted a profound effect on such types as Schleiermacher and Tieck. It mocked those who would liken the French Revolution to another Reformation and asserted that Germany was moving in "a slow, but certain path in advance of all the other European nations." While the others were caught up in war, speculation, and political divisions, Germany was building an epoch of higher culture through its development of the sciences and arts. Germany's striving, supreme pageantry, and deep studies would be concomitants of a Catholic revival that would also find a place for the remnants of a discontinued Protestantism.

The fascination of the Protestants Wackenroder, Tieck, and Novalis for the pageantry of the Middle Ages evolved out of their nascent nationalist desire for a united Germany. At the same time, they shared the attitude of the pietists and likened Catholicism to the form of an evangelical movement that promised to restore the Age of Belief. Since the time of Zinzendorf (who is mentioned by Novalis in *Christenheit* as an exception to Protestant vacuity), the pietists themselves adopted a sympathetic position towards the Catholic church. This tolerant attitude towards Catholicism was also manifested in other currents of the pietist movement. In fact, orthodox opponents of the pietists often attacked them as standing too close to the Catholics. The revival of medievalism also enhanced their position, and later some leaders of the pietist movement converted to Catholicism. Hence the nationalism of the medieval revival intersected with the pietists' emphasis on the connection between religion and patriotism.

When Tieck and Wackenroder traveled together through Franconia (centered on the Main River) and northern Bavaria, they sought contact with Catholic liturgy and art. They made excursions to Nuremberg and Bamberg in May; the trip to the first city made a particularly deep im-

pression on them, and they loved the splendor of the Catholic service that they witnessed in Bamberg. In Tieck's lyric drama, *Der Gefangene* (The prisoner), Catholicism was the buttress of despotic monarchy, but when he saw monks for the first time in Erlangen, he admired their devout and orderly lives. As he wrote his sister Sophie, having in mind the Revolution's anticlerical policies, "The monasteries should not by any means be stamped out; here he who rejects the world or whom the world rejects, finds a safe, holy place of refuge."[7]

Sympathy for the Gothic as the quintessential German style derived from its heretofore negative perception as uncouth, crude, barbarian, superstitious, and even "unwholesome." Johann Georg Sulzer's popular encyclopedia of the arts, *Allgemeine Theorie der schönen Künste* (1771–1774), even defines Gothic as the bad taste of the parvenu: "If a man who has been brought up in humble circumstances suddenly attains to power and riches, then his attempts to imitate the fashionable world will deservedly be called Gothic." Even Goethe claimed that he once designated as Gothic "everything which did not fit into my system, from the elaborate brightly colored carvings and paintings which our *bourgeois gentilhommes* decorate their houses to the solemn relics of our ancient German architecture."[8]

The Goth and the *Volk*

These late eighteenth-century definitions of the term were charged with class bias. Just as the idea of the peasant was transformed from an almost subhuman creature to that of a paragon of German virtue, so the idea of Gothic became aggrandized. Projected reforms brought the possibility of higher social status to the peasant and the opportunity to satisfy the need of German rulers for manpower to staff their armies. To attract such manpower, the peasants were granted more prestige as a class. Even those who held the peasant in contempt recognized that most Germans derived their livelihood from agriculture.

Reformers promoted the image of a peasantry capable of using the new gains in the interest of the wider community. The peculiar qualities of the peasantry were celebrated as authentically German, which coincided with a rising tide of sentiment against anything French. The so-called romantic opposition to the Enlightenment was more than an opposition to certain ideas or concepts; it was also part of the rejection of French style, fashion, literary expression,

and philosophy. Thus the metropolis of Paris, with its seething corruption and neoclassical artifice, is opposed by the uncorrupted rural fount of romantic wholeness. The most vociferous opponent of the Gallic influence was Christian Friedrich Daniel Schubart, the editor of the southern German periodical, *Deutsche Chronik*. He attacked the French for their obsession with refinement and elegance and called for "a little of the old coarseness of our character." Toward the end of his life he published a poem that recapitulated his national ideals:

If Germany its worth can feel,
No more 'fore foreign playthings kneel,
Preserve the ancient German ways
In word and action all its days
Ne'er let the Christian faith to fall,
And value truth well over all,
And does not call Enlightenment
What not from God's own light is sent,
If courage, as in Hermann's age,
In his descendants' hearts can rage,
Should Germany do all this, and stand,
The world will know no better land.

It is no coincidence that the Goth rose up to become the veritable emblem of raw masculinity and courage, a picture of the Teutonic past.

A leading figure in the revival of German culture was Herder, who believed that poetry and folk songs must be understood as the product of particular peoples and could not be judged by universal standards.[10] Therefore, what foreign critics often referred to as Germany's "coarse and crude" language could not be adjudged as inferior to any other national expression. It is the very authenticity of folk culture that gives it meaning and value. Herder's "doctrine of originality"—the authentic popular expression—in language and art generally had a distinctly unifying effect on German culture and elevated the status of the peasantry.

Not fortuitously, this notion began to take hold at a time when it was recognized that the conditions that had sparked agrarian unrest in France were apparent and simmering in Germany as well. As early as 1790, a number of local uprisings in Saxony culminated in a severe revolt by peasants influenced by the revolutionary activity in France. Such disturbances appeared frequently during the 1790s, especially following the declaration of war between the German states and France. Military force and harsh measures were used to suppress these uprisings, until finally

even the conservative landlords agreed that some moderate reforms must be allowed the volatile peasantry.[11]

Conservative groups of officials, nobles, and intellectuals, in the pietistic tradition, began to proclaim an affinity between nobles and peasants, using moral and religious suasion to discourage revolutionary fervor. Popular education was to be implemented by the circulation of *Volksbücher* (people's pamphlets) that would carry a series of catechisms for religion, health, and patriotism and also passages from the Bible, a hymnal, and a collection of prayers. In 1793 the Erfurter Gesellschaft oder Akademie gemeinnütziger Wissenschaften (Erfurt Society or Academy of Popularly Useful Sciences) organized a competition for the best writing intended for the underclass "whereby it may be taught of the goodness of its constitution and warned of the evils of immoderate freedom and equality."[12] Germany would be peaceful again under a return to conditions of the medieval past, the dominant classes were saying, before revolutionary ideas had undermined the social and religious fabric. Thus the search of Wackenroder and Tieck for an evangelical Christianity based in the Catholic Middle Ages coincides with the conservative attempt to redefine the peasantry in terms of the national ideal. Their enthusiastic response to Gothic architecture with all its so-called barbarous traits derives from the parallel celebration of peasant authenticity.

Wackenroder's pioneering collection of essays, entitled *Herzensergiessungen eines kunstliebenden Klosterbruders,* is structured around the ideal of an art-loving friar. Wackenroder praises the interdependence of art and Catholicism (anticipating Chateaubriand by about five years), celebrates the mystical-pietistic tradition, and defines the emotional outpourings as a form of direct communication with God. The Enlightenment is attacked in the language of the pietists: "He who believes a system, has expelled universal love from his heart."[13] It is no wonder that Goethe, a diehard classicist in the 1790s ("Klassische ist gesund, Romantische ist kranke"), used Tieck and Wackenroder as straw dogs in a polemical defense of his own ideological and aesthetic goals.

They ran up against the late classic phase of Goethe based on ancient Greek civilization. This late synthesis was in its own way a response to the impact of the French Revolution and the chaos in the German states. He opposed the romantics with his journal *Propyläen,* which he began in 1798. In the first issue, he restated the case for classical art,

hoping to lead people back through the gate, the entrance—the Propylaeum—of the temple. Goethe's introductory essay is highly politicized, urging the return to the culture of ancient Greece to advance modern art, and demanding that artists work on behalf of the public, which was to say the elite groups supporting high art. Goethe admitted in his essay that he himself wished to "remain in harmony with . . . a great portion of the public."[14]

That there was no doubt he had turned away from the Sturm und Drang sensibility is seen in his elaboration on the artist's responsibility to the "public" at this moment of political crisis:

The method by which the artist or amateur may derive most advantage from France and Italy, gives rise to a fair and weighty question, viz.: what other nations, and especially Germany and England, are to do, at this time of scattering and spoliation, in a true cosmopolitan feeling, which can be nowhere more at home than in matters of art and science, with a view to making the treasures of art which lie scattered abroad generally useful; thus helping to form an ideal body of art that may happily indemnify us for what the present moment tears away or destroys.[15]

Goethe was deeply concerned with the need to align himself with the privileged classes, his "public." At the height of his classical phase, he sought "a true cosmopolitan feeling." His vision of a "higher culture" modeled after Periclean Athens was in stark contrast to the ideals of Wackenroder and Tieck, with their sympathy for the Catholic church and medieval subject matter.

In *Herzensergiessungen* Wackenroder made the musician Joseph Berglinger (whose life is recounted by the friar) bemoan his self-indulgence and hermitlike existence. All around him raged "the horrible wars of nations, the bloody war of misfortune . . . and each passing second is a sharp sword that strikes wounds here and there and does not become tired, so that thousands of creatures scream pitiably for help!"[16] Clearly Wackenroder experienced deeply the contemporary conflicts, and it is not possible to deal with his ideas apart from the revolutionary wars which drastically altered the German nation. When he and Tieck made their voyage through southern Germany, France was occupying most of the Rhineland. There was a strong wave of support for the French Revolution in Mainz and Speier, and a republic was declared in the former city between October 1792 and July 1793. The anticlericalism would have made Wackenroder and Tieck uncomfortable, and their beloved

Strasbourg became a veritable propaganda mill for the production of pamphlets directed to a German public and bearing such titles as "Summons to Freedom to Our German Brethren" and "Summons to Suppress the Clergy." The year Wackenroder published the *Herzesergiessungen* (the title page is dated 1797, but it was published in the fall of 1796) Franconia had been successfully invaded by the French, and Bamberg and Nuremberg were forced to pay enormous taxes, with hostages taken and sent to France to assure the payment. At the same time many of the cultural treasures of Nuremberg—manuscripts, paintings, and other precious objects—were impounded by the French army.[17]

It was these events that gave such urgency to the publication of the *Herzensergiessungen* and assured a receptive audience among the younger generation. That Wackenroder's purpose in writing the book was polemical and political is seen on the first page where the friar-narrator rejects the writings of Friedrich Wilhelm Basilius von Ramdohr, who epitomized the Prussian ideals of enlightened despotism, cosmopolitanism, and classicism. He appeals to readers who feel uncomfortable with Ramdohr's intellectual position.

As against the elitist cosmopolitanism of Ramdohr and Goethe (who both hobnobbed with the aristocratic émigrés from France), Wackenroder pleaded for a *tolerance* of the oppressed. One chapter of his *Herzensergiessungen* entitled "A Few Words concerning UNIVERSALITY, TOLERANCE, and HUMAN LOVE in Art" defined art as the highest form of emotion, which strives in continuously changing form toward heaven and "the Universal Father." And taking his cue from Herder, Wackenroder emphasizes the divine tolerance of all human production: "The Gothic temple pleases Him as well as the temple of the Greek and the crude war-music of the uncivilized is for Him just as lovely a sound as artistic choirs and hymns."[18] Wackenroder's friar-narrator then laments that when he returns from his spiritual flight through immeasurable space where he has glimpsed "the Infinite One," he observes that his fellow creatures hardly try to resemble their "eternal model." They quarrel with one another, cannot communicate, and fail to see that they are all hastening toward the same goal. The friar asks these "narrow" types, "Why do you not condemn the American Indian, that he speaks Indian and not our language?" These same people would "condemn the Middle Ages" for not building temples as in

ancient Greece, and in a later section on Albrecht Dürer he is nostalgic about the medieval period: "You, who see boundaries everywhere where there are none! Are not Rome and Germany situated on one earth?"[19]

These passages do not represent specific pleas for a particular kind of architecture, but a general plea for universal tolerance of individual peoples and their cultural production. It would be as illogical to condemn the Middle Ages for not building Greek temples as it would be to blame native Americans for not speaking German. The same argument applies in the Dürer essay: "True art sprouts forth not only under Italian skies, majestic domes and Corinthian columns, but also under pointed arches, complexly decorated buildings and Gothic towers."[20] Wackenroder attacks the Winckelmann-Goethe monocular vision of arts and arrives at the real problems haunting him in his geographical metaphors. Boundaries, national frontiers relate to the very real territorial disputes of the period, and by pairing Gothic church and Greek temple, Germany and Rome, he also shrugs off the sense of inferiority of the indigenous culture and affirms its identity in the face of absorption by another nation. In the Dürer essay he announces that Dürer, the master, makes him proud to be a German and that the Middle Ages in Nuremberg was "the only age when Germany could boast of having its own native art."

Wackenroder's reference to the American Indian is no arbitrary example: he fears and rejects the colonial principle. Elsewhere, he attacks Winckelmann's racist hypothesis that the art production of Africans is inferior as the result of their intemperate climate: "If the disseminating hand of heaven had let the embryo of your soul fall upon the African sand deserts, then you would have preached to all the world the shining blackness of skin, the large flat face and the short, curly hair as essential components of the highest beauty and would have laughed at or hated the first white man."[21] Wackenroder's *Herzensergiessungen* reveal his progressive social feelings as well as his insecurities in the midst of war and upheaval that threatens to destroy the German identity.

Wackenroder saw his age as superficial, its art having become merely a "frivolous plaything of the senses." He had contempt for artists who "work for aristocratic gentlemen, who do not want to be moved and ennobled by art but dazzled and titillated to the highest degree," and called for a rejection of Enlightenment principles in favor of an orientation of art to the Godhead. This is analogous to the

quality of divine activity, since "all spirit goes forth from Him and, as an offering, penetrates through the atmosphere of the earth up to Him again."

While shunning orthodoxy and mechanical "systems," Wackenroder nevertheless embraced science and nature as essential components of art. He was fascinated by the scientific and artistic genius of Leonardo da Vinci, his knowledge of anatomy, perspective, light, and color, and by his inventions. What he objected to about systems was the exclusively rational and soulless disposition they encouraged; Wackenroder wanted a "system" that allowed for the expression of "universal love"—the emotional outpourings of the heart in tune with the divine.

Herzensergiessungen is a work of strong pietist influence. Like Wackenroder the pietists opposed cosmopolitanism and accepted the multiplicity of religions and states, celebrated emotionalism, called for universal toleration, appealed to the nonprivileged classes, taught respect for German language and culture, and preached the immediate and individual religious experience. Wackenroder actually superimposed pietistic ideals on the Catholic artisans and artists of the Middle Ages. Since medieval Catholicism contained elements of primitive Christianity akin to pietism, Wackenroder could exploit the Middle Ages as a model for his emerging nationalism. Medieval artists could show the way for their modern counterparts as a kind of monastic order that expressed its piety through art production.

Indeed, the choice of a friar as narrator derived from the pietist emphasis on a more practical religion. Active rather than scholarly Christianity came to be regarded as the essential mark of Christian life. The number of hermits and missionaries who appear in the writings of Wackenroder and Tieck is evidence of their concern for pietist practicality. Such pietist expressions as *brennen* (to burn), *Enthusiasmus* (enthusiasm), *Flamme* (flame), and *lebendige Kraft* (kinetic energy) demonstrate the active, immediate approach to religion and art. Even the title *Herzensergiessungen* relates to the legacy of Graf Nikolaus Ludwig von Zinzendorf, whose religion was described as a *Herzensreligion* based on heartfelt piety and on the feeling of love. Zinzendorf, who developed a liberal and tolerant attitude towards Catholics, said, "It is not a question of formulas and ceremonies, nor of taking on certain customs . . . The question is rather of the heart, in which all children of God are alike." Pietism was no homogeneous movement, but whatever the doctrinal differences of its various sects, they were all one in

stressing the need of the emotional as opposed to the intellectual, and in depending more on intuition than on reason. The psychological disposition engendered and developed within the religious sphere of pietism came in the course of time to be transferred to the realm of nationalism and nationality. This is seen in the most characteristic and central experience in the life of a pietist—the *Wiedergeburt* or "regeneration" that modern American evangelical religion terms "born-again." As in the case of Wackenroder's monk, who forsook his "worldly affairs' to engage contemporary youth on the spiritual nature of art, it was an experience that changed and completely recreated individuals and directed the subsequent course of their lives. This idea of individual regeneration was later converted into the idea of a national regeneration and found its way into the patriotic writings and art of the romantic nationalists.

It is no coincidence that in the essay on the Lombard painter Francesco Francia, Wackenroder writes that he is "tempted to sigh (like Ossian) because the power and greatness of this heroic period has now disappeared from the earth." [22] In comparing the "heroic age" of early Renaissance art to the warrior age of Ossian's forebears, Wackenroder gives us an insight into the wide appeal of the Celtic bard for the nascent nationalists. He uses pietist vocabulary to glorify the Italian *Wiedergeburt* and the extraordinary human beings who elevated themselves by their dedication. Their lives seem incredible to the moderns "because the enthusiasm which inflamed all the world during that golden age now flickers in only a few individual hearts, like a weak little lamp." The narrator is dissatisfied with the historical period in which he lives and wants to change it. Francesco exemplifies the heroic type of a person born to humble craftspeople, but who through a "constantly striving spirit . . . soared to the highest peak of fame."

Wackenroder uses the mountain metaphor as a signpost to Eternity, one among many drawn from nature, which in its entirety leads to exalted spheres: "One of the languages, which the Highest One Himself continues to speak from eternity to eternity, continuously active, infinite *Nature,* leading us through the vast expanses of the atmosphere directly to the Godhead." Thus views of valleys surrounded by steep cliffs inspire in the friar a spiritual emotion and an idea of god's omnipotence and infinite goodness: "Whenever I walk out of the consecrated temple of our monastery into the open air after the contemplation of Christ on the Cross, and the sunshine from the blue sky embraces me

warmly and vibrantly and the beautiful landscape with mountains, waters, and trees strikes my eye, then I see a special world of God arise before me and feel great things surge up in my soul in a special way."[23] Here the pioneer romantic exploited the philosophical writings of Fichte and especially Schelling to embrace noumena and phenomena.

Wackenroder "yearned for infinite," complete harmony, and Kantian philosophy failed to satisfy him. To him, the Enlightenment rationalists achieved their model of harmony by ingeniously limiting experience to phenomena intelligible to ordinary reason. In the face of the dislocation and disharmony of the late eighteenth century, this model showed itself to be artificial and hollow. On the other hand, the conflict set up by the Sturm und Drang movement between the emotional and the rational seemed unnecessarily discordant. Wackenroder had a horror of one-sidedness and wanted to be open to the vast complexity of the infinite universe. In place of the narrow, restricted realm to which he felt the previous literary movements had restricted themselves, he sought infinite diversity, fullness, and wealth—nothing less than a philosophy of life free from the limits of the rational.

Mountain and Moon as Signs of the Infinite in the Romantic Texts

The recurring metaphor of the mountain as a signpost to the Absolute is used in a double sense in literary exposition.[24] Often the traveler climbs a high mountain to survey the panoramic vista below, or he or she looks upward to the heavens which now seem closer than ever before. In both cases there is an attempt to embrace from the widest possible perspective the phenomena of nature and ultimately the Absolute itself. Curiously, in northern landscape painting of the Napoleonic period mountains show up mainly in the skyward view, with Infinity metaphorically represented beyond the highest peak. Visually this was the primary metaphor for the striving after the Boundless. The king in Tieck's *Der gestiefelte Kater* (Puss-in-Boots) climbs a tree because he "loves free prospects in beautiful nature," but in a painting the idea of the ruler's fantasy of an unlimited realm can only be suggested.

Tieck's satire also contains an amusing exchange between the king and Prince Nathanael of Malsinki, who has come to ask the king for permission to marry his daughter. The king expresses his astonishment at the countless num-

bers of countries and kingdoms in the world: "You wouldn't believe how many thousands of crowned princes have already been here to sue for my daughter." He then asked Nathanael the location of his land, and this is the response: "Mighty king, if you travel forth from here, first down the great highway, then deviate to the right and keep on that way; but when you come to a mountain, then to the left again. Then one comes to the ocean and sails constantly northward . . . and so, if the journey proceeds successfully, one arrives in my dominions in one and a half years."[25] Naturally, the king is totally confused by these nonsensical directions, and inquires again about the precise topographical situation. This time Nathanael notes that the "precise geography" of this country remains to be fixed, but it may develop "that in the end we'll be neighbors yet."

Tieck has found an amusing way to call attention to the patchwork quilt of German territories and the hope for their unification. The land that seems so remote needs only a simple fixing of the geography to be brought into contiguity with the king's realm. In the same way Wackenroder is haunted by the ideas of boundaries and the arbitrary and hierarchical division of cultures: "You, who see boundaries everywhere where there are none! Are not Rome and Germany situated on the earth?"[26] While this may seem far removed from the hard facts of public affairs and threatening armies, it seems clear that the stereotyped phrase "yearning for the Infinite" actually had a concrete signification—the longing for national unity. Unity with God, the Father, was another way of expressing the idea of a unified fatherland. Domestic divisions, territorial disputes, foreign invasions, and literary polemics all pointed to the lack of coherence in the national sense, and the unbearable tensions resulting from multiple opposing views. It is not surprising that this kind of thinking—which becomes endemic in the nineteenth century—should first be given systematic form in Germany, where the lack of territorial integrity and of a powerful middle class stimulated fantasies of "transcendental" unity.

In addition to the mountain the writers associated with the romantic movement cherished the image of the moon; often mountain and moon are combined together in a single passage or even sentence.[27] In 1799 Tieck published several of Wackenroder's tales together with several of his own writings in *Phantasien über die Kunst für Freunde der Kunst* (Fantasies on art for friends of art). One of these stories, "A Wondrous Oriental Tale of a Naked Saint," spins a

yarn whose leitmotif is the moon. A raving anchorite inhabits a cave and rages insanely as he hears the Wheel of Time grinding relentlessly. Whenever the moon appeared before the entrance to his dark cave, however, he stopped raging and sank to the ground crying like a baby. He despaired that the Wheel of Time prevented him from accomplishing anything on earth, from acting and creating effectively. He felt an all-consuming longing for unknown beautiful things; but when he tried to raise himself upright and make his body carry out his wishes he failed miserably. This went on for several frustrating years until one moonlit summer night, when he again fell on the floor of the cave crying and wringing his hands. The moon "radiated tender light," and the souls of the inhabitants who lived in the valley below were reflected "in the heavenly luster of the moonlit night." They were no longer blinded and stupefied by the sun's brilliance. Ethereal music floated up from the boat of two lovers drawn by the moonbeams as they rushed past the cliff grotto of the anchorite. The harmony of this music released him from his spell, and he was transformed into a spirit happily dancing on the white clouds floating in the heavens and lit by the radiant moon.

This association of spiritual release and creativity with the moon parallels the literary and artistic use of the motif in England and France. Here it is even more explicitly associated with the opposition to Enlightenment ideals. In Germany the symbol of the *Aufklärung* appears in a frontispiece of one of Christian Wolff's books depicting the sun breaking through clouds.[28] Thus the lunar motif, although present in much German poetry in the second half of the eighteenth century, is so pervasive in romantic art and writing that it becomes the logo of the younger generation, as the sun symbolized the Enlightenment.

As elsewhere, the image of the moon responds to the scientific and naturalistic tendencies of the period as well as to cosmological speculation. At the base of this evolution in Germany was Kepler's *Somnium,* published in 1634, a fantasy stimulated by scientific and philosophical contemplation of the moon and stars.[29] His vision had as its rational aim an argument, supporting the Copernican theory of the earth's motion, that involved shifting the observer from the earth to the moon. Here he rationalized the most persistent and appealing of all moon themes both before and after Newton, the idea that the moon was not only a world but a habitable one. The telescope disclosed to human eyes a world geographically like our own, a world that

seemed to our people as earth must appear to lunar inhabitants. Kepler's personal example of a devout Christian and nevertheless convinced Copernican inspired later scientists, poets, and artists. They tried to reconcile scientific knowledge of the cosmos with God's omniscience and omnipresence; and as the data became more precise this attempt at reconciliation challenged contemporary thinkers.

Among the most influential of the eighteenth-century English writers on the younger German writers was Edward Young, whose *Night Thoughts* (1742–1745) combined ideas of the universe revealed by the new astronomy of Newton and reflections on immortality as central to Christianity. His main theme is admirably summed up in this inspired line: "An undevout astronomer is mad" (Night 9, line 773). As he mediates on the "mathematic glories of the skies," he rises to ecstatic wonder and amazement. The idea of infinity is expressed in rapturous terms:

How distant some of these nocturnal suns!
So distant (says the sage) 'twere not absurd
To doubt, if beams, set out at nature's birth,
Are yet arrived at this so foreign world,
Though nothing half so rapid as their flight.
 (Night 9, lines 1225–1229)

Recognizing that many cherished views of the cosmos may be contradicted by new scientific evidence, he prays for an open mind to face the vast vistas introduced by the telescope.

Young found in Newtonian astronomy inspiration for new defenses of religion. Like Wackenroder's friar, he could soar beyond "earth's enclosure" and explore the boundless realms of love. The great glory of immortality is its promise of ever-continuing intellectual development and limitless knowledge, in keeping with the conceptions of infinity opened up by astronomy. Central to this outlook is the symbolic presence of the moon, which blurs the outlines of the sublunary world and opens the contemplation to an enlarged universe:

Night is fair Virtue's immemorial friend;
The conscious Moon, through every distant age,
Has held a lamp to Wisdom, and let fall
On Contemplation's eye her purging ray.
 (Night 5, lines 177–180)

Young's *Night Thoughts* first appeared in German in 1760, and its influence soon began to manifest itself in the

work of Friedrich Gottlieb Klopstock and his pupils. It coincided with, and reinforced, the related elegiac strain running through Ossian. Again, the trauma of the Seven Years' War made the educated public receptive to the profound melancholy underlying both *Night Thoughts* and *Ossian*. Closely bound up with this spirit was the resentment toward the French, which both Young and Klopstock shared. England and Austria were at war with France during the original appearance of *Night Thoughts,* and it is not surprising to find that Young inserted into his midnight meditations chauvinistic attacks against the foe. That in 1760 Prussia and England were aligned against France gave a topical urgency to Klopstock's interest in Young.

Klopstock produced a spellbinding effect on the young generation of writers who reached maturity in the last quarter of the eighteenth century. He gained his reputation for inspiring the larger emotions and for making—to use Schiller's phrase—"everything lead up to the infinite."[30] He gave utterance to religious idealism and a new faith in Germany's political future, further reinforced in old age by the outbreak of the French Revolution, which he greeted with joy. His odes, *Die frühen Gräber* (1764) (The early sepulchers) and *Die Sommernacht* (1766), use the moon to elevate the idea of friends and fatherland: "Welcome, O silvery moon, / Beautiful, silent companion of the night! / You vanish? Hasteway not; stay, friend of thoughts!"[31] The moon in *Die frühen Gräber* evokes in the poet painful memories of friendship and love that have been lost. At the same time, he welcomes the moon as a means of purging the pain and elevating the thought to a higher understanding.

In *Die Sommernacht* the moon loses its planetary function altogether: it is akin to a fluid element penetrating everywhere in the world. It does not need an intermediary like a body of water to achieve dazzling radiance, nor is it bounded and confined to a particular locale. Under the moonlight, temporality is suspended and mundane thoughts give way to glimpses of higher order. The moon dissolves objects as well as time and induces the mind to leave its attachment to the objective world. Similarly, in the *Hermanns Schlacht,* where the Ossianic influence is most strongly felt, the moon is associated with thoughts of the heroic national past: "How softly the moon shines on my corpse! Bards! Do not forget my name!"

No one has more vividly described the impact of Klopstock on the aspiring minds after mid-eighteenth century than Goethe in *Sorrows of Werther.* Lotte and Werther find

themselves alone for the first time at a garden party interrupted by a sudden thunderstorm. As Lotte stands near the window when the worst of the storm is over, she looks heavenward and her eyes fill with tears. She rests her hand upon that of Werther and says, "Klopstock," recalling the ode entitled *Die Frühlingsfeier* (The spring festival). Goethe's admiration for Klopstock may also be revealed in the numerous allusions to moon imagery in his novels and poetry. One of the most gripping scenes in *Werther* is when the protagonist—an ardent admirer of Ossian—faces the raging ocean, which echoes the raging passion within him. Late at night he runs outside to watch from the cliff "the stirring waves twisting in the light of the moon." As the moon rests above the black cloud, he stands facing the abyss and longing to hurl all his pain and suffering into it and "storm along like the waves." Here the moon stands witness for a longing to merge with elemental forces and overcome the pain of self-consciousness. We see also the knowledge of the moon as an influence on the tides of the sea. We know that Goethe was himself an amateur astronomer and through the telescope made many observations of the moon, which he scrupulously recorded.

It may be recalled that in the opening scene of *Faust*—that paragon of the human being striving for the highest aspirations—Faust is seated in a vaulted Gothic chamber as the full moon shines down on him in his "agony." When the Mephistophelean spirit enters the chamber the moon becomes "hid"—that is, the light of inspiration has been canceled by Faust's impatience to master the secrets of the universe. The antagonism of the moon to the embodiment of evil is stated again in scene 14 when Faust is alone in a forest cavern, and his musings on the "gentle moon" and its contemplative mood are abruptly broken by the thought of Mephistopheles' hold on his passions. In the second part of *Faust*, the two Walpurgis Nights—one a witches' sabbath and the other a classical festival—are symbolically polarized by the absence and presence of the moon. Whereas in the first the moon is obscured, in the other the moon sheds its "friendly light" on all of nature. Finally, the classical Walpurgis Night is a prelude to Faust's emergence as a social reformer with an ultimate vision of a unified land possessed by a free people living on a free soil.

Novalis, bright luminary of the younger generation, also fell under the influence of Young and Klopstock. His *Hymnen an die Nacht* (Hymns to the night), like *Night Thoughts*, depicts the revelation that persuades him of the

truths of the Christian faith. The *Hymnen* appeared in 1800 in the third volume of *Das Athenäum,* the journal founded and run by the Schlegels. Light and night are the antipodes in this cycle, like the sun and moon of Enlightenment and romanticism. The poet's link between the two realms is the image of the "lovely sun of night," clearly a lunar allusion. The images of light and night grow into opposing symbols of secular and Christian religions, thus putting into poetic form the conservative position he outlined in *Christenheit oder Europa.* The religion Novalis portrays as the religion of light is a worldly religion that fails to answer the supreme question of existence—the problem of death and what lies beyond the grave. Christianity is the religion of night because it reveals the true nature of death as a source of new life in the eternal realm of love that lies beyond the grave. Again eternity is foreseen as the union of the realms of light and night, depicted as the union of the stars with humanity. Then there will be one eternal night of bliss, in which God's countenance will be the light of all—an image reminiscent of the poet's depiction of his beloved as the "sun of the night."

Novalis utters climactically in the fourth hymn, "Does not all that inspires us wear the colors of the night?" In this poignant representation of the poet's experience we have the supreme expression of that devotion to night characteristic of the younger generation as a group. In this sense, the moon—the constant companion of the night—dramatically testifies to the larger perspective sought after by the group. The search for eternity as the result of the union of opposites and the identification of the Gothic and Catholic ideals with the moonlit night indicate that the image contained ideological references. More than simply serving as a mood-setter, it embodied the deepest longings for a united fatherland.

This shows up in 1792 in the context of German astronomical studies. In an article in the *Annalen der Physik* examining the formation of the moon's surface, the writer paused to acknowledge the great strides in the field made by Germans who have thereby glorified the nation, "mein Vaterland." He referred to the outstanding contributions of William Herschel, born in Hannover, who was the royal astronomer to George III, and to Johann Hieronymus Schröter, founder of a major observatory and writer of the book *Geographie des Mondes* (Geography of the moon). While the article takes up the theory of the volcanic origin of the moon's mountains, the author manages to make al-

lusion to Ossian ("the immortal poet of the North") for whom the holy light of the moon convoked the "ghosts of the heroes." Even more startling, at the end of the article Batsch puts his finger on the pulse of advanced German ideology:

Not in some flight of fantasy, but on the basis of a higher analogy of nature, on the basis of mathematically determined measurements, can we look upward to the moon, as to a living space of similar, thoughtful, noble creatures; may they, like the fire of their planet, strive to prepare a future happiness; may we, like the blissful streams of our earth going to the ocean, like countless good deeds, hastening to their father; may we all, members of one State, including the inhabitants of the remotest immensities of heaven, who live behind their shimmering sun in what is for us one indissoluble darkness, move toward the great goal of cosmic determination, the perfection of the species![32]

Even the scientific journals of the time impart the idea of the moon as metaphor for a higher form of unity, both political and social.

We find this in the poetry of Gotthard Ludwig Kosegarten (1758–1818), the mentor and friend of both Runge and Friedrich, whose work echoes Ossian, Young, Thomson, and Gray.[33] While he lived most of his life in Swedish Pomerania, he was born in the small town of Grevesmühlen in Mecklenburg, then a grand duchy in northern Germany. Kosegarten's father was a pietist pastor, and wishing his son to follow in his footsteps, he sent him to be educated at the University of Greifswald where pietism influenced the curriculum. He wrote in a homesick mood in January 1775,

Far from my fatherland
Far from the place of my birth,
While my foot was in a foreign land
Where there were no countrymen of mine.

He meditates on the landscapes of his native surroundings, and he recalls the mood of the forest and the moonlit meadows:

And a secret higher dawning
Scourges me through marrow and bone.
I flee the open meadow
And the bright moonlight
Throw myself in the dark sea
Where the wind supplies the reed
And its sweet lamentation
Calls nightingale and toad.

Earthly passions and concern drag him down as he struggles to achieve a higher state of consciousness:

High upon the beams of evening stars
I climb toward heaven, and see
Moon and earth shuddering in the deep
As I myself near Eden.[34]

Kosegarten has moved from homesickness for his regional "fatherland" to a higher view of existence, in which the moon metaphor is used as a medium of transition from one realm to the next.

Kosegarten's attraction to MacPherson is already evident during his visit to Wolgast in 1777. The nocturnal view of the seaport inspired this entry in his diary: "In the moonlight there is a splendid Ossianic view, simultaneously beautiful and gloomy." Under the influence of Klopstock and Ossian he wrote his popular *Der Eichbaum* (The oak tree), symbolizing the Teutonic nation and its ability to withstand calamity:

You strong one, you noble one,
My song greets you.
You king of the grove,
You father of the forest night
In the shimmering moonlight my song greets you.

The oak tree further provides the connecting link between earth and heaven:

Tree of God, you stand.
Tree of God, the stars greet your crown.
Your Creator wove the roots
Throughout the ribs of the earth.[35]

Similarly, Kosegarten's *Das Hünengrab* (The Hun's grave, or the dolmen), combines oak, moon, and national icon into a hymn to Germany's heroic past. Dolmens were common on the island of Rügen and believed to be prehistoric stone graves that marked the burial of the old Teutonic heroes. These dolmens evoked associations with the valiant actions of Hermann (or Arminius) against the invading Romans. Kosegarten's poem begins with the sanctified sense of both religion and nature: "The night is holy and sublime. / Dim and dreadful is the moonlit night. / Streaking lights shimmer through the forest." And he silences nature so that his imagination can summon up the dolmens:

Silence nightingales, silence toads!
Eery recollections whisper around me
In among the four moss-covered stones
And the three rustling oaks
Here I sit.

And he apostrophizes the heroes: "You who are slumbering below, / You who fell in the honorable fight for freedom / Slumber peacefully." [36] He yearns for the qualities of these ancestors and the times that fashioned heroes, considering himself a "weaker" version of those who still long for freedom. He then pledges to uphold the virtues of his forefathers buried under the "thousand-year-old stone" and continue the struggle against despotism and immorality. And in the final verse the poet feels an all-enveloping peace among the rustling oaks and "the moon smiling from behind the silvery clouds."

Lunar imagery pervades almost the entire poetic output of Kosegarten and is bound up with his pietistic beliefs. This imagery cannot be separated from the psychological and religious attitudes of the pietists, who took an active part in the formation and development of the romantic movement and its anti-French, pro-English and nationalist concerns. While moon imagery was not new in German literature, its frequent appearance in both the visual and literary arts of the younger generation and their mentors cannot be isolated from the peculiar political conditions and the psychological attitudes they engendered in the revolutionary and Napoleonic epochs.

This is especially evident in the work of Arndt, who as a youth was tutored by Kosegarten in the family home of Rügen. Lunar metaphors pervade his early poetry and, as in the case of "Auf den Grabe" (On the grave) of 1801, point to change and heavenly aspirations:

Cry not! the moon changes
With the silent stars it passes,
Glances on the golden moss, the thawing grasses,
That cover the hill in green.

Cry not! the nightingale warbles,
And the gnats whimper sadly
The funeral dirge, the clouds already envelop
The moon and the stars. [37]

In the "Reime aus einem Gebetbuch für zwei fromme Kinder" (Rhymes out of a prayer book for two pious chil-

dren), Arndt again projects a higher order of things through references to celestial orbs:

Then everything has become beautiful
Through childlike innocence in every moment
The suns and moons and brilliant stars
Which glisten and twinkle from remote space,
The flower's bud, the heart of man:
For that will move everything heavenwards.

Written in 1809, it expresses his nationalism in the wake of Jena and projects a heavenly realm beyond the nation:

O Spirit of spirits, carry me upward!
And make me one with You!
I have lost my fatherland:
But heaven is now mine.[38]

In "Gott der Hirt" (God the shepherd) of 1811, written with hope during the Napoleonic occupation, he closes the poem,

And when the moon with its stars
So lovingly shines down on me
Then feel I as if from that far off world
Your light on high beckons with delight.

With the onset of the Wars of Liberation Arndt's nationalism flares into a hymn to the idea of the fatherland as an infinitely expanding concept, and "Des Deutschen Vaterland" (The fatherland of the German) spells out in concrete terms what had only been prefigured previously:

What is the German's fatherland?
Is it Prussialand, is it Swabialand?
Is it where on the Rhine the grapes flourish?
Is it where the seagulls breed?
Oh, no! no! no!
His fatherland must larger be.

.

What is the German's fatherland?
Is it Pomeranialand, Westphalialand?
Is it where the dune sand blows?
Is it where the Danube blusters?
Oh, no! no! no!
His fatherland must larger be.

.

That is the German's fatherland,
Where anger consumes French trifles,
Where every Frenchman is called enemy
Where every German is called Friend

That shall it be!
The entire Germany shall it be!

The entire Germany shall it be!
O God from heaven see therein
And give us upright German courage,
That we shall cherish true and good.
That shall it be!
The entire Germany shall it be![39]

The same year his "Deutscher Trost" (German consolation)
tries to assure and steady the volunteers in the Wars of Liberation:

German heart, do not lose courage,
Do what your conscience says,
This beam of the heavenly light,
Do what's right and do not fear.[40]

"Des Knaben Abendgebet" (The boy's evening prayer) of
1813 translates this in more general terms:

You dear God who created for us the night
With moon and stars,
Made the celestial realm and the heart
For divine calling
To us the ray of heavenly light
Sunk deeply in the breast
With it we shall blessed be
Through your loving pleasure.[41]

Thus the moon imagery was converted into images of nationalism by the same process through which pietist rhetoric evolved into patriotic declarations.

No one used the moon more effectively than Tieck, who with Wackenroder could be considered the leader of the younger generation. His central works are all tales of initiation in which the protagonists' views of existence are radically expanded. They move to a larger vista that accords with the expansive principles of the imagination and the dream. His famous verses from the *Kaiser Octavianus,* published in 1804, have become the watchword of nineteenth-century romanticism:

Moon-illumined magic night,
Holding every mind enthralled,
Wonderful fairy-tale world,
Rise up in ancient splendor![42]

This motif is subject to multiple variations, and stresses the glory of knighthood, a veritable phantasmagoria of the

Middle Ages. In the allegorical prologue Love, the daughter of Greece and of Christianity, marries Faith. Their child is Romance, who appears on a white horse. The "moon-illumined magic night" thus sets the mood for the emergence of the new generation and their celebration of medievalism.

That the moon should be so integral to Tieck's thought is already seen in a 1792 letter to Wackenroder, describing a memorable night. Tieck tells how he left his friends to wander by himself one "divine evening," when the moon shone brightly. After ascending the cliffs of Giebichenstein, he felt a sudden wave of enchantment come over him:

How romantic everything lay before me. It seemed as though I were living in the most distant past; the ruins of the knightly castle looked over to me so solemnly; the cliffs opposite, the cliffs above me, the swaying trees, the barking of the dogs—everything was so awe-inspiring, everything attuned my fantasy to so pure and high a pitch . . . The setting of the moon is always touching to me, he sinks so calmly, so unpretentiously, to make room for one greater than himself . . . The breaking of day is always so fearful to me, so full of expectation, all nature seems to be on edge.[43]

Here his fondness for the moon, the wish to be transported into a distant past, the nocturnal picture of the castle ruins, the awe-inspiring atmosphere, the fluctuation between a dream state and a state of consciousness, and finally the subconscious fear of daybreak, all point to the need to escape to the medieval past and the anxiety over the present.

In *Franz Sternbalds Wanderungen* Tieck uses the moon repeatedly to suggest the contemplation of the *Heimat* (homeland) and eternity. His friend, the painter Runge, loved the scene in which Dürer and Franz talk for the last time, an interview in which the moonlight and the shadows of the oak trees mingle their effects. The solacing faculties of the moon received frequent mention in the novel; in one passage Franz stands meditating at his window watching the moonrise, thrilling his soul and giving him the sense of eternity. Above all, the spiritual beings (*Geister*) connected with artistic inspiration are invariably identified with moonrise and sunset. Since these *Geister* are inextricably linked with originality deriving from the artist's sense of oneness with God and the universe, they represent qualities of national aspiration and political unification.

One of the most spectacular scenes in *Sternbalds Wanderungen* has Franz and his friend Bolz coming upon an iron

forge late at night with the moon high over the horizon. In a passage reminiscent of the images of Joseph Wright of Derby and contemporary English landscapists like Turner, Tieck describes the remarkable combination of industrial sounds and light and the natural illumination of the rising moon. Despite their traditional views, both consider the view enchanted, and Franz especially feels it appropriate for major painting, although it does not fall into the category of the "ideal." As they stare at the fire and molten iron that illuminate the entrance to the ironworks and listen to the beating of the forge hammers, they think of Cyclops making weapons for Mars or Achilles. The French Revolution stimulated the Prussian ironworks especially in Silesia, and the association of ironworks with armaments in the novel suggests Tieck's awareness of this connection. Furthermore, as in the case of the English writers and artists of the Industrial Revolution, Tieck seeks to convey the awesomeness of the industrial scene in the context of mythological beings and *Geister*. As in England, the moon was central to these images, but in the German setting it took on a deeper religious and national meaning.

Franz's seriousness of purpose manifests Tieck's social and political position. At one point in the novel, Franz castigates his friend Rudolf for his flighty attitude to life: "Oh, you poet! If you were not so frivolous, you would create a great and marvellous poem, full of illusionist's radiance and changing sounds, full of will-o'-the-wisps and moon gleams." The moonlit event for Tieck is not the stereotypical "romantic" sense of the modern world, but an image that gathers into itself all the aspirations and feelings of a generation grappling with social and political change. It is associated with the search for truth, but it is truth of a higher order than that offered by the Enlightenment, for it includes the whole range of emotional and affective life. This takes on an increasingly self-conscious quality in the postrevolutionary period. The burgeoning nationalism transforms artistic subjectivism into a mania for originality, which cannot be explained merely as a protest against the dogmatism of the Enlightenment or as the self-advertisement of talents competing with each other in the marketplace. The spirit of free competition naturally presupposes this attitude, but it is also the expression of a restless, intimidated middle-class intelligentsia. The peculiar pathology of the "lunatic fringe" flows from the changes wrought by the economic, political, and social circumstances of the French Revolution and Bonapartism.

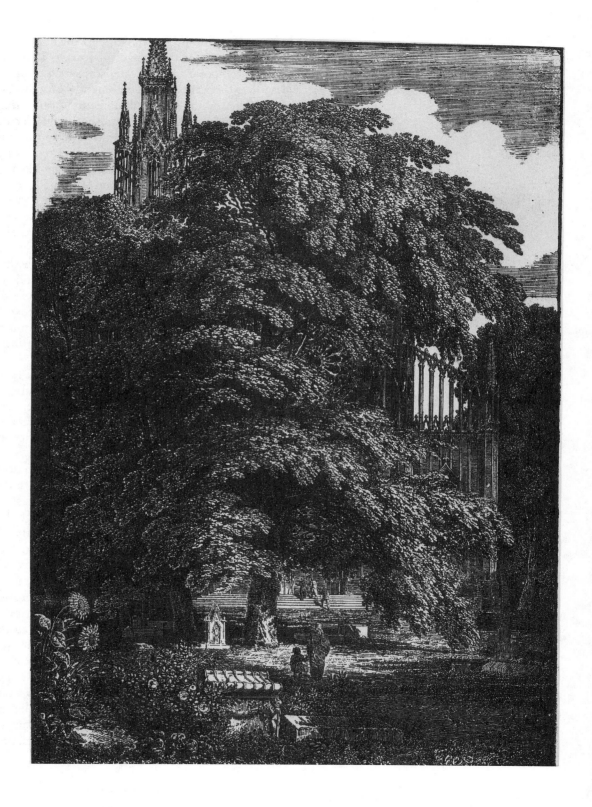

7 Patrons of the New Movement

7.1 Karl Friedrich Schinkel, *Cathedral among the Trees,* 1810, lithograph. Kunsthalle, Bremen.

Three of the primary patrons of the new movement, Friedrich Perthes and Sulpiz and Melchior Boisserée, descend from merchant backgrounds, and their political development parallels that of Tieck and Wackenroder. Perthes was an enterprising publisher who opened the first retail bookstore in Hamburg and exerted an enormous influence on the younger generation of artists and writers. His bookshop was frequented not only by the writers and artists of that city, but by intellectuals throughout Germany. He published Wackenroder's *Herzensergiessungen,* Tieck's *Franz Sternbalds Wanderungen,* and Runge's *Farbenkugel.* Not only was he in the vanguard of German publishing and art and literature, but he took an active role in the unification of Germany and the national movement of the Napoleonic period. Thus we need to examine the career of Perthes in some detail to better understand his particular contribution to the flow of history.

Friedrich Perthes

Perthes (1772–1843), patriot and publisher of the romantics, was born in the tiny principality of Schwarzburg-Rudolstadt in central Germany.[1] His father was treasurer to the house of Rudolf Schwarzburg and exercised jurisdiction over the estate of many families, but he died young, leaving the family all but destitute, and young Perthes was placed under the care of a maternal uncle. He received a solid education, although he knew early on that he was destined for a trade. He fell under the spell of Kantian philosophy and plunged into Enlightenment speculation. At this point, middle-class education encouraged study of even

385

metaphysical thought if it promoted bourgeois individual-
ism and provided a polish akin to that of the nobility.

Book Publishing in Turn-of-the-Century Germany

Through the influence of another uncle, a fairly successful
publisher and bookseller, Perthes was apprenticed to a pub-
lisher in Leipzig in 1787. Leipzig was one of Saxony's
wealthiest business towns and the center of German book
trade. Much of the work in the trade was connected with
the annual book fair which drew booksellers from all the
German territories. The leading publishers also visited
Leipzig at Easter and Christmas, bringing with them the
titles of their most recent publications. They called on each
other, showed title pages, bargained about prices, then de-
cided how many copies of each other's books they were
prepared to take. As books could not be returned if unsold,
there was great caution in accepting. Books were generally
hard to get in the widely dispersed bookshops of Germany,
and ordering directly from the publisher incurred enor-
mous expense and time. Only in Frankfurt am Main and in
Leipzig were there larger enterprises from which booksell-
ers could be supplied with immediate orders for current
titles.

Perthes's employer ran such a commission business; he
owned a large stock of expensive out-of-print books and
carried copies of most new books that he thought he could
sell the first year after publication. Perthes did most of the
bookkeeping for the firm, and from this gained an idea of
regional needs and German literary tastes. In 1793 he was
hired out to a Hamburg bookseller. Since Perthes's career
ultimately unfolds in this town, it is necessary to discuss
briefly its central historical position at that time.

Hamburg

Hamburg, an independent city since 1768, was the most
vital seaport in the German territories, an international
trade center, with a population of nearly one hundred thou-
sand. The close alliance of several major firms with France
during the Revolution had stimulated the city's economy
and had given it one of the highest standards of living in
Germany. Neighboring Altona, which then belonged to
Denmark, was the residence of wealthy merchants who
transacted business in Hamburg as well as locally; the Pal-
maille residential quarter along the Elbe had become the

equivalent of the Pall Mall in London, with lavish residences in the neoclassical style lining both sides of the street. The Elbe Chaussee further to the west was a perennial showcase of mercantile wealth.

The aristocratic tourist Baron Kaspar von Riesbeck wrote in the 1780s that "the first appearance of the free imperial city of Hamburg is very disgusting and ugly. Most of the streets are narrow, close and black, and the populace in them is fierce, wild, and generally speaking, not very clean."[2] Clearly, Hamburg had its slum districts and was highly stratified in its burgher class, like the Swiss cantons. Riesbeck was relieved to make his way into the principal houses of the merchant class, where he perceived "taste, cleanliness, magnificence, and at times even profusion."[3] He noted that most of the young people were sent abroad to form trading connections with the ports of London, Saint Petersburg, Calais, Bordeaux, and elsewhere where the Hamburg merchants had firms, and this created a cosmopolitan environment where tourists could feel at home. What impressed Riesbach most about the social milieu was the new wealth, the rapid changes in social status as entrepreneurs lost and gained fortunes. This accounted for a more conspicuous display of wealth than among the merchant class of other major seaports. The middle classes in Hamburg made a show of their affluence in townhouse, palace, gardens, and inevitable country villa.

The merchants, mostly Lutheran and often of a pietistic bent, considered their work a calling from God. Many aped the aristocrats in becoming patrons of artists and architects, but they were ultimately more concerned with insuring future financial success through intensive religious devotion and philanthropic programs. Towards the end of 1794 when the French threatened the Weser region, many influential merchant families from East Friesland, Oldenburg, and Hannover moved to Hamburg. They stimulated the art patronage, especially the theater, and they attracted a permanent French company from Brussels and an English one from Edinburgh. Artistic innovation and business innovation went hand in hand; this is seen in the important trade school founded by J. G. Büsch and the industrial art school promoted by the Hamburg Patriotische Gesellschaft (patriotic society).

Hamburg's dependence on France made it the most informed city in Germany on the progress of the Revolution. Emigrés of all shades found a haven there during the 1790s. By the time Perthes arrived in 1793, affection for the Rev-

olution was waning and trade with England was increasing. Perthes himself had at first greeted the outbreak of the Revolution with enthusiasm; as late as 1792 he felt that humanity would emerge from the present chaos to make "a great step forward towards the ideal." As a Kant disciple, he maintained that "self-mastery is the only true freedom for the individual; and if all were free in this way, civic freedom would soon follow, since we would no longer need an executive authority." He declared that as "a cosmopolitan" he rejoiced in the progress of French arms, but as a German he could only "weep." He regarded as "an eternal disgrace" the fact "that we recognized the right only after compulsion." [4]

But Perthes became disillusioned after 1793 and the execution of the French king and concluded that the masses of people were not yet ready for complete emancipation from despotism, whether enlightened or not. He wrote, "The lower classes and the scholars castigate the despots and the aristocrats; but if one of them smiles, they give up their dignity and become sycophants. And if they rise in the bureaucracy they behave even worse than those born to rank." By the spring of 1793, Perthes was condemning the French as "a wild and empty-headed people." [5]

Perthes's views were those of the cultivated society in which he longed to mingle. He wrote his uncle, "How my heart beats when I think of such eminent families as those of Büsch, Reimarus, and Sieveking, and when I meet with young men who are privileged to enjoy in their society the genuine pleasures of life, I must and will find a speedy entry." [6] A speedy entry into those rarefied circles required not only a shrewd business and social sense, but a flair for the rhapsodic language of the poets and philosophers. Thus Perthes's rhetoric is steeped in the florid language typical of his literary counterparts: "Oh, the melancholy which is the offspring of imagination, is the sweetest thing I know! . . . to lie in the stillness of nature, not knowing what one feels or thinks, and yet to know it so well! In such moments every blade of grass, every leaf is my friend—while as fancy prompts, I can extract from each, food for my imagination, and would fain shed tears of sweetest sadness for there and then is it revealed to man that God is the soul of all." [7] From these elevated thoughts and their peculiar expression it is but a short step to the upper social reaches he contemplates entering: "My heart yearns for the society of many, and of cultivated types. Such society is a necessity for me, and I must compass it unless I am to sink entirely." [8]

The most influential arbiters of opinion in Hamburg were substantial business or professional men of the type of Reimarus, Sieveking, and Büsch. Reimarus, son of the famous theologian, was a doctor whose interest in science made him comparable to his friend Erasmus Darwin. Sieveking, married to Reimarus's daughter, was a merchant prince who was also a patron of literature and generous benefactor. He hosted a major salon at his house on the Elbe outside the city. Both displayed the familiar pattern of boundless enthusiasm over the course of the Revolution, followed by bitter disillusionment, although Sieveking—at whose house the celebration of the first anniversary of Bastille Day was held—barely survived the accusation that he was shipping munitions to France with his other consignments.

Perthes came into contact with a younger group of friends who had business and social ties to Reimarus and Sieveking: Speckter, a Kantian scholar, Hülsenbeck, a businessman, and Daniel Runge, the brother of the painter, who ran the family warehouse in Hamburg. They brought Perthes into contact with Hamburg high society and kept him abreast of the latest literary events. Perthes's disappointment with the radical course of the Revolution predisposed him to view Enlightenment ideals as seriously flawed. What was needed was a speculative program that made room for a wider range of human feelings and faculties, a retreat into the individual rather than the collective ideal. This attitude was reinforced by his reading of Schiller's *Briefe über die aesthetische Erziehung des Menschen* (Letters on aesthetic education of human beings) of 1795, recommended to him by Speckter and Runge. Although Schiller condemned "the business spirit" as opposed to art, they felt they could break with the relentless demands of their professions and pursue ideas as well as profit. They shared the attitude that the cultivation of feelings was essential to individual freedom and the emancipation of the burgher class.

The warehouse and shipping firm of Runge, Hülsenbeck, and Speckter helped finance Perthes's first business venture. Although Reimarus and Sieveking offered earlier to set him up in the publishing trade, Perthes declined the offer, resolving to establish a business of his own. What was needed was a knowledgeable bookseller who could satisfy high taste and a large-scale trade that would elevate him in Hamburg's business community.

A hierarchical division of society existed in Hamburg,

with sharp distinctions drawn between the wholesale and retail businessmen, a distinction recognized in the city charter. The merchant could attain membership in the senate, while tradesmen could enter only the burgher colleges. Since bookselling was considered a retail business, those engaged in it were generally not admitted to Hamburg's "high society." Perthes was determined to overcome this caste distinction, and he did it in part through his connections with the Reimarus and Sieveking families, who loaned him the capital for his independent enterprise.[9]

At that time, publishing and bookselling were not two separate enterprises but usually combined. German booksellers met twice annually at Leipzig to trade their publications. Money seldom passed directly between hands, and if the books did not balance at one fair, the difference was carried over to the next. But the hesitation of publishers to trade first-rate works for the more popular items that began to circulate at the end of the century forced a new arrangement. Henceforth at the close of each fair all outstanding balances had to be paid in cash, which meant that all booksellers whose purchases exceeded their sales required ready capital to negotiate. Bookselling, which had previously existed within the publishing business, now found itself in a position to assume an independent form. Another change in this period furnished the growing trade of bookseller with a decisive advantage over the publisher. Previously, book dealer-publishers could not return works they had taken from other publishers; if a book were unsellable they had to absorb the loss themselves, and this encouraged a great caution in purchases. The publishers realized that their sales suffered due to the early exhaustion of the bookseller's limited stock, and, by way of experiment, they handed out, in addition to the purchase copies, a certain number on consignment. If unsold these could be returned. This custom caught on, and eventually almost all direct purchases were discontinued.

All risk of loss now shifted to the shoulders of the publishers, and bookselling received an extraordinary stimulus. The book dealer could trade on a very small capital, and with good timing and knowledge of the clientele a thriving business could be carried on in a dynamic community. Perthes figured he could launch such a business in Hamburg with minimum risk and small investment. Several Hamburg merchants backed him with their capital, and he opened his shop in July 1796 with several innovative ideas. He became the first book dealer to display a selection

of the best works in all the various fields, classified and arranged by subject matter. Like the modern bookstore, his shop had the appearance of a small but choice library. In addition to a large number of current periodicals, he carried every major European journal and published novelty.

Perthes diffused knowledge of recent German literature through his international contacts. He also ventured into publishing himself, issuing Wackenroder's *Herzensergiessungen* in the fall of 1796. A new market was emerging for the voice of a younger generation reacting to the failure of the Revolution and reflecting the general disillusionment with Enlightenment ideals. The innovative styles of Wackenroder and Tieck complemented Perthes's emphasis on the contemporary in the retail end of his business, and articulated the moderate views of his backers.

One of his first major clients was Friedrich Heinrich Jacobi, brother of the poet and famed for his critiques of Kant, Fichte, and Schelling. The son of a wealthy sugar refiner in Düsseldorf, Jacobi left the family business to pursue his literary and philosophical interests. He set up residence in Hamburg and Holstein, the native province of his father, and established close connections with such prominent families as the Reimaruses and Sievekings. Jacobi's pietist background predisposed him to a critique of Enlightenment ideals. His influential ties to the business and political realms gave weight to his publications. He wholly identified with the romantic movement, which he stimulated and from which he derived inspiration. Years later, Tieck wrote to Perthes that his meeting with Jacobi had been "epochal."

When Perthes met him, Jacobi was attached to the group known as the Göttingen Bund, a body of former students of the University of Göttingen, living for the most part in Holstein and united in loyal admiration of Klopstock. Jacobi frequently visited Perthes's bookstore in search of new German, French, and English titles, and a friendship sprang up between the two. Jacobi's circle included distinguished writers and aristocratic intellectuals, such as Matthias Claudius, the "Wandsbecker Bote"; Klopstock; Count Friedrich Leopold Stolberg; and the Reventlows. Except for Klopstock, most of this group developed an early hostility to the French Revolution. Claudius was close to reactionary, depicting in his poetry an idealized rural life while in actuality defending the privileges of the aristocracy. Stolberg became a bitter counterrevolutionary; his denunciation of French anarchy and irreligion led him

straight to Catholicism. Klopstock's initial zeal for the Revolution turned into loathing after the king's execution. Perthes fixed his position in this anticosmopolitan, counterrevolutionary society when he married Claudius's daughter, in 1797.

The young bookseller's aristocratic connections saved him from the commercial and monetary crisis of 1799 set off by England's blockade of Spanish commerce. Perthes then opened branches in Holstein and Mecklenburg and entered into partnership with another bookseller, Johann Heinrich Besser, whose education at Göttingen had drawn him into the Holstein group. The partnership was sealed when Besser married Perthes's sister.

During the Napoleonic period, Perthes became an ardent nationalist and advocated a united fatherland. He wrote to Jacobi in 1804, "Our hearts must and should be filled with shame, burning shame, at the dismemberment of our fatherland, but what are our nobles about? Instead of keeping alive their disgrace, and striving to gather strength, and wrath, and courage to resist the oppressor, they take refuge from their feelings in works of art!"[10] Perthes became an activist, advocating support for England against France in 1805 and, later, participating in the abortive Hamburg uprising of 1813. French troops occupied Hamburg for the first time in November 1806, and all trade with England was prohibited. English goods and property were confiscated. Since Perthes had extensive trade relations with London publishers and booksellers, the effect on him was ruinous.

Perthes then committed himself to the idea of an united Germany. He wanted to organize an underground league of German patriots to guide the country in the post-Napoleonic era, but this plan was dashed when the person he hoped to see lead this group, Johannes von Müller, was won over by Napoleon. He then decided to publish a journal that would uphold the idea of unity, but would do so in veiled terms to pass the French censors. He conceived the code word *Wissenschaft,* meaning "science" or "learning," and he entitled the new journal *Das vaterländischen Museum* (The museum of the fatherland).[11] His announcement expressed the hope to gather information about German scientific progress and scholarship and thus forge an intellectual unity. The journal made its appearance in the spring of 1810 with articles by Stolberg, Claudius, Arndt, and Görres, among others. The artist Runge executed one of the cover designs.

Later in the year, however, Hamburg was declared (like neighboring Lübeck) an integral part of the French empire. Under the Napoleonic occupation from 1810 to 1813, the French blockade and the English counterblockade impoverished the merchants. French troops pillaged the area, and taxes were levied upon the inhabitants. Hamburg and Altona were bankrupted by the occupation. In the final destructive retreat of the French in 1813, Perthes lost everything. His shop and warehouse were sealed and his house looted and assigned to French officers. Perthes was forced into exile and thereafter took part in the popular struggle.

The Boisserée Brothers

Perthes and his publishing ventures inspired the romantic nationalism of the illustrious brothers, Sulpiz and Melchior Boisserée.[12] Sulpiz is one of the most remarkable figures in the medieval revival, and his work deserves a place beside other great landmarks of German romanticism like Arnim and Brentano's *Dés Knaben Wunderhorn* and Grimm's fairy tales. Boisserée was the key figure in the revival of interest in the treasures of German medieval art and architecture when they were in danger of being destroyed.

Despite their name, the Boisserée brothers, as Sulpiz clarifies in the opening sentence of his autobiographical fragment, were not of French origin, but came from a wealthy merchant family in Cologne. The senior Boisserée was a shipping magnate specializing in foodstuffs and Rhine wine, and the family ranked among Cologne's most respected citizens. Cologne carried on extensive trade relations with Hamburg, and Sulpiz was sent to Hamburg in 1798 to learn the family trade from a business connection named Drewes and Company.[13] Drewes also had close business and personal ties with Georg Heinrich Sieveking, the Hamburg merchant whose son Karl become a friend and patron of Sulpiz and other romantics like Perthes, Schinkel, and Runge. The firm of Reimarus, Büsch, and Company, comprised of scions of notable Hamburg families, joined with Drewes in 1799. While Sulpiz worked for Drewes, he lived with Elise Reimarus, Georg Heinrich Sieveking's sister-in-law. Thus Sulpiz had privileged access to Hamburg's highest merchant circles.[14]

Both the elder Sieveking and Drewes were amateur botanists and cultivated large gardens; the former gave his name to a plant of the genus *Viola*, while the latter wrote a botanical guide in 1794 for young people and amateurs.[15]

The interest of merchants in botany was not exceptional, as we have seen in our study of the early Industrial Revolution: the search for plants and the quest for "plantations" were intimately related, and Hamburg was the main clearing house for colonial products in the German territories. Sulpiz soon found himself drawn to natural history and botany, which led to his friendship with Perthes, whose bookstore carried a major line of scientific publications. At the same time, Perthes introduced Sulpiz to his publications of Wackenroder and Tieck. When Sulpiz returned to Cologne the following year, he brought back books and pictures of the medieval period, and thereafter he and his brother began collecting German medieval masterworks. Sulpiz's dual interest in botany and medievalism was to make a significant contribution to the Gothic revival: the feeling for organic form and its expression in architecture became for him the very essence of the Gothic spirit.

When the French revolutionary army entered Cologne in October 1794, Sulpiz observed how the troops gradually alienated the townspeople. His elder brothers, full of the revolutionary spirit, took Sulpiz to a meeting with several guests from the French army. Sulpiz watched with astonishment as a soldier snatched the watch from his host and put it into his own pocket—a prelude of things to come.[16] Later, the libraries of Cologne's churches and religious houses were ransacked for manuscripts, incunabula, and copper engravings.[17] Valuable paintings, Roman antiquities, sepulchral monuments—all were plundered and shipped to Paris. This rape of Cologne's art treasures engendered Sulpiz's nascent patriotism, which developed with the incorporation of Cologne into France in 1797 and its reintegration into Napoleon's Confederation of the Rhine. A singular idea began to slowly form in Sulpiz's young mind, that of rescuing the priceless national treasures. His joyous return from Hamburg with medieval manuscripts, engravings, and Perthes's publications represented the first success in his rescue operation.

In autumn of 1803 the Boisserée brothers and their friend Johann Baptist Bertram paid a short visit to Paris.[18] The French capital had become the center of the art world because of the great collections that Napoleon looted from the conquered territories and assembled in the Louvre, renamed the Musée Napoléon. In Paris they made the acquaintance of Friedrich Schlegel and Dorothea Veit, who were living together at 19, rue de Clichy. This contact had a decisive impact on Schlegel, who under the influence of

the Boisserée brothers became an apostle of medievalism. At the end of April 1804 Schlegel accompanied the Boisserées and Bertram on a journey through Belgium to Aachen and from there to Düsseldorf and Cologne. The Boisserées covered the expenses of the journey and also financed Schlegel's stay in Cologne. Schlegel's famous travel letters of this trip, *Briefe auf einer Reise durch die Niederlande, Rheingegenden, die Schweiz, und einen Theil von Frankreich* (Letters on a trip through the Netherlands, Rhenish districts, Switzerland, and a section of France), comprised the first serious study of Gothic architecture by a member of the younger generation. Since this work (first published in 1806) is a critical landmark in the rediscovery and rehabilitation of German medieval architecture, it alone demonstrates the Boisserées' pivotal contribution.[19]

The acceptance of Gothic was complete. Schlegel reflects the Boisserées' unbounded admiration for the style and its analogy with organic nature. He proclaims that every nation has its peculiar architecture, and the Gothic is indigenous to the German lands. The most salient characteristic of Gothic architecture is its affinity with organic nature. It is Cologne Cathedral that calls forth Schlegel's most studied treatment of this idea; he sees in its exterior structures and embellishments analogies to the German *Wald* (forest), and close up the whole edifice reminds him of a monumental hunk of crystallization. The essence of the Gothic consists in its capacity to create, "like nature itself, an infinite multiplicity of forms and of flower-like decorations." Gothic is, simply, the expression of the Infinite. It accomplishes this through its capacity to convey the inexhaustible bounty of creation.

Gothic is native German and it expresses the Infinite—the formula of German romantic patriotism born of the Napoleonic epoch. Schlegel argues that the deepest meaning of Gothic architecture is found in the Christian symbolism that underlies it. He writes that the chief aim of the Gothic builders was to embody "the spiritual idea of the Church itself, whether the Church militant or the Church triumphant."[20] Not surprisingly, Schlegel converted to Catholicism four years after he wrote this passage. Here again he was influenced by the Boisserées, ardent Catholics by upbringing and conviction. While Wackenroder and Tieck were more affected by pietism, Schlegel and the Boisserées felt that the Gothic could only be understood as the symbolic expression of the Catholic faith. They helped forge the tie between the medieval revival and the Catholicizing

tendencies of the German patriotic movement. As in the case of Novalis, they identified the Revolution with the Reformation and looked back to the Middle Ages for their model of a united Christendom and a united fatherland.

For the Boisserées the physical as well as symbolic focus of this patriotic ideal was the unfinished Cologne Cathedral. It was in Cologne that Schlegel composed his published observations, of which he devoted a significant section to the cathedral. Schlegel acknowledged in a footnote to this section a debt to the antiquarian and historian of Cologne, Ferdinand Franz Wallraf. Wallraf had been rector of Cologne University during the occupation of 1794, and it was due to his intervention that the stained-glass windows and statues of the cathedral had been saved from destruction. He also began a collection of German medieval painters, especially of the Cologne school, and in this respect foreshadowed the Boisserées. But he was generally much more eclectic in his tastes, and his diverse medieval paintings, Roman antiquities, coins, gems, fossils, and minerals that he bequeathed to the city in 1823 became the core of the famous Wallraf-Richartz Museum.

Since the Boisserées' trip to Paris in 1803 the process of secularization under the Napoleonic decrees had advanced drastically. Many churches and monastic establishments in the German territories had been closed or demolished and the art works either confiscated by the French or sold off to dealers. Medieval masterpieces were found being used as tabletops and window shutters and, occasionally, for fuel. Sulpiz began purchasing from junk dealers (and at bargain prices) the start of what became the famous Boisserée collection.

In the winter of 1808 Sulpiz began to conceive of a series of engravings that would show the Cologne Cathedral as if it had been completed in all its glory—a project that gradually developed into the rallying point of the German Gothic revival. The restoration of Cologne Cathedral gathered into itself the many patriotic strands of the period. The lowest point in the fortunes of the cathedral was reached after the French occupation, when the building was taken over as a hay and forage magazine. In 1797 it was used as quarters for Austrian prisoners of war. Finally, as a result of the Napoleonic Concordat of 1801, the archbishopric was eliminated and the cathedral demoted to the position of a parish church. At one point it was even considered for total demolition. Angered by Napoleon's anticlericalism and taxes (Sulpiz had inherited the shipping

firm), Sulpiz was perhaps moved in 1808 by the news of the Spanish insurgency. At the same time, in October 1808, Napoleon threatened to close the mouths of the Rhine unless the Continental blockade was enforced. These events would have contributed to Sulpiz's "tremendous fermentation" that resulted in the conception of the cathedral project.

For the next two years Sulpiz studied the details and proportions of the cathedral, left unfinished when work halted in the sixteenth century. He used family money to finance his project, enlisting engineers and artists to measure and make the drawings and seeking influential support. He, Melchior, and Bertram moved from French-held Cologne to Heidelberg in 1810, then at the height of its fame as an intellectual and cultural center. The collection of German medieval masters, especially of the lower Rhenish school, followed bit by bit.

Meanwhile, the Boisserée collection of paintings and the Cologne Cathedral project became national preoccupations. Sulpiz lost no time gaining adherents to his cause. Already on the way to Heidelberg he stopped in Frankfurt to show his drawings to the influential Karl von Dalberg, archbishop of Mainz and primate of the Confederation of the Rhine. Dalberg had the ear of Napoleon while negotiating the best terms for himself and the German people. Sulpiz also showed his drawings to Schelling and the queen of Württemberg. But his greatest conquest was Goethe, the inveterate classicist who saw the project's historic, if not aesthetic, importance. Sulpiz wrote to him acknowledging his support: "In view of my love for the German past how could I help feeling moved to the depth of my soul by you—you who are the greatest German of your time and who were the first to revive the spirit of the German past, and were thus the originator of all our present endeavors to do likewise." Goethe referred to Sulpiz in his description of the Strasbourg Minster in *Dichtung und Wahrheit* (Poetry and truth); in observing the younger generation's passionate devotion to the Gothic, he singled out "the valiant Sulpiz Boisserée."[21] Goethe requested support "from the wealthy and influential" for Sulpiz's "patriotic endeavors." German patriots made pilgrimages to Heidelberg to see the medieval and early Renaissance pictures. Hardenberg wanted to acquire the collection for Prussia in 1815, but despite extensive negotiations the deal never went through. The designs for Cologne Cathedral were not published until 1823, but their appearance enjoyed a

huge success in the conservative atmosphere of the Restoration in Germany and France. Finally, the foundation stone of the cathedral extension was laid on 4 September 1842 by King Friedrich Wilhelm IV in the presence of exalted company including Metternich, Alexander von Humboldt, and a large array of generals and ecclesiastics. In his speech the king noted, "The spirit which builds these portals is the same which broke our fetters twenty-nine years ago, which brought to an end the humiliation of the fatherland and the alien occupation of this province. It is the spirit of German unity and strength."[22]

Karl Friedrich Schinkel

It was the king's father, Friedrich Wilhelm III, who took the first decisive step towards the completion of Cologne Cathedral when in 1816 he commissioned the architect Karl Friedrich Schinkel (1781–1841) to prepare a report on the state of the cathedral. Schinkel advocated not only that the cathedral should be repaired, but that it should be completed for technical and patriotic reasons. Schinkel also wrote to Sulpiz Boisserée to invite his participation in the project "since no one else has penetrated so deeply into the inmost secrets of this artistic monument as yourself."[23]

While Schinkel's recommendations for the completion of the cathedral were not heeded for many years, the report demonstrated his profound involvement in the medieval nationalism of the Napoleonic epoch and his obvious debt to Boisserée. His work is perhaps the best example of the infiltration of this nationalism into architectural ideas, and since he is considered the most distinguished German architect of the early nineteenth century, a study of his career will help clarify the movement of culture and ideology during the Napoleonic years.[24] For what is most striking about Schinkel's life is his exceptional devotion to Gothic art. Known chiefly for his neoclassical designs, such as the Neue Wache (Royal Guardhouse, 1816), the Schauspielhaus (National Theater, 1819–1821; 1823), and the Altes Museum (1823–1830), Schinkel did little in the way of actual Gothic building; and in fact his contribution to the Gothic revival was mainly in the form of paintings and scenic designs confined to the period 1810–1815.

Schinkel was born at Neuruppin in Mark Brandenburg, a small town northwest of Berlin and on the main route to Hamburg. His father, *Archidaikonus* (archdeacon) and inspector of churches and schools, tragically died in a fire,

leaving the family in a precarious position. As in the case of Perthes, Schinkel was on his own early in life. With his mother's efforts he managed to enter the first class of the new architectural academy, the Allgemeine Bau-Unterrichts-Anstalt für die gesamten Königlichen Staaten. At the time, architecture was stimulated by the young king's desire to stamp Prussia with the new classical mode. During the next few years, Schinkel made a living executing minor commissions and designing porcelain and furniture. In 1821 he began his series of model books for manufacturers and craft workers, *Vorbildern für Fabrikanten und Handwerker,* aimed at reaching a mass market. Schinkel's designs were clearly influenced by the Empire style and the work of Flaxman and his patron Thomas Hope.

During the early years of the nineteenth century, the architect found himself decisively influenced by the philosophical speculation of Schelling and Fichte. Schelling's *System des transzendentalen Idealismus* (1800), with its celebration of the work of art as a means of presenting concretely a harmony between object and subject, gave Schinkel a philosophical justification for his career and a sense of mission. Fichte he knew personally, and he took one of his books with him on his Grand Tour in 1803. Fichte's emphasis on the practical and active rather than on the purely cerebral—the actualization of the individual through the sense of duty or accomplishment—prepared Schinkel for the nationalist fervor that swept Germany in the ensuing years.

Schinkel returned to Berlin in January 1805 to find that the political and economic situation was extremely unfavorable to the architect. There was very little construction in Prussia between this date and the end of the war in 1815. Schinkel was forced to turn to illustration and painting for his livelihood, mainly landscape compositions, for which there was a growing market. During the period from about 1810 to 1815, he produced a series of medieval landscapes, influenced by Caspar David Friedrich, whose work he had seen at an exhibition in 1810. Although they are similar in many ways, Schinkel's landscapes differ from Friedrich's ruinous, desolate symbols in their depiction of entire medieval towns centered around majestic Gothic structures.

Schinkel's fantastic portrayals of the Gothic are designed to awe the spectator with theatrical effects. It is not surprising to learn that throughout this period Schinkel was supported by a show-business entrepreneur who manufac-

tured theater masks and invested in the panoramas then all the rage in Berlin. Later, Schinkel even designed stage sets for the Berlin state theaters. The most famous of these are his superb designs for Mozart's *Die Zauberflöte*. Schinkel's medieval designs are similarly "stagey," their ideology communicated with dazzling effects.

But it was mainly his relationship with the mask manufacturer, Wilhelm Ernst Gropius, and his sons that stimulated Schinkel's dramatic presentations. Gropius began sponsoring an annual Christmas special, a panorama of a historical or spectacular geographical site presented in a special building to accommodate large audiences. The history of the commercial panorama is inseparable from modern landscape developments. It may be recalled that Philippe-Jacques de Loutherbourg entertained London crowds in the early 1780's with his *Eidophusikon,* a contrivance for showing paintings on glass with special audiovisual accompaniment. He was both artist and entertainer, and he set the model for artists who wanted mass audiences outside the official exhibition mechanisms. The panorama was to prove the most popular of the aesthetic spectacles. In its earliest form it was a horizontal painting hung on the walls of a rotunda designed specifically for its display. The English Robert Barker pioneered in this field, and his patent stated that it was intended to exhibit "an entire view of any country or situation as it appears to an observer turning quite around . . . so as to make observers, on whatever situation the artist may wish they should imagine themselves, feel as if really on the spot."

Barker's successes—the *Edinburgh from Calton Hill,* which advertised "a complete prospect of the whole horizon as appearing from the top of the observatory on Calton Hill comprehending a circle of several hundred miles," and the *View of London from Albion Mills,* which was shown at the Leicester Square panorama building in 1793—encouraged other artist-entrepreneurs to patent their versions. Robert Fulton, the American artist/inventor, took out a ten-year patent on the panorama in Paris in April 1799. Later that year, he relinquished the rights to an American couple who built two rotundas on the stylish Rue Montmartre, now a mall named Passage de Panorama. The couple, James and Henriette Thayer, hired Pierre Prévost, a student of the landscapist Valenciennes, to paint such panoramas as *View of Paris from the Roof of the Tuileries* and *The Evacuation of Toulon by the English in 1793.* They were clearly designed to exploit patriotic fervor during the early Napo-

leonic years; the French victory at Toulon, for example, was due to the skill and advice of Bonaparte. Generally, these early panoramas stressed the indigenous landscape or military events, thus appealing to love of country. The more spectacular the presentation, the more the propaganda impressed itself on the early viewers. In 1807 Prévost hired as his assistant Louis Daguerre—the same man who would be credited with inventing the photographic process. No more dramatic example could be presented for demonstrating the critical contribution of popular entertainment to the history of nineteenth-century landscape and photography.

During his trip to Paris in 1804 Schinkel visited the panoramas of Thayer and Prévost. This is seen in his series of "perspectivisch-optische" paintings based on the travel sketches he had made. A master of perspective from his architectural training, Schinkel was the ideal type to design the panoramas for Gropius. The first panorama in Berlin was exhibited as early as 1800 and proved to be a popular form of middle-class diversion. Gropius decided to launch his venture in collaboration with Schinkel in December 1807. This was the period in which Schinkel plunged into painting, no doubt motivated by the publicity surrounding the new Paris extravaganza. While the 1807 exhibition was not a true panorama, it featured Schinkel's illusionistic scenes of historical sites like Jerusalem and Constantinople.

The success of this show encouraged Gropius to push his enterprise further, and the following year he constructed a special wooden structure for the exhibition of *Panorama of Palermo,* a true panorama based on Schinkel's travel sketches. The great appeal of this attraction developed into a kind of partnership between Schinkel and Gropius which proved highly profitable over the next few years. Schinkel became quite close to the Gropius family, joining their household for a time on Breitestrasse 22. In 1809 Schinkel collaborated with his friend Johann Gottfried Steinmeyer to produce large-scale painted scenes with dramatic lighting effects and music; these included *Saint Mark's Square in Venice, Schweizerthal at the Foot of Mount Blanc,* and a view of *The Milan Cathedral by Moonlight.* They were shown in a cylindrical interior, viewed from an elevated platform in the center, and accompanied by theatrical lighting and choral music. The royal family visited this panorama, and Schinkel was introduced to Queen Luise.

Around this time Schinkel fell into the literary circle of

the romantic nationalists who were reviving the folk songs, fairy tales, and sagas of the German Middle Ages: Achim von Arnim, Bettina von Arnim, Clemens Brentano, and Friedrich Karl von Savigny. Arnim and Brentano had already published *Des Knaben Wunderhorn,* a compendium of ancient folk songs, to revive the common consciousness of the German peoples. Arnim was soon to found the Christlich-deutsche Tischgesellschaft (Christian round table) in Berlin, a group hostile to the French and the Jews—revealing the dark side of the medieval revival. This group's voice would be heard in Kleist's journal *Berliner Abendblätter,* devoted to the king and the Prussian tradition. Both Savigny and Wilhelm von Humboldt recommended Schinkel for a post in the Prussian bureaucracy, and he was appointed to the rank of *geheimer Oberbauassessor* in the department of *Oberbaudeputation,* an office supervising the state and royal building commissions. Schinkel was charged with the supervision of the designs of all new Prussian buildings. His appointment may have been facilitated by his panoramas: he wrote King Friedrich Wilhelm III about his *Panorama of Palermo,* asking permission to install it in the theater room of the royal palace in Königsberg. He claimed to do this as a public gesture, but it is clear that he intended to exploit the publicity of his panoramas to further his social ambitions.

Queen Luise died in 1810, and Schinkel was commissioned to design her mausoleum. His proposed project was a remarkable example of the close bond between the medievalizing tendency and burgeoning nationalism. Schinkel believed that only a Gothic design would do justice to the purpose he had in view. In this case, however, the king preferred a small temple in the Doric style, which Schinkel executed for the Schlosspark in Charlottenburg. But the king had to yield to the strong current of national feeling, and Schinkel was allowed to design a second, more modest monument in cast-iron Gothic, erected at Gransee in 1811. This last commission was organized by the magistrate of Gransee, the son of the famous Prussian general, H. E. K. von Zieten. His constituency specifically demanded a work with a Gothic canopy to connect "religious and patriotic profession with the memory of Queen Luise."[25]

Schinkel's original plan is perhaps most important for the commentary that accompanied it. Taking his cue from the writing of Schlegel, Schinkel projected a chamber composed of structural elements embellished with plant and floral motifs. At the head and feet of the recumbent statue

of the queen, angels were to carry palm branches, scatter flowers, and gaze "heavenwards in rapturous contemplation of the transfigured spirit of the departed." Schinkel prefaced his description of the mausoleum with an analysis of architecture in general and of Gothic architecture in particular. For an artist who would establish his reputation on the basis of his neoclassical designs, it is astonishing to find his antagonism to the "classical." He opposed the two as spirit and matter, with the Gothic triumphing in its dematerialized and spiritual attributes. The Gothic is also an expression of the native German genius and is specifically Christian. In language reminiscent of the idealist philosophers, Schinkel called Gothic architecture "the outward and visible sign of that which unites Man to God and the transcendental world."[26]

Robson-Scott has neatly outlined Schinkel's Gothic schema,[27] based on the characteristics beloved of the romantics. What I want to do here is give each of these ideas their corresponding political and social meaning in order to illuminate the relationship between art and ideology.

Schinkel's Commentary	*Specific Material Basis*
Gothic is the expression of an idea.	Ideology.
Gothic represents the triumph of spirit over matter.	Gothic expresses the triumph of German people over Napoleon.
Gothic is Christian.	Gothic opposes the atheistic French and their anti-Christ.
Gothic is German.	Gothic is patriotic and exemplifies devotion to nation.
The unity of Gothic is an inner and organic unity.	Gothic is a metaphor for a united fatherland.

That the kind of thing Schinkel did during the Napoleonic period reflected and helped shape the nationalist mood is exemplified by the paintings he did for Gneisenau, with whom he developed a close friendship. While he never saw action, Schinkel trained for the *Landsturm* (national guard) in 1813 when he painted his first landscape for Gneisenau. For Gropius's Christmas show that year he exhibited a large panorama, *The Burning of Moscow,* a work that was assured of popular success. The next year he showed *The Battle of Leipzig,* another cheering subject for the German people. Finally, the panorama of Saint Helena exhibited in 1815 lowered the curtain on the final act of the emperor Napoleon.

There can be little doubt about Schinkel's nationalism as well as his insight into its commercial possibilities. At every stage of his career he met the demands of a powerful elite shepherding the romantic movement into channels for molding national opinion. This is most clearly seen in the medieval paintings begun after 1810. That year Schinkel saw Friedrich's *Monk by the Sea* and *Abbey in the Oakwood,* two medievalizing themes steeped in a funereal mood but hinting at redemption beyond the world. These works were shown at the 1810 exhibition at the Berlin Academy and were bought by Friedrich Wilhelm III of Prussia at the instigation of the crown prince. No doubt they resonated with the sense of loss over the death of Queen Luise. Although the king opted for a classical mausoleum for the queen, the purchase of these two works indicates the change in the royal taste under the pressure of the militant nationalists. Schinkel was quick to capitalize on this change, and his series shows the influence of the leading nationalist painter of the period.

Schinkel began doing illustrations, for lithographic reproduction, of the spectacular German countryside and the Gothic cathedrals. He contracted with noted publishers to distribute such works as the *Cathedral among the Trees,* which carried this legend: "An attempt to express the sweet yearning melancholy which fills the heart at the sound of divine worship emanating from a church." The spires of the cathedral seem to grow from the large oak trees below, at the foot of which are the ruins of an ancient graveyard (fig. 7.1). Schinkel clearly sums up the connection between

7.2 Karl Friedrich Schinkel, *Evening,* 1813. Destroyed.

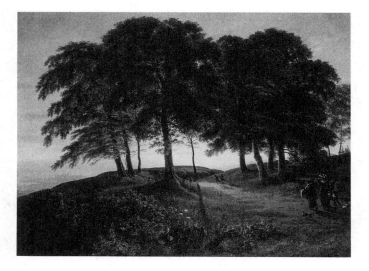

the medieval ideal and national unity (tiny diminutive figures enter the church under the canopy of the oaks), and stresses the transcendental realm of the fatherland. Two works that he did for Gneisenau in 1813, *Evening* (fig. 7.2) and *Morning* (fig. 7.3), seek parallels through landscape to the struggle against the French. In the first the viewer is located at the edge of an oak forest in the mountains and through the clearing confronts a rugged peak in the middleground. The view, moving upward, suggests heavenly aspiration. Storm clouds are gathering overhead, while two eagles (symbols of Prussia) soar towards the mountain peak.[28] The *Morning* shows the result of the struggle, the victorious outcome; day breaks as a party of romping children and strolling adults in medieval costume pass through a foliated portal formed by a row of oak trees on a high hill. A glimpse of the view below shows the sea stretching endlessly and a medieval town on the coast. This scene of peace and harmony is flanked on the far right by two guards in plumed hats and on the left by antique ruins, the passing of the Napoleonic order.

Cyclical series, such as this pair for Gneisenau, and other similar diurnal and seasonal sequences were popular among this generation of German painters. They corresponded scientifically to current meteorological and geological studies, and politically to the Fichtean belief that the German nation was completing the end of one cycle and starting another. Traditionally, depictions of the stages of life and their identification with the times of day and the changing seasons implied the desire to see human birth and

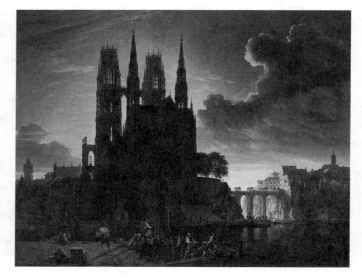

death as a cosmically regulated process on which to base a model of resurrection. Topographical portrayals of landscape in the Napoleonic years added the character of immediacy to the association of resurrection with military victory and national liberation. Schinkel did a cycle of six oils in 1813–1814, *The Times of Day,* for the Berlin townhouse of Jean Paul Humber, a silk merchant of French extraction who wanted scenes of the various German territories.

One of Schinkel's major medieval landscapes of this period is the *Gothic Cathedral by the Water,* originally painted in 1813. A version of this work was exhibited in the Berlin Academy show of 1814 and acquired for the collection of the crown prince. Unfortunately we know it only through a copy of the picture painted ten years later, but it is a reliable indication of the original (fig. 7.4). The bustle of the town under the exalted but sheltering Gothic edifice is the main theme. The view is again skyward, culminating with the majestic silhouette of the cathedral against the infinite expanse of sky. The central and dominant position of the cathedral gives unity to the lives of those who work beneath its protective spires.

The *Medieval City on a River* of 1815 is perhaps the most astonishing of the cathedral series (fig. 7.5). It depicts a royal procession moving in the direction of a towering cathedral confronting the viewer as a sudden revelation, the kind of experience repeatedly described in *Franz Sternbalds Wanderungen.* The previously overcast sky is gradually

clearing away as the sun illuminates the facade. The rainbow, the bright bow of promise, loops over the spires of the cathedral. Off to the left is the neighboring castle of the king, towards which the retinue is winding its way. The monarch, shown wearing a scarlet robe, is sheltered by a canopy in the middle of the procession. The local inhabitants run and wave to the parade and welcome their returning ruler. The symbolism is transparent but effective: while set in the Middle Ages, the picture refers to the triumphal return of Friedrich Wilhelm III from Paris, where he had entered in March 1814 with the allies of the coalition that defeated Napoleon and made way for the first restoration of Louis XVIII. The juxtaposition of the cathedral and the castle (which it nevertheless overwhelms) indicates the renewed alliance of throne and altar. The white banner of the Holy Roman Empire flutters atop the incompleted tower of the cathedral, pointing to "unfinished business" along the old lines. Finally, the conspicuous oak grove in the foreground makes it clear that it is the dawning of a new era for the German people.

Schinkel's spectacular effects of illumination (carefully studied from nature), dramatic orchestration of the compositional elements, and the ingenious perspectival rendering of the medieval town in the background demonstrate the qualities that made his panoramas so popular. He successfully transferred the qualities that gave his work mass appeal to his ideological projections of German nationalism. In other words, he learned how to deliver his political message while entertaining his audience. To a large extent

7.5 Karl Friedrich Schinkel, *Medieval City on a River,* 1815. Staatliche Museen Preussischer Kulturbesitz, Nationalgalerie, Berlin.

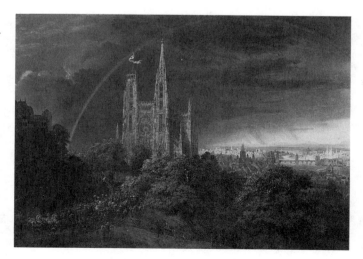

this reflected the greater outreach to the German people exemplified by the bureaucratic reforms and the need to mobilize the entire population. But it is not possible to disentangle this democratizing process from Schinkel's opportunity to profit from it. Down and out in Berlin, his ability to survive depended on how well he could perceive the winds of political and cultural change. While his own desires coincided with those of the most progressive and dominant group, he was not above manipulating the national mood to ingratiate himself with his patrons. Schinkel's architectural and theatrical experience served him well in the penurious years of the Napoleonic occupation.

With the coming of peace Schinkel could return to his more purely architectural activities. In 1816 he began the long series of masterpieces in the neoclassical style that transformed the look of Berlin and established his reputation. He did not completely abandon the Gothic, but when he took it up again it was mainly to exploit the national feeling over the Wars of Liberation. He designed several cast-iron monuments in the form of Gothic finials to commemorate the fallen heroes of the liberation struggle, but his most ambitious project of this sort was for a Gothic national cathedral on the Leipziger Platz in Berlin as a memorial to the Wars of Liberation. It was, however, deflated by the scheme for the restoration and completion of Cologne Cathedral which, as we have seen, became the architectural focal point of the postwar nationalism.

MELANCHOLIEN

Die ihr singend eure Erdentage,
Jauchzend eure Pilgerbahn durchwallt —
Gönnt dem finstern Wandrer seine Klage,
Die nur ihm und wenig Edeln hallt.

Stralsund, bey Christian Lorenz Struck.
1777.

8 Philipp Otto Runge

8.1 Johann Gottfried Quistorp, vignette for Gotthard Ludwig Kosegarten's *Melancholien*, 1777.

Both Perthes and the Boisserée brothers had close contact with the painter of Wolgast, Philipp Otto Runge (1777–1810).[1] Perthes could say of the artist;

If there was any German of the last century who was a genuine representative of Mysticism and Theosophy, it was Runge; for in him, as in no one else, were united the grand theosophic intuitions of Jacob Böhme, and the mystic spiritual love of Suso . . . for everywhere in nature he saw traces of the mysteries of creation, redemption, and sanctification, and he regarded it as the great duty imposed upon him to seek out those traces, and to represent them to others through his Art.[2]

Runge's father was a wealthy merchant shipper, shipbuilder, grain merchant, and even smuggler during the Napoleonic wars. He ran ships for friend and foe alike, did some smuggling, and enjoyed the peculiar political and geographical advantages of the port of Wolgast. Wolgast merchants traded with America during its war with England, and with England during its wars with France. Since Sweden was never included in the Continental system, Runge's family engaged in a smuggling operation between Pomerania and Hamburg. The elder Runge established his son Daniel in business in Hamburg and was then able to carry on his trade under both the Swedish and Hamburg flags. Philipp was meant to expand the firm and was apprenticed at age eighteen to the shipping and provision company of his brother in Hamburg. Although Philipp Otto's teacher and mentor, Gotthard Ludwig Kosegarten, counseled the father to encourage his son's artistic gifts, the elder Runge was determined to see "Otto" (as he was familiarly called) enter the family business.

As pedagogue, theologian, and poet, Kosegarten's role

in the intellectual development of Runge was profound.[3] He introduced the youth to pietistic ideals and showed him how to connect them with nature in poetic and visual metaphors. Kosegarten took over Runge's education around the time of the French Revolution, and his enthusiasm for it must have affected his young disciple. Kosegarten was strongly influenced by the ideals of the Revolution, which persisted even into the Napoleonic occupation of his country. In addition, Kosegarten spent much of his spare time translating the English poets and epic writers. He was as obsessed with Ossian as everyone else on the Continent and was certainly responsible for Runge's interest in Ossianic themes.

Gotthard Ludwig Kosegarten

It may be recalled that Kosegarten figured prominently in the intellectual life of Swedish Pomerania, although he himself hailed from a small town in Mecklenburg. One of his dearest friends in this period was Johann Gottfried Quistorp, nephew of the theologian and professor at the University of Greifswald. Quistorp, who also figures prominently in the lives of Runge and Friedrich, had studied painting in Dresden and from 1788 was the academic drawing instructor in Greifswald. But in the mid-1770s he studied mathematics and philosophy at the University of Greifswald. He and Kosegarten studied and hiked together, and Kosegarten dedicated his first publication *Melancholien* (1777) to Quistorp, who also did the designs for the title and end pages of the book (fig. 8.1).

Around the time of this publication Kosegarten began earning his living as a private tutor for prominent families on the island of Rügen. One such family was the Arndts, and it was in this way that Ernst Moritz Arndt received his first indoctrination in poetic writing. Kosegarten traveled up and down the island and got to know its "tausendfach gekerbten Rücken"—its "thousandfold cavernous ridges" and the wonder of Stubnitz and the Stubbenkammer. These sites inspired some of his finest poetry, and he ultimately became linked in the popular mind with a certain poetic rendition of Rügen's rugged terrain which he called "Deutschlands letzter Felsenspitze" (Germany's last crag). He gradually associated the often barren landscape with the past glory of the ancient Teutons, assimilating the ideas of

his heroes Klopstock and MacPherson and projecting them on to Rügen. Kosegarten was fascinated by the *Hünengräber* as evidence of this past glory, and in a poem on the subject he invoked the dolmen and the oak tree as metaphors for Germany's ancient heroes.

During the summer of 1784 he read and pondered Kant's *Kritik der reinen Vernunft,* which shocked and agitated him as it did so many of his contemporaries. The idea that the human mind is incapable of getting beyond experience and debarred from an apprehension of the infinite caused a great crisis in his intellectual life, but as he wrote in the dedication to Kant in his *Rhapsodieen* of 1789, he came to appreciate the role Kant assigned to the will, which acted at the highest level on the conviction that the world of appearances was the manifestation of an eternal—if unknowable—spiritual world. This instilled in him a certainty, an inner calm.

In 1785 he was appointed rector of the Stadtschule in Wolgast, a busy commerical town in Swedish Pomerania of nearly thirty-five hundred inhabitants. His first impression was hardly favorable: "This Wolgast is at first sight quite an unfavorable, chilling place. It is small and narrow. The lanes are crooked and bumpy and the houses within the walls are dirty and chaotically positioned. The pavement is rough and spiky."[4] But he noted that the high-vaulted church was light and airy and crowded with believers. He also wandered to the outer city and the harbor on the Peene River, which was full of ships. He liked the way the sailors and their families lived in long rows of houses along the shores. But he delighted above all in the old castle ruins, which he visited just after sunset. He was struck by the effect of the full moon and its illumination of the "dreadful ruins."

Eventually, he was presented to the leading families in the town, whom he described as "cold and prudent, quiet and reasonable, upright and formal."[5] They appreciated his complementary style, however, and he soon felt at home especially among the merchant community which dominated the town. He wrote a special bridal song for the wedding of Otto's sister Dorothea, and generally took over the private education of the Runge males (middle-class girls were lucky to receive primary education). Kosegarten's responsibilities as rector of the Stadtschule, however, engrossed most of his time.

The Stadtschule of Wolgast was originally a Latin school

that was gradually modified to accommodate middle-class needs. Kosegarten was certainly responsible for helping shape the new curriculum, which was divided into four classes; in the lowest no Latin was taught, but there was instruction in reading and writing German, religion, arithmetic, geography, and natural history. Next came Latin and Greek, and in the highest class the more difficult classical authors were studied. The program was too narrow to be prep school for a university, but it gave a cultured veneer to the children of the business community and supplied them with basic skills.

Kosegarten functioned primarily as a lackey of the expanding middle class who wanted to give their children polish and taste to help then in their own business careers. For this Kosegarten was ideal. His poetic and moralistic outlook perfectly suited the upwardly mobile burghers of Wolgast. The Runge family figures prominently in the subscription lists for Kosegarten's publications, and Daniel Runge, the successor to the family business, dedicated his first major poem to Kosegarten.

Kosegarten's participation in Otto's development was apparent on several levels. Runge's association of topography with patriotic devotion to homeland and fatherland (that is, to the national as well as regional ideal), and the faith of the idea of nature as a self-revelation of God, both stemmed from Kosegarten. The worship of God in nature was stimulated by the English Georgian nature poets such as Gray, Thomson, and MacPherson, all of whom Kosegarten drew upon for inspiration. His sermons breathe the heady air of their sentiment; in June 1784 he preached a sermon based on an interpretation of Psalm 19 that included references to the sun, moon, stars, cedar trees, eagles, caterpillars, cheese, people, and mites as heralding "omnipresent Nature, which is God's first, oldest and all-knowing revelation."[6] Elsewhere Kosegarten defined beauty as the "Göttliches in der Nature"—the Divine in nature.

Runge's famous rhapsody on Christian salvation in nature resonates with Kosegarten's ideas:

When above me the sky swarms with countless stars, the wind blusters through the wide space, the wave breaks roaring in the wide night, over the forest the atmosphere reddens, and the sun lights up the world . Every leaf and every blade of grass swarms with life, the earth is alive and stirs beneath me . . . There is no up and down any more, no time, no beginning and no end, I hear

and feel the living breath of God, who holds and carries the world, in whom everything lives and works.[7]

Kosegarten's faith in nature as the herald of the divine was sparked by the excitement caused by contemporary astronomical and botanical studies at the University of Greifswald. The university owned both an observatory and a major botanical garden and joined to their theological course a major program in the sciences. Since Greifswald was attended by a major contingent of the scions of well-to-do Swedish and German burghers, the curriculum stressed those sciences that were most useful for the mercantile classes. Astronomy was crucial for navigation (Greifswald was also a harbor town that depended on the university's meteorological and nautical tables), and botany, as we have seen, was considered essential for understanding both colonial and homegrown foodstuffs and other natural products. Comparable to the University of Maine in the United States, Greifswald's institution of higher learning taught principles of commerce, civil engineering, navigation, accounting, astronomy, geography, and surveying along with is solid liberal arts curriculum. But the university held that the discoveries of science sustained and explained the revelations of the Bible. Kosegarten's verses are filled with scientific metaphors for the divine, like "edle Elektron" (noble electron) and the "exalted power of the Magnetic Current."

Kosegarten studied widely in natural history, including geography, geology, and botany. His description of his environment in Wolgast attests to a profound knowledge of plant and floral life. Botany occupied pride of place in Greifswald's curriculum and the university's botanical garden was the delight of the townspeople. The first major botanist on the staff was Samuel Gustav Wilcke, a student of Linnaeus. Typically, he was also a theologian and pastor, but his lectures in botany and entomology shaped the natural history curriculum at Greifswald. His 1769 publication of *Flora gryphica* disseminated the methods of Linnaeus and established the university's international reputation. He was followed by Christian Ehrenfried Weigel, a physician in the mode of Darwin who taught botany and published a handbook of the flowers in Swedish Pomerania. His successor was the younger brother of Quistorp, who took over the botanical garden in 1788. The strong connection between Greifswald's botanical program and Kosegarten's scientific interests reveals itself in his poetry, a volume of

which he entitled *Blumen* (Flowers). Given Kosegarten's lifelong fascination for flowers, it is not surprising that Runge perceived them as the essence of great art. It was while he was a pupil of Kosegarten that he began cutting silhouettes of floral designs, which formed the basis of his mature art.

Throughout his career Kosegarten either translated directly or did variations of works by leading English writers. These include Milton's *Hymn to the Morning*, Gray's *Elegy in the Courtyard*, Thomson's *Seasons*, Young's *Night Thoughts*, and large segments of the Ossianic lore. Here again his identification with evocative, doleful, sublunary landscapes was reinforced in the public mind. Who else could have seen in the moonlit Wolgast harbor "a splendid Ossianic view, simultaneously beautiful and gloomy"?[8]

Wolgast's hardnosed business types were anxious for their children to learn English. Wolgast not only carried on direct trade with England, but as in the case of the Runges, most of Wolgast's merchants traded through Hamburg, whose commercial relations with England had steadily increased since the outbreak of the Revolution. Hamburg's advantageous position on the German North Sea had long marked it out as the port for bringing the north German plain into touch with England, and English firms established branches in Hamburg, and notable families even took up residence in nearby Altona. While Hamburg's population was international and embraced exiles of all kinds, English fashions and culture dominated the ideals of the prosperous merchant community, which prided itself for cosmopolitan and innovative ideas. Kosegarten's role in the education of the Wolgast children clearly stressed preparation for this fashionable world as much as the more pedantic fare typical of the Latin or grammar schools.

Meanwhile, Kosegarten's duties interfered with his own personal endeavors, and he labored to advance his career. In typical eighteenth-century fashion he dedicated his work to those most favorably positioned to further his ambitions. The dedication of his translation of Goldsmith's *Roman Tales* to the Swedish crown prince Gustavus Adolphus resulted in Kosegarten's appointment to the parish church of Altenkirchen in Wittow—the northernmost part of the island of Rügen. He assumed charge of the rich land controlled by the parish and took an active role in local politics. His fight against feudalism and defense of laissez-faire economics made him an opponent of the old regime and susceptible to the reformist ideals of the next decade.

The Hamburg Group

Runge's opportunity for developing his artistic and literary skills came about paradoxically as the result of his apprenticeship from 1795 to 1799 in his brother's Hamburg shipping and provision firm. Hülsenbeck, Runge, and Company handled just about everything in its warehouse, including decorative art objects, and was backed by Runge's father and other Hamburg investors. The Hamburg group, while pursuing their daily business activities, participated in a kind of "think tank" analogous to the Lunar Society. The book dealer Perthes, the merchants Friedrich August Hülsenbeck, Johann Friedrich Wülffing (also a business partner of Runge), and Johann Michael Speckter, the painters Gerdt Hardorff and Heinrich Joachim Herterich, and the poet Matthias Claudius (Perthes's father-in-law from 1797) engaged in lively intellectual and political debate in the Runge household in Hamburg. Their sphere of influence embraced the local business and intellectual leaders, and many of them left a lasting imprint on the city during the Napoleonic era. They encouraged the artistic development of Runge, who, when not occupied with his clerical duties, engaged with Daniel's friends in discussing the "mostly poetical and philosophical writings of the present and the past."[9]

One formal and institutional expression of this group was the Hamburgische Gesellschaft zur Beförderung der Künste und nützlichen Gewerbe (Hamburg society for the advancement of art and the useful crafts), popularly known as the "Patriotische Gesellschaft."[10] Founded in 1765 by private initiative, it was modeled upon William Shipley's Society for the Encouragement of Arts, Manufactures, and Commerce in London and the societies of Amigos del País in Spain. The industrial arts—relating mainly to textile manufactures—were especially promoted; courses in architecture, founded in 1767, soon comprised freehand and decorative drawing; in 1778 a special school in decorative painting was added; and by 1791 a full-blown school for neophyte artists, artisans, and factory workers was servicing a large student body. The emphasis was on the applied arts, although it was hoped that the encouragement offered to the crafts would induce fine artists to contribute to the general improvement of taste among industrial designers. During the decade 1790–1800, the Patriotische Gesellschaft sponsored five exhibitions in which were displayed works of arts, various mechanical models, and new inventions.

This was the authentic artistic ideal of Hamburg's business elite, which strongly influenced Philipp Otto Runge, who studied under Hardorff, one of the teachers at the drawing school, and followed the progress of the society which he later joined.

The applied arts dictated the rest of Runge's career. He could never have convinced his father to allow him to strike out as an artist or even rationalized his artistic activity for himself without justifying it in straight commercial terms.[11] His first idea, worked out with his brother, was to expand the Hamburg business with a stock of fine art goods. Daniel had begun dealing in works of art, prompted by the stream of pictures pouring into Hamburg as a result of the French Revolution. He hoped to sell at bargain prices a wide variety of pictures and prints, and for a moment toyed with the idea of sending Otto to London to negotiate with printsellers. Hülsenbeck, Runge, and Company's art dealing did well for a time, and the partners even hoped to engage J. H. Tischbein—who ran a commercial print workshop in Naples—in their affairs. Long after he left Hamburg, Otto purchased paintings and etchings he thought could sell and sent them to his brother.

The popularity of prints in this period sprang from a demand for decoration. While the walls of good houses had traditionally been paneled with wood, wood was no longer popular because it harbored vermin. Hangings, murallike decoration, and prints for bare walls increasingly came into vogue. The Runges tapped into this burgeoning market for home decoration, a decisive move for Runge's career, as his original plan as an artist had been to make his living as an interior decorator for the very rich.

Runge outlined his "life's plan" for his father in a letter of 13 January 1803, emphasizing that "the whole taste and preference of the day runs in the direction of elegance, fine decoration and ornamentation" and that he was most qualified to satisfy this fashion.[12] He planned to package something solid within an ethereal wrapping, which for him was "very easy, since I have already carried out with great success beautiful room decorations [*Zimmerverzierungen*], which nevertheless express my complete concept of art." Runge boasted that these had been enthusiastically received by everyone, "including old Graff, who exclaimed, "Bless my soul, I wished I had done that!" Runge claimed that he knew people in Copenhagen and elsewhere who could work according to his specifications and that he could tap into the new art school for artisans being organized at

Hamburg. It would be a workshop as existed in the time of the Renaissance and develop the skills of workers under his direction. At the same time it would provide a kind of showcase, akin to a "model home," where people could visit and order a particular set of decorations.

To be sure, Runge's letter exaggerates his practical intent to please his father, but earlier he had written Perthes of his dream to decorate "an entire house" and had observed that, of all his possibilities "interior decoration is the most fertile."[13] Runge's contacts in Copenhagen were made when he studied at the Royal Academy of Fine Arts (Kongelige Akademi for de Skøonne Kunster) from November 1799 to March 1801.[14] Like many academies in the Age of Enlightenment, the Copenhagen art school had been revamped to advance the level of taste in industrial goods. The regulations of 21 June 1771 created a basic course for artisans, with the goal of raising the level of taste in manufactures and crafts and producing homegrown designers to obviate the need of hiring foreigners. The influence of the curriculum on Runge helps clarify his remark on the ready pool of workshop collaborators in the Danish capital.

Close political, economic, and cultural ties existed between Hamburg and Denmark. Nearby Altona was under Danish suzerainty and a major mercantile center where many Hamburg business leaders took up residence. The Danish kings encouraged an extensive planting of trees in Altona, and it became a town of open spaces and parks which attracted the wealthy merchants who did business in Hamburg. There was also greater religious tolerance under Danish rule, and taxes were lower than in Hamburg. Johann Friedrich Struensee, the reformist minister of Christian VII responsible for the modifications in the academy's program, had been a leading physician in Altona. Danish sovereignty also extended to the duchy of Holstein, where many of the privileged elite in the circles of Perthes and Daniel Runge lived. Indeed, German influence in every sphere of Danish life was so preponderant by the end of the century that widespread protest broke out against a presence represented only by noble families and German merchants who amassed riches in Copenhagen.

As representative of a German firm, Runge undoubtedly felt his political situation deeply. He was not simply in Copenhagen to train as an artist but also to act as agent in the purchasing of prints for the Hamburg firm. While in a letter written to his father just prior to leaving for the Danish capital Runge claimed he wanted to put all thoughts of art

dealing aside, he also emphasized that "nothing good can come of the trade unless I have a name as an artist to give weight to my judgment."[15] His unease in this respect is shown in his bizarre dream that he described in a letter to Daniel of 31 March 1800. The Danish crown prince arrived with his retinue for the distribution of the prizes of the academy, and rebellion broke out among the students, who fought the soldiers and smashed the antique casts in the cast room (Antikensaal). Runge himself, together with other "unarmed brave young artists," helped drive back the rebels.[16] Runge was also alert to the political unrest of Danes in their conflicts with the English. In 1798 the convoys of the Danes and Swedes were increased to protect their shipping from privateers, but England, who reserved the right to seize goods owned by belligerent powers even when under a neutral flag, regarded the convoys with suspicion. On 25 July 1800 a Danish frigate, *Freja,* and six merchant ships under its protection were captured in the English Channel, and the British dispatched a squadron of nineteen warships to the Sound (Øresund). A lively exchange of state papers took place, and for almost a month each side stubbornly refused to make concessions, but by 29 August they arrived at an agreement whereby Great Britain restored the ships and Denmark suspended temporarily the grant of convoy. Runge's letter to his brother a week earlier noted with apprehension that everyone was "deeply uneasy" about the English, that batteries were being set up at the castle, warships rigged, and several Danish regiments marched to Helsingør. He noted that the cost of three potatoes in Helsingør had risen to a schilling and that everything was in chaos.[17]

In this very period Runge was preoccupied with Flaxman's illustrations for the *Iliad,* the *Odyssey,* and *La divina commedia.* We have already seen to what extent Flaxman's outlines sprang from the demands of the Industrial Revolution and their powerful impact on the work of his younger contemporaries. Runge responded with great enthusiasm to the copies of Flaxman's illustrations that Daniel sent him in August 1800. He described his reaction in the same letter of 23 August in which he observed the anxious climate in Copenhagen over the confrontation with the English: "The Flaxman contours—I thank you for them with tears. My God, this is something I have never seen before in my life."[18] He claimed that the contour studies of actual "Etruscan" vase paintings that a friend loaned him would now have to be set aside. Runge waxed more enthusiastic

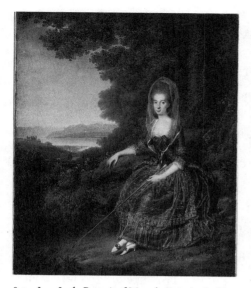

8.2 Jens Juel, *Portrait of Mme de Prangins in Her Park*, 1777. Statens Museum for Kunst, Copenhagen.

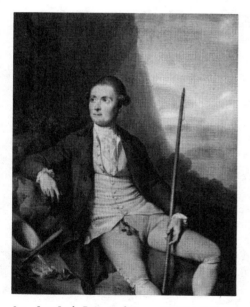

8.3 Jens Juel, *Portrait of Horace-Bénédict de Saussure*, 1778. Bibliothèque publique et universitaire, Geneva.

over Flaxman's industrial style than over authentic ancient designs. Flaxman's imagery must have reinforced Runge's own ideas for interior decor. He also asked Daniel to send him a copy of the Dante illustrations that had been commissioned by Thomas Hope (Runge did not know of the ban on its publication), the same patron whose *Household Furniture* disseminated the updated fashion of neoclassicism. English military and technical superiority impressed Runge's young mind bent on innovating in the realm of the decorative arts.

This ambition would have been sustained by his two principal teachers at the academy, Jens Juel (1745–1802) and Nicolai Abildgaard (1743–1809).[19] Juel painted the bourgeois environment in landscape and in portraiture, while Abildgaard actually painted ceilings and classical friezes and designed furniture for bourgeois and royal houses.[20] Juel's *Portrait of Mme de Prangins in Her Park* of 1777 depicts the Genevan aristocrat with a few of her family manors in the background with an imposing view of the Alps (fig. 8.2). His interest in geology in relationship to topography may be seen in his portrait of the Alpine explorer Horace-Bénédict de Saussure, represented together with the tools of his trade (fig. 8.3). Abildgaard had been trained in his youth as a house painter and throughout his life remained close to the artisan's situation. His appointment to the academy in 1778 reflected the changed conditions brought about by Struensee's earlier reforms in favor of crafts and manufactures. At the same time, Abildgaard's bizarre moonstruck depiction of *Ossian* (c. 1785, Statens Museum for Kunst, Copenhagen) and *Fingal's Vision of His Ancestors* (c. 1782, Statens Museum for Kunst, Copenhagen) share with painters like Fuseli and Wright of Derby a scientific interest in meteorology. Their histrionic character points to the theatrical interests of Frederik VI, while the subject matter takes off in the patriotic direction begun by Johannes Ewald, whose drama *Rolf Krage* was profoundly affected by the Ossianic mood and style.

Just before Runge arrived Abildgaard had completed a series of five grisaille decorative friezes for one of the four Amalienborg palaces, then known as the Levetzau Palace. They were designed as part of the overall interior refurbishing (including furniture) which Abildgaard executed for the king's brother Frederik, the heir presumptive. The grisailles were done for the audience room of Frederik's son Christian and depict the history of Achilles (fig. 8.4). As we shall see in a moment, Abildgaard's grisailles affected

8.4 Nicolai Abildgaard, *Achilles among the Daughters of Lykomedes*, c. 1794–1798, grisaille. Statens Museum for Kunst, Copenhagen.

Runge's first major art production, which was also planned as an interior embellishment.

In addition to Juel and Abildgaard, Runge profited from the guidance of Frederike Brun (a highly cultured artist and poet obsessed with antiquity), who introduced him to the drawings after the ancient vases, which Runge relegated to the dustheap after seeing Flaxman's illustrations. Brun had studied under Wilhelm Tischbein, who executed or supervised the execution of the copies of Sir Willim Hamilton's second vase collection.[21] Published in the period 1791–1795, Hamilton's catalogue was yet another effort to publicize his holdings and place himself in the forefront of advanced taste. (Brun herself, who hosted a brilliant salon where she promoted neoclassicism, was a kind of Danish counterpart to Hamilton.) Hamilton claimed to deliberately avoid the elaborate reproductions of his first set and confine the illustrations "to the simple outline of the fig-

8.5 Philipp Otto Runge, copy of plate 17, vol. 2, *Peintures des vases antiques de la collection de son excellence M. le chevalier Hamilton,* 1791–1795.

8.7 Philipp Otto Runge, copy of plates 27 and 61 of Hamilton's *Vases antiques*.

ures on the vases" and thus reduce the costs for himself and young artists who would want to use the works as models. Tischbein, director of the Royal Academy of Painting in Naples, was commissioned to hire a team and oversee the production of the copies.

These contour drawings, and probably sight of the published engravings, not only inspired Runge but prepared him for the more polished and breezy outlines of Flaxman. Runge hoped for a moment to study under Tischbein, and on another occasion he and Daniel hoped to induce Tischbein to "mass-produce" prints for their art trade. Both brothers joyfully anticipated the prospect of Tischbein teaching at the industrial art school run by the Patriotische Gesellschaft.[22]

Runge copied plates 17, 27, and 61 in volume 2 of Hamilton's vase collection, either directly or through the mediation of Frederike Brun's drawings (figs. 8.5–9). The practice of using contour in this way spread to his academic work when he began sketching the plaster casts in a similar way (fig. 8.10). He also began exploring more complex compositions while still using the simplified outline technique. One ink drawing of figures outlined against a dark background comes straight out of the Tischbein copies and is important for its relationship to the later independent picture, *The Nightingale's Lesson* (figs. 8.11–12). Thus months before he discovered Flaxman, Runge was already using the industrialized patterns of neoclassic artists and patrons in his academic training.

While in Copenhagen Runge received his first commissions for decorative work, which naturally attempt to syn-

8.8 Plate 27 of Hamilton's *Vases antiques*.

8.9 Plate 61 of Hamilton's *Vases antiques*.

8.10 Philipp Otto Runge, *Head of Meleager*, c. 1799, chalk drawing. Hamburger Kunsthalle.

thesize the influence of his mentors. The first of these, *Triumph of Amor,* was already conceived in 1797 as a decoration for Hamburg broker Gerhardt Joachim Schmidt, who had a notable collection of prints and drawings and hosted regular meetings of artists and connoisseurs.[23] The first sketch in ink and wash of 1800 shows the god of love playing his lyre and being transported in a procession by childlike sprites who cavort affectionately as they parade their hero. It is a rather amateurish effort that manifests a lingering rococo quality in both composition and subject, arranged along a diagonal coming out of a billowing cloud. Juel and Abildgaard must have offered their suggestions for

8.11 Philipp Otto Runge, *The Effect of the Comic and Tragic Masks*, c. 1799. Hamburger Kunsthalle.

8.12 Philipp Otto Runge, *The Nightingale's Lesson*, 1805. Hamburger Kunsthalle.

8.13 Philipp Otto Runge, *Triumph of Amor*, 1802. Hamburger Kunsthalle.

improvements. This initial attempt, however, inspired a second version, which was executed in Dresden after leaving Copenhagen in March 1801 (fig. 8.13). Planned as a decoration above the door of the music room (Tanzsaal) of his brother Jacob's new house in Wolgast, this version was done in grisaille (gray monochrome paint) and in the style of a frieze, showing the influence of Tischbein and Flaxman. It bears a striking resemblance in its technique and function to Abildgaard's decoration for the Levetzau Palace, and generally, it conforms to the current neoclassic taste of Hamburg's merchant classes. While Runge described the work as an example of the power of love from early youth to old age, what we see is merely a commonplace use of putti for a decorative frieze.

A short poem by Herder, published in Schiller's *Musenalmanach* for the year 1796, was the inspiration:

Love, a Wagon carries you, pulled by butterflies
And you reign so gently over all, playing the lyre!
Virtuous God, never let, never let the fetters touch you;
Under the melodious sound fly willingly and happy.

Herder followed Rousseau in praise of childhood, recommending the image of Amor as a noble motif for the fine arts, not merely for decorative but for symbolic purposes. The highest expression of childhood is love, and adulthood has the responsibility of replenishing childhood and maintaining its loving qualities.

Runge shows the child figures holding flowers, testifying to his fascination with botany and to the symbolic value he attributed to floral forms. While his later works assign them a more prominent role in the thematic and decorative structure, they remain for him primarily associated with childhood and generation. Flowers had an anthropomorphic character for Runge, identified with the beginning of a new, universal life cycle. Indeed, Runge had always studied, drawn, and cut silhouettes of botanical specimens.

Among his earliest works are the silhouettes of flowers done at the time of his training under Kosegarten.[24]

Runge's multilevel understanding of botanical forms was inseparable from his belief in nature as a self-revelation of God, a hieroglyphic script to be intuitively grasped. Here he revealed his involvement with the new philosophical directions sparked by Kant and developed by Fichte and Schelling. Runge studied their work and once regretted missing an opportunity to hear a series of lectures on Kant at the University of Göttingen. During a trip to Berlin, Runge had shown his work to August Schlegel and Fichte. Fichte had been very moved and wanted to see the work again, since he felt that one view was not enough to do justice.[25] Runge's knowledge of Fichte's philosophy is evident in a letter to his father of February 1810 that states, "Our life, from non-existence on up to the highest existence is only developed to the level of personality and effectiveness through activity." Runge aligned himself with Schelling when he wrote to him to discuss the philosopher's *Philosophische Untersuchungen über das Wesen der menschlichen Freiheit,* having found in the work a confirmation of his own search for a "total relationship of all appearances."[26] He mentioned that he planned to read it a second time to get a better grasp of its ideas, and that he intended to send him a drawing he did to illustrate the cover of a theater almanach.

Henrik Steffens

Runge's relationship to German idealist philosophy came through a number of channels but was undoubtedly motivated by his links with the Danish natural philosopher, Henrik Steffens.[27] As noted earlier, Steffens is important to this study because of his close ties with the arts and sciences and his participation in the Wars of Liberation between 1813 and 1815. He is a symbolic and actual linchpin in this madcap period of German history.

Steffens first studied botany at the University of Copenhagen in 1790 under Martin Vahl, the leading Danish disciple of Linnaeus. In the mid-1790s he was in Hamburg and in 1796 entered the University of Kiel, where he lectured and completed his dissertation, *Über die Mineralogie und das mineralogische Studium* (On mineralogy and the study of mineralogy). While at Kiel he came upon Schellings *Ideen einer Philosophie der Natur* (1797), which changed his life. The idea of combining scientific ideas with German idealist

philosophy began to form in his mind, and he took off from Hamburg in 1798 on a pilgrimage through the Harz Mountains, to Erfurt and then to Jena, researching "geognostic" phenomena—evidence of geological history—and in his spare time reading Fichte's *Wissenschaftslehre* in the Thuringian woods. Back in Jena he met Schelling, and the two developed a close discipleship. Steffens married the daughter of Reichardt, thus making him a distant relative to Tieck, whom he would meet again in Dresden in 1801. The same halcyon year Steffens went to Freiberg to study with Werner and ever after numbered himself among the Vulcanists.

In 1801 Steffens published his *Beyträge zur innern Naturgeschichte der Erde,* an attempt at marrying the systems of Werner and Schelling and showing the unity of nature and history (the science of which was "geognosy") as part of the divine intention. The same year he went to Dresden and saw Tieck often. They engaged in long conversations about natural philosophy and geology. Steffens expressed his belief in the existence of a relationship between nature and the life of the human soul. He also explained his deep interest in the folktales of the North, how they often reveal the character of their locale in the relation of saga to climate, topography, and other conditions. These conversations inspired Tieck's tale, *Der Runenberg,* written in 1802 and published the following year. It is a story of the enticing power of mountains, and the greed for the mineral treasures that they contain. The allure of subterranean rocks and metals was certainly obvious in Dresden and generally in Saxony, with their dependence upon the mineral riches mined from the Saxon Mountains. In fact, the distinguished Germans engaged in mining or who studied under Werner (including Goethe and Novalis, both of whom exploited mining incidents in their fiction) demonstrates the importance of geology and its close connection with a mining economy.

Der Runenberg is notable for its anthropomorphism. The protagonist, Christian, is resting high up in the mountains, in a profound state of depression. Whenever he pulls a mandrake root, a plaintive tone seems to issue from it. His father, a gardener in the distant lowlands, had often told him tales of the mountains, cliffs, and subterranean mines. Christian longed to visit them and does, ignoring his father's advice to be content with a gardener's life.

At the peak of his ascent Christian finds a wall that seems to reach into the clouds. He discovers a hall rich in stones and crystals, in which a stately woman of supernat-

ural beauty paces to and fro with a torch. When Christian takes the tablet she gives him, it all vanishes. In a daze he descends and discovers a pleasant village, where he meets a young woman named Elizabeth. Her father, a prosperous farmer, makes him his gardner, and he and Elizabeth marry and they have a daughter. In his happiness, Christian yearns to see his parents once more.

Setting out on his mission, he meets an old man who gazes intently at an unusual flower. The man is his father, and the flower possesses the power to prophesy the future, foretelling the father's reunion with his son. Christian learns of his mother's death and takes his father to see his new family. Life is harmonious again, and several more children are born to Elizabeth and Christian. One day a stranger, who seems familiar to Christian, stops at their home. He stays for a lengthy period, but leaves a great store of gold in Christian's care. Christian is sorely tempted by the gold but tries to overcome his temptation, recalling now that the stranger was in reality the strange woman in the mountain. He becomes fearful of flowers and plants and hears a groan whenever he uproots one. Plants are now to Christian symbols of decay, and his father concludes that his heart has turned to cold metal since he is drawn to wild crags instead of lovely gardens.

The stranger returns, this time in the form of an old hag, who introduces herself as the *Waldweib* (forest woman) and leaves again. Christian now dashes off to find the *Waldweib* and fails to return. Elizabeth remarries. One day a wild-looking man carrying a heavy load accosts her, claiming to have come down from the mountains with rich treasures. To Elizabeth's horror they are ordinary fieldstones of flint and quartz. It is Christian gone mad, and he disappears again, never to return.

Christian's "madness" is his romantic obsession with the idea of the Infinite, symbolized often by high mountains. The ordinary fieldstones of flint and quartz are precious treasures to geologists searching for the origins of mountains. Christian's demand for a more expansive existence leads him to abandon the narrow world of the plan. In the end—mad, barefoot, and wearing a crown of leaves—Christian has been able to reconcile the organic and inorganic poles of existence, the plants and the rocks. As in the case of the prophetic flower, the organic material on the plain points the way to a higher existence.

Steffen's geology, Tieck's "nature sense," and Runge's preoccupation with plants share the pantheistic world view

of the German idealist philosophers. In Steffens's most important work, *Geognostisch-geologische Aufsätze als Vorbereitung zu einer innern Naturgeschichte der Erde* (Geognostical-geological essays as preliminary to an internal natural history of the earth), he noted that geognosy was "a science of our own time, and of thoroughly Germanic origin."[28] Published in 1810, the work clearly signals the new national awakening in which Steffens took a leading role. After he lost his position at the University of Halle in the wake of Jena and Auerstädt, Steffens once again took to the road in the Holstein, Hamburg, and Lübeck areas, searching for his "roots." He became close to Scharnhorst and Gneisenau, and during the years 1813–1815 fought valiantly in the Wars of Liberation.

In the section following his statement about the Germanic sources of geology (having in mind Werner's pervasive impact) Steffens writes that he seeks to understand the structure of mountains. He laments that in Germany, even more than in other European lands, there is no single mountain chain that is totally known. He refers to Linnaeus's descriptive botanic and zoological systems as providing a common language that united all natural scientists, noting also that Linnaeus had the advantage of belonging to a powerful and unified "trading nation," which permitted him special channels for disseminating his ideas.[29]

The longing for national unity and power motivated Steffens to literally get to the "core" of geological evolution. This was his way of demonstrating Schelling's contention that God and Nature form part of an indivisible whole. By studying the earliest rock formations, Steffens was simultaneously making a claim for this transcendental unity. It is no coincidence that he begins his investigation with an analysis of the "external appearance" of the duchy of Holstein. Steffens's father was born in Holstein, and much of his patronage emanated from the same Holstein nobility that backed Perthes. The close connections of the Holstein nobility with the University of Kiel helped land Steffens a position there in 1796. These links explain why the first part of his book deals with geology of northern Germany either under Danish control or having been subjected to it in the past, such as Jutland, Holstein, Schleswig, and Mecklenburg. His attempt in his mountain research to hit "bedrock" is akin to his search for national identity in a fusion of God, Nature, and Germany.

In the preface to his book he noted that he had long pon-

dered how to render his "picture" (*Bild*) of external appearances.[30] Before achieving a successful picture, painters must examine a wealth of observations from which they must make a selection with their color relationships, the effect of light and shadow, and the mathematical relationships of the form in space. Just as the final result yields a scene in which the particulars are subordinated to the general effect, so Steffens would examine the apparent differences of individual phenomena and create the total picture by emphasizing some things and submerging others. The work of art is a model for Schelling's idea of the unity of the world resulting from thought. It is the individual's perception of the world that gives it unity. Out of the welter of sensations and experiences the self organizes a totality. As in the case of the artist painting a landscape, the different parts must be balanced and arranged with reference to each other. But it is the artist's mind that organizes it into a whole. When Steffens talks of the links between soul and nature he is thinking of the unity and organization that belongs to the self.

The same year that Steffens published *Geognostisch-geologische Aufsätze* Runge brought out a pamphlet on color theory, *Farbenkugel* (Colorsphere).[31] Runge studied color thoroughly and systematically, illustrating the relationship of color mixtures to each other, their hues, values, and saturation index, so that all the color nuances are seen at a glance. In addition to these practical demonstrations, Runge elsewhere developed a theory of the psychology of color perception and analyzed color as emblematic of the unseen forces in nature. Published by Perthes, it contained a supplementary essay by Steffens on the signification of color in nature (*Über die Bedeutung der Farben in der Natur*), which expands the artist's views in scientific terms. For both, color is a source of harmony in art and nature, indispensable to the unity with the world intuited by the artist as philosopher. The three primary colors symbolize the Trinity, and Runge generally associated cosmic ideas with color, which he organized in ingenious geometric diagrams. His color symbolism also served as a metaphor for universal creation, exemplified in his hexagon where red means the "ideal," and reading clockwise, blue and violet "women" and the "female passion," green the "real," yellow and orange "man" and the "male passion" (figs. 8.14–15).

The connection between Runge's *Farbenkugel* and German philosophical idealism is seen in the above-mentioned

8.14 Philipp Otto Runge, figure of Creation in *Farbenkugel,* 1810.

8.15 Philipp Otto Runge, diagram of color symbolism in *Farbenkugel.*

letter to Schelling of February 1810, notifying him that their "mutual friend" Steffens will supply an essay for his color treatise. The treatise was also basic to Runge's self-perception as decorative artist, since he sent a version of the work in manuscript to one of the leaders of the Patriotische Gesellschaft as a sign of his admiration for the organization, and it was clear that in writing it he had both the "craftsman and the artist" in mind. Runge's preoccupation with color began in 1806 and continued through the publication of his pamphlet in 1810—a period coinciding with the Napoleonic incursions into northern Germany. Ironically, almost exactly a year before Jena and Auerstädt Runge's friend Klinkowström wrote that it was now time to take sides against Napoleon. He related a popular anecdote then making the rounds that had the French emperor rejecting the idea of a German library in Paris because, even if it were filled with books on the exact sciences, "the Germans cannot talk about chemistry and physics without mentioning politics." [32] And later the same month Runge wrote his father condemning French "impudence" and warning that a coalition of nations was necessary to stop "the boundless misery that the French will bring into the world." In November 1805 Runge worried about the French threat but felt that in the end "we will triumph with God's help." As early as 14 June 1806 he wrote Daniel about his anxieties over the possibilities of the Swedish king opposing Napoleon successfully, and he prayed that the French would not "devour Germany." [33] When rumors spread that the Prussians would defeat the French, he then worried about Prussia's growing power, but implied that victory over the French would be the lesser of the two evils. And the ultimate defeat of the Prussians devastated Runge, who anticipated the tyrant's yoke. The French took temporary possession of Hamburg in November, and the imposition of the Continental blockade bankrupted Daniel, who owned a large stock of English goods. Runge was obliged to curtail his painting and come to the family's aid. No wonder that he could write sometime in 1806, "Color has such a friendly appearance, that I always see it with fresh delight, now with all its tints, like the spirits [*Geistern*] of the light, it nestles in and penetrates all physical forms, bringing the heart closer and closer to the Heavenly Fatherland [*das himmlische Vaterland*], so that the more spiritual and transparent the substance of the body is, the deeper and more heartfelt it can be united with color and penetrated by the light." [34] Color is a force for organizing

Fig. 4.

§. 14. Es ist daher das zweyte Dreyeck GrOV eben so groß wie das erstere BGR anzunehmen, und man wird sich jetzt die Totalität aller grünen, orangen und violetten Mischungen in ihrer wahren Richtung so vorstellen können, als wenn das Dreyeck GrOV sich um die Achse WS zwischen den Puncten B.G.R. hin und her bewegte, und so den ganzen Kreis bildete.

Fig. 5.

§. 15. Beide Dreyecke, oder das vorhin (Fig. 4.) aufgestellte gleichseitige Sechseck, enthalten, in der Folge: Blau, Grün, Gelb, Orange, Roth, Violett, die sogenannten

8.16 Diagram in Runge's *Farbenkugel*.

8.17 Diagram in *Annalen der Physik,* 1804, vol. 18, plate 3.

the self and uniting it with the higher order of things, here the "Heavenly Fatherland."

Runge and Science

Runge's seeming mystical world view was thoroughly grounded in contemporary science. Steffens tells us that Runge worked closely with a color chemist in Altona and made many scientific experiments with color.[35] Runge's scientific bent is shown in the fact that his diagrams follow the model of those regularly reproduced in the plates of the *Annalen der Physik* (figs. 8.16–17). Steffens dedicated his *Geognostisch-geologische Aufsätze* to Johann Albert Heinrich Reimarus, the Hamburg physician and scientist who published in the fledgling German journal of physics. *Annalen der Physik* printed extracts from leading foreign journals and maintained affiliation with English, Swedish, and French scientific societies. Its editor, Gilbert, was a familiar figure in Steffens's circle and had links with members of the Lunar Society like Darwin and Priestley, who published in his journal.[36] Significantly, Reimarus was a close friend of Erasmus Darwin, with whom he shared many interests.[37] They had known each other since their student days at the University of Edinburgh and kept up a correspondence over the years. Reimarus was deeply involved with all as-

pects of contemporary science, including botany. We know that *The Botanic Garden* had a following in Germany, principally among the disciples of Schelling. Although the English traveler and writer Crabb Robinson declared that Darwin was a favorite subject of ridicule for Schelling and his disciples, it is clear that they knew and profited from his writings.[38] One of Schelling's disciples, the natural scientist Gotthilf Heinrich von Schubert, contemplated doing a German translation of Darwin's work on the advice of Herder's widow, who owned a copy of *The Botanic Garden*.[39] Herder had felt the need for a complete German translation to make available to students this poetic exposition of the Linnaean system. Herder himself had written in his *Ideen* that Linnaeus's system constituted a classical pattern for other sciences, including anthropology. As he exclaimed at one point, "What a field of observation is opened to us, in the association of plants with man, could we pursue it!" He noted the extreme dependence of human beings on plants, "which maintain the health of the creatures that destroy them; and even their deaths are beneficent, they improve the Earth, and fertilize it for new beings of your own species." And he analogized between plants and humans:

As long as man is growing, and the sap rises in him, how spacious and pleasant seems to him the World! He stretches out his branches and fancies his head will reach the Heavens. Thus Nature entices him forward in life; till with eager powers, and unwearied exertion, he has acquired all the capacity she wished to call forth in him, on that field, or in that garden, in which he had been planted by her hand. After he has accomplished her purposes, she gradually abandons him. In the bloom of spring, and of our youth, with what riches does Nature everywhere abound! Man believes this world of flowers will produce the seeds of a new creation.

Herder's obsession with flower analogies is seen again in this declaration: "As the flower stands erect, and closes the realm of the subterranean inanimate creation, to enjoy the commencement of life in the region of day; so is man raised above all the creatures, that are bowed down to the earth. With uplifted eye, and outstretched hand, he stands as a son of the family, awaiting his father's call."[40]

Thus Herder's responsiveness to Darwin's work is perfectly understandable. Schubert actually completed a translation, owned by Herder, for the entire work, but for some reason it remained unpublished. Nevertheless, Schubert, a

close friend of almost everyone mentioned in this chapter, including Steffens, Arndt, Reimarus, and Friedrich, continued to promote Darwin's work among his friends. The spread of English ideas, and the intimate links between botany, colonial wars, and the national commerce and industry, made this a topical subject for Runge's business and social circles. It may even be claimed that the so-called unattainable blue flower of Novalis's *Heinrich von Ofterdingen* was in reality a material symbol of the contemporary celebration of botanical studies.

Runge, who derived inspiration from Herder's writing for his *Triumph of Amor,* wrote often about flowers in a similarly effusive vein: "The pleasure which we experience in flowers, that really still originates in Paradise. Thus we connect inwardly always a meaning with the flower, therefore a human figure, and that only is the true flower which we have in mind in our joy. When we thus perceive in all of nature only our life, it is clear that only then can the true landscape come about in complete opposition to the human or historical composition."[41] According to Runge, people would gradually get used to the idea of associating a given figure with a specific flower species in their minds, when viewing landscape painting, and eventually be able to abandon figures altogether. While he never achieved this goal in his own work, landscape was crucial to his theoretical outlook, and he claimed as early as February 1802 that "everything gravitates to landscape." Landscape is the totality of its plant life, and the array of colors of botanical forms. As he declared, "Flowers, trees, figures will then become intelligible—and we shall begin to understand color! Color is the ultimate in art. It is still and will always remain a mystery to us, we can only apprehend it intuitively in flowers."

In a letter written to Tieck in December of 1802 Runge explained that his depictions would inevitably involve "arabesques and hieroglyphics," and that, from these, "landscapes" ought to emerge. He goes on to say that "in no other way is it possible for this art to be understood except by means of the deepest religious mysticism."[47] It is no coincidence that Runge uses these terms in a letter to Tieck, who writes about hieroglyphs in *Franz Sternbalds Wanderungen.* The artist's capacity to make art worthy of the divine depends on the intuition of these hieroglyphs in nature. These hieroglyphs are closely connected to the *Geister,* the spiritual signs of God's presence that can be only dimly grasped by human beings. The "arabesque" is the technical treatment of the line for organizing the vari-

ous hieroglyphs into a decorative whole. It is the artistic equivalent of the hieroglyphic presence in nature, the latter occurring in the world and the other in the mind of the artist. Since according to German speculative thought the whole outside world is a projection of the ego, the "arabesque" derives from the intuiting of the unity of the self with God and nature and thus becomes the key to understanding art as a divine language.

At the heart of Runge's and Tieck's symbolic language is the invention of the composite *Geister*-flower symbol. Runge's highest ideal of landscape was the rendering of flowers in a generally comprehensible hieroglyphic idiom. Landscape for Runge furnishes a bridge between spirit and matter. While *Geister* of inspiration are also associated with other natural elements such as moon and sunset, they are almost always considered in connection with some idea of landscape—and this means primarily the teeming botanical life.[43]

Here an ambitious Runge reveals to us his quest for a material and spiritual success. His bourgeois longings for love coming out "from behind every fence and shrub" and merger with a "family" of the religious and artistic elite all point to a deep-seated need for unity in both the cosmic and immediate sense. This is interfused with the desire to find a new and original "language" that is simultaneously the language of the great masters. Runge thought he came upon it in the work of Flaxman, and it is no coincidence that the main German commentary on the English artist was written in 1799 by August Schlegel, who described his outline illustrations as "almost hieroglyphs." Schlegel claimed that Flaxman's drawings could suggest the power of Homer's poetry because pure outline came closest to the original conception. Hence Runge's attraction to Flaxman's style for its suitability to his ideas of interior decoration was predicated upon its compatibility with romantic aesthetic terminology. This is also confirmed in Runge's repeated use of the term *arabesque* to describe his hieroglyphic interpretations, a word borrowed from the decorative arts and originally applying to intricate design patterns and foliated ornamentation.

In other words, Runge's so-called mystical and abstruse theories spring directly from his middle-class ambitions and the search for a political, social, and economic unity that would allow him to live in bourgeois comfort. In part he wanted to succeed to please his father, and he also shared these aspirations with his class. This is clear from his three

prerequisites for truly great art: (1) our awareness of God, (2) the perception of ourselves in relationship with the whole, and out of these two (3) religion and art; that is, to express our highest feelings in words, tones, or pictures.[44] As in the case of Schinkel's program for the Gothic, there is a blending of the temporal and spiritual ideals to guarantee temporal success.

Runge's *Times of Day* is a pictorial cycle that he hoped to see installed in a neo-Gothic building. These four pictures, which began as projects for mural decorations in the fashionable style, were organized around floral motifs and plant forms, and it seemed natural to exhibit them in a special building that would be a "continuation of the Gothic rather than the Greek." The same month that he outlined these plans to his brother he wrote to his mother of his profound impression of the Gothic cathedral of Meissen in Saxony. It bothered him that such churches could no longer be built, and he wished that a fortune would fall into his hands so that he could build a church on the order of the one in Meissen. (The Meissen Cathedral is an example of the *Hallenkirche* style, i.e., built like a vast hall in which the nave and the aisles are of the same width and height.) In the same letter to his mother he wrote of his all-absorbing passion for flowers, in which we feel "love and unity embracing all the contradictions of the world."[45] *The Times of Day* recalls Sulpiz Boisserée's remark to Goethe (who owned a set of the prints) that the series recalled Beethoven's music in their fascination with the infinite.[46] Once again, trust in a moral order of the cosmos—such as Beethoven's—involved faith in the possibility of political order in Germany.

Runge and Tieck

Runge's Gothic scheme could be traced to the same source that inspired Boisserée's medieval dreams: Tieck's *Franz Sternbalds Wanderungen*.[47] On 3 June 1798 Runge wrote excitedly to Perthes's partner, Besser, "I have never been so stirred in my innermost soul as I have been by this book which the good T. has justifiably called his favorite child."[48] It spurred him on to Copenhagen, and his identification with the fictional hero was so thorough that he even contemplated an analogous journey. This is no unique experience in the development of the bourgeois imagination: youth who have the leisure to nourish their daydreams have often connected with a work of fiction that altered their lives. Henri Murger's *Scenes de la vie bohème* and Somerset

Maugham's *Moon and Sixpence* (based on Gauguin's life) affected the direction of more than one budding mind and filled it with fantasies of bohemian self-sacrifice and imperishable glory. Runge's encounter with *Sternbald* occurred just at the moment he had resigned himself to a career as art dealer, and it supplied him with a pretext for studying painting. At the very least, he thought, he would become highly knowledgeable about art production and become a sought-after "expert." The idea fit in well with the concept of "cultural overlay" that Kosegarten was hired to impart to the sons of Wolgast's merchant community.

Runge's passionate enthusiasm for *Sternbald* and other of Tieck's writings (in another letter Runge quoted from *Der gestiefelte Kater*) eventually brought the two together in friendship. They arrived in Dresden the same year and hit it off immediately; Runge wrote Daniel after their first meeting that Tieck was impressed that he "knew his writings so well."[49] Both were profoundly disillusioned at the time with *Aufklärung,* and resolved to move art along different lines than those plotted by the now classical-minded Goethe. Their friendship led to plans for several collaborative projects, although most of these went unfulfilled. In the autumn of 1802 they planned to write a play together for which Runge was to have supplied the decorations; in March 1803 Runge records that Tieck offered to write a poetical complement to the *Times of Day;* and in 1803 Runge drew five decorative vignettes to accompany Tieck's publication, *Minnelieder aus dem schwäbischen Zeitalter,* a collection of folk songs from the German Middle Ages.[50] Wackenroder's enthusiasm for medieval art had paved the way for Tieck's appreciation of medieval German literature and folklore. At the same time, Wackenroder celebrated the glory of the German past, that era when the country could still boast mighty emperors and a homogeneous religious and cultural outlook.

The exchange with Tieck had a major impact on Runge's work. When the painter first arrived in Dresden he still manifested a neoclassical tendency intimately linked with his ideas of decorative art. This is seen in his project for the annual Weimarer Bilderkonkurrenzen (Weimar art competition), which Goethe founded in 1799 to promote a classical direction in German art. Runge entered the Weimar competition in 1801 with the composition *Achilles and Skamandros,* a subject drawn from the *Iliad* depicting the moment when the river god Skamandros, outraged at the number of dead Trojans Achilles has deposited in his

8.18 Philipp Otto Runge, *Achilles and Skamandros,* 1801, pen and sepia wash with white highlights. Hamburger Kunsthalle.

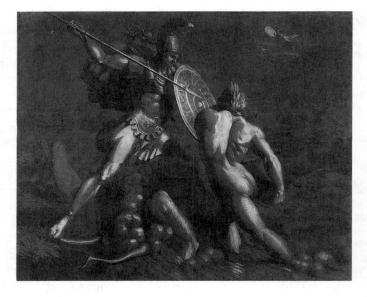

waters, rises with his fellow river gods to attack the Greek warrior (fig. 8.18). Runge chose this theme when still under Flaxman's sway and in fact leaned heavily on the English artist's illustration of *Achilles Contending with the Rivers* (fig. 8.19), and also referred frequently to other plates from Flaxman's *Iliad,* including *The Fight for the Body of Patroclus,* which David used for the *Sabines.*

The Weimar competition was an important stage in the genesis of Runge's conception of the new art, and a few words on its background may put things into a working perspective. Goethe returned from Italy in 1788 only to discover his dissatisfaction with the art of Germany. In 1798

8.19 John Flaxman, *Achilles Contending with the Rivers,* engraving in *The Iliad of Homer,* 1805, plate 33.

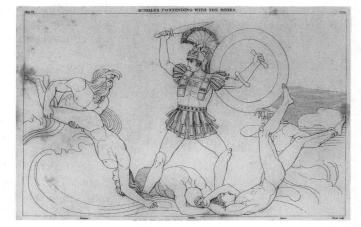

he inaugurated the *Propyläen* (The gate) and in the wake of this periodical founded the Weimar contest. The new war cry was "Nature und Altertum!" (nature and antiquity), but in its militaristic sounding it bore little relationship to the dynamic changes on the national outlook. Goethe's own political conservatism was matched by his aesthetic conservatism, but his call for a revitalization of German art inspired Runge, who now acclaimed the new program.

The first numbers of the *Propyläen* played a role in Runge's decision to take up art seriously. Already in Copenhagen (under the influence of his neoclassical teachers Juel and Abildgaard) he reported interest in the current Weimar matches and resolved to enter for the prize in the summer of 1801. Letters from Dresden in August and September suggest faith in Goethe's program and describe his presentation of *Achilles and Skamandros*. His mind was so deeply saturated with Flaxmanian illustrations that he saw the contest as an opportunity to adopt what he felt to be an updated version of neoclassicism for his entry. While Runge did shade his figures in the foreground (the contest called for tonal drawings), the background was kept flat and generally sustained the friezelike traits of the English artist.

What is most striking about Runge's sketch is the gargantuan character of the protagonists (influenced partly by Abildgaard) and the violence of their gestures. The bold swatches of light on the shaded figures and the dismembered body between them add a grisly note to the scene. It is as if the exaggerated movements and horrifying features were meant to do violence to the idea of neoclassicism itself. Nevertheless, it came as a shock to Runge when he learned at the beginning of 1802 that his entry had been rejected. The official notice stated that the drawing was poor and advocated "a serious study of antiquity and nature, in the sense of the old masters."[51] Runge was bitterly disillusioned, and while he at first tried to blame the retrogressive nature of the Weimar views on Goethe's advisers, he was forced in the end to recognize Goethe's complicity. Eventually, Runge and Goethe settled their differences and the *Dichter* even accumulated a collection of the artist's works. But as late as one year after the outcome of the contest Runge could write that Faust now seemed to him like Mephistopheles, the hideous character through which shone his creator.

Even before his drawing was rejected, he had begun to shift to a nonclassical position. The contact with Tieck and

his experience at the art and natural history collections of the court of Dresden stimulated his search of an expression more in keeping with the social and political conditions of the new century. As he wrote to his brother, "We are no longer Greeks."[52] While this sounds similar to the views of Wackenroder, it in fact attests to the budding of a new national sensibility that blossomed under the influence of the French occupation of the German territories and of Swedish Pomerania. Wackenroder did not plead for a rejection of the classical but for a toleration of the medieval. What he rejected was an exclusive preoccupation with the classical, and while this contained definite nationalistic and patriotic sympathies, it did not go as far as Runge's statement implied. In a letter to Daniel on 9 March 1802 he condemns the useless "chitchat" (*schnick-schnack*) of Weimar and also ponders what effect a war might have on European culture.[53] These curious thoughts point to the disillusionment he was suffering, but at the same time suggest a desire for drastic change and at the base of this desire a wistful hope that the Germans could bring it about just as they did when Hermann turned back the Romans. Here he spurned Goethe's cosmopolitanism in favor of Klopstock's nationalism. And this meant seeking a form of art or an interpretation of art appropriate to the incipient patriotic tendency.

Like Steffens, Runge's patriotism took him in search not only of his own roots but straight back to the origins of the universe. Taking his cue from the geologist's *Beyträge zur innern Naturgeschichte der Erde,* published in the previous year, he looked to Neptunist theory to clarify his fears about present-day culture. He wondered about "how the earth once looked, and how little by little the raw masses of granite and water, opposed to each other, increasingly united." This configuration was analogous to all experience, but it depressed him to think that the decline of religions was the historical condition for great masterworks of art, which carry the fossilized spirit of one vanished religion.[54] Although gloomy, this passage begins at physical creation, advances to cultural evolution, and culminates with Runge's own possibilities for creating a "masterwork" that would express "the highest spirit of the vanished religion" and reach a "more beautiful point" than ever before.

What makes this idea even more poignant is that Runge at the time was sitting in front of the *Triumph of Amor*, his first major work. Although the imagery shows a neoclassical influence, its origin in German poetry and its symbolic interpretation testified to his break with neoclassical

ideals. This brings us back to his contact with Tieck, and their common belief that a new art must arise that would differ from that which the Weimar competitions were attempting to create. In its final form *Triumph of Amor* was a monochrome relief of childlike spirits bearing aloft cupid Love, embracing, looking at flowers, and wistfully contemplating the quick passage of youth. The aim of Love's appearance is ultimately sexual, for he and his entourage approach several embracing couples. While the female figure of the nearest pair hides her face, the male stares apprehensively through the deep shadow they cast in the direction of figures personifying parental responsibilities and the woes of growing old. The cyclical nature of the subject corresponds to Runge's ideas of material and cultural evolution discussed earlier, ideas evidently sparked by the work itself.

He wrote in a letter to his father in January that Love is being carried on a shell to symbolize his origins in water (his mother Venus) and recalling the role of Eros in the giving of life to earth. And he specifically alludes to the work as depicting "the cycle of human life." He refers to his own birth and childhood, recalling that Love was the dazzling ray of light that illuminated his first hours. Love—the maternal principle in harmony with the Divine—sent an "electric shock" through him, and it was this "first flash of lightning that fell in the night of my youth." All these statements demonstrate to what extent the scientific discoveries of the period provided an empirical foundation for his seemingly mystical ideas. It is this expansion into abstract thought of the *Naturphilosophen* that marks the artist's peculiar contribution. Influenced by his friend Steffens, a lifelong follower of Schelling, he enunciated the idea that nature is the first step toward mind, from which in turn it is developed in a gradual progression. Steffens, in turn, would use these ideas to interpret Runge's work, to gain for art as well as for physics, a higher, spiritual meaning.

These speculative ideas derived from the reaction against the eighteenth-century *Aufklärung,* represented in the field of natural sciences by the Newtonian mechanical-atomistic explanation of all natural phenomena, a view supplanted by Schelling with a more dynamic and organic concept in which the riddles of the universe were solved by intuition as much as by experiment. The "inner" nature of things was given primary emphasis, and external realities were seen as transitory. Hence the interest of so many of Runge's colleagues in astronomy and the interior of the earth. As

noted, mining and disciplines like geology and mineralogy fascinated the intellectuals grouped around Schelling.

Scientists like Steffens, Oken, and Schubert, who under Schelling's influence tried to construct all natural sciences from speculative thought, posited the unity of all natural phenomena. They held that everything in nature took place by polar interaction between mind and matter, through which all generation and decay took place. Electricity and magnetism were fundamental forces of attraction and repulsion which created a cycle at work in the macrocosm as well as the microcosm, and between both. The discovery of galvanic electricity (Galvani, Volta) and the chemistry of gases (Black, Priestley, Lavoisier, Scheele), in the last decade of the eighteenth century, exerted an especially great influence on Runge's generation, on the strength of their application to the problem of the life-process and the unity of inorganic and organic nature. Galvani's experiments and the discovery of oxygen led to the belief that the connecting links between spirit and nature had been found. It was the discovery of oxygen that inspired Steffens with the idea that the elements of physics contained spiritual significance. Steffen's *Beyträge* is pervaded with ideas drawn from galvanic electricity (a popular subject in the pioneering *Annalen der Physik*) and the chemistry of gases. Schelling considered nature as one great organism, in which matter was carried up through dynamic processes such as magnetism and electricity to life and finally to mind. His pupils Steffens and Oken developed along with their empirical research a fantastic play of analogies, comparisons, and poetical explanations of nature and its phenomena. For these thinkers water was the one element indispensable to life; its chemical components are the primary life substances of the magnetic and electrical energies that bind them.[55]

Runge's fanciful analogies suggest that he was deeply imbued with the ideas of Schelling's *Naturphilosophie,* especially as it was manifested in the work of his disciples. His understanding of the polar theory of creation is expressed in a letter to his brother Daniel: "We feel that a pitiless severity, a terrifying eternity, and an eternal, sweet, boundless love stand opposing each other in a harsh and violent struggle, like "hard" and "smooth," or rock and water. We see those two everywhere, in the smallest and in the largest, in the whole as in the part: these two are the basic beings of the world and are based in the world, and they come from God and above them is only God."[56] As he sits in front of his picture he is suddenly aware of "the feel-

ings that are aroused in me each time by the noon, or by the sunset, the awareness of the *Geister,* of the destruction of the world, the clear consciousness of all that I ever felt about this—passed through my soul; and the consciousness of this would be with me to eternity." The making of art is the attempt to communicate these feelings of love and unity with the world, and this form of praising God is related to religion. The certainty of our own eternity comes through "a feeling of the relationship of the whole," and the artist attempts to hold fast to the features and symbols that correspond to the feelings. This requires the childlike love and receptivity to maintain the exalted feeling and thus present an image of "infinity."

Runge's manifesto rejects classicism and the Enlightenment. At this juncture, art, to be both novel and inspiring, must rely on the awareness of God and express religious feelings. The most pronounced external influence that his friendship with Tieck brought was the introduction to the work of Jakob Böhme (1575–1624), whose mysticism buttressed the ideas of the pietists in Runge's day. For Böhme, God's spiritual sources for material creation are the *Quellgeister* (*Quell,* "source," *Geister,* "spirits"), the essences of elements that have a dynamic, spiritual manifestation connected by a flash (*Blitz*)—the insight into which is given in inspiration. From Böhme, Tieck derived the idea of the *Geister* and in turn transmitted it to Runge. In the *Triumph of Amor* there are the traditional putti and those who wear butterfly wings, which, as in the case of Psyche, signified soullike attributes. What started out as a neoclassic frieze culminated as his first attempt to "capture" the *Geister* in pictorial terms. Although on the surface it is difficult to detect anything beyond the neoclassic forms, in Runge's mind putti could be transformed into *Geister.* In fact, these putti were like a Rorschach test for the artist, who kept the old container and filled it with new wine. By so doing, Runge managed to use the Flaxman's linear language for decorative purposes while infusing it with the various philosophical, scientific, and patriotic meanings cherished by the members of his social milieu. Here again the son of the Wolgast merchant struck a balance between the practical and the cultural.

Dresden

Runge finished his *Triumph of Amor* in time for the Dresden Academy exhibition in March 1802. Dresden's academy

was unique in sponsoring its own exhibitions, beginning in 1764. There was also a close relationship between the members of the academy and their students, whom they were obligated to train in their own studios. Runge studied informally at the academy and became close to several of its teachers and leading students, such as Anton Graff, professor of portrait painting, his son Karl, the landscapist Mechau (whose historical landscapes were based on the parks in Dresden), and Johann Joachim Faber, a painter born in Hamburg. Most influential on his work was Ferdinand Hartmann, who had known Frederike Brun in Rome and did work in the applied arts. But the advice of Hartmann (who had won the 1799 Weimar competition) proved of little use in the case of *Achilles and Skamandros,* since he too had shifted to a more symbolical approach to subject matter.

Thus Dresden represented an opportunity to converse with a circle of gifted artists, writers, and scientists including the Pomeranian landscapist, Caspar David Friedrich. Friedrich, who had settled in the Saxon capital in 1798, painted landscapes almost exclusively, infusing them with Ossianic and pantheistic meanings. Runge had met him briefly in Greifswald (where Friedrich was visiting his family) before going to Dresden; they remained friends until Runge's death. Their common background in Swedish Pomerania and their common mentors Kosegarten and Quistorp drew them together, and their relationship was cemented in their common hatred for the French invaders of 1806. Together they forged a type of landscape ideal that embodied their social, religious, and patriotic aspirations. And recognizing the market for their expression of religious symbolism and longing for a spiritual solitude in German forest, on German mountain, and along German seashore, Runge purchased Friedrich's work for resale in his brother's business.

Dresden was a prime site of cultural formation in this period, a place where literary and artistic careers were launched. It was a central trading point on the routes between Bohemia, Saxony, and Hamburg. Friedrich August III, who assumed the rule of Saxony in 1768, competed economically and culturally with Prussia and tried to attract new trade and talent to the capital. The elector's reforms were aimed at improving education and manufactures, and since so much of Saxony's commercial prosperity was founded on the mining and manufacturing of

Meissen porcelain, industrial design was promoted and encouraged both at the academy and the drawing school attached to Meissen. Mining was at the center of Saxony's wealth, and it may be recalled that it was at Freiberg, Saxony, that the School of Mines was founded under the directorship of Werner. Extensive mining activity went on in the Erzegebirge, whose foothills lay just south of Dresden. In addition to coal, lignite, and clay porcelain, there were beds of silver, amber, jasper, and such precious stones as agates, opals, sapphires, amethysts, and tourmaline. Goldsmiths and jewelers abounded at Dresden, while one of the striking exhibitions in the city was that of the Grünes Gewölbe (green vault), which contained one of the most valuable German collections of precious gems and costly applied arts such as Limoges enamels, ivory carving and cut crystal, gold and silver vessels, and of course, the Saxon crown jewels and ornaments. Runge, Tieck, and Novalis reveled in this museum in the Royal Palace, which inspired some of their finest works.

But what made Dresden seem to many like "the German Florence" was its famous art collection, greatly expanded by Elector Friedrich August. It may be recalled that Wackenroder's *Herzensergiessungen* expressed deep appreciation of these art treasures, which included Raphael's *Sistine Madonna,* Correggio's *Night Nativity* and *Madonna with Saint Sebastian,* Dürer's Dresdner altar, several important Rembrandts, van Dycks, and a large number of landscape and flower subjects from the Flemish and Dutch schools. Flower pictures especially appealed to the Saxon elector, since he had a special interest in botany. The many gardens of Dresden and especially the park at Pillnitz attest to his preoccupation with this burgeoning science.

Hence Dresden was a town of major cultural formation at the turn of the century, and had several unique features that would have attracted Runge. Its academy and annual exhibition, its museums, the decorative arts in its manufactures and specialized industry, and its aristocratic patronage encouraged the early romantic writers and painters. The elector of Saxony himself was an enlightened despot who encouraged the gathering of this talent so as to promote himself as patron of the arts, and his interests in botany and the applied arts could not have been missed by Runge. While the elector rejected basic social reform, his popular image was enhanced by his participation in the Austrian-Prussian coalition against the French in 1792, and he con-

8.20 Philipp Otto Runge, *The Return of the Sons,* 1800–1801, pen and ink. Hamburger Kunsthalle.

tinued to oppose them for a short time after the Prussian defection in 1795.

Thus Runge knew what he was doing when he arrived in Dresden in June 1801. He took advantage of the opportunities there to engage in a number of ventures, exhibiting at the academy's annual exhibition of 1802, taking on a commission from Perthes to illustrate Friedrich Leopold von Stolberg's translation of *Ossian,* collaborating with Tieck on the *Minnelieder* and the fairy tale *Die Geschichte von den Heymons Kindern* (The story of the Heymon children), began the *Times of Day* decorations, and even joined with the young art historian Karl Friedrich Rumohr to catalogue the collection of the Hamburg painter-collector Friedrich Ludwig Heinrich Waagen. And it was at Dresden that he married Pauline Susanna Bassenge, daughter of a Dresden glove manufacturer related to the great Bassenge banking house.

One work that sets Runge's outlook into perspective is *The Return of the Sons,* worked out in Copenhagen during the period 1800–1801 (fig. 8.20). Conceived of as a monumental wall decoration for his brother Jacob's new house in Wolgast, it shows Otto and Daniel being joyfully greeted by the entire Runge clan on a visit home. Although planned as a full-scale mural, it has a striking affinity with the outdoor family portraits dear to the English and with the family groupings of a more formal kind painted by Juel. It exemplifies less the aristocratic connection between self and landed estate that marks the work of Gainsborough and Reynolds, than the bourgeois ideals of family solidar-

ity and privacy. The domain depicted is more like a back-yard than a rolling estate, but it is one that still carries the idea of ownership and family control.

The scene takes place in the garden of Runge's parents just in front of the garden house and tea table. Daniel, the eldest son, and heir to the family trade, is greeted in the center by his parents, while Otto portrays himself at the far left being embraced by his younger brother Karl in the shade of an oak tree. (The embrace is a Freemasonic greeting.) The work celebrates bourgeois family virtues as well as property ownership, and at the same time permits a role for the artist within this context as a representative of high German culture. The family's dynastic pretensions are exemplified in the presence of Daniel, their need to display social refinement is exemplified in the presence of Otto. Runge has arranged the composition in the form of a shallow frieze appropriate to a wall decoration and testifies to his debt to Flaxman and Abildgaard.

Runge and Ossian

Feeding into the Gothic revival was the mania for Ossian, the mythic Celtic bard.[57] Ossian took Germany by storm soon after appearing in England, finding kindred upper-class receptivity in the aftermath of the Seven Years' War,[58] which converted the Celt into a primitive Teutonic warrior. Friedrich Gottlieb Klopstock, in opposition to slavish imitation of French literary models, exploited Ossianic lore and revived a pan-German cultural spirit. Klopstock had achieved a great success earlier with his dramas *Hermanns Schlacht* (1769) and *Hermanns Tod* (1787), which identified the ancient Teutons with the Celtic bards.

Klopstock recreated in an Ossianic mode a heroic German past centered around Hermann (Arminius), who drove back the invading Roman army. MacPherson's poems, with their vision of a primitive heroic world peopled by bards and shadowy warriors, provided the model. Klopstock came to believe that "Ossian was of German origin, because he was a Caledonian," and presented the German past as a conglomeration of Tacitus and the Celtic bard. Although the motif of Ossian was not specifically medieval, its literary and aesthetic use constituted a break with the neoclassical tradition and Enlightenment and went hand-in-hand with the Gothic revival. Both the premedieval world of Ossian and the medieval world of the

8.21 Philipp Otto Runge, *The Birth of Fingal: His Father Comhal Killed in a Duel,* 1804, pencil and pen drawing. Hamburger Kunsthalle.

Gothic contained the idea of a united fatherland with its primitive linguistic and cultural traits.

One vivid sign Klopstock and his followers shared with Ossian was the oak tree as a metaphor for the nation's manhood. While the romantics would frequently allude to the oak in a Teutonic or medieval German context, the oak that Klopstock regarded as the national tree—"die deutsche Eiche"—was as much at home in the highlands of Scotland as in the primeval forests of Germany. Klopstock would have found frequent references to oaks in "The Songs of Selma" and elsewhere in MacPherson's poetry. In the *Hermanns Schlacht,* Klopstock writes of one fallen warrior "thrown down in his blood, like the young, slender oak broken by the thunderstorm."[59] This may be compared with "The War of Caros," where we read "I must fall . . . like a leafless oak," and "Fingal": "Like a tree they grew on the hills; and they have fallen like the oak."[60]

At the end of 1804 Perthes commissioned Runge to do the illustrations for Stolberg's translation of MacPherson's poems, *Die Gedichte von Ossian dem Sohne Fingals.*[61] It may be recalled that Stolberg descended from the old Danish aristocracy residing in Holstein and was closely allied to the circle of Claudius and Klopstock. Stolberg's earliest poetry shows traces of Ossianic influence, and he even gained a reputation as an imitator of the Celtic bard. Like his idol Klopstock, he wrote revolutionary odes extolling freedom and denouncing tyranny, and he took over the idea of a Germanic Ossian as an appropriate vehicle for the transmission of his patriotic ideas. But the radical direction of the French Revolution completely unhinged him, and when he heard of the abolition of titles and armorial bearings in 1790 he began to condemn the bourgeois majority.[62] He had fully expected the nobility to retain their privileges and thereby maintain "morality and religion." On hearing of the September massacres, he called upon God to "strike the French with His scepter and break them in pieces like a potter's vessel." He was angry that any German could still sympathize with the Revolution, and he dreaded that the plague of "anarchy" would invade the German Enlightenment, and in reverence for classical antiquity, he even converted to Roman Catholicism. But his love for Ossian remained, now subject to his new political and religious position.

For Stolberg Ossian's world evoked the older hierarchical structures unthreatened by revolutionary voices and anarchy. The form of government was a mixture of aristoc-

racy and monarchy in whose hands the legislative and military power rested. If the religion was pagan, the culture was decidedly anticlassical and anti-Enlightenment in its vagueness and nebulousness. Indeed, its most striking features agreed with the salient ingredients of the Gothic mood: the moonlit landscape, the mist-clad mountains, and the elegiac note—the frequent laments for the noble warriors of the past and the invocation of their ghosts—all of these were intoxicating for Stolberg. He followed Klopstock in Germanizing Ossian, whose primitive heroic past now appeared to him as a vision of the utopian Teutonic world. That many of the early German publications on Ossian came out of Hamburg only indicated that the originals were most accessible there, but during the Napoleonic epoch the Ossianic literature assumed a symbolic status it previously lacked and, as in the case of Perthes, Stolberg, and Runge, underlined a political sympathy with England in its war with the French.

Perthes had already published Stolberg's translation of Aeschylus with illustrations in the style of Flaxman, and it was with this artist in mind that Runge planned nearly one hundred sketches of MacPherson's epic during the period 1804–1805. Runge had been primed for this project through the influence of Kosegarten, Klopstock, and the members of the Göttingen Bund. His fascination for lunar imagery (which pervades his project) and love of Nordic heroes made him the ideal illustrator for Stolberg's translation. But as in the case of *Triumph of Amor,* Runge required an approach that went beyond the conventional frame of reference and expressed a fresh symbolism based on the changing political and social outlook. His explicit borrowings from Flaxman's engravings for Dante's *La divina commedia* also suggest the need of both him and his publisher to exploit the popularity of the English sculptor and to identify themselves with the latest aesthetic fashion.

Runge combined the linear "hieroglyphs" with a religious and patriotic symbolism. He elaborated three basic character types based on the principal protagonists, Fingal, Ossian, and Oscar—father, son, and grandson—who were meant to embody the tripartite division of the first part of the poems. Fingal was associated with the sun, Ossian with the earth, and Oscar with the moon and astral realm. In addition to the lineal family scheme and its cosmic and regenerative attributes, Runge infused this project with a religious component. His drawing, *The Birth of Fingal: His Father Comhal Killed in a Duel* shows the birth of the Cale-

8.22 Albrecht Dürer, *The Resurrection,* 1511, woodcut. Graphic Arts Fund, The Los Angeles County Museum of Art, Los Angeles.

8.23 Philipp Otto Runge, *Fingal with Raised Spear,* 1804–1805, reed pen on Chinese paper. Hamburger Kunsthalle.

8.24 John Flaxman, *Beatific Image,* engraving in *Divine Comedy,* 1807.

donian hero in a chapellike room atop the fortress of Selma (fig. 8.21). The rays of the sun surround the child like an aureole, and he holds up a lance surmounted by a star. The identification of Fingal with the sun at the moment of his father's death suggests the idea of resurrection and recalls the conflation of the Apollonian sun god with the resurrected Christ—a familiar image in several prints of Albrecht Dürer (fig. 8.22). Runge's Ossianic project thus emphasizes cyclical and cosmic schema consistent with his own contemporary preoccupations, which were also those of Schelling and his disciples.

This emphasis is clear from examining the drawings of the principal protagonists: that of *Fingal with Raised Spear* depicts the hero with the sun as his shield, dynamically centered behind him and illuminating the universe (fig. 8.23). At the tip of his spear is the morning star, picking up on MacPherson's astral metaphors but also making Fingal appear as the incarnation of the cosmos. The particular image of the sun, with its two concentric haloes, was probably inspired by Flaxman's *Beatific Vision* from Dante's *Paradiso,* a graphic expression of the celestial emanation of divinity (fig. 8.24). As discussed in volume 1, the concentric haloes were ultimately derived from Priestley's work on electricity and optics, and this reaffirms the interaction of scientific, religious, and philosophical speculations in the period.

The study of *Ossian* shows the bard seated on the peak of a high mountain, holding his harp with his left hand, his

8.25 Philipp Otto Runge, *Ossian,* 1804–1805, reed pen on Chinese paper. Hamburger Kunsthalle.

right hand on his shield (fig. 8.25). Runge envisaged Ossian as the mediator between heaven and earth; he is both incorporated into the silhouette of the mountain and at the same time extends it skyward. Several pictorial puns reinforce the idea of the human-landscape fusion, including an anthropomorphic head below the pillar of the harp, and the harp itself, which seems to grow out of the mountain and whose neck and bridge are formed from an animal's horns, the pillar from a sword, and one of its strings from an arrow. A torrential stream flows beneath Ossian, dislodging a rock beneath his foot and uprooting a tree. Neptunists placed great emphasis on the action of water in the mountains, eroding channels through the landscape but also providing the valley below the fundamental life substance.

Directly above the head of Ossian glistens the North Star (Polaris), recalling that for northern peoples it was "the star at the top of the heavenly mountain." Just to the bard's left are shown several stars in the constellation of the Great Bear making up the Big Dipper, including the prominent Dubhe and Merak, which serve as the "pointers" to Polaris. Runge has accurately depicted this relationship in the drawing, demonstrating not only that he grasped the meteorological and astral significance of MacPherson's personal contribution but that he was deeply concerned with scientific accuracy in his work. Runge, as the son of a merchant shipper, would have been grounded in the facts of astronomy at an early age. Polaris was known as the "Steering Star" because its location and relative brightness made it a convenient object for navigators in determining latitude and the north-south direction in the northern hemisphere. Since shipping was the basis of the entire Wolgast economy, astronomy would have constituted a fundamental part of every middle-class youth's training. At Greifswald, the university maintained an observatory that served the merchant shippers in the region as well as the professional astronomers. Its curriculum included navigation, astronomy, geography, and surveying. In addition, general astronomical investigation of the period owed a great deal to German research. German astronomy, like German geology, served to make sense of the Teutonic people in the cosmic context.

Runge's preoccupation with this science further reveals itself in the drawing of *Oscar* (fig. 8.26). The hero is shown standing like a colossus on the low horizon line, looking downward toward the right as the sun has almost entirely sunk below the horizon. His shield, which is tilted toward

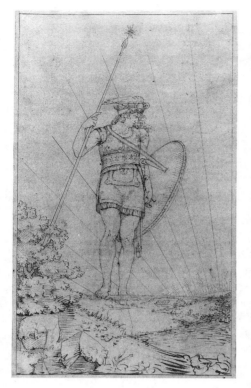

8.26 Philipp Otto Runge, *Oscar*, 1804–1805, reed pen on Chinese paper. Hamburger Kunsthalle.

the right in the direction of the horizon, is the new moon whose edge appears as a narrow crescent with the horns turned away from the sun. This again agrees with astronomical fact, and is verified in this description by Runge in his plans for book 5 of *Fingal:* "The sun nears its descent. The moon in its first quarter as narrow crescent [*als schmaler Streif*]."[63]

Runge's Ossianic series demonstrates his position on the cutting edge of contemporary science and art. Statistically, references to the moon predominate, but his numerous allusions to rainbows, storm clouds, sunset, and sunrise reveal his participation in the main scientific currents of his time. Although they often correspond to MacPherson's metaphors, in Runge's project they take on a much more scientifically precise character. For example, the latter's version of the poem of *Lathmon* has the moon waxing and waning according to exact lunar phasing. In the end, however, it was all too much for Stolberg, who rejected the project as too "pantheistic." His perception of Ossian as a German aristocratic hero clashed with Runge's symbolic incarnation of God and nature. It was less a question of religion than of class: Runge's Ossianic heroes derive their power not from arbitrary noble superiority but from their intrinsic connection with nature. Stolberg rejected such a concept and published his translation in 1806 without illustrations.

Runge's "Source" Themes of 1805

Runge's vignettes and illustrations during his Dresden period point to his continuing self-perception as commercial illustrator and designer. At the same time, the lessons he derived from this practice informed his nonreproductive explorations. Important projects conceived in this period (although completed later in Hamburg) center around the concept of the *Quelle,* meaning "source" in the sense of a waterspring or fountain of origin. Two related works, *The Source and the Poet* (*Die Quelle und der Dichter*) and *The Mother at the Source* (*Die Mutter an der Quelle*) were formulated in 1802 when Runge was in close contact with Tieck (figs. 8.27–28). The only missing ingredient was the *Dichter,* who in the final version appears as an Ossianic bard seated with his harp beneath an oak tree—an addition conspicuously influenced by Runge's work on Stolberg's translation.

Runge described his first idea of *The Source* as a picture

8.27 Philipp Otto Runge, *The Source and the Poet*, 1805, pen and wash. Hamburger Kunsthalle.

that "will be a source in the broadest sense of the word; as much the source of all the pictures I intend to made (the source of the new art I have in mind), as a *source* for its own sake." And he continued, "The nymph lies at the source and plays with her fingers in the water, and bubbles spring up large and the merry children sit in the bubbles and want to come out, and as the bubbles burst they fly into the flowers and trees; the character of the youths are in complete harmony with the flowers to which they belong so that

8.28 Philipp Otto Runge, *The Mother at the Source*, 1805? Formerly Hamburger Kunsthalle, destroyed by fire.

they give us a real bodily impression of the flowers. The lily stands in the brightest light and the oak stands as a hero with its branches over them."[64] One week later, Runge analyzed the picture again in a letter to Tieck, mentioning how often they discussed it together:

I wanted to paint in this picture all the well-known flowers which I know and which have meaning: all flowers do if we only observe them for that purpose. I would try to express by means of the composition of the flowers the whole idea, beginning with the first formation, so that the lily stands in the brightest light where the red, yellow, and blue flowers are clustered and where the oak tree, like a hero, stretches its branches over them. The flowers shall receive their true significance through the lively sounds of the source which vanishes among the flowers . . . As the spirit [*Geist*] is in the flowers, so it is also in the trees. Of course it is necessary to find the right spot for the figure in the flower.[65]

Runge emphasized the anthropomorphic character of the landscape, to accustom the public to thinking about flowers in association with human feelings. For this reason he rejected the idea of *pure* landscape, that is, flower compositions without figures. Finally, each flower "contains a certain human *Geist,* concept or feeling, and it is clear that it must have originated in Paradise."

Runge's correspondence on the subject of *The Source* is shot through with ideas based on Jakob Böhme's *Aurora; oder, Morgenröthe im Aufgang.* He actually mentions the mystical theologian in his letter to Daniel and refers to his polarities of Light and Dark, Good and Evil.[66] As we have seen, the two terms that recur throughout this work are *Quelle* and *Geister,* which are even joined as *Quellgeister,* which gets short shrift in English adaptations as "fountain spirits." Böhme was after nothing less than the originative spirits of all material existence. He attempted to show how the various polarities of creation emanate from a single source. But his chief interest was how the divided world could be made one again, how the destructive principle in nature and stubborn recalcitrance of human sin were to be overcome and reconciled in a grand spiritual unity.[67]

It was Tieck who introduced Runge to Böhme's work. Böhme appealed to pietists like Tieck and Novalis because he was ridiculed by the rationalists, and his theology bridged the gulf between faith and knowledge, intellect and fantasy. Everything in Böhme conveyed the impression of unity, of an undivided whole where God's spirit reigned. The paradoxes of existence were harmonized dialectically as different characteristics of the same source, *mysterium*

magnum. Böhme's rationalization of evil as the means of manifesting God's hidden goodness appealed to Tieck's longing for religious union. Fichte and Schelling were also deeply influenced by Böhme, in maintaining that everything operates by the action of antagonistic forces of attraction and repulsion. Hence their interest in astronomy, botany, mining, and geology, sciences that stimulated them to dynamic and organic explanations that could further be linked to higher consciousness and society. Böhme's frequent comparison of humans with flowers, as well as his love of stars and of precious stones, was a magical attraction for Steffens, Novalis, Tieck, and Runge, and his theosophy became a critical factor in Tieck's mental conditioning. It was Novalis who called Tieck "der Verkündiger der Morgenröthe"—the herald of Böhme's *Aurora*.

Starting with the first chapter of *Aurora,* Böhme treats water as the fount of all earthly life—synonymous with the primordial earth mother: "Water flows in all living and travailing things in this world: in water exists the body of all things, and in the air the spirit." Out of "the water of life," the mother or source of existence, emanates the "new-born love, which rose out of the water of life in the light *in* the stars, and *in* the whole body of the world, is wholly bound and united with the eternal, unbeginning, infinite love, so that they are *one* heart and *one* spirit, which supporteth and preserveth all." *Geister* are qualities of the Godhead and intimately related to the water source: "when the light riseth up, then one spirit seeth another; and when the sweet spring water [*süsse Quell-Wasser*] riseth up *in the light,* through all the spirits [*Geister*] become *living,* and the power of life penetrateth all." These spirits express divine love, and it is through them that come "the *understanding* and distinction in God, in angels, in people, in beasts, in fowls, and in *everything* that liveth." These spirits are the source of all earthly creation: "Out of and from the same *body* of the seven spirits of God are *all things* made and produced, all angels, all devils, the heaven, the earth, the stars, the elements, men, beasts, fowls, fishes; all worms, wood, trees, also stones, herbs and grass and *all* whatsoever is." Since these spirits or qualities are continually generating one another, and one is never without the other, it followed that there existed one only eternal almighty God.[68]

Runge referred to *Barmherzigkeit* (compassion) to offset the devil's wrathful destruction, a concept that is central to Böhme's system. He wanted to build his art on "revealed religion," and it is within us to build an ideal, "this land

that we call Paradise." [69] The male and female of God's likeness must be disclosed in their spiritual setting. He told Tieck about his interpretation of Genesis 2:19, where God brought Adam all the animals and fowls for him to name—whatever spirit the man put into them became their identity. Flowers, too, he believed had been present for naming; each flower contained a certain human *Geist,* concept, or feeling, and this spirit originated in Paradise. Böhme had likened angels in Paradise "to little children who walk in the fields in May, among the flowers . . . and always talk together of the several forms or shapes of beautiful flowers, leading one another by the hand when they go to gather flowers."

Runge's "source" pictures are his attempt to wed Böhme's theosophy to neoclassic decoration and allegorical landscape. *The Source* retains the decorative emphasis in its floral and vegetative arrangement in the foreground. The overlapping foliage of the trees creates a frame for the action and sustains the friezelike movement from bard to nymph. The identification of the anthropomorphic *Geister* (now seated on top of, rather than within, the bubbles) with the lilies is seen in the conformation of their cherubic bodies with the stems and leaves. The body of the bard undulates in agreement with the serpentine movement of the oak's branches. The bard and the oak are seen as synonymous, "the hero" offering protection to the nymph and *Geister.*

The "source" of all creation is the life-giving water, seen even more directly in the spin-off picture of *The Mother at the Source,* a work now destroyed. There an "earth mother" substitutes for the nymph, holding a babe in one arm as it reaches to see its reflection in the water. The curve of the child's body and its reflection creates a dynamic oval rotating in a cyclical action like a waterwheel. The maternal principle and the creative water process are dramatically joined to symbolize the source of all life. Runge likened the earth itself to a human being that is being formed as the "embryo is formed from the egg," and when its birth occurs its poor soul in the center will reach the light. [70] Like the bending lily and other plants growing out of the water, the child is an "idea" that literally "springs" from the watery source. The lily was purity, innocence, and immortality and the major botanical symbol of Mary, hence its conspicuous presence in both "source" pictures constituted a pantheistic component of Runge's landscapes.

At the same time, the union of the bard and the oak in

The Source attests to a continuing exploration of national and patriotic expressions. The work suggests that the whole of creation is moving towards perfection, a state connected to a resolution of Germany's dilemma. The personification of the forces of nature brings infinity within the ken of surveyable possibilities and hints at a place for a united fatherland within the cosmic scheme. In letters to Daniel and Tieck on *The Source* he referred to an ideal "land" that remained to be "discovered," and to his obligation to disclose it gradually for a needy public. This "land" was closely related to Böhme's Paradise, a land of spiritual and material unity in which the lilies of the field "toil not, neither do they spin" but nevertheless manage to outshine "Solomon in all his glory." The *Geister* and the bard, in their identification with flowers and trees, signify the unity and harmony of human beings in nature and society.

Runge began a companion piece to *The Source,* entitled *Rest on the Flight to Egypt,* which he hoped would be accepted as an altarpiece for the Marienkirche of Greifswald.[71] Runge's ambition was to do public art; a letter from his brother Jacob in 1805 indicates his delight with the public's access to his altar project. Ultimately, the Marienkirche commission was not offered to Runge (Jacob suggested that to some his work seemed "mystical"), though he had started on the final painting and left it in an incomplete state (*Untermahlung*). He sent sketches of both *The Source* and *Rest* to his friend Karl Schildener in Greifswald, referring to them as the *Evening of the Occident* and *Morning*

of the Orient. The first depicts the twilight of a Nordic, primordial world, the second the dawning of the Christian era in its focus on the fugitive Holy Family (fig. 8.29). The works should be seen as two phases of creation, metaphorically presenting a unity of Christian belief with German speculative philosophy and science. Both at sunset and at sunrise the *Geister* appear, the key moments of inspiration when humans feel in harmony with the universe. The two concepts illustrate the identity of nature and spirit and the underlying unity of organic and inorganic nature.

Runge silhouetted his foreground figures sharply with a swooping movement shaped like a bowl in the center. The figure of Joseph at the left, tending the fire, dominates in terms of sheer mass, and together with the incredibly foreshortened donkey nibbling leaves at his side literally frames the picture. The movement of his arm leads to the sprightly infant Jesus and finally to Mary; in turn mother and child are emphasized by the magnolia tree that frames the right-hand side. The magnolia tree (a botanical specimen native to Asia and North America) is inhabited by two *Geister,* one facing the dawn and receiving its light and the other holding a lily and looking down in adoration at the child. While the parents fit into enclosed shapes, the child breaks through the organizing curve with his outstretched arms to catch the first rays of the sun. Runge deliberately made the infant Jesus the most lively point in the picture; he signifies new life and new light coming out of the east. The dawn is

8.30 Philipp Otto Runge, study for *Rest on the Flight to Egypt,* 1805. Hamburger Kunsthalle.

a revelation of a new epoch based on the unity of spirit and nature.

The picture is also a curious amalgam of fact and fantasy. The striking naturalism of the light as it falls on the flesh of the child, and the close attention to topographical detail manifest Runge's scientific interests. The north-south direction of the Nile has been accurately shown, since the sun is coming at a right angle to it. The bald-headed and slightly cross-eyed Joseph is certainly a contemporary portrait and heightens the picture's realism. What is not "real" in terms of the narrative are the subdivided farms in the background hills and the rolling Nile. Furthermore, the family would have been resting near the northern part of the Nile, where vegetation is scanty. Some of this is obviously symbolic: the large red rose at the far right is the rose of the Virgin, or Resurrection plant, which was supposed to have sprung up wherever the Holy Family stopped during their flight to Egypt.

On the other hand, Runge's nationalistic bias comes through dramatically in the preliminary study of the entire landscape without figures, where the dominant motif is an oak tree whose silhouette conforms to that of Joseph and the donkey combined (fig. 8.30). While Joseph is somewhat in shadow, his dominant presence gives the scene a patriarchal character in keeping with bourgeois family life and property relations of Runge's own period. In this sense, the close-up view of the Holy Family surrounded by lush vegetation looks more like a middle-class family in their garden than hunted fugitives resting on their flight. The panoramic perspective below is thus the privileged view from their hilltop estate.

Runge sent sketches of both *The Source* and *Rest* to Karl Schildener in Greifswald. Schildener was a jurist who specialized in Scandinavian and German property laws, managed the university's library, and helped organize that of Wolgast. He also owned a major collection of paintings and etchings, including works by his mentor Quistorp, Runge, and Friedrich. He was at the center of university life in Greifswald, and a close friend of Arndt, the Quistorps, Friedrich, the Muhrbecks, and other distinguished middle-class intellectuals in Pomerania. His expertise in land law was requested by Gustavus Adolphus in working out the Pomeranian land reform in the period 1805–1806, and in the same period he took an active role in promoting the fine arts in Greifswald.

Runge's brother Jacob wrote him on 6 July 1805 to tell him that a delegation consisting of Schildener, Arndt, Muhrbeck the younger, and others visited from Greifswald to look at his pictures. Schildener was especially intrigued by the painter's work, and mentioned that Quistorp was now definite about the commission for the altarpiece. Quistorp's reservation, that Runge's approach would be too mystical for the public, was balanced by Kosegarten's judgment that the artist would come up with something that had both popular appeal and a deep meaning.[72] Runge's constituency in Pomerania consisted of politically progressive community leaders, mainly middle-class professionals connected with the University of Greifswald. Their ideal art form was public and profound—but not overly obscure. Far from being hermetic and esoteric, Runge was developing a pictorial style and a lifestyle consonant with the demands of his middle-class patronage. Not surprisingly, he looked to Schildener as a regular client and as a go-between for prospective buyers.

Portrait of a Bourgeois World

The pictures of Runge's family and friends in the period 1805–1806 offer more of the closed domestic realm already glimpsed in *The Return of the Sons*. The earliest of these portrait groups is known as *We Three*, a gift for Runge's parents depicting the Hamburg branch of the family (fig.

8.31 Philipp Otto Runge, *We Three*, 1805. Destroyed by fire.

8.31). The three are elegantly attired in the latest fashions; Otto and his wife Pauline are shown cuddling together at the right, while Daniel leans against a sturdy oak tree, linked only by the intertwining of his left hand with Pauline's right, which gives him an impossibly long left arm. The anatomical distortion, however, is consistent with the theme of human–nature identification. Directly above these clasped hands is a pair of crossed saplings whose triangular base mirrors the V-shape of the arms. Like the bard in *The Source,* Daniel's body conforms to the trunk of the tree he leans against, while the tree's protective foliage shelters his brother and sister-in-law. The eldest son heads the Hamburg branch of the family business, and this "branch" (the German word *Zweig* has the same double meaning as the English word) now sustains the creative and procreative side of the family. All three figures gaze solemnly at the spectator, establishing them as powerful presences within the landscape. They are brought up close to the frontal plane and assert their claims to proprietorship over the grounds. The picture sends a clear message to the parents that the Hamburg branch of the family is in control, nurtured by the soil of the *Vaterland.*

The next portrait in the series shows the Hülsenbeck children, the three younger children of Daniel's partner (fig. 8.32).[73] The landscape is a garden; in this case the gar-

den of the Hülsenbeck home at Eimsbüttel, another suburb of Hamburg north of Altona, where merchants lived in preference to the overcrowded city. The city's towers and roofs, however, can be glimpsed at the horizon. Runge's topographical accuracy is shown by the clearly identifiable church towers, including those of Saint Katharinen, Saint Nikolai, Saint Petri, and Saint Jakobi. Also on the horizon at the far right is the dye works of Hülsenbeck's father, who worked for the flourishing textile industries in Hamburg and made use of plant-derived dyes like indigo.[74] The striking motif of the sunflowers on the left attests to both the economic and symbolic importance of plants for Runge and his circle.

The Hülsenbeck house and garden is enclosed, hedged off and private, but this self-sustaining unit is also connected with the larger configuration of city and state. The unity of Hülsenbeck's domestic realm is echoed by the global unity of trade and international commerce, and beyond by the spiritual realm of the church spires and towers. At the same time, we are brought close to the children, from whose viewpoint is the cosmic whole. Their presence is highlighted not only by scale but by their cylindrical bodies and large heads, the fixity of their gaze, and the great care lavished on their clothing. Runge's attention to minute details of weave, button, and collar manifests a concern for children's costume. At the end of the eighteenth century, children of bourgeois families were no longer dressed as miniature adults, but given special clothes to designate their cultural and economic role. This was in keeping with Rousseau's view that childhood is a state that needs to be nurtured individually according to the child's own pace. Runge give special priority to the children, assigning them high status in an environment conducive to the free expression of their abilities.

Nevertheless, these three unsentimentalized children seem to anticipate their adult lives. They constitute a miniature version of the Holy Family on the run, only in this case looking out over the valley of the Elbe rather than the valley of the Nile. The "mother" is concerned for the welfare of the infant in the wagon she helps to pull; the baby shows slight control over its rotund body as its pudgy hand grasps involuntarily at one of the lower leaves of the sunflower towering over him; the "father" in the center, although younger than his sister, dominates the group with his vigorous whip and forward thrust. The girl turns back to warn the baby against pulling the leaf, which would not

only damage the plant but whose rough surface might injure the baby's delicate flesh. Epitomizing the maternal, protective instinct of the female, the girl watches out for the baby as if it were a tender plant. The active boy, on the other hand, resembles *Fingal with Raised Spear;* here the whip substitutes for the lance, and the sunflower supplies the cosmic energy. The boy is portrayed in the mold of the Nordic hero, and the national connection is further emphasized by the ubiquitous oak tree at the right. Not only does Runge sustain the privatized bourgeois world and its property rights, but he links it to a regenerated *Vaterland.*

Akin to the *Naturphilosophen,* Runge asserts the organic unity of plant and human existence. The glow of the children's faces, their globular heads snuggled into their collars, resemble the three sunflower blossoms looming overhead. The color of the flowers match the color of the boy's trousers, and the curly locks of the girl and baby are repeated by the yellow-rayed petals. The primal force shown in the two males connect them with the powerful stalks of the sunflower and the teeming plant life surrounding them.

One key to this universal identity is seen in the spherical forms atop the posts of the picket fence. At the left, this spherical form is so conspicuous that it assumes a critical role in the picture, linking the garden with the neighboring houses and the city beyond. It seems to be the object of the girl's outstretched hand and to constitute a kind of pictorial leitmotif that is repeated in the sunflower, in the children's heads, in the wheels of the baby cart, and in the buttons of the older boy. These buttons literally repeat the dramatically foreshortened series of spherical forms on the right side of the fence.

Lorenz Oken

The pure geometry of the sphere is the natural symbol of infinity and one close to the hearts of the pioneer romantics, as in the nature philosophy of Lorenz Oken. As stated earlier, Oken was a leading disciple of Schelling and pursued every implication of his philosophy in the natural sciences. Oken published his first major work, *Grundriss des Systems der Naturphilosophie* (Outline of the system of natural philosophy) in 1802, which stated that unity was the chief criterion of the new science, and one of his most influential books, *Die Zeugung* (Generation), was published in 1805. *Die Zeugung* argued that all organisms are aggregates of fundamental building blocks that the author called infu-

8.33 Title page of Lorenz Oken's *Zeugung*, 1805.

soria or protoplasm (*Urschleim*). While he did not distinguish the various parts of these basic life constituents, it represented a pioneering effort in cell theory.

Oken's interest in the dynamic process underlying all nature was ideally suited to embryology. The human being, the microcosm, reflected universal or macrocosmic development. He declared that the action or the life of God consists in eternally manifesting, eternally contemplating itself in unity and duality, eternally dividing itself and still remaining one. And again "Polarity is the first force which appears in the world . . . The law of causality is a law of polarity. Causality is an act of generation. The sex is rooted in the first movement of the world."

The title page of Oken's *Zeugung* is decorated by two intertwined serpents biting their tails—the ancient symbol of infinity (fig. 8.33). This work seeks a mathematical scheme for the whole of creation, which he views as the ultimate synthesis. He formulated the rule of the primal zero whose chief relationships are space and time, that is, the arena in which generative activity will take place. The use of mathematical symbols to denote relationships between the real and the ideal confused many people, but Oken presented a dynamic picture of cosmogony that inflamed the imagination of Schelling's disciples and followers.

The primal zero, symbolized in his writings by a 0, calls up its opposite, being. The 0 is the absolute of mathematics, and while it needs the plus and minus to form the mathematical trinity (*Dreieinen*), the creation of the world has to be comprehended "as the creation out of the nothing." Thus the fundamental law is the 0; the 0 is the eternal quality of the plus and minus in the $+/-$ 0. This rules every biological phenomenon. Oken's zero is symptomatic of the visual form of the circle (*Kreis*) that governs his thinking: motion without constraint is circular, and equilibrium is found at the center of that circular motion. Plants are based on the model of the circle, with their "active diameter inseparable from the passive periphery." Oken's discussion of the germination of plants, nuclei, yolk, embryo, and polyp all lead to the basic shape of the circle, ready to metamorphose into the next stage of development.

Oken anthropomorphizes his plants, writing in one place that the "plant is only part mother of the growing progeny whose sorrow the earth shares with her; this is the real yolk, or breast, which contains the milk for the em-

bryo originating in the seed-pod and enables it to sprout." [75]
This anthropomorphic vision of plants finds its pictorial
analogue in Runge's work, with its myriad allusions to
motherhood, plant growth, germination, fecundation, and
metamorphosis. Runge wrote to his friend August von
Klinkowström on 24 February 1809 that the scientist's anti-
Newtonian *Erste Ideen zur Theorie des Lichts, der Finsterniss,
der Farben, und der Wärme* (Jena, 1808) delighted him
greatly. Runge felt that it reinforced his own opinion, and
allowed the artist a role in laying bare appearances that the
Naturphilosophen try to penetrate to the inner core. One
day, he mused, "each art and science will stand like a vital
and sturdy tree," having approximated the archetypal
ground plan upon which they were built. [76] Each generation
attempts this ever more successfully until it reaches perfec-
tion. This is another idea borrowed from Oken, whose
work Runge knew intimately.

Oken converted his model for the underlying unity of
organic and inorganic nature into a model for a unified po-
litical structure. *Naturphilosophie* developed against a back-
ground of political revolution and the French invasion.
Oken used science as a rallying point for German patriots.
A major obstacle to the realization of a program of nature
philosophy in German universities was their entrenched
particularism. Oken seized the initiative in founding orga-
nizations supportive of an all-German science. He sought
to place German scientific achievements on a par with the
French and English efforts, and exploited his teaching plat-
form to politicize the youth, hoping to imbue the new gen-
eration with optimism and self-confidence. While he was
in constant conflict with the regional authorities, he had a
large and important following before and after the Wars of
Liberation. Analogously to Fichte in philosophy, Oken
counseled the German scientific community to unite be-
hind *Naturphilosophie* and make it a German science. In the
preface to his *Beiträge zur vergleichenden Zoologie* of 1805 he
claimed that there were still "many undiscovered lands on
the map of the animal kingdom," and it was time to surpass
the French in this area. He enthusiastically promoted the
idea of a united scientific community to foster the idea of a
national science. [77]

Family Portrait

Runge's portrait of the Hülsenbeck children also serves to
move beyond mere appearances to the underlying unity of

8.34 Philipp Otto Runge, *The Artist's Parents*, 1806–1807. Hamburger Kunsthalle.

all existence by focusing on a bourgeois family as the paradigm for national unity. This alliance of science, art, and politics recurs again in the largest of Runge's group portraits, a full-length study of his parents with his eldest son and nephew (fig. 8.34). Begun in the spring of 1806, it was not completed until the following year, during a particularly trying period after the Prussian defeat at Jena, which had disastrous consequences for the Hamburg branch, and the French occupation of Pomerania, which broke up the family in April–May 1807. Runge's preliminary sketches for the outcome, done before Jena, project an entirely different mood than the final picture. The oil study of his mother's face is a sympathetic portrayal of age with its care-lined texture and understanding eyes, while in the definitive work the mother greets the spectator with a foreboding scowl. While no such study exists for the father, the severity of his stare matches the mother's. Between the inception of the picture and its completion, the trauma of political intervention affected Runge's conception. The red rose in the mother's left hand, a traditional Christian symbol of martyrdom, attests to the trauma of the French occupation.

The parents are on the verge of leaving their home for a promenade. They turn to face the spectator, with the father holding his top hat in his hand in a sign of greeting. They wear conservative English-style fashions; the mother wears a black satin cloak with hood and a cloth cap fastened around her chin with a ribbon, while the father sports a deep-purple cloth coat, knee breeches, woolen stockings, and shoes, and a fancy walking stick with a silver knob. He is especially dated by the wig, which had been steadily going out of fashion since the French Revolution. The sobriety of their gaze is matched by the orderliness of their costume, conveying the punctiliousness and formality observed by Kosegarten and suggesting that relations between parents and son were also formal. Above all, Runge depicts his parents trying to maintain their dignity in the face of their straitened circumstances.

The family shipyard, lumberyard, dry dock, and saw mill on the Peene River are seen just over the fence at the right (fig. 8.35). What was normally a thriving, dynamic work site is now empty and inactive. The preliminary drawing of this detail reveals a near-deserted shipyard with ships standing idly in the harbor (fig. 8.36). A Swedish flag waves from one of the large ship's masts, indicating that

8.35 Philipp Otto Runge, *The Artist's Parents*, detail.

Runge's father sailed under the protection of Gustavus IV, who, since the execution of the duc d'Enghien, saw himself upholding the historic German empire in face of the French threat. This, combined with his commercial interests, induced Gustavus to join England and Russia in forming the third coalition against Napoleon in 1805. No military expert, however, his abortive operations in the northwest ended when Napoleon's army overwhelmed his troops at the fall of Lübeck in November 1806. Thereafter his role was confined mainly to Pomerania, but even there his defects and the poor quality of Swedish troops made the engagement a fiasco. Throughout the first half of 1807 the struggle in Pomerania went back and forth (including fighting in the vicinity of Wolgast), but soon Gustavus decided to sue for an armistice and abandoned the mainland of Swedish Pomerania. In September he was compelled to hand over the island of Rügen to the French commander. Thus the Swedish flag is itself emblematic of the family's misfortunes in that period.

Only the two children relieve the severity of their grandparents; they delight in examining the lily plants and signify the regeneration of the human and plant families and their ultimate spiritual affinities. Runge's eldest son points with a pudgy forefinger at the stamens within the receptacle of the lily's petals. The pollen-bearing stamens, essen-

8.36 Philipp Otto Runge, preliminary sketch for *The Artist's Parents*. Hamburger Kunsthalle.

8.37 Philipp Otto Runge, *Louise Perthes,* 1805. Staatliche Kunstsammlungen, Weimar.

tial in the production of seed and thus in the continuation of the species, are the "male" sex organs in Linnaeus's system, and Oken affirmed that the male principle was primal in the sexual act. The boy's older cousin grasps the stem of a lily with his left hand and with his right grabs the arm of Runge's son, looking up at his grandmother as if to wait for affirmation of the younger boy's action. But the grandmother is too self-absorbed to respond to the children. It is the younger generation who are identified with the flowers and beckon to the idea of procreation in human and plant life. They symbolize the continuity of the Runge family and continued hopes for a brighter future.

Back in Hamburg Runge did a portrait of Perthes's daughter Luise, painted in 1805 (fig. 8.37). Luise was then only three years old, but Runge made her look precocious and knowing. As in the case of the Hülsenbeck children, we see Luise's world from her perspective. She stands on a chair to see out the open window, turning momentarily toward the beholder, as if to share the view. Through the window is the water basin at the northern edge of the city, known as the Binnenalster. The basin was a popular attraction, its irregular quadrilateral form bounded on three sides by quays lined with trees. The fourth side, known as the Aussen Alster, was laid out in promenades connected by means of the Lombardsbrücke (Lombard bridge; fig. 8.38). The bridge is visible just beyond the windmill, indicating the choice location of Perthes's home on the Jungfernstieg, a fashionable promenade of palatial residences (fig. 8.39). A photograph of this site taken in 1859 from nearly the

8.38 Popular image of the Jungfernstieg, looking north.

8.39 View of Jungfernstieg, looking south.

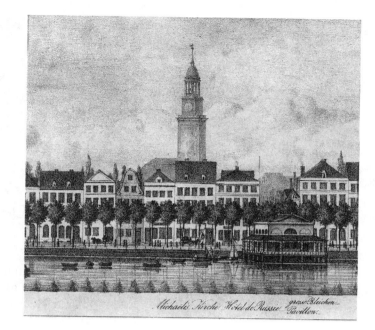

Michaelis Kirche. Hotel de Russie. grosse Bleichen-Pavillon.

8.40 Photograph of the Lombardsbrücke and windmill, 1859.

8.41 Photograph of the Lombardsbrücke after the fire of 1842.

same direction attests to Runge's topographical accuracy (fig. 8.40). Located at 22 Jungfernstieg, the house was destroyed in the devastating fire of 1842, as seen in a photograph of that year from the opposite direction (fig. 8.41).[78] Runge emphasized Perthes's social status by transforming his infant daughter into a kind of a princess surveying her father's privileged domain and staking it out for the viewer.

Runge's Decorative Projects, 1803–1810

During the years in Dresden and Hamburg, Runge embarked on a series of decorative and applied arts projects in which he sought to bring middle-class interiors into harmony with the conditions of idealist philosophy and his own dreams of a national political consciousness. In the period 1803–1804 he executed a wallpaper border made up mainly of pasted flower cut-outs for the banker Dehn of Altona. Dehn was closely affiliated with the Sievekings and helped finance the civil defense of Hamburg against the French in 1813.[79] There were also designs for the Graf von Biernacky's buildings in South Prussia, and for the dining room of Erbandsmarschall and Reichsgraf von Hahn's home in Güstrow.[80]

Runge seems to have had a thorough understanding of textile design, guiding his niece with flower studies and practical advice for embroidering of upholstery, and through the elder Graff he collaborated with needlepoint workers. He was also commissioned to design a curtain backdrop for a Hamburg opera house in 1809. He chose as his subject Arion's sea journey, based on a Greek myth that had been cast into the form of a ballad by Tieck in one of the stories of the *Phantasien* (fig. 8.42). A musical genius, Arion was kidnapped by pirates off the coast of Sicily for the wealth he had earned from his talent. Just as they were about to toss him overboard, he begged permission to play his music for the last time. The pirates consented. His clear notes floated over the sea and attracted a school of dolphins, one of which rescued Arion and carried him safely to the

8.42 Philipp Otto Runge, *Arion's Sea Journey*, 1809. Hamburger Kunsthalle.

8.43 Philipp Otto Runge, *Nightingale's Bower*, 1810. Hamburger Kunsthalle.

nearest shore. Runge has set the scene in a moonlit landscape; in the center Arion glides off in calm waters, while on either side *Geister* play music or gather around huge poppy plants which form islands. While the atmosphere and motifs were Tieck's, Runge supplied the panoramic vista of the Binnenalster and the level land bordering it. He also added swans, which were not mentioned in Tieck's ballad but were a familiar sight on the Binnenalster.

In 1808–1809 Runge designed the models for a deck of playing cards for the etcher and engraver Forsmann, who owned a playing-card factory, then a new and important industry in Hamburg.[81] Forsmann developed a new production method of wood engraving that allowed for an almost unlimited number of editions, with which he hoped to saturated the Continent. Runge used historical and biblical characters to personify the kings, queens, and jacks, and Murat for one of the "knaves." Brentano, the archconservative compiler of fairy tales, admired Runge's designs, especially the medieval series in which "such brave knaves are serving the king, and such kings inspire by their sword and their heart, and such ladies carry flowers and the veil."[82]

During these years, Runge painted decorations for the ships of his father and brother, cover designs for theater programs and Perthes's short-lived magazine, and a variety of illustration jobs. His *Nightingale's Bower* of 1810 was destined for a long frieze in a music room, making use of his favorite floral and *Geister* themes (fig. 8.43). The central motif is framed by the looping curve of two oak branches in the middle of which is a scrupulously executed iris known as the *Iris germanica*. This flower was closely identified with the Germanic lands, where it traditionally was seen as the harbinger of spring. Extending outward from the oak branches is a sprig of acacia—the symbol of innocence, and an important Masonic device. At the base of the iris and its erect stems are passionflowers, forming a symbolic connection between Germany, the Christian religion, and Masonry.

8.44 Philipp Otto Runge, *The Joys of the Hunt,*
1808–1809, pen and watercolor on paper. Hamburger Kunsthalle.

Other nightingale subjects meant for decoration display the national preoccupation. *The Nightingale's Lesson* (fig. 8.12) was done twice, initially in the period 1802–1803 and later in 1805 for Hahn's house in Güstrow. For the first time he attempted to provide an elaborately decorated margin-frame for his subject, to make it conform to a particular interior setting. The narrative scene was done in an oval, while in the surrounding field he painted a monochromatic bas-relief imitation of coiling tendrils of lilies, roses, and oak leaves from which sprout the *Geister* who extend their arms to touch the nightingales in the margin. Both the title and the theme of the decoration were inspired by one of Klopstock's odes:

You must flute, at time with strong sounds
At times with softer ones, until the tones become lost;
Then you must warble until the treetops resound—
Flute, flute, until the tones vanish in the rosebuds.[83]

Music is fundamental to Runge's presentation both as subject and internal structure, with Psyche shown instructing Amor in song under the canopy of thick oak forest, darkened by the evening sky. Though in the original myth the two lovers met beneath a bower when the nightingales trilled their evening song, the two figures here nestled in the branches of an oak tree are themselves symbolic incarnations of the nightingale. They commune with nature, both within their immediate setting and without in the margin-frame, where the *Geister* and actual nightingales frolic amid the oak branches. Runge claimed to have painted a visual "fugue," a composition based on the elaboration of a single theme enunciated by the several parts and subjected to contrapuntal treatment.

Based on Tischbein's illustrations for Hamilton's catalogue, the figures shift the classical forms to the German *Wald.* This is an idea inspired by Tieck and related to a later work entitled *The Joys of the Hunt,* a large watercolor executed in 1808–1809 as a room decoration (fig. 8.44). The field is again divided into an oval scene and a decorated margin-frame filled with animals, flowers, and miscellaneous people. The huntress Diana, now depicted in peasant dress, wanders into the forest of oaks and fir trees (*Tannenbäume*). The margin-frame is rich with foliated arabesques and wild conceits like the faun at the bottom covered with leaves and blowing four trumpets at once. Peasant women on either side do a balancing act as they aim their bows and arrows at a ferocious bear, here probably symbolizing Rus-

sia, whose treaty with France in July 1807 (Treaty of Tilsit) humiliated Prussia and sealed the fate of Sweden. Thus the deity has been displaced from her classical setting and given a modern, national meaning. It is poeticized by the *Geister* stretched out among the trees, recalling a theme suggested by Franz's friend Rudolf in *Franz Sternbalds Wanderungen*. Even the large blue flowers in the lower corners hint at Novalis's Heinrich von Ofterdingen's yearning for the mysterious "blue flower." Runge's painted decorations ingratiate both the taste and the ideology of his patrons.

Linnaeus

Runge's profound involvement in the sciences of meteorology, astronomy, mineralogy, biology, and especially botany aligned him with the *Naturphilosophen*. The specialization of knowledge had not yet sharply divided the labors of the botanist, zoologist, and physiologist, and unification into an all-embracing system was left to the natural philosophers. The individual who helped set these sciences on their individual footing and stimulated the philosophical discussion was Carolus Linnaeus (1707–1778), the methodical natural scientist of Sweden.[84] Linnaeus's disciples spread his ideas in the educational institutions of Swedish Pomerania, and Runge looked upon the scientist as a culture hero.

Linnaeus's career illustrates the conjunction of scientific knowledge and ideology, and indicates how the specialization of such knowledge is shaped by economic pressures. While yet a schoolboy he displayed a keen interest in botany, but since it had no independent standing at the time, he took up the study of medicine, under which it was included. While at the University of Uppsala in 1730, he wrote an essay on the sexuality of plants. The fact that plants, like animals, reproduce by means of male and female organs—stamens and pistils—had been asserted by earlier scientists, but it was a theory disputed by others and it was left to Linnaeus to prove. The sexual system was based on the number of stamens and pistils in the flower, and their arrangement into twenty-four classes among which all plants were distributed was to prevail in botany into the nineteenth century. Linnaeus developed the binomial nomenclature that established botany as a separate science and provided a model for other scientific disciplines. Still at Uppsala he compiled his *System naturae* or classification of the three natural kingdoms. Published in 1735, it

8.45 Carolus Linnaeus, *Hernandia*, plate 23, *Hortus Cliffortianus*.

8.46 Carolus Linnaeus, *Cliffortia,* plate 32, *Hortus Cliffortianus.*

sets forth his principles and major groupings for the classification of plants, animals, and minerals.

The progress of botany as an independent field paralleled growing knowledge of the economic uses of plants. Linnaeus made a historic journey through the Lapland wilderness in search of plants and animals, as much for commercial as for scientific information. While in Holland he earned his degree as a doctor of medicine and sought out the contact of prominent scientists in Leiden, through whom he met George Clifford, a wealthy Anglo-Dutch merchant who became his patron. Clifford was director of the Dutch East India Company and carried on an extensive trade with the colonies; on his country estate he maintained a magnificent botanical garden and a large herbarium of exotic plants acquired from his trading outposts. Clifford hired Linnaeus as his physician and caretaker of the botanic garden, which included such commercial and medicinal plants as the coco palm from Asia, the aloe from Africa, yams and magnolias from the New World, and spices from the Dutch colonies.

Clifford subsidized the research and publications of Linnaeus. It was at Clifford's that he published the *Hortus Cliffortianus,* with its examples from the patron's garden and its beautiful illustrations of Clifford's plants.[85] The book's attention to floral details marks the beginning of a new era in botanical illustration and foreshadows Linnaeus's great flower-book production which exerted such a powerful influence on the eighteenth-century mercantile and aristocratic classes (fig. 8.45–46). The scientist Linnaeus acted here analogously to Winckelmann in Albani's employ and d'Hancarville in that of Sir William Hamilton and Charles Towneley. All exerted a major influence through sumptuous publications paid for by the patrons whose collections (whether art or botanical) they published.

Jan Wandelaar's frontispiece for the *Hortus Cliffortianus* makes very clear the connection between Clifford's botanical interests and commercial activities (fig. 8.47). In the center of the illustration sits the personification of Mother Earth, who is being exposed to the sunlight by the god Apollo, while Diana, the moon goddess, retires. Allegorical representations of the New World, Asia, and Africa pay homage to Mother Earth with their exotic plants (Africa carries the aloe). The plan of Clifford's garden is shown in the foreground, and his bust appears on a pedestal with the emblem of the serpent biting its tail, being festooned with a garland of flowers by the goddess Ceres.

When Linnaeus returned to Sweden, he fulfilled numerous commissions for industrial and pharmaceutical uses of plants; he catalogued native plants serviceable for drugs, traveled to report on the natural productions of various sites and agricultural production, and as superintendent of the botanic garden of the University of Uppsala devoted himself to raising seeds and cultivating plant transfers from colonial satellites. Like other botanists of the period, he explored the possibilities of plant cultivation in areas where cheap colonial labor was available, and studied economic plants to determine whether native-grown might substitute for imported. He unsuccessfully tried to acclimatize certain plants such as tea, which he hoped could be grown as easily as lilac. When his dreams of having Swedish tea plants failed, he moaned of his frustrated desire to "shut the door by which all the silver in Europe goes out."

In addition, his position as professor of botany and medicine at Uppsala enabled him to train generations of professional botanists for colonial expeditions, mercantile companies, and botanic gardens, as well as for teaching proper. Since Sweden was a major maritime power, his disciples could undertake journeys that covered the entire world. Many of them brought back outstanding collections that are now preserved in museums in Uppsala, Stockholm, Copenhagen, and London. His pupil Daniel Solander accompanied Sir Joseph Banks on James Cook's famous first circumnavigation of the globe in HMS *Endeavor* during the years 1768–1771. Martin Vahl, the most famous Danish disciple of Linnaeus, was Steffens's teacher at the University of Copenhagen. All the professors of botany at the University of Greifswald in the second half of the eighteenth century either studied directly under Linnaeus at Uppsala or under his disciples. One of these was Samuel Gustav Wilcke, whose *Hortus gryphicus* of 1765 classified all 1,438 plants in the university's botanic garden. Christian Ehrenfried Weigel grouped all the plants in Pomerania according to the Linnaean method in his *Flora Pomerano-Rugica* of 1769. In 1788 Johann Quistorp, the younger brother of Runge's mentor and patron Quistorp, assumed the directorship of the botanic garden and taught according to Linnaean principles. The faculty used as their texts the beautifully illustrated works of the master, such as *Philosophia botanica* (1751), *Hortus Cliffortianus* (1737) and *Fundamentorum botanicorum* (1786).

Runge not only lauds the Linnaeus system in his writings, but his many single studies of plants and flowers show

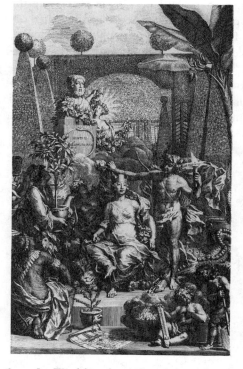

8.47 Jan Wandelaar, frontispiece for Linnaeus's *Hortus Cliffortianus*.

8.48 Philipp Otto Runge, study of cress, 1808–1809, pen and ink drawing. Hamburger Kunsthalle.

the influence of Linnaeus's publications (figs. 8.48–49). The artist's geometric reduction of a cornflower could serve as an illustration to a botanical textbook (fig. 8.50). In addition, it is astonishing to find in *The Times of Day* the number of plants prized for their practical, rather than ornamental, value. Flax, aloe, larkspur, poppy, sunflower, foxglove, and violets all figured significantly in the "economy of vegetation" as raw material for textiles, dyes, medicine, and domestic aids. Runge provided a direct link between the increasing involvement in economic botany and the apparent affinity of vegetable nature with the Gothic

8.49 Philipp Otto Runge, leaves and blossoms of cress, 1808–1809, pen and ink drawing. Städelsches Kunstinstitut, Frankfurt.

8.50 Philipp Otto Runge, *Cornflower*, 1808–1809, pen drawing. Hamburger Kunsthalle.

style. Whatever else it may have been, Runge's dream of a Gothic chapel in which to house *The Times of Day* is ultimately inseparable from German commerce and nationalism.

It has often been observed that a striking affinity exists between Runge and William Blake. They share a common source in the social dynamic that originated in England. Blake's graphic style and his ideas derived from the industrial changes of the second half of the eighteenth century, and an analogous evolution can be traced in Runge's cultural production. Just as early German industry took its cue from English machinery and technical skill, so Runge borrowed his graphic ideas from the style and motifs of Blake's friend, Flaxman. In fact, once Runge contemplated going to London to study the print business, just as many youths from Hamburg were sent there for commercial training. Runge's linearism and his patronage must be understood within the context of the critical role played by the English in Hamburg's economy as well as culture. His connections with Blake and Flaxman (both direct and indirect) indicate the spreading influence of the Industrial Revolution on European culture.

Another connecting link between Runge and the English is the work of Erasmus Darwin and other members of the Lunar Society. Darwin, Priestley, and Wedgwood were popular figures in German science and industry. We already have seen that Darwin's contributions influenced the *Naturphilosophen,* especially Schubert, who had one time contemplated translating *The Botanic Garden.* Darwin's work was well known to the Hamburg intellectual and mercantile elite through the prominent position of his friend Reimarus and must have been distributed by Perthes. Darwin's synthesis of science, industry, poetry, and art was based on the central role of the botanic gardens in contemporary European commerce and culture. His title *The Botanic Garden* was well chosen, with part 1 labeled "The Economy of Vegetation."

Darwin's inspiration for *The Botanic Garden* is revealed in the "Advertisement" that precedes the actual text. After explaining his design "to inlist Imagination under the banner of Science," he declares that his end in using his analogies and metaphors was "to induce the ingenious to cultivate the knowledge of Botany, by introducing them to the vestibule of that delightful science, and recommending to their attention the immortal works of the celebrated Swedish Naturalist, LINNEUS [sic]."[86] In Part 2, "The Loves of

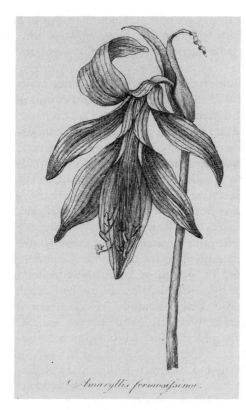

8.51 Engraving of *Amaryllis* from Erasmus Darwin's *The Botanic Garden*.

the Plants," Darwin explains the Linnaean system of classification: "Linneus, the celebrated Swedish naturalist, has demonstrated, that all flowers contain families of males or females, or both; and on their marriages has constructed his invaluable system of Botany."[87] Darwin's profound regard for the botanist is seen in his founding of the Lichfield Botanic Society, whose primary aim was to publish translations of Linnaeus's writings.

Darwin's allegorical creatures are able to metamorphose into plants and elemental forces of nature. In using the idea of hieroglyphs to describe these associations, referring in his "Apology" to the ancient "names of hieroglyphic figures representing the elements," Darwin even antedates Tieck. Darwin's Venus rising from the sea was "an hieroglyphic emblem of the production of the earth beneath the ocean."[88] This may be compared to Runge's statement that in the alignment of the exalted feelings with objects of inspiration "we represent the symbols of our thoughts of great forces in the world: these are the pictures of God or of the Gods."

The illustrations in *The Botanic Garden*—many of them engraved by William Blake—display the carefully drawn, diagrammatic character of Runge's *Times of Day*. Darwin alluded to several of the plants Runge depicted in *Night* (fig. 8.55): his verses on poppies, for example, evoke Runge's conception: "Sopha'd on silk, amid her charm-built towers, / Her meads of asphodel, and amaranth bowers, / Where Sleep and Silence guard the soft abodes."[89] Elsewhere, Darwin noted the special properties of jasmine and geraniums as emitting their fragrance "only in the night," and devoted a long footnote to the association of the nightshade with witchcraft and superstition. Both Darwin and Runge loved the *Sprekelia formosissima* (the amaryllis); Darwin's illustration and Runge's painted study of this plant show the same degree of emphasis on its six stamens and elongated pistil (figs. 8.51–52).

Runge differs from Darwin, however, in matters of religious exaltation. He shared with the *Naturphilosophen* the identification of God and nature in a form of pantheism—an appealing solution for those who needed to reconcile the religious impulse with the awesome achievements of science and industry. English landscape was more directly related to topographical and meteorological actuality, resonating with the ideas and aspirations of powerful landowners and farmers who dominated the political process. German intellectuals like Runge, Schelling, and Tieck suf-

fered from a lack of vital contact with real political power and of a sense of national purpose. Lacking the practical means to change their world, religion became their "unifying factor." It was Runge's need for a metaphysical, as opposed to political, unity that culminated in the hybridized landscape forms of *The Times of Day*.

The Times of Day

This is even more clearly seen in Runge's famous series known as the *Tageszeiten,* or *Times of Day,* which preoccupied him off and on for almost the entire first decade of the nineteenth century.[90] It was the artist's most complete decorative statement based on landscape as a metaphor for the union of the material and spiritual realms. *Morning, Day, Evening,* and *Night* were first conceived in a linear style and engraved for a prospective clientele, although the ultimate intention was to paint them on the walls in tempera or fresco, or even as murals in a neo-Gothic chapel, where they could be viewed with a musical accompaniment.

Such a scheme has brought about the interpretation of the project as a *Gesamtkunstwerk* (total work of art). Yet nothing could have been more alien to Runge's mind: the *Gesamtkunstwerk* was conceived of many years later by Richard Wagner in connection with his ponderous operas. The casual application of this term to Runge's work constitutes part of the process of mystification that enables formalists to deal with a gifted intellect who produced no "masterpieces." Since Runge's ideas fit the "romantic" category, his presumably "inferior" technical abilities can be systematically set aside analogously to the status bestowed upon the more contemporary Duchamp.

The Times of Day series was formulated in the very period in which Runge announced his intention to become a serious interior decorator. A letter to his father on 13 January 1803, outlining his plans to execute beautiful room decorations to satisfy the current fashion, refers to his strategic trip to Hamburg to paint a model interior as a lure for a major clientele. At the end of the same month he described *The Times of Day* as "Decorationen," and while he observed that they would be "somewhat costly" interior designs, he hoped for more modest spin-offs from the central idea and did accomplish two minor commissions based on this series.

Thus Runge's cycle began as a project for wall decorations in the fashionable neoclassical style. Not surprisingly,

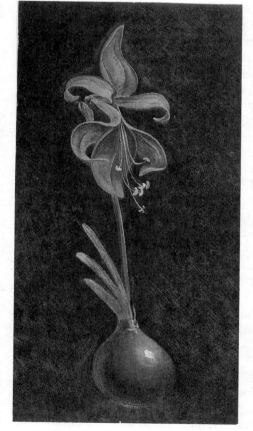

8.52 Philipp Otto Runge, *Amaryllis formosissima,* 1808. Hamburger Kunsthalle.

they display the inevitable influence of Flaxman and his patron Thomas Hope. The series was etched by a Dresden painter in the form of an album and became his "sample book," a portfolio of models for presentation to prospective buyers. His patron Perthes—who published a larger second edition of the etchings in 1807—commissioned an alcove cover from him that was a variant of the *Night*. Gradually, the series unfolded as an increasingly ambitious scheme backed up by a philosophical scenario; but even the painted versions of the *Morning* (a sketch and an incomplete definitive projection of the years 1808–1809) were meant to be seen as murals.

The idea of complementary music is hardly original: it may be recalled that many of Runge's decorations were done for leisure spaces like music and dance chambers. Goethe hung the etched *Times of Day* in his own music room; it was the experience of hearing Beethoven performed on the piano in this room that inspired Sulpiz Boisserée's insight into the relationship of Runge's concept and the composer's music. As in his previous interior designs, Runge's cycle was destined to furnish the prosperous Hamburg merchant community with an exclusive art form that could express their cultural pretensions.

This did not preclude Runge's attempt to make this project a vehicle for philosophical, scientific, and social views. He used interior decoration to help shape bourgeois consciousness. He did for Hamburg what Flaxman did for London, and it is no coincidence that he attached himself to the Englishman's linearity at the very moment when Hamburg's trade relations with Great Britain grew tighter than ever. Runge hoped to join to his project, however, a strictly Germanic scenario, which Tieck himself had agreed to write. Tieck eventually lost interest, but his earlier commitment shows that when Runge conceived the project Tieck was still the single most important intellectual influence in his life.

Most recent Runge scholars also tend to fetishize this series for its supposed "incomprehensibility." They take their cue from Goethe, who declared that the series was "enough to drive one mad" and described it as "a true labyrinth of dark relationships." [91] Goethe's vexation, however, is understandable and stemmed from his ongoing dedication to the classical tradition, which Runge's project simultaneously affirms and confutes. Despite the classical organization of the series, the content negates everything the Enlightenment and its stylistic counterpart represented. Even Daniel

8.53 Philipp Otto Runge, *Morning*, 1803, pen and ink drawing. Hamburger Kunsthalle.

could not give an adequate explanation, claiming that his brother painted mainly decorative schemes and allowed others to interpret them since "he liked to leave to others the freedom to express the pure impressions they received from them."[92]

The series represents the twenty-four-hour cycle as a metaphor for the unity of father-mother God and Creation. As the artist outlined his definitive scheme to Schildener in March 1806,

The first picture (*Morning*) I ask you to consider as approximately such as caused by the sun, which rises above the morning fog; to think of it in such a manner that the spheric section of the earth rolls like a distant mountain in the mist of dawn; the foreground formation would be merely an arabesque alluding to the background. The second (*Day*) would be seen in pure sunshine and clear skies, a day when the pollen permeates the air, etc. The third (*Evening*) would appear in its color in such a manner as if the evening glow had equal brilliance with the glow of the moon in the sky and the glow of both would fuse; the colors of the flower and the tones of the instruments would imitate this mood. The fourth (*Night*) would at the bottom burn in a fire, a fire of flowers which would concentrate where the sleeping figures are; they may be certain of love and protection which comes from above quietly and eternally and in which, always anew and in a perpetual cycle, all with blossom, beget and again perish.[93]

The compositions are organized around the decorative and symmetrical form of flowers, whose seasonal variations have been traditionally associated with the cycle of existence. The *Morning* is obvious: a large springing lily plant with four descending buds forming archways emerging out of the morning mist and clouds constitutes the basic floral motif and symbolizes the dawn of revelation (fig. 8.53). Rising perpendicularly to the sky and along the central vertical axis is the calyx of the lily, on which nine *Geister* in groups of three perform a kind of affectionate acrobatic act. The three uppermost figures embrace and hold up Venus, or the Morning Star, which occupies the apex of the composition. Four other *Geister,* playing various musical instruments, sit on the arcs of the drooping tendrils, while the lily buds open to eject roses on the earth's surface, represented by the curve of the globe. Runge's symbolic intention is made clear in his statement to his brother: "The light is the lily and the three groups, according to their disposition, are related to the Trinity. Venus is the pistil or the center of the light and I have endeavored to give her no other form but that of the star." The association of the lily

with light and purity dates from antiquity, but Runge adds his own original twist in aligning Venus as the Morning Star with the flower's pistil—the seed-bearing organ. Here the feminine principle is invoked for the symbolic birth of a new day, and at the same time brings into harmony the astronomical-spiritual realm with the botanical-earthly realm.

This theme is complemented by the motifs in the margin-frame which, as in the other three times, indicate "closer and larger relationships and transitions from one picture to the next." Below, aligned with the central axis, there are two crossed upside-down torches encircled by the emblem of the serpent biting its tail. The reversed torches signify the extinguishing of the limited world view, while the symbol of eternity encircling them points to the dawn of a new era. The idea of redemption is symbolized by the two *Geister* with Psyche wings, fleeing the reversed torches toward the corners where other *Geister* await them in lotus blossoms floating on the water like floral ships of salvation. The *Geister* navigating the lotus blossoms hold in the form of a standard the stalks of the amaryllis plant that rise on the sides of the margin-frame. At midpoint, a *Geist* is shown emerging from the blossom, tugging at the pistils as it works its way upwards. The stem of a lily grows out of the amaryllis blossom, and its inflorescence acts as a pedestal for an angel kneeling in prayer. The two angels at the corners bow toward the center of the upper margin, where a crowd of *Geist* heads surround a radiant aureole in which the Hebrew word *Yahweh* is inscribed.

The entire action and symbolic system in the margin-frame signals the dawn of ideas as successive stages of progress leading to the radiance of the Divine Glory. The presence of the Morning Star just below the dazzling aureole points to the east as the source of both material and spiritual light, or truth. In the physical world the morning is ushered into existence by the reddening dawn of the eastern sky, when the rising sun diffuses its illuminating rays to every part of the visible horizon, warming the whole earth with its embrace of light, and giving newborn life and energy to flower and human, who, at the healing touch, awake from their dark slumber.

The rising of the sun is the metaphorical representation of the *Weltseele* (world soul), conceived by Schelling as the common principle of organic and inorganic nature. Both are dynamic rather than mechanical, with the final substratum for all of nature being energy rather than matter. Since

all of nature is fundamentally dynamic and active rather than mechanical and passive, the world cannot be adequately characterized as a great machine; it must be understood as the manifestation of primal force, or "world soul." In addition, nature for Schelling is structured through dynamic polarities that correspond to the organism's capacity to act and be acted upon. Runge's marginal motifs allude to positive and negative poles that imply the antithesis of finite and infinite. The world soul gives existence and intelligence to the universe as the sun yields light and truth.

Infinite space is peopled with divine ideas, reflecting God's mind in countless spiritual forms. These *Geister* assume various guises and become the images and metaphors of aesthetic inspiration at the key moments in the diurnal cycle. Runge, like Tieck, almost always considers these *Geister* of inspiration in connection with a landscape experience. In March 1802 he observed that he always perceived in himself "at the time of moonrise or sunset this presentiment of *Geister*," while in December of the same year he wrote that in contemplating the elements of landscape it seemed to him that "land, water and flowers, clouds, moon and meadows are engaged in a dialogue, then I see these images living before me." Another time he declared, "I wish to represent my life in a series of works; when the sun sets and when the moon tints the clouds golden then I shall capture the fleeting *Geister*."

Morning's counterpart, *Evening,* also moves from the real to the ideal, basing its metaphorical structure on concrete observations akin to Schelling's methodology (fig. 8.54). The lily calyx with its nine affectionate *Geister* now appears at the bottom of the picture, sinking behind's the earth's arc like the setting sun. Venus is now the Evening Star, shown in the western sky below the center of the composition. From both sides of the interior scene spring symmetrically paired rose shrubs providing perches for *Geister* who play musical instruments. Just above the rose plants appears an overarching poppy plant with its widely spreading leaves, stems, capsules, and blossoms. Two reclining children on the topmost stems, each with one leg pressed against a capsule, emphasize the symbolic connection of the poppy plant with the theme of *Evening*. Opium and its alkaloids (e.g., morphine) are obtained from these capsules or unripe fruits of the poppy. The sleeping *Geist* at the left completes the narcotic association. A Madonna–like figure rising above the poppy plant crowns the composition; with her outstretched arms she literally unfolds the

8.54 Philipp Otto Runge, *Evening,* 1803, pen and ink drawing. Hamburger Kunsthalle.

huge mantle of evening like a bedspread and darkens the scene. One part of the shroud arches widely over her head, behind which appears the disc of the moon like a halo. The curving windblown shroud is dotted by a series of seven stars above the halo and below with a row of eight, totaling fifteen in all.

The theme of the margin-frame is similar to that of the *Morning,* although the motifs differ somewhat. The bottom border contains the Cross with the inscription "INRI," the Latin acronym for "Jesus of Nazareth. King of the Jews," which is combined with other Passion symbols like the chalice and crown of thorns. On either side of the Cross sits a *Geist* on the leaf of an aloe plant (symbol of bitterness and sorrow), holding a reversed torch. Along the sides of the margin-frame the aloe raises its stalk terminated in the center by a cluster of violets; a *Geist* stands on the leaves of the violets holding the leaf and stalk of a larkspur (in German *Rittersporn,* or "knight's spur," hence the association with bravery). This leads us to the horizontal top border where a *Geist* accompanied by the Lamb of Christ sits within a radiant aureole like the sun. As in the case of *Morning,* the reading of the marginalia from bottom up leads to the Resurrection and Paradise.

In each top corner of *Evening* an angel looks downward, holding the stem of a sunflower upside down. The calyx of the full-grown blossom points downward just as it does at the end of the day. This motif is a transition to the theme of *Night,* in which the sunflower occupies a salient position in the lower register of the composition (fig. 8.55). On either side of the sunflower a pair of *Geister* sleep in each other's arms in the shelter of a foliage arbor, partially cut off by the picture plane. Further in the middleground a child is asleep on either side amid a profusion of plants, all of which are identifiable and include cornflowers (*Kornblume* or *Centaurea cyanus*), starflowers (*Sternblume* or *Lysimachia trientalis*), primroses, thistles, storkbills, and thimbleweed. On either side of the sunflower fire lilies spring, and expanding outward from them are two bushes of night violets, and the five-petal starflowers. Two angels flying to the sides at midpoint act as a covering for the lower register. The floral array is filled out by the foxglove (*Fingerhutblumen* or *Digitalis*), and the primroses which glow out of the darkness like owl's eyes—echoing the motifs in the bottom border of the margin-frame, monkshood (*Aconitum*), nightshade, jasmine, and moon lilac. It is clear that Runge chose his flowers carefully either for their metaphorical connections

8.55 Philipp Otto Runge, *Night,* 1803, pen and ink drawing. Hamburger Kunsthalle.

8.56 Philipp Otto Runge, *Day,* or *Noon,* 1803, pen and ink drawing. Hamburger Kunsthalle.

with night or for their actual nocturnal properties. While the sunflower is conspicuous in the lower register, it is totally overwhelmed by the starflowers and night violets.

Indeed, crowning the entire composition is an enormous poppy plant (again tying it to *Evening*), whose center stalk runs along the vertical axis and is occupied by the Madonna-like personification of *Evening*. She draws her garment closer to her and nods her head sleepily in her guise as *Night*. On each of the plant's eight stems a *Geist* sits, staring straight out and communicating by a ritualistic semaphore with its arms and hands. Above each head is a star, while the full moon appears above the female personification (an early sketch showed this as a crescent). Together they form a regular curve tracing the "vault of heaven." One of Runge's friends, who wrote a long poetic interpretation of the cycle, had been informed by the artist himself that the figures on the stems were the "*Geister* of the stars, the judges of the life of the earth dwellers."

The margin-frame again complements the main scene and points to regeneration. The bottom border shows a fire fed by the twigs of an olive tree; the smoke billows out towards the corners where an owl with eyes like primrose blossoms perches on the end of an olive-tree branch. As we ascend the sides of the margin-frame, floating urns hold a floral arrangement of roses, cornflowers, and marigolds—known in German as *Totenblumen* (death flowers) because they were used in funeral wreaths and for placing around graves. The allusion to death in connection with sleep and night is made in the figure of the slumbering *Geist* at the left whose supine position recalls more the topos of the dead hero than the napping child. The burning olive tree could not in this context symbolize peace, but must refer to the Mount of Olives where Christ and his disciples meditated together just prior to his prayer in Gethsemane. As a prelude to the Crucifixion and the Resurrection, it is an appropriate motif for Runge, and not surprisingly we find in the top border the Dove (or symbol of the Holy Spirit) appearing in the center of a radiant aureole emitting dazzling rays that extend to the corners where three *Geister* worship in adoration. Hence we move from the burning material world through death to the final overcoming and immortality of the soul.

In *Day* (or *Noon*) the lily motif again dominates, this time elevated above an allegorical scene of abundance (fig. 8.56). It is encircled by a floating elliptical wreath of cornflowers resembling a floral diadem. Below an earth-mother

figure sits in a hemispherical niche formed of grape leaves and a variety of foliages, held together by an arch consisting of clusters of fruits such as apricots, cherries, blueberries, plums, and grapes. The Earth Mother is surrounded by playful *Geister,* one of whom she breastfeeds while another nestles in her lap. Below her feet an anthropomorphic urn pours forth into a circular pool "living water." On either side a *Geist* holds the stalk of a bellflower plant, while a profusion of nettles, violets, thistles, and hyacinths fills in the lower register of the composition. At the extreme ends, a giant iris shoots up, whose long reeds form an arch above the hemispherical niche and upon which two *Geister* repose and reach for fruit in an upturned corolla. At the left, a stalk of flax, and at the right, a stalk of wheat (whose spikes have been precisely rendered and resemble the German Einkorn variety) complete the composition of the main scene.

This time the motifs of the margin-frame refer to the overcoming of the Adamic man and regeneration as Christ. In the bottom border a type of guardian angel holding a sword aloft keeps watch over two *Geister* in the corners who tend stalks of grain. Growing out of the spikes is the mullein plant, whose inflorescence curves beyond the reach of the *Geist* climbing its stalk. The mullein produces a flowering shoot in its second year of growth and then dies. Runge declares his refined knowledge of botany by showing the inflorescence turning toward the ground, the so-called geotropic response of this plant to the earth's gravity. In the top half of the side margins the passionflower ascends with a snake coiling around its stem, while its calyx supports an angel paying reverence to the central motif of the top border: the deific symbol of the triangle. This powerful symbol of the Trinity circumscribes a flaming sun from whose center emanates dazzling rays which enshroud the entire motif, and arching over it is a refulgent rainbow fulfilling the divine promise.

The references to the serpent, to the labor in the fields, to the Passion, and finally to the Resurrection clearly allude to 1 Corinthians 15, where the most succinct interpretation of the transformation of the Adamic race is found: "For as in Adam all die, even so in Christ shall all be made alive." Paul here uses the Resurrection to exemplify the resurrection of all humanity: "But now is Christ risen from the dead, and become the first-fruits of them that slept." Paul then answers the question of how this is to be accomplished with a parable of the sower: "Thou fool, that which thou

8.57 Philipp Otto Runge, *Morning* (small version), 1808. Hamburger Kunsthalle.

8.58 Philipp Otto Runge, *Morning* (large version), 1809. Hamburger Kunsthalle.

sowest is not quickened, except it die: And that which thou sowest, thou sowest not that body that shall be, but bare grain, it may chance of wheat, or of some other grain: But God giveth it a body as it hath pleased him, and to every seed his own body." This is likened unto the resurrection; "it is sown in corruption; it is raised in incorruption." And finally: "The first man Adam was made a living soul; the last Adam was made a quickening spirit."

Here the cycle is completed and Runge's meaning made clear. As often stated, it is steeped in the writings of Böhme, but it is expressed with the clarity and precision of a scientific mind. Böhme wrote in the *Aurora*, "As the Father generateth his Son, *that is*, his heart or light out of all his powers, and that *light* which is the Son generateth the *life* in all the powers of the Father, so that in the same light, in the Father's powers, goeth forth all *manner* of growing, vegetation, springing, ornaments and joy; so is the kingdom of angels also constituted, all according to the *similitude* and being of God." Runge extrapolated from Böhme's opaque prose the essential ideas regarding the resolution of Good and Evil in the universe. Light and dark are necessary complements of one another, without which neither is understandable. Böhme devoted a major section near the end of *Aurora* to the times of the day, dividing them, as Runge does, into day and night, morning and evening. Much of it anticipated Runge's cycle, including references to the breaking of day and Creation as the "opener of the innermost birth," presenting itself "in the outermost birth upon the *rainbow*." Böhme asserted that day and night preceded morning and evening, which could only have come about after the creation of the sun and stars. Day and night took place at the moment when God spoke, "Let there be light." Light then broke through the darkness covering the world, the primal insight into cosmic bleakness. Day and night emerge before solar light, and hence light in this context means revelation and progress. This is the quintessential meaning of the aurora or "morning-redness," a phrase used by Runge and his contemporaries to signify the dawn of a new era. It is the rebirth going on hourly, by which human beings may entertain *Geister*, the true ideas of God, the spiritual sense of being.

This is the key to understanding the two painted versions of the *Morning*, the smaller one being the sketch for the large, incomplete production (figs. 8.57–58).[94] Runge planned, almost from the time of his initial conception of the cycle, to translate it into painted murals. The sketch

shows us how the frame would have looked had he completed the definitive version. The crossed, upside-down torches in the bottom border of the drawings and etchings have been replaced by the sun just emerging from behind the darkened earth and illuminating its edges. Two *Geister* flee from the dark disc with its radiant corona toward opposite sides where, in each corner, another child extends a helping hand from a kind of cage formed by the roots of a *Sprekelia* (then known as *Amaryllis*) bulb. As the plants rise upward along the side borders, *Geister* work their way through the brilliant red blossoms, leading to the lilies near the top, upon which angels kneel in adoration before the heavenly choir illumined by the radiant extension of the sun's rays emanating from the lower margin.

The main scene has now been radically transformed. The symbolic globe has been replaced by a specific landscape, in this case a panoramic tract of meadow in the valley of the Elbe. The sun's rays from the border seem to penetrate the scene, forming a path of light through the plains toward the horizon. A newborn infant lies on its back with its hands and feet upraised in the center foreground, just above the rising sun in the bottom margin and directly in the path of light. *Geister* on either side sprinkle rose petals of dawn over the supine baby nestled in among the dewy plants. The large lily calyx with the affectionate *Geister* has been retained, but now it functions as an explosive passage of white light from whence the *Geister* spring. Three winged cherub heads hover above the lily and gaze at the Morning Star just above them on the central axis. Additionally, Venus or Aurora has now been given form as a nude female appearing in the center of the picture. Her golden hair envelops her body as she steps forward to herald the sunrise and the new era. The radiant beams issuing from the bottom border diffuse their conical pattern through the central area to emphasize Aurora's association with the morning light. The red rose petals and the streaks of crimson in the sky illustrate the "morning-redness" so dear to Böhme and his disciples Tieck and Runge.

The definitive attempts exist today only as a series of fragments. Just before he died, Runge requested Daniel to destroy the large version, since it lacked its decorative border and was otherwise unsatisfactory to him. Daniel did not comply with this request, but later in the century someone else did. The nine partial segments were reassembled only in 1927 and mounted on a neutral gray ground. Although the reconstituted parts hardly reveal the general

effect, they do show enough to indicate his basic scheme. The three winged cherubim at the top have now been changed into full-fledged *Geister* forming a pyramid as they strive to reach the Morning Star. The landscape has been depicted naturalistically, and scholars have observed that the panoramic vista is specifically northern German and was based on the flatlands of the Hamburg region in the Elbe River valley. The plant life is scrupulously rendered, dominated by the textbook accuracy of the irises on either side of the child in the center foreground. Moving into the middleground we see a cluster of aloe rosettes, which appear just beyond the infant on his back. The baby's hypnotic gaze is fastened on the nude figure of Aurora, and the sense of revelation is reinforced by the rays of light that illuminate their section.

The curious blend of the specific and the cosmic, the universal and the national, harkens to the consolidation of German nationalism in the years 1808–1809. This very mixture of universalism and patriotism helped give to German nationalism first its chiliastic and eschatological character of the pietistic *Wiedergeburt* or regeneration, then the foundation of its mission idea, and finally its expansionist pan-Germanism. Universalism and nationalism are fused through the concept of the German mission to advance the rest of the world. This differed from the universalism of Herder, that of a garden of diverse colors to create a kind of rainbow coalition in a richly variegated universe. Out of the humiliation of the Napoleonic wars emerged a purified and ennobled Germany destined to lead to a medieval Christian order. Adam Müller, the conservative who romanticized the concept of the Estates General under aristocratic domination as a living, organic collectivity, claimed that all European nations are bound together, but Germany is "the mother of the nations of present-day Europe."

This position goes directly to the heart of Runge's annotations for *The Times of Day,* centered on the idea of the "boundless" (*gränzenlose*): "*Morning* is the boundless illumination of the Universe. *Day* is the boundless figuration of the creatures which fill the Universe. *Evening* is the boundless annihilation of existence into the origin of the Universe. *Night* is the boundless depth of the knowledge of the indestructible existence in God. These are the four dimensions of the creating spirit. God, however, accomplishes all in all. Who can depict the way he communicates with creation?"[95] The painted versions of *Morning* especially clarify the connection between the metaphysical in-

terpretation of "boundless" and its pictorial expression as a vast expanse of northern land moving beyond territorial borders. Regeneration as allegorized in the idea of birth and dawning carries with it the concept of the new German mission established firmly on native cultural and scientific progress.

The child's open hands and outstretched fingers rhyme with the leaves of the aloe plant and with the waves of Aurora's golden hair running parallel to the horizon. Here we see a series of metaphorical links uniting all the constituent parts of Creation leading upward to the divine. The personification of dawn combines two aspects of the feminine principle, the Virgin Mary and Venus. She is at once the spiritual and temporal harbinger of light and knowledge, the generative force of matter and of divine understanding. The child also bears a dual allusion, first to the infant Jesus and second to the idea of a new day, the beginning of creation. Runge established the pictorial grounds of an inner connection between all forms of life and expression on organic and dynamic principles in the best tradition of *Naturphilosophie*.

Schelling's disciple, Gotthilf Heinrich von Schubert, linked the landscape and the child in his treatise of 1806, *Ansichten von der Nachtseite der Naturwissenschaft* (Views on the dark side of natural science). Referring to a cycle of pictures by Caspar David Friedrich illustrating the seasons of the year, the times of the day, and stages of human development, Schubert described the beginning of childhood as the emergence from a kind of dream:

When we wake from that dream we find ourselves in the morning glow [*Morgenröthe*] of an everlasting spring day and no trace of bygone autumn tinges its bright green. We awake among flowers by the clear source [*Quell*] of life, where the eternal sky is mirrored in its primal virgin purity . . . There the first ray of that longing which guides us from the cradle to the grave touches an early unfolding mind, and, unaware of the endless distance which separates us from the eternal source of light, the child's arms open wide to grasp what he believes to be within his reach.[96]

There are so many elements in this passage that recall Runge's work that it seems as if the artist had Schubert in mind when he began painting. Runge clearly thought about the *Naturphilosophen* as he began the project; Steffens wrote him on 18 April 1808 about the new sketch of *Morning,* "You write that it is definitely first for me, and then for Schelling."[97]

Steffens in fact supplied one of the most compelling interpretations of the painted *Morning*, concentrating on the child as the embodiment of its deeper significance.[98] Steffens compared the newborn baby with animals who are mobile almost immediately after birth. The helpless child lying on its back is superior since it is liberated from nature's guardianship. The instinctual process of animal life remains under nature's control, while the human baby is located on a higher plane, "born to be carried in the arms of Love."

Steffens noted Runge's emphasis on the extremities of the baby. The infant's feet and legs are virtually inactive in the first months of life; she may observe her toes, but the feet seem to be an object detached from the body. Creeping and crawling are only latent in the lower limbs, just as speech is inherent in the tot's incoherent gurgling. Gradually, an inner awareness takes over and contemplation is transformed into movement, babbling into language. In the wriggling of Runge's baby we see the first glimmerings of action and language. The watching of this unfoldment is a mother's rich reward, and its most sacred expression is dawn. The child is the incarnation of dawn and emancipating love, with the mother (Aurora) mediating between childbirth and daybreak.

The playful and gurgling baby bears a world in itself, like a sprouting bud. There is communication between the baby and the flowers, both formally and thematically. Steffens made it clear from the botanical similes that Runge, like himself, sought a higher unity between art and science, the material and spiritual realms.

The Times of Day and Freemasonry

Runge and Friedrich incorporated Masonic symbols into their work. Perhaps an indirect clue to this source of Runge's hieroglyphics may be found in *The Botanic Garden*. Darwin wrote that the "Rosicrucian doctrine of Gnomes, Sylphs, Nymphs, and Salamanders was thought to afford a proper machinery for a Botanic poem," and he speculated that these were the original "names of herioglyphic figures representing the elements," confusing the eighteenth-century brotherhood with its supposed origins in ancient Egypt.[99] Darwin had been a member of the Freemasons, and the Lunar Society shared many Masonic tenets for an ideal society based on fraternal love. It was widely believed that Freemasonry originated from Rosicrucianism, and

that the two secret societies shared many of their essential characteristics, among them the signs and symbols that were considered a derivation from ancient Egyptian hieroglyphs.

Freemasonry, which took its modern form only in 1717, early became the largest fraternal organization in the world. While today it is collectively apolitical, in the eighteenth and early nineteenth centuries it was overtly political in its opposition to tyranny and promotion of social equality. Its members actively participated in the American and French revolutions, often encountering overt religious and political opposition from the Roman Catholic Church and reigning governments. On the other hand, it enjoyed the support of a notable section of the aristocracy, and its nonsectarian membership (except in German lodges which often excluded Jews) embraced numerous Catholics.

Masonic lodges—the basic administrative unit of Freemasonry—had an especially firm footing in Prussia (Friedrich II was himself a well-known Mason), Hamburg, Saxony, and Swedish Pomerania.[100] Crabb Robinson, referring to Freemasonry, wrote in January 1801 that the "secret societies" were "a fashion & a rage in Germany."[101] He had in mind many scientists and philosophers who flocked to Masonic lodges in the interests of fundamental social reform. Except for French sympathizers, like Kosegarten, most of them—Fichte and Steffens among them—directed their efforts against Napoleon and assumed an active role in the preparation and execution of the Wars of Liberation.

Freemasonry was anticlerical but not antireligious: belief in God was the basic requirement for membership. Many of its features would have appealed to the younger generation of German intellectuals and patriots. First, the concept comes straight out of the medieval world of cathedral builders: that is, from Gothic "masons" who grouped themselves into "free" or independent unions. Second, the writings of Jakob Böhme—in particular his interpretations of light—figured prominently in the ideas of European Masonry. Third, Masonry made abundant use of allegorical emblems and complex symbols that Masons attributed to the Gothic builders and that they thought of as hieroglyphs.

God was understood as the Great Architect of the Universe. One of the key symbols of Freemasonry is the square and compass of the stonemason's trade, often shaped into opposing triangles. The trowel signified the spreading of the cement of affection needed to unite all the members

of the Masonic movement. The shovel symbolically taught the Mason to remove the rubbish of passions and prejudices, and unite all factions in the common goal of the new society. Finally, the plumb—which also became associated with the French Revolution—signified moral straightness or justice.[102]

Freemasonry in Germany (*Freimaurerei*) was abetted by other movements, most notably the Illuminati (*Die Illuminaten*), a secret society founded by Adam Weishaupt. Educated in a Jesuit school, he admired the discipline of the Jesuits but deplored the content of their teachings; he thus resolved to create an organization along similar lines for the defense of the very principles they attacked. Weishaupt first learned of Masonry in 1774 and borrowed many of its outward forms to found the new republic of which he dreamed.

There were elaborate initiation procedures. Members were sworn to secrecy; a cipher language was constructed, with classical names used for purposes of concealment. In 1778 the movement was joined by Adolph, Freiherr von Knigge, a member of an old Hannoverian family who had previously entered a Masonic lodge, and he brought with him a number of disillusioned Masons looking for a more effective social voice. Like Weishaupt, Knigge favored a "stateless" universal world order where princes and nations had no place. Liberty and equality formed the secret kernel of Christ's teachings, and Christianity was therefore the foundation of the new order projected by the Illuminati. Religion and authority, however, were to be preserved and respected. The aim of the Illuminati was not to overthrow the state and establish institutions by force, but to aid the natural processes of evolution, to keep monarchs from the path of despotism, and to plant its members—including an order planned for female members—not only in the chief places of government, but also in the schools and the workshops.

But outside pressures began to take their toll on the international organization. When the French Revolution broke out, both Masons and Illuminati were seen as a threat to thrones everywhere, and the ruling classes were on guard against them. Though the secret societies applauded the French Revolution, their influence on events was exaggerated in order for the forces of reaction to suppress what they labeled an "international conspiracy."

As in other segments of Germany, the progress of the French Revolution disappointed most of the secret soci-

8.59 Frontispiece for Gotthard Ludwig Kose-
garten's *Legenden,* 1804.

eties, and by the time of the Napoleonic occupation they
followed the lead of the Italian Carbonari (also based on
Masonic principles) and dedicated themselves to the over-
throw of Bonaparte. The German government could once
again look with favor upon the Freemasons. This changed
attitude is seen in an article published in the *Hamburgischen
unparteiischen Korrespondenten* of 6 May 1815, which de-
clared, "When the history of our time finally comes to
light, it shall be quite clear that the Freemasons had long
prepared and fostered the fall of Napoleon, without ever
making their own politics the object of their efforts." [103]
German Freemasonry temporarily abandoned its interna-
tional, cosmopolitan philosophy in favor of a specific pro-
nationalist goal. This is not to suggest that all German
Freemasons of the period espoused this goal—Goethe cer-
tainly did not—but that its progressive membership trans-
lated Masonic ideals into nationalist aspirations.

Those who made this transition included the philoso-
pher Fichte, a member of the lodge Pythagoras of the
Flaming Star, who actually wrote on the subject of Free-
masonry. He declared that the Freemasons were not reli-
gious but thought and behaved religiously; orthodoxy was
not the concern of the Freemason, but he focused his con-
sciousness "always on Eternity." Other notable *Freiheits-
krieger* who belonged to Masonic lodges were Arndt, Stein,
Scharnhorst, Hardenberg, and undoubtedly Gneisenau,
who was so close to them. They used Masonic codes and
names to communicate during the Wars of Liberation, al-
though the infiltration of French spies into the lodges even-
tually made this a dangerous game. Already in 1808 in Lü-
beck Steffens, also a Freemason, argued against using
Masonic signs of recognition in an anti-French society
(which included Rumohr) for fear of the infiltration of the
French secret police. [104] Christian Gottfried Körner, father
of the patriotic poet Theodor Körner, was another well-
known Mason whose influence on his friend Schiller shows
up in *Die Räuber,* a work profoundly imbued with Masonic
ideals. Körner also affected the thinking of Arndt and with
him took a leading role in the liberal nationalist movement.

Freemasonry in the German territories had a long and
established tradition; it produced the largest quantity of
Masonic literature, beginning in the late 1770s with Johann
Joachim Christoph Bode's *Almanach.* Bode established
himself at Hamburg as a bookseller and translator of En-
glish works and belonged to both a Freemason lodge and
the order of the Illuminati. Lessing, another prominent

Mason, made his *Nathan der Weise* a Masonic plea for religious toleration—a striking argument in favor of Jewish emancipation as yet rejected by the author's own fellow Masons. One exception to this rule were the lodges in Hamburg, where Jews and other ethnic minorities fared better than elsewhere in the German states. Indeed, of all the German Grand Lodges—the chief Masonic authority in a particular geographical area—the Grand Lodge of Hamburg deserves special mention because it was the oldest in the German territories and had its origin in the English system. One of the most prominent Masons in Hamburg was the venerable actor and dramatic poet Friedrich Ludwig Schröder, who devoted much of his energies in reforming and organizing the Masonic system. Schröder was well known to Tieck, Steffens, and Runge and their circles in Hamburg and Berlin.

Given the number of friends of Runge who were Freemasons and the importance of this movement in social and political reform, it can be safely assumed that Runge was familiar with Masonic rites and symbols. Kosegarten's deep involvement with Masonic ritual shows up in the frontispiece design for his *Legenden,* where the radiating triangle is joined to a scene of the Holy Family (fig. 8.59). Masonic spiritual and utopian ideals correspond with much of Runge's thought, and the impact of the movement on progressive thought may explain some of the more "arcane" features of his work. For example, in his watercolor design of the *Nightingale's Bower* a sprig of acacia has been worked into the composition as an illogical extension of the oak branches. A *Geist* sits at the curve of the sprig on either side and terminates the sketch. Now the sprig of acacia was a familiar part of Masonic legend crucial to the Third Degree, the degree of the Master Mason. Hamburg Mason medals from as late as 1873 still show the sprig of acacia, a manifestation of Masonic involvement with the symbolism of sacred plants. The acacia was esteemed a sacred tree because it grew abundantly in the vicinity of Jerusalem. In the mythic system of Freemasonry it is preeminently the symbol of the Immortality of the Soul—a doctrine essential to its system. The acacia is an evergreen tree that enjoys "an eternal spring." Thus acacia is associated with the Master Mason by its evergreen and unchanging nature, metaphorically linked with the spiritual nature imparted to us by the Grand Architect of the Universe. A secondary association of the plant is innocence, deriving from the Greek word that stood for both the tree

8.60 German lodge jewels, plate 30 of R. F. Gould's *History of Freemasonry,* 1900, vol. 3.

8.61　Berlin lodge medal, plate 25 of Gould's *History of Freemasonry*.

8.62　Frankfurt lodge jewel, plate 28 of Gould's *History of Freemasonry*.

and the moral quality of purity of life. Both meanings of the emblem would have agreed with Runge's plant symbolism.

While many of the Masonic symbols and allegories are similar and even identical with conventional forms, it is nevertheless striking to find in the margins of *The Times of Day* a number of emblems central to Masonic thought. These include the serpent biting its tail, the dove, the Morning Star, the sun, and especially the radiant triangle enclosing the Hebrew letters representing *Yahweh*.[105] The triangle was the basic symbol of deity, and the single most important symbol in Freemasonry. Most typically, rays emanated from the center of the triangle and enshrouded it (figs. 8.60–62)—a reference to the Divine Light as we find it in Runge's *Noon*. The idea of "light"—influenced in part by Böhme—was fundamental to the Masonic rituals. The motto of Freemasonry is *Lux e tenebris* (light out of darkness). This motto is related to the critical stage of the initiation ceremony, when candidates prepared to received the full communication of the "mysteries" through which they had passed. The communication of light or *lux* was regarded as the doctrine of Divine Truth by which the path of those who have attained it will be illuminated. It is the symbol of both knowledge and revelation, and its reception also taught the lesson of regeneration and the Resurrection.

In the "mysteries" of international Masonry, the candidate was made to pass through spaces of utter darkness before being admitted to the brilliantly illuminated *sacellum,* or "sanctuary." Darkness was the symbol of initiation, reminding candidates of the world which Freemasonry would enlighten and from which it would rescue them. Light was the full fruition of Masonic truth and knowledge; after the darkness came the full blaze of Masonic light. One must precede the other, as the evening precedes the morning. One of Runge's most vivid drawings was a vignette he included in a New Year's letter to his brother Daniel, ostensibly to schematize a festive illumination for the New Year he had seen but in actuality the Masonic sun of regenerative truth he had borrowed from the obverse of a Hamburg masonic model (figs. 8.63–64).

Freemasonry also placed special importance on number symbolism; it venerated only the odd numbers like three, five, seven, nine, twenty-seven, and eighty-one. Three was sacred because of its association with the triangle, and nine, or three times three, was held in veneration because the

Vivat 1801.

8.64 Hamburg lodge medal, plate 2 of Gould's *History of Freemasonry*.

three constitutive elements of bodies (fire, earth, water) were regarded as tertiary. Aspirants had to knock nine times on the door at their acceptance, while in the catechism of the First Degree they had to answer the question, "What is true fraternization?" The answer was "the connection of one, three, five, seven, and nine." One, the beginning, three the Trinity on which five, or Being, arises, seven, or revealed wisdom, and nine the end of all created things. A curious parallel to this catechism is Runge's geometric symbol of creation, illustrated in a letter to Tieck in 1803. The series of overlapping circles traced from their respective centers (with a triangle inscribed in the central circle) alludes to a similar number system, with emphasis on one, three, five, and seven. The unfoldment of Creation is situated in the context of God's decisive expression, "Let there be light!" which pierced the darkness with the divine revelation. Runge's *Morning* is notable for its division of the *Geister* on the sepals of the lily into three groups of three, totaling nine in all, while in the margins of the four works the *Geister* number either seven or six divided into triadic groupings, and mainly odd-number sequences predominate in the main scenes. Above all, the eight *Geister* (who with the Madonna form a row of nine) seated on the arcs of the poppy stem must embody the esoteric signs of the Freemasons. It has often been remarked that they gesture in a formal manner, each placing their hands in a particular position like a signal. Masons had their own grips and hand signals for instant recognition, done with the hand and fingers in contact with the head, hand in hand, or the chop-

ping of one hand with the other. The importance of the hand in German Freemason ritual is seen in the fact that the newly initiated was presented with two pairs of white kid gloves, one pair of which was meant to go to his spouse or betrothed. In the German lodges the word used for acts was *Handlungen*, or "work of the hands." The gloves awarded the candidate implied that the acts of the Freemason should be as pure as the gloves. Thus the various hand movements of the *Geister* in Runge's *Night* may stand for both insiders' signals and for the pure spiritual dimension of the heavenly realm.

One further clue to Runge's likely Freemason involvement is the role of this composition in Schinkel's stage designs for Mozart's *Zauberflöte* (fig. 8.65). After 1815, Schinkel was employed as a set designer for the Berlin Royal Opera; he was charged with the sets for *Die Zauberflöte*, which was to open in January 1816 to celebrate both a belated centennial of the coronation of the first Prussian king and the Prussian triumph over Napoleon. Perhaps the most unusual of his twelve designs was the domical *Hall of Stars of the Queen of Night*, showing the malevolent protagonist standing on an upturned crescent moon against a stupendous vault of stars arranged symmetrically in rows of three. While the dramatic perspective is alien to Runge, the close relationship of the Queen of Night to Runge's allegorical personification of the moon as the unveiling Queen of Heaven, and the accompanying *Sterngeister* in *Night*, attest to a direct connection. Schinkel had seen the prints of *The Times of Day* and even formulated his own version of them. Runge in turn idolized Mozart and especially loved

Die Zauberflöte.[106] Mozart, Schinkel, and Runge knew that the covering of the Freemason lodge was known under the technical name of the "clouded or starry-decked heavens"—a symbol of the future celestial condition for humanity. What makes the exchange so fascinating is that the opera was a well-known Masonic allegory composed by one of the most famous Masons of the eighteenth century. The presentation of *Die Zauberflöte* for the celebration of state power and national peace suggests recognition of the Masonic role in the defeat of the male counterpart of the evil Queen of Night—Bonaparte.

Runge's Nationalism

Runge's symbolism was informed by his unwavering commitment to the idea of Germanic nationhood.[107] Runge's correspondence demonstrates that he was profoundly affected by political developments and that he was remarkably well informed on current events. But it could not have been otherwise: the political upheavals interrupted the progress of his daily life and sometimes kept him from working. Despite his sense that Europe was on the brink of total catastrophe, he maintained his faith—as seen in the painted versions of *Morning*—in the dawn of a new national era. It was the beginning of the new century, and he had become conscious of his own artistic potential.

As in the case of Arndt and Friedrich, Runge had to work through his Swedish affiliation and suspicion of Prussia before declaring in favor of a united Germany. Several options seemed possible during the first decade of the nineteenth century, but as the Swedish and Austrian governments proved inadequate against the designs of Napoleon, most German patriots rallied around Prussia as the best solution to the nationalist question. Hostility to the French and outrage at the impotence of Gustavus Adolphus forced the issue of divided German loyalties in Swedish Pomerania.

Runge wrote Perthes in January 1799 that "the biggest and saddest piece of news" of the hour is that "the French are again in Rome." By 1805 he remarked to his father-in-law that the "impudence of the French grows so great that it now appears impossible for nations still wishing to remain neutral not to see the light." He hoped for a vast coalition to prevent the "boundless misery" that the French would bring over the world, and predicted that Spain would break with France in favor of peace with England.

Near the end of the year he expressed his fear of war and the growing French menace. He still held out hope that in the end "we will triumph with God's help."[108]

In the spring of 1806 Runge was back in Wolgast, at the very moment the Swedish king was in Greifswald working out the details of the new land reforms. Runge had his reservations about the king; while he liked him personally he seemed "limited." Runge, anticipating a showdown between Gustavus and Bonaparte, wrote "we shall soon see if he can effectively oppose Napoleon." And he concluded his letter to Daniel with a prayer: "God help you and all of us, to defend and preserve us before spring is ended so that the French can never again devour German land [*Deutschland*]!"[109] Runge clearly saw the grave risks of Gustavus IV's involvement in the third coalition but had not yet abandoned all hope. In September 1806—one month before the Prussian debacle—Runge wrote his brother that everyone sensed the "winds of victory over the French." He worried about Swedish Pomerania (over which Prussia had designs) in the event the Prussians did emerge victoriously from an encounter with the French, but he wished it "anyway from the bottom of my heart."[110] In short, he saw the Prussian defeat of the French as the lesser of two evils.

After Jena and Auerstädt, Runge lapsed into profound depression. "The reality is terrifying," he wrote Daniel on 25 October. The French, in pursuit of retreating Prussians, reached the outskirts of Wolgast in November, and Runge described the chaotic and wretched condition of the inhabitants. People were fleeing to Sweden in every available craft, and all industry, farming, and administration had come to a complete halt. Wolgast citizens burned their wagons to prevent them from falling into French hands, and escaped in rafts and improvised boats across the Peene River. Runge wrote that his brother Jacob spent the entire day helping direct the flow of refugees across the river. The French reached the town on 4 November and proceeded to forage and loot; citizens were attacked and some killed, while the invading troops made demands for horses, saddles, bridles, wagons, arms of every sort, and cash for the maintenance of the troops.

The trauma of the ensuing months was repeated in the spring of the following year when the French took up arms against Swedish troops. Runge and his family returned to Hamburg to help his brother. Meanwhile, the ruin of the Hamburg and Wolgast businesses took its toll. The Treaty of Tilsit in July, which all but completed the suppression of

Swedish Pomerania and the German territories, added to Runge's depression. His hopes for his artistic future began to unwind, and Daniel attributed to his mental state the debilitation that eventually killed him three years later. Runge continued to watch with chagrin as the French occupied Rügen and the rest of Swedish Pomerania, bitterly lamenting the relentless pressures of Napoleonic imperialism. He was horrified by Napoleon's decisive defeat of the Austrian troops in Bavaria in late April 1809, which closed off another option for German nationalists.

His return to *The Times of Day* in the form of the painted versions of *Morning* during the period 1808–1809 must have been a way of working through his depression. A metaphoric unity of heaven and earth in a boundless northern landscape had immediate significance to devastated Germany. It is the material realization of what is termed the romantic *Sehnsucht,* the longing for the unattainable national unity. Translated in this way, *Sehnsucht* became an ideological weapon against the foreigner and an escape from the sight of a country in ruins.

Runge's etching for a New Year's greeting card for 1806–1807 (fig. 8.66) was a Pandora's box in the form of a classical urn uncovered by a satanic arm tatooed with the year "1806."[111] Exploding from the urn in smoke and flame is every demonic creature imaginable: serpents, spiders, newts, salamanders, toads, lizards, and winged and fanged monsters darken the sky. The plinth of the pedestal on which the urn rests carries an image of destroyed Prussian artillery, broken swords, bayonets, and abandoned flags. The smoke of a smoldering bomb billows upward to the base of the urn and seems to come out at the other end in the form of the vile discharge. Between the urn and the plinth an inscription reads, "Die Hoffnung blieb drin"— Hope remained within. The pitiable message—written only a short while after Jena and Auerstädt—anticipates the bleakest of futures for the fatherland.

Later in 1807 he recouped his energies and wrote his brother Gustaf that if their fatherland (i.e., Pomerania) could hold fast to the "German mentality and nationhood" then it would be possible to preserve the characteristics of national unity. The fear of French influence on German culture was an irresistible motive-force for thinkers like Runge and Perthes. It may be recalled that in 1809 Perthes published *Das vaterländischen Museum,* a magazine typical of a certain type of publication that appeared in the German lands to combat the humiliation felt under Napoleon. Akin

8.66 Philipp Otto Runge, *New Year's Card,* 1806. Whereabouts unknown.

8.67 Philipp Otto Runge, *The Fatherland's Fall,* 1809–1810. Rejected for publication. Hamburger Kunsthalle.

to the Masonic signs of recognition, the magazine's message was meant to be a rallying point for patriots and nascent nationalist energies.

Significantly, Perthes commissioned Runge to design front and back covers of the journal for the years 1809–1810.[112] We know at least two pairs of designs for it, although the most ambitious of these was rejected for publication. This was the *Fall des Vaterlandes,* the theme of which plays on the double meaning of the word *Fall* as "downfall" and "condition" (fig. 8.67). In the lower foreground a murdered man lies stretched out naked beneath the sod, lightly covered with grass. His wrists are bound together above his head, and a sharp rock has been pushed under the small of his back. Unknowingly, his widow guides a plow pulled through the turf by Amor just above her dead husband. Their infant sits on the shoulders of the mother and holds on to her head. She carries the burden of child rearing as well as that of maintaining of the land. As in *The Times of Day,* a symbolic frame complements the scene: a knight's lance rises on either side surmounted by a plumed helmet, and these lances in turn support crossed swords at the top, from whose hilts in the middle dangles a Janus head. Winding around the entire margin-frame are the stems and leaves of the passionflower, which also circles the body of the slain victim. This design, however, was deemed too strident to be published.

Fall des Vaterlandes may be viewed as an allegory of the ugly reality behind the escapism of *The Times of Day.* Instead of *Geister* joyfully inhabiting the flowers, the soil envelops and weighs heavily on a corpse. The allegorical personifications have now been recast as a mourning peasant mother. The Cupid figure does not inspire love but soberly drags the plow across the body of the fallen victim. The landscape is no longer a symbol of cosmic and national unity but a representation of a ravaged land. The Prussian agrarian reforms of 1807 freed the peasants to a large degree from services and in some cases allowed them to become owners of their land, but the French demands on the rural areas devastated the countryside. Runge's design shows that the peasantry is now worse off than it was under feudalism (symbolized by the medieval accessories); not only are the peasants still at the "bottom" of the social hierarchy but they have been physically destroyed.

Events accelerated to transform the peasant into an active citizen-patriot. The peasant became the image of the authentic German, immune to the cultural influences of the

foreigners. Medieval allusions convey the sense of the folk past, the preoccupation with a distinctive German national character. While this search for "Germanness" and "folkness" began earlier, the full meaning of the doctrine of nationality became clear only through the confrontation of Germany with Bonapartism. There now emerged the image of the peasant as defender of the fatherland. Gneisenau himself wrote in 1807, "What infinite forces sleep in the lap of a nation, undeveloped and unused! . . . While an empire perishes in its weakness and disgrace, perhaps a Caesar is following his plow in the most wretched village, and an Epaminondas is living scantily off the income of the work of his hands."[113] Runge's identification of the peasant-warrior with his own land points to heroic self-sacrifice in the service of the homeland, but also comments ironically on the "empire" perishing "in its weakness and disgrace."

Runge's cover design has to be understood in the context of theorists and intellectuals who proclaimed the peasant as the potential savior of the fatherland, both as an abstract symbol of true Germanness and as defender of German political integrity. Karl Dietrich Hüllmann's history of the origins of social classes in Germany, published in the years 1806–1808, regarded agriculture as the primary social basis of the new national outlook. Agriculture, and rural labor, came to be seen as fundamental to the sense of Germany and a national purpose. This new sense of public dedication, described as the *Wiedergeburt,* was an interpretation of the actual condition of a socially, politically, and militarily bankrupt Prussia. The land reforms of 1807 became the first political step in making immediate the relationship of the state to the peasant, and it is no wonder that Runge's design was rejected for its political allusion to this process. The agrarian situation was widely discussed, and no reforms were more energetically promoted than those that pertained to the life and work of the peasantry.

The soil in Runge's design was enriched by the body of the slain warrior. The widow bears up under her grief. The passionflower symbolizes the Passion of Jesus, persecution, and martyrdom, but also resurrection. The child borne aloft on the shoulders of the mother holds out the promise of a new generation dedicated to the fatherland. The double-headed Janus refers to both war and peace, to endings and beginnings. The cover expresses a moderately conservative viewpoint, finding a political symbol to comment on the social and psychological dislocations of the Napoleonic period. Almost all sectors of the society were

8.68 Philipp Otto Runge, *Plight of the Fatherland,* 1809–1810, pen and ink drawing. Hamburger Kunsthalle.

8.69 Philipp Otto Runge, *Plight of the Fatherland,* 1809–1810, pen and ink drawing. Hamburger Kunsthalle.

able to find in the peasant some measure of hope that the worst could be avoided and the best preserved. It is precisely the fact that the peasant could be developed as a propaganda image for both the progressives and the conservatives that led Perthes to reject Runge's design as unacceptable to French censorship.

Runge then executed a second pair of designs for the journal that were published as the front and back covers of all six issues in 1810 (figs. 8.68–69). These were entitled *Plight of the Fatherland* (*Not des Vaterlandes*) and relate more closely to the cosmic conception of *The Times of Day.* They represent a conservative retreat to the symbolism of Böhme and Freemasonry, clearly less objectionable than the first design. This time there was no central scene, and Runge activated solely the motifs of the margin-frame to make his point. In the center of the bottom border an angel steps into the crevice of a broken heart, brandishing a whip overhead. Out of the crevice sprouts the vine of the passionflower, which climbs on either side up a shaft that is a halberd (a combination axe-spike-spear weapon) at the top and a shovel at the bottom. The two ends of the vine come together, where the leaves and blossom crown a Janus head. The partial disk of the setting sun silhouettes the angel whipping the broken heart.

For the back cover Runge did a variation of the heart motif, which according to Daniel now signifies the intention to restore "inner peace." In the lower margin the heart is burning brilliantly in a light fire, while the angel strokes it tenderly with a small stick. This time a lily-of-the-valley sprouts from the top of the heart, spreading its stems and tiny delicate flowers in both directions along the bottom. Blossoms frame a dazzling aureole, in the center of which hovers a dove of peace carrying a twig of an olive tree in its beak.

The two covers indicate a transition from one state to another; the beating of the broken heart, symbolizing chastisement and contrition, has given place to the heart enflamed by religious fervor and tended by divine love. The fatherland has sinned, repented, and may now expect redemption. This change is already anticipated in the front cover, with its passionflowers and two-headed Janus turned in opposite directions. More importantly, the halberd has been transformed into a farm implement, symbolizing a conversion from war to peace and fulfilling the prophecy of Isaiah: "They shall beat their swords into plowshares, and their spears into pruninghooks: nation shall not lift up

sword against nation, neither shall they learn war any more." The promise of regeneration for repentance is fulfilled in the second design with its blazing noontide splendor: "Arise, shine; for thy light is come, and the glory of the Lord is risen upon thee." And just as Isaiah foretells the coming of the Messiah, so Runge uses the lily-of-the-valley to herald the advent of Christ.

Thus the four designs for *Das vaterländischen Museum* (the back cover of the rejected pair simply showed a frame of passionflowers) parallel *The Times of Day* in its theme of rebirth. But the cosmic allegories have been replaced by political allegories commenting upon real time: instead of a cyclical theory of history Runge engaged the historical progress diachronically—as a succession of events. He now dealt specifically with the history of his nation, its heart burning with the flame of higher patriotism, seeing Germany as a vital community with the living urge to growth and expansion. Runge's own nationalist feeling is obvious in his precise rendering of the plants: Daniel described the plant springing from the heart in the back cover as *Convallen,* a regional name used (with variations such as *Konvalljen*) in Hamburg, Holstein, Mecklenburg, and Pomerania. While still patterned after the scientific models of Linnaeus, Runge's plants, like his landscape, had a geographical base from which he derived his metaphors for the rebirth of the German nation (figs. 8.70–72). Conservatives like Brentano, however, could apply the most narrow interpretations to Runge's designs. As he wrote the artist on 18 March 1810, "May the people, who have split the heart, learn their lesson from this cover and its contents, so that they will not pierce the roots of the fatherland's enterprise." [114] But Runge did not live to see the undertaking fulfilled: he died of consumption on 2 December 1810, just a few days before Hamburg was officially annexed to the French empire.

Saint Peter on the Waves

One final example of Runge's blend of religious and nationalist fervor is *Saint Peter on the Waves,* painted in the critical period of 1806–1807 (fig. 8.73). Its content, its history, and even the events surrounding it sum up several of the issues of German art and thought of the period. The work was commissioned in 1805 by Kosegarten, as an altarpiece for his projected seaside chapel in Vitte, near Arkona, the northernmost point of the isle of Rügen. [115] Her-

8.70 Carolus Linnaeus, *Folia simplicia,* plate 1 of *Philosophia botanica,* 1751.

8.71 Carolus Linnaeus, *Folia determinata*, plate 3 of *Philosophia botanica*.

rings were caught in great abundance near the coast; the shoals swept in to spawn close to the surface, so that their movements could be easily detected. But this meant that the fishermen had to keep an hourly watch for the movement of the shoals and could not leave to attend services at the parish church of Altenkirchen, nearly eight kilometers inland. Since the seasonal fishery trade involved a major portion of Kosegarten's congregation—farmers who temporarily forsook the land, women who gutted, cleaned, salted, and packed the fish, coopers who fabricated the barrels for storage, and finally, the mariners and fishermen— he chose to hold outdoor services directly on the coast. These open-air sermons proved so popular that he decided to build a permanent chapel (*Bethaus*) for use also during the spring herring season when the stormy weather made the outdoor assembly impossible.

A fund-raising drive netted the seed money for the erection of the chapel. Support came in from all quarters, including a number of Freemason lodges, and construction began in late 1806. It was designed in the form of an octagon, approximately 270 feet in circumference with 30-foot-high walls. Kosegarten wanted the spacious chapel to blend in with the rugged surroundings, so he had it constructed of local fieldstone with a shingled roof. He emphasized that its modest and unassuming appearance would present a handsome and cheerful prospect to the worshippers.

Runge visited the island in 1806 to familiarize himself with the landscape around Arkona and integrate it with his biblical scene. Kosegarten gave him the choice of two subjects, Jesus stilling the tempest or Peter walking on the waves. Runge chose the latter. Not only was Peter a fisherman who abandoned his net to follow Jesus and become a "fisher of men," but the biblical event occurred on the sea after Jesus fed the multitude with the miraculous loaves and fishes. It was then that Jesus ordered the disciples to depart in a ship while he disbanded the crowd (Matthew 14). When evening fell, the ship ran into storm-tossed waves, and Jesus walked on the sea. The disciples feared they were seeing a phantom, and Peter called Jesus to "bid him come unto the master" on the water. Jesus commanded Peter to join him, and the disciple began walking on the water toward Jesus. However, when the wind suddenly whipped around him, he grew frightened and began to sink, crying out to Jesus, "Lord, save me." Jesus held out his hand for Peter just before he disappeared below the waves, uttering

8.72 Carolus Linnaeus, *Partes flores,* plate 7 of *Philosophia botanica.*

8.73 Philipp Otto Runge, *Saint Peter on the Waves,* 1806–1807. Hamburger Kunsthalle.

as he did so the oft-quoted "O thou of little faith, wherefore didst thou doubt?"

As Runge wrote Goethe on 4 December 1806, he chose to emphasize the very moment when Jesus asked the question. He added that he intended painting a moonlit scene ("im Mondenschein") and bringing into accord the mood, pictorial effect, and subject with the physical setting of the island: "It is a moonlight scene, and in order for the whole to be seen in accord with the building and make an imposing presentation—especially since it will be the only picture displayed—the waves, moonlit effect, the sails of the vessel must be pulled together in order to harmonize [*in Einklang stehend*] with the surrounding landscape on Rügen." Thus Runge tried to express Kosegarten's concern for the appropriateness of the theme and presentation in keeping with the nature of the chapel. The subject itself had direct relevance to the fishing village of Vitte as well as to the outdoor sermons organized by Kosegarten. Kosegarten's open-air preaching reminded him of the primitive Christians who gathered to listen to Jesus.

Runge also incorporated his mentor's patriotic attachment to the specific features of Rügen. The lunar motif set in the wild Rügen landscape alludes to the Ossianic fantasies associated with the region. The island was well known for its giant gravestones, believed to be the authentic relics of primitive German tribes. Writers as diverse as Klopstock and Kosegarten used these dolmens (*Hünengräber*) as metaphors for the heroic attributes of Hermann and his follow-

ers who triumphed over the Roman invaders. Runge's painting further synthesizes primitive Christian faith with the memory of the indigenous German tribes, and blends religion and landscape into a pantheistic ideal that evokes the spirit of Kosegarten's poetry.

The words of Jesus at the moment he saves Peter are addressed to Kosegarten's congregation. Runge's treatment of this motif had a political as well as social and historical motivation. The letter to Goethe demonstrates that the events of Jena and Auerstädt contributed to his formulation. His New Year's Day card of 1807 was bitterly pessimistic, with its keynote message being that "Hope remained within"— that the spirit of hope had not yet been released to aid afflicted humanity. Runge's need for the restoration of his own self-confidence preceded his faith in the liberation of the Germanic peoples. The picture is thus a plea to himself as much as it is an exhortation to Kosegarten's congregation and, by extension, to the whole of German society.

For Kosegarten's flock the theme would have had a special urgency after the Prussian debacle. The coastal fisheries of Rügen had constituted a vital part of the island's trade since the early Middle Ages. Even the name of the fishing village, Vitte, had its origin in the medieval period and meant the "camp" or "fishery station." The handling and preparation of the herrings for the market took place in these camps (*Vitten*), and there still remained a major smoking and preserving trade. Here the barrels of herring were packed for the shipping merchants of Pomerania, Lübeck, and Hamburg. The fact that herring could be stored for long periods made it a favorite food of armies. The population of the island knew that once the French troops arrived they would monopolize the fisheries on the Baltic coast for their own use, a fear that was realized when the French defeated the Swedish army on Rügen in August 1807 and occupied the entire island.

The island's economy was already paralyzed in the aftermath of the Prussian defeat and the announcement of the Continental blockade. This is evident in an exchange of correspondence between Runge and Kosegarten in January 1807. Runge wrote Kosegarten for permission to paint his picture directly on the spot, and Kosegarten responded the day after receiving the note, on 16 January, outlining the pros and cons of such a visit. He expressed gratitude for Runge's "precious gift" and anticipated having a spectacular opening of the chapel to allow spectators to view it in context. He was unsure about Runge's intention to paint it

on the spot: did he mean to paint it directly on the wall of the finished chapel, or in the vicinity such as in Altenkirchen? He welcomed such a visit in any case and invited the artist to make himself at home at the parish residence. He mentioned that since the death of one of his assistants, a modest but comfortable dwelling could be made available to him nearby for a reasonable rent. Things were as yet unruffled by the deafening noise of the drumbeat and the blinding reflections of the bayonets. Nevertheless, Kosegarten wanted to lay out all the possible risks that such a visit would entail. The situation was fraught with danger, and the island's economy was paralyzed. The artist would have to live at his own expense, and it was unlikely that he could support himself: "This is no land for you." He himself could not spare any money for his support, and many of the funds that he counted on for construction of the chapel had not arrived. Kosegarten clearly felt ambivalent about the situation; he would have wanted Runge to come, but he could not hide from him the terrible realities of Rügen's situation.[116]

Thus the work meant to restore his own self-confidence and sustain the faith of Kosegarten's humble congregation floundered on the very economic problems it tried to address. Work on the chapel itself was suspended in this period because of the French occupation and Kosegarten's appointment to the University of Greifswald in 1808. Runge did not return to the project until 1810, the year of his death. Exactly one year earlier he had written in despair to his mother-in-law about the economic stranglehold of the French and the hopelessness of the opposition: "The Great Emperor has become Lord of the world, and what he decrees must come to pass." But in typical Rungian fashion he concluded his letter with an uplifting thought: "From time to time things go sour in the household; but it is only the sour dough [i.e., leaven] with which the eternal life can rise within."[117]

9 Caspar David Friedrich

Runge did not live to see Germany liberated, but the work of his fellow Pomeranian, Caspar David Friedrich, incarnates the German striving toward independence, and then its lapse into reaction after 1815. There were many points of contact between Runge and Friedrich, including their decisive contact with Kosegarten and Quistorp. In fact, Kosegarten first went to Friedrich with the commission for his new chapel, since Friedrich was a landscape painter well acquainted with the island of Rügen. Friedrich evidently turned down the commission for political reasons, and his most famous work, *Monk by the Sea* is intimately bound up with this experience.

Friedrich (1774–1840) was born in Greifswald, Swedish Pomerania, about fifty kilometers west of Wolgast.[1] Greifswald was a much larger harbor town than Wolgast, with about 50 percent more population, and had an important university and a major saltworks. Whereas Wolgast was dominated by the merchant community, Greifswald had a prosperous artisan class and large contingency of academics who formed a liberal social force. Friedrich's father, Adolf Gottlieb Friedrich, was a well-to-do soap boiler and chandler who had migrated from Neubrandenburg, just south of Swedish Pomerania in the duchy of Mecklenburg. The family owned a house on the main street (now Strasse der Freundschaft) and a soap-boiling firm. Soap boilers did well during the revolutionary and Napoleonic wars which cut off the trade in mineral alkali (soda) used in the finest soap, and this raised the price of their product considerably. Friedrich, like Runge, grew up in comfortable circumstances and could devote a significant portion of his youth to intellectual pursuits. His father's artisanal background, however, predisposed him to a more progressive political

position, less passive and resigned than Runge's, full of rage like Arndt's.

Friedrich's youth was clouded by a series of family tragedies. When he was only seven years old his mother died. His sister Elisabeth died the following year (1782), and five years later his brother Johann Christoffer perished in an ice-skating accident. This event occurred while the brother tried to save Caspar from drowning, and the effects of this trauma overshadowed much of his adult life. Then in 1791, another sister died. With this hammer effect, it is not surprising that Friedrich's landscapes often manifest a melancholy, even morbid, desolation. Friedrich's landscape was an extended space within which to release his grief.

This tragic sense of life was partly inculcated by the pietistic leaning of the Friedrich household. Since pietism stressed the inner sense of religious conviction, the landscape became a vehicle to express God's solace and power. Friedrich's earliest known works are decorated moral texts like the homilies of Franklin's *Poor Richard's Almanac*. Even when he turned to landscape and refined his thought, he held fast to a deeply moralistic position. Friedrich's works come much closer to the sermons of Kosegarten than do those of Runge; despite the latter's call for a religious revival, his *Geister* and flowers often convey a sensuality more consistent with the taste of the Hamburg bourgeoisie than with northern pietism. At the same time, Friedrich was able to find a secular outlet for his emotional enthusiasm in the national group; the extended landscape space became a metaphor for the larger kinship group from which he could derive emotional support.

The development and progress of Friedrich as an artist and thinker depended on a cultural formation centered on the University of Greifswald, which lay close to his home and where he visited often in the company of his father. The university (now known as the Ernst-Moritz-Arndt-Universität) was founded in 1456 and played a major role in the life of the town.[2] Originally organized to educate the children of the royal families of Saxony and Pomerania when it passed into Swedish possession after the Thirty Years' War, its student body consisted mainly of Swedish nobles who were there to train for the Swedish bureaucracy and a handful of others desirous of entering the ministry. By the eighteen century, the economic progress of Greifswald—which traded with Scandinavia, Finland, Russia, Hamburg, Holland, England, France, and Spain and did over one-fifth of the commerce of Swedish Pomerania—

forced the university to expand its student population as well as its curriculum to allow for more practical subjects. The university now taught principles of economy, the natural sciences, civil engineering and navigation to aid the local shippers and traders, as well as astronomy, geography, surveying, business administration (*Kaufmannschaft*), topographical mapping, arithmetic, and geometry. While feudal bureaucracy still controlled the university, the actual curriculum was geared to the middle class. A small fraternity of a dozen students kept the old system alive, and though their motto was "Moral Purity and Irreproachable Valor," they had a reputation mainly for gambling, drinking, and dueling.

The university was the heart of the town, with its important library, mineral collection, natural history museum, observatory, and botanic garden. It was the center of political agitation during the revolutionary and Napoleonic wars. In the mid-1790s when the artisans demanded increased representation in the city council, they were supported by the university students and were able to achieve their demands. The radical character of the student body (and some faculty) was well known to the French; when they occupied Greifswald in 1807 one of their first acts was to install their own handpicked staff and faculty to run the university. Although never technically a student, Friedrich used its facilities and kept in touch with the university's philosophical and scientific currents. In 1790 Friedrich began a four-year apprenticeship under Johann Gottfried Quistorp, the drawing instructor of the university. Quistorp, it may be recalled, was a close friend of Kosegarten, who in 1790 was educating Runge, and the older brother of Johann Quistorp, professor of natural history and botany at the university. The younger brother became the father-in-law of Arndt, who studied at the university in the same period Friedrich studied with Quistorp.

Quistorp trained Friedrich to sketch after standard academic copybooks. As seen in the basic text of Johann Daniel Preissler (1666–1737), these books comprised engravings of parts of the body and architectural details in which every line could be seen and studied.[3] Modeling in these engravings was achieved through hatchings, the tiny parallel marks bunched together at various widths (figs. 9.1–2). It is certain that Friedrich's affinity with neoclassical precision and his sharply defined technique derived in part from this early training. It was the method used to teach both fine and industrial art, since it was methodical, pains-

9.2 Model from Johann David Preissler's *Die durch Theorie erfundene Practic,* Nuremberg, 1728–1731.

taking, and accurate. In 1794 Friedrich followed the normal progress of would-be artists in the north and went to the academy in Copenhagen. He concentrated for two years on the freehand drawing class, where he copied drawings of old masters; this was followed by two years sketching after the antique, or plaster casts, and finally, the life drawing class. An example of his figure drawing shows that his indoctrination in drawing from engravings was carried over into his life drawing, with both background and bodily shadows formed of diagonal hatchings (fig. 9.3). While the figure won a minor medal, life drawing was evidently not Friedrich's forte.

Friedrich did not work in oils until he was about to return to Greifswald in the spring of 1798. His main interest was apparently to master graphic rather than oil-painting techniques and to become a topographical draftsman. View painting was in fact a major commodity of cultural practice at the end of the eighteenth century. The Grand Tour formula, which presupposed the client's humanistic education and an aristocratic awareness, was expanded into an increasingly more postcardlike portrayal of the most popular, picturesque, and memorable sites likely to be visited by tourists. The rapid growth of the middle classes in England made the English the principal clientele for the view painter, though it was the fashion in major metropolitan centers with a dominant merchant class as in Hamburg and Copenhagen. This group hung prints and colored sketches of memorable places to map their trade connections, as tangible souvenirs of sites and buildings visited, as emblems of good taste, and simply as decorations. Friedrich supplemented his income in the Danish capital by coloring prints after drawings by a recently deceased view painter named Erik Pauleson. An etcher and genre painter as well, Pauleson had traveled throughout Europe recording views for Crown Prince Frederik of Denmark; during a journey in Norway in 1788 he rendered topographical views of the Norwegian mountains, which were later reproduced as prints.

Throughout his life Friedrich earned much of his income from selling views and even reproducing them from travel books.[4] As in the case of Girtin and Turner, this commercial activity had a decisive influence on his formative style. No less than Runge, Friedrich had to justify an artistic career in terms his family could understand. The practical and commercial advantages of landscape views would have been readily understood in the harbor town of Greifs-

9.3 Caspar David Friedrich, *Male Nude*, 1798, black chalk drawing. Kunstakademiets Bibliotek, Copenhagen.

wald, which did a brisk trade with Amsterdam, London, and Hamburg and presented similar picturesque possibilities for the view painter. Even Quistorp owed his position in Greifswald's university in part because of the need to train topographical surveyors and mapmakers.

Friedrich also came into contact with Danish landscape painting through the works of Jens Juel and Christian August Lorentzen, who both taught at the academy. While they worked in every pictorial category, Juel depicted picturesque views from the gardens, parks, and estates of his wealthy clients, and Lorentzen executed views from all corners of the world. Both labored to satisfy the demands of a well-to-do class during the mid-1790s, a period of widespread prosperity in Denmark. Internal peace and an active overseas trade unhampered as yet by Napoleonic strategies are vividly illustrated in the idyllic landscapes of Juel, such as *The Little Belt, Seen from a Height near Middelfart*, executed near the turn of the century (fig. 9.4). The Little Belt was the body of water separating Jutland from the island of Fünen and Middelfart, and was located at the northwest edge of the island. Hence the view is facing westward toward one of the peninsular extensions of Jutland, from a commanding site occupied by rich landowners. The lord and lady of the manor have just returned from horseback riding, a servant holds open the gate for them, while at the other end of the picture children gesticulate at their arrival. Beyond the stone fence are the neatly manicured grounds and, moving further into the landscape, the harbor and the winding waters of the Little Belt. Juel ingeniously shows us this prospect from inside the estate and

9.5 Jens Juel, *View of Hindsgavl*, c. 1800. The Thorvaldsen Museum, Copenhagen.

links up the path leading from the gate to the hedgerows of the field and the undulating body of water. The patron's sense of his own power and wealth was heightened by incorporating the vista with the real estate. This seems to have been a repeated formula, as we see in another example of the same period, *View of Hindsgavl* (fig. 9.5).

That Juel's landscape painting of the 1790s was in fact tied to "real" estate is seen in his *A Thunderstorm Brewing behind a Farmhouse in Zealand* (fig. 9.6), done for another landowner in Fünen.[5] The scene depicts a thunderstorm approaching a farmhouse a few kilometers north of Copenhagen. Heavy rain clouds are forming, with gusts of winds bending the trees and rattling the leaves. The particular

9.6 Jens Juel, *A Thunderstorm Brewing behind a Farmhouse in Zealand,* 1790s. Statens Museum for Kunst, Copenhagen, Denmark.

farmhouse shown in the painting had been built in connection with an agrarian reform in the mid-1760s carried out on the estate of Graf Johann Hartvig Ernst Bernstorff, the Danish minister of foreign affairs. The miserable conditions of the Danish peasant, still chafing under oppressive feudal laws, led to widespread desertions and depopulation of the countryside. The government of Frederik V decided to sell the crown lands, but only in small localities in Fünen and Jutland could peasants afford to purchase their tenant farms. The greater part of the royal domains were bought by speculators, with the result that new landed estates were created and contributed to the extinguishing of farms and villages. Just before the king died Bernstorff conducted an agrarian experiment in North Zealand in which individual peasant holdings were consolidated and the farmhouses were moved from the villages to the fields. He hoped thereby to make agriculture more efficient and enable peasants to own and retain their land. This was the model for the reforms of the 1780s carried out by Bernstorff's nephew, A. P. Bernstorff, minister of foreign affairs.[6] Feudalism was abolished, and the peasant tenants were encouraged to consolidate their strips into individual holdings. Compulsory labor was abolished, the tithe was exchanged for a cash payment, and hereditary farming was decreed. The nobility vigorously protested, but public sentiment was in favor of the peasantry. In fact, the crown prince erected in 1792 the Obelisk of Liberty at Frihedstøtten, in the center of Copenhagen, which commemorated the new laws. An inscription on one side reads, "The King has ordered the abolition of forced domicile so that the free peasant may take confidence, become enlightened, laborious, virtuous, an enlightened and happy citizen." Juel's rather sudden interest in landscape in the 1790s was largely motivated by these agrarian reforms, seen from the perspective of his upper-class clientele. The farmhouse menaced by the thunderstorm parallels the threatened position of the wealthy landowners who saw the reforms as ominous.

Friedrich, who studied with Juel at the very time the Danish master was developing a consistent landscape style, could not have been unaffected by the master's naturalistic and overtly ideological style. Juel's picture portrays accurately the unique light effect that precedes a storm and anticipates Friedrich's own fascination for unusual light conditions. The economic threat to Juel's patronage in the 1790s was immediate, and Juel could express it only in actual terms. It was Juel's three-year stay in Switzerland that

9.7 Caspar David Friedrich, *Emilie's Spring,* 1797, watercolor. Hamburger Kunsthalle.

inspired his interest in natural representation. There he painted portraits of the natural scientist Charles Bonnet and the Alpine explorer and geologist Horace-Bénédict de Saussure. Portraits from this period generally show close attention to the topography and botanical details of the sitter's estates. The work in Geneva prepared him to deal with the crisis of the landowning class.

Many of Friedrich's early drawings and sepias from his Copenhagen period are scenes of picturesque arrangements of parks, private homes, and their surroundings. One example is his watercolor sketch of *Emilie's Spring,* revealing an involvement in the fashion for evocative ruins and monuments (fig. 9.7). Located in the park of Sølyst near Klampenborg north of Copenhagen, the monument was erected over the source of a stream by Graf Ernst Schimmelmann in memory of his first wife, Emilie, who died in 1780. Abildgaard designed it, and Juel painted it in 1784. Friedrich recorded the monument's inscription on the back of his sketch.

Ernst Schimmelmann, born in Dresden, was one of the popular members of the Danish ministry in the last two decades of the eighteenth century. An expert on finance and commerce, he orchestrated the tariff laws of 1797, participating in the reform movement led by A. P. Bernstorff and Christian Ditlev Reventlow. Highly cultured, Schimmelmann kept abreast of the artistic and literary trends of the day. He deeply admired Rousseau, Thomson, and Young

9.8 Caspar David Friedrich, *Landscape with Pavilion,* 1797, watercolor. Hamburger Kunsthalle.

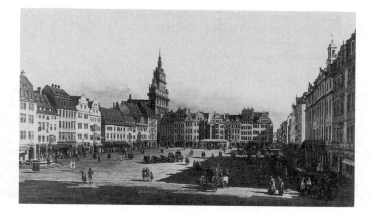

and attached himself to the interpreters of the new epoch. He subsidized the work and studies of Öhlenschläger and Steffens, and generally promoted the contemporary arts and literature.[7]

Another watercolor from this period, *Landscape with Pavilion,* expresses Friedrich's topographical interests during his Copenhagen stay (fig. 9.8). The pavilion shown in the sketch was a terraced belvedere situated at Klampenborg, located on the Baltic coast north of Copenhagen. It was a popular seaside resort (Schimmelmann and his first wife spent their summers there), and the terrace of the pavilion afforded a magnificent view of the coastline. Friedrich, however, chose the view from behind the pavilion, an unkempt garden with a small thatched hut and a small wooden bridge barricaded at both ends. The contrast of the neoclassical elegance of the pavilion with the untidy promenade is striking. A humble shelter for tourists caught in a rainstorm has given way to the private pleasures of the owner of the beach property.

Friedrich continued to work in this mode when he made a permanent move to Dresden in the fall of 1798. Dresden was the center of a dazzling cultural enterprise.[8] Sustained by a major colony of English as well as local residents, topographical draftsmen and view painters could earn a decent living. The legacy of the famous Venetian landscapist Bernardo Bellotto—a nephew of Canaletto—was everywhere in evidence. Bellotto had been appointed court painter at Dresden in 1748, and he gained international fame for his panoramic views of the town and surrounding countryside which he did for the Saxon king and a number of other patrons (fig. 9.9).[9] All the royal commissions were exhib-

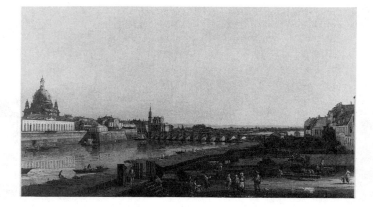

9.10 Bernardo Bellotto, *Dresden from Right Bank of the Elbe, before the Augustsbrücke*, 1747. Gemäldegalerie Alte Meister, Staatliche Kunstsammlungen, Dresden.

9.11 Bernardo Bellotto, *The Old Fortifications of Dresden*, 1749–1751. Staatliche Kunstsammlungen, Gemäldegalerie Alte Meister, Dresden.

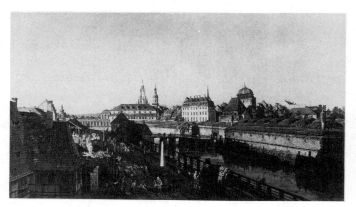

ited in the Dresden gallery, and their topographical precision made a lasting impression on young Friedrich. Although Bellotto—who had taught perspective briefly at the Dresden academy—was more concerned with urban complexes, his views over the Elbe and conversing figures glimpsed from behind influenced Friedrich's definitive style (fig. 9.10). Even such a specific motif as Friedrich's *Wanderer at the Milestone* was borrowed from Bellotto's *The Old Fortifications of Dresden* (fig. 9.11).

Friedrich's *Greifswald Marketplace*, done around 1818, seems remarkably close to Bellotto's *Marketplace of Pirna* as well as the whole tradition of view painting traceable to Canaletto (figs. 9.12–13). While this type of view is rare in Friedrich's work, its specific content throws light on the connection between view painting and bourgeois ideals. The picture is an autobiographical depiction of his family and their cultural position in the town of Greifswald. The watercolor shows us a westerly view straight up the old Lange Strasse, the main street of the town, on which the

Friedrich house was located. At the left we see the Rathaus (town hall) and the tower of the Nicolai-Kirche, Greifswald's cathedral. Just in front of the start of the Lange Strasse stand two of his brothers (who now ran the family business), a third who has become a cabinetmaker, and their brother-in-law, a prominent local merchant.[10] Flanked by their wives and children, the males are a dominant presence at the threshold of their property, and occupy a strategic position within the town itself.

In addition to the tradition established by Bellotto, there existed a school of landscapists who took their cue from the Dutch model. Chief among them was Adrian Zingg, whose work Friedrich systematically copied. Zingg pro-

9.12 Caspar David Friedrich, *Greifswald Marketplace,* c. 1818, watercolor and pen. Museum der Stadt Greifswald.

9.13 Bernardo Bellotto, *Marketplace of Pirna,* 1743–1754. Gemäldegalerie Alte Meister, Staatliche Kunstsammlungen, Dresden.

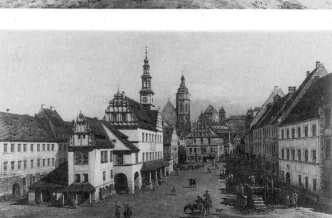

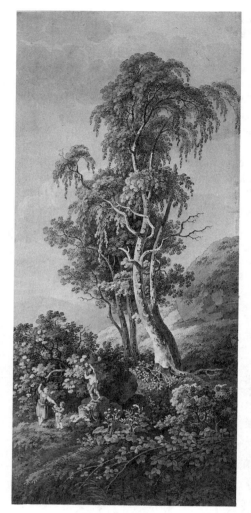

9.14 Adrian Zingg, *Landscape near Tharandt*, c. 1798. Schlossmuseum, Weimar.

duced a highly popular and profitable landscape type that focused on humbler dwellings and rural people set deep into a forest interior (fig. 9.14).[11] It is probable that it was Zingg who stimulated Friedrich's careful studies of botanical forms that begin to appear in the sketchbooks of his tours around Dresden in 1799 and 1800 (figs. 9.15–16). These sketches recall the examples of Runge and were similarly informed by the reproductions in the works of Linnaeus.

As in the case of Runge, Friedrich most often used a delicate outline to record his forms: neoclassical linearity was still the predominant mode of cultural topographical design in Dresden as in Copenhagen. It was Quistorp who started him off in this direction, giving him the plates of academic copybooks to reproduce in outline and hatching. This technique was indispensable to topographical rendering, which required a deep and correct knowledge of perspective. Friedrich continued to exhibit precision in his forms even when his work became more affective, and in this sense it is again analogous to the case of Runge, who took the outward traits of neoclassicism and reinvented them with unconventional effects.

Quistorp's presence haunts Friedrich during this period of struggle in Dresden. As teacher of architectural and practical drawing, Quistorp must have encouraged Friedrich's inclination. Not only did he train him in his mode and encourage him to study in Copenhagen, but he certainly must have made available the numerous art objects in his personal collection. Quistorp owned fifty paintings and almost fourteen hundred drawings and etchings, a number of which derived from the Dutch school of the seventeenth century. Quistorp was also instrumental in Kosegarten's decision to collect, and he persuaded his friend to purchase Friedrich's early views of Rügen. Quistorp's personal ideal is perhaps seen in the vignette he composed for Kosegarten's *Melancholien*, showing a cozy cottage nestled in the woods (fig. 8.1). Friedrich showed his awareness of this ideal in his 1799 etching, *Farmhouses at the Foot of a Mountain*, which he dedicated to Quistorp, expressing "gratitude" and identifying himself as the master's "student" (fig. 9.17). The view is of the rocky valley of Plauen, a suburb of Dresden located west of the town on the left bank of the Elbe. Known as the Plauenscher Grund, its hills were riddled with mines and its plains dotted with factories. But Friedrich's carefully contrived study preserves the rustic charm of an almost medieval world. He deliberately sets off

9.15 Caspar David Friedrich, studies of plants, 1799, pen drawing. Staatliche Museen Preussischer Kulturbesitz, Nationalgalerie, Berlin.

9.16 Caspar David Friedrich, studies of plants, 1799, pen drawing. Staatliche Museen Preussischer Kulturbesitz, Nationalgalerie, Berlin.

the cottages at sharp right angles to each other and to the steep slope behind. The effect is to anchor the rural dwellings securely to the foot of the mountain and incorporate them into the powerful rocky mass, thus predicating a symbolic idea on actual fact: the masonry of the nearest cottage was clearly built on a foundation of fieldstone borrowed from the nearby foothills.

Friedrich's lifelong fascination for mountains is perhaps even more striking in the preliminary drawing of this scene (fig. 9.18). By the subtle manipulation of light and dark and the compositional pull, the eye is pulled upward from the apparent horizon to the sensible horizon at the mountain peak, culminating with a sense of exaltation in the parting clouds above. I wish to call this effect the *transcending horizon* and the motif itself the *reverential gaze*. The beholder is literally positioned by the artist to gaze along the plane that is tangent to the earth at the beholder's place and that extends upwards to the celestial sphere. While this effect is by no means exclusive to any time or region, it is so characteristic of northern and especially German landscape painters in the nineteenth century that it requires special discussion. The heavenward movement casts into visual terms Friedrich Schleiermacher's metaphorical description of mountain masses "in corporeal nature which are boundless, unlimited . . . reflecting the greatness and majesty of the universe." Schleiermacher was the patriotic preacher of the Napoleonic era, profoundly steeped in pietistic ideals. The underlying idea is always that the basic feeling of infinite and living nature has its specific expression in the organization of creation. As with every pietist idea in this period, the religious sense is converted into patriotic and nationalistic forms.

This metamorphosis shaped by economic and political pressures was a dynamic force in Friedrich's work. The etching done for Quistorp was part of a larger series begun in October 1799 on the basis of sketches made that summer. The first group of ten etchings were executed in rapid succession between October 1799 and February 1800, marking the transition into the new century. They are for the most part typical scenic views of woodland and park, with the stereotypical gesticulating figures in the foreground. Since examples of most of the views belonged to the collection of Friedrich August II, it is likely that the views were done for the elector of Saxony and other notable patrons.

Only the *Rocky Crag with Caves and Masonry* reflects

9.17 Caspar David Friedrich, *Farmhouses at the Foot of a Mountain*, 1799, etching. Staatliche Museen Preussischer Kulturbesitz, Nationalgalerie, Berlin.

9.18 Caspar David Friedrich, pencil and ink drawing for *Farmhouses at the Foot of a Mountain*. Kunstmuseum, Düsseldorf.

Friedrich's attraction to mountain formations (fig. 9.19). While the transcending horizon is absent in this scene, the rocky formation is set off against the unencumbered sky like an awesome mass. The motif was actually derived from the precipitous sandstone cliff known as the Regenstein, on whose east side a castle had been erected in the tenth century. The castle had been captured by Wallenstein during the Thirty Years' War and later demolished by Friedrich II of Prussia. All that remained of it in the artist's time were the vaults, embrasures, and cavities hewn into the rocks. The Regenstein was located in the Harz Mountains, northwest of Dresden, an important source of inspiration for Friedrich. Although the area later became a favorite summer and winter resort, early guidebooks claimed that the mountain system was hardly worthwhile exploring unless the traveler was a geologist or lover of mining operations. The caves of the Baumanns and the Bielshöhle, with their valuable fossil remains, were of special interest to geologists. One could find a combination mining school and mineral museum in the major mining town of Clausthal. The Rammelsberg—a storehouse of gold, silver, copper, lead, and zinc—had been dug for over seven hundred years and was unusual for its abundant deposits in so small a space. It was riddled in all directions by miner's shafts and galleries.

Friedrich always lived and worked near or within an environment of rich mineral stores and where mining and quarrying were principal occupations. It is no coincidence that Saxony hosted both the principal mining school (Freiberg) and one of the most important cultural centers of north Germany (Dresden). The porcelain manufacture of Meissen and the Grünes Gewölbe collection of precious metals and minerals in Dresden demonstrated the intimate links between mining operations and the surplus wealth spent on the fine arts. This thriving community, whose prosperity was founded on the wealth extracted from the mines by the Saxon princes, was rich in pictures and art objects; the Grünes Gewölbe, in the royal palace and comprised of a series of vaulted galleries on the ground floor, contained the "splendors of Dresden." Freiberg, the capital of the mining district in Saxony, held jurisdiction over a hundred mines of silver, copper, lead, and cobalt. Miners were regimented in military fashion and formed a quasi-military corps; they were called out several times a year for inspection or parade in full-dress uniform. These martial

processions were led by a band playing the miners' march and accompanied by the banners of the miners' guild. The School of Mines, founded in 1765, emphasized mineralogy and geology but probably contributed more to the advancement of natural science than the German universities. As the residence of the Saxon princes, Freiberg had both an economic and symbolic importance for the Saxon people and played a major role in the life of nearby Dresden.

Friedrich's close study of mountain formations preceded the pictorial and ideological application of the transcending horizon and its expression in the form of the reverential gaze. The cultural practice in Dresden was dependent upon the wealth produced by the mountains, making them a critical source of inspiration for geologist and painter alike and the patrons they served.[12]

Friedrich's view of the Regenstein also glorifies the integration of the human construction with the natural configuration. Striving for a "higher" state of consciousness culminates in actual physical possession of the top of the mountain. Upward yearning and reverential gazing constituted the obverse of physical domination. The feudal lords in the German territories often built their castle or manor house on a steep slope or mountain overlooking their domains. Although essential to protection in medieval times, the practice was continued through the nineteenth century for aesthetic rather than strategic reasons. But the ability to command the view in either sense still implied domination. (The Latin *domus* of *Dominus* [Lord God], and the cognate words *domain* and *domination*, relate to territorial and prop-

9.20 Caspar David Friedrich, *Schloss Kriebstein*, 1799, pen and pencil sketch for lost watercolor or sepia. Hamburger Kunsthalle.

9.21 Caspar David Friedrich, *Manor House near Loschwitz Overlooking Elbe Valley*, 1799. Kunsthalle zu Kiel.

erty rights.) Friedrich carefully observed such sites: in 1799, he sketched the Schloss Kriebstein, a fifteenth-century castle, high above the River Zschopau in Saxony, and the more modest manor house on a hill near Loschwitz overlooking the Elbe valley (figs. 9.20–21). These studies may be regarded as secular equivalents of the reverential gaze, in which the subordination is directed to a temporal power atop the mountain.

During the early years of the new century, Friedrich continued to take orders for topographical views. One set was done in the Plauenscher Grund, the rocky valley along the Weisseritz River which attracted the Dresden view painters like Zingg. The four gouache (a type of opaque watercolor) scenes depict flour and powder mills along the Weisseritz and a glass factory in Döhlen, now a part of the industrial city Freital (fig. 9.22). The flour and powder mills give no inkling of their function; the plants are set deep into the landscape and depicted from a perspective that hides the waterwheels and emphasizes the pastoral character of the countryside. The glassworks (*Glashütte*) alone evokes its interior activity, with its billowing clouds of smoke extending high into the sky. But its position in the middleground, the surrounding hills, and the placid foreground give the scene the bucolic air of Wright of Derby's *Arkwright's Cotton Mill*.

In the same period, Friedrich began a series of sepia drawings of the Rügen countryside and coastal regions that he visited in June 1801 and May 1802. The sketches he did

on a visit to the island in June 1801 demonstrate a new eye for the breadth of the landscape, which he subsequently conveyed through the medium of sepia. Sepia is a brown pigment obtained from the inklike secretion of various cuttlefish, and could be used with pen or brush. It was a method then in vogue, and as a monochromatic technique could be used in connection with neoclassic outline. Sepia allowed for a great range of tonal modulation and gradations of light and appealed to art collectors somewhat weary of the strictly linear presentation. It also permitted the artist to render atmospheric perspective with a minimum of effort.

Friedrich apparently made his sketching tours of Rügen primarily to gather material for his topographical views. The sketches formed the basis of his sepia and gouache drawings, which sold well, especially to his fellow Pomeranians, who included Quistorp, Kosegarten, Schildener, Prinz Malte von Putbus (the island's largest landowner), and even Runge himself. Runge wrote Daniel on 6 April 1803, "Here is young Friedrich from Greifswald, a landscapist who has exhibited a pair of views of Stubbenkammer in sepia, singularly large, beautifully illuminated, rendered and executed. They are generally acclaimed and deserve to be so."[13] Runge added that one drawing he wished to buy for Daniel had already been sold to the Freiherr von Rackwitz, of old Dresden nobility. Rackwitz was master of ceremonies (*Hofmarschall*) and lord chamberlain at the Saxon court, and controlled vast mining interests. He wrote on a variety of subjects—including art his-

9.22 Caspar David Friedrich, *Glass Factory in Döhlen*, c. 1802. Whereabouts of original gouache unknown; outline etching reproduction at Kupferstich-Kabinett, Staatliche Kunstsammlungen, Dresden.

tory, geology, agriculture, and even the taste of "superior people"—but he was primarily a musician. As "directeur des plaisirs," supervising Dresden's theaters and orchestras, Rackwitz exercised a strong influence on the local art and culture. Runge negotiated with Friedrich for another, but the sale had not yet been finalized. He mentioned two views from Rugard to Jasmund and beyond to the Prora and the distant sea, and another embracing the coastline from Putbus to Mönchgut, with the Pomeranian coast (including the towers of Greifswald and Wolgast). These Friedrich planned to render as "Morning" and "Evening". Runge wrote Daniel that he purchased them for thirty-nine *Thaler* each (one Thaler = one silver dollar), and that he intended to take the views to Leipzig where "you will be able to sell them at a good profit." Runge's astonishing letter indicates to what extent both he and Friedrich looked upon their art as a financial undertaking, bargaining over them like merchants at the Leipzig book fair. Indeed, Runge as agent bought directly from the artist so as to resell them at a profit. Friedrich was an able businessman in his own right, carefully gauging the demands of the aesthetic marketplace with his views of Rügen.

The popularity of Rügen in this period depended upon two separate but related phenomena: its growing attraction as a tourist site and its growing historical importance for the nationalist revival. The largest island in the German territories, it was separated from the mainland on the southwest by the Strelasund. Deep bays indented the island in every direction to form a number of peninsulas, connected by narrow strips of land. The most important of these were Wittow and Jasmund on the north and Mönchgut on the southeast side of the island. The scenery on the east coast of the island appealed to every sightseer for its beechwoods, chalk cliffs, and startling blue water. Binz and Sassnitz were bathing resorts, and the most dramatic lookout points were Stubbenkammer, Putbus, and the Jagdschloss. The Rugard was a three-hundred-foot-high cliff not far from the capital of Bergen; it was crowned with an ancient entrenchment and had a majestic view to the east. The most spectacular point on Rügen, however, is the Stubbenkammer, situated on the east coast of the peninsula of Jasmund, a furrowed chalk cliff rising almost perpendicularly from the sea to a height of four-hundred feet. The summit, called the Königsstuhl (king's throne), commanded an extensive view in all directions, including one of Arkona at the northernmost point of the island. The

view from the promontory of Arkona embraced the coast of Jasmund, the Tromper Wiek, and the Danish island of Møen in the distance.

The island was popular for its giant gravestones (*Hünengräber*), pagan ritual mounds, and deep entrenchments.[14] On Arkona one could find the ruins of an ancient stronghold of the Wends (a Slavic people once dwelling there), consisting of a circular ditch that contained the temple of their four-headed idol Swantevit (destroyed by the Danes in 1168). There was an almost animistic attachment to the rocks on the island of Rügen. Large ramparts of loose stones and barrows covered the island; some of these large dolmens were ancient sepulchers in which skeletons and clay urns full of bones and ashes had been found. These were celebrated in Scandinavian and north German poetry and mythology as memorials of Nordic heroes. Ancient remains such as tumuli (mounds) and cromlechs (circles of upright stones or monoliths) attested to the civilization that withstood the assault of Rome and finally overthrew it. Odoacer, who finally captured the imperial capital, was king of the Rugii, and the cradle of the barbarian hordes who formed his army was none other than this remote island and the neighboring coast of Pomerania.

The combination of heathen constructions and rugged scenery appealed to both the rising nationalist feelings of the north Germans and their pantheistic beliefs. Friedrich and his friends made frequent excursions to the island both for pleasure and to steep themselves in the atmosphere of the heroic past. They would visit Kosegarten in Altenkirchen within easy distance from the Stubbenkammer, which they climbed to see the sun rise and set, and Arkona, also partly a chalk cliff with a distant view. Kosegarten infused the ancient relics with patriotic and nationalist meaning, and glorified the island's unusual and variegated surface terrain, as in his poem, *Das Hünengrab*, which recalls "ancestral virtues." Rügen's role in the imaginative background of the pastor predisposed him to identify it with the Ossianic epic, and it is hardly surprising that he and other contemporary German writers confounded MacPherson's heroes with the primitive peoples of the island. At the same time, the animistic attachment to the stone relics was easily converted into the pantheistic ideals encouraged by Schelling and his disciples. This was reinforced by their geological speculations, which made the rugged island with its innumerable grooved ridges, chalk cliffs, and caves an ideal site for field investigation.

9.23 Title page of Gotthard Ludwig Kosegarten's *Poesieen,* 1798.

9.24 Caspar David Friedrich, *Stubbenkammer,* 1803. Missing.

Like his mentor and patron Kosegarten, Friedrich made Rügen the leitmotif of his cultural production. Poems like *Der Rugard, Rugard im Sturm, Ralswiek, Stubnitz,* and *Stubbenkammer* read like a catalogue of Friedrich's work, with allegorical productions that make frequent allusions to the topography of the island and its mythical and romantic associations. It is no coincidence that Kosengarten reproduced on the title page of his *Poesieen* (1798), opposite his engraved portrait, a view of the rugged landscape of the east coast of Rügen showing the Stubbenkammer, the Königsstuhl, and what was known as the Kleine Stubbenkammer to the south (fig. 9.23). The same view is conspicuous in Friedrich's early work, demonstrating that the autobiographical associations had become synonymous with the public persona and the nationalist aspirations of their public (fig. 9.24).

Throughout his career Friedrich made excursions to the island and depicted its topography, its natural and human constructions, its social and economic life, with scenes of the Stubbenkammer, the Königsstuhl, Mönchgut, Jasmund and Arkona, the *Hünengräber,* and the island's fisheries (figs. 9.25–26). Like Runge, he never felt the need to make the traditional visit to Italy or to follow in the footsteps of the Italian masters. To do so, he thought, would risk the loss of the expression of "the beauty, the spirit of Germany, its sun, moon, stars, rocks, seas and rivers."

Exhibited at the annual show of the Dresden Academy

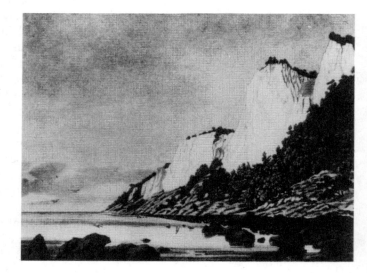

9.25 Caspar David Friedrich, *Prospect from Rugard towards Jasmund,* 1803, sepia. Missing.

in 1803, the sepia drawings of Rügen were admired by the public and won critical praise. Friedrich repeated—with only sight variations—a single motif several times, suggesting that certain views were in great demand. In addition to the Stubbenkammer motif, his *View of Arkona with Shipwreck* was done at least six times between the years 1801 and 1806 (fig. 9.27). This and two others belonged to Quistorp, one substituting fishing nets for the shipwreck and the other eliminating the motif altogether in the right-hand foreground (fig. 9.28). It is possible they were conceived as a series, since they show different times of the day including moonrise and sunrise (fig. 9.29). In his famous

9.26 Caspar David Friedrich, *Königsstuhl,* c. 1801, sepia drawing. Missing.

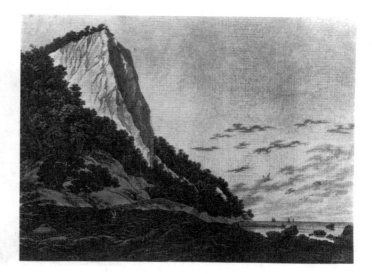

9.27 Caspar David Friedrich, *View of Arkona with Shipwreck,* c. 1802, sepia drawing. Whereabouts unknown.

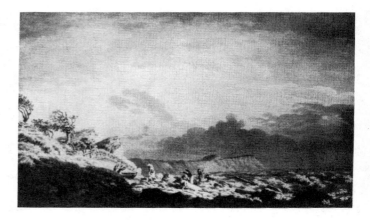

treatise of 1800, *Elémens de la perspective pratique,* the French landscapist Valenciennes recommended outdoor studies of "the same view at different times of day, so as to observe the modifications of form under the action of light."[15] Valenciennes's work was certainly known in the Dresden art world, and its authoritative explanation of perspective would have made it an indispensable guide to every beginning landscape painter. Friedrich apparently not only took his advice but added one scene with a moonlit effect, attesting more to marketplace demands than to his own artistic sensibility.

View of Arkona with the Rising Moon of 1806 is the finest work in the series (fig. 9.30). In the middle distance is the northernmost point on Rügen, viewed from the shore of Vitte to the south, the fishing village where Kosegarten was to build his chapel. Although the nets are absent in this

9.28 Caspar David Friedrich, *View of Arkona with Rising Moon and Fishnets,* c. 1803. Whereabouts unknown.

version, the moored fishing boat in the middle foreground is a leitmotif of every work in the series. On the distant headland of Arkona is the thirty- to forty-foot-high mound that once contained the temple of the Wends. With the soft light of the rising moon and ethereal silhouettes of the coastline, it becomes a picturesque view, capturing the island's special character. Not surprisingly, Kosegarten reproduced the headland of Arkona on the title page of the second volume of his *Poesieen*, viewed this time from the opposite direction, looking south towards Vitte (fig. 9.31). Thus the Stubbenkammer and Arkona were the alpha and omega of Rügen for Kosegarten, Friedrich, and their public.

9.29 Caspar David Friedrich, *View of Arkona with Sunrise*, c. 1803, sepia drawing. Hamburger Kunsthalle.

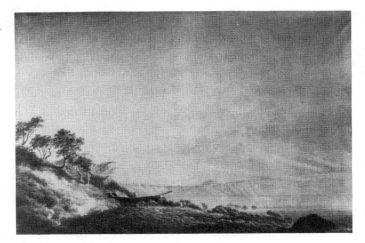

9.30 Caspar David Friedrich, *View of Arkona with Rising Moon*, c. 1806, sepia and pencil drawing. Albertina, Vienna.

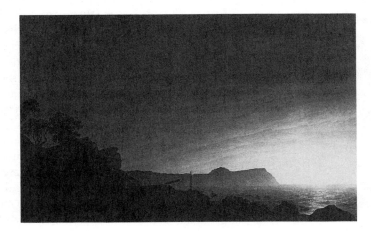

9.31 Title page of Gotthard Ludwig Kosegarten's second volume of *Poesieen*, 1798.

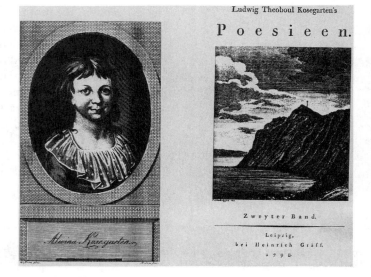

9.31 Title page of Gotthard Ludwig Kosegarten's second volume of *Poesieen*, 1798.

Gotthilf Heinrich von Schubert

Friedrich's psychic aesthetic involvement with Rügen is confirmed by Gotthilf Heinrich von Schubert, a close friend of the painter in Dresden during the years 1806–1809.[16] A physician as well as natural philosopher, Schubert was in many ways the German counterpart of Erasmus Darwin, whose *Botanic Garden* he deeply admired. Schubert wrote on geology, botany, and astronomy as well as religion and psychical research. Like his friend Steffens, he was an intimate disciple of Schelling and counted himself among the *Naturphilosophen*. In 1808 the appearance of his important *Ansichten von der Nachtseite der Naturwissenschaften* (Views from the dark side of natural science) stirred the intellectuals with its talk of a dark side of mental life that embraces such phenomena as somnambulism, dreams, hallucinations, visions, and animal magnetism.[17] The book was originally presented as a series of lectures delivered in Dresden during the winter of 1807/8. Friedrich was referred to twice in the lectures, once when the author interpreted one of Friedrich's sepia cycles in the context of human fate, and again to praise the painter's grasp of rock formations.[18] Schubert called Friedrich a "nature painter" (*Naturmahler*) whose work was well known to all of the members of the audience, and he singled out one painting in particular of the chalk cliffs of Rügen, which would aptly characterize this type of geological formation. This remark was made in the context of his discussion of the cliffs on the

coast of Rügen that resemble "a lofty gravestone over a fallen world of titans, and surmounting this the graves of the giants [*die Gräber der Hünen*]."

Elsewhere Schubert wrote that the quiet wilderness of chalk cliffs and oak forests on Rügen provided the fundamental environmental experience of Friedrich's homeland, "his constant, most favorite place during the summer, but even more so during the stormy times of late fall and during awakening spring when the ice broke on the ocean close to the shore."[19] Schubert's perception of the seasonal variations in Friedrich's life and work lay at the heart of his extended discussion of the sepia cycle known as *The Seasons*. (Although the series was expanded much later, it consisted originally of four scenes executed in 1803.) It was unmistakably influenced by Runge's *Times of Day* (begun in Dresden toward the end of 1802) and indicates a parallel landscape development in his work, affected by natural philosophy.

Friedrich's *Spring*, *Summer*, *Fall*, and *Winter* constitute an allegory on the four stages of human life. Schubert's interpretation demonstrates the close affiliation between Friedrich's landscape development and the influence of *Naturphilosophie*. The idea that birth and death are part of a cosmic process like that apparent in nature might be a basis for the hope of resurrection. In *Spring*—morning and childhood—infants cavort amid young blossoming oak trees next to a stream, while playful lambs and birds complete the arcadian scene (fig. 9.32). Schubert's description of this work probably inspired Runge's painted version of

9.32 Caspar David Friedrich, *Spring*, 1803. Whereabouts unknown.

Morning from the *Times of Day.* In *Summer,* the stream has become a river flowing through a broad, fertile valley, while two lovers embrace in a bower (fig. 9.33). On the human level, the river is inner striving, "grown stronger and more powerful," carrying the individual further into the world. The mind, not yet aware of its limitations, is convinced that all deep longing can be fulfilled. This is the noontime of existence, when youthful love encloses itself in contentment from the outside world. Friedrich uses his botanical knowledge to signify the abundance of creation; among the rich vegetation we find the lily and the rose, symbols of innocence and love. But above the roses and lilies the sunflower raises its golden head which "follows

9.34 Caspar David Friedrich, *Autumn,* or *Evening,* c. 1808. Whereabouts unknown.

the path of the eternal light." Thus a deeper longing has yet to be stilled, and anticipates the next stage of existence.

Spring and *Summer* are quite conventional in their appearance, reminiscent of the classical landscape style of the seventeenth century. Intimating the mature painter, however, *Autumn*, or *Evening*, projects dramatic mountain peaks rising in the remote distance (fig. 9.34). The oak trees in the right foreground bend toward the distant peaks, and the flowers have disappeared, except for the blossoms of the autumn crocus (*Colchicum autumnale*) "in the shade of the evening light." The crocus blossoms in the autumn, but its leaves and seedpods do not appear until the following spring; the Germans call it *Herbstzeitlose*, or "the timeless one of the autumn." For Schubert, this plant was a sign of a "new, distant spring beyond winter," connecting it with the idea of transcendence implied by the mountains. The meaning of that deeper, unfulfilled striving finally becomes clear to us in the autumnal evening of our lives: "See these immortal heights with their three-peaked summit, lofty above the soaring clouds, shrouded by the everlasting snow, but still in untroubled serenity, gleaming in the rays of the sun, an elevated symbol of the eternal light. There the soul strives with its highest powers towards the immortal heights." This is not accomplished without struggle against obstacles in order "to reach the other bank and the high mountains," for it is only in the exalted moments that "the spirit rises towards the immortal heights like that eagle who has left the clouds and the river far behind." Thus we come to understand that the destination of our longing is not on earth, but in that abode symbolized by "the cross which rises peacefully above the cliffs."

Schubert and Friedrich, both raised in the pietist tradition, had arrived at a pantheistic outlook and were predisposed to see "the Divine in everything." This necessitated scrupulous observation of phenomena, either in the form of Friedrich's landscapes or Schubert's scientific investigations, because the more realistic the depiction or description the more convincing would be the role of God in the organization of the universe. Realism and scientific fact served as the framework of their worship and their religious understanding of the Universal Spirit.

In the final work of the series, *Winter*, an old man in medieval garb contemplates an open grave in the shadow of a medieval ruin and a barren oak tree (fig. 9.35). One of Friedrich's favorite motifs was the ruined monastery at Eldena, built in 1199 by Sistine monks and destroyed during

the Thirty Years' War. Eldena was located due east of Greifswald at the mouth of the Ryck River, which empties into the Baltic Sea. This locale Friedrich ingeniously used to portray the place where "the river of life" flows back to the sea and ends its course. The scene, dramatized by the moonlight that falls over a row of gravestones, combines the ingredients of the Gothic mood—graveyard allusions, melancholy and moonlight, Ossian, and bardic nostalgia.

Schubert's response to *Winter* connects the painter's imagery with the ideology of the *Naturphilosophen:*

Before our very eyes, part of our work which seemed built for eternity has fallen into ruins and is forgotten by the young world. Only the will, the striving within us which has persevered to the very grave, becoming all the while purer and better, has remained ours; and in it we put our inner trust. The quiet coast where the once very powerful stream has become lost in the ocean has been reached and the gray wanderer finds himself lonely among the graves. . . . And there the moon shines in full brightness through the ruins of an ancient noble past. The sky reveals itself above the sea once more in its clear blueness as it did in our early childhood. There in a prophetic glimmer we get the vision of the coast of a far-away land across the sea. We have heard of its everlasting spring and how in it our soul, which we bring there as a bud, will ripen. Then take away time, even the memory of the path we have followed and let us, if it be the command of your eternal law, arrive slumbering in the fatherland which we have desired for so long.

Schubert restates and even advances the pantheism of Kosegarten, which invested the island of Rügen with mythic and patriotic associations. The moon illuminates the ruins

of the ancient past, temporarily neglected by the present generation. The medieval ruins conjure up an epoch of united Christendom and a united fatherland. But there is not yet the full-blown confidence in the ability of the moderns to achieve this unity in the face of the French machine, Thus "the fatherland which we have desired for so long" remains on an ephemeral plane.

Under the influence of the *Naturphilosophen*, Friedrich expanded his landscape repertoire in the early years of the nineteenth century to include a moralizing category that carried patriotic associations. It is clear from Schubert's testimony that the painter had established himself in Dresden and even had a following among the elite. In his autobiographical novel, *Eine Sommerreise* (A summer's journey), Tieck recorded his recollections of the painter in the period around 1803: "In his landscape themes Friedrich tries to express and suggest most sensitively the solemn sadness and the religious stimulus which seems recently to be reviving our German world in a strange way. This endeavor finds many friends and admirers and, much more understandably, many opponents."[20] Based on notes that Tieck made during a trip through southern Germany in the summer of 1803 (which took him through Dresden in June), the short novel is full of ardent love for his fatherland and of true appreciation of the rich and varied beauty of its landscape. While he wrote it at a later time to remind himself of "the good old days," Tieck nevertheless recalled Friedrich as part of the then new intellectual and patriotic current: "Thus a new spring is approaching us in art and poetry as in philosophy and history."

Friedrich could legitimately think of himself as being part of the "new wave." He was an avid reader and familiar with the literary and philosophical movements in Jena, as well as with the Weimar luminaries Goethe and Schiller. As early as 1799 he embarked on a series of illustrations of Schiller's play, *Die Räuber* (The robbers), a drama that piqued the imagination of Friedrich's contemporaries. It also frightened royalty and appealed to middle-class youth as the great play of liberty, as the essence of all that was great in the struggle against despotism. The third edition of the play appeared in 1799, which may have sparked Friedrich's illustrations, but most probably it showed the impress of the French Revolution, which by the end of the century appeared despotical to most cultivated Germans.

The play involves a series of duplicitous schemes and tragic misunderstandings which cause a rift between the

9.36 Caspar David Friedrich, *Die Räuber,* act 1, scene 2 (Skizzebuch 11/652, page 33), 1799, pen, ink, and watercolor. Staatliche Museen Preussischer Kulturbesitz, Nationalgalerie, Berlin.

Graf von Moor and his eldest son Karl. Believing that his father has rejected him, Karl von Moor agrees to become chief of a band of robbers to wreak vengeance on his class. The play is full of contradictions and impossible plot twists, with the nobles providing both the heroes and the villains. At the end, Moor decides to expiate his life of crime by giving himself up to a day laborer with eleven children, who will then gain the reward on his head of one hundred ducats. None of the characters is really sympathetic, but throughout the drama Karl utters many quotable lines. When trying to gain the confidence of his fellow thieves Karl binds his right hand to an oak branch, and after rousing them to battle he releases himself saying, "I feel an army in my fist.—Death or Liberty!" Later, he apostrophizes the landscape of his native land when he returns to his father's castle: "Hail to thee, Earth of my Fatherland!—Heaven of my Fatherland!—Sun of my Fatherland!—Ye meadows and hills, ye streams and woods!—Hail, hail to ye all!" And when he laments the loss of his innocence and decries his outcast status, he wishes for a collective unity based on the "whole world one family, and one Father above."

There is no doubt that Friedrich would have been moved by such patriotic declarations; many of them are fleshed out in his later landscape paintings. These, however, sublimate the message so that the symbolic language is often indistinguishable from the features of the actual site. What is fascinating about Friedrich's early illustrations of Schiller's play is that they capture the gush of youthful enthusiasm in their theatrical gestures. They indicate that the painter experienced without reflection the patriotic ardor that was later to become assimilated to a well-thought-out system of political beliefs. For example, in his rendering of the scene in act 1, scene 2 of the meeting between Franz von Moor—the arch-villain who tries to usurp his brother's inheritance as well as his betrothed—and the steadfast Amalia in her chamber, Friedrich dramatically contrasts the coldheartedness and cynicism of the one with the compassion and tenderness of the other (fig. 9.36). Franz sits nonchalantly with a mischievous smile on his face, while Amalia turns away from him towards the window with an expression of grief. Franz has just told her that Karl traded her ring, which she gave him as a pledge of her love, for the caresses of a prostitute who has hopelessly infected his body. While the figures are crudely drawn after the manner of Abildgaard, Friedrich already demonstrated his pictorial gifts in

9.37 Caspar David Friedrich, *Die Räuber,* act 5, scene 7, c. 1800–1801, pen and sepia ink. Museum der Stadt Greifswald.

the plunging space of the eighteenth-century interior, the dynamically contrasting movements of the protagonists, and the play of light filtered through the window.

Friedrich also depicted a charged moment near the conclusion of the drama in act 5, scene 7, when Amalia pleads with Karl von Moor to kill her: "To you it is so easy, so very easy; you are a master in murder—draw thy sword, and make me happy" (fig. 9.37). Karl von Moor finds himself in a dilemma: surrounded by a restless crew who suspect him of abandoning the ship, his father lying dead in front of the dungeon where Franz incarcerated him, and Amalia begging him to end her life, he stands transfixed in an eerie light, his body twisted awkwardly in the agonizing predicament. Friedrich's tense composition demonstrates his flair for the theatrical, and while he essentially concentrated on landscape, he also managed to infuse these illustrations with high drama.

One of the illustrations of *Die Räuber* was exhibited at Dresden Academy's exhibition of 1801, and during the autumn and winter of that year he embarked on a series of allegorical and literary subjects, each of which showed a single figure and a symbolic attribute. These were executed in roughly the same vertical format, suggesting that they were designed as book illustrations. Three of these drawings were made into woodcuts by Friedrich's brother Christian, a carpenter and cabinetmaker, and exhibited at the academy's exhibition of 1804. In this way Friedrich ex-

9.38 Philipp Otto Runge, illustration for Ludwig Tieck's *Minnelieder,* 1803.

9.39 Caspar David Friedrich, *Traveler at the Milestone,* 1802, pen and sepia. Staatliche Graphische Sammlung, Munich.

panded his commercial work to include reproductive images for the growing book-publishing market and for home decoration. Perhaps he took his cue from Runge, whose illustrations for Tieck's *Minnelieder* appeared in 1803 (fig. 9.38). It should be recalled that Leipzig—the chief commercial city in Saxony—was the center of the book trade in the German territories as well as an important art market and exerted a major influence on the cultural production of Dresden and Hamburg. Indeed, Friedrich's collaboration with his brother in the interests of marketing his imagery greatly resembles the partnership of the Runges.

Two examples like the *Traveler at the Milestone* in 1802 and *Woman with Spider's Web between Bare Trees* in 1803 are characteristic of the series as a whole (fig. 9.39–40). In *Traveler* a sepia drawing depicts an exhausted traveler seated on a rock next to a milestone at the side of a road. The inscription on the milestone reads "nach Haynichen 1½ Stunde," the time required to reach the town of Hainichen, west of Freiberg in Saxony. Despite the specific geographical location, however, the milestone closely resembles a gravestone, and when juxtaposed to the stereotypical pose of *Melancholia*—associated with contemplation on the transience of human existence—the road must symbolize the Path of Life. The attitude of the traveler is based on Albrecht Dürer's famous engraving *Melancholia I,* which gave the theme its decisive visual formulation (fig. 9.41). The motif was already a cliché in Friedrich's time, a favorite topic of eighteenth-century English poets like Young and Grey and anti-Enlightenment German intellectuals like Tieck and Kosegarten. Melancholy and the Gothic mood went hand in hand, mingling with nostalgia for an older epoch and also resulting from frustrated Faustian ambitions. The thought that the present age and the lack of time could prevent the achievement of an immortal work made the theme all the more poignant. Indeed, Kosegarten's first collection of poetry was entitled *Melancholien* after his poem *Melancholikon.* One of its verses is especially apt for Friedrich's drawing:

Portentous thought, that makes me gloomy,
 Speak, what dost thou here?
Voice, that whispers to me,
 Speak more lucidly!
The sun is setting;
From Hesperus's cold cheeks
 Drip frozen tears
 On the traveler [*Wanderer*]!

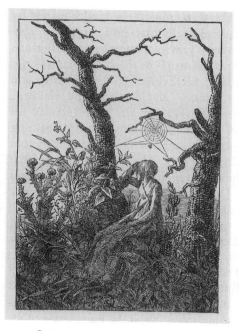

9.40 Caspar David Friedrich, *Woman with Spider's Web between Bare Trees,* 1803, woodcut. Staatliche Graphische Sammlung, Munich.

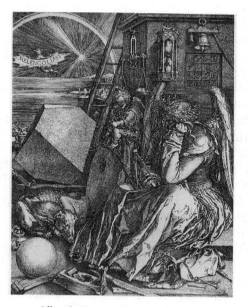

9.41 Albrecht Dürer, *Melancholia I,* 1514, engraving. The Mr. and Mrs. Allan C. Balch Collection, The Los Angeles County Museum of Art, Los Angeles.

Thus Friedrich distilled several familiar pictorial and literary ideas for his image, aiming it at a specific market. What makes it somewhat singular is the topographical reference to a town lying west of Dresden, giving an actual site for Kosegarten's metaphorical use of the setting sun and the Greek deity of the west.

Woman with Spider's Web, a woodcut reproduction, depicts a woman resting the crook of her elbow on a broken branch of a barren tree, while all around her weeds have sprung up (including the sickening thistles, traditional symbol of melancholy), and a spider has spun a huge web into which an unsuspecting fly is about to enter. Presumably, the woman has been waiting for her lover and has lost all sense of time. She seems almost engulfed by the forces of nature, helplessly awaiting her fate. Another woodcut of approximately the same size is clearly a companion piece, *Woman with a Raven on a Precipice* and offers an eerie admixture of mountain scenery and the fairy-tale world (fig. 9.42). This picture shows a wild, disheveled woman at the edge of a precipitous cliff, grasping a branch like an oar, while a raven caws and a serpent slithers around the other end of her stick.

Both illustrations conjure up characters in the fairy tales of Tieck, especially *Der blonde Eckbert* (1797) and *Der Runenberg* (1803). In these tales there are women deserted by their lovers, old hags who inhabit the forest or the tops of mountains, and men and women who long for, while suffering from, extreme loneliness. *Der blonde Eckbert* is a weird story of sin, belated remorse, and retribution. One autumn evening, by the fitful light of the moon and the fireplace, Eckbert's wife, Bertha, tells his friend Walther her memories of her youth—how she left home and wandered off to live with a strange old woman, who owned a dog and a bird. The bird laid a precious egg-jewel every day and sang a song whose theme became associated with German romanticism ever after, "Waldeinsamkeit" (Forest loneliness):

Forest loneliness,
You make me glad,
So tomorrow as today
And for all time
Be my gladness,
Forest loneliness.

One day in the old woman's absence Bertha stole the bird and fled; its song grew more plaintive, until Bertha

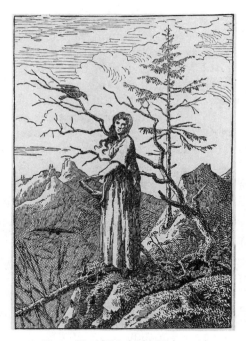

9.42 Caspar David Friedrich, *Woman with a Raven on a Precipice,* c. 1802–1803, woodcut. Hamburger Kunsthalle.

strangled the bird. She then enjoyed the wealth earned by the precious eggs and eventually married Eckbert.

Walther seems to have previous knowledge of Bertha's story, for he mentions the name of the old woman's dog. Suddenly, his friendship for Eckbert cools markedly, and Bertha, tortured by remorse and disturbed by Walther's changed demeanor, dies. Eckbert no longer trusts his friend and kills him, becoming a morose hermit, roaming the forests and mountains, until he chances upon the old woman with her dog and bird. She explains to him that Bertha was actually his sister, and that she failed to stand the test to which she was put when entrusted with the bird. It was her conduct that led to the pair's undoing.

Eckbert and Bertha fall victim to an overwhelming demonic force residing in nature. Both are alone and mistrustful. Bertha finds herself in the woods, alone. Later, she confesses her deed to overcome her isolation and create a bridge to society. But she cannot escape her retribution and would have been better off in the woods. The term *Waldeinsamkeit* is both lonesome solitude and the knowledge of secure enclosure in the arms of nature. More generally, it refers to glorification of an agrarian ideology. Though in England the "demonic" forces of nature were harnessed by advancing technology, the German ruling class still resisted industrialization. *Waldeinsamkeit* designates aristocratic resistance to middle-class ascendance, expressed in words and images by their compliant protégés to escape the material conditions of their own class background.

There is no need to recapitulate the tale of *Der Runenberg,* inspired by an exchange between Tieck and Steffens in Dresden in 1801. But recollection of some of its details may help clarify Friedrich's imagery. The motif of the woman waiting recalls Elizabeth awaiting the return of Christian after he dashed off to find the wild "Waldweib"—the Forest Woman. Christian is drawn to the rocky heights where he hopes to find the old woman. Here the mountain is demonized and incarnated in the character of the witch, a character that comes close to Friedrich's *Woman on a Precipice.* The various animal and plant forms of the woodcut suggest the existence of a world beyond appearances, a secret realm that is accessible only to those who risk leaving the security of the plains. The highly energized landscape of the mountains is revealed through the self-assertiveness and independence of the woman and the various forms of nature. In *Der Runenberg* this image is heightened by a vista of moonlit

mountains that provide a direction for Christian's exalted energies seeking a vision of totality.

This is comparable to Friedrich's sensations before a panoramic view that he recorded in his journal in 1803:

I just stepped out of the dark, still forest and found myself on a rising hill. In front of me I saw a valley, surrounded by fertile hills, in which a town stood . . . Through the richly flowered, carpeted meadow the river meandered . . . And behind the hills lay the mountains . . . cliff after cliff rose far out into the horizon . . . Filled with soaring joy I stood there for a long time and gazed at the beautiful area.[21]

Friedrich moves beyond the cultivated part of the landscape to the distant peaks that uplift his spirit. The world of the plains reflect a commitment to order, subordination, community, and control. The mountains counter this with their wild, infinitely extending system, which offers its own brand of salvation. The two spatial areas of mountains and plains point the way to emancipation and flight—"flight" meaning both escape and air-bound ascent. Referring to his spiritual transport at the sight of "a beautiful valley surrounded by fantastic rock forms," Wackenroder wrote in his *Herzensergiessungen* that "infinite nature draws us up through the wide spaces of air directly to God." While the *Naturphilosophen* would interpret this as the transcendence of self through union with the life force, more literal-minded German scientists were fascinated with actual attempts at flight in the same decade. In 1808 the *Annalen der Physik* published the experiments of a Viennese who invented a set of mechanical wings (fig. 9.43).[22]

Another woodcut in the series (based on a sepia), *Boy*

9.43 Set of mechanical wings in *Annalen der Physik*, 1808.

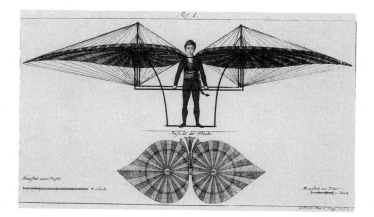

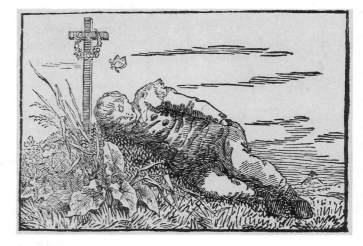

9.44 Caspar David Friedrich, *Boy Sleeping on a Grave*, c. 1802–1803, woodcut. Hamburger Kunsthalle.

Sleeping on a Grave, shows a butterfly flitting upwards to the top of the cross marking the grave site (fig. 9.44). The metamorphosis of the caterpillar into the butterfly typically signified the release of the soul from the body, and in the picture sleep is a metaphor for death. The soul aspires to the cross on the grave site like the imagination soaring to the cross on the mountain summit. The child sleeps on the grave of a loved one, and dreams of eternity where their souls will unite. Thus these early allegorical and literary images set out the themes that Friedrich will later declare through the mountain landscape alone. They indicate how he progressed under the influence of the Dresden romantics, later infusing his landscape with the demonic energy and brooding qualities that he could only suggest in his first attempts.

Friedrich's Landscape and Fairy Tales

One of the most startling intellectual phenomena of the period is the number of German writers and artists drawn to the fairy tale;[23] even Friedrich and Runge wrote such stories, with the latter contributing to the collection of the brothers Grimm. Runge's two tales, *Vom dem Machandelboom* (The juniper) and *Vom dem Fischer und syner Fru* (The fisherman and his wife), attest to a dark side of his personality seething with fear of, and hostility to, women. The fisherman cannot calm his wife's mad ambition and is forced to humiliate himself before the enchanted flounder. Like Tieck, Runge demonizes the landscape; each time the fisherman calls on the flounder to grant a wish the sea be-

comes darker, ranker, and more turbulent until it throws up "black waves as high as church steeples and mountains." In the *Machandelboom*, the tree blossoms and bears fruit to the same rhythm of the woman's pregnancy. She dies in bearing a child and is buried under the juniper. Her husband remarries, but the second wife is jealous of the boy and kills him. Her distressed daughter collects the remains of her stepbrother and lays them beneath the juniper tree, which suddenly stirs and brings its branches together as if in hand clapping. Achim von Arnim felt that these two tales were entirely unsuitable for children and would have wanted them omitted from the Grimm's collection. But these tales were not intended for children; they point to a latent fear of nature relating to the female, whose life-giving potential makes her a rival—like the fisherman's wife—of God himself. Thus the ultimate mystery of the mountain world for the *Naturphilosophen* was the mystery of the womb. In *Der Runenberg* Christian's ascent culminates with the sight of the *Waldweib* inside of a castle, the living embodiment of the mountain world. Fully clothed, she had seemed to incarnate the external landscape of the mountains; when she disrobes, her marblelike body with its "gleaming forms" suggests the internal treasures of the stone realm.

Entranced as a youth by the folklore associated with Rügen, Friedrich wrote his own tale, *Eine Saga*, about a mysterious deep crevice in the chalk cliffs near Stubbenkammer.[24] From this pit came a continuous wailing, day and night, and one heard the cawing of flying ravens, the hissing of poisonous serpents, and the screeching of owls and eagles. While elsewhere the trees grew to proud heights, around the crevice stood only dead and dying oaks and beeches, thistle and the hemlock. A reward was offered to anyone brave enough to descend into the pit and discover the cause of the subterranean groaning, but no one came forth to claim the prize.

It happened in Stralsund, however, that a man unjustly accused of a crime swore under pain of torture that he had no knowledge of the crimes in question. One of his judges had the idea of sparing his life if he would descend into the pit. The accused was lowered with a rope until he could be seen no longer, and after a long time signaled for the ascent. When he emerged he held in his hand a golden chalice filled with wine in which floated a consecrated wafer. This he put in the sunlight and the reflected rays temporarily blinded those surrounding him. Suddenly there came a whirling

tornado, and the pit vanished along with the wailing sound.

The man then described what he had seen: in a fiery chamber, on seven heated spikes a young maiden sat, cuddling a dragon with flaming eyes. She had pointed to three objects, of which one was the golden chalice, and asked him to choose one to take back. His story told, the man fell dead, while out of the brilliantly gleaming chalice the wine rose by its own power and sprinkled itself over him. The storm had parted the dark clouds, and the clear blue of the heavens lay above him. It was then recalled that back when the pit was first discovered, a golden chalice had been stolen from the altar of Bubbin—a village in Jasmund on Rügen. Suspicion had fallen on a young girl who had been in the minister's house, but, though guilty, she swore that she would go to the devil if she had stolen from the church. She then disappeared into the pit and began her eternity of wailing.

Friedrich's tale is a product of a characteristic ideological mind-set that harks back to forgotten, neglected, and misunderstood traditions. Like his woodcut illustration of *Woman on a Precipice*, it deals with a marginalized person whose destiny is bound up with a mountainous landscape. The young girl who stole the chalice has been condemned to alienation, and redemption is possible only when another sinner dares to descend into the cavernous depths and bring back the stolen object. When this happens both sinners are released from their earthly restraints.

The understanding of what lies within the crevice and raising it to the light of day is analogous to the geognostical researches of the *Naturphilosophen*. Critical to their systems are the organic connections between spiritual and temporal realms, hence the religious solution in the tale based on a material mined from the mountains (gold). Again it is the female who embodies the subterranean world of rocks and minerals; the fiery, hellish depths are the realm of volcanic activity ignited by coal deposits and producing the final localized geological deposits. Both threatening and receptive, in the end she offers the pledge of communion.

It may be recalled that the inspiration for Tieck's *Der Runenberg* came from Steffens. Steffens expressed to Tieck his belief in the existence of a mysterious relationship between nature and the life of the human soul. He also explained his interest in the folktales of various nations, how they reveal the character of their locale, and in the relation of saga to climate and topography. This was particularly true of tales

set in mountainous areas, like the Harz and the Riesenge-birge, major chains in north Germany. In 1823 Steffens collaborated with other fairy-tale enthusiasts like Ernst Theodor Wilhelm Hoffmann and F. H. von der Hagen, and in the next decade published *Gebirgs-Sagen* (Mountain sagas), a compilation of his favorite fairy tales.[25]

Steffens claimed that as a scientist (*Naturforscher*) he developed a special awareness of the "physiognomies of fairy tales of different mountain chains."[26] Different rock formations like granite, schist, and limestone exert a major influence on their surrounding landscape and stamp the panoramic view with their own characteristics of vegetation, open and closed terrain, climate, and consequently light and shadow. As a youth Steffens loved to wander in the secret recesses of mountain regions, which instilled in him the sense that these pristine locales held the secrets of the universe.

The meanings of the folktales were clear to the original audiences. The symbols were significations, and only later did they become "secrets" that remained unlocked until thinkers searched for experiences of primitive peoples who had conceived and cared for them. Steffens was struck by the links between folktales emanating from the north side of the Harz Mountains and their peculiar topographical features, and he learned to distinguish granite and schist fairy tales from those emanating from a limestone region. Just as he believed in the intimate connection between nature and the soul, so he subscribed to the inner connection between nature and the folktale, which embodied the intuition of the higher realm.

In addition to the Harz, Steffens loved the tales originating in the area of the Riesengebirge, an Alpine-like chain just southwest of Dresden on the frontier of Prussia and the Austrian empire, which separated Bohemia from Silesia. The so-called Giant Mountains reach an average height of 4,000 feet, with its greatest peak, the Schneekoppe, soaring to an altitude of 5,266 feet. The highest mountain in north and central Germany, the Schneekoppe is a blunted cone covered with debris of granite and mica schist. The geological composition of the Riesengebirge is mainly granite, but in the southern part of the range gneiss and schist enter largely into its structure. It was the peculiar topography of the Riesengebirge that gave rise to the series of fairy tales based on the adventures of Rübezahl.[27]

Rübezahl was the *Berg-Geist* (Mountain spirit) of the Riesengebirge, a moody, changeable being who ruled over

the mountain chain. The heart of his empire was inside the stone realm, from where he continually surveyed his estates, normally deprived of light and sun. He occupied himself with the fertile metallic lodes in the virgin grottoes, and watched over the progress of the mines where his numerous gnomes worked incessantly. He also supervised the building of dams and embankments capable of controlling fire and water in the mines. On occasion he rested in his palace of gold, silver, and bronze, seated on a throne sparkling with a thousand precious stones. When he grew tired of thinking and governing, he took off for the aerial confines of the Riesengebirge, often assuming the form of a giant, with a gray color like that of the earth. Capricious and vain, immodest and timid, lively and melancholic at the same time, his character was a singular assemblage of Heraclitean qualities. Often brusque, he could suddenly became polite, attentive, and even compassionate. It was impossible to define his exact nature.

Long before human beings appeared, Rübezahl roamed the Giant Mountains chasing the wild beasts from the oak forests. Fatigued by these chases, he retired to his cavernous domain and stayed there for several years. When he finally emerged and returned to the Schneekoppe, he was astonished to find that everything had changed. The endless forests had disappeared, and in their place were fertile fields running right up to the foot of the mountain. There were fruit trees, herds of sheep and goats in the green prairies, and little picturesque villages whose houses belched forth a noxious, black smoke.

Rübezahl was momentarily mesmerized by this view, but suddenly he realized that these recent inhabitants had taken his land. At first, he decided to destroy everything, but on reflection he realized that the newcomers did not know of his existence when they settled on his property. He decided to assume different guises and enter this human realm to learn about his "new" subjects. This leads to a series of adventures that form the core of the Rübezahl folktales. Perhaps the most important of these is the one that gave him his name. Once in his wanderings Rübezahl came across the beautiful Emma, daughter of Prince Barsanuph, who reigned over part of Silesia. She had a favorite place of solitude which Rübezahl capriciously transformed into a spacious grotto, paved with precious minerals of various colors, granite rocks of all sizes and shapes, and sparkling rock crystals. He next transported her to his private domain, giving her a dozen carrots to transform into devoted

friends. One of these manages to get a message through to her real love, Prince Ratibor, who makes haste to rescue Emma, while she contrives a scheme to preoccupy her would-be husband. Emma pretends to succumb to Rübezahl's affections but requests that he first count all the carrots in his fields as proof of his steadfastness. Rübezahl then begins counting the carrots. When he finally finishes and rushes to tell Emma, she has fled on a winged horse to where Ratibor and his warriors are assembled. Ratibor and Emma are married, and the city of Ratibor is founded in the memory of their union. The fable of the encounter between the Mountain Spirit and Emma entered into the popular folklore, and henceforth the people called him Rübezahl—short for *Rübenzähler*, or "root counter."

Superstition gave Rübezahl the character of a coal peddler with flaming eyes and a red beard, and his famous trademark, a gnarled stick. Rübezahl set up rude huts in the Riesengebirge where he awaited travelers, or peasants. He became an intermediary between "good Christian folk" and Jewish usurers, frightening the latter into reforming their ways. He was vengeful to scientists who were unable to accept the supernatural; when a doctor scoffed at the idea of Rübezahl, Rübezahl disguised as a woodcutter tore him limb from limb—after which the doctor became a staunch believer in gnomes and ogres, as well as in God and the Gospels.

The Rübezahl tales are intimately related to the geographical, political, and economic situation of the region around the Riesengebirge. The giant is a projection of the fears of the mountain chain, the different climactic regions, and dramatic meteorological variations; rapid changes in the weather parallel the moodiness of Rübezahl's temperament. The ominous character of the giant has to do with proximity to the foot of the mountain. In the Harz and other mountain chains there is usually a gap between the inhabited areas and the foothills, whereas the plains next to the Riesengebirge stretch right to the foothills. The population lives directly in the shadow of the mountains, feeling the awesome character of the dark rocks and cloud-covered peaks.

Land tenure and peasant rights made the native population insecure: the land status of Silesia was in doubt until the end of the Seven Years' War, when the Hapsburg dynasty decided to recognize Prussian control. Allusion is made in the Rübezahl stories to the king of Bohemia, who is Rübezahl's rival for ownership of the mountains. The ru-

ral population was also plagued by credit, debt, and bankruptcy, which explains why a number of the Rübezahl tales feature a stereotypical, scapegoated Jew. The insecurities of the peasants under the shadow of the Riesengebirge inform the capricious personality of Rübezahl.

The other basic occupation of the region was mining, which figures in the character of the Gnome King who hoards great treasures below. The heart of his empire is the interior of the mountain, filled with richly endowed metallic lodes. Rübezahl had as his allies *Kobolds*, tiny inhabitants of the mountain interior whom the miners called *Bergmännchen* (little men of the mountains). Miners subject to hallucinations from cobalt vapors often swore that they observed these creatures.

Given all these implications of the tales, it is no wonder that Steffens found in them a key to his own aspirations and anxieties. His need to connect geognosic processes with the origins of the universe and demonstrate their intimate connections with the human species was actually summarized in the conduct of Rübezahl, hoarder of mineral wealth and author of changes in the weather. Rübezahl's earthy image, coupled with his defense of Christian virtues, made him almost a projection of the reformers' idealized peasant. Thus Rübezahl became a national folk hero akin to the American Paul Bunyan, a symbol of the ascendancy of the common national culture. For Steffens, Rübezahl embodied his ideal synthesis of science, religion, and state.

The idea of the female embodiment of the landscape is absent in Rübezahl, except that it should not be overlooked that it is a woman who gave him his name and forced him to come to terms with the human world. Much of his own restlessness and capriciousness arises from his bitter disappointment over the deception by Emma. She actually provides the bridge between the internal space of the mountains and the community of the plains. If she is not the essence of the mountain realm, she helps rationalize it.

Arndt's Fairy Tales

Ultranationalist Arndt was fascinated by fairy tales and published a compendium of childhood reminiscences in 1806.[28] The tales originated in the island of Rügen, which, although it still belonged to Sweden, was predominantly German in population, language, and customs. There is a close resemblance between Rübezahl and the powerful giant Balderich who ruled over the cliffs of Rügen. His

stomping grounds were in the mountains of the western part of the island near Rambin, which once linked Rügen to the mainland. When a channel was cut through the mountains, Balderich went into a rage; he hated to wade across the sea to Pomerania.

Near Rambin lived tiny dwarfs who made music in the moonlight to attract local children whom they spirited, away into the interior of the mountains. These children had to serve the little folks for fifty years before they could return. The children were seduced by the splendid interior: one entered the mountain by means of a glass entry at the top, and walked along passageways whose walls and ceilings were covered with thousands of diamonds and glittered with a "perpetual sparkling light." The underground people hoarded precious metals and stones. Sometimes the children escaped and returned with enough gold and gems to retire for life. Johann Dietrich, for example, bought up almost all the land of Rügen—estates, towns, and villages—and became ennobled because he had the courage to descend into the mountain and ferret out its treasures. Here was surely the collective fantasy of the downtrodden islanders, eager for their emancipation and for the chance to possess their own land. Fritz Schlagenteufel, the hero of another Rügen folktale, used his treasure to become the richest sheep owner on the isle. This tale involved real people and contained a kernel of truth; Arndt's father moved the family to Grabitz in 1780, where he leased the estate from a descendent of Fritz, Colonel von Schlagenteufel.

The dynamic of Arndt's existence derived from the family's leap from serfdom to ownership and the need to hold fast to newly gained possessions. His nationalism and attachment to the property are anonymous. In his *Germanien und Europa* he wrote, "I should make my people secure and joyful on earth; let them first cultivate a fixed plot of land; then I should wish them to see how high in heaven they can climb." Here then is the link between real estate and the transcending horizon which secures its place in the universe.

In another of Arndt's stories the peasant Johann Wilde found a glass slipper that belonged to one of the wee folks, which gave him a measure of power over them. He and his sons exchanged it for the mountain treasures with which they procured large estates. Indeed, the attainment of an estate is the typical "happy ending" of the Rügen tales and hints at the unfulfilled longings of the island's serfs. The

dream of discovering a precious mineral vein in the cliffs or the treasures of ancient peoples in the prehistoric mounds entered into the popular folklore and whetted the imagination of Rügen's youth. By gaining his freedom from serfdom and eventually leasing his own estate, Arndt's own father turned out to be one of the lucky few who began the climb to heaven.

One story recalls Friedrich's *Eine Saga* and Tieck's *Der Runenberg*; entitled *Die Prinzessin Svanvitha*, it recounts the adventure of a beautiful but bewitched princess forced to reside under the rampart of Garz, at the southern end of the island. She was incarcerated in a forbidden chamber, sitting bent over heaps of gold. Many daring youths—lured by her legendary beauty and wealth—descended to secure her release, but without success. Here again sexuality is associated with the attraction of the underground world of rocks and metals. The visceral response to the woman is in exact proportion to her capacity to yield up the "subterranean" treasures and engender a social rebirth.

The Novel *Heinrich von Ofterdingen*

Arndt praised these tales for their patriotic associations and for their glorification of primitive German culture, but there is also the constant lure of mineral wealth and the demonization of the mountains. The same theme pervades Novalis's *Heinrich von Ofterdingen*, often taken as the paradigmatic statement of German romanticism. Written at the turn of the century and published posthumously in 1802, it is redolent with moonlit scenes, hidden pathways to unknown worlds, venerable hermits poring over prophetic books, *Geister* of every type, voices, visions, and reincarnations. All of this is highlighted by the hero's obsessive quest for the "blue flower" of a higher realm, which captivated the imagination of the author's peers. What has not been generally observed is that the subterranean realm is as persistent a motif as the "blue flower," and that together they symbolize the two passions of Novalis. The two most sympathetic characters in the novel are an old miner (who is really a geologist) and a botanist, who resemble one another.[29]

Novalis followed the lead of Fichte and Schelling in their nature speculations. Toward the end of 1797 he made a pilgrimage to Freiberg, where he studied under Werner, who opened for him a new vision in geology and mineralogy. *Heinrich von Ofterdingen* is in reality an allegory of *Natur-*

philosophie; in the end the hero reaches a stage of existence where "humans, beasts, plants, stones, stars, elements, sounds, colors, commune with each other like one family, act and talk like one race."

Heinrich spends much of his time climbing mountains, and in the first chapter his father shares a startling dream with him which took place in the Harz Mountains and whose impact on Heinrich resonates throughout the rest of the novel. (In the dream the father descends a stone stairway leading into the mountain, which opened up into a spacious cavern where an old man seated at an iron table is staring at the figure of a woman carved in marble.) But it is the critical chapter 5, glorifying the work of the royal mines, which reveals the mainsprings of the novel. Heinrich and his friends meet a native of Bohemia, an old miner who worked in the Riesengebirge. The old man recounts his career, starting from his youth when he developed an inordinate curiosity about what may be buried in the mountains, where springwater came from, and where the precious metal and stones originated. He used to gaze with fascination at the bejeweled icons and relics of a nearby monastery, and wished that they could tell him of their origins. Soon he began exploring the caves, clefts, grottoes, and subterranean corridors and vaults for the precious materials. This all but decides his career when he is advised that only the miner's labors could satisfy his driving curiosity.

Through this character Novalis describes in detail the miner's activities and the working conditions of the mine—somewhat of an intrusion in this tale of fantasy and hallucinations. While he calls mining a "rare, mysterious art," Novalis does almost sociological fieldwork in characterizing the labor structure in the mine. He also ties the work to religion. A monk appears to say mass for the miners, calling on heaven "to take the miners into its holy care, to sustain them in their dangerous labors, to protect them against evil spirits, and to bestow rich veins upon them." The miner claimed that never had he prayed "more fervently" or experienced the "high significance of the mass more keenly," but the ritual also implies the terrible hazards of mining. Nevertheless, he now saw miners as "subterranean heroes" whose association with the primeval rocks equipped them to receive "heavenly gifts and to be joyfully exalted above the earth with its afflictions."

The old miner then recalled his mining master, through whose expertise the duke of Bohemia was supplied with

immense treasures, thereby drawing people to the region and making it prosperous and flourishing. All miners honored him as their father. His name (as we might have expected) was Werner. The old man then turned to Heinrich with tears in his eyes, declared that there was no art which might make its participants happier and nobler, "which would do more to arouse men's faith in a heavenly wisdom and providence, and which would keep the innocence and childlikeness of the heart in greater purity, than mining." He then goes on to define the miner's attitude in terms that would delight the heart of the sternest capitalist, claiming that the miner is born poor and dies poor. He is content to know where the metals are found and to bring them to the light of day, but their dazzling glamor has no hold on his pure heart. He enjoys their peculiar structures and habitat, but they have no attraction for him once they are transformed into commercial items. He had rather look for them within the cavernous depths amid a thousand risks and drudgeries than to follow them into the world and strive after them by means of deceit and aggressiveness: "These drudgeries keep his heart fresh and his mind stout; he enjoys his scanty wage with deep gratitude, and every day he climbs out of the dark pits of his calling with renewed joy in life."

Then the old man sang a song of his youth:

That man is lord of earth
Who fathoms well her deeps
And finds his peace and mirth
Where she her treasure keeps.
.
Faithful he serves the king
With arms whose luck is sure,
Yet stays an underling,
For he by choice is poor.

What though in vales they kill
For greed of goods and gold;
High upon yonder hill
The Lord of earth doth behold.

From this point, the narrative takes an increasingly investigative character, seeking comparisons between geological and other kinds of material and spiritual phenomena. When the old miner led Heinrich and his group to the local caves by the light of the moon, Heinrich became enraptured with the reflection on "that mythical, primeval age when every bud and germ still slept by itself, lonely and untouched,

yearning in vain to unfold the obscure wealth of its own immeasurable existence." Soon the night became enchanted, and Heinrich felt as if his soul were in touch with the world, unlocked and revealing to him "as to an intimate friend all its treasures and hidden charms." He imagined his own little room "by a lofty cathedral from whose stone floor the solemn past arose, while from the dome the bright and cheerful future soared."

Descending into the depths, Heinrich's discovery of prehistoric remains incites wild speculations on their origins:

How would it be possible for an enormous world of life all its own to move around under our feet? For unheard-of creatures to carry on within the strongholds of the earth and be forced by the inner fires of the earth's dark womb to grow into forms gigantic in size and powerful in mind? Could these dreadful strangers, driven up by the penetrating cold, possibly sometime appear among us, while perhaps at the same time celestial guests, living speaking forces of the constellations, might become visible overhead? Are these bones remains of their migrations to the surface or signs of their flight into the depths below?

The idea of contact between extraterrestrial beings and subterranean creatures nurtured in the "earth's dark womb" is repeated when the group meets the underground hermit, Graf Friedrich von Hohenzollern, who is writing a history of contemporary deeds. The miner and the hermit become fast friends, with the Graf declaring that "miners are almost astrologers in reverse." He goes on to elaborate: "Whereas they gaze incessantly at the heavens and stray through those immeasurable spaces, you turn your gaze into the earth and explore its structure. They study the powers and influence of the constellations, and you investigate the powers of rocks and mountains and the manifold effects of the strata of earth and rock. To them the sky is the book of the future, while to you the earth reveals monuments of the primeval world." The miner accepts this comparison and even posits a cosmic link between stellar and geological material:

Perhaps those luminous prophets play a chief role in that old history of the amazing structure of the earth. In time we may be able to know and explain them by their works and their works by them. Perhaps the greatest mountain ranges reveal the traces of their former roads and their former desire to nourish themselves and to go their own way in the sky. Some of them reared up boldly enough to become stars and must therefore now forgo the beautiful green garment of the lowlier regions. And they have

received nothing in exchange except that they help their fathers make the weather and serve as prophets for the lower-lying country which they now protect and now inundate with storms.

Hence the totality of all existence can be surmised from the rocky crust; Steffens himself could not have been more eloquent than the old miner in his observation that everything tends toward greater harmony: "Nature is approaching human beings; whereas she was formerly a wildly producing cliff, today she is a tranquil, growling plant, a silent human artist."

It may be recalled that in Schelling's teachings nature and spirit were identical—nature was visible spirit and spirit invisible nature. He posited only one substance, which is God, the Divine Absolute, and the visible world consisted of multiform emanations from this Divine Substance, which may differ in attributes but remain essentially one, since they formed part of an identical whole. The human being is one emanation; a flower or a mineral are other forms. The human being is nature become self-conscious, but is otherwise akin to the flowers and stones. Humans emerge for a time as self-conscious beings, but after a while are reabsorbed into the unity of Divine Being.

The artist, the thinker, can perceive the relationship of the individual in the divine all-embracing Substance from which all things are derived. Close to the center of German philosophical thought in this period lies the awareness that beneath the mass of sense perceptions that make up the world of everyday life there exists a deeper meaning, a unifying substratum of consciousness. This hidden relationship of all things consists of a substance that is, if not supernatural, at least "supersensuous." This world beyond the range of the senses must be intuited through nature's hieroglyphs in stone and flower.

It is easy to see why *Heinrich von Ofterdingen* appealed to the younger generation. It fuses the essence of philosophy, science, religion, and politics at the turn of the century, rejecting rationalism and utilitarianism in favor of the more mystical and imaginative. One disciple of both Novalis and Schelling, the gifted writer Ernst Theodor Wilhelm Hoffmann (*Tales of Hoffmann*) read Novalis and was immediately led to Schelling's natural philosophy.

Several of Hoffmann's famous tales were inspired by the *Naturphilosophen*. The most notable of these is *Die Bergwerke zu Falun* (The mines of Falun), an account of the affinity between humanity and stone. The idea for the story

was actually sparked by a reading of Schubert's *Ansichten von der Nachtseite der Naturwissenschaft,* and although the tale did not appear until 1819, it was inspired by the work of Schubert, Novalis, and Tieck. Moreover, Hoffmann's cultural maturation occurred well before the end of the Napoleonic epoch. The spellbinding hold of the mineral world in *Der Runenberg* and *Heinrich von Ofterdingen* also lies at the heart of *Die Bergwerke zu Falun.* However, in Novalis's novel, state-controlled mining is highly idealized in keeping with a monarchical ideology, while in Hoffmann's tale it is a private enterprise and described as a "dirty business" run mainly for profit. Both Novalis and Hoffman were social conservatives who identified their interests with the Junker class, but Hoffmann witnessed the rise of the entrepreneurial class in the operation of the mines.

Die Bergwerke zu Falun opens with the Swedish sailor Elis Fröben arriving in Göteborg from a long voyage to the East Indies. In the midst of his merrymaking he learns that his mother—the last surviving member of his family—has died. Having fallen into a deep depression, he meets an old miner—a kind of satanic version of the character in *Heinrich von Ofterdingen*—who sings the praises of the miner's life. When Elis retorts that it is a messy job meant for profit and not for glory, the old man reproves him with the idea that the human eye becomes more clear-sighted in the deepest shafts and finally glimpses "in the marvelous metals a reflection of that which is hidden in the clouds." At last the old man wins him over, and that night a strange dream lures him on, in which he visits the mineral world and finds himself standing on a floor of crystal in a space vaulted over by shining black stone. Marvelous flowers and plants of shining metal rise from the floor. He can see the roots springing from the hearts of beautiful young women. Finally, he beholds the face of the majestic Queen, and as he gazes upon her he feels his very self melting away into the glistening stone.

Awakening, Elis takes the road to Falun. Here he finds work in the mines, gains the favor of the boss, and falls in love with a girl named Ulla. One day when he is alone in the depths of the mine, the old man appears, now openly revealing supernatural connections. He warns Elis that he will be punished for his disloyalty to the mineral world and the Queen, and that he must abandon Ulla. Elis descends into the mine, where now his earlier dream becomes waking reality. A blinding light seems to pass through the mine

shaft, making the walls "transparent as crystal," and through them he looks into paradisiacal fields of glorious metal trees and plants on which hang fruits and flowers of sparkling gems. As in the dream, he comes face to face with the Queen, but his vision is suddenly interrupted by his prospective father-in-law, who has come to express approval of Elis's courtship. On the very morning of the wedding, however, Elis goes down into the mine for a wedding gift—the sparkling cherry-red Almandin—and never returns. Fifty years later his body is discovered, preserved in stone, and only an old hag recognized the man who was once her long-lost love.

So it was that a rich body of scientific, quasi-scientific, folkloristic, and fictional literature informed and complemented the landscapes of Caspar David Friedrich. As with his topographical design and woodcuts, Friedrich exploited popular themes to enhance the commercial potential of his work. In the process he developed strategies for visual dramatization, transposing the theatricality of his figure works to his landscapes. Aristocratic clients responded favorably, not only to the patriotic associations but also to the supersensuous qualities. Fairy tales had attained the level of "high art."

Friedrich was ready to abandon the popular market in favor of an aristocratic clientele. He explored use of atmospheric perspective to create new forms of spatial illusion; one favorite device for suggesting vast distances was a thin strip of dark foreground contrasted with a broad, brightly illuminated background, while another was to silhouette a foreground image (a tree or person seen from the rear)

9.45 Caspar David Friedrich, *Landscape with Sunrise,* 1804–1805, sepia ink. Nationale Forschungs- und Gedenkstätten der klassischen deutschen Literatur in Weimar, Goethe-National-museum, Weimar.

9.46 Caspar David Friedrich, *Mountain Landscape,* 1804–1805, sepia ink. Nationale Forschungs- und Gedenkstätten der Klassischen deutschen Literatur in Weimar, Goethe-National-museum, Weimar.

against an unspecific background. This marked stylistic change of the artist coincides with larger transitions as German society moved from feudalism to early capitalism: the decline of the French Revolution from emancipatory movement to what was perceived as dictatorship; the invasion and occupation of German soil; the introduction and enforcement of *Code Napoléon* in the Rhineland; the reduction of over three hundred principalities to eighty; censorship; the growth of the German bureaucracy, the impact of *Naturphilosophie*—all these social realities were influential in Friedrich's aesthetic transition.

In the early 1800s he produced commodities for the old and newly arisen industries: commercial publishing, popular imagery, and topographic illustration. The artist's defense against proletarianization lay in a new emphasis on the originality and uniqueness of the work of art. Friedrich repeatedly declared, to the delight of the aristocracy, that art was the product less of a particular craft than of the artist's inner life. *Naturphilosophen* gave his work depth, and the French occupation gave it its sense of urgency.

Friedrich's sepia drawings of 1804–1805 anticipate his ultimate style. The two owned by Goethe, *Landscape with Sunrise* and *Mountain Landscape,* attempt an effect of vast distance by juxtaposing a dark foreground band with a broad, brightly lit background and projecting an interminable gap between one near and one remote point (figs. 9.45–46). In the first a farmer pauses with his hoe to gaze at the rising sun; his small silhouetted form provides the starting point for a representation of a reverential gaze which crosses endless hills and valleys to a remote peak

bathed in brilliant sunlight. The farmer stands on his neatly terraced land, at the bottom of which is a church steeple amidst the trees. The emphasis is not on the institution of religion but rather on the miracle of sunrise and the vastness of creation. At the same time, the farmer's land becomes a link in the cosmic chain leading to Infinity. In the other sepia, the foreground figure is replaced with a row of fir trees and a cross. From a peak, the view is across a cloud-streaked mountain range to an even higher summit in an inaccessible region of space. The pinnacle is split into rocky sections like the towers of the Gothic cathedral, reversing the meaning of its pendant. Nevertheless, as in Schelling, nature and theology are not only reconciled but so totally interfused that they become parts of an identical whole.

"Mountain" and "infinite space" functioned as metaphors for exalted states of being.[30] This is both Kantian and Fichtean, it posits the noumenal world beyond appearance, but at the same time this ultimate reality is brought down from the heavens and relocated within the self. The landscapist brought the mountain to Mohammed after all. The broad vista, punctuated by the inaccessible peaks, is identical with the noumenal or spiritual realm. Such biblical episodes as the Sermon on the Mount and the gift of the Ten Commandments on Mount Sinai demonstrate the antiquity of the association, but far from being a kind of casual metaphor for celestial experience, the reverential gaze was specifically ideological. The eye is led through an upturned cone to its apex, through incommensurable reaches of space to a precise symbol of unity. The beholder in Friedrich invariably looks upward, sensing the overwhelming power of the universe and a concomitant release of ego. The search skyward is for the controlling force of the cosmos, metaphorically conceived as a point above a mountain peak. It is a kind of spiritualized "one-point perspective" in which the All-Seeing Eye replaces the vanishing point. Absolute Being constitutes the focus of all the hopes for a regenerated fatherland. Beyond the furrowed plains, beyond all geographical and spatial boundaries, lies the Divine Mind which unifies all.

Official recognition came in 1805 when the Weimarer Kunstfreunde, the art society founded by Goethe and the Swiss artist Heinrich Meyer, awarded his two sepia drawings *Procession at Sunrise* and *Summer Landscape with a Dormant Oak* one-half the prize offered, though his work did not depict the program's subject. Friedrich shared the prize

with Joseph Hoffmann, who did follow the program, a scene from the *Leben des Herkules* (Life of Hercules) by Friedrich Wilhelm Reimer. It was the first time in the history of the Weimar contest that an artist received a prize for works not based on classical mythology. This event intimated the ascendence of the Dresden school, for it was clear that the level of submissions to the competition fell woefully short of the expectations of its founders. What Goethe and Meyer hoped for was nothing short of a cultural renaissance based on the vivifying influence of Greek culture; what they received were for the most part weak imitations of older work or derivations from contemporary neoclassicists. Thus word reached the Dresden circles that the Weimarer Kunstfreunde were ready to receive works with subjects outside the realm of mythology, underscoring the historical moment of political and cultural change. Two of Goethe's own protégés, the Riepenhausen brothers, had been strongly influenced by Flaxman's outlines but joined forces with the medievalizing Catholic group. It is not surprising to learn that the 1805 competition was the last in the series.

Procession at Sunrise conveys the artist's attachment to the medievalizing trend, with a procession celebrating the festival of Corpus Christi, the spring festival honoring the Eucharist on the Thursday after Trinity Sunday (fig. 9.47). The procession has made its way to the top of a hill, where it stands at the threshold of a pair of intertwining oak trees forming a Gothic portal. Its destination is a wayside crucifix that can be understood in this context as an altar. A priest in the center of the procession holds the monstrance

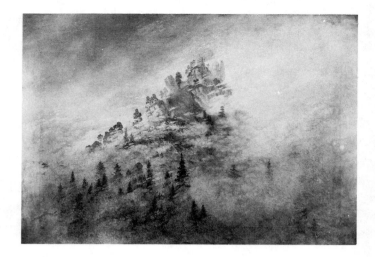

which contains the consecrated Host. It is neatly aligned with the sun, receiving its full rays and reminiscent of the motif of the chalice in Friedrich's *Eine Saga*. Here the natural elements of landscape coincide with the components of liturgical worship.

Both in theme and mood this drawing recalls the writings of Wackenroder and Tieck, who made numerous references to pilgrims, processions, and wayside shrines. For them medieval Catholicism stripped of its doctrine and dogma equalled pietism, and this they expressed in the relation between art and religion, and in the union of nature and religion. The direct and prayerful communion in a natural setting is the essence of their religion. Friedrich's diminutive pilgrims, silhouetted against a vast panoramic backdrop, convey an unfeigned love for God on the secluded hilltop. Here false pomp and pageantry are impossible—the ideal setting for the practice of what he considered "true" religion.

The work was reviewed by Meyer, whose most important praise was reserved for its originality and its execution. He admired the "ingenious" arrangement of the procession against the view of a wide valley, and the excellent drawing which combined "a great deal of firmness, diligence and neatness." He and Goethe wanted to lead people back through the entrance (the Propylaeum) of the temple of classical perfection. But in 1805 they accepted Friedrich's Gothic gateway formed by oak trees, his rejection of the Enlightenment and cosmopolitanism, and his assertion of a new patriotic ideal. He demonstrated that good art not only sprouted "under Italian sky, under majestic domes and

Corinthian columns, but also under pointed arches." Friedrich reverses the point of view of the reverential gaze to specify its concrete objective. The pilgrims have physically traced the visual flight to the crest of the hill. It is a unique example of this reversed perspective and in a way represents a concession to conventionality, which no doubt aided him in his efforts to win the prize.

More consistent with his development is the *Morning Fog in the Mountains,* painted in 1808 (fig. 9.48). As in several previous works, the beholder stands on a mountain peak looking across a valley and upward to a majestic summit. This time the crucifix that crowns the summit is seen at the apex of the triangular mass, climaxing the visual cone in the demonstration of the Absolute, the oneness of infinity conceived pictorially as the Spiritual Point that unifies all experience. This is what a visitor to Friedrich's studio saw in 1808: "A towering mountain swathed in clouds, on the highest peak of which a cross can be seen in the blue atmosphere."[31] The tiny cross is surrounded by a patch of clear sky as if enveloped in an aureole, again specifically identifying exalted heights with the Divine Ego to which everything gravitates. In Friedrich's intimate social circle, this picture was considered key to understanding his outlook: "The rocky summit, emerging out of the fog towards the direction of the sun, that was his image [Das war sein Bild]."[32] In 1808 this implied the striving for national unity as well as the expulsion of the enemy, but as we see in this picture, bridging the gulf between dream and actuality seemed well-nigh impossible.

The Tetschen Altar

But it is in this period that Friedrich associates his art with the anti-Bonapartist forces and attempts to play a role in the practical struggle for liberation. The key to this stepped-up activity is the famous *Cross in the Mountains,* or Tetschen Altarpiece, begun early in 1808 (fig. 9.49).[33] It constitutes a synthesis of Tieck's ideas, *Naturphilosophie,* and the new Gothic symbolism. Based on a sepia drawing of a cross in the mountains exhibited at the Dresden Academy in March 1807, it embodies the most advanced thought of Tieck and Runge regarding the role of landscape. When the painting was exhibited in the artist's studio during the Christmas season, its originality sparked a lively critical debate.

The painting depicts a crucifix of a type common to

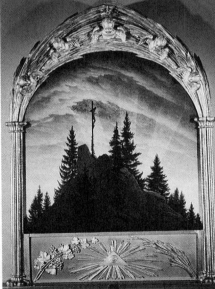

9.49 Caspar David Friedrich, Tetschen altarpiece, 1808. Staatliche Kunstsammlungen, Gemäldegalerie Alte Meister Dresden.

Catholic countries as a point of pilgrimage. As in the *Procession,* it stands on the summit of a mountain, but this time set among a row of fir trees at the moment when the rays of the setting sun form a circle like a Glory. The point of view is from slightly below the summit, looking skyward across a shallow gap. The lack of foreground disallows the beholder from entering the picture in the conventional way, thus creating a disorienting effect. The work expresses a type of patriotic *Naturphilosophie* in linking north German landscape with spiritual experience, a link reinforced by the astonishing frame, whose symbols were carved by the Dresden sculptor Gottlieb Christian Kuhn in a gilt-wood format according to Friedrich's specifications. At each side rises a Gothic column from which spring palm branches to form a Gothic arch; emerging from among the branches are the heads and wings of five *Geister* who gaze upon the scene with adoration. Directly above the head of the central *Geist* shines the Evening Star, seen in the west after sunset. Venus as Evening Star was also known as the "Shepherd's Star," which guided the Magi to the infant Jesus. Below, in a broad inset, the all seeing-eye of God is enclosed in a triangle from whose center radiate rays of the Divine Light. Ears of corn (wheat) and grapevines bend in the direction of the radiated triangle. Friedrich's concept was most likely influenced by Runge, or derived from a shared body of philosophic convictions. The use of margin-frame to comment on the main scene, the play of *Geister,* astronomical/botanical allusions, and the religious application of the landscape distinctly recall *The Times of Day.*

It may be recalled that Runge and Friedrich had planned traveling to Rügen together in 1806 to visit their mentor Kosegarten. Kosegarten had drawn up a plan for either of the artists to do an altarpiece for his new chapel on Vitte. But Friedrich preferred a scene with a landscape motif more appropriate to his own kind of nature worship. While the commission eventually went to Runge, who did the *Saint Peter on the Waves,* Friedrich's Tetschen altarpiece probably grew out of his exchange with Kosegarten and Runge.

Tieck must also be counted as a major source of inspiration for the landscape altarpiece. *Franz Sternbalds Wanderungen* promoted the idea of a religion of art, which placed creative work in a category with divine services, and this assumed a patriotic character in its emphasis on German medieval art. The novel taught that the highest achievement in art is an allegorical Christian landscape, which in

and through nature best reveals the ideology of the Christian religion. In the seventh chapter of the first book of *Sternbald*, the hero projects a landscape with the Annunciation of the birth of Jesus. He imagined a landscape surrounded by mountains illuminated by the deep "evening red" of the setting sun.

The political significance of this work relates to the artist's own interpretation and to the confusing circumstances surrounding its destination. Responding to the controversy ignited by his picture, Friedrich wrote;

Jesus Christ, nailed to the tree, is turned here towards the setting sun, the image of the eternal life-giving father. With Jesus's teaching an old world dies—that time when God the Father moved directly on the earth. This sun sank and the earth was not able to grasp the departing light any longer. There shines forth in the gold of the evening light the purest, noblest metal of the Saviour's figure on the cross, which thus reflects on earth in a softened glow. The cross stands erected on a rock, unshakably firm like our faith in Jesus Christ. The firs stand around the cross, evergreen enduring through all ages, like the hopes of man in Him, the crucified.[34]

Although in this instance the evergreens replace the oak, the statement clearly alludes to the political situation. As with Perthes's *Vaterländisches Museum,* Friedrich disguised his patriotic message with religion. The faith to which he refers is faith in the ultimate overthrow of the French invaders.

We can grasp Friedrich's mentality in this period through his correspondence and the testimonies of his friends. Even before the campaigns of Jena and Auerstädt, Friedrich's concern about the French threat had made him too ill to work. He wrote to Runge on 4 October 1808 that he was not sure if he would visit his family in Greifswald, and in any case it would have to be a dire emergency "so long as the enemy remains in my fatherland."[35] The following month he received a letter from his brother Christian postmarked "Lyon," and the idea of his brother visiting France profoundly irritated him. He scolded him with the thought that "it is simply not right that you, a German, should be in France." His anger was such that he told his brother not to write again from France.[36]

Perhaps the first example of Friedrich's patriotic painting was *Eagle over Fog-Shrouded Sea,* recalled by Schubert in his memoirs of their meeting at the end of October 1806. Schubert recorded that Friedrich spoke with his usual in-

dignation against the French but at the same time expressed his pain about the defeat and humiliation of Prussia. Pointing to the eagle in his painting, Friedrich declared, "The German spirit will work its way out of the storm and the clouds—towards the mountain peaks which stand firm in the sunshine. If the storm had not struck, perhaps the eagle would have remained down below in the fog where no prey could have been seen or caught, and would have gone hungry or wander aimlessly. The German has to warm up before he raises his arm, but once he does so, he 'gets on swimmingly,' as we say in Pomerania."[37] Friedrich then related an anecdote to illustrate his last point. An Englishman hired a strong Pomeranian peasant as his personal bodyguard for his travels. But when held up by brigands in Italy, the servant did nothing to protect his master. The Englishman accused him of idleness and began beating him with a stick. After awhile the Pomeranian ran off into the bushes, beat up the thieves, and returned with his master's possessions. When questioned about this belated reaction, the Pomeranian answered that Germans in general have to warm up first and only then can they stand up to their adversaries. And Friedrich concluded his story with the thought that the Germans, "once they have warmed up—that is after they have become fraternally united—will do the same to the French."

The quest for German freedom and unity is symbolized by an eagle soaring towards distant mountain peaks. That Friedrich spoke for Schubert as well is demonstrated by an autobiographical statement in Schubert's memoirs. During the winter of 1809, the political and economic crisis forced Schubert to abandon temporarily his writing and devote himself to full-time teaching. In this situation he recalled Friedrich's painting of the eagle soaring above the fog: "From below, of course, one only saw darkness and thick fog, but above it the sun was shining brightly and here and there her rays were breaking through the dark gloom until they, becoming stronger and stronger, finally dissolved the darkness altogether."[38]

Although the Tetschen altar is more overtly religious than the picture Schubert observed, I wish to argue that in Friedrich's work the religious and political components were inextricably linked. This is further confirmed by the switch in the work's original destination: Friedrich had intended to present the painting to the king of Sweden, Gustav IV, but changed his mind some time in the fall of 1808. Since the previous September, when the king handed over

the island of Rügen to the French, Pomeranians grew increasingly disappointed with the king's performance. Denmark and France entered into an alliance in October 1807, and the presence of French troops in Denmark constituted a tangible threat to Sweden itself. Meanwhile, Czar Alexander exerted diplomatic pressure on Sweden to come to terms with Napoleon. When these efforts failed, Russian troops attacked Finland (which then belonged to Sweden) at the end of February 1808, and on the same day Russia issued an ultimatum to Sweden requesting it to join forces with Russia, France, and Denmark. Gustav IV steadfastly refused, and by November the Swedish troops were forced to evacuate Finland. While the ignominious end of the king's Pomeranian expedition in 1807 caused great discontent among his people, the attack made by Russia on Finland rekindled their sympathies for him. Yet when the Swedish troops lost their hold on Finland, the king's ineffectiveness cost him his crown the following year. After this period there occurred a rapid growth of pro-French feeling in Sweden. It is in the context of Friedrich's switch from loyalty to disenchantment that we must understand his decision to bestow the gift on another patron.

We can grasp Friedrich's outlook by comparing it with that of his friend and fellow Pomeranian, Arndt.[39] After Russia's defeat of Sweden in the fall of 1808, Arndt became enraged at his own helplessness to resist the tide of Napoleonic conquest. What hopes he had left were more than ever focused on Germany. He left the relative comfort of Sweden and moved about in Germany under several disguises, becoming an ardent Prussian patriot. Making a comparison to the demands of Jesus on his disciples, Arndt declared that it was "the highest religion to love the fatherland more dearly than lords and princes, fathers and mothers, wives and children."[40]

Concluding his second part of the *Geist der Zeit* (1809), Arndt presented a plan for a reorganized German state. He proposed that Austria be made the central focus of the new state, and there the Hapsburgs must continue in power. An independent Prussia must also be maintained, so that when the whole country got rid of the foreigners, only Prussia and Austria must remain as independent Teutonic powers. The petty princes, counts, and barons should be allotted castles, estates, and political perquisites in various parts of the empire; they would thus constitute an honorary hereditary caste and, as imperial peers, would act as advisers to the princes of the blood and the kings. Austria loomed

large in Arndt's plan, since at the time it was the only German nation taking up arms against Napoleon.

Another major figure, Freiherr vom Stein, looked to the military cooperation of Austria and Prussia in this period. After his dismissal as Prussian chancellor in 1808, Stein took up exile in Prague. His epoch-making reforms and his role in the "liberation" strategy induced Napoleon to seek his dismissal and banishment. He quickly resumed his plans for a Prussian insurrection against French ascendancy, calling for the speedy military cooperation of Prussia and Austria and a popular uprising in northern Germany. Thus during the period 1808–1809, German patriots looked to the alliance of the two most powerful German states to bring about the end of Napoleonic hegemony.

Friedrich was one such patriot, and it was his hope for a successful Austrian-Prussian alliance that prompted him to sell the Tetschen altar to the Graf von Thun-Hohenstein and his bride-to-be for their sanctuary in Schloss Tetschen. Members of ancient Austrian aristocracy, the Thun-Hohensteins were powerful feudal lords who occupied a castle at Tetschen in the Bohemian mountains southeast of Dresden overlooking the valley of Elbe. The Graf supported the renewed military action of the Austrians against the French which ultimately began in January 1809. But plans for the mobilization of the Austrian troops would have been known sooner, around the time the Graf received the picture.

The change in the picture's destination is seen in the letter of the Graf's fiancee, Theresia Anna Maria Gräfin von Brühl (her maiden name), who wrote on 6 August 1808 to Franz Anton Graf von Thun-Hohenstein that "the beautiful cross is regrettably not for sale! the courageous northerner has promised it to his king." The note sounds as if the Graf had attempted to negotiate for it previously, and this might relate to the confusion over the origin of the commission. According to a report by Friedrich's friend, Rühle von Lilienstern, Theresia Anna Maria saw a sepia drawing of the same subject at the Dresden show in March 1807 and suggested having it executed in oils. The meeting probably occurred, but the time and details of Theresia Anna Maria's attempt to get the picture for herself and future husband are misrepresented. That she ultimately succeeded is shown in Friedrich's letter to his brother Christian of 25 November 1808, referring to the altarpiece: "At Christmas I hope to receive two hundred thalers for a picture which is almost ready." Thus the turn of events in the fall of 1808 prompted

Friedrich to award the altarpiece to a member of the Austrian nobility in symbolic solidarity with Stein and Arndt.

While he personally sought a liberal solution to Germany's problem, his need for aristocratic patronage hinted at the dilemma of German liberals. They allowed themselves to be used in the name of national liberation, but in reality they were serving the narrow interests of the conservative classes who had no intention of liberalizing governments or drawing up constitutions once the invaders were expelled. The symbolic position of the Thun-Hohensteins in the Schloss elevated above the rest of the land is consistent with Friedrich's landscape development. The very name "Hohenstein"—after an estate belonging to Thun—means "high rock." The feudal lord is identified with the spiritual Lord, both of whom reside atop the mountain. While Friedrich interpreted the subject as signifying the "unshakably firm" faith in Jesus, Thun-Hohenstein was confirming his faith in the permanence of the feudal system.

Significantly, two of the main parties attending the transaction held high military posts and were members of the conservative Junker class. These were Johann Jakob Otto August Rühle Von Lilienstern, a Prussian officer and writer who espoused the cause of *Naturphilosophie*. He was a prótegé of Scharnhorst, and while in Dresden in 1807 he participated in the nationalist circle of Kleist and Adam Müller. When Theresia Anna Maria visited Friedrich in 1808 she was accompanied by Dietrich von Miltitz, a Prussian general and Junker who owned the estate Siebeneichen (seven oaks) just south of Meissen in Saxony. His castle, like that of the Thuns, overlooked the valley of the Elbe. A specialist in communications and supplies, Miltitz lent his expertise to both the Russians and the Austrians in his effort to stop Napoleon.

When Friedrich opened his studio to the public at Christmastime 1808, the Tetschen altar aroused strong reactions. Those who favored it were anticlassical, ardent nationalists and followers of *Naturphilosophie,* including Kleist, Müller, Ferdinand Hartmann (Runge's close friend), Gerhardt and Marie von Kügelgen, Rühle von Lilienstern, and Christian August Semler. Semler held a post at the Dresden Royal Library, wrote on gardens, landscape painting, and the allegorical applications of interior decoration. He also advocated nature philosophy and helped Friedrich formulate his published explication of the Tetschen altar. Marie von Kügelgen recorded her impression of the scene:

"I crossed over the other side of the Elbe to Friedrich's studio to see his altarpiece. I found many friends there, including Chamberlain Riehl and his wife, Prince Bernhard [crown prince of Saxony], Beschoren, Seidelmann, Volkmann and the Bardua sisters, to name but a few. Everyone who came into the room was as moved as if they were entering a church."

The most vociferous opponent of the painting was Friedrich Wilhelm Basilius von Ramdohr, a lawyer and amateur art historian–archaeologist from the region around Hannover. He studied law and aesthetics at the University of Göttingen, the training ground of the Hannoverian elite. In 1784 he spent a year in Rome under the guidance of Johann Reiffenstein, a Russian painter, archaeologist, and dealer in antiquities. Reiffenstein performed a service analogous to Gavin Hamilton and Charles-Louis Clérisseau and other promoters of neoclassicism. Not surprisingly, Ramdohr's publication of 1787, *Über Mahlerei und Bildhauerarbeit in Rom für Liebhaber des Schönen in der Kunst* (On painting and sculpture in Rome for lovers of the beautiful in art), served as a kind of advertisement for his mentor's collections. Like other backers of academic classicism, Ramdohr attached himself to Enlightenment philosophy. He became an ardent Francophile, and this explains why his essays are larded with French phrases and quotes. While disillusioned with the excesses of the Revolution, he maintained his support of its original aims. Politically, he belonged to the group known as the "Hannover Whigs," constitutionally minded conservatives who decried both the doctrinaire radicalism of France and German autocracy. He cooperated with French occupation troops in 1803, and as part of a diplomatic team helped induce Napoleon to suspend those forces in Hannover at the end of the year. Later, when the Prussians took temporary control of Hannover in 1805–1806, he received an appointment to Dresden as court chamberlain. After Jena and Auerstädt, the French again occupied Hannover, and he carried out only the most perfunctory diplomatic duties. He spent his spare time in Dresden writing art criticism and compiling research for a major work on civil law, which he developed on the basis of Prussian common law and the *Code Napoléon*.

Ramdohr's aesthetics and his politics were ideologically linked, and he had early aroused the antagonism of the anti-Enlightenment generation. On the very first page of the *Herzensergiessungen*, Wackenroder attacked the writings

of Ramdohr and declared that anyone who liked the critic's work "may immediately put out of his hand that which I have written, for it will not please him." Given this hostile confrontation, it is not surprising that Ramdohr experienced Friedrich's altarpiece with indignation and castigated the philosophy that justified it. He must have seen it as a vindication and fulfillment of the ideas of Wackenroder and Tieck.

While Ramdohr's arguments center on the differences between Friedrich's painting and traditional landscape, it is clear from several of his observations and from the ensuing debate that the aesthetic battles were being fought on political grounds. It was Ramdohr—Francophile, Napoleonic admirer, and opponent of German autocracy—who confronted the supporters of Friedrich. Ramdohr's long critique of the Tetschen altar rejected the very idea of using a landscape for an altarpiece and linked its conception to the new "mysticism"—the Jena school of philosophy, literature, and natural science, which fed the aspirations of the new patriots.

The article appeared in serial form in the fashionable Dresden daily, *Zeitung für die elegante Welt,* during 19–21 January 1809.[41] He opened his piece with an apology. Ordinarily, he claimed, he would prefer to sit still rather than come out publicly with criticism of the work of a contemporary artist. If the picture had met the expectations of a traditional altarpiece, whether competently or incompetently executed, he would have remained silent. But Friedrich's picture deviated so unexpectedly from the norm and so greatly excited the public that he felt compelled to point out the danger. To remain silent would be cowardly, since the work related "to a spirit that is the unfortunate spawn of the present age, and the dreadful omen of a rapidly onrushing barbarism." Ramdohr did not view the work simply as an aesthetic event, but as a real threat to the social values he cherished. His criticism was not directed against Friedrich's picture, but against "the system that projects from it: against a group of concepts which seem false to me and which are now creeping into art and science."

Ramdohr immediately dismissed the idea of "art for art's sake." He anticipated a question designed to mute his attack: "The picture produces an effect; what more should one ask?" Ramdohr admitted this and even gave Friedrich credit for possessing "what Diderot called *the secret.*" But it is precisely because Friedrich had this gift that he must guard against deliberately manipulating the emotions of

the crowd. The power of a work is tied less to its effect than to the observance of principles basic to the category to which the work belongs. Ramdohr asserted that it would be a "veritable presumption if landscape painting were to sneak into the church and creep on the altar." Thus he attacked what he considered Friedrich's subversion of a traditional category.

Ramdohr then proceeds to an analysis of the picture's content, carefully describing its details. He could identify the trees with precision and observed that from the mountaintop jutted out a pair of granite boulders. He even hinted, although mockingly, that the artist drew his motifs from herbaria and mineral collections. He was certain that Friedrich observed the scene in nature, but he also believed that an allegorical intention lay behind it, "intended to evoke in the viewer a pious mood akin to partaking of the Lord's Supper." He interpreted the crucifix in solitude as a sign of transition between dark and light, earth and heaven. The motif of the mountain and the crucified Christ point to "the enthroned high above the highest in nature, visible to all who seek Him!" Ramdohr's reading confirms both the scientific and religious synthesis analyzed in the context of *Naturphilosophie,* and demonstrates that Friedrich's elite audience grasped the meaning of the reverential gaze.

Why then did Ramdohr react so indignantly to Friedrich's picture? The answer comes soon after, when he explains that the concept would have been perfectly understandable to him if he had read such a description in a novel in the taste of *Atala.* For example, if the owner of a chapel in the vicinity of this mountain with the crucifix were to have an opening set into the altar, and the gaze of the faithful who approach the altar were led by perspective toward the scene in nature, Ramdohr could imagine that under certain conditions the view could inspire a mood akin to the one Friedrich might have experienced. (Here he admitted discomfort before Friedrich's fractured perspective and the lack of mediating pathways to guide the beholder into the work.)

Ramdohr's reference to Chateaubriand's *Atala* in his analysis is significant. *Atala,* with its sensational blend of religious evangelicanism and eroticism, achieved a major European success. It had been excerpted from *Génie de christianisme,* which represented a reaction against the Enlightenment and the deistic outlook of the Revolution. Its author promoted a revival of religious fervor, stressing the emotional and aesthetic components of Catholic ritual and

symbolism. The *Génie* was a full-scale apology for Christianity, designed to demonstrate the inherent superiority of Catholic religion as a source of moral and artistic inspiration. In this sense, it played a role similar to Wackenroder's *Herzensergiessungen* and Novalis's *Die Christenheit oder Europa*. But whereas Napoleon favored such a revival in France to preserve social order, he could only have looked upon the parallel movement in Germany with suspicion. It was precisely because of the discouragement of religious fervor and nationalism in Germany that the evangelical and medievalizing thought took on a subversive character. Although Ramdohr could understand how Friedrich's motif might have worked in the literary context, he still took a dim view of the popularizing "taste" of Chateaubriand's novel. Nevertheless, his comment is invaluable for pointing out common strains in European culture during the Napoleonic epoch. There is a great deal of *Atala* in Friedrich's Tetschen altar; indeed, its blend of sensational drama, Catholic imagery, and geological and botanical accuracy recalls Girodet's interpretation of the story. But while both were anticlassical and antirevolutionary, Girodet's formulation visually supported the goals of Napoleon while Friedrich's was meant to undermine them.

Ramdohr did not mention Girodet's picture, painted the same year as Friedrich's altarpiece; no doubt he would have derided its mawkish sentiment and erotic quality. His response to Friedrich, on the other hand, seems quite out of proportion today. He questioned the use of landscape to express a specific religious idea, and felt that Friedrich's manipulation of nature was incompatible with true piety. Friedrich's painting violated the rules of neoclassical landscape theory gleaned from the works of Claude and Poussin. Ramdohr cited Valenciennes's *Elémens de la perspective pratique*—"the best of all the perspective treatises"—to support his contention that Friedrich broke the laws of aerial and linear perspective. The artist insulted "the rules of optics" in depicting his scene: there is no gradual unfolding of the space through a series of planes, and instead the entire visual space is filled with the single crag of a cliff, like a cone. In order to have seen this view of the mountain the artist-beholder would have to have been situated several thousand paces away, almost on the same level as the mountain, but if so he could not have seen any detail within the outlines of the mountain. Ramdohr noted that the further the distance from the object in nature the more blue it becomes, due to the scattered light affecting the air between

the observer and the object. But in Friedrich's painting the mountain is shown as green and brown as if the artist were right on top of it. Moreover, light is shown falling across the summit of the mountain, a phenomenon possible only if Friedrich were painting from the side with the sun behind him. In the Tetschen altar, however, the view is from behind the mountain below which the sun sinks. This is tantamount to the artist putting his hand in front of his face and blocking out the light. Finally, Ramdohr complained that Friedrich could not have seen the sun in the position where the rays converge: for the light to reach the clouds the sun would have to have been close to the horizon, but the apparent height of the mountain precludes this sight.

Ramdohr was technically correct in this criticism, except that in actuality the rays converge more or less at the sun's vanishing point, and modern photographs of similar phenomena tend to bear out the accuracy of this particular light effect. But Ramdohr's technical observations, accurate as they may have been, were meant primarily to discredit the philosophical view that he felt was implied in the work. He challenged the use of landscape to allegorize a religious idea. He concluded that Friedrich deliberately violated all the basic principles of landscape painting in order to arouse certain feelings. For Ramdohr, the ordinary content of landscape was so familiar that it was impossible—short of destroying the integrity of the natural phenomena—to find allegory within it. One should not confuse the "expression" of landscape such as one finds in Ruisdael's *The Jewish Cemetery* (then in the Dresden Gallery) with allegory. It awakens a solemn religious emotion that stems from the contemplation of the transitoriness of human existence, but conveys no specific meaning or concatenation of ideas. Secondly, it is necessary to distinguish between emotional and aesthetic feeling:

Enter into the true nature! The fresh air which you breathe, the true brilliancy of the sun, the height of the mountains, the broad expanse of the surfaces, et cetera, affect directly all your organs, awaken and strengthen . . . those ideas of grandeur, well-being and life in general which move every wholesome mind to love, gratitude and admiration for the Creator. It is absurd to expect such truly touching pathos from a painting which completely lacks the means for it.

On the contrary, what art offers is a special sentiment by which the beholder, always conscious of the distance from real life enjoys the game that art plays with our feelings.

What would art gain if it simply reproduced the emotions instilled in us by nature? We would then lose the aesthetic experience and the enjoyment of the beautiful, and the work of art would lose out in competition with the commonest relic and grossest caricature.

After attacking the very structure of Friedrich's conception, Ramdohr drove home his main point: Friedrich not only offended good taste but used shameful means to invoke a sense of religious devotion. The source of this conception is strikingly clear to the critic. It is

that mysticism which currently insinuates itself everywhere and wafts across us from art and science, from philosophy and religion, like a narcotic vapor . . . That mysticism which sells word games instead of concepts; builds principles upon remote analogies and everywhere cares only to have a presentiment where it ought either to know and recognize or else modestly keep silent. That mysticism for whose followers ignorance of facts and literature serves as a shibboleth. That mysticism which prefers the time of the Middle Ages and its institutions to the age of the Medici, Ludwigs and Friedrichs [i.e., Friedrich der Grosse, etc.] . . . That mysticism, finally, which makes me tremble in fear of consequences of the present times and reminds me of those who toward the end of the Roman monarchy brought the decline of true learning and taste!

Here Ramdohr revealed the wellsprings of his anxieties aroused by the confrontation with Friedrich's altarpiece. Without naming the intellectual influence on the Dresden circles in which Friedrich participated, he clearly identified it with the philosophy of the Jena school and those philosophers, scientists, poets, and artists nourished by the ideas of Fichte and Schelling. When Friedrich stated that a painter "should not merely paint what he sees in front of him, he ought to paint what he sees within himself," he was acknowledging Schelling's perception of the artist as one who grasps and acts upon the relationship between the external world and the inner self. Ramdohr perceived that the "mysticism" emanating from the Jena group not only affected the cultural attitudes of the younger generation but also promoted social change that verged on the edge of "barbarism." The disturbing elements in the picture for Ramdohr went beyond technical and conceptual considerations to the very roots of Ramdohr's concern for modern German society. He could not fathom the artist's peculiar blend of national and religious "mysticism" (read "activism"), which threatened to invalidate Ramdohr's own social position. In this sense he was far more honest than cer-

tain aristocrats like Thun–Hohenstein who encouraged the forces of nationalism for their own ends and disavowed them almost immediately after the foreigners were expelled. Few could have accepted Arndt's pronouncement without trepidation: "It is the highest religion to love the fatherland more dearly than lords and princes, fathers and mothers, wives and children." Arndt scorned institutionalized Christianity; it was *Naturphilsophie* that Arndt and Friedrich espoused and which formed the basis of the idea of the Tetschen altar.

Friedrich's friends rushed to his defense, including Semler, another advocate of *Naturphilosophie* who helped him formulate his published statement of the work, and Ferdinand Hartmann, the friend of Runge who wrote a long rebuttal to Ramdohr's argument. The most spirited defense, however, came from the history and portrait painter, Gerhardt von Kügelgen, who belonged to the party of the patriots.[42] He hammered away at Ramdohr's old-fashioned ideas, pointing out that if the ancients had accepted Ramdohr's rules, art would never have progressed. He blamed critics in general for censuring original works from the standpoint of the classical. He observed that Ramdohr's idea of grandeur derives from empty "English copper engravings and a mania for forms aping the style of antique statues." Friedrich's originality, in other words, sprang from native talent and should be warmly received by the German public. Von Kügelgen was also making a plea for originality, confirming the commercial risks of the new artist–entrepreneur.

Perhaps the most politically charged statement was that Ramdohr's critical approach smacked of the "dictatorial." Ramdohr, in his own counterstatement against Hartmann and von Kügelgen, lashed out with fury against the implications of this term. He used the term *Despotismus* (despotism) in place of von Kügelgen's *diktatorisch*. Using a very sarcastic tone, Ramdohr began taking apart the idea of despotism in the context of taste and the ways in which people could exploit its various meanings. His most significant application emerges in connection with the 'despotism of sectarian-minded parties." He mocked the spirit of political sectarianism: "Alas, if we were to doubt the superiority of one of the members of these elected little ant-hills!" Ramdohr tried to dissociate himself from all party affiliations, and in turn pin the label on his adversaries. *Despotism* was a loaded word at the time. The initial German support of the French Revolution came from the fact that the Prussian

people chafed under a despotism as thoroughgoing as that which the French forcibly ousted. Then Napoleon appeared on the scene, and Arndt, for one, charged him with tyranny: "After the Italian campaign and the assumption of the Lombard crown, his complete despotism was finally consummated." Arndt was equally hard on the princes and the nobility in the German territories who had become "vicious and petty" in the process of selling out to Napoleon. He called out to all those who were still free to arm themselves with the greatest courage and "with the most ardent love of fatherland": "Show the French that you do not cringe before them and their tyrants, that you do not covet their land but only your own God-given freedom. Thus only will the decadent regime, confounded in its own conceit, disappear. That will also be the end of despotism which now obtains in most states of Europe . . . Nothing else will avail you princes who venture to disobey laws set up as the only supreme bond between you and your subjects."[43]

Ramdohr's reaction to Friedrich's painting was politically motivated, demonstrating that the work was hardly neutral. Ramdohr clearly opted for the status quo, rationalizing the Napoleonic hegemony as an extension of "enlightened despotism." Friedrich's party was bent on change and used the religious image to arouse the German people from complacency and resignation. The image of the crucified Jesus reasserted the Christian creed rejected by the Enlightenment and raised the hope that the German people could restore, quicken, and rebuild the fallen world.

Yet Ramdohr's accusation of "mysticism" missed the mark; Friedrich's landscape is spiritualized in accordance with *Naturphilosophie* but demystified in the context of the painter's scientific knowledge. The critic himself validated Friedrich's geological studies. The *Naturphilosophen* believed that geology made a useful contribution to religion, not only in stimulating consciousness to the discovery of the universal design of God but also in demonstrating how the Creator supplied physical needs. Christianity's God was also nature's God. Steffens claimed that it was Schelling who gave him the "grand thought," the conception of the Eternal, the One who embraces all things in his thought, and that it was Werner who awoke in him the idea of introducing this conception into the study of nature as a working force. This gave rise to his book on natural history in its relation to God, what he called "the natural history of the interior of the earth." The object of *Beyträge zur innern*

Naturgeschichte der Erde was to find a way to unite all phenomena, and from this union to find the traces of a Divine Mind ruling over and unfolding all. Both Werner and Steffens attempted to explain the origins of mountains in general through their study of the Harz region, especially the rock formation of the Brocken rising on the boundary between the Oberharz and the Unterharz. The Brocken was a huge mass of granite, the highest mountain in north Germany after the Saxon and Silesian ranges. The interest in the Brocken arose from a central point of Werner's theory that regarded granite as the basis of mountain formations.[44] The Neptunist synthesis presupposed that the "primitive" mountain formation (*Urgebirge*) was granitic and constituted not only the basis of the earth's crust but also formed the highest peaks. Granite was the unifying material as well as the foundation of the earth's surface. Friedrich literally erected his crucifix on the "rock of ages."

Thus geology came to the support of religion in a manner that could be expressed in landscape painting. Steffens, who fought in the Wars of Liberation, claimed that his speculations could take a practical turn because the desire to get at the spiritual import of creation reflected "the moving-spring of the mind of Germany." The drive for the unity of all phenomena was a drive for the unity of German people. In practice this was achieved during the Napoleonic occupation through secret societies in Prussia and Austria, based on the Masonic model. A major patron of Friedrich, Herzog Karl August von Sachsen-Weimar, was a dedicated Freemason. That Friedrich participated in the "secret league" is suggested by the frame that he designed for the Tetschen altar. While the triangle with radiating shafts of light is a conventional Christian symbol, when combined with the All-Seeing Eye it becomes one of the most pervasive symbols in Freemasonry. One medal of the Grand Officers of the Grand Mother Lodge of the Three Globes, founded by Friedrich II in 1740, consisted in part of a gold triangle and the irradiated All-Seeing Eye in the center. Friedrich's design appears far less a religious image than a straightforward secular emblem. Corn and grapes (i.e., wine) are also basic Masonic symbols, and even the winged *Geister* resemble the motif of the Lodge of the Three Seraphim, founded in Berlin in 1744 (fig. 9.50). The curious blend of Masonic emblems, pantheistic philosophy, political propaganda, and Christian imagery gives to Friedrich's work the hybridized character that deeply disturbed Ramdohr.

9.50 Detail of plate 30, R. F. Gould's *History of Freemasonry*, 1900, vol. 3.

Friedrich's *Monk by the Sea*

One of the most unusual pictures that Friedrich painted during the Napoleonic occupation was *Monk by the Sea* (*Der Mönch am Meer,* fig. 9.51).[45] Repainted several times in the period 1809–1810, it was exhibited together with his *Abbey in the Oakwood* at the Berlin Academy exhibition of 1810 and purchased by Friedrich Wilhelm III at the instigation of the fifteen-year-old crown prince (fig. 9.59). It followed on the heels of the Tetschen altar but is gloomier, and the landscape is starkly barren. It gives visual utterance to his personal trauma during this period, and the critical response to it demonstrated that it resonated with the prevailing tragic mood of the ruling elite—a mood suffused with the mourning for the recently deceased queen.

On the face of it, the painting shows a friar in a Capuchin habit who stands at the edge of a promontory overlooking a wind-tossed sea and a vast expanse of darkening sky soon to envelop him. The lack of foreground, the diminutive scale of the figure, and the starkly barren landscape all project the effect of a helpless creature teetering on the brink of catastrophe. This effect is heightened by the sway-backed posture of the friar, who appears to be wavering from the impact of the infinite prospect before him.

Friends would have recognized in the shape of the monk's head, his thick blond hair and sideburns, the physical likeness of Friedrich himself (figs. 9.52–53).[46] They also would have located the scene on the island of Rügen on the Baltic Sea, one of Friedrich's favorite sketching sites and the summer or permanent residence of some of his

9.51 Caspar David Friedrich, *Monk by the Sea,* 1809–1810. Verwaltung der Staatl. Schlosser und Garten, Schloss Charlottenburg, Berlin.

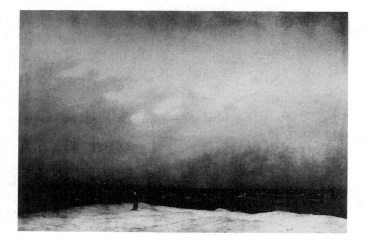

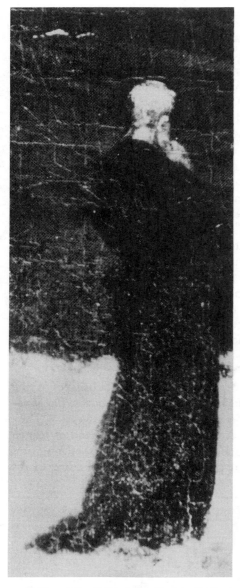

9.52 Caspar David Friedrich, *Monk by the Sea,* detail.

closest friends. But though it is the artist himself in a monk's habit—the sign of self-abnegation in behalf of a spiritual ideal—we experience him as totally out of synch with an environment he knew and loved so intimately. He is homeless in his native land.

Friedrich's friends and contemporaries perceived the work as bizarre and discomfiting. Marie Helene von Kügelgen—who loved the Tetschen altar—mentioned the picture that she saw in an incomplete state in a letter to her husband on 22 June 1809:

I also saw a large painting in oils which did not appeal to me at all. It shows a wide, endless expanse of sky, under it a stormy sea, and in the foreground a strip of white sand, along which the darkly shrouded figure of a hermit is seen creeping. The sky is clear and indifferently calm. There is no storm, no sun, no moon and no thunder. Yes, even a thunderstorm would be consolation and pleasure, for then one would at least see some kind of movement and life. For there is no boat or ship, indeed not even a sea monster to be seen on the endless ocean. And in the sand there is not even one blade of grass. Nothing but a few seagulls flitting around, which makes the loneliness of the scene all the more grim and desolate.[47]

Its topographical and political significance emerges from the review of the work by Heinrich von Kleist, which appeared in his *Berliner Abendblätter* of 13 October 1810. After confessing that it thwarted his normal response to seascapes, Kleist declared, "No situation in the world could be more sad and eerie than this—as the only spark of life in the wide realm of death, a lonely center in a lonely circle. With its two or three mysterious objects, the picture appears like the Apocalypse, as if it were dreaming Young's *Night Thoughts,* and because of its uniformity and boundlessness, with nothing but the frame as a foreground, one feels as if one's eyelids had been cut away."[48] I will return to this astonishing notion of a "lidless" vision,[49] but it is important to note here that Kleist received the work positively. He claimed that in this original, insightful picture he saw a breakthrough in German art, and through the painter's power "a square mile of Prussian sand, with a barberry shrub and a solitary crow ruffling its feathers could take on the effect of an Ossian or a Kosegarten."

This reference to Kosegarten was no arbitrary one: Kleist had in mind the poet's specific attachment to the rugged Baltic coastlands of Rügen. His identification of the spiny barberry bush—found in inhospitable zones—with

9.53 Caspar David Friedrich, *Self-Portrait*, c. 1810, chalk drawing. Staatliche Museen Preussischer Kulturbesitz, Nationalgalerie, Berlin.

Kosegarten acknowledges the metaphorical links between Friedrich's picture and his mentor's poetry.

Friedrich's engagement with his native scenery took on increasing significance with the growth of the anti-French nationalist movement in which he actively participated. The intellectual resistance was encoded in visual signs of Germany's glorious past, its cathedrals and mythical heroes, and its present in the form of its literature and its topography. Especially popular was the myth of Hermann, the first-century warrior who led the Teutonic tribes to victory over the Roman invaders of Quintilius Varus. In particular, Kleist's *Hermannsschlacht,* read aloud by the participants in the Dresden circle in 1808, gave the old myth its pungent modern political meaning. Inspired by the insurrection of the Spanish people against Napoleon's troops in May 1808, Kleist glorified the first great uprising of the Germanic peoples against foreign tyranny. A lively member of the Dresden circle, Friedrich was deeply moved by *Die Hermannsschlacht.*

Kleist's reading of Friedrich's painting is of the greatest value for an understanding of its reception in 1810. His remarks were in fact a reworking of a review by Clemens Brentano and Achim von Arnim, not published in its original form until many years later.[50] Their combined insights, however, not only provide clues to its content but also signal the social-historical wellsprings of its theme. Kleist, Arnim, and Brentano led the cause of pan-German patriotism in this period; Arnim and Brentano had published the first volume of their *Des Knaben Wunderhorn* in 1805, devoted to medieval folksongs and tales. Of old Prussian nobility, Kleist and Arnim belonged to the Patrioten und Kriegspartei (patriotic and war party) and to the Christlich-deutsche Tischgesellschaft (Christian-German dinner society), as well as a number of other similar clubs and secret societies. Their efforts were bent toward two interrelated goals: liberation from Napoleon's yoke and a renaissance of German culture to restore and enhance their lost prestige. Their voices were heard in the *Berliner Abendblätter,* devoted to a policy faithful to the king and the Prussian tradition.[51]

The witty dialogue of Arnim and Brentano, supposedly overheard by them in front of Friedrich's picture, contains valuable insights into its content and context. One spectator is reminded of Ossian playing his harp while looking at the sparse and rugged terrain; two young women who overhear the remark argue whether they heard "Ossian" or

"ocean." Later, a governess enters the room with two demoiselles and explains that the picture shows "the sea by Rügen." The first demoiselle answers: "Where Kosegarten lives," and the second, "Where the fancy foodstuffs come from." The governess then complains, "Why does he only paint such a dull sky? How nice if he had painted fishermen of amber in the foreground."

Friedrich's audience was able to identify the geographical locale of the scene, to observe its Ossianic character, and to identify it with the painter's mentor, Kosegarten. The specifically Germanic character of the setting is then seen by another spectator as an externalization of the monk's state of mind: "He *is* the picture, and while he seems to dream into this region as into a sad mirror of his own isolation, the encompassing, shipless ocean restrains him like his vow, and the barren sandy shore, joyless as his life, seems symbolically to drive him forth again like a lonely self-prophesying shore plant." His female companion, who has been silent for a long time, replies, "As it is, it seems to me a nightmare, yearning in a dream for the fatherland. Come along, it's making me sad."

The last word, however, belongs to the narrator, the persona of Arnim and Brentano. While he admires the "moving effect" of the picture, he is disturbed by the position of the monk, whom he would have wished to see posed more traditionally "stretched out sleeping or praying or laid down gazing in all humility so that he would not ruin the view of the spectators, upon whom the broad sea evidently makes more of an impression than the minute Capuchin." Arnim and Brentano were unsettled by the friar's disorientation—his failure to conform to their expectations of the meditative recluse in the face of eternity, like the pious pilgrims of *Franz Sternbalds Wanderungen* and *Heinrich von Ofterdingen*. In this sense, Kleist cast their review in a more positive light and upheld the work's pessimistic affect as integral to its originality.

Kleist, Arnim, and Brentano all identified the hermit—a popular German romantic alter ego—as a Capuchin friar (the German term *Mönch* can mean either friar or monk). Recent scholarship tends to dispute this identification, but except for his bare feet—a trademark of the Capuchins—the precise classification of this holy figure is not possible to determine by internal evidence alone.[52] The fact is that Friedrich's contemporaries received it as such, and Brentano—a Catholic trained in a Jesuit school—entitled the review "Various Perceptions of a Friedrich Seascape with a

Capuchin Friar." Friedrich chose a Capuchin as an example of exaggerated devotion and self-sacrifice. A mendicant branch of the Franciscan order, the Capuchins first reached the German territories at the end of the sixteenth century.[53] While they settled for the most part in southern Germany, where Catholicism predominated, they founded friaries and missions in Saxony, Prussia, and Pomerania. During the Thirty Years' War, when Pomerania first fell under Swedish control, many of these missions were plundered by the invader and individual Capuchins murdered. Memories of the Thirty Years' War were revived during the Napoleonic occupation of Pomerania, including those associated with the sufferings of the Capuchins and other Catholic orders. Religious orders were suppressed or severely curtailed, and monasteries and friaries confiscated. The Capuchins bitterly detested Napoleon, and in this sense Friedrich's lone figure is a displaced person, uprooted by the Napoleonic machine.

The Capuchin was a sympathetic type to pious north Germans, and especially to the German romantics. Capuchins had few possessions or permanent abode and engaged in evangelizing and missionary work. They were noted for their piety and the simplicity of their religious teaching, for roaming about the countryside and addressing the rural folk rather than a cultured elite as did the Jesuits. The Capuchins were devoted to health care, often attending plague victims or sufferers from sudden catastrophe. One of Kleist's most endearing tales tells of a Capuchin who accompanied a criminal to the gallows in horrible weather.[54] The condemned moaned of God's injustice in making his last mile such a dreadful one. Wishing to give him godly comfort, the Capuchin replied, "You rascal, what are you complaining about? You have only one way to go, but I must return by this same road in this same miserable weather." Kleist's moral points out that those who have made the bleak return from a place of execution, even on a lovely day, could easily grasp the import of the Capuchin's response. Kleist's reading of Friedrich's figure as a Capuchin was not accidental; he associated the friar not with the contemplative orders but with those who underwent privations to do missionary work.

Thus Friedrich identified himself with an evangelical preacher wandering bewilderedly in a zone soon to be enveloped in fog—a metaphor at that time, as in terms like *Nebelirre* and *Nebelsehen,* for those who have gone astray or are perplexed.[55] All references to the spiritualized landscape

that still marked the Tetschen altar have been eliminated. The absence of traditional Christian props such as crucifix, radiating beams, and evergreen trees as symbols of eternity create a sense of confusion. The fracturing of perspectival unity and lack of closure further adds to the disorientation of the spectator. There are no mediating accessories or pathways to guide the beholder or to indicate the path by which the beholder has arrived at the present standpoint. While the monk seems to be poised on the metaphorical threshold of the spiritual realm, our normal expectations of resolution are defeated by the sense of dislocation.

Hence Friedrich makes the actual beholder experience the same unease as the protagonist of his painting. Kleist noted in looking at the picture that he "became the Capuchin monk" and the picture became the "dune" from which he beheld nature. Here he encountered the same feeling of rupture he experienced in reality when his yearning to cross the unbridgeable gap of an "infinite solitude by the sea" remained unfulfilled. The picture induced in him the same sense of rupture, a breaking off (*Abbruch*) of negotiations, so to speak, between the yearning heart and the impersonal "other." To Kleist, "nothing could be sadder and more uncomfortable than this position in the world . . . the lonely center in a lonely circle." The sense of pain and disharmony, in this experience—exacerbated by the lack of foreground—was so intense that it was as if "one's eyelids had been cut away."

Kleist's violent language attempts to find verbal equivalences for the expressive signs and gestures of the picture. Friedrich's use of the so-called *Rückenfigur*—a figure-observer seen from behind—positions the beholder in such a way as to impel an identification with the visual protagonist, in this case, the painter himself.[56] The *Rückenfigur* is no mere visual device but a politicizing motif declaring the appropriate standpoint for a particular constituency. Unlike most, especially French, late eighteenth-century and early nineteenth-century painting, in which the visual drama is enacted by characters so deeply preoccupied with their own mental or physical actions that they seem oblivious to an external monitor, Friedrich positions the beholder to assume the same standpoint as the protagonist of the picture.[57] While the earlier landscape and genre tradition tried to make the scene so invitingly real that the spectator could daydream directly into it like another promenader, Friedrich's design specifically negates this attitude. He completely explodes the pleasurable view and makes the

beholder, like the pictorial actor, a hapless victim of the internal circumstances. Whether intended or not, Friedrich's anti-French politics are visually transcribed in a space antithetical to the French eighteenth-century conception of painting. Indeed, at this very moment the German patriotic movement was rejecting the French Enlightenment as alien to German religious, social, and political progress. It was Friedrich's attempt to induct the spectator into the picture and behold the scene from an eccentric viewpoint that provoked Kleist's novel response.

If the bewildered soul in Capuchin habit was Friedrich himself, the personal crisis brought on by social and political upheaval extended to his immediate friendships as well. These were severely disrupted by Napoleonic military policies and civil censorship. Maréchal Soult of the French occupation forces had dismissed Friedrich's close friend Ernst Moritz Arndt from his teaching post at the University of Greifswald and replaced him with Kosegarten.[58] During the occupation both Kosegarten and Quistorp, Friedrich's intellectual mentors, had gone over to the French side. They were both rewarded with key positions at the university, where they altered the curriculum to conform with French and, specifically, Bonapartist ideology. "It was a time of storm," declared Arndt, whose personal suffering was caused

chiefly from the indifference and foreign sympathies of many who I ought to have held in honor from early recollections and family ties. Kosegarten had become a professor in Greifswald. He and my father-in-law Quistorp, and his brother, Quistorp the painter, were so spellbound by the magic of Napoleon and the French, and by the idolization of their so-called liberal ideas, that our old hearty intercourse was completely disrupted, our opinions were wholly divided, and we took entirely different views.[59]

Arndt, however, made it appear as if Kosegarten had been momentarily taken in by the French and their promises of political and social reform. In fact, Kosegarten's progressive politics had always been more practical than those of Arndt. Kosegarten despised the selfish princes who ruled autocratically over the German territories and had no sympathy for the exploiting Junker caste. He shared Arndt's loathing for Rügen's serfdom, but while Arndt was content to write about the problem, Kosegarten used his position as a pastor in Altenkirchen to organize the peasantry and help defend them against the outrages of their feudal landlords.[60] His suspicion, moreover, of the German

princes who promoted nationalism in return for constitutional reform prevented him from throwing in with the aristocracy, and he did not suffer the disillusionment of Arndt and Friedrich after 1815. Judging that nothing short of abolition of the entire political system would put an end to social injustice, Kosegarten accepted Napoleon as a godsend and was delighted to swear an oath of loyalty to the French regime.[61]

Kosegarten began lecturing at the university in October 1808, around the time Friedrich was finishing the Tetschen altar. He taught modern European history and Greek literature and shared with Quistorp the duties of administration. The university now offered a course in the *Code Napoléon*, taught in both French and German. In the main window of the new rector's office, a sign proclaimed: "Napoleonti Heracli Musagetae," "Napoleon as the Hercules of the Muses," signifying the emperor's cultural contribution to the revamped curriculum.

The climax of German liberal support for Bonaparte occurred on his birthday on 15 August 1809: a major festival was organized, and in the evening the university was brilliantly illuminated. Kosegarten was called upon to deliver the keynote address to the faculty and students on "Napoleon Day."[62] His stirring talk was published as a brochure entitled *Rede am Napoleonstage des Jahres 1809* (Address on Napoleon's Day 1809) and went through numerous editions by the French-influenced press.[63] Kosegarten's rather long-winded speech began as a kind of dithyramb in honor of Napoleon, but astutely ended on a note of hope for a united fatherland inspired by the model of past German heroes, reminding the emperor to keep in mind the particular genius of the German peoples.

Kosegarten tried to separate Napoleon from party and faction, claiming that he embodied "holy truth and justice." Napoleon delivered Pomerania from a corrupt and autocratic political system and incarnated the liberal spirit of all ranks. Kosegarten spoke of his disenchantment with the later stages of the French Revolution, and how his hopes had revived temporarily with the Directory, which threw its weight behind middle-class business and industry. But France had its *Wiedergeburt* only with 18 *brumaire*, when Napoleon was called by God to become the "instrument of the World Spirit" and shape "the age anew." Thanks to Napoleon, Germany had been stabilized by "natural boundaries and a natural constitution, by its own sky and earth, by its mountains, streams and woods, by its

language, and above all, by the indelible national stamp of its children."

Kosegarten stressed Napoleon's role in sweeping away the old decaying social structures in order to build the new social order. The horrible conditions under which German people had labored and suffered justified the exceptional actions of Napoleon. Although he could hardly be unmoved by the victims of the nations he had touched, he had to unhesitatingly follow out his promptings and resist his fears. In short, Napoleon stood on a pinnacle outside of his time. All geniuses have to serve a higher end, which each day brings them closer to knowledge of the Divine. The higher destiny that often eludes mortals is glimpsed by the genius.

Napoleon had been a force for unification. Instead of absorbing the conquered nations into an extension of his own land like the majority of despots, he had reinforced their self-confidence and identity. Wherever he ruled the chains of the people fell, feudalism was eliminated, privileges disappeared, intolerable burdens had been lifted, laws improved and simplified, and national education expanded.[64]

Kosegarten joked that it was unfortunate that Napoleon was not born a German, but in actuality genius transcended national boundaries! Kosegarten prayed that Bonaparte would exchange his laurels for the olive branch so that his name "might not only be admired but loved as well." He should allow the German people free speech and free expression, and he must bear in mind the greatness of Germany—the homeland of Hermann, Wittekind, Luther, Hutten, Dürer, Kepler, Leibniz, Kant, Klopstock, and Herder as well as a host of others whose genius, like that of the emperor's, belongs to the whole of humanity.[65]

Kosegarten's conclusion was zealously nationalistic. Each German had the obligation to maintain the inherent characteristics of the "unshakable love of order and the deep-rooted regard for that which is true, right, and holy!" The German language, which was pure and clear and strong, tender, warmhearted, and emotionally moving, must be treasured and protected like a Palladium of German independence. The hearty German song of Luther, Opitz, Haller, Kleist, and Klopstock must be held up above the beguiling melodies of foreign countries. The German adult should inspire the young with a seriousness more consistent with the German temperament than the lightheartedness and nimble wit of Germany's neighbors. The hearts of all the social classes should be united by one

strong belief, one burning love, one enthusiastic hope, and then surely, the time of regeneration (*Wiedergeburt*) would not be far off.

Friedrich could hardly have read Kosegarten's apologetics without utmost anguish. Even the most neutral citizen in Pomerania had difficulty adopting Kosegarten's optimism in the frightful wake of the French war machine in the occupied territory. By September 1807 the business community had to comply with the imperatives of the Continental blockade and renounce all claims to English merchandise. By November they had to feed, garrison, and entertain a large contingent of troops in Greifswald. The following January the area was required to pay a 3-million-franc war retribution. In March a planned invasion of Sweden led to the requisitioning of most of the ships in Greifswald's harbor. Though the invasion was never accomplished, the ships were not returned. Most outrageously, churches were put to military use: the Marienkirche was used to store hay and straw for the horses, the Jakobkirche became a field kitchen, and the Schwarze Kloster, formerly a Dominican monastery and used by the university as a medical facility, was converted into a military hospital.[66] Memories of the Swedish invasion during the Thirty Years' War were revived when the university's administration building became a barracks for the cavalry, and the Eldena monastery—which figures so often in Friedrich's work, including *Abbey in the Oakwood*—was reduced to ruins by Swedish troops.

Friedrich's response to this would have been consistent with his loathing for Napoleon as the antichrist, an enemy so despicable that Friedrich would not permit his brother to write him as long as he remained in French territory, or refused to visit his family in Greifswald "so long as the enemy stood on his native soil."[67] Like Arndt's, Friedrich's nationalist preoccupations and dreams for an authentic and united Germany required the extirpation of the French enemy. Thus the behavior of Kosegarten, advising hearty collaboration, must have been particularly wounding. The image of the desolate monk encodes this state of abandonment and desertion.

The infusion of religion into the political domain was closely bound up with the influence of pietism on north German cultural life.[68] The intellectual, psychological, and emotional reactions engendered and developed within the religious sphere of pietism came in the course of time to be transferred to the realm of nationalism and nationality.

Fueling this movement was the work of Kant, himself raised and educated in the pietist tradition.[69] His *Kritik der reinen Vernunft* (Critique of pure reason, 1781) caused a crisis among young German intellectuals, including Kosegarten and Kleist.[70] The fact that Kant was later the great German exponent of Rousseau and the French Revolution further complicated his role for the romantics. Friedrich and his circle were all affected by the Kantian revolution and the reaction of the pietistic-evangelical Friedrich Schleiermacher, whose *Reden an die Religion* (Speeches on religion, 1799) aimed at resolving the self-contradictory state of mind of Kant's disciples and demonstrated the indispensability of religion for complete human beings.[71] He preached that a fundamental impulse of the mind is to wish to surrender itself to the Infinite and feel at one with the universe. True religion is a sense and feeling for the Infinite. This is not a hardship; the aim of all religion is to love the *Weltgeist* (World Spirit) and to joyfully regard its operations in the actual world. Both Kosegarten and Schleiermacher—who preached in Pomerania during the years 1802–1804—shared these principles and as a result were often accused of harboring pantheistic beliefs.[72]

For Schleiermacher the process of achieving this sense of unity is a social one; we intuit it in fellowship with others who have been freed from dependence on their own transient selves. We feel a special affinity to those whose actions have guided us through our own self-dependence and made us aware of our life in the Whole. In this way self-love is submerged in sympathy with others, and the individual becomes a compendium of humanity. There are moments when, despite all distinctions of gender, culture, or environment, we think, feel, and act as if we were really this or that person. It is in pious communion with the whole of humanity that "we become conscious that our Ego vanishes, not only into smallness and insignificance, but into one-sidedness, insufficiency and nothingness."[73]

Under French domination this feeling of dependence that Schleiermacher stressed as most characteristic of Christianity, the feeling of the utter helplessness and isolation of those without God, became a feeling of dependence that an individual possessed as a member of a nationality. From 1806 to 1813 in a long series of patriotic sermons Schleiermacher linked the idea of nationality with Christian morality and doctrine, denouncing cosmopolitanism and declaring that Christianity commands attachment to the nation.[74] The person who lacks the anchor of the na-

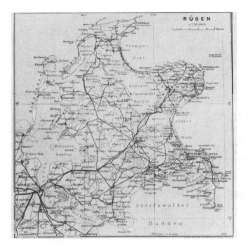

9.54 Map of Rügen.

9.55 Photograph of Arkona.

tional idea and the love of the fatherland is not only little worthy of respect but is condemned to roam the world as a lost soul. The confounding of religion and nationalism made it inevitable that the search for God was also the search or yearning for the fatherland, as one of the characters in the dialogue of Arnim and Brentano says of Friedrich's *Monk by the Sea*. The unity of the one with others and thence with the whole stands for the nation under God; the unity with the Infinite is the metaphor for love of the fatherland. Hence the disruption of the relations between Kosegarten and Friedrich signals a disunity in the fatherland, embodied as a religious crisis in the symbol of the disoriented monk.[75]

Friedrich's disaffiliation with Kosegarten had begun before Jena and Auerstädt, when Friedrich had declined the commission for Kosegarten's new chapel at Vitte.[76] The two men had most likely quarreled over politics. Friedrich's strong anti-French position would have put him on a collision course with his mentor, culminating in Kosegarten's acceptance of a leadership role in the French program of the university. While the Tetschen altar has been rightfully cited as Friedrich's response to the chapel project, it is the *Monk by the Sea* which embodies the torment of Friedrich's relationship with Kosegarten during the years of the Napoleonic occupation. Indeed, I wish to argue that the monk persona is derived from Kosegarten, who preached out-of-doors in summer and sought divine inspiration on the coasts of Rügen. Any reference, metaphoric or otherwise, to a spiritual hermit on the island would have immediately conjured up the poet-pastor. Like Wackenroder and Tieck, Kosegarten wrote eloquently and sympathetically of anchorites in his *Legenden,* for him the highest type produced by nascent Catholicism.[77]

We have seen that Friedrich's contemporaries associated the scene with Rügen and Kosegarten. This is because the precise locale is the headland of Arkona, towering 151 feet above the Baltic Sea and the northernmost point of Rügen. Arkona swings outward to the east, and it is literally the end of the world for the islanders (figs. 9.54–55). Originally Friedrich intended to show in the sky both the Morning Star and the waning crescent moon, a combination only visible in the predawn eastern sky. Arkona was the site of Kosegarten's outdoor services for the fishermen and their families working in nearby Vitte during the late summer herring season. The stillness and solitude of nature had

FORCE 5

a profound impact on the congregation, reinforced by the infinite expanse of sea and sky before them.[78]

The friar in Friedrich's picture stands on a headland projecting beyond the line of the coast—not on the shore as is often assumed, since there are no breakers spilling over the rocky foreground and the whitecaps in the distance indicate a fresh breeze. The action of the waves accords closely with number 5 on the Beaufort wind scale (the standard classification for wind speeds), indicating a breeze of approximately nineteen to twenty-four miles per hour (fig. 9.56). The effect of this wind action is seen also on the top layer of the fogbank, which has the typical "shredded" appearance of the fractostratus cloud (fig. 9.57).[79] The foreground is clearly elevated above the shore; the landscape is viewed from a point high enough to subordinate everything to the horizon, which enabled Friedrich to eliminate almost the entire foreground. The monk is thus situated on the headland portrayed by Friedrich in his many views of Arkona seen from the beach of Vitte where Kosegarten built his chapel. The sun is rising in the northeast, setting the scene in the summer in this region. It coincides with the herring season, and this may explain the fishing boats Friedrich originally intended to paint in the distance. Identification with the fishing industry is apparent in an earlier, roughly analogous work, but which contains the comforting guideposts of traditional landscape and a more prosaic effect of

9.57 Photograph of early morning fracto-
stratus clouds over the Pacific Palisades, Califor-
nia. Photo by Stanley Gedzelman.

light (fig. 9.58). *Seashore with Fisherman* shows a lone figure
gazing at a vast expanse of sea and sky—but he is one ca-
pable of negotiating with the world in the Fichtean sense;
he does not contemplate it so much as perceives his situa-
tion as a task that must be overcome. The picture conveys
none of the terror of the later work, but the view of a nar-
row foreground strip as a threshold between the fisherman
and his activity may be seen as a preparatory stage in the
development of *Monk by the Sea*.

Both Friedrich—a chronic depressive—and Kosegarten
looked for peace of mind among the rocks of the Stubben-
kammer and Arkona.[80] Friedrich's friends frequently com-
mented upon his melancholia, often in connection with his
family history, and he himself openly admitted it.[81] Kose-

9.58 Caspar David Friedrich, *Seashore with
Fisherman*, c. 1807. Kunsthistorisches Museum,
Vienna.

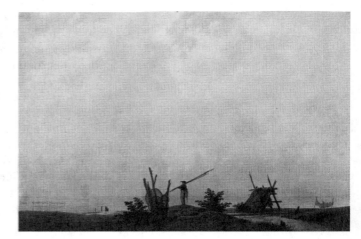

garten sought spiritual exaltation on Arkona in spare moments and in communion with his flock. For eight successive Sundays, during the summer herring season, the minister preached on Arkona to the fishermen, including those assembled in their boats at the foot of the chalk cliff. Most, however, gathered near the ancient mount of the temple of Swantevit, which is often outlined in Friedrich's views of Arkona. Contact with the pagan past stimulated Kosegarten's syncretic expression of Ossianic, pantheistic, and primitive Christian elements. In his *Hymne an die Insel Rügen* (Hymn to the Island of Rügen), Kosegarten cherishes Arkona as consecrated ground that gives special meaning to his preaching: "High stands Swantevit now on the surrounding rampart of Arkona / Looking out over the four corners of the earth." People still came to pray, to bring gifts and sacrifices to the priest, to receive consolation. Lamenting the destruction of the ancient temple and the loss of the island's previous glory, Kosegarten noted that the pilgrim still visited it with sacred devotion, constantly referring to the wide vista which reached to the heavens: "Island, suckled at the breast of the sea and the earth and the heavens!" In the final stanzas of *Stubnitz und Stubbenkammer* he rose to a pitch of patriotic frenzy, glorifying the fatherland symbolized by the "eternal, loftier Königsstuhl," and bending head and knee before "Germany's splendor!" "Full like the sea is Germany's power, / And which is consolation, like this coastal wall, / For fate and time."[82]

Kosegarten's idyllic *Jukunde*, first published in Schiller's annual *Musenalmanach* in 1797, gives many autobiographical details about his outdoor preaching. As in his other poems about Rügen, many passages refer to the association of the water's edge with spiritual awakening: "Still waiting for the father, deeply involved with scriptural studies, with the duty / To preach twice tomorrow; first in the church, / Next outside on the seashore. So time-honored custom will have it." Passages like "the father stands on the precipitous peak, gazing downward with wonder into the gloomy waters of the roaring sea," instantly recall Friedrich. But it is especially in the third eclogue that he poeticizes his experiences on Arkona, rhapsodizing on "the infinite [*unendliche*] fullness of the sea," the assembly of his congregation praying before "the countenance of sea and heaven." And finally "All around the beholders lay, so far as vision could extend, / Open, exposed, endless, the boundless [*unermessliche*] universe."[83] Kosegarten claimed that

"the vast boundlessness" of the surrounding scene heightened the devotional character of his outdoor services even without the sermon and the solemn chanting of the congregation.[84]

The closest juncture of Kosegarten and Friedrich is found in Kosegarten's remarkable autobiographical poem, *Arkona*.[85] The poet-pastor watches the sun set as he walks along the winding beach near Vitte; the wind is calm, seagulls and swans cavort in the waves, and a seal sunbathes on a "granite bed." Mounting the path leading to the top of the chalk cliff, he dreams of the ancient civilization in old Rugia with its center at Arkona. He climbs the rough jagged rocks of the ancient mound, stepping with "daring foot on to the holy mountain's nape, / And gazed far over land and sea into the Boundless, into the Immeasurable" ("Und schaute schrankenlos fern über Land und See / Ins Unermessliche").

At the sight of the limitless space he experiences a sudden release of pressure, and in a striking verse that anticipated Kleist's insight that "one feels as if one's eyelids had been cut away," Kosegarten utters, "The blindfold and hood roll away from the eyes." The sun has almost sunk below the horizon, and the moment of this release coincides with his sensing of the overwhelming presence of the Divine Being. He can now forego the endless philosophical divagations and conceptualizations that had previously driven him into cycles of hope and despair; even if no syllogism could solve the problem of God's existence, no amount of sophistry could alter his faith: "I believe that you are!" The Harmony of the Sphere bears witness to God's existence, the heaven declares it to the earth, the earth to the seas, the seas to the island. The thunderstorms, rushing cataracts, and exploding volcanoes whose mouths expel molten rock, the oak tree and the moss, the lotus plant, the grain of sand and Mont Blanc all testify to the existence of the Supreme Being. The universe is the Divine Mind thinking itself, the expression of the Absolute Ego, who knows no opposing force or "boundary" (*Schranke*).

At this point, the poet-narrator experiences liberation:

"I shall, I can, I will! The shackles are broken!
Divine Law of duty you have set me free!
Necessity, your slave, shakes your fetters off
And looks upon you as a spirit, a hero and a god!"

Kant's *Kritik der reinen Vernunft* argues that humans as moral beings are capable of acting in defiance of the laws of

necessity. Regardless of the outcome of moral decisions, we are capable of choosing to act in accordance with universally valid moral laws, which reason prescribes to our will. These moral laws—Kant's categorical imperatives—free us from the shackles of the phenomenal world and the space-time limitations inherent in the human mind. Though there can be no guarantee that the moral laws we adopt have noumenal universality, to act in this way helps free us through self-determination. Kosegarten's momentary flush of liberation with his self-directed imperatives closely follows upon his understanding of Kant.

But suddenly the mood of the landscape drastically alters. The sun has now completely disappeared, and "hanging low over the black waves and the dune's snow is a mourning veil, / Creation became sublimely quiet like a grave." In the distance a storm awakens and the waves begin to roar; lightning flashes in the south and west, and thunder rumbles. The heavy air resounds through the hollows of the coastal ramparts and Jasmund's vast shore. "And tearing like an arrow shot by an oaken bow / The weather came flying like the Last Judgment." The waves began to pound the shore, and devastation hurled down on the nearby countryside. A sleepy little village is reduced to ashes and despair; the hail destroys the newly planted seed, a dismasted ship crashes on the rock. Above the loud thunder rises the scream of terror and the mourning of hopelessness. The poet-narrator is seized with shuddering fear, and the whirling wind of doubt shakes his newly gained confidence. Scornfully he scans the heavens for the throne of the thunder-maker which flashed with lightning, and shouts defiantly, "Thor, where is your god now? / Where is the holiness, the Divine One, the Just one!"

The poet surveys the wreckage of the storm; the flaming thatched roof of a villager, the helpless shipwrecked victim moaning from the threshing of the waves, the wailing infants, the frenzied inhabitants. Were their cries of pain sublime psalmody to the creator? Now his previous belief is shattered. The creator, the tyrant is simply iron fate determining everything by rigid law. Crushed and bruised by a "dragon's tail, / Eaten away by the larvae and snarled at by the Furies," the poet-narrator collapses to the ground, where he lies senseless; the hailstones beat down upon his body. The very rocks that support "the doubter" tremble like an earthquake. After "two dark hours" the shafts of lightning and the stock of hailstones are depleted, and the thunder dies down. A soft rustling runs through the re-

freshed air, and from the calmed fields arises the fragrance of sacrifice. He staggers to his feet to behold the curtain of the other world parted and revealing all its glories. "There stood in festive splendor / The Holiest of Holiest. Thus stood in sublime magnificence the infinite starry night."

The poet now contemplates the unfathomable distances of the heavens, the unending stream of suns, moons, and planets. He identifies the stars and even assigns to them a color: Regulus, Spica (which he calls by the Arabic *Azimech*), and the Urn in the constellation of Aquarius (which he calls *Guss,* or "Fountain"), and in almost Blakean terms envisions worlds rolling unendlessly to other worlds, suns rushing to other suns. He foresees the blessed abundance of life, its happiness, its joys, and undergoes yet another mental and spiritual transformation, more in line with *Naturphilosophie.* He sees in nature the signs of God's eternal presence and feels at one with the universe, snuggled in the arms of the Father together with the angels, the worms, and the gnats. Dawn now breaks over Arkona as the poet descends:

Strengthened I climbed down from the Mountain of Tribulation
 [*Prüfungshügel*].
In the east the morning's saffron wings were already flying.
. .
Nature stood in glittering bridal garments,
The sea in amethyst, the field an emerald.
On the beach strewn with ruins, amidst the wreckage of the
 burnt huts,
I appeared as a savior among the impoverished ones.
I filled their cup with the virgin honey of pity,
And went home consoled!

While Kosegarten's vertiginous bout with exaltation and depression culminates with a "whimper" instead of a "bang," his mental and spiritual conflicts on Arkona conjure up imagery strikingly parallel to Friedrich's *Monk by the Sea*. The clash between darkness and light in the painting corresponds to the alterations in weather and mood of the poem. Indeed, in the first version Friedrich planned to include two storm-tossed boats heading for shore but keeling over from the force of the wind and waves. As in the poem, the monk protagonist has wrestled with his thoughts until daybreak.

Kosegarten not only supplied the literary source for the picture, but also its fundamental reason for being. *Monk by the Sea* owes its originality and power to the artist's capacity

to express his personal sense of alienation and displacement. The work may have begun with the more conventional theme of the spiritual wonders of the universe, but with the disclosures of his mentor's wholehearted support of Napoleonic policy, it evolved into a scene of menacing vastness and bleakness. The agonizing rift between him and his mentor pointed to the larger political and social divisions in the German territories during the French occupation. Thus for Friedrich's supporters and patrons the work functioned cathartically for their frustration and bitterness. The disorientation of the monk is a sign of Friedrich's shaken faith and of Kosegarten's betrayal of his assigned spiritual function. It catches the sense of utter hopelessness Friedrich felt in the wake of Kosegarten's defection and the seeming invincibility of Napoleon.

The fusion of Friedrich and his ex-friend Kosegarten into a single persona (in this case, the Capuchin friar) is not uncommon in clinical psychiatry. Freud demonstrated that "mourning and melancholia" are closely related, typifying the reaction to the loss of a loved person or to the loss of some abstract ideal that has taken the place of one, such as the fatherland or liberty.[86] While in clinical melancholia the loved object has not died but has become lost as the object of love, it shares with mourning a profoundly painful dejection and chronic passivity. It is distinguished from mourning by a lowering of self-esteem that often assumes the form of self-reproach. In fact, the self-reproaches are reproaches against the lost object, which has been shifted on to the patient's own ego. In this way the sense of loss becomes transformed into a cleavage between the criticizing faculty of the ego and the ego as altered by the identification. Friedrich has been abandoned by Kosegarten like a deserted lover; his monk image exposes his pain of desolation and at the same time unites Friedrich to the source of this pain. Suffering from profound depression and psychosomatic illness during this period, Friedrich responded to an internal psychic collapse by merging his personality with the attributes of his friend who has abandoned him. Tragedy then struck Friedrich again on 9 November 1809—a scant three months after Kosegarten's address on Napoleon's Day—when his father died. Friedrich was suddenly without father, surrogate father, and fatherland. This catastrophic conjunction of events would have brought to the surface his childhood traumas centering on the losses of mother and brother, the memory of which impelled him

frequently to seek solace amid the forlorn rocks of Rügen. Friedrich's attempt at gaining "wholeness" in the face of overwhelming disruption resulted in the peculiar configuration of *Monk by the Sea*.

Kleist's response to the work was predicated on an analogous psychic state. He actually wrote several patriotic poems in 1809 which express his pain over his ineffectiveness in goading Prussian leaders to action.[87] The most intense is *Germania an ihre Kinder*. As mother of many German peoples, Germania calls upon her offspring to rush to arms, to leave their huts and every pursuit to rush over the foe like a boundless sea. They are to avenge the countless wounds dealt by the haughty, scornful enemy, to whiten the land with their bones, to dam the Rhine with their corpses, and to rid the country of the French in savage carnage.

This cry of desperation, masking Kleist's sense of impotence, is clarified by another poem of the period, "An den Erzherzog Karl" (To the archduke Karl of Austria); helplessly standing on the edge of an abyss (the word *Abgrund* also means "precipice"), the German does not demand victory but at least a struggle, which, glaring up like a torch, may make him worthy of his grave. The tragic inability of Kleist and his fellow patriots like Friedrich to stir their frightened rulers to action and to unite all Germans in a war of liberation is voiced in *Das letzte Lied* (The last song). Here an Ossian-like minstrel on a rocky promontory (*Feldrisse*) "far off on the horizon," who has vainly sung of the joy of fighting for one's fatherland, is overcome with depression as his song dies away unheard and unheeded. Ending his chant, he desires to die with the ebbing notes, and with tears streaming down his cheeks he lays down his lyre for the last time. That Kleist explicitly identified with the minstrel is seen in his dedicatory distich at the head of the manuscript for *Hermannsschlacht,* which agonizingly confesses to his despair in not being permitted to sing of the glory of his country.

Also in 1809 Kleist tried to publish a patriotic journal entitled *Germania,* which never saw the light of day. The prefatory statement proclaims the journal as the voice of the hopes and miseries of brave Germans which have remained suppressed during the three years of French occupation. Kleist's pent-up rage and frustration is expressed in the *Hermannsschlacht;* Hermann, in order to arouse hatred of the invader, spreads exaggerated rumors of atrocities committed by Roman legions. He sends out troops dis-

guised as Romans who follow behind Varus, pillaging and destroying life and property. At his command, the body of Hally, a girl raped by the Romans, is cut into fifteen pieces, each of which is sent to one of the German tribes to incite them to revolt. Kleist's violent metaphor for the look of Friedrich's landscape (*weggeschnitten*) is a symptom of his own bottled-up rage and despair verging on self-destruction. With his plans and projects blocked by the French, he entered into a suicide pact with a close friend one year after his review. He was not as fortunate as Friedrich, who lived to see the enemy expelled.

Abbey in the Oakwood

Abbey in the Oakwood, also painted in the years 1809–1810, represents a terrifying climax to the narrative of its companion piece (fig. 9.59).[88] Like a scene from a horror movie, it brings to bear on the subject all the Gothic clichés of the late eighteenth and early nineteenth centuries. A procession of monks, dwarfed by the scale of the background, bears a coffin through the portal of a Gothic ruin. The train moves past an open grave towards a crucifix on the other side of the portal which frames it. Presumably, they intend to conduct a service in front of the crucifix before burying the deceased. A mist shrouding the background slowly rises in the late evening glow after sunset. A waxing crescent moon and the light of the *Doppellampe*—the two torches flanking the crucifix—add to the eerie mood of the wintry scene. The snow-covered ground provides a contrasting field for the dark grave markers in the surrounding

9.59 Caspar David Friedrich, *Abbey in the Oakwood,* 1809. Verwaltung der Staatl. Schlösser und Gärten, Schloss Charlottenburg, Berlin.

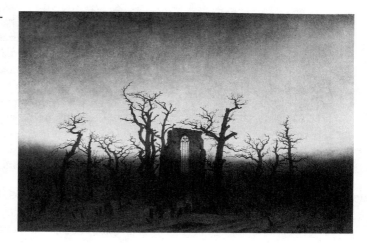

cemetery. The row of oak trees, with their bare, twisting branches, provide a ghostly complement to the Gothic ruins and the funereal motif.

It is a spine-tingling presentation of death and decay. Its blank despondency could have meaning only in terms of the historical moment, the sense of utter hopelessness Friedrich felt in the wake of Kosegarten's defection and the seeming invincibility of the French. The barren oaks do not symbolize past German greatness, but refer to the spoliation of the national goods. They stand in the same relation to the fatherland as the Gothic ruins, themselves a product of a defeated people. Friedrich modeled these ruins on the remnants of the Cistercian monastery at Eldena near Greifswald, which the artist used for several other works. The Eldena monastery was actually reduced to ruins by the invading Swedish troops during the Thirty Years' War. The devastation of that conflict was still part of the living memory of most north Germans: Friedrich's own father was a descendant of an old Silesian family who had been forced to flee their lands during the Thirty Years' War. His use of the motif in *Abbey in the Oakwood* refers explicitly to the churches in Greifswald that were transformed into military facilities by the French. The Marienkirche, the Jakobkirche, and the Schwarze Kloster were all converted for military use. These actions immediately raised comparisons with the analogous conduct of the Swedish invasion. The bleak pendant of *Monk* focuses on a symbol of foreign devastation and religious conflict, and the funeral procession moving through the portal of the ravaged monastery in the later painting sustains the mood of finality and dejection.

As the companion piece to *Monk,* the work has to be interpreted as the funeral procession of the bewildered friar on Arkona. Kosegarten's renegade action meant the death of a friendship and a blow to the nation. Whereas Kosegarten himself poeticized the oak and *Hünengrab* as heroic reminders of the past, Freidrich used these symbolic motifs as negative metaphors of Germany's defeat and betrayal. Friedrich's own despondency is projected onto his former friend, who serves as an alter ego. Hence *Abbey in the Oakwood* is in a sense a double funeral for Kosegarten and Friedrich, signifying the burial of Germany's hopes for resurrection.

The bitter pessimism of the work was perceived by his contemporaries, including Friedrich's young friend, Theodor Körner. Deeply moved by the two paintings, Körner

wrote a pair of sonnets based on *Abbey in the Oakwood*, entitled *Friedrichs Totenlandschaft* (Friedrich's landscape of death). Soon to distinguish himself as the lyric poet of the Wars of Liberation, Körner's own gloom is mirrored in the first sonnet:

The earth is silent with deep, deep grief,
Enveloped by the faint ghostly exhalations of the night.
Hark now the storm rustles through the old oak trees,
And howling rushes through the ruined walls!

Upon the graves lies, as if it wants to last forever,
A deep snow, silently united with the earth.
And a sinister fog, that enshrouds the night with gloom,
Embraces the world with cold shudders of death.[89]

While the second sonnet shifts to a brighter key, the allusions are no longer to the picture. Körner suggests that "those are companions in salvation / Who trudge through the grave to eternal light." But his last lines give the game away: he demands of himself to stop dispassionately questioning what he sees, and to "trust the dictates" of his own heart, which wants to see the painter "led gloriously to the most beautiful goal / The sweet, holy favor of the gracious muses." This is in such violent contradiction to his first sonnet—clearly manifesting his immediate response—that it can be discounted as an attempt to shake off the depressing effect of Friedrich's work.

Although Körner, like all his contemporaries, ordinarily used the oak metaphor as a positive symbol of German steadfastness and heroism, in *Die Eichen* (Oak trees) of the same year he exploited it in a manner similar to Friedrich's imagery in *Abbey:*

Lovely image of old German trustworthiness,
When it looked out on better times,
When with joyful, bold, deathly sacrifice
Citizens built solidly their nations.
Oh, what good does it do to revive this pain?
Everyone is familiar with this pain!
German people, you most glorious of all,
Your oak trees stand, you have fallen!

By 1810 Napoleon was securely in control of the German territories with nearly 500,000 troops. Austria had signed a peace treaty with France in October 1809, Friedrich Wilhelm III dismissed Scharnhorst under orders from Napoleon, the French emperor threatened to seize Silesia, the whole northwest coast of Germany (including Ham-

burg and Lübeck) was annexed to France, and throughout the German territories the Continental blockade stifled commerce. That the Prussian king bought both the *Monk* and its companion piece in 1810 meant more than mere recognition of Friedrich's originality: they clearly gave shape to the king's troubled state of mind, their mournful scenes offering a cathartic release.

A Bow of Promise

One faint glimmer of light broke through the clouds for Friedrich that year: in January the Swedish envoy signed a treaty with France, accepting the adoption of the Continental system by his government, and in return Napoleon restored to Sweden Pomerania and the island of Rügen. In the spring Arndt returned to his post at the University of Greifswald. While the area was still occupied by French troops, and a large number of the faculty and students had become ardently Francophile, Arndt managed to form a club for the training of youths in his patriotic German principles. This project rekindled Arndt's hopes for the ultimate triumph of an independent and united Germany, a feeling seconded by the founding of the University of Berlin in the fall of 1810, which everyone felt would produce a patriotic pro-Prussian generation. Friedrich produced in this period two landscapes with rainbows—both part of a package of five works purchased by Herzog Karl August von Sachsen-Weimar on the recommendation of Goethe.

9.60 Caspar David Friedrich, *Landscape with a Rainbow,* c. 1810. Formerly Kunstsammlungen, Weimar; stolen in 1945.

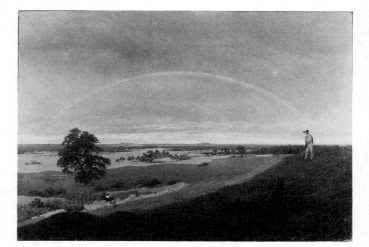

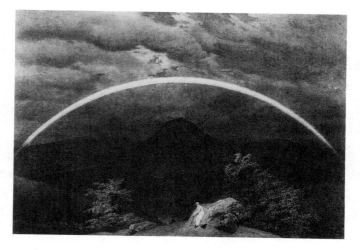

Landscape with a Rainbow is based on a motif taken from the island of Rügen (fig. 9.60). It depicts the lone figure of a shepherd standing on a hill overlooking the Baltic Sea, while the rainbow unites him with the object of his distant view. In striking contrast to the *Monk* and *Abbey* conceived in the previous year, the light is cheerful, the scene peaceful and serene, an oak tree flourishes in the meadow below, and the rainbow links the protagonist affirmatively with the source of his longing in the heavens. The theme was derived from a poem by Goethe, the *Schäfers Klagelied* (Shepherd's lament) of 1802. While the poem singles out the rainbow as a symbol of joy and consolation, it is seen primarily as a source for nostalgia for the shepherd who dreams of his distant lover:

High over yonder dwelling,
There rises a rainbow gay;
But she from home hath departed,
And wander'd far, far away.

Friedrich took Goethe's fleeting motif of the rainbow and made it dominant in his picture. The link between earth and heaven, God and his creation, it redeems the suffering and self-torment manifested in *Monk by the Sea*.

A second landscape with the rainbow motif has a more lugubrious atmosphere; the sky is dark, and a lone wanderer in the foreground gazes out over a valley enveloped in mist (fig. 9.61). One the far side of the valley rises the silhouette of a mountain over which the rainbow springs. It is possible that the picture was originally planned as a night scene with the moon partially concealed by the

clouds; the rainbow itself appears as an afterthought, painted thinly over the clouds after the rest of the work had been finished. Here again the lone figure seen from behind is a surrogate for the artist. The picture is almost bilaterally symmetrical, with the figure, the mountain peak, and the rainbow arch on a line. The arc of the rainbow accents the peak of the mountain, the metaphor for the source of all blessings.

Friedrich's rainbow motifs also tapped a growing scientific interest in optics and color theory. The Herzog, Karl August, who purchased the two pictures, was disposed towards science in general and had chosen Goethe as a general cultural, scientific, and political adviser for his duchy. Goethe was soon involved in botanical, geological, and optical studies, publishing two pamphlets on optics in 1790–1792. He also began his feverish study of color, which lasted through the first decade of the nineteenth century. During this decade, there was a significant body of data published on the nature of haloes, auroras, and rainbows, as is evident from the articles in *Annalen der Physik*. (The journal also published Luke Howard's cloud classifications in 1815 that profoundly impressed Goethe: indeed, Goethe would try to commission Friedrich in 1816 to execute a series of cloud studies, and although Friedrich refused, the event points to the cross-cultural currents in science affecting landscape painting throughout Europe.) In 1810 Runge and Goethe, both of whom rejected Newtonian theory, came out with publications on color. While these may have come too late to have influenced Friedrich's pictures, he would have been long familiar with their theories through his direct contact with them.

Goethe attempted to refute Newton's analysis of light into different wavelengths, preferring the classical notion that color properties were localized and made visible by the effect of light falling on them and interpreted subjectively by the viewer. He hated the idea of the spectrum as a cold, calculating concept and claimed that light is one and indivisible. Only the rainbow gave him trouble because it seemed to justify Newton's spectrum. There in the sky was a play of colors that looked remarkably like the detested spectrum. For Goethe it was the most complex problem of refraction, complicated by the reflection in the rain drops. But his own experiments came up with a rainbow with a dominant yellow band bordered by violet and blue, the same color combination found in the rainbows of Friedrich. It is probable that Goethe recommended the purchase

of the rainbow works as evidence in support of his own theory.

Both the Herzog and Goethe promoted the scientific investigations of the faculty at the University of Jena. Goethe had recommended Schelling's disciple Oken for the Jena faculty, admiring both his organic approach to science and his assertion of German scientific thought over that of the Newtonian-inspired French. Oken soon became the center of a developing anti-French movement at Jena, mixing his science with his politics. In 1808 he published his *Erste Ideen zur Theorie des Lichts, des Finsterniss, der Farben, und der Wärme* (First ideas on a theory of light, darkness, colors, and heat), which extended Goethe's assault upon the mechanistic tradition of Newtonian science. He even sought to refute Newtonian optics by attributing some of Newton's ideas to Johannes Kepler, the great German astronomer. Like Goethe, Oken saw the rainbow as the result of polarities that occurred because of the conflict between light and darkness, and this tension between the two accounted for the various colors. Hence Friedrich's bizarre nighttime rainbow corresponds to the anti-Newtonian theories of Oken and Goethe, making it a political as well as religious confession of faith.

During the next year, Friedrich returned to his mountain motifs, which were inspired by a walking tour in the Riesengebirge with the painter Georg Friedrich Kersting in July 1810. The two friends climbed the various peaks, including the Schneekoppe, and made sketches from the rocky summits. One of the works that emerged is the *Morning in the Riesengebirge,* a scene viewed from the summit of a granite

9.62 Caspar David Friedrich, *Morning in the Riesengebirge,* 1810. Verwaltung der Staatl. Schlosser und Garten, Schloss Charlottenburg, Berlin.

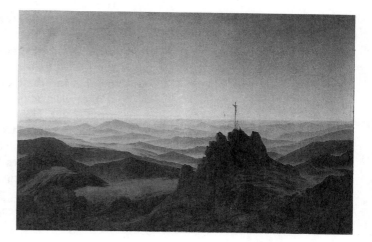

cliff on which stands a crucifix (fig. 9.62). A female figure has reached the foot of the cross and helps pull up her male companion—Friedrich himself.[90] From their location can be seen a seemingly unlimited vista of cloud-enveloped peaks carrying the eye to the far left where the rising sun provides a second focal point on the horizon. Most likely it is the panorama from what was called Rübezahls Kanzel (Rübezahl's pulpit), a granite rock close behind the Schnee-gruben-Baude that afforded a spectacular view eastward towards Silesia.

The peaks in the distance are actually higher than the peak on which the crucifix stands, so that the upward diagonal—although not rising dramatically—is still felt as part of the visual experience. This is reinforced by the lofty crucifix, which breaks through the visible horizon into the heavenly void and represents the goal of the climbers. The eye follows their upward striving towards the cross, while being carried along another route to the celestial realm via nature's guideposts. The light of the rising sun (the vanishing point of the composition) sheds its warm, luminous rays on the cross, the two figures, and the tips of the granite rocks.

Once again Friedrich attempts to reconcile orthodoxy with *Naturphilosophie*. The sight of the mist-covered crests reminded him of waves in the sea, and he captured this vision in the picture where the combination of cloudy wreaths and rocky pinnacles resembles the surface of an ocean. The work may be seen as a metaphorical representation of Werner's primordial chemical soup, out of which the primitive granitic rocks crystallized and which, subsequently through the action of the sun on the water, gave rise to the first life forms. As Oken succinctly phrased it, "The sea beholds the sun and comes alive." The presence of the clouds further recall the role of mountains in the natural water cycle: geognostical theory argued that water vapor in the form of clouds was attracted by the colder and denser heights and there divested of its vaporous form by the action of electricity and returned to the earth in the form of fresh water. Hence the idea of renewal in Friedrich's work is characterized through the religious symbolism, Wernerian theory, and the cyclical action of nature. *Morning in the Riesengebirge* states the claim for Germany's resurrection through its spiritual identification with the Absolute and scientific genius.

The white-robed female assisting Friedrich is not simply an allegory of faith and of hope, but a tribute to the late-

lamented Queen Luise of Prussia. Luise had been the most popular queen in the history of the Prussian state, most affectionately known as the *Landesmutter* (first mother of the land). She died the very month Friedrich made his walking tour in the Riesengebirge, and it is certain that he—along with most patriotic Prussians—mourned her loss as for the mother of her country. Luise actually came from the same duchy as both of Friedrich's parents, Mecklenburg-Strelitz, but beyond this Friedrich would have valued her genuine contributions to the regeneration of her country. The queen took an active role in politics and conducted secret meetings with Prussian officers to discuss policy and military plans for the overthrow of the French. She backed Stein's far-reaching social reforms and subsidized the secret organization known as the Patriotenpartei (party of patriots), of which Stein, Blücher, Gneisenau, and Scharnhorst were members and which was dedicated to the expulsion of Napoleon. She supplied the missing backbone of her husband, Friedrich Wilhelm III, and was the center of the national hope at the time of her death.

Luise possessed a deeply religious nature, as seen in a little volume of moral and religious reflections she wrote during the trials of the Prussian state, entitled *Himmlische Erinnerungen* (Heavenly memories). She noted that it was mainly religion that fortified her against "this bronze age"—a dig at Napoleon—and expressed her faith in God's deliverance. The entry for March 1809 states that the suffering and pain that she and her people have undergone have brought her nearer to God, and that she cherishes more than ever her "feelings regarding the immortality of the soul."

Luise's memory inspired those who volunteered in the Wars of Liberation: Körner's ode to the saintly Luise ("Thou saint, hear thy children's prayer") apotheosizes her as the "guardian angel" leading Germans out of darkness into light:

So shall thy picture in our banners wave,
And light our way through the dark night of victory.
Luise, be thou our guardian angel of the German Cause,
Luise, be the watchword of vengeance![91]

It may have gone unnoticed at the time because of the diminutive scale of the figures, but the woman in the picture is blonde and wears the same hair style as did the queen in 1810. No wonder that Friedrich Wilhelm III admired the work and purchased it when it exhibited in Berlin in 1812.

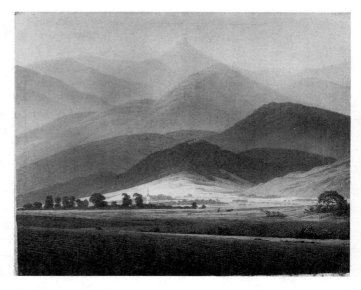

9.63 Caspar David Friedrich, *Landscape in the Riesengebirge,* c. 1810. Pushkin State Museum of Fine Arts, Moscow.

One final mountain scene of the years 1810–1811 is noteworthy as to Friedrich's ideological landscape. This is the *Landscape in the Riesengebirge,* painted from sketches made in the outskirts of the town of Warmbrunn, looking south towards the northern slopes of the mountains (fig. 9.63). Friedrich skillfully directed the gaze from the plowed terrain of the foreground, past the spire of the village church, up the slopes to a castle in the middleground, and thence to the remotest heights, culminating with the Kleine Sturmhaube (4,711 feet). It is the time of the spring planting; a farmer pushes his plough along with the line of the horizon. While the extended vista differs dramatically from the work of Constable, the English landscapist, the stillness and harmony of the scene invites comparison. The plowman's labors move in tandem with the natural cycle, and he is all but lost in the landscape. But unlike Constable, who held fast to property as an affirmation of middle-class achievement, Friedrich made his landscape a hymn of praise to an updated feudal order.

The entire region was the property of the Grafs Schaffgotsch, an ancient noble family of Silesia inhabiting at the time a *Schloss* overlooking Warmbrunn. At one time the family had inhabited the magnificent castle known as Kynast, built into the northern slopes of the Riesengebirge on a granite foundation above the mountain village of Hermsdorf. The ruins of this castle—destroyed by fire in 1675—are seen in Friedrich's picture; the walls still stood, as well as a tower, which offered a spectacular view of the Hirsch-

berg valley towards the north. Unlike his images of El-dena, however, the ruinous condition of the castle is not visible from the distance, and it appears as a symbolic site on the mountaintop. The village church, Kynast, and the crest of the Kleine Sturmhaube are almost all on a line, confirming my earlier observation about the Tetschen altar and its relationship to the Thun-Hohensteins. The secular lord and the spiritual Lord (symbolized by the topmost peak) express their power through their relationship to the land. The temporal domain of Graf Schaffgotsch is mapped out in precise topographical terms, right down to the neat furrows of the terrain. The reverential gaze moves upward to a mist-enveloped realm that seems to sanctify the Graf's vested authority, while the church tower impels the movement heavenward.

It is significant that most of Friedrich's later patrons were members of the aristocracy, the king and crown prince of Prussia, the Erzherzog von Saxe-Weimar, the Thun-Hohensteins, the princes of the House of Wettin, Baron Speck von Sternberg, Prinz Putbus of Rügen, the czar of Russia, and a score of others. Although he loved Germany itself more than its nobles and princes, his metaphorical allusions often require the presence and even intervention of royalty. Like Arndt, his hopes for a reconstructed Germany called for a constitutional regime in which the nobility, princes, and states recognized a common superior to be styled "emperor" or "king," and a *Reichstag*, or parliament, consisting of representatives of the nobility, burghers, and peasants throughout the nation. Friedrich, Arndt, and Steffens could not see beyond immediate class interest; they could not envision a stable society without a hierarchical ranking of the classes.

Nevertheless, their position also called for the elimination of the direct mediative role of the noble in the peasant's relationship to the state, and the conversion of serf into citizen. Again, as Gneisenau wrote, "While an empire perishes in its weakness and disgrace, perhaps a Caesar is following his plough in the most wretched village." They would have agreed with Stein, who felt that peasant freedom and proprietorship were essential ingredients of peasant participation in the national goals. They were less concerned for laissez-faire economics than for a system in which the peasant could be a proprietor.

Friedrich's landscape suggests the potential impact of the Stein-Hardenberg agrarian reforms on the Prussian state. While the relationship of the plowman to the land is uncer-

tain, he is shown as an integral part of the landscape. His work is clearly evident in the foreground, given over symbolically to the farmer, just as the middleground is given to the noble, and the distant heights to God and country. The harmony that informs this scene derives in part from the equilibrium of these three realms, each formed by layers of planes that cut into the picture laterally and intersect one another, building a dynamic composition to the utmost peak. The social classes are set into a larger framework that can almost be diagrammed by these planes. If actual labor is blurred, it is nevertheless shown as part of the fixed plan in which the free peasant has a place. This world does not lead, as in Turner, to the mansion of a landowner who controls parliament; rather, ultimate unity and rule must be located outside the earthly realm until the state can be reorganized.

The mountain peak stands for both the spiritual realm and the ideal state. Friedrich's work embodies the mountain's geological, economical, and cultural associations, which are paralleled in the writings of his contemporaries. The Grafs Schaffgotsch actually leased out some of their mountain property for mining, eventually industrializing their estates, which they found to be more profitable than farming.

Theodor Körner wrote his poem *Kynast* during a trip to the Riesengebirge, a retelling of a tragic mountain tale. Mountain metaphor is prevalent throughout Körner's work. Drawn early to the study of the natural sciences, he went to Freiberg in 1808 and enrolled in Werner's mining academy. He studied geology, mineralogy, and chemistry for two years before deciding to become a playwright and poet, and such works as *Kynast* and *Bergmannsleben* (The miner's life) attest to his lifelong fascination with science and mountain lore. Körner often explored the Riesengebirge, which fascinated him. In 1809 he climbed the Schneekoppe in the company of his fellow playwright Kleist, and their experience upon reaching the summit was recorded in the guest book kept then at the Schneekoppe Lodge (now in the collection of the Graf Schaffgotsche Majoratsbibliothek, Bad Warmbrunn). Körner's entry expresses his exaltation on the peak of what he calls the "Riesenkoppe":

High up on the pinnacle
Of your mountains
I stand, astonished,

Glowingly enraptured,
Holy peak,
Heaven-storming Titan.
.

Blossoming meadows,
Shimmering cities,
Joyous realms of
Three Kings
I look out enraptured
I look out with higher,
Heartfelt joy.

Thus my fatherland's
Frontier I behold
Where I first saw the
Friendly light of day
Where love
Pious yearning
First seized me.

I send you my blessing
Here from the heights,
Gentle homeland!
I send you my blessing,
Land of my dreams!
Circle of my loved ones,
I send you my greetings!

Körner's descriptive imagery expressly associates the transcendental realm with the perspective that alone gives meaning and political unity to the fatherland. It embraces also the circle of his "loved ones," the family hearth to which Schiller owed so much of his support. As in Friedrich's pictures, we move step by step from the family unit to the ideal state and finally to cosmic unity. His unfinished tale, *Eduard und Veronika; oder, die Reise ins Riesengebirge* (Eduard and Veronika; or, The journey into the Riesengebirge), was also written in 1809 and contains precise descriptions of the topography and ruins of Kynast. Specific topographical sites are contrasted with the lofty grandeur of the peaks, moving, as in Tieck's stories, from the secure *Heimat* and *Schloss* to the greater heights. Indeed, the story begins at the entrance to the castle and progresses with Eduard, who is drawn "heavenward" by the rising sun and the magnificent peaks overlooking the citadel of Kynast. On one side is the mining town of Schmiedeberg (from whence one began the climb to the Schneekoppe), with its innumerable rooftops, and on the other the "proud, lofty mountain striving toward heaven with mighty power, and

his yearning impelled him up to the summit of the mountain. Oh! and the audacious power of the wildly enraptured soul drove him up and over the mountains, over the earths and the worlds!"[92]

Friedrich's landscapes and Körner's poetry before the Wars of Liberation (1813–1815) evidence a passive longing for unity; they become more active, as Germany began to rise up against the French, the imagery becomes more explicit. Körner, for example, no longer disguised his ideals under the rubric of the mountain peak:

Yet, brothers, we together stand;
That keeps our courage firm;
Bound by one speech, a holy band;
Linked by one God, one fatherland,
One faithful German blood.[93]

This was written in the field, and the volunteer soldiers of the Wars of Liberation sang it as they marched out of Zobten in the eastern foothills of the Riesengebirge.

Schloss Erdmannsdorf

One work by Friedrich, *View from the Terrace of the Erdmannsdorf Estate,* exhibited at the Dresden and Berlin exhibitions of 1812, seems rather sedate for the hectic period just preceding the Wars of Liberation (fig. 9.64). The scene is viewed from the terrace of the castle, where a woman sites reading. The grassy areas of the terrace have been neatly clipped and geometrically shaped in the French garden style. Friedrich ingeniously concentrated visual move-

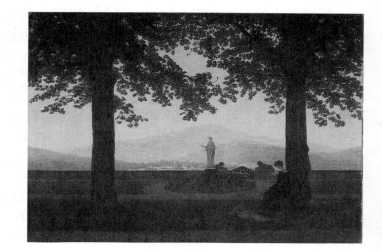

9.64 Caspar David Friedrich, *View from the Terrace of the Erdmannsdorf Estate,* 1811–1812. Staatliche Schlösser und Gärten, Potsdam-Sanssouci, Potsdam.

ment by framing the mountain vista with two sturdy trees in the foreground flanking the central motif. A diagonal pulls from the seated woman past the statue of Flora to the remote mountain crest, tracing the transcending horizon. The fanciful gate which provides the threshold lying between the terrace and the world beyond is made to rhyme with the mountain tops. its medallionlike grillwork encloses a cross, thus linking the religious symbol with the natural sign of the Deity.

The scene recalls Tieck's opposition of the secure world of the garden and the wild unknown regions of the rocky heights. But here the world of the mountains is harmoniously enclosed by the trees, reducing it to the conventional character of a view from a picture window. It suggests that Friedrich has begun to formalize his themes. Yet no previous work attests more dramatically to his need to make real estate compatible with the divine estate. Starting with the privatized garden terrace of the feudal domain, the picture gradually opens out to embrace the spiritual realm. Here again Friedrich's landscape serves to consolidate the ideology of the dominant classes.

Erdmannsdorf was one of several estates belonging to the Graf Friedrich Adolf von Kalkreuth, a descendant of old Silesian nobility who had served with distinction in the army of Friedrich der Grosse. He was an old veteran by the time of the Napoleonic wars, but his role in the defense of Danzig compared favorably with that of the governors of other Prussian fortresses in 1807. He was adviser to Friedrich Wilhelm III and Queen Luise, but his ardent Francophilia undermined his credibility with the patriots. He blundered during negotiations for France's restitution of the Prussian lands it conquered east of the Elbe, allowing the restitution of these areas when the reparations were paid, but failing to set a limit on the amount of such reparations. While this seriously compromised his reputation, he remained loyal to the Prussian cause and was regarded affectionately by the public.

As a major figure in the Silesian army, Kalkreuth would have entertained important military chiefs at Erdmannsdorf. No doubt one of these would have been August Wilhelm Anton Neithardt von Gneisenau, who had assisted Kalkreuth in the defense of Danzig. Gneisenau married into Silesian nobility, and his wife—Caroline von Kottwitz—purchased a small estate near the Riesengebirge. During the period 1794–1806, Gneisenau served in the Silesian army, his primary military duties consisting of re-

connaissance missions in the Riesengebirge, mapping important strategic and tactical sites between Schmiedeberg and the Schneekoppe. Gneisenau in fact purchased the Erdmannsdorf estate from the elderly Graf Kalkreuth in 1816. While this took place after the expulsion of Napoleon, Gneisenau's comments illuminate the interrelationships of nationalism, mountain symbolism, and private ownership. After his wife bought their first estate, Gneisenau wished to leave the army and devote his entire energy to agriculture. He was obsessed with managing an estate but decided to remain in the army for fear that Napoleon's actions would prevent him from carrying out the improvements necessary to make his estate pay. In November 1805 he wrote his wife, "As a soldier, I see nothing but disorder about me and, as a landowner and father of a family, I am afraid of being ruined . . . And yet I still look trustfully to Him who governs everything for the best and I strengthen my heart with confidence in him."[94] He bemoaned his experiences in the wake of the Prussian disaster of 1806: "My fine establishment in Silesia is destroyed. I was on the road toward being a well-to-do person, but am now a beggar. The difference is not great when one compares this short space with eternity, and this is the only authentic standpoint." Gneisenau's nationalism was based on his need for land, and he looked to the Divine Being for support both in the liberation of the fatherland and in securing himself an estate.

He was so delighted with the purchase of Erdmannsdorf that he wrote to friends boasting of his fine view and his contiguity with such neighbors as Graf Schaffgotsch. He claimed that "the location is heavenly," and he hoped to have the ingenuity "to form one of the most beautiful estates in the world." To the princess Radziwill he claimed that everywhere he turned he discovered new landscapes. He especially loved the spectacle of the Riesengebirge before his very eyes, with "the Schneekoppe directly in front of my window." All this he acknowledged as "a gift from heaven."[95]

The testimony of Gneisenau, a leading Prussian patriot and military chief, and friend of almost every writer, artist, and natural philosopher mentioned in this chapter, gives substance to the visual implications of Friedrich's landscapes. The *View from the Garden Terrace of the Erdmannsdorf Estate* projects a landscape that would have been filled with patriotic associations, harmony, and equilibrium between private property and national and cosmic unity that helped

shape the viewpoint of the public in the critical phase of German preparation for the Wars of Liberation. It is as if Friedrich were furnishing a glimpse of the ideal, post-Napoleonic epoch. The artist had learned at last how to transform the commercial topographical view into high art for a high price.

The Wars of Liberation

As the painting was being exhibited at the Berlin Academy in 1812, Napoleon launched his disastrous campaign in Russia. This event provided the catalyst for the events leading to liberation of the German people. As Tolstoy chronicled in *War and Peace,* Napoleon's poor planning, the ingenious strategy of the Russian general Kutuzov, the harsh winter weather of 1812–1813, and the operations of guerrilla bands and irregular Russian troops transformed Napoleon's foray into a nightmare for the Grande Armée. The Prussian contingent deserted, sparking mass defections from the empire, along with them the formation of a new coalition against Bonaparte.

In the ferment, the level of propaganda arose dramatically in Prussia; German publicists proclaimed a popular war of liberation—perhaps in ultimate tribute to the French Revolution. Against the background of growing nationalist sentiment and military reform, the diplomats worked and waited. Finally, early in 1813 Friedrich Wilhelm III signed a treaty with Russia, forming the nucleus of an offensive coalition against Napoleon. Austria continued to claim neutrality and offered to mediate the dispute. Metternich offered Napoleon the option of restoring all his conquests after 1802, which he promptly rejected. The allies sighed with relief, since the proposal was primarily a stalling tactic until Austria could ready for war.

In August Emperor Franz I finally declared war on his son-in-law, while Napoleon learned of new defeats in Spain. Napoleon was able to field one last army with underage conscripts, but he found that his major south German ally, Bavaria, had defected just days before the critical showdown at Leipzig. A major battle raged in Leipzig for three days in mid-October, at the end of which the French were decimated. Of nearly 250,000 French troops, only a small remnant of some 40,000 managed to retreat safely across the Rhine. The rest, dead, wounded, or imprisoned, remained in the Germanies. Napoleon, now driven back into France, steadfastly refused the terms of the coalition.

By the end of March 1814, the rulers of Prussia and Russia marched into Paris in triumph. The price for this last defeat was the demand for unconditional surrender and the emperor's abdication. Napoleon was removed to the island of Elba, and, after twenty-two years of exile, the Bourbons returned to France.

To retrace the turbulent events for a perspective of Friedrich's work of the period 1813–1815: The Prussians were well aware by September 1812 that the French army had been caught in a Russian quagmire. Despite his outward show of loyalty to Napoleon, events were impelling Friedrich Wilhelm III to action against the emperor. Already in May 1812 Stein, exiled in Prague, had accepted an invitation from Czar Alexander to join him in the Russian capital as his adviser. Stein proceeded to Saint Petersburg and lost no time in attempting to persuade Alexander to abandon the French alliance and repudiate the Continental blockade. At the same time, he stepped up his plans to foment a popular revolt in northern Germany as a necessary adjunct to the Russian defection. He tapped the various patriotic and sympathetic Freemason societies to provide the institutional network, relying on agents such as Blücher, Gneisenau—the brains behind Blücher—Scharnhorst, Hardenberg, and others who played instrumental roles in the uprising.

Stein emphasized the need to "heighten and intensify the patriotic feeling of the people" through the dissemination in Germany of literature that inspired the people to overthrow the enemy. He invited Arndt to join him in Saint Petersburg and write patriotic songs, poems, and pamphlets for distribution among the German people. Stein and Arndt collaborated not only to enlighten and edify Germans, but to attach them to an actual German Legion—an irregular military organization consisting of German soldiers and officers who had deserted Napoleon's auxiliary regiments as well as of patriotic civilians. Organized in Russia in the summer of 1812 under the auspices of several members of the German nobility, its value was chiefly its propaganda appeal. The opportunity also made Arndt into one of the great lyric poets of the Wars of Liberation, a distinction that he was to share with Körner, the son of a famous Freemason, and Max von Schenkendorf, a Freemason poet.

Arndt's daring pamphlets were smuggled into Germany and defied the French censorship code. His collection *Zur Befreiung Deutschlands* (On the liberation of Germany),

published early in 1813, included the stirring "Aufruf an die Preussen" (Proclamation to the Prussians), calling them to the mission of defending "liberty and honor" and rescuing "German virtue." Arndt wanted every Prussian to become a crusading and militant patriot and help in the liberation of the state from foreign domination. This is also the period of Arndt's famous songs, such as "Des Deutschen Vaterland" (The German fatherland), which enjoyed a great popularity in the period. The leading line of each verse goes, "What is the German fatherland?" A series of rhetorical questions follow: Is it Prussia? Is it Pomerania? Is it Bavaria?, and so on, to which the refrain of each stanza answers, "Oh, no! no! no! His fatherland must larger be." And the song ends with the resounding claim of Friedrich's mountain imagery: "Dass ganze Deutschland soll es sein!"—"The entire Germany shall it be!"

One of Arndt's devoted disciples at Greifswald, Friedrich Ludwig Jahn—nicknamed *Turnvater* (Father of Gymnastics)—also contributed to the rising patriotic ferment of these years. He had been swept up in the revival of German folklore and songs, and his book *Deutsches Volksthum* (German popular life) condemned cosmopolitanism and called for one people, one nation, one empire, all united under one constitution. In Berlin in 1810 he obtained a teaching position and used it to preach the gospel of Hermann, who inflamed his followers against the caesar in Rome. He conceived of the idea of drilling and training young people into disciplined fighters right under the nose of the enemy, by labeling his program as gymnastic exercises. Singing was at once made a part of the exercises, particularly on the march to and from the field, and Jahn took great pains in selecting songs emphasizing love of country.

The king's call for volunteers on 7 February 1813 encouraged the idea of forming independent divisions made up of *Freiheitskrieger* (freedom fighters) from all the German territories who, not being Prussian, would be ineligible to serve in the Prussian line. The various divisions were called the *Freikorps,* or "free corps," and while their success in the field was limited (desertions ran high), they greatly supplemented the Prussian army, which could not muster more than eighty-thousand troops at the beginning of the campaign. The response demonstrated the effectiveness of the propaganda program and the reforms enacted by Stein and Scharnhorst. Women dressed as men fought in the major battles, or else, like Henrietta Herz and Rahel Levin Varnhagen, nursed the wounded. Only Jews were

excluded from the volunteer army unless willing to shoulder all personal expenses of food, equipment, and transportation—which many of them still agreed to do.

The best known of the *Freikorps* was that of Major Adolf von Lützow, whose motley band of patriots symbolized the unity of their ideal fatherland. The Lützowers took for its banner not the black-and-white colors of Prussia, but the black, gold, and red tricolor of a united Germany. Their uniform was black, with red piping and brass buttons. (After 1815 this tricolor would carry the same signification of rebellion as the French, and the king would repudiate it.) The Lützowers were recognized as a *Freikorps* on 18 February and permitted to operate separately from the main army. Although few in number—the regiment never exceeded three thousand volunteers—they inspired fervent patriotic devotion. Every German state was represented for symbolic reasons, but for the same reason they were treated harshly by Napoleon's troops.

Jahn was one of the first to join the corps and was its most energetic recruiting agent in securing the broad representation of the German territories. Most of the volunteers came from the cultivated middle class, and some of them had already distinguished themselves as writers and artists. Körner entered the ranks as a private and wrote his most stirring battle verses while wearing the Lützower uniform. He was to be cut down tragically on 26 August 1813. Other intellectuals belonging to the corps were Joseph von Eichendorff, Karl Immermann, Philipp Veit, and Friedrich's friend in the Riesengebirge, Georg Friedrich Kersting. According to Schubert, several of the Lützowers had been members of the group of Dresden patriots who gathered at Friedrich's studio. In March 1813, when Kersting volunteered, Friedrich and Kügelgen supplied him with money and ammunition.

Schubert also mentioned that Ernst von Pfuel, Scharnhorst's adjutant in 1813, participated in Friedrich's circle. Scharnhorst stood with Stein at the head of the work of political and military reconstruction in Prussia, and it was they who put into action the *Freikorps* and the famous concept of the *Landsturm*. Analogous to the French *levée en masse,* it decreed that every male Prussian between ages fifteen and sixty who had been exempted from the regular army, should enroll in the *Landsturm* whenever the enemy invaded the country. Like the Spanish guerrillas, they would wear no distinctive uniform and their function was to harass the invaders, sever their lines of communication,

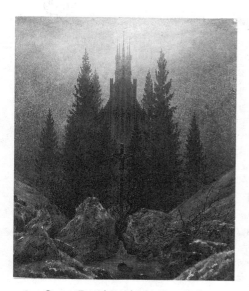

9.65 Caspar David Friedrich, *Cross in the Mountains*, 1812. Kunstmuseum, Düsseldorf.

deprive them of food and sleep, and keep them jumpy and demoralized. The *Landsturm* was the fulfillment of the idea of Scharnhorst and Stein of a nation in arms, the realization of the peasant as an active and vital part of the nation. Scharnhorst did not live to see the country liberated by the *Freikorps* and *Landsturm* he helped create; in May 1813 he fell at Grossgörschen, one of the earliest battles in the Wars of Liberation. That Friedrich had contact with Scharnhorst, however, gives us an insight into his active identification with the policies of the war party. As early as 1814 Friedrich had written to Arndt about a memorial they were planning for Scharnhorst, but he doubted that such popular monuments to patriots could be erected "so long as we remain lackeys of the princes."[96]

This planned collaboration between Arndt and Friedrich further suggests the extent to which Friedrich contributed his art of the great phase of propaganda in the period 1812–1814. It may be said that Friedrich painted what Arndt and Körner verbalized, and helped shape the views of his public in line with the aims of Stein, Scharnhorst, and Gneisenau. Foreshadowing the phase of Friedrich's overt political painting are visionary landscapes depicting Gothic cathedrals as heavenly apparitions. Especially interesting is the *Cross in the Mountains* of 1812, which fuses the church architecture with natural elements of the landscape (fig. 9.65). The tall fir trees, flanking the portal of the west facade, substitute for the towers of the typical Gothic cathedral. Their open, leafy silhouette is echoed in the toothed upper portion of the nave tower. In the middleground rises a crucifix firmly embedded in rocks from whence a spring gushes forth. The view is clearly from below upward, tracing the reverential gaze to the top of the crystalline spire. There can be no doubt that the entire cathedral complex hovering above the rocks is meant to recall the mountain forms of the Harz region, which he explored in June and July of the previous year. Given the number of symbols of regeneration (the evergreen trees, the stream of life), it may be concluded that Friedrich deliberately substituted the Gothic = German formula for the divine mountain peak and shifted the idea of salvation from God the Father to the Fatherland.

This type of landscape had a great impact on the work of the architect Schinkel, whose own visionary Gothic landscapes center on this period. It may be recalled that Schinkel could not earn his living as an architect during the Napoleonic occupation, and he was forced to take up paint-

ing for his livelihood. That he chose a style similar in manner to Friedrich demonstrated the marketability of these Gothic landscapes and signaled the influence of Friedrich's work on public opinion. Schinkel and Friedrich shared an identical political outlook in these years: the architect belonged to the ultrapatriotic Christlich-deutsche Tischgesellschaft, whose members also included Kleist, Arnim, and Brentano. Almost in the same period as *Morning in the Riesengebirge,* Schinkel designed a mausoleum for Queen Luise in the style of a Gothic chapel, and his commentary stressed the transcendental, Christian and German characteristics of the style. Schinkel was a close friend of Gneisenau, for whom he painted several pictures with medieval motifs in the years 1813–1817, and later designed a house for him at Erdmannsdorf. One landscape he did for the general, entitled *Evening,* was a frank imitation of Friedrich's political allegory described by Schubert as an eagle striving against the elements to reach a distant peak (fig. 7.2). Schinkel added a second Prussian eagle and filled the foreground with an oak wood, but the striking similarity to his idol again testifies to the effectiveness and profitability of Friedrich's propaganda.

Friedrich's fusion of tree, rock, and cathedral underscores his wholehearted acceptance of the ideas of the Gothic as an organic outgrowth of the indigenous German environment. His reason for equating Gothic and Germanic may not have been entirely geographical or historical, but he certainly agreed with Friedrich von Schlegel's view that the really distinguishing characteristics of medieval architecture were strictly Germanic in origin. Schlegel had likened the distant view of the cathedral's exterior and its elaborate system of turrets, pinnacles, and other embellishments to a forest, and the close-up view of an enormous piece of crystallization. His analysis of Gothic architecture as a dynamic, living organism displaying a powerful affinity with natural phenomena actually exemplified *Naturphilosophie's* synthesis of religion, art, and science. Schelling contended that the Gothic, like other forms of architecture, was an allegory of the organic expressed in an inorganic medium, whose prototype was the organism of plants. It was Schelling who formulated the definition of beauty as the representation of infinity in finite terms, a logical parallel to his famous concept: "Nature is visible spirit; spirit is invisible nature." To Schlegel this meant that Gothic architecture "can represent and realize the infinite through the more imitation of nature's bounty." Hence it took the

9.66 Caspar David Friedrich, gothic monument of type promoted by Karl Friedrich Schinkel, c. 1815. Städtische Kunsthalle, Mannheim.

9.67 Caspar David Friedrich, *Gravestone with Knight's Helmet,* c. 1815. Städtische Kunsthalle, Mannheim.

quintessential German science to disclose the meaning of the quintessential German style.

The Gothic revival, now actively promoted by Prussia's privileged classes, could be exploited by both Schinkel and Friedrich for its commercial potential during the propaganda campaign leading to the Wars of Liberation. Their exchange became reciprocal: Friedrich executed a large number of designs for war memorials and monuments combining images of military and Gothic motifs in the popular fashion promoted by Schinkel (figs. 9.66–67). Under the infuence of the architect and of the Boisserée brothers, he even prepared plans for the restoration of the Marienkirche—a late Gothic church of the fifteenth-century—in Stralsund. His timely Neogothicism contributed to the publicity campaign of the patriots and at the same time assured him—as the case of Arndt's pamphlets—of his livelihood.

Friedrich returns in this period to the *Hünengräber* as souvenirs of past glory and monuments to modern heroism. He painted more than one evocation of an imaginary tomb of Hermann (Arminius), which in these years would have had a political bite lacking in the older allusions to the ancient Teutonic hero by writers like Klopstock and Kosegarten. (Even Kosegarten, however, embarked on a new series of pointed patriotic poems in the years 1812–1814, which made numerous allusions to Hermann in the context of the Wars of Liberation.) Soon after the fall of Prussia at Jena and Auerstädt, Arndt wrote his *An die Deutschen* (To the Germans), which evoked the precedent of Hermann in a spirit of revenge:

What Herman, not a tear for your people?
Not a tear? and dishonor burns,
And the enemy reigns, where the free
Conquered and fell!
. .
And you, Hermann, and you fearless people?
Up! Awake! rattle your chains,
That the world perceive the ignominy, soon also
Bloody vengeance.[97]

But it was especially Kleist's *Hermannsschlacht,* read aloud by the participants in the Dresden circle in 1808, that charged the old myth with its modern political meaning. Inspired by the rising of the Spanish people against Napoleonic troops, *Hermannsschlacht* glorified the first great rising of Germanic people against foreign tyranny and con-

9.68 Caspar David Friedrich, *Old Heroes' Graves,* 1812. Hamburger Kunsthalle.

stantly reiterated that the hour of action had come. Kleist's model for present glory left a lasting impression on his contemporaries: like Arndt's poetry the story goaded them to action. Under the influence of Kleist and Arndt, Steffens left his teaching post to join the Prussian army (facilitated by Scharnhorst), Oken wrote a treatise on new weaponry to terrorize the French, Körner transferred his energies to writing military songs, and Friedrich painted his *Old Heroes' Graves.*

Old Heroes' Graves is set against a backdrop of cave and steep rock face originally sketched in the Harz Mountains (fig. 9.68).[98] This was inspired by the curious rock formations of Rübeland where the cave known as Hermannshöhle was located. In the foreground there is an ancient monument of jagged rocks carrying the inscription "Arminius." A serpent, the embodiment of all evil, slithers over the tomb: an unmistakable allusion with its skin tinted in the hues of the French tricolor. The surrounding foliage, however, suggests the flowering of national sentiment for the ancient hero. Several other tombstones also bear inscriptions referring to heroes who had died for the fatherland. The most luminous passage in the painting—glowing as if by some inner force—is a brand new obelisk with the inscription, "Noble youth, deliverer of the fatherland." The initials "G.A.F." above an insignia of crossed swords clearly refers to recent martyrs of the Napoleonic wars. The sarcophagus on the left carries the message "Peace in your tomb—Deliverer in need," while the one on the right reads, "To the noble martyrs for freedom and justice.

F.H.K.," referring to three Lützower who fell in 1813, Friesen, Hartmann, and Körner. This tomb brings us full circle to the entrance of the cave where two French infantrymen, dwarfed by their surroundings, stand transfixed. The effect of this claustrophobic site is to literally entrap the French chasseurs with the dolmens and tombs. conveying a sinister quality reminiscent of Kleist's *Hermannsschlacht*.

The initials of Friesen, Hartmann, and Körner have given rise to a confusion in the dating of the picture. It is generally accepted as the work of this title that exhibited at the 1812 Berlin Academy exhibition, but this contradicts the reference to the Lützower, who were killed one year later. The fact must be that either these initials were added later, or there was similar work which has since been lost. The work was featured at an exhibition of patriotic art that opened in Dresden on 24 March 1814, celebrating the victories of the Wars of Liberation.[99]

Friedrich's peers were also making direct reference to victims of the war. Arndt, for example, wrote a poem in 1816 entitled *Klage um drei junge Helden* (Lament for three young heroes), which mourns the loss of Friedrich Eckardt, Karl Friedrich Friesen, and Christian Graf zu Stolberg:

I am lamenting very deeply,
And many lament with me:
Three heroes have been slain
In the flower of their youth;
They were three young riders,
Who rode off gaily into the sunset,
They rode off much further
To God's heavenly mansion.[100]

Like Friedrich, he associated them with the ancient Germanic tribes:

High up in Cheruschan Land
There stands an old castle
On a green mountain slope,
From which my Stolberg sprouted;
It sent a glorious messenger
Out into the gloomy night,
And now laments him among the dead on high,
Who fell in the fatherland's strife.

Reminiscent of Friedrich's work are Arndt's lines for Eckardt, "Whom God and fatherland called, / Now the young lion slumbers / In a deep and quiet grave." Arndt ends on a note of jubilant expectation of the "last day" when a "new

9.69 Georg Friedrich Kersting, *At the Advance Post,* 1815. Staatliche Museen Preussischer Kulturbesitz, Nationalgalerie, Berlin.

9.70 Caspar David Friedrich, *Cave with Tomb,* 1813–1814. Kunsthalle, Bremen.

morning" will dawn red again for the three heroes who rode out for the fatherland's victory.

Friedrich's friend, Georg Friedrich Kersting, also commemorated three young heroes in his painting *At the Advance Post* of 1815 (fig. 9.69). He depicted his friends Friesen, Hartmann, and Körner, with whom he enlisted in the Lützower regiment. (Of the Dresden volunteers he alone survived.) His fallen comrades wear the Iron Cross, the popular German decoration conceived by Gneisenau in 1811, and the black uniform with red piping of the Lützower corps. The dense oak forest forms the complement of their watchful positions. Significantly, however, they are not cast in heroic postures but seem almost bored and even disillusioned with military duty. These elegant youths with their wistful expressions yield an insight into the class origins of Lützow's troopers, who appear misplaced in the setting and in their military garb. The horrors of actual combat must have quickly dissolved their idealized projection of war; we know, for example, that desertions from the *Freikorps* ran high after the initial battles. Done in the aftermath of the Wars of Liberation, Kersting's picture probably gives us a more accurate image of the Lützower than the overblown propaganda of Arndt, Friedrich, and Körner— the lyric enthusiast who is now shown seated with an unexpected air of dejection.

Another work of Friedrich's based on the Hermann theme was *Cave with Tomb,* painted in the period 1813– 1814 and also exhibited in the 1814 show (fig. 9.70). Again a rocky wall rises up dramatically to enclose the pictorial

9.71 Caspar David Friedrich, *The Chasseur in the Woods,* 1813–1814. Private collection, West Germany.

space, but this time huge, jagged outcroppings of granite at the left and right of the scene impart an even more menacing mood. Hermann's tomb is set deep into the cave interior with the lone French soldier keeping watch. The lid of the sarcophagus has been raised, and a massive chunk of the mountain wall hangs ominously over the puny figure of the soldier. Here German geology, German history, and German landscape threaten to engulf the invader completely.

The sense of impending doom emanating from the landscape against the enemy is felt most powerfully in *The Chasseur in the Woods,* which was shown together with the other two landscapes in 1814 (fig. 9.71). The evening sky and dark interior make the winter forest unusually forbidding. Friedrich's chasseur—an elite cadre of the French cavalry—is confronted by a towering, dense *Wald* which looms threateningly before him. The chasseur stands frozen to the spot, disoriented by the surrounding forest. As one review put it, "A raven perching on an old stump sings the death song of the French chasseur who is wandering alone through the snow-covered evergreen forest."[101]

The raven, traditionally held to be a symbol of ill fortune, is used by Arndt in his famous *Vaterlandslied* (Song of the fatherland) against those who fear to take part in the modern-day *Hermannsschlacht:*

Oh Germany, bright fatherland!
Oh German love, so true!
Thou sacred land, thou beauteous land,
We swear to thee anew!
Outlawed, each knave and coward shall
The crow and raven feed;
But we will go to the *Hermannsschlacht,*
Revenge shall be our need.[102]

Arndt's coupling of the raven and the *Hermannsschlacht* was no doubt inspired by Kleist's drama: in act 5 the Roman chief, Quintilius Varus, wanders into the strange fir forest. There he comes upon an old sorceress who informs him that a raven had predicted that "Varus is but a few steps away from the grave." Kleist also wrote in his review of *Monk by the Sea* that Friedrich could take "a square mile of Prussian sand, with a barberry bush and solitary crow ruffling its feathers" and with his powers give it the effect "of an Ossian or a Kosegarten."[103]

Not surprisingly, the work was purchased by Prinz Malte von Putbus of Rügen, one of the active aristocratic

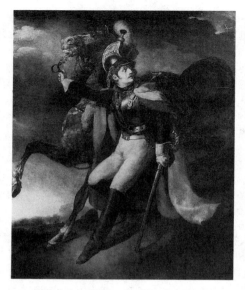

9.72 Théodore Géricault, *Wounded Cuirassier Leaving the Field of Battle*, 1814–1815. Musée du Louvre, Paris.

supporters of the Wars of Liberation and the biggest land-owner on the island. The dislocation and helpless exposure of the monk has now been projected on the actual invader. The triumphs of the Wars of Liberation permitted the painter to transfer his pessimism and frustration to the other side. No individual German hero or military encounter subdued the enemy, however. It is rather the nation, the fatherland symbolized by its indigenous landscape, which has defeated the French. *The Chasseur in the Woods* is the obverse of *Monk by the Sea:* what previously appeared as an unbridgeable gulf for Friedrich has now become an insurmountable barrier for his enemy. The sense of foreboding has not been transformed into total defeat of the French.

Théodore Géricault's *Wounded Cuirassier*

Friedrich's chasseur was a member of a light cavalry unit often used in reserve to pursue and rout the enemy. The fact that he is shown unhorsed adds to his disorientation and vulnerability. Coincidentally, the same year Friedrich displayed this work, a young French painter named Théodore Géricault exhibited his *Wounded Cuirassier Leaving the Field of Battle* at the biennial Salon in Paris (fig. 9.72).[104] A native of Rouen, Géricault executed this picture between the time of Napoleon's banishment to Elba in April–May 1814 and his temporary return to power less than one year later. During the interval, Louis XVIII governed in what may be considered the first stage of the French Restoration. Some of the Russian and Prussian troops who entered Paris on 31 March 1814 roamed the Champs-Elysées, while the English bivouacked in the Bois de Boulogne. The Bourbon king still required the presence of the allies to shore up his shaky throne, and his government decreed the Salon that year to project an air of stability as a medium of propaganda. Artists were pressured into making a hasty ideological adjustment and producing works compatible with the outlook of the new regime.

Géricault's work, which flatters the Restoration government, is a unique battlefield picture. Its dimensions are heroic, but its format is vertical rather than horizontal; and instead of presenting a panorama of action, it isolates a single combatant and his horse as if it were a military portrait by Reynolds. Above all, the dashing cuirassier in full imperial garb is shown dismounted and wounded—a subject unheard of in the Salons of the Napoleonic period. The cuirassiers were the pride of Bonaparte's army. They wore

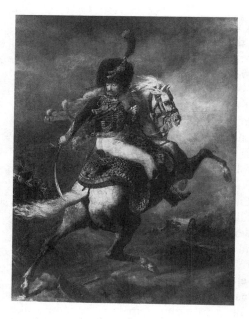

9.73 Théodore Géricault, *Charging Chasseur,* 1812. Musée du Louvre, Paris.

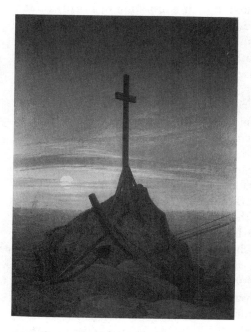

9.74 Caspar David Friedrich, *The Cross on the Baltic Sea,* 1815. Verwaltung der Staatl. Schlösser und Gärten, Schloss Charlottenburg, Berlin.

backplate and breastplate, stayed in reserve for shock battle service, and were organized in homogeneous brigades and divisions. It would be the cuirassiers in massed formation who could charge Wellington's squares in the gloomy afternoon of Waterloo. Typically, the cuirassier was shown charging into battle in formation; that Géricault represented the cuirassier disabled, isolated, and dismounted communicated a message that no Salon-goer could have missed.

As if to emphasize his point, however, Géricault exhibited as its pendant his *Charging Chasseur* (listed in the catalogue as *Portrait équestre de M.D.* ★★★), which first hung in the previous Salon of 1812 on the eve of Napoleon's Russian campaign (fig. 9.73). Here the light-cavalry officer of Napoleon's elite Imperial Guard engages in virtuoso horsemanship in full confidence of easy victory. By showing these two works together Géricault literally traced the demise of Bonaparte. At the moment of *Wounded Cuirassier,* Géricault was an ardent supporter of Louis XVIII, and the following year he even accompanied the king as part of his elite household cavalry in the flight to Gand during Napoleon's brief return to power, known as the One Hundred Days. Similarly, in 1814 Goya welcomed Fernando VII with his *Second* and *Third of May, 1808,* and Friedrich rallied support for Friedrich Wilhelm III with his *Chasseur in the Woods.* Ironically, all three lapsed into bitter disappointment as the Restoration unfolded, and ultimately attached themselves to the opposition. This meant embracing the principles embodied by their ex-nemesis, Bonaparte.

But for the time being, Friedrich was satisfied. He was allied with the victorious party, and he expected some form of constitutional government to prevail. By means of a complicated series of transactions, Prussia managed to add Swedish Pomerania to its Baltic possessions in June 1815. Friedrich's work was sought out by the great aristocratic collectors in Germany and Russia, and his admirers included some of Germany's most gifted intellectuals. He owned a summer home at Loschwitz and a major property in Pirna, a suburb of Dresden. His work at the end of the Napoleonic epoch incarnated this newly regained hope and confidence. *The Cross on the Baltic Sea* of 1815 is cautiously optimistic about the fatherland, emphasizing the idea of consolation for the recent sufferings (fig. 9.74). The foreground is dominated by the granitic mass on the rocky shore of the Baltic, upon which a somewhat rickety wooden cross has been mounted. A large anchor leans

against the rock, which also supports a cluster of poles used by sailors to test the depth of the water for maneuver of their boats near the shore. The full moon above the horizon casts a gentle glow across the sea, giving the scene an aura of tranquility.

"The picture for your lady friend is already begun," Friedrich wrote to the artist Luise Seidler, "but it will not contain a single church, tree, plant, nor even a single blade of grass. The cross is erected on the bare seashore; to some, a symbol of consolation, to others simply a cross." [105] The friend to whom Friedrich referred was either Caroline Bardua or Therese Emilie Henriette aus dem Winckel, who, together with Seidler, constituted a group of gifted women painters. These women had studied under Kügelgen and, on the recommendation of Goethe, had become attached to the Weimar court. The daughter of the equerry of the University of Jena, Seidler exemplified the progressive sort of middle-class woman in the wake of the French Revolution. She was closely allied to strong female personalities like Henrietta Herz and Rahel Levin Varnhagen and encouraged the aspirations of her sister artists. Seidler, Bardua, and Winckel were united in their admiration of Friedrich, and Seidler later functioned as Friedrich's agent in gaining him commissions from the Weimar court. They watched and waited for the outcome of the Wars of Liberation and its promise of increased civil rights for all German citizens.

Friedrich's personal interpretation of the picture focuses on the theme of consolation. The hope of resurrection is symbolized by the anchor, a traditional Christian emblem of immovable firmness, hope and patience. A tiny ship making its way to shore signals the idea of arriving safely in port from whence the symbolic anchor derived. It is also an important Masonic symbol of well-grounded hope in a peaceful harbor. Besides the links between Freemasonry and art during the Napoleonic epoch, the symbol has added pertinence in the fact that Goethe—whose importance for Friedrich and Seidler at this time is well documented—was a well-known Mason himself. Despite his conservative politics, Goethe shared the general mood of optimism in the wake of the Wars of Liberation.

One contemporary source of inspiration for *The Cross on the Baltic Sea* was the drama of the same title by Zacharias Werner. Werner, a convert to Catholicism, published his play in 1806, a work resonating with religious fervor and nationalism. The story relates the conflict between the rugged heathen of the Baltic and the Teutonic knights. Out

of this conflict Werner saw rising the Prussia of his day. Past and present appeared to him as an organic unit and as integral parts of the great drama of German life still being enacted. Above all, he was inspired by the thought of German unity. That Friedrich wanted his own work to resonate with the same ideas is seen in his choice of title and from the fact that a lost sepia of circa 1806–1807 bore the inscription "Das Kreuz an der Ostsee nach Zacharias Werner" (The cross on the Baltic after Zacharias Werner).

Friedrich's basic textual source for the work was Saint Paul (Hebrews 6:18–19), exhorting the people to wait patiently for God's promise of consolation "which hope we have as an anchor of the soul, both sure and steadfast." But the scriptural text is graphically rendered not with orthoddox trappings like the church but with the elements of *Naturphilosophie*. It is the rock of geognosy as much as the Rock of Salvation, the moon of astronomy as much as the moon of Revelation, which builds the image. Schubert, in his compendious *Allgemeine Naturgeschichte* (Popular natural history), devoted major sections to the Neptunist origin of rocks and the history of the moon. Thanks to the telescopic explorations of Schröter, he writes, it is now possible to know the moon almost as well as the earth; indeed, in some ways the moon is now better known than many parts of Asia. The lunar regions can be identified in small districts not much larger than the "smallest provinces of our fatherland." At the same time, however, sustained viewing of the lunar orb makes the observer aware of "a feeling of loneliness and desolation" akin to the experience of the solitary Alpine hiker or to the observer of the Pinchincha volcanic crater "which since the beginning of the world has not been covered with a green blade of grass or a bit of moss." Friedrich's description of his work as lacking even "a single blade of grass" signifies his own desire to create an image of primitive simplicity—to literally get back to the basics. Even the crude cross has been built of driftwood and found lumber, a testament to the sincerity of the genuine believer rather than the conventional churchgoer.

Friedrich's paint was applied thinly and crudely, although the forms are outlined with the same precision of his sepia sketches. He wanted his technique to correspond with the subject matter and rough-hewn sincerity, though as a student of *Naturphilosophie* he could never have foregone the careful and scrupulous rendering of natural form. As Schubert wrote, "Corporeality is the ultimate goal of

God's work." Yet Friedrich was anxious to retain as much as possible the vision that revealed itself in his imagination. Carus noted that Friedrich never made sketches, cartoons, or color studies for his paintings because he feared that his imagination would cool down through such aids. He began immediately with the neatly stretched canvas, first lightly tracing a chalk-and-pencil outline and then finalizing the contours with pen and india ink. Then he laid in the underpainting, the first rough application of paint to grasp the broad masses of light and dark. Friedrich was certainly aware of the sketch-finish compartmentalization; he noted about a fellow painter that his studies from nature were excellent, but when they were used for definitive pictures the qualities of the sketches vanished. In other cases, he observed that artists draw painstakingly and awkwardly from nature, but he felt it infinitely preferable to use a previous sketch for painting, for "then everything gains life and soul." At the same time, he detested the practice of taking motifs from several sketches and synthesizing them into a new combination—a method he labeled as "patching and mending." What he wanted was to capture the totality of a scene with the "mind's eye." "The artist should not only paint what he sees before him, but also what he sees within him. If, however, he sees nothing within him, then he should also skip painting that which he sees before him."

Friedrich was endowed with a rare capacity for concentration on his first vision without preliminary compositional aids. He did make individual studies of plants, rock formations, and motis of all kinds that later appeared in his definitive paintings, but he never reworked these into a full-blown composition that he transferred to the canvas. At the same time, his gradual building up of a picture in a series of layers is like the sketch-and-finish procedure. The thin paint strokes in the *Cross of the Baltic* could have been refined and carried through a more highly polished surface, but he left them in that state for ideological purposes. This constituted the subjective side of his pictorial technique, which normally took the form of external precision and sharp detachment of objects against the background. His rigorous control of the surface gave him visual dominion over the landscape he depicted.

The sense of dominion certainly characterizes his self-assurance following the Wars of Liberation. This is especially conspicuous in *Traveler above the Fog* of circa 1815, which restates his subject matter of the previous years in an affirmative voice—a fitting example with which to close

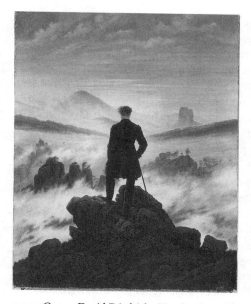

9.75 Caspar David Friedrich, *Traveler above the Fog*, c. 1815. Hamburger Kunsthalle.

this chapter (fig. 9.75). It represents in the most lucid terms his love of *Naturphilosophie,* his religious exaltation in the form of the reverential gaze, and the coincidence of mountain, Godhead, and nationhood. The traveler, seen directly from the rear, stands sharply outlined on a granite promontory, looking out over the cloud-enshrouded mountain peaks in Saxon Switzerland. He has ascended through the fog-enveloped plains to reach the summit. His silhouetted form occupies the entire central portion of the composition where all the diagonals converge. His position is erect and commanding, and he steps to the summit with a sturdy foot and heroic demeanor. He fastens his gaze upon the distant mountain that emerges into the clear air directly before him—the ultimate aim of his ascent. Friedrich makes his spiritual point by exploiting the scientific fact that in mountainous regions visibility depends more on altitude than on distance, an inversion of normal atmospheric perspective. Taken together with the outline of the granitic mass Friedrich's figure echoes the conical shape of the mountain, a visual allusion to his identification with the Absolute. *Monk by the Sea* shares many of the devices of this painting, but where the earlier work expressed alienation, *Traveler above the Fog* is masterful, self-assured, and one with the universe.

The immediate textual source is again biblical, this time from the book of Psalms. Psalm 18 was sung by David after his deliverance from Saul and makes many references to God as a "rock." Verse 2, for example, praises the Lord as "my rock, and my fortress, and my deliverer . . . the horn of my salvation, and my high tower." And verse 46 cries out in joy, "The Lord liveth; and blessed be my rock; and let the God of my salvation be exalted." The allusion to this psalm, like a pietist sermon by Schleiermacher, states the case for eternal life and the idea of the creation of male and female in the image of God.

According to the tradition handed down by the previous owners of the picture, the traveler in the scene was one "Herr von Brincken," which best identifies Friedrich Gotthard von Brincken, a colonel in the Saxon infantry who fought on the side of Prussia during the Wars of Liberation. He stands in the mountains of his native Saxon Switzerland, looking due south towards the crest of the Rosenberg and the unusual rock formation of the Zirkelstein on the right. He himself is probably standing on the summit of the Wachberg or Schweizerkrone, lower than the Rosenberg by nearly four hundred feet. This identification of a

national hero with his native landscape, bound by the upsurge of the transcending horizon, offers a striking demonstration of Friedrich's interchangeability of the Absolute with the idea of the fatherland.

As in the previous work, the choice of a granitic rock as a platform from which to view the world indicates the quest for exaltation on a scientific base. Friedrich shares the elation expressed in the last paragraph of Schubert's thirteen-hundred page *Allgemeine Naturgeschichte*. Having traced the origins of the universe, Schubert climaxes his book with a dithyramb of praise for human beings as the highest stage of creation: in view of the immense task still remaining to usher in the millennium, it is essential that people maintain the integrity of their inner lives and guard the purity of their souls. Then Man shall spread his wings and fly to the heights, without fearing to fall like "wingless, helpless worms"; he shall break from his wax cage, and like the released bird "soar up to the mountains of his origin." [106] Friedrich's persona stands on the summit as if he has indeed achieved the highest goal of mankind.

There was a difference, however, between the aims of the patriots, the leaders of the Prussian army, Stein and his propagandists, and the work of the diplomats and their aristocratic lobbyists. Stein, Arndt, Schleiermacher, Friedrich, and the readership of the new *Rheinischer Merkur* wanted a great German empire with an emperor at its head and with corporative institutions. They wanted to chase away the princes of the Confederation of the Rhine, of Bavaria, Saxony, and Württemberg. They also demanded that France return at least the former imperial provinces of Alsace and Lorraine, insisting also on the severest possible terms to cure once and for all the desire for war. The diplomats did not want this; neither the Austrian chancellor Klemens von Metternich, who now directed his country's foreign policy, nor the south German rulers, nor even the Prussian prime minister, Hardenberg, wanted this. None of them regarded a new *Reich* (empire) as either desirable or obtainable, or wanted to follow the French Revolution with a German one. The order that they established after Napoleon's collapse was called a "restoration," which in principle sought to turn the clock back to the ancien régime, but in practice was far more complicated. Some of the rulers deposed by Napoleon did return to their thrones, but this did not affect the basic social, or even the diplomatic, changes of the Revolution. What happened at the Congress of Vienna was not that pre-Napoleonic Europe

was restored, but that Napoleonic Europe was divided, with the result that Austria now ruled where France had ruled in Italy, Prussia ruled where France had ruled on the Rhine, and Russia ruled where France had ruled in Poland. In this way, the major powers—who had ostensibly fought for justice—benefited from Napoleon's system and even continued it.

It was not possible to return to pre-1789 conditions, or to create democratic nation-states in Germany and Italy. The emergence of such states would have entailed the self-destruction of Prussia and Austria and an internal movement of revolutionary energy and scale that did not exist. There were disillusioned patriots like Arndt and Friedrich, but no popular movement to realize their ideal. Worse, these essentially moderate liberals came to be seen as fiery radicals, and they suffered in the climate of reaction. The story of this development and its influence on Friedrich's later art must await the next volume of this series, *Art in an Age of Counterrevolution*.

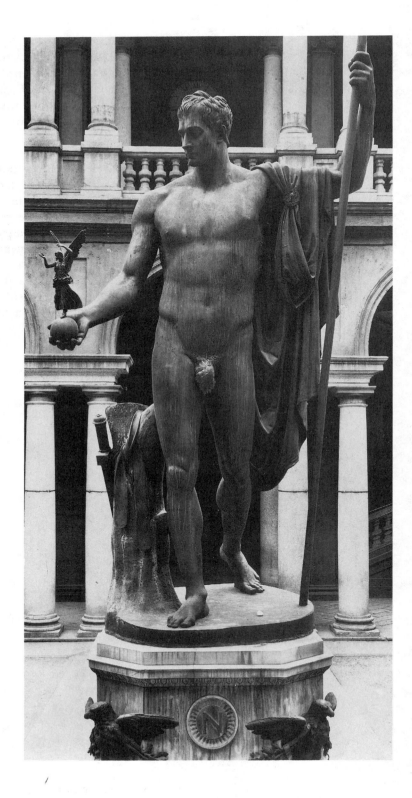

10.1 Antonio Canova, *Napoleon as Mars,* 1806.
Apsley House, London.

The final chapter is a short one. But if Italian art during the Napoleonic epoch developed as an adjunct to French culture to which it was institutionally subordinated, it nevertheless manifested original qualities that would be developed in the art of the subsequent generations.[1] The concept of a unified Italian state first emerged during the Napoleonic period, providing the objective conditions for the development of a national art. The Congress of Vienna put a temporary damper on this development, but even during the Restoration we see the entry of gifted patriotic painters like Francesco Hayez and Massimo d'Azeglio, who parallel the literary contributions of historical novelists like Manzoni and Guerrazzi. Finally, since the body of post-Napoleonic reaction looked to Rome as its symbolic heart, the conclusion of this chapter looks forward to the next volume in this series.

Like Germany, Italy before Napoleon was a checkerboard of dynasties. Bonaparte scattered the dukelings and their feudalism: he carried the pope off to France, not once but twice, and rearranged the country to suit himself. The Cisalpine Republic became the Italian Republic under his presidency and, in 1805, the kingdom of Italy under the rule of the new emperor. He was crowned king with regal splendor in the Cathedral of Milan and then nominated his stepson Eugène de Beauharnais to act as viceroy. He divided the country into three large protectorates and introduced the *Code Napoléon* and a common administration over the whole peninsula; in the interest of economy he encouraged Italian national aspirations. Except in Piedmont and Tuscany, he let Italians manage the administration: he destroyed all local privileges in the way of centralization, suppressing monasteries and redistributing their estates.

For reasons of strategy, he undertook many public works. Roads were constructed, especially in the direction of the Alpine passes. At Venice, the lagoon was dredged and refortified as a naval base. He introduced schools on a standard pattern, mainly as a means of indoctrinating a younger generation with Napoleonic dogma. His rule of order stimulated science in the large universities of Pavia and Bologna.

Under Eugène's moderately enlightened reign there was economic improvement and the kingdom of Italy was successively increased by the addition of Venice in 1806, of the Marches in 1808, and of the Italian Tyrol in 1810. Napoleon further built up a "French Italy," an Italy annexed to the empire, with Piedmont being the first test case. From 1802 to 1814 Piedmont, divided into six departments, was administered as a French province by French laws. French language, formerly fashionable, now became the official tongue, and a bilingual newspaper, the *Courrier de Turin*, was provided by the government. The Piedmontese debt was taken over by France; tithes and feudal dues were suppressed and the French fiscal system introduced. The boundaries of French Italy were eventually expanded by the annexation of Parma and Pacenza, of Tuscany, and of the remaining portions of the Roman state.

The kingdom of Etruria, annexed in 1808, was an important addition to the empire. The policy of the court of Florence was not controlled by Napoleon, who quartered his troops in the country, carried home to Paris the *Venus de' Medici*—the most admired classical statue in Florence— and other masterworks, and prescribed his *Code*. The queen regent, the Spanish Bourbon Maria Luisa, was unable to oppose his schemes. In October 1807 a secret treaty signed with Spain at Fontainebleau deposed the queen regent, and on 30 May 1808 Tuscany was united to France. A French prefect was sent to Florence, and the country was rearranged into three departments. The Italian language, however, was admitted into official acts and documents—a wide concession to Tuscans, who perceived their language as the genuine Italian tongue, and in time many prominent Tuscans rallied to the new government. The grand duchy of Tuscany, as it was called, was given to Elisa Bonaparte, whose powers were limited to transmitting the orders received from Paris to Napoleon's appointees.

Of all the Italian states, Tuscany had least to gain and most to lose by the imposition of the French system. Its judicial order had been excellent and its penal law humane

in comparison with that imposed by Napoleon. Tuscany had already emancipated itself from feudalism and established an administration in keeping with a society historically versed in the arts of management. Economically, however, the French made major contributions: they improved the law of mortgage, stimulated the production of cotton and woolen manufacturers, and supported the academies and universities. But the peasantry hated the system of recruitment and conscription, and Bonaparte's military policy in general aroused deep resentment among many Tuscans. The annexation of Rome and the Gallicizing of the Vatican also angered them, as it did most Italians.

Napoleon's reforms, however, balanced out his imperialism in the Italian states, and this part of the empire remained fairly stable. While moderate liberal writers like Alfieri and the younger Foscolo covertly opposed Napoleon for not living up to their dreams of national unity and independence, most of the artists and writers fell into line. Napoleon's understanding of the ideological component of art predisposed him to favor art and letters and encourage their support. The poet Vincenzo Monti, at first poet laureate of the Cisalpine Republic, was subsequently appointed historiographer of the kingdom of Italy. He was relieved of professorial duties but continued to draw a stipend for teaching. Monti assumed his role enthusiastically, writing poems celebrating Bonapartist military victories, family weddings, and baptisms.

Napoleon also exploited the Italian art academies, bringing their curricula into line with all other areas of political and social life under his domain. New regulations issued by the academies proclaimed him as the type of hero-subject of which great historical painting is made. Academies could claim that the reign of Napoleon promised a period of magisterial art akin to the Age of Pericles.

Everywhere in the Italian territories Napoleon established fine arts commissions, which organized the regional art community (including native and foreign artists) and distributed orders for pictures, sculptures, and architectural projects. Artists benefited from numerous commissions, ranging from effigies of the sovereign and his family to decoration of the palaces and embellishments of the cities.[2] Large-scale projects at Turin, for example, included a colossal monument recalling the victories of the French armies in Italy and the union of Piedmont with France. A monumental fountain was planned for Lucca, crowned with an allegory of the triumph of Napoleon, while at

Florence a projected marble column in honor of the great hero for the Piazza Santa Croce was deemed too modest and was replaced with the idea of a colossal Napoleon forum. Even David was called in to design a decoration for a Florentine festival to commemorate a visit from the emperor; he planned to make over the Loggia dei Lanzi (a popular souvenir of the rule of the Medici where Cellini's *Perseus* and Giovanni da Bologna's *Rape of the Sabines* stood) into a glorification of the new ruler of Florence.

Naturally, such widespread involvement in the arts induced artists of all types to flock to Napoleon's banner. Official painters, sculptors, and architects had no difficulty transferring their allegiance, since it was their function to follow the patronage of the government in power. Others climbed aboard the bandwagon as the surest means of achieving success. The Tuscan sculptor, Lorenzo Bartolini, however, genuinely admired Bonaparte; he not only named his first two sons Girolamo-Napoleone and Paolo-Napoleone, but also made a pilgrimage to Elbe in 1815 to visit the exiled ex-emperor. More typical was the case of the sculptor Antonio Canova (1757–1822), who was feted in Rome and Paris by Napoleon and whose appointment as the head of the Accademia di San Luca in 1810 gave him virtual control of the fine arts network in Rome. But Canova's attitude towards Napoleon was always ambiguous; he admired him for unifying Italy and for modernizing its institutions, but at the same time he resented the conquest of his native land and the removal of Italian masterpieces to French soil. His feelings emerge from the colossal nude statue of the emperor that he completed in 1806, showing him as a victorious but unarmed Mars (fig. 10.1).[3] Based on sculptures of ancient rulers in the guise of classical deities, Canova stressed Napoleon's propagandized self-image of 1802–1803 (when it was first conceived) as a primarily peace-giving statesman. Peace with Austria and England and peace with the pope through the Concordat had given Bonaparte overwhelming prestige throughout Europe. The larger-than-life-sized figure of the emperor holds in his right hand a globe of the world surmounted by a statue of Victory, but he has removed his breastplate and sword and set them against a stump of a tree while raising the scepter of rule. The figure walks frontally in the direction of the beholder, but his head is turned to the right, thus giving the work an air of indecisiveness. All the trappings of heroic statuary are present, but the swaying pose and flaccid gestures undermine the traditional projection of heroism.

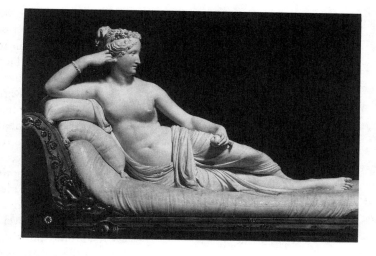

Napoleon himself was unsatisfied with the outcome, and it was sequestered in the Louvre until 1816, when it was purchased by the English government and given as a souvenir to the duke of Wellington.

Canova also provided Napoleon's family with similar grandiose projections, including Letizia Ramolino Bonaparte (Madame Mère; 1804–1808), which was based on the antique statue of Agrippina, and the well-known reclining nude image of Napoleon's sister Pauline Borghese in the guise of Venus (fig. 10.2). While the precedent of the intriguing mother of the emperor Nero may not have been a flattering one for Madame Mère, Canova tried to explain it away on the basis of its superficial formal similarity. Madame Mère gave the statue to Napoleon, wishing it to be placed facing his throne in the Tuileries, but consistent with his resistance to what he perceived to be his mother's meddling, he had it relegated to a storeroom. Canova's use of the antique models for the Bonaparte family had a fashionable and historical side. Madame Mère, for example, was fond of dressing in the classic mode as an example of the latest fashion. At the time of the celebrations of Napoleon's elevation to consul for life, she dressed for one ball as the tragic bacchant Erigone.

Closely attached to his sister, Napoleon arranged Pauline's second marriage with one of the wealthiest Italian princes, Camillo Borghese. The two were married in November 1803 and lived in the Borghese palace in Rome. They drifted apart, however, and Pauline returned to Paris, where she lived an extravagant and high-spirited lifestyle, surrounding herself with theatrical personalities and in-

dulging in amateur-night forms of entertainment. In 1807 Napoleon induced the prince Borghese to sell his family's prize art collection for absorption into the French national collections, and the following year the prince and his wife were given the titles of duc and duchesse de Guastalla, and he became the governor-general of Piedmont and Genoa.

Canova's reclining image of Pauline as Venus Victrix invokes the precedent of David's Madame Récamier, although it is more frankly erotic. Canova was granted the commission the year following the marriage, and he completed it the year of the couple's political advancement. As in the case of her mother, Pauline dressed up in the antique fashion, and Canova shows her nude except for a loose shift loosely thrown over her body, with a hairdo in the style of the antique and the latest Parisian fashion. Pauline-Venus holds the golden apple in her left hand, the symbol of victory. Here there was no mistaking the antique connection, in the equation of the emperor's sister with the goddess of beauty. The sinuosity of the bodily contours and the relaxed pose still manages to convey an image of sensuality and ease of living that squares with the historical accounts.

Canova's ambivalence toward the Bonapartes has been well documented, admiring of the Napoleonic reorganization of Italy but wary of the heavy hand of the despotic ruler. As noted, this ambivalence declares itself in the antique allusions in his effigies of the imperial family. Since Canova was raised on the notion of the antique as the channel for attaining the Ideal, he applied the principle to all of his sculptural projects, regardless of their political destinations. In the end, he is an excellent case study of how artists of a different political persuasion from their patron can nevertheless serve that patron's interests through the formal devices and values assigned them by the institutional network.

Canova's national consciousness, as in the case of the Spanish and German artists, was focused by the presence of Napoleon. When Vittorio Alfieri, the dramatist-patriot who had vociferously opposed foreign domination, died in 1803, Canova enthusiastically accepted the commission for his tomb.[4] The monument was to be installed in the church of Santa Croce in Florence, which enshrined Italy's pantheon of heroes. Canova depicted an allegorical personification of Italy, shown weeping at the side of Alfieri's sarcophagus. The very embodiment of the national idea of Italia was probably not possible before the advent of Napoleon. The patriotic poet Ugo Foscolo stressed the con-

nections between Santa Croce and Alfieri in his poem *I Sepolcri* (The tombs, 1807) while Canova was working on the commission. Foscolo wrote that the tombs were "monuments which will stir present and future generations to throw off the shackles of foreign oppression." Foscolo, Canova, and Alfieri were social conservatives whose romantic nationalism depended on past example rather than on present reality for their objective creations, but the reception of their work in the later stage of the Risorgimento pointed to their ideological possibilities for the middle-class proponents of national regeneration.

Giacomo Spalla

The same ambiguity can be seen in the work of Canova's disciple, Giacomo Spalla (1775–1834), a native of Turin.[5] The center of French influence in Italy was Piedmont, always culturally and materially influenced by its neighbor. Spalla began working for Bonaparte as early as 1804, when he received the order to restore six antique statues for the Palazzo Stupinigi, which Napoleon reserved for his personal use, and two years later he did a pair of medallions of Napoleon and Joséphine. In 1807 he became the official sculptor of Napoleon and curator of the Museo Imperiale in Turin. He also received commissions from the viceroy, Eugène de Beauharnais, including a bust of the emperor for the palace in Milan. There he followed the model designed by the French sculptor Antoine-Denis Chaudet, whose bust became the standard for all official institutions.

In 1807 Spalla was commissioned to execute four bas-relief panels for the Galleria del Beaumont in the Palazzo Imperiale of Turin; the sculptor proposed as his subjects the battles of Marengo, Austerlitz, Jena, and the coronation ceremony at Notre-Dame. Napoleon approved this proposal, and the plaster sketches were delivered early in 1810. Meanwhile, Spalla, ever courting Napoleon's favor, wrote the emperor in May 1809 that he hoped that the sight of his completed projects would induce him to commission more images of his recent victories to transmit to posterity. A brand-new list of subjects for bas-reliefs was drawn up for Spalla, which included the Battle of Eylau, the establishment of the Confederation of the Rhine, the Treaty of Tilsit, the capture of Madrid, and a host of others. While only the Battle of Eylau seems to have been completed, the list indicates Spalla's key role in the emperor's politicization of art.

10.3 Giacomo Spalla, *Battle of Jena*, c. 1810–1813, bas-relief, marble. Palazzo Stupinigi.

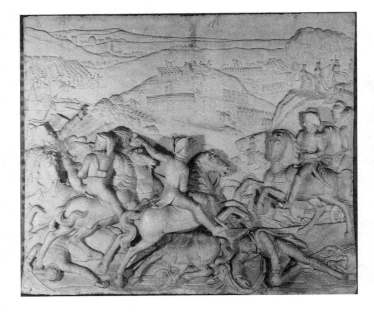

Spalla's bas-reliefs glorify the emperor in the midst of battle or in the aftermath setting the peace terms; invariably Napoleon dominates the central foreground. The *Battle of Jena*, for example, depicts Napoleon on a charging horse on the crest of a hill, looking over the battlefield below (fig. 10.3). He commands the large troop movements and issues orders to his officers. Spalla's figures have the look of miniaturized, toylike characters rather than that of monumental sculpture. There is a distinct preciosity of detail, such as the landscape foliage and the cannon and buildings in the background. Spalla depended upon French prints of the events he depicted, and his work appears like a sculpted version of an engraving. Nevertheless, it is clear that the narrative was uppermost in his mind—the explicit depiction of a historical event. Spalla functioned more like the official historiographer of the Napoleonic court than the official artist.

The *Coronation*, the sketch of which was executed by Spalla's assistant, Amedeo Lavy, borrows consciously from David's immense painting of the same theme (fig. 10.4). It differs mainly in its telescoping of the central portion of the previous work to draw members of the imperial family into the scene. Napoleon gently lays the crown upon Joséphine's head without the dramatic flourish of the David, giving an air of prosaic truth to the ceremony. Here again the miniaturization of the figures and the incredible detail

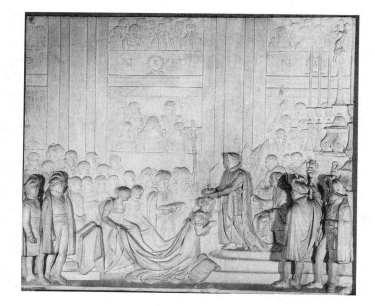

10.4　Giacomo Spalla, *Coronation,* c. 1810–1813, marble. Palazzo Stupinigi, Turin.

(right down to the buckles on the shoes) indicate a desire for historical fact rather than for idealized trumpery.

This is also seen in the *Battle of Eylau,* based on an engraving of the work by Gros (fig. 10.5). The pictorial description in this bas-relief is breathtaking, with even scattered fragments of cannon, wheels, and discharged ammunition shown in bold relief. Napoleon's position is even more prominent in Spalla than in Gros, heightened by the fact that the emperor occupies the compositional center and his horse is moving frontally towards the spectator as he directs his surgeons to care for the wounded. Thus the bas-relief attempts to reconcile a sense of journalistic truth with the need to project a heroic image of Bonaparte.

10.5　Giacomo Spalla, *Battle of Eylau,* c. 1810–1813, bas-relief, marble. Palazzo Stupinigi, Turin.

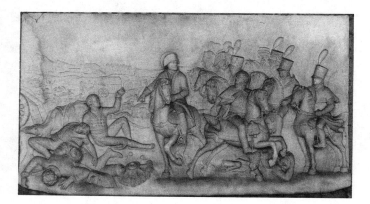

Spalla's dollhouse approach and documentary detail manifest the sobriety of the Piedmontese, whose capital city is unique in Italy for its gridlike development and regularity of construction. Far different from Turin's systematic growth was the evolution of Milan, the capital of Lombardy, whose culture was characterized by the grandiose courts of Barbarossa and the Visconti and Sforza families, and by its extraordinary Gothic cathedral, next to Saint Peter's at Rome and the cathedral at Seville the largest church in Europe. The facade of the huge edifice, founded by the splendor-loving Gian Galeazzo Visconti in 1386, remained incomplete until in 1805 Napoleon (whose marble statue, in antique costume, is among those on the roof) inaugurated a new building campaign. Milan's position as one of the most powerful cities in the Italian states was considerably heightened by Napoleon's decision to make it the capital of the new kingdom of Italy. Consistent with the bombastic character of Milan, Napoleon chose as his leading regional artist Andrea Appiani (1754–1817), who had developed his taste under the guidance of the chief sculptor of the Milan cathedral.

Andrea Appiani

A native of Milan, Appiani had first served Napoleon as a member of the fine arts commission for the Cisalpine Republic, and he aided in the formulation of the new regulations for the Accademia di Milano and the Brera Museum.[6] He became the official portraitist of Napoleon and, following a series of major commissions, was appointed first painter in 1805—the equivalent of David at Paris. His early portrait of Bonaparte as First Consul (Villa Melzi, Bella-

10.6 Andrea Appiani, fresco celebrating Napoleon's victories, 1810–1811. Palazzo Reale, Salon of Caryatids, Milan.

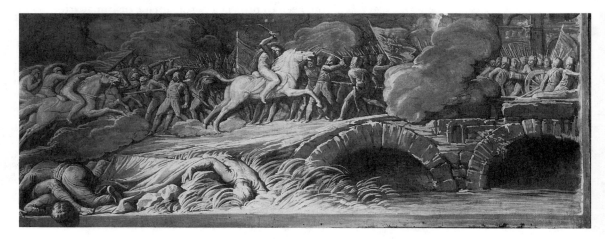

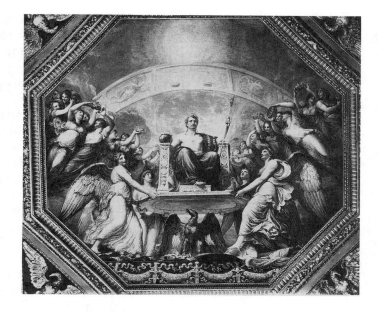

gio) takes off from Gros's precedent representing him as the able tactician and decisive actor. His right hand rests on a map and bridges the northern part of the Italian peninsula, while pointing to it with left index finger. This naturalism is sustained in the period of the consulship and begins to break down after Napoleon becomes emperor. During the period 1803–1807, Appiani executed a monumental monochromatic fresco in the Salon of the Caryatids in the Palazzo Reale (the site of the former residence of the Visconti and Sforza) celebrating Napoleon's victories, which is now known only through engravings. The *Passage of Saint Bernard* is a panoramic view of the French army that rejects Davidian hero-worship in favor of a more practical role for Napoleon and stresses the hardships of the maneuver that made victory possible (fig. 10.6). Actual battle scenes, however, show a sweep and energy opposite to Spalla's modest depictions, portraying Napoleon and his troops hurling apocalyptically through the ranks of their antagonists.

In the period 1808–1810 Appiani completed another series of large-scale frescoes in the Palazzo Reale, the most elaborate of which, done for the vault of the emperor's throne room, was entitled *The Triumph of Jupiter-Napoleon, Dominating the World* (fig. 10.7). An awesome image of baroque pomp, it conflates Flaxman's engravings and the hieratic portrait of Napoleon by Ingres. Appiani's grandiose projection of Napoleon is already anticipated in the

portrait of the newly crowned emperor in Vienna (1805, Kunsthistorisches Museum). Enveloped—or shrouded—in a plethora of imperial wrappings Napoleon reaches uneasily for the crown on the cushion at his left. This residual touch of realism disappears altogether in the Olympian orchestration of Milan. Appiani's mythologizing follows the Parisian line; the reference to Jupiter both hierarchically as deity and symbolically through the eagle in turn inspired Ingres's *Jupiter and Thétis*—an allegory of the emperor's omnipotence done while the French painter resided in Italy. Appiani's ceiling fresco transports us to an Olympian realm where an adoring throng of celestial females (sporting butterfly and angel wings) bear aloft the magnificent throne bearing the Napoleonic deity, and descend to lay kingly crowns at his feet. The throne is adorned with ancient imperial symbols, and beneath the pedestal is the emblem of the serpent biting its tail, signifying the immortality of the Bonapartist dynasty. Perched underneath the airborne throne is the Jovian-Napoleonic eagle, crowned by the serpent emblem like a halo over a saint's head. Indeed, seated in majesty, with his right hand on a globe of the world and his left holding the royal scepter, Napoleon's effigy communicates a power reminiscent of both classical and Christian divinities.

A radiant solar disk above the emperor's head symbolizes his enlightened rule and further identifies him with deific supremacy. Beneath the blazing disk, and arcing over his head like a rainbow, is a zodiacal band with the visible signs of Virgo, Libra, and Scorpio—an idea borrowed from Ingres's portrait of Napoleon. The main allusion is to the eighteenth *brumaire*, 9 November 1800, when Napoleon first seized control of the French government. Upon closer examination, however, the band also encompasses Leo at the extreme left and Sagitarius at the far right, a time spread from 22 July to 21 December that includes the emperor's birthdate (15 August), the signing of the Treaty of Campo Formio (18 October) in which Austria recognized the Cisalpine Republic, and the coronation (2 December). Napoleon's rise to power was decreed in the stars, but his authority will be marked by justice as emphasized in the sign of Libra (balance) just below the solar disk and directly above Napoleon's head. Appiani's heavy-handed allegory defies historical change, declaring the immutable reign of the new sovereign of Lombardy on the very site in which the Visconti and Sforza dynasties once ruled.

Pietro Benvenuti

Tuscany, traditionally the heart and soul of Italian culture, was then ruled by Napoleon's sister, Elisa Baciocchi (née Bonaparte). The first painter to the court of the grand duchess was Pietro Benvenuti (1769–1844), a native of Arezzo.[7] Trained at Rome, he worked in a neoclassical mode modified by the Italian baroque tradition. Highly cultivated in the arts and sciences, Benvenuti was appointed to the chair of painting at the accademia in Florence—a position he held for over forty years. He was never a wholehearted supporter of Napoleon, but labored faithfully for Elisa, whose portrait he painted many times. One of his outstanding official works was his 1813 painting of the grand duchess surrounded by her court, which included her daughter, the young Princess Napoleon.

Napoleon himself took great pains to cultivate the talent of Benvenuti and invited him to Paris in 1809. The Italian painter stayed for several months and met David and his disciples. In 1812 Napoleon commissioned the monumental work entitled *The Oath of the Saxons to Napoleon after the Battle of Jena* (fig. 10.8). The background of the actual event related to Napoleon's desire to separate Saxony from Prussia to protect his flanks. Prior to Jena and Auerstädt, on 10 October 1806, he issued a proclamation to the Saxon people declaring that he had come to deliver them from Prussian domination. The day after the battle of Jena at Weimar he made a similar address to the Saxon officers who had been taken prisoners, offering to allow them and their troops to return home on condition that they took an

10.8 Pietro Benvenuti, *The Oath of the Saxons to Napoleon after the Battle of Jena,* 1812. Galleria d'arte moderna di Palazzo Pitti, Florence.

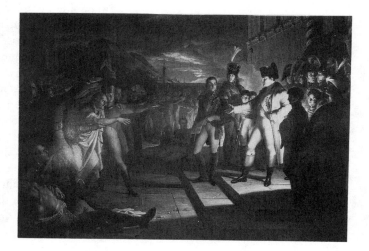

oath never to bear arms against him in the future. This led the Saxon division to separate itself from the Prussians, with whom they had been unwilling allies, especially at Jena. Afterwards, the elector of Saxony (promoted to king by Napoleon) attached himself to the coattails of Bonaparte and was considered a prisoner of war when Saxony was conquered by the allies in 1814. But the relationship between Napoleon and Friedrich August left Saxony in comparative calm during the Napoleonic occupation and explains why the painter Friedrich could work in peace during those years.

The subject clearly invoked the precedent of David's oath pictures, and it is not surprising that Benvenuti drew heavily on the French master's precedent. As in the *Horatii* and *Tennis Court*, the Saxon officers are shown spread-eagle swearing allegiance to the symbol of the state. There are also allusions to Girodet's *Ossian* scene; the grouping of the figures at the left, the bizarre nocturnal effect involving lunar and artificial light, and the variety of facial expressions and dramatic gestures distinctly recall that work. But Benvenuti departs from the Davidian school in his play of medieval elements: the Gothic tower on the horizon and the large crescent moon connect the scene with the work of the young German painters.

Benvenuti's fascination for the light effects anticipates the *Third of May* by Goya and indicates his awareness of Napoleon's novel forms of illumination in the field. While a fire behind the main groups in the fore- and middlegrounds illuminates the background, the main light sources come from tubular torch lamps held by pages on either side of the emperor. Too large and too powerful to be candles, they probably represent some form of oil lamp to brighten the battlefield. The combination of this artificial light and the lunar glow, however, imparts the mood of a mystic ceremony, more like a Satanic rite than the swearing of fidelity to a head of state.

The oath taking is not unqualified: at the left, a young soldier standing in the shadows has to sustain the arm of an old veteran who is supposedly too weak to make the salute, but whose scowl suggests a strong reluctance to swear an oath to the usurper of the German states. The motif has an almost comic quality in the way the hidden officer manipulates the body of the older officer from behind the scenes. The depiction of this blatant hesitation in the oath-taking ceremony, which had such a stirring impact on the public, is unprecedented in the neoclassic tradition and points to

Napoleon's temporal loss of power the year the picture was executed.

It seems clear that the original commission in 1812 was related to the shifting alliances in Germany; Prinz Metternich endeavored to strengthen his position through the princes of the Rhine Confederation, proposing to Saxony, Bavaria, and Württemberg a kind of neutral league that should aim at a peace assuring the independence of Germany. Friedrich August was tempted at that moment to go over to the other side, but Napoleon's threats brought him back into line. An important contingent of Saxon troops marched with Napoleon's army into Russia two months later. Benvenuti's painting may very well have been ordered as a reminder of the original commitment, most likely for the benefit of Tuscan and French audiences. Tuscany had suffered under Austrian rule prior to Napoleon, and Metternich's machinations might well have been spotlighted as a warning to the people of central Italy. When the work was completed, it was exhibited first at the accademia in Florence and then shipped to Paris. But the weakening position of Napoleon that year is manifested in the contradictions of the picture: even while exalting the emperor, Benvenuti almost willfully subverts the tradition upon which he generously drew for his inspiration. Ironically, Benvenuti reclaimed his painting after Napoleon's collapse: the artist was sent to Paris as part of a delegation to recover Tuscan masterpieces looted by Bonaparte and in the process discovered his own work and had it returned to Florence.

Vincenzo Camuccini

The major painter at Rome was Vincenzo Camuccini (1771–1844), a student of Pompeo Batoni and the most admired neoclassicist in the papal states.[8] Elected to the Accademia di San Luca in 1802, he became its head (*principe*) in December 1805. His official position and talent made him, next to his rival Canova, the most influential and sought-after artist in Rome in this period. Napoleon's contingent sought his allegiance, and he worked for both the emperor and his brother-in-law, Murat, king of Naples.

In 1811 Camuccini headed the list of Italian painters selected to decorate the Palazzo del Quirinale for Napoleon's proposed visit to Rome early in 1812.[9] Elaborate preparations were made for a triumphal sojourn in the Eternal City. The ex-pontifical palace—vacant since Pius VII had been escorted to France—required a whole new set of dec-

10.9 Vincenzo Camuccini, *Charlemagne Summoning Italian and German Scholars to Found the University of Paris*, 1811–1813. Palazzo di Montecitorio, Rome.

orations. This is the same commission for which Ingres painted *The Dream of Ossian* and *Romulus, Conqueror of Acron*. Camuccini's two projects were intended for the emperor's apartment, whose decorative cycle was planned around the theme of state patronage of arts and letters throughout history. Camuccini depicted *Charlemagne Summoning Italian and German Scholars to Found the University of Paris* and *Ptolemy II Philadelphus among Scholars Brought to the Library of Alexandria*—both making clear allusions to Napoleon's energetic patronage of academic and educational institutions (figs. 10.9–10). The head and pose of Ptolemy recall Canova's statue of Napoleon as the peace-giving Mars, an approach used consistently in the Quirinale's decorative program, as in the case of Paul Duqueylar's *Trajan Distributing the Scepters of Asia*, which depicts the historical emperor with the traits of Bonaparte. That the new sovereign wished to cultivate his image in Italy as a renaissance patron of the arts, letters, and sciences is shown by the allegorical commission awarded to Laurent Pencheux, a French painter living in Piedmont: *Napoleon, Creator of the Imperial University of Turin*. In addition, any representation of Charlemagne in this period would have automatically invoked Napoleon, since the two were linked in song, picture, and rhetoric. When Napoleon issued the imperial decree annexing Rome to the empire, he specifically referred to the example "of Charlemagne, our august predecessor." Camuccini's commissions participated in the didactic

scheme of the emperor, which constituted a historical pre-figuration of the current empire. Napoleon's performance was equated with that of the most renowned leaders in history.

Napoleon placed great emphasis on the symbolic character of his presence in Rome; in 1810 he made it the second capital of the empire, and in 1811 he named his son the king of Rome. Unfortunately, preparations for the Russian campaign and its stupendous disaster prevented a sojourn in Rome, and he never gained another opportunity. In March 1814 the pope returned to Rome and quickly abrogated the changes wrought by Bonaparte, restoring government by priests. On 26 September 1815 the emperors of Russia and Austria and the king of Prussia entered into a pact known as the Holy Alliance, which proclaimed that their official conduct would be regulated by the principles of the Christian religion. This bolstered the prestige of the pope and facilitated the support of the returning Bourbon dynasty. Rome was once more the center of the Holy Roman Empire—symbolically, if not in fact.

The papal states returned to their previous state of reaction with one major qualification: things could never be entirely the same after having been subject to the Bonapartist system, which had ushered in a climate of liberalism that would henceforth be a standard of justice and liberty. Autocratic as it was, Napoleon's administration in Italy was

10.10 Vincenzo Camuccini, *Ptolemy II Philadelphus among Scholars Brought to the Library of Alexandria*, 1811–1813. Palazzo di Montecitorio, Rome.

not without redeeming benefit. He represented a clear advance over the papacy, the Austrians, and the Bourbons. The emphasis on merit as opposed to birth and privilege attracted able officials from the middle classes, and civilians succeeded to ecclesiastics in every branch of government. The *Code Napoléon* eliminated an almost medieval legal system in most parts of Italy and recognized—at least in principle—the rule of equality before the law.

In addition to the uniform system of law, Napoleon broke down the old boundaries over most of Italy, swept away local prejudices (in Rome he gave the Jews their freedom), and gave the population its first glimmer of national consciousness. Italians began to think of themselves as Italians rather than Piedmontese or Tuscans. In the south of Italy the worst features of feudalism were eliminated. His treatment of the church showed to all the world that the possession of temporal power was not necessary for the church's spiritual function. Privileges and exemptions were minimized whether of nobility or ecclesiastics, and all had to contribute to meet Napoleon's economic demands. Napoleon encouraged middle-class talent, and many Italians who later became prominent received their training outside Italy in the service of the empire. Italy's fortunes were directly tied to the rest of Europe and contemporary political, cultural, scientific, and social currents.

Sixty thousand Italian youths died in the battlefields of Spain and Russia; certainly the country was not sorry to see Napoleon disappear. Except as cannon fodder he had scarcely noticed the peasantry, but by teaching the youth of the country to fight, he prepared them for the national uprisings of the ensuing decades. Ongoing military campaigns and conscriptions taught Italians the latest fighting techniques; for the first time in centuries an army of Italians, led by Italian officers trained in France, had fought with distinction on the battlefields of Europe. Many veterans of these battles would also participate in the Italian struggle for independence known as the Risorgimento, or "resurgence." Under Napoleon they had fought for the kingdom of Italy. The Lombard and Piedmontese who marched side by side with the Tuscan and Neapolitan perceived their common interests and kindred heritage exactly as in the case of the Germans during the Wars of Liberation. Above all, future liberals observed that petty princes and even the pope himself—whom they had always regarded as necessary and inevitable—could be deposed by a strong and united front. In such a way Napoleon made substantial

contributions to the movement for national unity and independence.

Inadvertently, Bonapartism created another institution furthering the aims of the Risorgimento: the secret societies known as the Carbonari, or "charcoal burners."[10] The Carbonari were actually an offshoot of Italian Freemasonry, from which they borrowed many of their terms, rituals, and signs. They had developed out of opposition to the despotism of Napoleon, but their creed was aimed at the expulsion of all foreigners. They never produced a popular leader or an effective body of troops, but they penetrated everywhere, so that in the last phase of the empire neither Murat in the south nor Beauharnais in the north could rely wholeheartedly on the trustworthiness of his subordinates. Besides this, the one valuable work they performed was to hold fast to the idea of independence and to spread it unceasingly among all classes of the community. No one who joined a secret society, with all its paraphernalia of oaths and signs, was very likely to forget that he or she had sworn to achieve Italian independence. This idea of independence under a constitution was so often reiterated, with such dramatic flourish, that it worked its way into the very fabric of the national consciousness.

Thus, although Napoleon and the secret societies were in bitter opposition, each was in actuality complementing the other in laying the foundations for a national consciousness—Napoleon clearing the site and the Carbonari providing the program. When all dreams of any immediate realization of their aims were dissipated by the Restoration in 1815, the secret societies remained the hidden repository for the hopes of Italian independence. It is no wonder that in the reactionary aftermath of the pontiff's return to Rome, the Sacred College—led by Napoleon's archenemy Cardinal Bartolomeo Pacca—obtained the condemnation of the Freemasons and the Carbonari.

The conservatives who dominated the Congress of Vienna and orchestrated the Restoration viewed Christianity as the source of Europe's strength, and Christian fear as a necessary brake on individual pride and selfishness. Naturally, they wished to rationalize their own domination and thus declared that without religion society would dissolve into revolution and anarchy. Conservatives therefore connected religion with their own politics, attaching the church to aristocracy and monarchy. A political battle became a showdown between Christendom and paganism. Such views gave conservatives a militancy and depth on be-

half of their own self-preservation. Only authority could check the selfish wills of individuals, and authority required undivided sovereignty, social hierarchy, and the vigilant suppression of subversive ideas. Church and state must be closely linked, they declared, and they held that the international authority of the papacy was a social necessity.

As a result, Rome enjoyed a new prestige. Artists from every western country would make the pilgrimage, not only for the sake of the Grand Tour but for the latest political alignments. Even the second-generation German romantics, well aware of their predecessors' loathing for the voyage to Rome, journeyed to the Eternal City as part of a concerted movement. They carried their medievalism to much greater lengths, even to the extent of forming a monastic brotherhood known as the Nazarenes. But their medievalism was an aesthetic complement to the forces of reaction. They helped shape the ideology of the allies who now envisioned themselves as latter-day crusaders. Similarly, the zealous artists who established residence in Rome defended the alliance of Throne and Altar. The story of this development, with its conservative—albeit energetic—extension of the medieval revival, is told in the next volume in this series.

Notes

Chapter One

1. A. Fournier, *Napoleon the First* (New York, 1903), 106.
2. *Description de l'Egypte; ou, Recueil des observations et des recherches qui ont été faites en Egypte pendant l'expédition de l'armée française, publié par les ordres de sa majesté l'empereur Napoléon le Grand*, 23 vols. (Paris, 1809–1828).
3. Ibid., p. i.
4. Ibid., p. xcii.
5. See R. Rosenblum, "Painting under Napoleon, 1800–1814," in *French Painting 1774–1830: The Age of Revolution* (Detroit, 1975), 161–173; H. Grant, *Napoleon and the Artists* (London, 1917). For an excellent general study of Napoleonic culture see W. Markov, *Die Napoleon-Zeit: Geschichte und Kultur des Grand Empire* (Leipzig, 1985). See also R. B. Holtman, *Napoleonic Propaganda* (Baton Rouge, La., 1950), 145–168.
6. Grant, p. 131.
7. For a solid study of the Vendôme Column see the series of articles by J. Dementhe, "Histoire de la Colonne," *L'Illustration* 62 (16, 23, and 30 August, 6 and 13 September 1873).
8. L. de Fourcaud, *François Rude sculpteur, ses oeuvres et son temps (1784–1855)* (Paris, 1904), 165–182.
9. Humboldt lived mainly in Paris during the years 1804–1827, where he worked closely with French scientists and also with artists who drew his illustrations. See L. Kellner, *Alexander von Humboldt* (London, 1963), 66–77; H. de Terra, *The Life and Times of Alexander von Humboldt, 1769–1859* (New York, 1955), 193–195.
10. J. Bosscha, *La correspondance de A. Volta et M. van Marum* (Leiden, 1905), 143–145.
11. F. Boyer, "Napoléon et l'attribution des grands prix décennaux 1810–1811," *Bulletin de la Société de l'histoire de l'art français* (1947–1948), 66–72.
12. A. Boime, "The Prix de Rome: Images of Authority and Threshold of Official Success," *Art Journal* 44 (Fall 1984), 286.

13. The bible of the empire style was the famous *Recueil de décorations intérieures* by Charles Percier and Pierre-François-Leonard Fontaine, Napoleon's architects. It appeared in 1812 and shows how antique forms were adopted to glorify the reign of Bonaparte. For example, they conceived of the council chamber at Malmaison "in the form of a tent, supported by pikes, *fasci,* and insignia, recalling those of the most famous warrior peoples of the world."

14. S. Grandjean, "Napoleonic Tables from Sèvres," *Connoisseur,* May 1959, 147–153.

15. For a reproduction, see Musée Carnavalet, *Alexandre-Théodore Brongniart* (Paris, 1986), 237.

16. The tables were listed as numbers 501 and 701 in the Salon catalogue. I am grateful to Barry Shifman for bringing this information to my attention.

17. The Arts Council of Great Britain, *The Age of Neo-classicism* (London, 1973), 744–745, no. 1600. Napoleon's clockmaker, Jean-Joseph Lapaute (1768–1846), designed a clock in a Sèvres porcelain mount in the form of the column of the Place Vendôme. Napoleon made the gift of one of these to his officer, Maréchal Ney. See ibid, pp. 754–755, no. 1615.

18. P. J. B. P. Chaussard, *Le Pausanias français* (Paris, 1806), 449–451.

19. Ibid., pp. 450–451. See J. Brédif, *Printed French Fabrics: Toiles de Jouy* (New York, 1989), for an illustrated history of the Oberkampf factory.

20. Vivant Denon, *Voyage dans la basse et la haute Egypte, pendant les campagnes du général Bonaparte,* 2 vols. (Paris, 1802); C. Truman, *The Sèvres Egyptian Service 1810–1812* (Kent, 1982), 6, 8–9, 19.

21. R. G. C. Ledoux-Le Bard, "Les dessins de Benjamin Zix: Denon entouré d'objets d'art au Louvre et leur intérêt pour l'art napoléonien," *Bulletin de la Société de l'histoire de l'art français,* (1950), 57–64.

22. K. C. Lindsay, *The Works of John Vanderlyn* (Binghamton, N.Y., 1970); Y. Bizardel, *American Painters in Paris* (New York, 1960), 52–56, 95–97.

23. S. Y. Edgerton, Jr., "The Murder of Jane McCrea: The Tragedy of an American *Tableau d'histoire,*" *Art Bulletin* 47 (1965), 481–492. Two years later Napoleon would officially put a premium on sculptural works that humiliated England and Russia: see Grant, p. 136.

24. J. A. Holden, "Influence of Death of Jane McCrea on Burgoyne Campaign," *New York State Historical Association Proceedings* 12 (1913), 249–310.

25. J. Barlow, *The Columbiad* (Philadelphia, 1807), 239.

26. K. C. Lindsay, p. 71.

27. F. Markham, *Napoleon* (New York, 1966), 132.

28. *Correspondence of Aaron Burr and His Daughter Theodosia,* ed. M. Van Doren (New York, 1929), 216–217. He was vindicated by his Knickerbocker admirer, Fitz-Greene Halleck, who once on his Broadway strolls "thought of Bonaparte and Belisarius, Pompey,

and Colonel Burr, and Caius Marius." See F.-G. Halleck, *The Poetical Writings* (New York, 1869), 454–455.

Chapter Two

1. P. Larousse, *Grand dictionnaire universel du XIXe siècle,* 17 vols. (Paris, 1866 et seq.) vol. 3, part 1, p. 237.
2. P. J. B. P. Chaussard, *Le Pausanias français* (Paris, 1806), 183–188.
3. G. Duruy, ed., *Mémoires de Barras,* 4 vols. (Paris, 1895–1896), 1:56–59.
4. J. L. Jules David, *Le peintre Louis David (1748–1825): Souvenirs & documents inédits* (Paris, 1880), 393.
5. L. Junot [duchesse d'Abrantès], *Memoirs of Napoleon, His Court and Family,* 2 vols. (New York, 1895), 1:222.
6. Ibid., 343.
7. The *machine infernale* was a complicated explosive device installed in a cart in the Rue Niçaise on the route from the Tuileries to the Opéra, where Napoleon was on his way on 24 December 1800 to attend a performance of Haydn's oratorio *The Creation.* Napoleon and Josephine escaped the explosion by seconds, but many others in his party were killed or wounded.
8. Chaussard, p. 163.
9. Chaussard, pp. 353–360.
10. David, pp. 428–429.
11. Cited in M. Delafond, *Louis Boilly: 1761–1845* (Paris, 1984), 47–48.
12. A. Mabille de Poncheville, *Boilly* (Paris, 1931), 116–117.
13. A. Boime, "Declassicizing the Academic: A Realist View of Ingres," *Art History* 8 (March 1985), 53–54; R. Rosenblum, *Jean-Auguste-Dominique Ingres* (New York, 1967), 68.
14. This was inspired to large extent by J. L. Connolly, Jr., "Ingres and Allegory," a talk delivered at the College Art Association, January 1970.
15. Chaussard, pp. 177–182.
16. Anonymous, "Duke of Hamilton and Brandon, K. G.," *Gentleman's Magazine,* n.s., vol. 38 (October 1852), 424–425.
17. H. Grant, *Napoleon and the Artists* (London, 1917), 155.
18. J. MacPherson, *The Works of Ossian, the Son of Fingal,* 2 vols. (London, 1765), 1:v–vi, viii.
19. P. Van Tieghem, *Ossian en France,* 2 vols. (Paris, 1917), 2:14–15.
20. H. Toussaint, "Ossian en France," in *Ossian,* ed. H. Hohl and H. Toussaint (Paris, 1974), 73–74.
21. MacPherson, 1:345; M. Le Tourneur, *Ossian, fils de Fingal, barde du troisième siècle: Poésies galliques,* 2 vols. (Paris, 1777), 1:270–271.
22. See R. Rosenblum's biography and entry in *French Painting 1774–1830: The Age of Revolution,* ed. F. J. Cummings, P. Rosenberg, and R. Rosenblum (Detroit, 1975), 345–347, no. 19.
23. Chaussard, pp. 259–264.
24. See G. Lacambre's biography and entry, *French Painting 1774–1830,* pp. 347–348, no. 20.
25. H. Okun, "Ossian in Painting," *Journal of the Warburg and Cour-*

tauld Institutes 30 (1967), 346; G. Levitine, *The Dawn of Bohemian-ism* (University Park, Pa., and London, 1978), 111–113.

26. E. J. Delécluze, *Louis David, son école & son temps: Souvenirs* (Paris, 1860), 95, 425–428.

27. See P. A. Coupin, *Oeuvres posthumes de Girodet-Trioson,* 2 vols. (Paris, 1829), 2:284–297; G. Levitine, *Girodet-Trioson: An Icono-graphical Study* (New York, 1978). Girodet's explanation to Bo-naparte (25 June 1802) reveals the true meaning of Ossian for con-temporaries: "I have tried to trace the *apothéose des héros* for whom France mourns."

28. G. Levitine, "L'*Ossian* de Girodet et l'actualité politique sous le Consulat," *Gazette des Beaux-Arts,* 6e pér., vol. 48 (October 1956), 39–56.

29. Ibid., p. 53.

30. See B. M. Stafford, "Les 'météores' de Girodet," *La Revue de l'Art,* no. 46 (1979), 46–51.

31. P. Bertholon, *De l'électricité des météores,* 2 vols. (Paris, 1787).

32. M. de Rome de L'Isle, *Cristallographie, ou description des formes propres à tous les corps du règne mineral,* 3 vols. (Paris, 1783), 2:310–311.

33. C. C. Gillispie, *Genesis and Geology* (Cambridge, Mass., 1951), 42–49.

34. See D. Berthelot, "Eclairage," *La grande encyclopédie,* 31 vols. (Paris, 1886–1902), 15:339–340.

35. D. Ternois, "Napoléon et la décoration du palais impérial de Monte Cavallo en 1811–1813," *Revue de l'art* 7 (1970), 68–89.

36. MacPherson, 1:157.

37. Ibid.

38. See the entry by Jacques Foucart in *French Painting 1774–1830,* pp. 419–422.

39. Ibid., p. 421.

40. G. Grappe, *P.-P. Prud'hon* (Paris, 1958), 171.

41. Ibid., pp. 228–229; C. Clément, *Prud'hon, sa vie, ses oeuvres, et sa correspondance* (Paris, 1872), 314–321; H. Weston, "Prud'hon: Jus-tice and Vengeance," *Burlington Magazine* 117 (1975), 353–363. One critic observed that the painting expressed as well as a paint-ing could the functions of the court, and that it would set an ex-ample of "salutary terror" for criminals as well as salon viewers. See M. B., "Beaux-Arts, Salon de 1808, no. 6," *Journal de L'Em-pire* (3 November 1808).

42. "Mouvement des arts et de la curiosité," *Gazette des Beaux-Arts* 6 (1860), 310–312; S. Laveissière, "Prud'hon: La Justice et la Ven-geance divine poursuivant le Crime," *La revue du Louvre* 36, no. 2 (1986), 153–154. Prud'hon's letter on the subject stresses the court's fearful reprisal and its "crushing verdict" which strikes the guilty with death.

43. P. Manuel, *La police de Paris dévoilée,* 2 vols. (Paris, 1793), frontis-piece, vol. 1.

44. F. Markham, *Napoleon* (New York, 1966), 113.

45. A. W. Ward, G. W. Prothero, and S. Leathes, eds., *The Cambridge Modern History,* 13 vols. (Cambridge, 1934), 9:172–173.

46. Ibid., p. 176. This is confirmed by the duchesse d'Abrantès, who reported that people fearful of crime looked to Bonaparte as someone who "would take justice" into his own hands, and that Napoleon himself thought that civil crimes should be "instantly revenged by the laws": Junot, pp. 218–220.

47. D. Wakefield, "Chateaubriand's 'Atala' as a Source of Inspiration in Nineteenth-Century Art," *Burlington Magazine* 120 (1978), 13–22.

48. Markham, p. 93.

49. R. Rosenblum, *Transformations in Late Eighteenth-Century Art* (Princeton, 1974), 95–97; W. Friedlander, "Napoleon as 'Roi Thaumaturge,'" *Journal of the Warburg and Courtauld Institutes* 4 (1940–1941), 139–141.

50. There is debate over whether the seventeenth-century building that housed the makeshift hospital was a mosque or an Armenian monastery. See H. H. Mollaret and J. Brossollet, "A propos des 'Pestiférés de Jaffa' de A. J. Gros," *Jaarboek Koninklijk Museum voor Schone Kunsten* (Antwerp, 1968), 263–307, esp. 292.

51. J. H. Dible, *Napoleon's Surgeon* (London, 1970), 31–32.

52. R. G. Richardson, *Larrey: Surgeon to Napoleon's Imperial Guard* (London, 1974), 63.

53. Chateaubriand, *De Buonaparte, des Bourbons, et de la nécessité de se rallier à nos princes légitimes, pour le bonheur de la France et celui de l'Europe* (Paris, 1814), 15.

54. J. Dillenberger, *Benjamin West: The Context of His Life's Work* (San Antonio, 1977), 79–83.

55. H. Honour, *Neo-classicism* (Harmondsworth, 1968), 186, 207.

56. See his main work, H.-B. de Saussure, *Voyages dans les Alpes,* 4 vols. (Geneva, 1779–1786).

57. Ibid., 1:ii.

58. J. A. Deluc, *Letters on the Physical History of the Earth, Addressed to Professor Blumenbach: Containing Geological and Historical Proofs of the Divine Mission of Moses* (London, 1831); Deluc, *Lettres physiques et morales sur l'histoire de la terre et de l'homme adressées à la reine de la Grande Bretagne,* 3 vols. (Paris, 1779); Deluc, *An Elementary Treatise on Geology* (London, 1809).

59. Gillispie, pp. 42, 74, 271.

60. Coupin, 1:101–102; G. Levitine, "The Influence of Lavater on Girodet's *Expression des sentiments de l'âme,*" *Art Bulletin* 36 (1954), 33–44. Lavater's essays constituted a kind of "semiotics of the head" and passed for a semiscientific system.

61. G. Levitine, "Some Observations on *The Deluge:* Ambiguity and Invention," Panstwowe Wydawnictwo Naukowe, *Ars Auro Prior, Studia Ioanni Bialostoscki,* Sexagenario Dicata (Warsaw, 1981), 619.

62. See Levitine, "Some Observations," pp. 619–623, and Coupin, 2:343–344.

Chapter Three

1. A. Cunningham, *The Life of Sir David Wilkie,* 3 vols. (London, 1813), 1:104–105.

2. A. S. Byatt, *Wordsworth and Coleridge in Their Time* (London, 1970), 74–76.

3. Ibid., p. 90.

4. S. T. Coleridge, *The Complete Poetical Works,* ed., E. H. Coleridge, 2 vols. (Oxford, 1968), 1:197, lines 248–252.

5. Ibid., p. 246, lines 64–71.

6. Ibid., p. 262, lines 182–197.

7. S. T. Coleridge, *Essays on His Times,* ed. D. V. Erdman, 3 vols. (Princeton, 1978), vol. 3, part 2, p. 76.

8. M. Butlin and E. Joll, *The Paintings of J. M. W. Turner,* 2 vols. (New Haven and London, 1977), 1:6–7, no. 10.

9. J. Macpherson, *The Works of Ossian, the Son of Fingal,* 2 vols. (London, 1765), 1:136–147.

10. Butlin and Joll, p. 39, no. 58.

11. Turner monitored the news of the Napoleonic wars, which engaged his deepest interest: see W. Thornbury, *The Life of J. M. W. Turner* (London, 1904), 109.

12. Ibid., p. 93.

13. H. von Erffa and A. Staley, *The Paintings of Benjamin West* (New Haven and London, 1986), 222.

14. Ibid., pp. 220–225, nos. 108–111.

15. J. Thomson, *The Poetical Works,* 2 vols. (London, 1847), 1:178–179.

16. Most of the Alpine geologists and explorers commented upon Hannibal's crossing: see H.-B. de Saussure, *Voyages dans les Alpes,* 4 vols. (Geneva, 1779–1786), 2:434 ff.; J. A. Deluc, *Letters on the Physical History of the Earth Addressed to Professor Blumenbach: Containing Geological and Historical Proofs of the Divine Mission of Moses* (London, 1831; originally appeared in the *British Critic,* 1793–1795), 2. Deluc's nephew, M.-J.-A. de Luc, was a geologist who wrote *Histoire du passage des Alpes par Annibal.*

17. Butlin and Joll, pp. 79–80, no. 126. One of the best discussions of the work remains J. Lindsay, *Turner: His Life and Work* (New York, 1966), 117–122. See also L. R. Matteson, "The Poetics and Politics of Alpine Passage: Turner's *Snowstorm: Hannibal and His Army Crossing the Alps,*" *Art Bulletin* 62 (1980), 385–398.

18. Thornbury, pp. 430–431.

19. Napoleon himself encouraged this association: one of his ablest generals, Guillaume de Vaudoncourt, published a history of Hannibal's Italian campaigns that reflected this preoccupation. It appeared the year Turner exhibited his picture. See G. de Vaudoncourt, *Histoire des campagnes d'Annibal en Italie,* 3 vols. (Milan, 1812). Ironically, Georges Cadoual, who fomented domestic insurrection against Napoleon and was supported by the English, reminded his friends that Bonaparte could be defeated in Paris as

Hannibal defeated the Romans in Italy. See P. de Polnay, *Napoleon's Police* (London, 1970), 80.

20. E. P. Thompson, *The Making of the English Working Class* (New York, 1966), 484–602. The Luddite movement, which, Thompson claims, gave rise to the working-class "presence," was particularly strong in Yorkshire. See also C. Calhoun, *The Question of Class Struggle* (Chicago, 1982), 60–72.

21. Thornbury, 168.

22. Thomson, 2:217–218, 223.

23. *Transactions of the Geological Society* 1 (1811), vi–viii. Typically, the society claimed ascendance with a flourish of chauvinistic sentiment: "No country contains, within an equal space, a greater variety of mineral substances; while our long and broken line of coast, and our numerous mines, furnish the most ample opportunities of making geological observations."

24. J. F. Berger, "Observations on the Physical Structure of Devonshire and Cornwall," *Transactions of the Geological Society* I, pp. 110–11; Butlin and Joll, p. 86.

25. Thornbury, p. 236.

26. J. MacCulloch, "On Staffa," *Transactions of the Geological Society* 2 (1814), 501–509.

27. J. MacCulloch, *A System of Geology, with a Theory of the Earth, and an Explanation of Its Connection, with the Sacred Records,* 2 vols. (London, 1831; originally published 1821), 2:481–482.

28. D. Hill, *In Turner's Footsteps* (Salem, N.H., 1984), 17–18.

29. During his Yorkshire tour of 1800 Turner sketched steam engines at Coalbrookdale, the Swansea copper works, and the iron foundries of Abraham Darby at Madeley Wood. See Thornbury, pp. 473–474.

30. A. Young, *Arthur Young and His Times* ed. G. E. Mingay (London, 1975), 145.

31. Turner was fascinated by de Loutherbourg's effects: Thornbury, p. 112.

32. C. Johnstone, *John Martin* (London, 1974), 13.

33. T. Balston, *John Martin, 1789–1854: His Life and Works* (London, 1947), 131.

34. M. L. Pendered, *John Martin, Painter: His Life and Times* (London, 1923), 196–215; F. D. Klingender, *Art and the Industrial Revolution* (London, 1975), 106–109.

35. Pendered, p. 89.

36. C. Morell [James Ridley], *The Tales of the Genii; or, the Delightful Lessons of Horam, the Son of Asmar,* 2d ed., 2 vols. (London, 1764). The work was dedicated to the Prince of Wales: "As this work is designed to promote the Cause of Morality, I have presumed to lay it at the Feet of your Royal Highness; whose early Entrance into the Paths of Virtue, under the Conduct of an Illustrious and Royal Mother, and the Direction and Auspices of the best of Fathers and of Kings, has encouraged me to hope, that these Tales will hereafter meet with your Royal Highness's Approbation."

37. Ibid., 1805 ed., 1:xxxii.

38. Ibid., pp. xxxii–xxxiii.

39. B. Alexander, *William Beckford, England's Wealthiest Son* (London, 1962).

40. W. Beckford, *Vathek: An Arabian Tale* (London, 1900), 5–6. *Vathek* originally appeared in 1786.

41. M. Kitson, "Turner and Claude," *Turner Studies* 2 (Winter 1983), 5. See also J. Ziff, "Copies of Claude's Paintings in the Sketch Books of J. M. W. Turner," *Gazette des Beaux-Arts,* 6e pér., vol. 65 (1965), 51–64.

42. Butlin and Joll, pp. 9–10, no. 13.

43. Thomson, 2:102.

44. E. T. Cook and A. Wedderburn, eds., *The Works of John Ruskin,* 39 vols., (London, 1903–1912), 3:240–241.

45. R. Russell, *Guide to British Topographical Prints* (London, 1979).

46. Thornbury, p. 71.

47. See most recently A. Wilton, "The 'Monro School' Question: Some Answers," *Turner Studies* 4 (Winter 1984), 8–23. While Monro's collection contained a large number of Turner sketches, the sum barely touches on the intensity of the painter's production for the physician. Monro had financial investments in several madhouses and ran them strictly for profit, being more considerate of "gentleman lunatics" than of "pauper lunatics." He purged and bled indiscriminately, and eventually his brutalization of the poorer patients led to his dismissal from Bethlem (Bedlam) Hospital. See K. Jones, *Lunacy, Law, and Conscience 1744–1845: The Social History of the Care of the Insane* (London, 1955), 92–95, 105, 112–113, 146.

48. J. Gage, *Colour in Turner: Poetry and Truth* (London, 1969), 25.

49. Ibid., pp. 25, 54 ff., 62.

50. Ibid., p. 81. Turner literally documented the operations of the large landowning patrons including ploughing, harrowing, hedging, ditching, felling trees, and sheep washing.

51. W. Angus, *The Seats of the Nobility and Gentry in Great Britain and Wales in a Collection of Select Views Engraved by W. Angus from Pictures and Drawings by the Most Eminent Artists with Descriptions of Each View* (Islington, 1787–1811), plate L.

52. A. J. Finberg, *The Life of J. M. W. Turner, R.A.* (Oxford, 1961), 60–61.

53. Thornbury, pp. 91, 112, 472; J. Gage, ed., *Collected Correspondence of J. M. W. Turner* (Oxford, 1980), 50–51. A Turner letter to John Britton in 1811 makes a distinction between "Elevated Landscape" and "Map Making."

54. W. Mason, *The English Garden: A Poem* (Dubin, 1772), 4.

55. See W. D. Templeman, *The Life and Work of William Gilpin* (Urbana, Ill., 1939); C. P. Barbier, *William Gilpin* (Oxford,
56. 1963).

57. Barbier, p. 145.

W. Gilpin, *Observations, on Several Parts of England, Particularly the Mountains and Lakes of Cumberland and Westmoreland, Relative*

Chiefly to Picturesque Beauty, Made in the Year 1772, 2 vols. (London, 1808), 2:43.

58. Ibid.

59. Ibid., p. 45.

60. Ibid., pp. 263–264. See also his comments on Boulton's iron manufactory: 1:57.

61. W. Gilpin, *Moral Contrasts; or, the Power of Religion Exemplified under Different Characters* (Lymington, England, 1798), iii.

62. Gilpin, *Observations, on Several Parts of England*, pp. viii–ix.

63. Gilpin, *Observations, on Several Parts of England*, 1:viii–xi.

64. W. Gilpin, *Observations on Several Parts of the Countries of Cambridge, Norfolk, Suffolk, and Essex. Also on Several Parts of North Wales; Relative Chiefly to Picturesque Beauty, in Two Tours, the Former Made in the Year 1769, the Latter in the Year 1773* (London, 1809), 120–121, 174; ibid., 1:xvii–xviii.

65. W. Gilpin, *Observations on the River Wye, and Several Parts of South Wales, etc., Relative Chiefly to Picturesque Beauty; Made in the Summer of the Year 1770* (London, 1792), 47.

66. R. Turner, *Capability Brown and the Eighteenth-Century English Landscape* (New York, 1985), 78.

67. Gilpin, *Observations, on Several Parts of England*, pp. 7–8.

68. W. Gilpin, *Observations on the Coasts of Hampshire, Sussex, and Kent, Relative Chiefly to Picturesque Beauty: Made in the Summer of the Year 1774* (London, 1804), 20–21.

69. W. Gilpin, *Three Essays: On Picturesque Beauty; on Picturesque Travel, and on Sketching Landscape: To Which is Added a Poem, on Landscape Painting,* (London, 1792; paginated separately), p. 16.

70. J. Farington, *Diary*, 6 vols. (New Haven and London, 1978 et seq.), 4:1129.

71. See D. Hall, "The Tabley House Papers," *Walpole Society* 38 (1960–1962), 59–122; S. Whittingham, "A Most Liberal Patron: Sir John Fleming Leicester, Bart., 1st Baron de Tabley, 1762–1827," *Turner Studies* 6 (Winter 1986), 24–36.

72. G. Jackson-Stops, ed., *The Treasure Houses of Britain,* (Washington, D.C., 1985), 584, no. 520.

73. D. H. Solkin, *Richard Wilson: The Landscape of Reaction* (London, 1982), 231, no. 124.

74. Butlin and Joll, p. 62.

75. Finberg, pp. 159, 168.

76. A. Young, *Autobiography* (London, 1898), 315, 363, 434–435; Jackson-Stops, p. 614, no. 547.

77. Gilpin, *Observations, on Several Parts of England*, pp. 11–12.

78. Butlin and Joll, pp. 73–74, no. 116.

79. Finberg, p. 189. This followed a conversation on the merits of Turner's *Hannibal*, exhibited that year at the Royal Academy.

80. Gilpin, *Three Essays*, p. 87.

81. Finberg, pp. 164–173.

82. I have found very useful the recent works on Constable: J. Barrell, *The Dark Side of the Landscape* (New York, 1980), 131–164; M. Rosenthal, *Constable: The Painter and His Landscape* (New Haven

and London, 1983); R. Paulson, *Literary Landscape: Turner and Constable* (New Haven and London, 1982); M. Cormack, *Constable* (Cambridge, 1986); A. Bermingham, *Landscape and Ideology* (Berkeley and Los Angeles, 1986), 87–155.

83. *John Constable's Correspondence,* ed. R. B. Beckett and (for vol. 7) L. Parris, C. Shields, and I. Fleming-Williams, 7 vols. (Ipswich, England, 1962–1975), 2:66 (hereafter referred to as *JCC*).

84. *JCC,* 6:194. In July 1832—the year of the Reform Bill—Constable walked away from a geology lecture on volcanoes, muttering, "We inhabit a fearfull planet": *JCC,* 3:78.

85. Paulson, pp. 142–143.

86. *JCC,* 1:296.

87. Bermingham, pp. 125–126, 220. Charles Rhyne, to whom both Bermingham and I are indebted, first made the case (in unpublished lectures) that the family house lay at the center of Constable's associations.

88. *JCC,* 1:90, 92, 94.

89. *JCC,* 2:69.

90. As he wrote to his future wife on 14 May 1812, "You know I have succeeded most with my native scenes. They have always charmed me & I hope they always will—I wish not to forget early impressions. I have now very distinctly marked out a path for myself, and I am desirous of pursuing it uninterruptedly": *JCC,* 2:70.

91. *JCC,* 6:78.

92. *JCC,* 2:31–32.

93. *JCC,* 6:64.

94. The work has gone through numerous editions. I am using G. White, *The Natural History of Selborne* (London, 1872), 253.

95. Ibid., pp. 25, 202, 207.

96. C. R. Leslie, *Memoirs of the Life of John Constable* (London, 1951), 285.

97. K. Badt, *John Constable's Clouds* (London, 1950); L. Hawes, "Constable's Sky Sketches," *Journal of the Warburg and Courtauld Institutes* 32 (1969), 344–365. See also the forthcoming *Sky in Art* by S. D. Gedzelman.

98. L. Howard, "On the Modifications of Clouds, and on the Principles of their Production, Suspension, and Destruction; being the Substance of an Essay read before the Akesian Society in the Session 1802–3," *Philosophical Magazine* 16 (June–September 1803), 97–107, plates 6–8, 344–357 (explanation of the plates); 17 (October–December 1803), 5–11.

99. Ibid., 16:97.

100. A. W. Slater, ed., "Autobiographical Memoir of Joseph Jewell 1763–1846," *Camden Miscellany* 22 (1964), 116–125.

101. T. I. M. Forster, *Researches about Atmospheric Phaenomena* (London, 1813), vii. Constable owned the second edition, published in 1815: see *John Constable: Further Documents and Correspondence,* ed. L. Parris, C. Shields, and I. Fleming-Williams (London, 1975), 44–45.

102. Rosenthal, pp. 71–74.

103. R. Bloomfield, *Collected Poems,* 5 vols. (Gainesville, Fla., 1971), 1:91–92, 7.

104. At that time Old Hall, East Bergholt, was owned by John Reade; Godfrey bought it in 1804.

105. Leslie, p. 280.

106. *JCC,* 6:171.

107. Bloomfield, p. 89.

108. Anon, "Some Account of Richard Kirwan, Esq.," *Philosophical Magazine* 14 (1802), 353–355.

109. R. Kirwan, *The Manures most Advantageously Applicable to the Various Sorts of Soils and the Causes of their Beneficial Effect in each Particular Instance* (London, 1796), 5, 15, 94.

110. Ibid., p. 23.

111. Leslie, p. 272.

112. J. Whitehurst, *An Inquiry into the Original State and Formation of the Earth* (London, 1778), 143.

113. Ibid., pp. 194–195.

114. *John Constable's Discourses,* ed. R. B. Beckett (Ipswich, England, 1970), 69.

115. *JCC,* 7:31. Constable's library contained several of Gilpin's writings. See also 2:7 for his early awareness of Gilpin's "stile."

116. *JCC,* 1:101.

117. Leslie, p. 279.

118. A. Boime, *The Academy and French Painting* (London, 1971), 136–139.

119. P.-H. de Valenciennes, *Elémens de la perspective pratique* (Paris, 1800).

120. Ibid., 2d ed. (1820), xvii.

121. Ibid., pp. 338–339.

122. Leslie, p. 85.

123. *John Constable's Discourses,* pp. 9–10. The original statement in *Various Subjects of Landscape, Characteristic of English Scenery, from Pictures Painted by John Constable, RA, Engraved by Robert Lucas* (London, 1830), was nonpaginated.

124. Ibid., p. 9.

125. *JCC,* 2:70.

126. *JCC,* 3:126; *John Constable's Discourses,* p. 60. Constable also described the figures in David's *Sabines* as "savages who had accidentally found and snatched up these weapons and accoutrements."

127. *JCC,* 2:120.

128. *JCC,* 2:67. Constable did not at all like the liberal Martin and ridiculed him often: *JCC,* 6:113, 116.

129. *JCC,* 6:21.

130. For Wordsworth and Constable see R. F. Storch, "Wordsworth and Constable," *Studies in Romanticism* 5 (1966), 131–138; K. Kroeber, "Constable and Wordsworth: The Ecological Moment of Romantic Art," *Journal of the Warburg and the Courtauld Institutes* 34 (1971), 377–386.

131. W. Wordsworth, *The Complete Poetical Works* (New York, 1904), 277.

132. F. Owen, *Sir George Beaumont, Artist and Patron* (London, 1969).

133. *JCC*, 7:290. As Constable noted, Beaumont's estate had a "privileged" prospect: "There is a magnificent view from the terrace over a mountainous region, and there is a winter garden."

134. Wordsworth, p. 91.

135. *JCC*, 6:117, also 4:185, 5:76.

136. Wordsworth, p. 543.

137. Byatt, pp. 151–152.

138. Wordsworth, p. 307.

139. Ibid., pp. 387–388.

140. Ibid., p. 388.

Chapter Four

1. See G. H. Lovett, *Napoleon and the Birth of Modern Spain*, 2 vols. (New York, 1965).

2. J. Trainie and J.-C. Carmigniani, *Napoleon's War in Spain* (London, 1982), 44–68.

3. See J. Cabanis, *Le sacre de Napoléon, 2 décembre 1804* (Paris, 1970).

4. Cited in D. Hill, *Mr. Gillray, the Caricaturist* (London, 1965), 130.

5. Cited in A. Brookner, *Jacques-Louis David* (New York, 1980), 151.

6. David gave Boilly permission to reproduce the work: see D. and G. Wildenstein, *Documents complémentaires au catalogue de l'oeuvre de Louis David* (Paris, 1973), 180.

7. M. de Villars, *Mémoires de David, peintre et député à la Convention* (Paris, 1850), 185.

8. E. E. Y. Hales, *Napoleon and the Pope* (London, 1962), 88–90. The Spanish catechism in 1808 went somewhat differently: the child was asked, "What is the emperor Napoleon?"—"A wicked being, the source of all evils, and the focus of all vices." See L. Junot [duchesse d'Abrantès], *Memoirs of Napoleon, His Court and Family*, 2 vols. (New York, 1895), 2:305.

9. L. Hautecoeur, *Louis David* (Paris, 1954), 207.

10. F. Markham, *Napoleon* (New York, 1966), p. 113.

11. R. Rosenblum, *Ingres* (New York, 1967), 84; A. Boime, "Declassicizing the Academic: A Realist View of Ingres," *Art History* 8 (March 1985), 54–55.

12. P. J. B. P. Chaussard, *Le Pausanias français* (Paris, 1806), 401–404.

13. A. Schreiber-Favre, "Enseignements de M. Ingres (d'après les notes de deux élèves genevois)," *Le mois suisse* 4 (December 1942), 69.

14. E. J. Delécluze, *Louis David, son école & son temps: Souvenirs* (Paris, 1860), 313.

15. See for the most complete study H. Thomas, *Goya: The Third of May, 1808* (London, 1972). Also E. LaFuente Ferrari, "Goya: The Second of May and the Executions," in *Goya in Perspective*, ed. F. Licht (Englewood Cliffs, N.J., 1973), 71–91.

16. For the stepped-up production of lamps in the Napoleonic years see J.-A. Bordier-Marcet, *La parabole soumise à l'art, ou essai sur la catoptrique de l'éclairage* (Paris, 1819), 24. For the experiments with new forms of lighting in the Spanish campaign see J.-C. M. de Brettes, *Des artifices éclairants en usage à la guerre* (Paris, 1851), 5.

17. F. Klingender, *Goya in the Democratic Tradition* (London, 1948), 69 ff.; F. J. de Salas, *Goya, la familia de Carlos IV* (Barcelona, 1944); F. Licht, "Goya's Portrait of the Royal Family," in *Goya in Perspective*, ed. F. Licht, pp. 162–167; P. Gassier and J. Wilson, *The Life and Complete Work of Francisco Goya* (New York, 1971), 148–152.

18. F. Almela y Vives and A. Igual Ubeda, *El arquitecto y escultor valenciano Manuel Tolsa (1757–1816)* (Valencia, 1950).

19. C. Bargellini, "El Caballito visto a través de la historia del arte," *Ingenieria* 1 (1980), 80–85.

20. G. A. Williams, *Goya and the Impossible Revolution* (London, 1976); J. Held, *Francisco de Goya in Selbstzeugnissen und Bilddokumenten* (Hamburg, 1980); R. Herr, *The Eighteenth-Century Revolution in Spain* (Princeton, 1958).

21. For Goya's tapestries see V. de Sambricio, *Tapices de Goya* (Madrid, 1946); J. Held, *Die Genrebilder der Madrider Teppichmanufactur und die Anfange Goyas* (Berlin, 1971).

22. J. Townsend, *Journey through Spain in the Years 1786–1787*, 3 vols. (London, 1792), 1:267–268.

23. L. Williams, *Arts and Crafts of Older Spain*, 3 vols. (London, 1907), 1:149.

24. Herr, pp. 154 ff.

25. G. Anes, "Freedom in Goya's Age," in A. E. Pérez Sánchez and E. A. Sayre, *Goya and the Spirit of the Enlightenment* (Boston, 1989), xxviii.

26. J.-F. Bourgoing, *Modern State of Spain*, 4 vols. (London, 1808), 1:273. This book first appeared in French in 1788 and could only have referred to the tapestries.

27. E. Helman, *Jovellanos y Goya* (Madrid, 1970), 248.

28. P. de Campomanes, *Discurso sobre la educación popular de los artesanos y su fomento* (Madrid, 1775), 56, 97 ff., 110; Townsend, 3:116–117.

29. Klingender, pp. 15 ff.; Herr, p. 151.

30. Campomanes, pp. 129–130.

31. Sambricio, document 38.

32. Gassier and Wilson, p. 64.

33. Ibid., pp. 108, 382.

34. Ibid., p. 110.

35. P. Pinel, *Traité médico-philosophique sur l'aliénation mentale, ou la manie* (Paris, 1801), 225–226.

36. For Goya and Jovellanos see E. Helman, *Jovellanos y Goya;* F. Nordstrom, *Goya, Saturn, and Melancholy* (Stockholm, 1962), 133–141; S. A. Mansbach, "Goya's Liberal Iconography: Two Images of Jovellanos," *Journal of the Warburg and Courtauld Institutes* 41 (1978), 340–344.

37. See L. Domergue, *Jovellanos à la société économique des amis du pays*

de Madrid (1787–1795) (Toulouse, 1971); J. H. R. Polt, *Gaspar Melchor de Jovellanos* (New York, 1971).

38. A. Morel-Fatio, eds., *La satire de Jovellanos contre la mauvaise éducation de la noblesse* (Paris, 1899).

39. G. M. de Jovellanos, *Informe de la ley agraria* (Madrid, 1795).

40. J. H. R. Polt, "Jovellanos and His English Sources," *Transactions of the American Philosophical Society*, n.s., vol. 54, part 7 (1964), 9–10, 16–21, passim.

41. D. L. A. de Cueto, ed., *Poetas liricos del siglo XVIII*, in *Biblioteca autores españoles* (Madrid, 1917), 63:250–51 (to be abbreviated as *BAE* henceforth).

42. *BAE* 63:250.

43. G. Levitine, "Literary Sources of Goya's *Capricho 43*," *Art Bulletin* 37 (1955), 57; Nordstrom, pp. 137–141. Meléndez Valdés dedicated a number of his poems to his benefactor; in fact, his first volume of poetry, published in 1785, was dedicated to Jovellanos.

44. W. E. Colford, *Juan Meléndez Valdés* (New York, 1942), 104; G. Demerson, *Don Juan Meléndez Valdés et son temps (1754–1817)* (Paris, 1961), 114–130.

45. "Al Excelentísimo Señor Don Gaspar Melchor de Jovellanos en su feliz elevación al Ministero Universal de Gracia y Justicia," *BAE* 63:209.

46. M. Godoy, *Memorias*, ed. D. C. Seco Serrano, in *BAE*, (Madrid, 1956), 88:234–235.

47. *BAE*, 63:199–200.

48. Cited in Polt, *Gaspar Melchor de Jovellanos*, p. 95.

49. *BAE*, 63:256.

50. *BAE*, 63:207–208.

51. See J. A. Llorente, *A Critical History of the Inquisition of Spain* (Williamstown, Mass., 1967). This celebrated canon sat for Goya and was an *afrancesado:* after the abolition of the Inquisition by Napoleon's decree of December 1808 Llorente was commissioned to write its history, which first appeared in Paris in 1817–1818. See also H. Kamen, *The Spanish Inquisition* (London, 1965).

52. *BAE*, 63:199–200.

53. J. A. Perez-Rioja, *Proyección y actualidad de Feijóo* (Madrid, 1965); I. L. McClelland, *Benito Jerónimo Feijóo* (New York, 1969).

54. Herr, p. 40.

55. Townsend, 3:165–166.

56. J. Bowling, *Leandro Fernández de Moratín* (New York, 1971), 141.

57. E. Helman, "The Younger Moratín and Goya: On *Duendes* and *Brujas*," *Hispanic Review* 27 (1959), 103–122.

58. Gassier and Wilson, p. 64.

59. Nordstrom, pp. 153–171.

60. P. Salmon, *Resumen historico de la revolución de España año de 1808* (Cadiz, 1812), 178.

61. Nordstrom, pp. 154–158.

62. E. Darwin, *The Botanic Garden*, 4th ed., 2 vols. (London, 1799), 2:121–124.

63. See J. Lopez-Rey, *Goya's Caprichos: Beauty, Reason, and Caricature,*

2 vols. (Princeton, 1953); E. Helman, *Trasmundo de Goya* (Madrid, 1973), 219–241; X. de Salas, "Light on the Origin of *Los Caprichos*," *Burlington Magazine* 121 (1979), 711–716.

64. The advertisement appeared in *Diario de Madrid,* a conservative newspaper committed to the "facts" rather than their interpretation. It reported the gossip and cultural events, and pretended to steer clear of politics.

65. In addition to the other references cited above see especially W. Hofmann, "Traum, Wahnsinn, und Vernunft," *Goya: Das Zeitalter der Revolutionen, 1789–1830* (Hamburg, 1980), 54–59.

66. Herr, p. 411.

67. Darwin, 2:128.

68. Ibid., p. 72.

69. *BAE,* 63:250.

70. T. de Iriarte, *Collección de obras en verso y prosa,* 6 vols. (Madrid, 1787), 4:1–2.

71. Ibid., 6:360–361; R. Merritt Cox, *Tomás de Iriarte* (New York, 1972), 91–92.

72. Iriarte, p. 362.

73. P.-L. Gérard, *The Count de Valmont; or, The Errors of Reason,* 3 vols. (London, 1805), 2:87.

74. P. A. de Olavide, *El Envangelio en triunfo, o historio de un filosofo desengañado,* 5 vols. (Madrid, 1803), 1:105–106.

75. Ibid., 4:289–290.

76. G. M. de Jovellanos, *Poésias,* ed. J. Caso González (Orvieto, 1961), 235–240.

77. C. el Conde de la Viñaza, *Goya: Su tiempo, su vida, sus obras* (Madrid, 1887), 328.

78. *Los Caprichos by Francisco Goya y Lucientes,* introduction by P. Hofer (New York, 1969), no. 80.

79. Viñaza, p. 332.

80. *Los Caprichos,* no. 75.

81. Viñaza, p. 328.

82. Ibid., p. 342.

83. Iriarte, 1:16–17, 7–8.

84. Viñaza, p. 342.

85. Ibid., pp. 342–343.

86. Iriarte, 1:40–41.

87. Viñaza, p. 345.

88. Ibid., p. 347.

89. A. Puigblanch, *La inquisición sin mascara* (Mexico City, 1824), 85–86.

90. Bourgoing, 2:342–343.

91. For the correspondence of Murat regarding this event and collateral material see *Lettres et documents pour servir à l'histoire de Joachim Murat (1767–1815),* ed. P. Le Brethon, 8 vols. Paris, (1908–1914), 6:21–62.

92. Ibid., pp. 40, 49. A French source claimed that two hundred Madrileños and one hundred peasants from the surrounding villages were killed during 2–3 May.

93. For the accounts of this event and its background see Lovett, 1:303–316; Salmon, pp. 168–170; C. Martin, *José Napoleón I, "Rey Intruso" de España* (Madrid, 1969), 233–241. The best description of the picture is J. Tripier Le Franc, *Histoire de la vie et de la mort du Baron Gros le grand peintre* (Paris, 1880), 278–280.

94. Salmon, p. 168; Lovett, p. 310.

95. Tripier Le Franc, p. 280.

96. BAE, 63:159

97. Demerson, pp. 282, 315, 342.

98. A. E. Pérez Sánchez and E. A. Sayre, *Goya and the Spirit of the Enlightenment* (Boston, 1989), 157.

99. For an alternative reading see N. Glendinning, "Goya and Arnaza's 'Profecia del Pirineo,'" *Journal of the Warburg and Courtauld Institutes* 26 (1963), 363.

Chapter Five

1. See J. McCoubrey, "Gros' *Battle of Eylau* and Roman Imperial Art," *Art Bulletin* (1961), 135 ff.; R. Herbert, "Baron Gros's Napoleon and Voltaire's Henri IV," in *The Artist and the Writer in France: Essays in Honour of Jean Seznec,* ed. F. Haskell, A. Levi, and R. R. Shackleton (Oxford, 1974), 52 ff.

2. L. Junot [duchese d'Abrantès], *Memoirs of Napoleon, His Court and Family,* 2 vols. (New York, 1895), 2:212–214. Even Napoleon's most loyal supporters believed he was lying; his own officers accused him of making "the French uniform . . . the insignia of its mutilated corpses."

3. D.-J. Larrey, *Memoirs of Military Surgery, and Campaigns of the French Armies, on the Rhine, in Corsica, Catalonia, Egypt, and Syria; at Boulogne, Ulm, and Austerlitz; in Saxony, Prussia, Poland, Spain, and Austria,* 2 vols. (Baltimore, 1814).

4. J. H. Dible, *Napoleon's Surgeon* (London, 1970), 73.

5. *Lettres de Napoléon à Joséphine et de Joséphine à Napoléon,* ed. J. Haumont (Paris, 1968), letter dated 14 February 1807,

6. Junot, 2:213.

7. For good reviews of the problem in English see J. G. Gagliardo, *From Pariah to Patriot: The Changing Image of the German Peasant 1770–1840,* (Lexington, Ky., 1969), 10–15; G. S. Ford, *Stein and the Era of Reform in Prussia 1807–1815* (Princeton, 1922), chaps. 6 and 7.

8. For Stein see J. R. Seeley, *Life and Times of Stein; or, Germany and Prussia in the Napoleonic Age,* 2 vols. (Boston, 1879).

9. K. Freiherr vom Stein, *Briefwechsel, Denkschriften, und Aufzeichnungen,* ed. E. Botzenhart, 7 vols. (Berlin, 1931 et seq.), 2:583.

10. E. M. Arndt, *Versuch einer Geschichte der Leibeigenschaft in Pommern und Rügen* (Berlin, 1803).

11. A. G. Pundt, *Arndt and the Nationalist Awakening in Germany* (New York, 1935), 36.

12. I. Andersson, *A History of Sweden* (London, 1956), 298–299.

13. See G. P. Gooch, *Germany and the French Revolution* (London, 1920).

14. L. W. Beck, *Early German Philosophy: Kant and His Predecessors* (Cambridge, Mass., 1969), 430.

15. K. S. Pinson, *Pietism as a Factor in the Rise of German Nationalism* (New York, 1934).

16. Ibid., pp. 50–51.

17. *The Popular Works of Johann Gottlieb Fichte,* 2 vols., tr. W. Smith (London, 1889).

18. J. G. Fichte, *Addresses to the German Nation,* tr. R. F. Jones and G. H. Turnbull (Chicago and London, 1922).

19. E. H. Zeydel, *Ludwig Tieck, the German Romanticist* (Princeton, 1935), 1.

20. Ibid., pp. 63–70.

21. L. Tieck, *Frühe Erzählungen und Romane,* in *Werke in vier Bänden,* 4 vols. (Munich, 1966), 1:353–355.

22. Ibid., p. 355.

23. Ibid.

24. Ibid., p. 467.

25. Ibid., p. 587.

26. For a good introduction to Schelling's work see A. White, *Schelling: An Introduction to the System of Freedom* (New Haven and London, 1983); W. Marx, *The Philosophy of F.W.J. Schelling* (Bloomington, Ind. 1984); F.W.J. Schelling, *System of Transcendental Idealism (1800),* tr. P. Heath (Charlottesvelle, Va. 1978).

27. J. L. Esposito, *Schelling's Idealism and Philosophy of Nature* (Lewisburg, Pa., 1977), 128–129, 131–132.

28. Ibid., pp. 137–159; H. Knittermeyer, *Schelling und die romantische Schule* (Munich 1929) 136–201.

29. H. Steffens, *The Story of My Career,* tr. W. L. Gage (Boston, 1863; this is a condensation of H. Steffens, *Was ich erlebte,* 10 vols. [Breslau, 1840–1844]); F. Paul, *Henrich Steffens* (Munich, 1973); Esposito, pp. 138, 150; C. Güttler, *Lorenz Oken und sein Verhältniss zur modernen Entwickelungslehre* (Leipzig, 1884); A. Ecker, *Lorenz Oken: A Biographical Sketch,* tr. A. Tulk (London, 1883); P. C. Mullen, "The Romantic as Scientist: Lorenz Oken," *Studies in Romanticism* 16 (Summer 1977), 381–399; G. H. von Schubert, *Der Erwerb aus einem vergangenen und die Erwartungen von einem zukünftigen Leben,* 5 vols. (Erlangen, 1854–1856); D. G. Nathanael, *Gotthilf Heinrich Schubert in seinen Briefen* (Stuttgart, 1918); F. R. Merkel, *Der Naturphilosoph Gotthilf Heinrich Schubert und die deutsche Romantik* (Munich, 1913); Knittermeyer, pp. 357–364; C. G. Carus, *Lebenserinnerungen und Denkwürdigkeiten,* 2 vols. (Weimar, 1865–1866); Carus, *Neun Briefe über Landschaftsmalerei* (Leipzig, 1831). A partial translation of his *Nine Letters on Landscape Painting* may be found in E. G. Holt, *From the Classicists to the Impressionists* (New York, 1966), 88–93.

30. F. W. J. Schelling, "Concerning the Relation of the Plastic Arts to Nature," tr. Bullock, in H. Read, *The True Voice of Feeling* (London, 1953).

31. A mountain of literature exists on this subject, but for Germany under Napoleon see E. N. Anderson, *Nationalism and the Cultural Crisis in Prussia, 1806–1815* (New York, 1939).

32. Ibid., pp. 16–63.

33. Ibid., pp. 35–36.

34. Gagliardo, pp. 199–210.

35. E. M. Arndt, *The Life and Adventures of Ernst Moritz Arndt,* ed. J. R. Seeley (Boston, 1879), xi–xii, 116.

36. H. von Kleist, *Sämtliche Werke,* ed. K. F. Reinking (Wiesbaden, 1972), 10.

37. Anderson, p. 116.

38. Kleist, p. 1229.

39. G. H. Pertz, *Das Leben des Feldmarschalls Grafen Neithardt von Gneisenau,* 5 vols. (Berlin, 1864–1880).

40. Ibid., 1:389.

41. H. Delbrück, *Das Leben des Feldmarschalls Grafen Neithardt von Gneisenau,* 2 vols. (Berlin, 1908), 1:210.

Chapter Six

1. F. G. Nauen, *Revolution, Idealism, and Human Freedom* (The Hague, 1971), 3.

2. J. Hermand, ed., *Von deutscher Republik 1775–1795,* 2 vols. (Frankfurt am Main, 1968), 1:90–91.

3. W. D. Robson-Scott, *The Literary Background of the Gothic Revival in Germany* (Oxford, 1965), 119–120.

4. W. H. Wackenroder, *Confessions and Fantasies,* ed. M. H. Schubert (University Park, Pa., and London, 1971), 112.

5. L. Tieck, *Franz Sternbalds Wanderungen,* ed. A. Anger (Stuttgart, 1966), 26.

6. For an English translation see Novalis, "Christendom or Europe," in *Romanticism,* ed. J. B. Halsted (New York, 1969), 123–138.

7. E. H. Zeydel, *Ludwig Tieck, the German Romanticist* (Princeton, 1935), 49.

8. Robson-Scott, pp. 12, 82.

9. Cited in J. G. Gagliardo, *From Parish to Patriot: The Changing Image of the German Peasant 1770–1840* (Lexington, Ky., 1969), 138–140.

10. J. G. Herder, "Auszug aus einem Briefwechsel über Ossian und die Lieder alter Völker", *Sämtliche Werke,* 33 vols. (Berlin, 1877–1913), 5:186.

11. Ibid., p. 154.

12. Wackenroder, p. 111.

13. J. W. Goethe, *Propyläen: Eine periodische Schrift,* 3 vols. (Tübingen, 1798), "Einleitung," 1:x.

14. Ibid., xxxvii.

15. Wackenroder, p. 195.

16. S. S. Biro, *The German Policy of Revolutionary France,* 2 vols. (Cambridge, Mass., 1957), 2:637.

17. Wackenroder, p. 109.
18. Ibid., pp. 108–111.
19. Ibid., p. 117.
20. Ibid., p. 110.
21. Ibid., p. 87.
22. Ibid., p. 120.
23. See U. Christoffel, *Der Berg in der Malerei* (Bern, 1963); G. Grundmann, *Das Riesengebirge in der Malerei der Romantik* (Munich, 1965); H. J. Neidhardt, "Das Gipfelerlebnis in der Kunst um 1800," in *Studien zur deutschen Kunst und Architektur um 1800,* ed. P. Betthausen (Dresden, 1981), 94–117.
24. L. Tieck, *Der gestiefelte Kater,* ed. and tr. G. Gillespie (Edinburgh, 1974), 60–61.
25. Wackenroder, p. 112.
26. K. H. Spinner, *Der Mond in der deutschen Dichtung von der Aufklärung bis zur Spätromantik* (Bonn, 1969); A. G. Roth, "Der Mond in der Malerei," *Du, schweizerische Monatsschrift* 7 (1947), 8–18.
27. G. P. Gooch, *Germany and the French Revolution* (London, 1920), 19.
28. J. Kepler, *Somnium,* tr. E. Rosen (Madison, Wis., 1967).
29. K. Francke, *A History of German Literature as Determined by Social Forces* (New York, 1916), 234.
30. F. G. Klopstock, *Ausgewählte Werke,* ed. K. A. Schleiden (Munich, 1962), 108.
31. Prof. Batsch, "Ueber die Naturgeschichte der Mondsfläche, nach Herrn Schröters Bermerkungen," *Journal der Physik* (later, *Annalen der Physik* (1792), 15–17.
32. H. Franck, *Gotthard Ludwig Kosegarten: Ein Lebensbild* (Halle, Germany, 1887). Kosegarten modified his name from to time, hence the variations in various literary productions.
33. L. G. Kosegarten, *Dichtungen,* 12 vols. (Griefswald, 1824–1827), 6:5–12.
34. L. T. Kosegarten, *Poesieen,* 2 vols. (Leipzig, 1798), 1:147–149.
35. Kosegarten, *Dichtungen,* 12 vols. (Greifswald, 1824–1827), 6:5–12.
36. E. M. Arndt, *Werke,* ed. W. Steffens, 12 vols. (Berlin, n.d.), 1:18.
37. Ibid., p. 41.
38. Ibid., pp. 126–127.
39. Ibid., pp. 132–133.
40. Ibid., p. 135.
41. L. Tieck, *Schriften,* 28 vols. (Berlin, 1828–1854), 1:33.
42. Zeydel, p. 41.

Chapter Seven

1. C. T. Perthes, *Memoirs of Frederick Perthes; or, Literary, Religious, and Political Life in Germany, from 1789 to 1843,* 2 vols., (Edinburgh and London, 1856).
2. J. K. Riesbeck, *Travels through Germany, in a Series of Letters,* 3 vols., tr. M. Maty (London, 1787), 3:73.

3. Ibid.

4. Perthes, 1:25.

5. Ibid., p. 26.

6. Ibid., p. 46.

7. Ibid., 1:41–42.

8. Ibid., p. 43.

9. Ibid., pp. 44–46, 57.

10. Ibid., p. 143.

11. Ibid., pp. 166–169.

12. M. Boisserée, *Sulpiz Boisserée*, 2 vols. (Stuttgart, 1862), 1:12–13, 21; E. Firmenich-Richartz, *Die Brüder Boisserée* (Jena, 1916), 44, 48.

13. Boisserée, 1:13; Firmenich-Richartz, p. 44.

14. H. Sieveking, *Karl Sieveking 1787–1847: Lebensbild eines hamburgischen Diplomaten aus dem Zeitalter der Romantik,* 3 vols. (Hamburg, 1923), 1:36–37, 57, 163.

15. Ibid., p. 55; entry "Dreves (Johann Friedrich Peter)," in H. Schröder, *Lexikon der hamburgischen Schriftsteller bis zur Gegenwart,* 2 vols. (Hamburg, 1854), 70–71.

16. Boisserée, pp. 10–11.

17. S. S. Biro, *The German Policy of Revolutionary France,* 2 vols. (Cambridge, Mass., 1957), 2:299–300.

18. Boisserée, pp. 21 ff.; W. D. Robson-Scott, *The Literary Background of the Gothic Revival in Germany* (Oxford, 1965), 156–157.

19. Robson-Scott, pp. 131–132.

20. Ibid., p. 138.

21. J. W. von Goethe, *Goethes Werke: Weimarer Ausgabe,* 143 vols. (Weimar, 1887–1919), 1:27, 279–280.

22. F. von der Leyen, ed., *Das Buch deutscher Reden und Rufe* (Wiesbaden, 1956), 190–191.

23. Boisserée, p. 317.

24. See most recently *Karl Friedrich Schinkel: Architektur, Malerei, Kunstgewerbe* (Berlin, 1981); H.-J. Kunst, "Die politischen und gesellschaftlichen Bedingtheiten der Gotikrezeption bei Friedrich und Schinkel," in *Bürgerlichen Revolution und Romantik,* ed. B. Hinz (Giessen, 1976), 17–42; H. Gärtner, "Patriotismus und Gotikrezeption der deutschen Frühromantik," in *Studien zur deutschen Kunst und Architektur um 1800,* ed. P. Betthausen (Dresden, 1981), 34–52.

25. *Karl Friedrich Schinkel,* p. 124, no. 22.

26. Robson-Scott, p. 235.

27. Robson-Scott, pp. 236–237.

28. This work was destroyed in World War II; for an illustration and some remarks on it see *Karl Friedrich Schinkel,* p. 22, no. 177. It has been thus far overlooked that *Evening* owes its inspiration to a lost work by Caspar David Friedrich. See G. H. von Schubert, *Der Erwerb aus einem vergangenen und die Erwartungen von einem zukünftigen Leben,* 5 vols. (Erlangen, 1854–1856), 2:186–188.

Chapter Eight

1. There is an enormous literature on Runge; my main sources have been D. Runge, ed., *Hinterlassene Schriften von Philipp Otto Runge,* 2 vols. (Hamburg, 1840; hereafter *HS;* published by Perthes and dedicated to Tieck and Steffens); J. B. C. Grundy, *Tieck and Runge* (Heidelberg, 1930); O. von Simson, "Philipp Otto Runge and the Mythology of Landscape," *Art Bulletin* 24 (1942), 335–350; G. Berefelt, *Philipp Otto Runge zwischen Aufbruch und Opposition* (Stockholm 1961); R. M. Bisanz, *German Romanticism and Philipp Otto Runge* (DeKalb, Ill., 1970); J. Traeger, *Philipp Otto Runge und sein Werk* (Munich, 1975); *Runge in seiner Zeit,* ed. W. Hofmann, (Hamburg, 1977); "Philipp Otto Runges Kunst als Reflexion und Aneignung gesellschaftlicher Totalität," special issue of *Kristische Berichte* 6, no. 4/5 (1978), 5–77.

2. C. T. Perthes, *Memoirs of Frederick Perthes; or, Literary, Religious, and Political Life in Germany, from 1789 to 1843,* 2 vols. (Edinburgh and London, 1856), 1:117–118.

3. Berefelt, pp. 21–39.

4. H. Franck, *Gotthard Ludwig Kosegarten: Ein Lebensbild* (Halle, 1887), 132–133.

5. Ibid., p. 140.

6. Ibid., p. 120.

7. *HS,* 1:9.

8. L. G. Kosegarten, *Dichtungen,* 12 vols. (Greifswald, 1824–1827), 12:45–46.

9. *HS,* 2:447.

10. See G. Kowalewski, *Geschichte der Hamburgischen Gesellschaft zur Beförderung der Künste und nützlichen Gewerbe (Patriotische Gesellschaft)* (Hamburg, 1897 et seq.); Kowalewski, *William Shipley und die ersten Patriotischen Gesellschaften* (Hamburg, 1907).

11. That he accepted this view for himself is seen in his letter to brother David on 18 January 1800: he had drawn caricatures of two Frenchmen at his inn who later turned out to be thieves. His drawings helped the police to catch them. This taught him "how useful, downright useful, art can be": *HS,* 2:42.

12. *HS,* 1:28–31.

13. *HS,* 2:186–187.

14. For Runge's academic career see P. Betthausen, "Philipp Otto Runge und die Akademie," in *Studien zur deutschen Kunst und Architektur um 1800,* ed. P. Betthausen (Dresden, 1981), 118–137.

15. *HS,* 2:17.

16. *HS,* 2:50–51.

17. *HS,* 2:54.

18. For Runge and Flaxman see S. Symmons, *Flaxman and Europe: The Outline Illustrations and Their Influence* (New York and London, 1984), 211–219.

19. E. Poulsen, *Jens Juel* (Copenhagen, 1961); "Jens Juel: Master Portrait Painter," *Connoisseur,* February 1962, 70–75; B. Skovgaard,

Maleren Abildgaard (Copenhagen, 1961); *N. A. Abildgaard: Tegninger,* with an English introduction (Copenhagen, 1978); P. Kragelund, "The Church, the Revolution, and the 'Peintre Philosophe': A Study in the Art of Nicolai Abildgaard," *Hafnia: Copenhagen Papers in the History of Art,* no. 9 (1983), 25–65.

20. E. Lassen, *Danske Møbler: Den Klassiske Periode* (Gyldendal, Denmark, 1958), pp. 12–16, plates 6–17.

21. Berefelt, pp. 118–119; *HS,* 2:47–48; W. Hamilton, *Peintures des vases antiques de la collection de son Excellence M. le chevalier Hamilton,* 2 vols. (Florence, 1800).

22. For an excellent discussion of Tischbein's relations with the Runges see H. Mildenberger, "J. H. W. Tischbein—Philipp Otto Runge—Friedrich Overbeck: Aspekte des künsterischen Austauschs," in *Jahrbuch des Schleswig-Holsteinischen Landesmuseums Schloss Gottorf,* neue folge, vol. 1, 1986–1987 (Neumünster, Germany, 1988), 31–69.

23. *HS,* 1:217.

24. This interest was further stimulated by the botanical preoccupations of Hamburg merchants, science buffs, and the burgher class generally. A veritable "flower cult" existed in Hamburg, where exotic plants and flowers lined the walkways. See A. Lichtwark, *Philipp Otto Runge: Pflanzenstudie mit Scheere und Papier* (Hamburg, 1895), 16–17.

25. *HS,* 2:242.

26. *HS,* 1:156–159.

27. Steffens not only contributed an essay to Runge's work on color theory known as the *Farbenkugel* but probably wrote some of the most penetrating prose on the painter's life: see H. Steffens, *Was ich erlebte,* 10 vols. (Breslau, 1840–1844), 5:335–365. A drastically condensed version of his autobiography in English does not include the section on Runge: Steffens, *The Story of My Career,* tr. W. L. Gage (Boston, 1863).

28. H. Steffens, *Geognostisch-geologische Aufsätze als Vorbereitung zu einer innern Naturgeschichte der Erde* (Hamburg, 1810), 147–148. Steffens also credited Werner as being the "discoverer and founder of the new geognosy."

29. Ibid., pp. 150 ff.

30. Ibid., p. xiv.

31. P. O. Runge, *Farbenkugel* (Hamburg, 1810).

32. *HS,* 2:293.

33. *HS,* 2:308, 322.

34. *HS,* 1:70.

35. Steffens, *Was ich erlebte,* 5:341.

36. See "Dr. Darwin's Theory of Electricity as the Source of the Fairy Rings," *Annalen der Physik* 17 (1804), 354 ff.

37. H. Sieveking, *Karl Sieveking 1787–1847: Lebensbild eines hamburgischen Diplomaten aus dem Zeitalter der Romantik,* 3 vols. (Hamburg, 1923), 1:20. The Sievekings were related through marriage to the Reimaruses and close to the Runges: ibid., pp. 50, 66–67, 223.

38. E. J. Morley, ed., *Crabb Robinson in Germany 1800–1805* (London, 1929), 117, 119; F. W. J. von Schelling, *Philosophie der Kunst* (Darmstadt, 1960), 91.

39. G. H. von Schubert, *Der Erwerb aus einem vergangenen und die Erwartungen von einem zukünftigen Leben,* 5 vols., (Erlangen, 1854–1856), 2:105–106, 118; *Gotthilf Heinrich Schubert in seinen Briefen: Ein Lebensbild*, ed. D. G. N. Bonwetsch (Stuttgart, 1918), 15; F. R. Merkel, *Der Naturphilosoph Gotthilf Heinrich Schubert und die deutsche Romantik* (Munich, 1913), 34 ff.

40. J. G. Herder, *Outlines of a Philosophy of the History of Man* (London, 1800), 29–30, 131.

41. *HS,* 1:17.

42. *HS,* 1:27.

43. *HS,* 1:4–5. This is summed up in Runge's appreciation of the dynamic character of the universe: "The living force which created heaven and earth, and of which our living soul is the image, must stir and move and flourish in us, so that we may discover how much love there is in ourselves and all around us. Once we come to see and believe it, this hidden love will be found to gaze at us benevolently from every flower and color, from behind every fence and shrub, from behind the clouds and the most distant stars. I think that it must be a great joy to find a language within ourselves to express this feeling, even if only for family talk. How good to live in a family in which one can converse in this language . . . I think that the Apostles, the pious musicians, the great poets and painters really wanted to form such a family."

44. *HS,* 1:13.

45. *HS,* 2:220.

46. M. Boisserée, *Sulpiz Boisserée,* 2 vols. (Stuttgart, 1862), 1:114.

47. Grundy's *Tieck and Runge* has as its subtitle "A Study in the Relationship of Literature and Art in the Romantic Period with Especial Reference to 'Franz Sternbald.'" See also C. Franke, *Philipp Otto Runge und die Kunstansichten Wackenroders und Tiecks* (Marburg, 1974).

48. *HS,* 2:9.

49. *HS,* 2:99.

50. L. Tieck, *Minnelieder aus dem schwäbischen Zeitalter* (Berlin, 1803), titlepage, opp. p. 1, opp. p. 280, pp. 1, 284, These bear a striking resemblance to the marginalia of the *Tageszeiten.*

51. *HS,* 2:514.

52. *HS,* 1:6.

53. *HS,* 1:8. "Once upon a time I thought about a war that could change the whole world, or how such a war might occur; but today throughout the world, when war has become a science, the possibility of real war no longer exists; since there is no longer a nation that could massacre all Europe and the whole civilized world, *as the Germans once did with the Romans when all spirit had left that race*—I saw . . . no other means except that Last Judgment Day, when the earth would open and swallow us all . . ." (emphasis added).

54. *HS*, 1:8–9.
55. H. A. M. Snelders, "Romanticism and Naturphilosophie and the Inorganic Natural Sciences, 1797–1840," *Studies in Romanticism* (Summer 1970), 197–198; T. Mitchell, "Caspar David Friedrich's *Der Watzmann:* German Romantic Landscape Painting and Historical Geology," *Art Bulletin* 66 (1948), 463.
56. *HS*, 1:10.
57. R. Tombo, *Ossian in Germany* (New York, 1901).
58. W. Hofmann, *Ossian und die Kunst um 1800* (Hamburg, 1974), 63–64.
59. F. G. Klopstock, *Sämmtliche Werke,* 8 vols. (Leipzig, 1854), 6:85.
60. J. MacPherson, *The Works of Ossian, the Son of Fingal,* 2 vols. (London, 1765), 1:142, 103.
61. *HS*, 1:257–346.
62. G. P. Gooch, *Germany and the French Revolution* (London, 1920), 131–135.
63. *HS*, 1:311. For Runge's consistent use of astronomical metaphor in his *Ossian* series see ibid., pp. 259, 261, 292, 294, 299.
64. *HS*, 1:20–21.
65. *HS*, 1:26–27.
66. *HS*, 1:20.
67. L. W. Beck, *Early German Philosophy: Kant and His Predecessors* (Cambridge, Mass., 1969), 154–156.
68. J. Böhme, *The Aurora,* tr. J. Sparrow, ed. C. J. Barker and D. S. Hehner (London, 1914).
69. *HS*, 1:20.
70. Ibid.
71. *HS*, 1:246–249.
72. *HS*, 2:291–292.
73. *HS*, 1:365; Traeger, p. 86.
74. For the importance of dyeworks in the Hamburg economy see F. L. von Hess, *Hamburg topographisch, politisch, und historisch beschrieben,* 2 vols. (Hamburg, 1787–1789), 2:228–229.
75. L. Oken, *Elements of Physiophilosophy* (London, 1847), 21; Oken, *Die Zeugung* (Bamberg and Würzburg, 1805), 26–27, 29, 116–117, 119–120, 123–124.
76. *HS*, 1:172–173.
77. Oken, *Beiträge zur vergleichenden Zoologie* (Bamberg and Würzburg, 1806), vi—vii.
78. *Hamburgisches Adress-Buch auf das Jahr 1807,* p. 243.
79. Sieveking, 2:53.
80. *HS*, 2:242–243, 265, 269, 288.
81. *HS*, 1:255–256. Also Hess, 2:252.
82. *HS*, 1:256.
83. *HS*, 1:222–224.
84. B. D. Jackson, *Linnaeus* (London, 1923); Jackson, *A Linnaean Keepsake,* (Pittsburgh, 1973).
85. C. Linnaeus, *Hortus Cliffortianus* (Amsterdam, 1737).
86. E. Darwin, *The Botanic Garden,* 4th ed., 2 vols. (London, 1799), 1:iii.

87. Ibid., 2:1–2.
88. Ibid., 1:xvii, 242.
89. Ibid., 2:97.
90. Ibid., pp. 226–242; Bisanz, pp. 106–120; Traeger, pp. 343–363, nos. 265–287.
91. *HS*, 2:529.
92. *HS*, 1:227.
93. *HS*, 1:68–69.
94. Traeger, pp. 417–433, 455–472, nos. 382–414, 472–506.
95. *HS*, 1:82.
96. G. H. von Schubert, *Ansichten von der Nachtseite der Naturwissenschaft* (Dresden, 1808), 303–304.
97. *HS*, 2:360.
98. Steffens, *Was ich erlebte*, pp. 348 ff.
99. Darwin, 1:xvii.
100. For Freemasonry in the German territories see F. J. Schneider, *Die Freimaurerei und ihr Einfluss auf die geistige Kultur in Deutschland am Ende des XVIII. Jahrhunderts* (Prague, 1909); J. R. Haarhaus, *Deutsche Freimaurer zur Zeit der Befreiungskriege* (Jena, 1913). H. Wernekke, *Friedrich Ludwig Schröder als Künstler und Freimaurer* (Berlin, 1916); G. Deile, *Goethe als Freimaurer* (Berlin, 1908); R. F. Gould, *The History of Freemasonry*, 3 vols. (Edinburgh, 1900), 3:224–285; A. G. Mackey, *Encyclopedia of Freemasonry*, rev. R. I. Clegg and supp. vol. by H. L. Haywood, 3 vols. (New York, 1966), 1:402–403.
101. E. J. Morley, pp. 49–50.
102. A. G. Mackey, *Symbolism of Freemasonry: Its Science, Philosophy, Legends, Myths, and Symbols*, rev. R. I. Clegg (Chicago, 1945).
103. Haarhaus, p. 3.
104. Steffens, *Was ich erlebte*, pp. 372–373.
105. Lenning [pseudonym], *Allgemeines Handbuch der Freimaurerei*, 3 vols. (Leipzig, 1863–1867), 1:211.
106. *HS*, 2:230.
107. V. H. Miesel, "Philipp Otto Runge, Caspar David Friedrich, and Romantic Nationalism," *Yale University Art Gallery Bulletin* 33 (October 1972), 37–51.
108. *HS*, 2:20, 294, 300.
109. *HS*, 2:308.
110. *HS*, 2:322.
111. Ulmer Verein, "Philipp Otto Runges Kunst als Reflexion und Aneignung gesellschaftlicher Totalität," *Kritische Berichte* 6, no. 4/5 (1978), 47–48.
112. *HS*, 1:355–361.
113. Quoted in J. G. Gagliardo, *From Pariah to Patriot: The Changing Image of the German Peasant 1770–1840* (Lexington, Ky., 1969), 178.
114. *HS*, 1:360–361.
115. *HS*, 1:346–349, 2:315, 323, 329, 333.
116. Ibid., 2:335–336.
117. Ibid., pp. 391–392.

Chapter Nine

1. For Friedrich, I have found most useful the following works: K. Eberlein, ed., *Caspar David Friedrich: Bekenntnisse* (Leipzig, 1924); S. Hinz, *Caspar David Friedrich in Briefen und Bekenntnissen* (Berlin, 1968); W. Sumowski, *Caspar David Friedrich Studien* (Wiesbaden, 1970); W. Vaughan, *Caspar David Friedrich* (London, 1972); H. Börsch-Supan and K. W. Jähnig, *Caspar David Friedrich* (Munich, 1973); H. Börsch-Supan, *Caspar David Friedrich* (New York, 1974); W. Hofmann, ed., *Caspar David Friedrich 1774–1840* (Munich, 1974); R. Rosenblum, *Modern Painting and the Northern Romantic Tradition* (New York, 1975); L. Siegel, *Caspar David Friedrich and the Age of Romanticism* (Boston, 1978); W. Geismeier, *Caspar David Friedrich* (Vienna and Munich, 1973); B. Hinz et al., eds., *Bürgerliche Revolution und Romantik: Natur und Gesellschaft bei Caspar David Friedrich* (Giessen, 1976); J. Hermand, "Das offene Geheimnis: Caspar David Friedrichs nationale Trauerarbeit," in *Sieben Arten an Deutschland zu leiden* (Königstein, 1979), 1–42; W. Vaughan, *German Romantic Painting* (Boston, 1980), 65–116; M. Ohara, "Demut, Individualität, Gefühl: Betrachtungen über C. D. Friedrichs kunsttheoretische Schriften und ihre Entstehungsumstände" (doctoral diss., Die Freie Universität Berlin, 1983).

2. For the University of Greifswald and its history see *Festschrift zur 500-Jahrfeier der Universität Greifswald,* 2 vols. (Greifswald, 1956); W. Scheler, ed., *Ernst Moritz Arndt 1769–1969: Katalog der Ausstellung der Ernst-Moritz-Arndt-Universität Greifswald,* (Leipzig, 1969).

3. Preissler was the director of the Nuremberg Academy, and his text, *Die durch Theorie erfundene Practic* (Nuremberg, 1728–1731), was revamped by his sons and used throughout the nineteenth century. See J. D. Preissler, *Theoretisch-praktische Unterricht im Zeichen* (Nuremberg, 1831). For Friedrich's use of Preissler see Sumowski, p. 45, plate 4, figs. 12–15.

4. T. F. Mitchell, "From *Vedute* to Vision: The Importance of Popular Imagery in Friedrich's Development of Romantic Landscape Painting," *Art Bulletin* 64 (1982), 414–423.

5. *Danish Painting: The Golden Age,* catalogued by K. Monrad (London, 1984), pp. 82–83, no. 4.

6. H. Steffens, *Was ich erlebte,* 10 vols. (Breslau, 1840–1844), 1:280 ff.

7. Ibid., pp. 285, 5:5–9; S. C. Bech, "Schimmelmann, Heinrich Ernst," in *Dansk biografisk leksikon,* 16 vols. (Copenhagen, 1979–1984), 13:89–92.

8. For a general background see A. Lütteken, *Die Dresdener Romantik und Heinrich von Kleist* (Leipzig, 1917), 3 ff.

9. G. Briganti, *The View Painters of Europe* (London, 1970), 26–27, 297, plates 147–171.

10. Börsch-Supan and Jähnig, pp. 349–350, no. 251.

11. Sumowski, pp. 57–60, plate 20, fig. 74, plate 21, fig. 78; T. F. Mitchell, pp. 415, 417.

12. A recent study explores in depth Friedrich's use of rocks and mineral formations as pictorial motifs: T. Grütter, *Melancholie und Abgrund: Die Bedeutung des Gesteins bei Caspar David Friedrich* (Berlin, 1986).

13. D. Runge, ed., *Hinterlassene Schriften von Philipp Otto Runge,* 2 vols. (Hamburg, 1840), 1:208.

14. Grütter, pp. 178–193.

15. P.-H. Valenciennes, *Elémens de la perspective pratique* (Paris, 1800), 339–340.

16. Schubert lived in the same house with Friedrich's close friends, Gerhard and Helene von Kügelgen: see W. von Kügelgen, *Jugenderinnerungen eines alten Mannes* (Munich, 1927), 19, 31, 48, 130.

17. W. Lechner, *Gotthilf Heinrich von Schuberts Einfluss auf Kleist, Justinus Kerner, und E. T. A. Hoffmann* (Borna-Leipzig, 1911).

18. G. H. von Schubert, *Ansichten von der Nachtseite der Naturwissenschaften* (Dresden, 1808), 303–308, 196.

19. G. H. von Schubert, *Der Erwerb aus einem vergangenen und die Erwartungen von einem zukünftigen Leben,* 5 vols. Erlangen, 1854–1856), 2:183–185.

20. Cited in Eberlein, p. 211.

21. Ibid., p. 72.

22. J. C. Stelzhammer, "Ueber die Flugmaschine des Urmachers Jacob Degen in Wien," *Annalen der Physik* 30 (1808), 1–11.

23. See J. Zipes, *Breaking the Magic Spell* (Austin, Tex., 1979), especially chaps. 2 and 3.

24. Eberlein, pp. 67–71.

25. H. Steffens, *Gebirgs-Sagen* (Breslau, 1837).

26. Ibid., pp. 12–13.

27. G. Grundmann, *Das Riesengebirge in der Malerei der Romantik* (Munich, 1965), 11.

28. E. M. Arndt, *Fairy Tales from the Isle of Rügen,* tr. A. Dabis (London, 1896).

29. We find this combination in many of Werner's disciples, including Steffens and Schubert. Schubert in fact wrote one of the important texts on mining and geology: G. H. von Schubert, *Handbuch der Geognosie und Bergbaukunde* (Nuremberg, 1813). Quotations in the following discussion are from Novalis, *Henry von Ofterdingen,* tr. P. Hilty (New York, 1978).

30. H.J. Neidhardt, "Das Gipfelerlebnis in der Kunst um 1800," in *Studien zur deutschen Kunst und Architektur um 1800,* ed. P. Betthausen (Dresden, 1981) 94–117.

31. Börsch-Supan and Jähnig, p. 300.

32. W. von Kügelgen, p. 109.

33. Börsch-Supan and Jähnig, pp. 300–302, no. 167; N. Schneider, "Natur und Religiosität in der deutschen Frühromantik: Zu Caspar David Friedrichs 'Tetschener Altar,'" in *Bürgerliche Revolution und Romantik: Natur und Gesellschaft bei Caspar David Friedrich,* ed. B. Hinz et al. (Giessen, 1976), 111–143; E. Reitharovà and W. Sumowski, "Beiträge zu Caspar David Friedrich," *Pantheon* 35 (1977), 43–47; W. Hofmann, "Caspar David Friedrichs 'Tetsche-

ner Altar' und die Tradition der protestantischen Frömmigkeit," *Idea: Jahrbuch der Hamburger Kunsthalle* 1 (1982), 135–162.

34. Eberlein, p. 206.
35. *HS*, 2:310, 365.
36. S. Hinz, pp. 21–22.
37. Schubert, *Der Erwerb*, 2:186–188.
38. Ibid., 3:335.
39. A. G. Pundt, *Arndt and the Nationalist Awakening in Germany* (New York, 1935); E. M. Arndt, *The Life and Adventures of Ernst Moritz Arndt*, ed. J. R. Seeley (Boston, 1879).
40. Pundt, p. 80.
41. The long critique and the rebuttals by Friedrich's friends may be found in S. Hinz, pp. 134–188. A partial translation of Ramdohr's critique is found in E. G. Holt, *The Triumph of Art for the Public* (New York, 1979), 152–165.
42. For a condensed English version see Holt, pp. 165–168.
43. Pundt, p. 76.
44. T. Mitchell, "Caspar David Friedrich's *Der Watzmann*: German Romantic Landscape Painting and Historical Geology," *Art Bulletin* 66 (1984), 452–464; Grütter, pp. 40–41.
45. There exists a voluminous literature on this particular picture: H. Ost, *Einsiedler und Mönche in der deutschen Malerei des 19. Jahrhunderts* (Düsseldorf, 1971), 108–121, 220–226; Börsch-Supan and Jähnig, pp. 302–304, no. 168; Börsch-Supan, pp. 79, 82–84; Hofmann, *Caspar David Friedrich*, pp. 31, 162–163; W. Hofmann, *Das Irdisches Paradies: Motive und Ideen des 19. Jahrhunderts* (Munich, 1974), 43; Rosenblum, pp. 10–15; Siegel, pp. 72–75; Vaughan, p. 93.
46. H. Börsch-Supan, "Caspar David Friedrich's Landscapes with Self-Portraits," *Burlington Magazine* 114 (September 1972), 620–630.
47. M. H. von Kügelgen, *Ein Lebensbild in Briefen*, ed. A. and E. von Kügelgen (Leipzig, 1901), 161.
48. H. von Kleist, "Empfindungen vor Friedrichs Seelandschaft," *Berliner Abendblätter*, 13 October 1810.
49. This is the point of departure for Jörg Traeger's interpretation of the novel painting tendencies at the turn of the century: "Als ob einem die Augenlider weggeschnitten wären": *Kleist-Jahrbuch* (1980), 86–106.
50. The entire review has been published both in German and English: see Eberlein, pp. 250–259; S. Hinz, pp. 213–217; P. B. Miller, "Anxiety and Abstraction: Kleist and Brentano on Caspar David Friedrich," *Art Journal* 33 (Spring 1974), 205–210; Holt, pp. 169–178.
51. The king himself, however, ever pressured by the French, was responsible for the journal's demise.
52. Ost, p. 118; Börsch-Supan's letter to me dated 2 June 1986, which states that Friedrich probably had the Cistercians in mind. But the Cistercians take vows of stability and are a contemplative order, and would be less likely candidates for the figure in the painting.

Indeed, there was no precedent in the history of art for showing a monk at the seaside.

53. Father Cuthbert, *The Capuchins: A Contribution to the History of the Counter-Reformation,* 2 vols. (New York, 1929), 2:284, 320–321.

54. H. von Kleist, *Sämtliche Werke,* ed. K. F. Reinking (Wiesbaden, 1972), 941.

55. J. and W. Grimm, *Deutsches Wörterbuch,* 16 vols. (Leipzig, 1854–1954), 7:474–490. *Nebel* is also the root of *Nibelung,* which carries the connotation of unseen danger. The *Nibelungenlied,* so dear to the romantics, conjured up a mystic land of mist akin to the world of Ossian and Hermann with the basic motifs of vengeance and impending doom. My thanks for this and other suggestions to my colleague Peter Klein.

56. W. Kemp, *Der Anteil des Betrachters: Rezeptionsästhetische Studien zur Malerei des 19. Jahrhunderts* (Munich, 1983), 51–52.

57. In addition to Kemp's work (ibid.), an entire body of literature is being given over to the subject of the beholder in relation to the reference point of the actors in a composition. See especially M. Fried, *Absorption and Theatricality: Painting and Beholder in the Age of Diderot* (Berkeley and Los Angeles, 1980); Fried, "The Beholder in Courbet: His Early Self-Portraits and Their Place in His Art," *Glyph* 4 (1978), 85–129; Fried, "Painter into Painting: On Courbet's *After Dinner at Ornans* and *Stonebreakers,*" *Critical Inquiry* 8 (Summer 1982), 619–649. Also W. Kemp, "Death at Work: A Case Study on Constitutive Blanks in Nineteenth-Century Painting," *Representations* 10 (Spring 1985), 102–123.

58. H. Franck, *Gotthard Ludwig Kosegarten: Ein Lebensbild* (Halle, Germany, 1887), 291; *Festschrift zur 500-Jahrfeier der Universität Greifswald,* 1:78.

59. E. M. Arndt, *Werke,* ed. A. Leffson, 12 vols. (Leipzig, n.d.), 2:91; Arndt, *Life and Adventures,* p. 158. Arndt's language gives us a clue to the social divisions of the period: he despised the "croakers" who bewailed "in hopeless dirges, the German nation," who were ready to "justify cowardice and shame," but there were others who protested against "this detestable doctrine of fatalistic submission," among whom, "thank God, there were a great many in Greifswald": ibid., p. 159.

60. Franck, pp. 183–188. Arndt had published his controversial *Versuch einer Geschichte der Leibeigenschaft in Pommern und Rügen* (Berlin, 1803).

61. Franck, p. 293.

62. Ibid., p. 304; *Festschrift zur 500-Jahrfeier der Universität Greifswald,* p. 79.

63. The complete text was published in Franck, pp. 437–467.

64. Ibid., p. 462.

65. Ibid., pp. 464–465. Kosegarten even suggested that through Napoleon he saw "glimmering on the furthest horizon of the shrouded present the dawn of a glorious future."

66. *Festschrift zur 500-Jahrfeier der Universität Greifswald,* pp. 65, 77, 79.

67. S. Hinz, pp. 21–22. As early as spring 1806 Friedrich became psy-

chosomatically ill as a result of the political situation. His close friend Schubert noted that the pain of Jena and Auerstädt was felt very deeply by Friedrich and that he frequently raised his voice in indignation against the French. He declared that the Germans are slow to action, but once they are aroused, "that is, after they have become fraternally united," they will stand up to their adversaries. (This sense of lethargy, of the need for external stimulus, is a further clue to Friedrich's depressive state.) Friedrich executed a picture in this period showing an eagle wending its way out of storm and clouds towards distant mountain peaks in the sunlight. This allegory meant that "the German Spirit will work its way out of the storm and clouds." But this optimism was short-lived and gave way to the mood of despair externalized in *Monk by the Sea*.

68. K. S. Pinson, *Pietism as a Factor in the Rise of German Nationalism* (New York, 1934).

69. L. W. Beck, *Early German Philosophy: Kant and His Predecessors* (Cambridge, Mass., 1969), 430.

70. Franck, pp. 164, 170; Kleist, pp. 1132–1139. Kosegarten dedicated his *Rhapsodieen* to Kant.

71. F. Schleiermacher, *On Religion: Speeches to Its Cultured Despisers*, tr. J. Oman (New York, 1958); K. Lankheit, "Caspar David Friedrich und der Neuprotestantismus," *Deutsche Vierteljahrsschrift für Literatur, Wissenschaft, und Geistgeschichte* 24 (1950), 129–143.

72. Franck, pp. 214–215; G. Berefelt, *Philipp Otto Runge zwischen Aufbruch und Opposition* (Stockholm, 1961); M. Redeker, *Schleiermacher: Life and Thought* (Philadelphia, 1973), 43–45.

73. Schleiermacher, p. 78.

74. For Schleiermacher's nationalism see J. Dawson, *Friedrich Schleiermacher: The Evolution of a Nationalist* (Austin, Tex., 1966).

75. German pietism stressed a simpler and more heartfelt form of religion akin to the monastic sensibility. Purity of life, saintliness of behavior, active Christianity came to be regarded as the essential marks of Christian life. It is this which accounts for the pietists' development of welfare and philanthropic works, and for their great missionary activity throughout the world. See Pinson, pp. 14–16.

76. Runge, 1:347–349; Vaughan, pp. 57–58.

77. L. G. Kosegarten, *Legenden*, 2 vols. (Berlin, 1804); Ost, pp. 114–115. Titles such as "Die Katze des Eremiten," "Die Creaturenliebe des heiligen Franziscus," and "Des heiligen Franziscus Sonnengesang" yield a clue to Kosegarten's genuine love of the early Christian anchorites.

78. Franck, pp. 206–209; J. G. L. Kosegarten, "Kosegartens Leben," in L. G. Kosegarten, *Dichtungen*, 12 vols. (Greifswald, 1824–1827), 12;143–145; Runge, 2:335–336.

79. My colleague in atmospheric sciences at UCLA, George L. Siscoe, helped me identify the fractostratus cloud blown by north winds.

80. Schubert, *Die Erwerb,* 2:183–185. Schubert stated that Friedrich's general state of melancholy, brought on by the death of his younger brother in an ice-skating accident, impelled him to seek solace on the island:

> The quiet wilderness of the chalk-mountains and the oak forests of his fatherlandish Rügen were his constant, most favorite place during the summer but even more so during the stormy time of late fall and during awakening spring when the ice broke on the ocean close to the shore. Most often he stayed in Stubbenkammer where there was no modern inn yet . . . Fishermen watched him with worry when he climbed through the cliffs . . . as if he willingly was searching his tomb in the surf below. When the waves were highest . . . he stood there, wet with the mist from the waves . . . as if he could not watch this powerful play long enough.

81. S. Hinz, pp. 191, 220, 227–228.
82. L. T. Kosegarten, *Poesieen,* 2 vols. (Leipzig, 1798), 1:183.
83. Franck, p. 207.
84. Kosegarten, *Dichtungen,* 12:143–145.
85. Kosegarten, *Poesieen,* 2:285–295.
86. S. Freud, "Mourning and Melancholia," *Collected Papers* (London, 1954), 4:152–170.
87. Kleist, *Sämtliche Werke,* pp. 1069–1074, 1079–1080.
88. Börsch-Supan and Jähnig, pp. 304–305, no 169.
89. T. Körner, *Werke,* ed. A. Weldler-Steinberg, 2 vols. (Berlin, 1908), 1:112–113.
90. Kügelgen's son said that the work had a special meaning for his parents; the woman who reaches the summit first and then aids the man whom she loves to reach the peak, recapitulated in visual terms their relationship. See W. von Kügelgen, p. 229.
91. Körner, 1:27.
92. Ibid., p. 191.
93. Ibid., pp. 27–28 ("Jägerlied").
94. G. H. Pertz, *Das Leben des Feldmarschalls Grafen Neithardt von Gneisenau,* 5 vols. (Berlin, 1864–1880), 1:96–97.
95. H. Delbrück, *Das Leben des Feldmarschalls Grafen Neidhardt von Gneisenau,* 2 vols. (Berlin, 1908), 1:54, Pertz, 5:165, 171–172.
96. S. Hinz, p. 24. Friedrich signed his letter to Arndt "Your Landsmann."
97. E. M. Arndt, *Werke,* ed. W. Steffens, 12 vols. (Berlin, n.d.), 1:31.
98. V. H. Miesel, "Philipp Otto Runge, Caspar David Friedrich, and Romantic Nationalism," *Yale University Art Gallery Bulletin* 33 (October 1972), 44–50; Siegel, pp. 84–89.
99. Börsch-Supan and Jähnig, pp. 327–328, no. 207; Sumowski, pp. 98–99.
100. Arndt, p. 173.
101. Börsch-Supan and Jähnig, p. 327.
102. Arndt, p. 101.
103. In the very first scene of Kleist's ultrapatriotic *Prince Friedrich of Homburg,* the elector of Brandenburg repeats this thought in wondering where the prince could have found laurel "in the sandy soil

of my Brandenburg"—attesting to a special sympathy for Prussian land.

104. L. E. A. Eitner, *Géricault, His Life and Work* (London, 1983), 60–66.

105. S. Hinz, p. 27.

106. G. H. von Schubert, *Allgemeine Naturegeschichte; oder, Undeutungen zur Geschichte und Physiognomik der Natur* (Erlangen, 1826), 1188.

Chapter Ten

1. See E. Bairaiti and A. Finocchi, *Arte in Italia,* 3 vols. (Turin, 1988), 3:312–347.

2. G. Hubert, *La sculpture dans l'Italie napolienne* (Paris, 1964); F. Boyer, *Le monde des arts en Italie et la France de la révolution et de l'empire: Etudes et recherches* (Paris, 1970).

3. F. Licht and D. Finn, *Canova* (New York, 1983), 101–102.

4. Hubert, pp. 306–307; E. Castelnuovo and M. Rosci, eds., *Cultura figurativa e architettonica negli stati del re di Sardegna 1773–1861* (Turin, 1980), 212–213, nos. 228–230.

5. J. Henry, "Antonio Canova and Early Italian Nationalism," in *La scultura nel XIX secolo,* ed. H. W. Janson, Acts of the Twenty-Fourth International Congress of Art (Bologna, 1984), 17–26.

6. A. Zappa, *Andrea Appiani e l'arte neoclassica nel suo spirito e nella sua derivazione letteraria* (Milan, 1921).

7. F. Bellonzi, *La pittura di storia del'ottocento italiano* (Milan, 1967), 89–90.

8. U. Hiesinger, "The Paintings of Vincenzo Camuccini, 1771–1844," *Art Bulletin* 60 (1978), 297–313.

9. D. Ternois, "Napoléon et la décoration du palais impérial de Monte Cavallo en 1811–1813," *Revue de l'art* (1970), 68–89.

10. J. S. Bartholdy, *Memoirs of the Secret Societies of the South of Italy, Particularly the Carbonari* (London, 1821); T. Frost, *The Secret Societies of the European Revolution, 1776–1876,* 2 vols. (London, 1876), 1:209 ff.

Photo Credits

1.10: (1977.254.3) © The Metropolitan Museum of Art. All rights reserved; 1.13; © Photo Réunion des Musées Nationaux (R.M.N.); 1.17, 1.18: Victoria and Albert Museum/Art Resource, N.Y.; 1.19: © Photo R.M.N.; 1.20: © Wadsworth Atheneum. Joseph Szaszfai, photographer; 1.22: The Fine Arts Museums of San Francisco, gift of M. H. de Young to the M. H. de Young Memorial Museum; 2.2, 2.4: © Photo R.M.N.; 2.3: Giraudon/Art Resource; 2.5, 2.6: Phot. Bibl. Nat. Paris; 2.7: © Photo R.M.N.; 2.8: Cliché, Musées de la Ville Paris © by S.P.A.D.E.M. 1990; 2.9: Acc. No. 74:1989, The Saint Louis Art Museum purchase, Mr. and Mrs. R. Crosby Kemper through the Crosby Kemper Foundations; 2.11: © Photo R.M.N.; 2.13: Phot. Bibl. Nat. Paris; 2.14: Giraudon/Art Resource, N.Y.; 2.15: Photo courtesy of the National Gallery of Art, Washington, D.C.; 2.16: © Photo R.M.N.; 2.23: Ecole Nationale Supérieure des Beaux-Arts; 2.26: © Photo R.M.N.; 2.29: Alinari/Art Resource, N.Y.; 2.31: © Photo R.M.N.; 2.32: © The Detroit Institute of Arts, Founders Society purchase, Robert H. Tannahill Foundation Fund, 2.34: Das Erdbeben, colorierte Radierung, 185 × 249 mm, von Johann Michael Voltz. Verlag Friedrich Campe, Nürnberg. Staatliche Bücher- und Kupferstichsammlung Greiz, Inv.-Nr.: B 6471; 3.2: Tate Gallery, London/Art Resource, N.Y.; 3.14: © 1989 Indianapolis Museum of Art. Gift in memory of Evan F. Lilly; 3.15: Tate Gallery, London/Art Resource, N.Y.; 3.17: Reproduced by courtesy of the Trustees of the British Museum; 3.29: Victoria and Albert Museum/Art Resource, N.Y.; 3.37: Tate Gallery, London/Art Resource, N.Y.; 4.2: RB 225625, v. 1/294 [leaf 82v-83r]. Reproduced by permission of The Huntington Library, San Marino, California; 4.3: © The Metropolitan Museum of Art, New York. All rights reserved; 4.4, 4.7, 4.8: © Photo R.M.N.; 4.9, 4.10: Giraudon/Art Resource, N.Y.; 4.12: Marburg/Art Resource, N.Y.; 4.13, 4.15: Giraudon/Art Resource, N.Y.; 4.17: Marburg/Art Resource, N.Y.; 4.19: Giraudon/Art Resource, N.Y.; 4:23: The Metropolitan Museum of Art, The Jules Bache Collection, 1949. (49.7.41); 4.25: Marburg/

Index

Abbey in the Oakwood (Friedrich), 581, *601–4*, 605
Abilgaard, Nicolai, *421–22*, 439, 447, 518
d 'Abrantès, duchesse, 202–3, 318
Accademia di San Luca, 651
Achilles among the Daughters of Lykomedes (Abildgaard), *421–22*
Achilles Contending with the Rivers (Flaxman), *438*
Afrancesados, 243, 250, 252, 253, 257, 265, 278, 289, 290; ambiguous status of, 229–37; Goya's affiliation with, *227–35, 230–34, 237–43, 252*, 278; and Joseph Bonaparte, 300, 302–4; vs. *Majismo*, *222–29*; ousted by Fernando VII, 312
Agricultural reform, 243–45, 281, 517
Agriculture (Goya), *243–44*
Alarma espagnola (Valdés), 303
Alfieri, Vittoria, 639, 642, 643
AllaModdin (Tieck), 359
Allegory of the City of Madrid (Goya), *302–3*
Allegory of the condition of France before the Return from Egypt (Franque), *70–71*
Allegory of Denon (Zix), *25*
Allemagne, De l' (de Staël), 206, 327
Allgemeine Naturgeschichte (Schubert), 631, 634
Allgemeine Theorie der schönen Künste (Sulzer), 362
Almanach (Bode), 494
Alpine scenery, fascination with, 116, 125

Altamira, count of, 230
American War of Independence, 229, 240, 411, 492
Amigos del País, 219, 239, 245, 305, 417
An die Deutschen (Arndt), 623
"An den Erzherzog Karl" (Kleist), 600
Angus, William, *138–39, 151*
Annalen der Physik, 376, *432*, 442, *545*, 606
Annales de musée (Landon), *207*
Ansichten von der Nachtseite der Naturwissenschaft (Schubert), 490, 534, 559
Antiquities of England and Wales (Turner), 136
Appiani, Andrea, *646–48, 647*
Arabian Nights, 128
Aranda, conde de, 232
Arc de Triomphe de l'Etoile, Paris, xxv, 6, 12, *13*
Arkona (Kosegarten), *596–98*
Arndt, Ernst Moritz, 353, 355, 392, 412, 434, 459, 460, 494, 499, 587, 604, 624, 634, 658 nn.59, 60; *Zur Befreiung Deutschlands*, 618–19; charges Napoleon with tyranny, 579; *An die Deutschen*, 623; endorsement of Stein's emancipation edict, 324–25; fairy tales of, 552–54; *Geist der Zeit*, 569–70; *Klage um drei junge Helden*, 625–26; nationalism and German peasantry, 347–51; political affinities with Friedrich, 611, 621; use of moon imagery, 379–81; *Vaterlandslied*, 627
Arnim, Achim von, 402, 547, 583, 592, 622

Arnim, Bettina von, 402
Arnold, Gottfried, 328–29
Arrival of Her Majesty the Empress in the Reception Room of the Palace of Compiègne, The (Auzou), *207–8*
Ars poetica (Horace), 274–75
Artist's Parents, The (Runge), *466–68*
Aritst's Parents, The, sketch (Runge), *466–67*
Astronomy, 373, 375, 376, 415, 451–52
Asylum (Goya), *236*
At the Advance Post (Kersting), *626*
Atala (Chateaubriand), 78–79, 81, 574–75
Athenäum, Das, 376
d'Auberteuil, Michel René Hilliard, 28–29
"Auf den Grabe" (Arndt), 379
Aufklärung, 441
Aurora: oder, Morgenröthe im Aufgang (Böhme), *455–56*
Austen, Jane, *165–66, 169*
Austria, 10, 36–37, 351, 374, 569–70, 617–18, 635, 640
Auto de Fe Celebrated in the City of Logroño during 7–9 November 1610 (Moratín), *252–53*
Autumn, or *Evening* (Friedrich), *536–37*
Auzou, Pauline, *207–9, 208*
d'Azeglio, Massimo, 637

Baciocchi, Elisa, 649
Bacon,Francis, 250
Ballgame (Goya), *224–25*
Barbus, the, 60, 70
Bardua, Caroline, 630
Barker, Robert, 400

Barlow, Joel, 25–26, 30
Barras, Joseph, 37, 39
Bartolini, Lorenzo, 640
Bassenge, Pauline Susanna, 446
Batoni, Pompeo, 651
Battle of Eylau, 37–38, 315–18, 347
Battle of Eylau (Spalla), *645*
Battle of Jena, 346, 352, 466, 500
Battle of Jena (Spalla), *644*
Battle of Nazareth, The (Gros), *29–30*
Battle of Trafalgar, 102, 104–6, 190, 199, 295
Battle of Trafalgar as Seen from the Mizen Starboard Shrouds of the Victory, The (Turner), *104–6*
Bauernstand, Der (Arndt), 324
Bavaria, 340–41, 501
Bayeu, Francisco, 234
Bayle, Pierre, 249
Beatific Image, engraving in *Divine Comedy* (Flaxman), *450*
Beaufort wind scale, *593*
Beauharnais, Eugène de, 205, 637–38, 643
Beaumont, Sir George Howland, 194, 196, 668 n.133
Beckford, William, 122, 127–35, 137, 138; as art patron, 131–35; and Fonthill Abbey, 129–31, 134; writings of, 128–30
Beethoven, Ludwig von, xxvi, 202
Befreiung Deutschlands, Zur (Arndt), 618–19
Beiträge zur Berichtigung der Urteile des Publikums über die französische Revolution (Fichte), 345
Beiträge zur vergleichenden Zoologie (Oken), 465
Bellotto, Bernardo: *Dresden from Right Bank of the Elbe, before the Augustsbrücke*, 520; *Marketplace of Pirna*, 520–21; *The Old Fortifications of Dresden*, 520; *The Old Market, Dresden, from Schlosstrasse*, 519–20
Benvenuti, Pietro, *649–51*
Berger, J. F., 117
Bergmannsleben (Körner), 612
Bergwerke zu Falun, Die (Hoffmann), 558–60
Berliner Abendblätter (Kleist), 352, 402, 582
Bernadotte, Jean-Baptiste, 61, 68
Bernstorff, A. P., 517, 518
Bernstorff, Graf Johann Hartvig Ernst, 517
Berthier, Louis-Alexander, 201, 205

Bertram, Johann Baptist, 394, 397
Besser, Johann Heinrich, 392
Betwitched by Force, The (Goya), *259–60*
Beyträge zur innern Naturgeschichte der Erde (Steffens), 427, 579–80
Biernacky, Graf von, 470
Birth of Fingal: His Father Comhal Killed in a Duel, The (Runge), *448–50*
Blair, Hugh, 55
Blake, William, 98, 184, 270, 477, 478
Blindman's Bluff (Goya), *224–25*
Bloomfield, John, 174–75
Bloomfield, Robert, 162
Blonde Eckbert, Der (Tieck), 543–44
Blücher, Gebhard Leberecht von, 609, 618
Bode, Johann Joachim Christoph, 494
Böhme, Jakob, 328, 336, 443, 454–57, 487, 492, 496
Boilly, Louis-Léopold, 47–49, *48*, *202–3*
Boisserée, Melchior, 385, 393–98, 411, 623–24
Boisserée, Sulpiz, 385, 393–98, 436, 480, 623–24
Bonaparte, Elisa, 638
Bonaparte, Joseph (king of Spain), 300–307, 311
Bonaparte, Letizia Ramolino, 641
Bonaparte at Arcole (Gros), *34–35*
Bonnet, Charles, 518
Borghese, Camillo, 641–42
Borja, Francisco de, 255–57
Botanic Garden, The (Darwin), 263–64, 271, 337, 433–34, 477–79, *478*, 491, 534
Botany, 394, 415, 433, 445, 473–75
Bourbons, xxvii, 11, 13, 86, 201, 217, 618, 653
Bourse, the, xxv
Boy Sleeping on a Grave (Friedrich), *546*
Brentano, Clemens, 402, 471, 505, 583, 592, 622, 684 n.50
Briefe auf einer Reise durch die Niederlande Rheingegenden, die Schweiz, und einen Theil von Frankreich (Friedrich von Schlegel), 395–96
Briefe über die aesthetische Erziehung des Menschen (Schiller), 389
Brincken, Friedrich Gotthard von, 633
British Institution for the Encouragement of British Art, 150–51

British Manufacturer's Companion and Callico Printer's Assistant (O'Brien), 158
Brongniart, Alexandre, 23–24
Brown, Lancelot ("Capability"), 142–43, 146, 148, 151
Brühl, Theresia Anna Maria Gräfin von, 570, 571
Brun, Frederike, 422, 444
Buch, Leopold von, 91
Burke, Edmund, 141, 143, 304–5
Burlador de Sevilla, El (Zamora), 260
Burr, Aaron, 27, 32–33, 658–59 n.28

Caballero, José Antonio, 266–67
Cabarrús, Francisco, 229–30, 232, 237, 265, 300
Cadalso, José, 274
Calicoes, 22
Calificadores, 248
Callcot, Augustus W., 157
Cambacérès, Jean Jacques Régis de, 205
Campomanes, P. de, 221, 222, 223–25, 229, 232, 245, 246, 274, 305
Camuccini, Vincenzo, *652–53*
Canal system, England, 192–93
Canaletto (Antonio Canal), 519, 520
Cañizares, José de, 289
Canova, Antonio, *636*, 639, 640–43, *641*, 651, 652
Capitulation of Madrid, 4 December 1808 (Gros), *300–2*, *301*
Capricho 43, The Sleep of Reason Produces Monsters (Goya), *269–78*
Caprichos, Los (Goya), 235–37, *236*, 240, 260, 267, *279–91*, *281*, *284*, *286–90*, 308; call for educational reform in, 283–85; critique of marriage in, 281–82; form of, 282; Iriarte's fables, influence on, 285–*87*, 286; meaning of, 268–69; Meléndez Valdés's influence on, 282–85; Moratín's influence on, 281–82; thematic content of, 281–85; and witchcraft and the Inquisition, *287–90*, *288*, *289*
Capuchins, the, 584–85
Carbonari ("charcoal burners"), 655
Carlos III in Hunting Dress (Goya), *232–33*
Carlos III, of Spain, 223, 225–26, 229, 232–*33*, 238, 251, 253, 266, 281, 300; cultivation of industry, trade, science, and the arts,

219–22, 248; "regalism" strategy of, 217–18, 241
Carlos IV and His Family (Goya), 212–15, *213*
Carlos IV (Tolsa), *215*
Carlos IV, of Spain, 41, 199, 228–29, 232–33,253, 264, 278; abdication of throne, 295; ascendancy of Inquisition under, 290; Goya's *Carlos IV and His Family*, 212–15, *213*; and Jansenist-ultramontane conflict, 266–67
Carthage, 111–16
Carus, Carl Gustav, 339, 632
Casa de la Misericordia of Zaragoza, 246
Catechismo del estado (Villaneuva), 271
Cathedral among the Trees (Schinkel), *384*, 404–5
Cathedral of Valencia, Capilla de San Francisco de Borja, 255–56
Catholicism, 77, 83, 203, 217, 248, 251–53, 270, 311, 364, 368, 585; and Chateaubriand, 79–80, 574–75; in German romanticism, 361–62, 395–96; in Goya's work, 261–62
Cave with Tomb (Friedrich), *626–27*
Censor, El, 279
Ceruti, Giacomo, 305
Chalgrin, Jean-François-Thérèse, 13
Chamisso, Adelberg von, 320
Chapter-House, Salisbury (Turner), *140*
Charging Chasseur (Géricault), *629*
Charlemagne Summoning Italian and German Scholars to Found the University of Paris (Camuccini), 652–53
Charpentier, Constance, *57*
Chasseur in the Woods, The (Friedrich), *627–28*
Château de Choisy, 315
Chateaubriand, François-René, 78–83, 86, 94, 95, 278, 361, 364, 574–75
Chaudet, Antoine-Denis, 23, 58–59, 643
Chaudet, Jeanne-Elisabeth, *58–59*
Chaussard, P. J. B. P., 37, 42–43, 52–53, 58, 208
Christenheit oder Europa, Die (Novalis), 361, 575
Christianity, 78, 79, 82–83, 251, 261, 328, 343–44, 361, 364, 368, 373, 376, 575, 591, 655
Christlich-deutsche Tischgesellschaft, 402, 583, 622

Cisalpine Republic, 637, 646, 648
Civil Code (*Code Napoléon*), xxiii, 8, 10, 68, 205–6, 323, 572, 588, 637, 654
Claudius, Matthias, 391, 392, 417, 448
Clifford, George, 474
Cliffortia, plate 32 (Linnaeus), *474*
Clothed Maja (Goya), *292–94*
Cloud Study (Constable), *170*
Coalbrookdale (Shropshire, England), 119–21
Coalbrookdale by Night (Loutherbourg), *121*
Cockermouth Castle (Turner), *141–42*
Coleridge, Samuel Taylor, 98–101, 194
Collectors and collecting, 142–43
Cologne Cathedral, 395–98
Columbiad (Barlow), 30
Commerce (Goya), *246–47*
Complaint of Ninathoma, The (Coleridge), 99
Comte de Valmont: ou, Les Egaremens de la raison, Le (Gérard), 277
Concordat of 1801, xviv, 8, 9, 77, 80, 201, 640
Conde de Cabarrús (Goya), *230*
Conde Floridablanca y Goya (Goya), *231–32*
Condesa-duquesa de Benavente (Goya), *255*
Confederation of the Rhine, 316, 319, 323, 394, 634
Congress of Vienna, 355, 634–35, 637, 655
Constable, Golding, 161–62
Constable, John, 130, 149, 159–62, *177–78*, 186, 610, 665 n.82, 666 nn.84, 87, 90, 97, 667 nn.123, 126, 128, 130, 668 n.133; attitude towards rural citizenry, 163–64, 175–77, 191; Bloomfield, influence of, *174–78*, *175*, *177*; and Bonapartism, 190–93, *191*; concept of "truth" in his art, 168–69; and Jane Austen, 165–66; meteorological forecasts, *170–78*, *171–75*, *177*, 188; patrons, 160–61; Pierre-Henri de Valenciennes and the aesthetics of landscape, 185–90, *189*; regionalism of, *162–69*, *163*, *165–67*; studies and sketches, *182–85*, *183*; and Turner, 159–60, 162, 185, 189–90, 192; and Wordsworth, 193–95
—, works: *Cloud Study, 170; Dedham from Langham* (1802), 188–

89; Dedham from Langham (1812), *182–84; East Bergholt House*, 166–67; *Flatford Mill*, 170–71; *Flatford Mill from the Lock*, 170–71; *Golding Constable's House at East Bergholt*, 166–67; *Golding Constable's Kitchen Garden*, 161–62, 176; *Golding Constable's Kitchen Garden*, drawing, 163–64; *His Majesty's Ship Victory, Capt. E. Harvey, in the Memorable Battle of Trafalgar, between Two French Ships of the Line*, 190–91; *Landscape with Double Rainbow*, 171–72; *Landscape: Ploughing Scene in Suffolk*, 174–75; *Old Hall, East Bergholt*, 175–76; *Various Subjects of Landscape, Characteristic of English Scenery*, frontispiece mezzotint for, 164–65; *View of Dedham*, 177–78; *View of Dedham*, oil sketch, *183–84*
Continental blockade, 102–3, 109, 110, 114, 122, 154, 295, 397, 411, 431, 508, 604
Cooke, W. B., 159
Cornflower (Runge), *476–77*
Corona, Camillo, 37–38
Coronation, The (David), *198*, 201, 203–5
Coronation (Spalla), 644–45
Corps législatif, 51–53, 67
Corsica, 3, 4
Cortes of Cádiz, 311–12
Cowper, William, 162
Cozens, John Robert, 137
Creoles, 216
Crockery Vendor, The (Goya), *220–22*, *221*
Cross on the Baltic Sea, The (Friedrich), *629–32*
Cross on the Baltic Sea, The (Werner), *630–31*
Cross in the Mountains (Friedrich), *621–22*
Crowd Standing before David's Painting of the Coronation, The (Boilly), *202–3*
Crystallography, 65
Cuvier, Georges, 124

Daguerre, Louis, 401
Dance on the Banks of the River Manzanares (Goya), *223–24*
Darstellung meines Systems der Philosophie (Schelling), 337
Darwin, Erasmus, 263–64, 271–73, 337, 389, 432, 433, 434, 477–79, *478*, 491, 534, 678 n.36

David, Jacques-Louis, xxv, xxvi, 4, 24, 29, 38, 50, *53–54*, 73, 82, 94, 113, 184, 211, 256, 266, 640, 646, 650, 668 n.6; conceptual dualism in work exemplified in *Distribution of the Eagles, 44–47, 46;* Constable's dislike for, 190; *The Coronation, 198,* 201–5, 211, 214–15, 644; and Napoleon, *39–49, 44,* 46, 210, 211; *Napoleon Crossing the Saint Bernard, 39–43; Napoleon in His Study, 53–54;* perimeters of Bonapartist visual and historical "truth," 47; role in shaping Bonapartist propaganda, 40, 42, 43

Davy, Sir Humphry, 123–24

Day, or *Noon* (Runge), *485–86*

Death of Jane McCrea, The (Vanderlyn), *27–29*

Death on the Pale Horse (West), *88–89*

Dedham from Langham, 1801 (Constable), *182–83,* 188

Dedham from Langham, 1802 (Constable), *188–89*

Dehn of Altona, 470

Deluc, Jean André, 91–92, 173, 180

Denmark, 419–20, 517, 569

Denon, Dominique-Vivant, *22–24, 25–26*

Departure of the Conscripts in 1807 (Boilly), *47–48*

Deposition (Michelangelo), *82*

dePujol, Alexandre-Denis Abel, *18–19*

Desastres de la guerra, Los (The Disasters of War), (Goya), 307–12, *308–11*

"Despidida del anciano, La" (Valdés), 242

Description de l'Egypte, 2, 6, 14, 15

Desgenettes, Nicolas René Dufriche, 83, *84–86*

Deutsche Chronik (Schubart), 363

"Deutschen Vaterland, Des" (Arndt), 380–81

"Deutscher Trost" (Arndt), 381

Deutsches Volksthum (Jahn), 619

Diablo predicador, El (Zamora), 259

Diario de Madrid, 268

Dictionnaire historique et critique (Bayle), 249

Diderot, Denis, 573

Directory, the, xxiii, 4, 5, 7, 14, 26, 36, 39, 70, 74, 265

Discurso sobre la educación popular de los artesanos y us fomento (Campomane), 221

Discurso sobre el fomento de la industria popular (Campomane), 221

Distribution of the Eagles (David), *44–47, 46*

Distribution of the Eagles, drawing (David), *46–47*

Divine Justice and Vengeance Pursuing Crime (Prud'hon), *73–75*

Divine Justice and Vengeance Pursuing Crime, (drawing), (Prud'hon), *74*

Dolomieu, Déodat Guy Silvain Tancrede Gratet de, 92

Domine Lucas, El (Cañizares), 289

Don Fernando, Prince of Asturias, 213–14

Douglas, Alexander, 53

Dream of Ossian (Ingres), *67–68*

Dresden from Right Bank of the Elbe, before the Augustbrücke (Bellotto), *520*

Drewes and Company, 393

Duqueylar, Paul, 60, 68, 652

Durch Theorie erfundene Practic, Die (Preissler), model from, *513*

Dürer, Albrecht, 367, *449–50, 543*

Earthquake (Voltz), *89–90*

Earthquake in Greece (Saint-Ours), *89–90*

East Bergholt House (Constable), *166–67*

Economic Society of Madrid, 239

Eduard und Veronika; oder, die Reise ins Riesengebirge (Körner), 613–14

Effect of the Comic and Tragic Masks, The (Runge), *425*

Egerton, Francis, 139–40

Egremont, Lord (Wyndham), 145, 153–55

Eichbaum, Der (Kosegarten), 378

Eichen, Die (Körner), 603

Eichendorff, Joseph von, 620

Eine Saga (Friedrich), *547–48,* 564

Eine Sommerreise (Tieck), 539

Electricity, 64, 66, 442

Elegy in the Courtyard (Gray), 416

Elémens de la perspective pratique (Valenciennes), 185, *531–32,* 575

Embarkation for Cythère (Watteau), *228–29*

Emilie's Spring (Friedrich), *518*

Enclosures, 157, 160, 162, 194

England, xxiv, 10–11, 21, 33, 63, 71, 112, 117, 118, 126, 133, 199–200, 216, 262, 294–95, 338, 374, 383, 392, 419–20, 640; canal system, 192–93; continental blockade, 102–3, 109, 110, 114;

cultural influence on *ilustrados,* 263; expansion of colonial interests in India, 126–27; patriotic attachment to land, 148–49, 195; sorcery and witchcraft, interest in, 263–64; war with France, 11, 63, 97–98. English Art, 98, 135–36, 150–51. See also Constable, John; Turner, Joseph Mallord William

English Landscape Scenery (Constable), 188

Enlightenment, the, 326, 334–36, 343, 347, 361, 385, 391, 574; rejected by German Romantics, 362–64, 367, 372, 449, 564. See also Spanish Enlightenment

Erfurter Gesellschaft oder Akademie gemeinnütziger Wissenschaften, 364

Erste Ideen zur Theorie des Lichts, der Finsterniss, der Farben, und der Wärme (Oken), 465, 607

Erster Entwurf eines Systems der Naturphilosophie (Schelling), 336

Essays on the Picturesque (Price), 147

Essen, Baron Hans Henrick von, 325

Evangelio en triunfo: o, Historia de un filosofo desengañado, El (Olavide), 277–78

Evening (Runge), *483–84*

Ewald, Johannes, 421

Eyck, Jan van, 52

Faber, Johann Joachim, 444

Fabrica de armas of Madrid, 306

Fall of an Avalanche in the Grisons, The (Turner), *116*

Farbenkugel (Runge), *430–32, 431*

Farington, Joseph, 149

Farmer's Boy, The (Bloomfield), 174–75

Farmhouses at the Foot of a Mountain (Friedrich), 522, *524*

Farmhouses at the Foot of a Mountain, drawing (Friedrich), *523–24*

Fatherland's Fall, The (Runge), *502–3*

Faust (Goethe), 375

Fawkes, Walter Ramsden, 108–9, 115, 119, 122, 149

Fears in Solitude (Coleridge), 101

Feijóo y Montenegro, Benito Jerónimo, 249–52, 256, 257, 258, 262

Fernando VI, of Spain, 250

Fernando VII, of Spain, xxvii, 199–200, 213, 214, 295, 298–99, 311–12
Fichte, Johann Gottlieb, 339, 347, 348, 352, 353, 355, 391, 426, 465, 492, 494, 554, 562, 577; influence of Böhme on, 455; leading intellectual of German nationalism, 331–33, 344–46; *Reden an die deutsche Nation*, 318–19; Schinkel, influence on, 399; *Wissenschaftslehre*, 335, 427
Fielding, Joseph, 281–82
Fifth Plague of Egypt, The (Turner), *132–35*
Fingal with Raised Spear (Runge), *450*
Fisher, John, 160, 168, 169, 192
Flatford Mill (Constable), 170–71
Flatford Mill from the Lock (Constable), 170–71
Flaxman, John, 71, 264, 337, 420–21, 425, 435, 443, 449, 477, 563, 647, 677 n.18; *Achilles Contending with the Rivers*, 438; *Beatific Image*, *450*; *Jupiter and Thétis*, 207
Flora gryphica (Wilcke), 415
Flora PomeranoRugica (Weigel), 475
Floridablanca, Conde de, 217, 221, 222, 227, 228, 231, 232, 268, 270
Folia determinata, plate 3 of *Philosophia botanica* (Linnaeus), 505, *506*
Folktales: Rübezahl, 549–52; Rüger, 552–54
Fontaine, Pierre-François-Leonard, 23, 44, 60, 201
Fontanes, Louis de, 80
Fonthill Abbey, England, 127–31
Fonthill Abbey at Sunset (Turner), *131–32*
Fonthill House (Turner), *138–39*
For Being of Jewish Ancestry (Goya), *252*
Forge, The (Goya), *305–6*, 310
Forner, Juan Pablo, 246, 275, 286
Forster, Thomas Ignatius Maria, 173
Foscolo, Ugo, 639, 643
Fouché, Joseph, xxiii, 74
Fragonard, Alexandre-Evariste, *16–17*
France, 21, 27, 49, 90, 97–98, 102–3, 126, 216, 233, 253, 342, 569; continental blockade, 102–3, 109, 110; and Spain, 245–46, 290–92, 294–300 (See also under Spain); war with England, 11, 63, 97–98, 103, 112–13

France: An Ode (Coleridge), 100–101
Franklin, Benjamin, 338
Franque, Jean-Pierre, *70–71*
Franz Sternbalds Wanderungen: Eine altdeutsche Geschichte (Tieck), 360–61, 382–83, 406, 434, 436–37, 473, 566–71, 584
Freemasonry, 491–99, 580, 630, 681 n.100; and German nationalism, 494–95; Italian, 655; and Runge's *Times of Day*, 491, 495, 496–99, 497
Freiheitskrieger, 619–20
Freikorps, 619–20
French Revolution, xvii, xxvi, 4, 76, 79, 92, 99, 147, 194, 210, 237, 270, 298, 365, 398, 391, 412, 466, 492, 493, 539, 591; and the *Afrancesados*, 226–28, 232–34; and German nationalism, 319, 320, 342, 357–62, 579; and German romanticism, 322, 326, 327, 383, 448; and Kant, 329–30
Friedrich, Adolf Gottlieb, 511
Friedrich, Caspar David, 324, 327, 339, 347, 357, 377, 399, 404, 434, 459, 490, 499, *510*, 511–12, 566, 611, 635, 682 n.1, 683 n.12, 684 nn.41, 45, 70, 685–86 n.67; affinities with Runge, 444, 491, 511, 512, 514, 522, 527–28, 530, 535, 542, 565–66; allegorical and literary subjects, *541–46*, *542–44*; Copenhagen Academy education, 514–19, *518*; early picturesque and topographical works, *518–22*, *521*, *526–27*; and German landscape painting, 320–21, *523*; gothic motifs and affinities with Schinkel, *621–23*; Hermann themes, 623–27, *624*, *626*; and Kosegarten, 511, 512, 527, 529, 533, 542; mountain motif, fascination with and function of, *523–26*, *524*, *525*, 545, *560–62*, *561*, *605–8*, *607*, *610–14*; *Naturphilosophie* and his landscape development, 535, 539, 548, 561, 565–66, 574, 579–80, 608, 631, 633; and Quistorp, 513, 522, 523, *524*; and Rügen, *526–33*, *530–32*, 534–35, *582–83*; and Schubert, 534–39, *535*, *536*, *538*, 567–68, 634; studies of botanical forms, *522–23*, 632; stylistic transition in early 1800s, *560–62*, *561*; technique, 631–32; and Tieck,

539, 543–45; and view painting, 514–15; youth and early education, 512–14
—, works: *Abbey in the Oakwood*, 581, *601–5*; *Autumn*, or *Evening*, *536–37*; *Boy Sleeping on a Grave*, *546*; *Cave with Tomb*, *626–27*; *The Chasseur in the Woods*, *627–28*; *The Cross on the Baltic Sea*, *629–32*; *Cross in the Mountains*, *621–22*; *Eine Saga*, *547–48*, 554, 564; *Emilie's Spring*, *518*; *Farmhouses at the Foot of a Mountain*, 522, *524*; *Farmhouses at the Foot of a Mountain*, drawing, *523–24*; *Glass Factory in Döhlen*, *526–27*; *Gravestone with Knight's Helmet*, *623*; *Greifswald Marketplace*, *520–21*; *Königsstuhl*, *531*, *533*; *Landscape with Pavilion*, *518–19*; *Landscape with a Rainbow*, *604–5*; *Landscape in the Riesengebirge*, *610–14*; *Landscape with Sunrise*, *560–62*; *Male Nude*, *514*; *Manor House near Loschwitz Overlooking Elbe Valley*, *528*; *Monk by the Sea* (see main entry); *Morning Fog in the Mountains*, *564–65*; *Morning in the Riesengebirge*, *607–9*, *622*; *Mountain Landscape*, *561–62*; *Mountain with a Rainbow*, *605–6*; *Old Heroes' Graves*, *624–25*; *Procession at Sunrise*, *562–66*, *563*; *Prospect from Rugard towards Jasmund*, *530–31*; *Die Räuber* illustrations, *539–41*, *540*; *Rocky Crag with Caves and Masonry*, *524–25*; *Schloss Kriebstein*, *526*; *Seashore with Fisherman*, *594*; *The Seasons* series, *535–39*, *536*, *538*; *Self-Portrait*, 581, *583*; *Spring*, *535–36*; *Stubbenkammer*, *530*; *Summer*, *536–37*; *The Tetschen Altar*, or *Cross in the Mountains* (see main entry); *Traveler above the Fog*, *632–34*, *633*; *Traveler at the Milestone*, *542–43*; *View from the Terrace of the Erdmannsdorf Estate*, *614–17*; *View of Arkona with Rising Moon*, *532–33*; *View of Arkona with Rising Moon and Fishnets*, *531–32*; *View of Arkona with Shipwreck*, *531–32*; *View of Arkona with Sunrise*, *530–31*; *Winter*, *537–38*; *Woman with a Raven on a Precipice*, *543–44*, 548; *Woman with Spider's Web between Bare Trees*, *542–43*
Friedrich, Christian, 541, 570
Friedrich II, of Prussia, 524

Friedrich August III, of Germany, 444, 523, 650

Friedrich Wilhelm III, of Prussia, 322–23, 333, 407, 581, 603, 609, 617, 618, 629

Friedrich Wilhelm IV, of Germany, 398

Friedrichs Totenlandschaft (Körner), 603

Frochot, Comte, 72–73

Frühen Gräber, Die (Klopstock), 374

Fulton, Robert, 25–26, 186, 400

Fundamentorum botanicorum (Linnaeus), 475

Funeral of Atala (Girodet), 77–79, 78, 575

Fuseli, Henry, 88, 93, 95, 183, 256–57, 264, 271–74, 421

Gainsborough, Thomas, 446

Gallegos (Galicians), 306

Galleria del Beaumont, Palazzo Imperiale of Turin, 643

Galvini, Luigi, 65, 66, 338, 442

Gaspar Melchor de Jovellanos (Goya), 238

Gebirgs-Sagen (Steffens), 549–52

Gedichte von Ossian dem Sohne Fingals, Die (Stolberg), 448–49

Gefangene, Der (Tieck), 362

Geist der Zeit (Arndt), 349, 569–70

Génie de christianisme (Chateaubriand), 79–80, 83, 574–75

Geognostisch-geologische Aufsätze als Vorbereitung zu einer innern Naturgeschichte der Erde (Steffens), 429–30

Geographie des Mondes (Schröter), 376

Geology, 91–92, 117–22, 124–25, 179–81, 427, 429, 579

George III, of England, 126, 128, 137

Gérard, François, 60–62, 61, 64, 65, 70

Gérard, Philippe-Louis, 277

Géricault, Théodore, 628–29

German fairy tales, 546–52; Arndt's, 552–54

German nationalism, 318–20, 326–27, 331–33, 343, 489; and Arndt, 347–51; and Fichte, 344–46; and freemasonry, 494–95; and the French Revolution, 357–59; and Gneisenau, 353–55; and Kleist, 351–53; and medievalism, revival of, 326–28, 359–62, 368, 395–96, 402–3; and philosophy, 341–44; and Runge,

499–505, *501–4;* and Schinkel, 403–8; and Schleiermacher, 591–92

German peasantry, 362–64, 502, 504, 551–52, 611–12, 672 n.7, 681 n.113

German philosophy, 328–41, 426–32, 441–42

German prints, 418

German publishing, 389–93, 542

German romanticism, 489, 585, 675 n.24; cyclical series in, 405–6; and medievalism, revival of, 326–29, 359, 360–61, 393–96, 437, 447–49, 621–23; mountain and moon metaphors in romantic texts, 369–83; and Novalis' *Heinrich von Ofterdingen,* 554–58; and Ossianic literature, 447–49; Schinkel and gothic art, 398–408; and Tieck's *Franz Sternbalds Wanderungen: Eine altdeutsche Geschichte,* 360–61; and Wackenroder's *Herzensergiessungen eines Kunstliebender Klosterbruders,* 364–70

Germania an ihre Kinder (Kleist), 600

Germanien und Europa (Arndt), 553

Germany, 10, 49, 357–70, 386–93, 396, 431, 603–4, 617–20, 651, 674 n.31; Battle of Eylau, 315–18; Dresden, 443–46, 519, 524–25; Hamburg, 417–20, 680 n. 74; landed property in, 321–26. See also Prussia

Geschichte des Herrn William Lovell, Die (Tieck), 329, 334–36

Geschichte von Heymons Kindern, Die (Tieck and Runge), 446

Gessner, Salomon, 93

Gestiefelte Kater, Der (Tieck), 370–71

Ghent Altarpiece (van Eyck), 52

Ghosts of French Heroes, Killed in the Service of Their Country, Led by Victory, Arrive to Live in the Aerial Elysium Where the Ghosts of Ossian and His Valiant Warriors Gather to Render to Them in Their Voyage of Immortality and Glory a Festival of Peace and of Friendship, The (Girodet), 61–64, 62

Giant, The (Goya), 304–5

Gichtel, Johann Georg, 328

Gillray, James, 202

Gilpin, William, 141, 143–49, 155, 157–58, 163, 194, 667 n.115

Girodet-Trioson, Anne Louis, 98–99, 102, 123, 125, 172, 317, 575,

660 n.27, 660 n.30; and Chateaubriand, 80–82, 95; and contemporary science, 64–68; *Funeral of Atala,* 77–79, 78, 81–83; *Ghosts of French Heroes, The,* 62; and Ossianic literature, 60–64, 62, 71; *Scène de Déluge,* 92–95, 93

Girtin, Thomas, 136–38, 514

Glass Factory in Döhlen (Friedrich), 526–27

Gneisenau, August Neithardt von, 323, 333, 403, 405, 429, 494, 503, 609, 611, 618, 622; as military nationalist, 353–55; service in Silesian army, 615–16

Godoy y Alvarez de Faria, Manuel, 199, 233, 237, 240–42, 252, 254, 258; dependent upon Napoleonic policies, 290–92, 294–95; educational reforms of, 283; liberal policies of, 261, 264; resignation of, 265–66; scientific development under, 246–47; supportive of Jansenists, 266–67

Godoy and Goya: allegorical commissions, 243–48, 245, 246; Godoy's exploitation of women referred to in *Maja* paintings, 291–94, 292; portrait by, 290–92, 291; position in *Carlos IV and His Family,* 213–15

Goethe, Johann Wolfgang von, 327, 334, 362, 397, 427, 436, 480, 494, 507, 604, 630; anti-Newtonian theories of, 606–7; call for revitalization of German art, 439–40; opposition to German romantics, 364–66; *Sorrows of Young Werther,* 374–75; and the Weimarer Kunstfreunde, 562–63

Goicoechea, Don Juan Martín de, 218, 219

Golding Constable's House at East Bergholt: Birthplace of the Painter (Constable), 166–67

Golding Constable's Kitchen Garden (Constable), 161–62, 176

Gondouin, Jacques, 12

Görres, Joseph von, 339, 392

Gothic art, German revival of, 362–70, 395–96, 447–49, 621–23; and Schinkel, 398–408

Gothic Cathedral by the Water (Schinkel), 406

"Gott der Hirt" (Arndt), 380

Götz von Berlichingen (Goethe), 327

Gould, R. F., 496–97, 580

Goya y Lucientes, Francisco, 200,

212, 218–19, 228, 312, 629, 668
n.15, 669 nn.21, 36, 670 nn.43,
63, 671 n.92, 672 nn.1, 93, 96;
Afrancesado affiliation, *227–35,
230–34, 237–43,* 252, 278; career
up to the Napoleonic invasion,
216–22, *220, 221;* English influ-
ences on, 263–64, 271–72; and
Godoy (*see* Godoy and Goya);
and Joseph Bonaparte, 300, *302–
3, 304, 312;* and Jovellanos, 237–
38, 240–41, *243–44; Majismo* vs.
Afransecamiento, 222–29, 223–27;
and Meléndez Valdés, 241–43,
242, 282–83; mental and physi-
cal illnesses of, 233–36; occult
and witchcraft series, *255–62,
256, 258, 259, 261;* and the Os-
suna Family, commissions for,
253–62, *255, 256, 258, 259, 261;*
and plight of working people,
305–7, 306; portrait painting,
229, *230–34, 238,* 240–41; and
the Spanish Enlightenment and
witchcraft, 250, *252*–53; tapestry
cartoons, *220–29, 221, 223–27;*
Zamora's influence on, *259–60*
—, works: *Agriculture, 243–44; Al-
legory of the City of Madrid, 302–*
3; *Asylum, 236–37; Ballgame,
224–25; The Bewitched by Force,
259–60; Blindman's Bluff, 224–25;
Los Caprichos* (see main entry);
*Carlos III in Hunting Dress, 232–
33; Carlos IV and His Family,
212–15, 213,* 290; *Clothed Maja,
292–94; Commerce, 246–47;
Conde de Cabarrús, 230; Conde
Floridablanca y Goya, 231–32;
Condesa-duquesa de Benavente,
255; The Crockery Vendor, 220–
21; Dance on the Banks of the
River Manzanares, 223; Los de-
sastres de la guerra* (The Disasters
of War), *307–12, 308–11, 315,*
318; *For Being of Jewish Ancestry,*
252; *The Forge, 305–6,* 310; *The
Giant, 304–5; Industry, 245–46;
The Injured Mason, 220; Kite
Flying, 224–25; The Knife
Grinder, 305–6; Manuel Godoy,
290–92, 291; Manuel Osorio de
Zuñiga, 230–31; The Meadow of
San Isidro, 226–28; Naked Maja,
292–94; San Francisco de Borja
Exorcising an Evil Spirit from an
Impenitent Dying Man, 256–57;
Sebastian Martínez y Perez, 234;
The Second of May 1808 in Puerta
del Sol, 296–98; The Straw Mani-
kin, 225–26; The Third of May,*

*1808, 210–12, 211, 297–300, 650;
The Water Carrier, 305–6; The
Wedding, 227–29; Witches in
Egypt, 258; The Witches Sabbath,*
261–62
Graff, Anton, 444
Graff, Karl, 444
Gravestone with Knight's Helmet
(Friedrich), *623*
Gray, Thomas, 377, 414, 416, 542
Great Sanhedrin, 9
Greifswald Marketplace (Friedrich),
520–21
Gropius, Wilhelm Ernst, 400–401,
403
Gros, Antoine-Jean, 32, 35, 38,
54, 72, 315, 645, 661 n.50; *The
Battle of Nazareth, 29–30; Bona-
parte at Arcole, 34; Capitulation of
Madrid, 4 December 1808, 300–
302, 301; Napoleon in the Pest-
house at Jaffa, 83–87, 84, 317;
Napoleon on the Battlefield of
Eylau, 314–18; Portrait of the First
Consul, 49–50*
*Grundriss des Systems der Naturphi-
losophie* (Oken), 463
"Grundzüge des gegenwärtigen
Zeitalters, Die" (Fichte), 345–46
Grünes Gewölbe, 445, 524
Guérin, Pierre-Narcisse, *86–87*
Guillemardet, Ferdinand, 265
Gustav IV, of Sweden, 325–26,
568
Gustavus IV, of Germany, 459,
467, 499, 500

Hagen, F. H. von der, 549
Hahn, Reichsgraf von, 470
Hall, James, 117
*Hamburgischen unparteiischen Kor-
respondenten,* 494
Hamilton, Sir William, 91–92,
422–23
Hardorff, Gerdt, 417
Hartmann, Ferdinand, 444, 571,
578
Harvey, Elisabeth, *56–57*
Hauser, Arnold, 191
Hayez, Francesco, 637
Head of Meleager (Runge), *424*
Hearne, Thomas, 138
Heath, James, 106
Hechizado por fuerza (Zamora),
259–60
Hegel, Georg Wilhelm Friedrich,
339, 357, 358
Heinrich von Ofterdingen (Novalis),
554–59, 584
Henley, Samuel, 129
Her Majesty the Empress, Before Her

*Marriage, at the Moment of Taking
Leave of Her Family, Distributing
Her Mother's Diamonds to the
Archdukes and Archduchesses* (Au-
zou), *208–9*
Herder, Johann Gottfried von,
326, 327, 347, 363, 425, 433
Hermanns Schlacht (Klopstock),
447, 448
Hermanns Tod (Klopstock), 447
Hermannsschlacht, Die (Kleist),
352, 583, 600–601, 623–24, 625,
627
Hernandia, plate 23 (Linnaeus),
473
Herschel, Sir William, 66, 376
Herterich, Heinrich Joachim, 417
Hervas y Panduro, Lorenzo, 270–
71, 276
Herz, Henrietta, 619, 630
*Herzensergiessungen eines kunstlie-
benden Klosterbruders* (Wacken-
roder), 360, 363–70, 545, 572–
73, 575
Herzog, Karl August, 606
Himmlische Erinnerungen (Luise, of
Prussia), 609
*His Majesty's Ship Victory, Capt. E.
Harvey, in the Memorable Battle of
Trafalgar, between Two French
Ships of the Line* (Constable),
190–91
*Historia del famoso predicador Fray
Gerundio de Campazas, La* (Isla),
251
Historia de la vida del hombre (Her-
vas), 270–71
History of Freemasonry (Gould),
496–97, 580
Hoare, Sir Richard Colt, 140,
149,152
Hoffmann, Ernst Theodor Wil-
helm, 549, 558–60
Hoffmann, Joseph, 563
Hogarth, William, 229, 264, 281
Holy Alliance, xxvii, 653
Holy Roman Empire, 319, 320,
322, 327, 407
Hope, Thomas, 421, 480
Hortus Cliffortianus (Linnaeus):
frontispiece by Jan Wandelaar,
474–75
Hortus gryphicus (Wilcke), 475
Household Furniture (Hope), 421
Howard, Luke, 172–73, 180, 606
Hüllmann, Karl Dietrich, 503
Hülsenbeck, Friedrich August,
389, 417
Hülsenbeck, Runge, and Co., 417
Hülsenbeck Children, The (Runge),
461–63

Humboldt, Alexander von, 16, 65–66, 91, 93, 398, 657 n.9
Humboldt, Wilhelm von, 319, 346
Hume, David, 337
Hünengrab, Das (Kosegarten), 378–79
Hünengräber myth, 623–24
Hutton, James, 65, 71, 91, 92, 93, 118, 123, 180
Hymn to the Morning (Milton), 416
Hymmen an die Nacht (Novalis), 375–76
Hymne an die Insel Rügen (Kosegarten), 595

Ideen einer Philosophie der Natur (Schelling), 426
IdentitätsSystem (Schelling), 337–38
Illuminati, 493
Ilustrados, 221, 225, 226, 233, 247, 249, 253, 254, 263, 265, 268, 282
Imitated from Ossian (Coleridge), 99
Immermann, Karl, 620
India, 126–27
Industrial Revolution, 21, 120, 121, 123, 125, 138, 158, 173, 179, 184, 192, 274, 383, 394, 477
Industry, 22–23, 119–21, 123–24, 212
Industry (Goya), 245–46
Infante Don Luis Antonio de Borbón, 230, 233
Infante Francisco de Paula Antonio, 213, 296
Informe de la ley agraria (Jovellanos), 239, 240, 243–44, 281
Ingres, Jean-Auguste-Dominique, 54, 71, 209–10, 647, 652; *Dream of Ossian*, 67–69; *Jupiter and Thetis*, 206–7, 304; *Napoleon I on the Imperial Throne*, 50–52; *Oedipus and the Sphinx*, 51; Romulus, Conqueror of Acron, 67–69, 68
Injured Mason, The (Goya), 220
Inquiry into the Original State and Formation of the Earth, An (Whitehurst), 180–81
Inquisition Unmasked, The (Puigblanch), 289
Institut National de France, 14–16, 18
Institute of Cairo, 5
Interior of an Iron Foundry (Turner), 119
Iriarte, Bernardo de, 268
Iriarte, Domingo de, 233, 235, 237

Iriarte, Tomás de, 254, 257, 258, 274–76, 282, 285–87, 300
Iron Works at Nant-y-glo (Robertson), 121–22
Isabey, Jean-Baptiste, 21–23, 22, 203
Isla, Padre José Francisco de, 251, 258, 259
Italian art, 637, 688 n.1. *See also* Appiani, Andrea; Benvenuti, Pietro; Camuccini, Vincenzo; Canova, Antonio
Italy, 4, 10, 18, 36, 37, 49, 635; and Napoleon, 637–42, 653–56
I've Got to Hope I'll be Done Soon (anonymous), 285

Jacobi, Friedrich Heinrich, 391–92
Jacobins, 4, 11, 98
Jacuras, 282–83
Jahn, Friedrich Ludwig (*Turnvater*), 619, 620
Jansenists, 248, 266–67, 270
Jansenist-ultramontane debates, 266–67, 270–71, 276, 290
Jefferson, Thomas, 32–33
Jewish Cemetery, The (Ruisdael), 576
Joseph (king of Spain). *See* Bonaparte, Joseph
Jovellanos, Gaspar Melchor de, 232, 246, 252, 253, 263, 265–66, 272, 282, 300, 311, 669 n.36; arrest and confinement of, 290; denounced to Spanish Inquisition, 267; educational reforms proposed by, 285, 285; and Goya, 237–38, 240–41, 243–44, 278–81, 279, 280, 283–85, 284; *Informe de la ley agraria*, 239–40, 243–44; receptive to English culture, 272, 274; resistance to Spanish Inquisition, 249; on witchcraft, 258
Joys of the Hunt, The (Runge), 472–73
Juan Antonio Meléndez Valdés (Goya), 242
Juel, Jens, 439, 446; contact with Friedrich, 515–18, 516; *The Little Belt, Seen from a Height Near Middelfart*, 515–16; *Portrait of Horace-Bénédict de Saussure, 421; Portrait of Mme de Prangins in Her Park, 421; A Thunderstorm Brewing Behind a Farmhouse in Zealand*, 516–17; *View of Hindsgavl*, 516
Jukunde (Kosegarten), 595–96
Jungfernstieg, view of, *468–69*

Jung-Stilling, Johann Heinrich, 328
Junkers, the, 321–22, 324, 559, 571, 587
Jupiter and Thétis (Ingres), 206–7, 209–10
Jupiter and Thétis, engraving (Flaxman), 207

Kaiser Octavianus (Tieck), 381–82
Kalkreuth, Graf Friedrich Adolf von, 615–16
Kant, Immanuel, 328, 348, 358, 385, 388, 391, 413, 426, 562, 591; Kleist's encounter with, 351–52; *Kritik der praktischen Vernunft*, 330–31; *Kritik der reinen Vernunft*, 329–30, 596–97; relationship to Fichtean philosophy, 333, 335
Kepler, Johannes, 372, 607
Kersting, Georg Friedrich, 607, 620, 626
Kirwan, Richard, 178–79, 180
Kite Flying (Goya), 224–25
Klage um drei junge Helden (Arndt), 625
Kleist, Heinrich von, 351–53, 355, 402, 571, 591, 612, 623, 627, 682 n.8, 684 n.50, 688 n.103; Friedrich's *Monk by the Sea*, interpretation of, 582–85, 586–87, 600–601
Klinger, Maximilian, 327–28
Klinkowström, August von, 465
Klopstock, Friedrich Gottlieb, 374–75, 391, 413, 440, 447–48, 472, 507, 623
Knaben Wunderhorn, Dés (Arnim and Brentano), 393, 583
Knigge, Adolphe, Freiherr von, 493
Knight, Richard Payne, 147–48, 151
Königsstuhl (Friedrich), 531
Körner, Christian Gottfried, 494
Körner, Theodor, 602–3, 609, 620, 621, 624, 626; *Eduard und Veronika: oder, die Reise ins Riesengebirge*, 613–14; *Kynast*, 612–13
Kosegarten, Gotthard Ludwig, 377–79, 411, 413, 416, 426, 437, 444, 466, 492, *494–95*, 522, *530*, 542, 591, 623, 675 n.33, 685 n.65; and Friedrich, 511, 512, 527, 529, 533, 566, 587–90, 592, 593–600, 602; and Runge, 412, 414–15, 505–9, 507
Kottwitz, Caroline von, 615

Kritik der praktischen Vernunft (Kant), 330
Kritik der reinen Vernunft (Kant), 329–30, 413, 591, 596–97
Kügelgen, Gerhardt von, 571–72, 578, 620, 630, 683 n.16
Kügelgen, Marie Helene von, 571–72, 582, 683 n.16
Kuhn, Gottlieb Christian, 566
Kynast (Körner), 612–13

Labor and laborers, 163–64, 175–77, 191
Lamentation and melancholy in art, 57–58
Landon, C. P., 207
Landowners, as a class, 139–43, 179–80, 191
Landscape, The (Knight), 147
Landscape with Cattle and Peasants (Lorrain), 131–32
Landscape with Double Rainbow (Constable), 171-72
Landscape Painting, 130, 135–38, 148, 156–57, 184–90, 189, 318, 320–21, 478, 606. *See also* Constable, John; Friedrich, Caspar David; Runge, Philip Otto; Turner, Joseph Mallord William
Landscape with Pavilion (Friedrich), 518–19
Landscape: Ploughing Scene in Suffolk (Constable), 174–75, 176
Landscape with a Rainbow (Friedrich), 604–5
Landscape in the Riesengebirge (Caspar David Friedrich), 610–14
Landscape with Sunrise (Friedrich), 560–62
Landsturm, 620–21
Larrey, Dominique-Jean, 85–86, 317
Lascelles, Edwin, 149
Latouche-Tréville, Admiral, 104
Lavater, John Caspar, 327, 328, 661 n.60
Le Brun, Charles, 204
Le Thière, Guillon, 35–37, 36
Lebon, Philippe, 66–67
Legenden (Kosegarten), frontispiece, 494–45
Leicester, Sir John Fleming, 122, 149–50, 665 n.71
Lepère, Jean-Baptiste, 12
Lesser, Creuze de, 55–56
Lessing, Gotthold Ephraim, 494–95
Letzte Lied, Das (Kleist), 600
Liberty (Thomson), 109
Lighting in art, 212

Lilienstern, Johann Jakob Otto August Rühle Von, 570, 571
Limekiln at Coalbrookdale (Turner), 119–22, 120
Linnaeus, Carolus, 429, 433, 473–79, 474, 478, 505–7, 506, 522
Literary Fables (Iriarte), 285–87
Little Belt, Seen from a Height near Middelfart, The (Juel), 515–16
Locke, John, 329
Lombardsbrücke, photographs of, 469
London (Turner), 108–10
Lorimier, Henriette, 58
Lorrain, Claude, 131–32, 142–43, 158, 194, 195, 575
Louis XIV, of France, 18, 218
Louis XV, of France, 315
Louis XVI, of France, 4, 76, 90, 232
Louis XVIII, of France, 628–29
Louise Perthes (Runge), 468–69
Loutherbourg, Philip James de, 121, 123, 127, 129, 130, 131, 400
Louvre, Paris, 17, 18, 25, 52, 394
Lowther, Sir James, 149
Lowther, William, 152–53
Lowther Castle, Westmoreland, the Seat of the Earl of Lonsdale: Mid-Day (Turner), 152–53
Luddite Revolts, 114–15, 154, 191, 663 n.20
Ludwig, Crown Prince of Bavaria, 340–41
Luise, of Prussia, 401–3, 609, 622
Lunar Society, 180, 262, 264, 334, 417, 432, 477, 491
Lunéville Peace Treaty, 63, 64
Lutheranism, 328
Lützow, Major Adolf von, 620
Luzán, José, 218
Lycurgus Presenting the Heir to the Throne (dePujol), 18–19

MacCulloch, Johh, 118–19, 127
Machine infernale, 659 n.7
Machine infernale, La (anonymous), 60
MacPherson, James, 54, 60, 63, 93, 128, 413, 414. *See also* Ossianic literature
Male Nude (Friedrich), 514
Malton, Thomas, 136
Malvina Mourning Oscar (Harvey), 56–57
Manning, William, 127
Manor House near Loschwitz Overlooking Elbe Valley (Friedrich), 526
Mansfield Park (Austen), 165–66

Mantell, Gideon, 124
Manuel, Pierre, 74–75
Manuel Godoy (Goya), 291–92
Manuel Osorio de Zuñiga (Goya), 230–31
Manure, 178–79
Manures Most Advantageously Applicable to the Various Sorts of Soils and the Causes of Their Beneficial Effect in Each Particular Instance, The (Kirwin), 178–79
María Luisa, of Spain, 199, 213, 225, 233, 266, 279, 638
Marius amid the Ruins of Carthage (Vanderlyn), 30–31
Marketplace of Pirna (Bellotto), 520–21
Martin, John, 123–27, 130, 131, 167, 172, 191
Martin, William, 123–24
Martinéz y Perez, Sebastian, 234
Mason, William, 142
Maugham, Somerset, 437
Meadow of San Isidro, The (Goya), 226–28
Medieval City on a River (Schinkel), 406–7
Medievalism, 322, 327, 329, 359–62, 363–70; and German romanticism, 393–96; and Klopstock's exploitation of Ossianic literature, 447–49; in the work of Friedrich and Schinkel, 621–23
Melancholia I (Dürer), 542–43
Melancholien (Quistorp), 410–11
Melancholy (Charpentier), 57
Meléndez Valdés, Juan, 236, 237, 244, 263, 269, 273, 274, 282, 300, 305, 670 n.43; on education, 282–84; and Godoy, 243; and Joseph Bonaparte, 302; "El melancólico, a Jovino," 241–42; receptivity to English culture, 272, 274; views on the Spanish Inquisition, 249, 258
Mengs, Anton Raphael, 217–18, 221
Mercure de France, 80–81
Meteorology, 64–65, 66, 99, 128, 133, 170–73, 421
Metternich, Klemens von, 398, 617, 634
Meyer, Heinrich, 562–63, 564
Michelangelo, 82, 93
Michelet, Jules, 318
Miltitz, Dietrich von, 571
Milton, John, 416
Mining, 444–45, 524–25; in German fairy tales, 555–56, 559

*Minnelieder aus dem schwäbischen
Zeitalter* (Tieck), 437, 446, *542*
Miollis, General Sextus-
Alexandre-François, 67–68
Miss McCrea: Roman historique
(d'Auberteuil), 28–29
Molière, François, 259
Monk by the Sea (Friedrich), 511,
581–601, 582, 602, 605, 627, 633;
Brentano and Arnim's review
of, 583–85; disaffiliation with
Kosegarten reflected in, 592,
598–600; identification of
monk, 584–86, 587; Kleist's in-
terpretation of, 582–85, 586–87,
600–601; Kosegarten's *Arkona*
as literary source, 596–98; Ko-
segarten's support for Napo-
leon, 587–90; monk persona de-
rived from Kosegarten,
argument for, *592–600, 593, 594;*
pietism, influence of, 590–92;
use of the *Rückenfigur*, 586–87
Monro, Dr. Thomas, 137–38, 664
n.47
Monti, Vincenzo, 639
Montijo, condesa de, 266–67
Moon: in art, 71–72, 121–22, 128,
262–63; in German Romanti-
cism, 369–83
Moon and Sixpence (Maugham),
437
Moratín, Leadro Fernández de,
252–53, 254, 258, 259, 262, 281,
300
Morell, Sir Charles, 126
Moriscos, the, 247
Morning (Runge), *487–91*
Morning, drawing (Runge), *481–83*
Morning Fog in the Mountains
(Friedrich), *564–65*
Morning in the Riesengebirge (Fried-
rich), *607–9,* 622
Mother at the Source, The (Runge),
452–54, 453
Mountain Landscape (Friedrich),
561–62
Mountain with a Rainbow (Fried-
rich), *605–6*
Mountains in art: in German ro-
manticism, 369–83. *See also*
Friedrich, Caspar David
Mozart, Wolfgang Amadeus, 498–
99
Müller, Adam, 352, 571
Müller, Johannes von, 392
Murat, General Joachim, 205, 212,
222–23, 295, 296, 299, 319, 651,
671 n.91
Murger, Henri, 436
Musenalmanach (Schiller), 425

Naked Maja (Goya), *292–94*
Napoleon and Napoleonic Era, 5–
11, *19–20,* 26, 34, 52, 53, 59,
72, 76–77, 101, 102, 205–10,
253, 661 n.46, 668 n.8, 672 n.2;
and Appiani, *646–48, 647;* and
Austrian-Prussian alliance, 569–
70; and Benvenuti, *649–51;* and
Camuccini, 651–53, *652;* and
Canova, *636,* 640–43, *641;* and
Catholicism, 77, 79–80; and
censorship, 11–12; and Chateau-
briand, 79–83, 86; Coleridge's
view of, 101; and Constable,
190–93, *191;* consulate, 7–8, 26,
75; cultural renovations and
means of maintaining power,
xxii–xxv; and David, 4, *39–49,
44, 46, 53–54. See also* David,
Jacques-Louis; decorative arts,
exploitation of, 19–21; defeat
and abdication of, 617–18; early
years, 3–6; Egyptian campaign
and visit to Jaffa, 83–88, *84;*
"Empire style," 20–21, 24–25,
658 n.13; and geologists, 43,
65–66, 91–92; and Géricault,
628–29; and German freema-
sonry, 494, 498–99; and Ger-
man nationalism, 331–33, 343–
55, 499–505; and Germany,
315–20, 322, 326–28, 331, 339,
393, 394, 431, 467, 572, 575,
581, 583, 587–90, 603–4, 617–
20, 651, 674 n.31; and Girodet,
64–67, 68, 92–95, *94;* and Gros,
300–302, *301,* 314–18; and Goya,
210–12, *211,* 296–300, *304–5,*
307–*312,* 318; and Godoy, 290–
92, 294–95; hybridized imagery
of period, xxvi, 38; Institut Na-
tional de France, 14–16, 18; and
Italy, 637–42, 653–56; mar-
riages, 201, 207–9; military
conflicts, 5–7, 36–37, 41, 83–
87, 90–91, 102, 133–34; Napo-
leonic effigies, 49–54; Napo-
leonic hero, xxv–xxvi, xxvii;
Napoleonic wars, 122, 124, 125,
129, 130, 149, 154, 156, 167,
193, 195, 200, 212, 411, 489,
511, 615; and Ossianic litera-
ture, 54–64, *56–58, 61, 62,* 67,
69–72, 81, 315; and pictorial
propaganda, 6, 17, 19, 25, 40,
42, 210; police-state methods
under, 74–76; and Prud'hon,
72–77, *73, 74;* public works pro-
grams and the arts, support of,
17–18; and Saxony, 649–50; and
scientific developments, 14–24,
75; and Spain, 41, 105, 199–
200, 210–11, 216, 232–35, 290,
295–300, 303–7; and Spalla,
643–46, *644, 645;* and Turner's
The Fifth Plague of Egypt, 132–
34; and Turner's *Hannibal Cross-
ing the Alps, 111–16;* and Van-
derlyn, *20,* 26–33, *31;* view of
women, 205–7; visual arts as
vehicle for self-glorification,
12–13, 17; war with England,
11, 63, 97–98, 102, *104,* 106;
and Wordsworth, 195–97, 210,
305
Napoleon on the Battlefield of Eylau
(Gros), *314–18*
Napoleon Crossing the Saint Bernard
(David), *39–41*
Napoleon I on the Imperial Throne
(Ingres), *50–52,* 210
Napoleon as Mars (Canova), *636,*
640–41
Napoleon and Oberkampf (Isabey),
21–22
*Napoleon Pardoning the Rebels at
Cairo* (Guérin), 86–87
Napoleon in the Pesthouse at Jaffa
(Gros), 83–87, *84*
Napoleon on the Pont de Kehl (en-
graving after Ingres), *50–51*
*Napoleon Restoring the Institutional
Basis of the Jewish Religion*
(anonymous), *9*
Napoleon in His Study (David), *53–
54*
Nathan der Weise (Lessing), 495
Nationalism, German. *See* Ger-
man nationalism
Natural History of Selborne (White),
168–69
Naturphilosophie (Schelling), 337–
40, 441, 442, 463, 465, 477, 478,
490, 534, 547, 571; and Fried-
rich, impact on, 535, 539, 548,
561, 565, 566, 574, 579–80,
608, 631, 633; and Hoffmann,
inspiration for, 558; and Noval-
is's *Heinrich von Ofterdingen,*
554–55
Nazarenes, 656
Nelson, Admiral Horatio, 103–7,
109, 131, 133–34
Neoclassicism, 420–21, 423, 437,
439
Neptunists, 65, 91–92, 117, 125,
440, 451, 580, 631
New Spain, 215–16
New Year's End (Runge), *501*
Newton, Issac, 126–27, 373, 606–
7
Niebuhr, Berthold Georg, 323

Night (Runge), *484–85*
Night Thoughts (Young), 274, 373–74, 416
Nightingale's Bower (Runge), *471*
Nightingale's Lesson, The (Runge), *425, 472*
Novalis, 327, 361, 375–76, 427, 445, 454, 455, 473, 559, 575, 674 n.6; *Heinrich von Ofterdingen*, 554–58, 559

Oath of the Horatii clock, *20–21*
Oath of the Saxons to Napoleon after the Battle of Jena (Benvenuti), *649–50*
Oberkampf, Christopher-Philippe, 21–22
Observations on the River Wye, and Several Parts of South Wales, etc., Relative Chiefly to Picturesque Beauty (Gilpin), 147
Occult, the, 249–50, 252. *See also* Witchcraft
Oedipus and the Sphinx (Ingres), 51
Oken, Lorenz, 339, 442, 463–65, 607, 608, 624
Olavide, Pablo Antonio de, 257, 277–78
Old Fortifications of Dresden, The (Bellotto), *520*
Old Hall, East Bergholt (Constable), *175–76*
Old Heroes' Graves (Friedrich), *624–25*
Old Market, Dresden, from Schlosstrasse, The (Bellotto), *519–20*
Old Regime, 51, 75
Oscar (Runge), *451–52*
Ossian (Runge), *450–51*
Ossian Evoking the Shades with His Harp on the Banks of the Lora (Gérard), 61–62
Ossianic literature, 81, 128, 194, 334, 448; affect on art production, 67; English art, influence on, 99, 103, 121, 125; and German romanticism, 369, 374, 375, 377–78, 444, 447–49, 529, 583; moon motif in, 71–72; and Napoleon, 54–64, 56–58, 61, 62, 69–72, 315, 317–18; and Runge, 448–452, 507
Österrich, Erzherzog Karl von, 36
Osuna Family, 253–62, 264

Pacca, Cardinal Bartolomeo, 655
Pagerie, Joséphine Tascher de la, 201, 203, 204–5
Palazzo de Quirinale, Rome, 67–68, 651

Palazzo Reale, Salon of Caryatids (Milan), *646–48, 647*
Panoramas, 400–410
Pantheism, 99–100
Partes flores, plate 7 of *Philosophia botanica* (Linnaeus), *505, 507*
Passage of the French Army across Saint Bernard, Commanded by His Majesty the Emperor, the 28 Floréal Year 8 of the Republic (Thévenin), *42–43*
Passage of the French Army across Saint Bernard, engraving, *42–43*
Patrioten, Die (Fichte), 346
Patrioten und Kriegspartei, 583
Patriotenpartei, 609
"Patriotische Gesellschaft" (Hamburgische Gesellschaft zur Beförderung der Künste und nützlichen Gewerbe), 417–18, 423, 431, 677 n.10
Patrons and patronage: and Friedrich, 611; landowning patrons, 139–43; and Turner, 108–11, 122, 131–35, 139
Pauleson, Erik, 514
Pauline Borghese as Venus Victrix (Canova), *641–42*
Pencheux, Laurent, 652
Peninsular War, 196, 200, 212
Peninsulars, the, 215–16
Percier, Charles, 23, 44, 60, 201
Percy, Pierre-François, 317
Perthes, Friedrich, 385–93, 394, 399, 411, 417, 429, 449, 469, 499, 501; Runge's commissions for, 446, 448–49, 480, *502–3*
Peter Schlemihl (Chamisso), 320
Petworth, Sussex, the Seat of the Earl of Egremont: Dewy Morning (Turner), *153, 155*
Pfuel, Ernst von, 620
Phantasien über die Kunst für Freunde der Kunst (Tieck), 371–72
Philosophica botanica (Linnaeus), 475
Philosophical Inquiry into the Origin of Our Ideas on the Sublime and Beautiful (Burke), 304–5
Philosophical Magazine, 172–73, 178
Philosophie der Kunst (Schelling), 337, 339
Phöbus, 352
Picturesque, the, 141–53, 188
Picturesque Views of the Southern Coast of England (Cooke), 159
Pietism, 328–29, 339, 361, 364, 368–69, 379, 391, 395, 512,

523, 537, 590, 686 n.75; Swabian, 358–59
Pignatelli, Ramón de, 218, 219, 246
Pius VII (pope), xxiv, 8, 11, 68, 77, 201, 651
Plight of the Fatherland (Runge), *503–5, 504*
Poessien (Kosegarten), title page, *530*
Police Dévoilée, La (Manuel), 74–75
Pomerania, 324–26, 347, 348, 350, 377, 411–13, 444, 459, 466, 467, 492, 500, 511, 569, 585, 694
Poor, as a class, 97
Portrait of the First Consul (Gros), *49–50*
Portrait of Horace-Bénédict de Saussure (Juel), *421*
Portrait of Mme de Prangins in Her Park (Juel), *421*
Portugal, 210–11, 290–92, 295
Pottery, 220–21
Poussin, Nicolas, 575
Preissler, Johann David, *513,* 682 n.3
Preliminary Peace Treaty of Leoben, The (Le Thière), *35–37, 36*
Prévost, Pierre, 186, 400
Price, Uvedale, 147
Pride and Prejudice (Austen), 165–66
Priestley, Joseph, 264, 334, 432, 442, 477
Prinz Putbus of Rügen, 527, 611, 627
Prinzessin Svanvitha, Die (Arndt), 554
Procession at Sunrise (Friedrich), *562–65, 563, 566*
Propyläen (Goethe), 364–65, 439
Prospect from Rugard towards Jasmund (Friedrich), *530–31*
Protestantism, 328, 349
Prud'hon, Pierre-Paul, 72–77, *73, 74,* 94, 262, 660 nn.41, 42
Prussia, 326, 351, 353, 354, 359, 374, 399, 431, 445, 466, 492, 499, 500, 503, 634; Arndt's *Geist der Zeit,* 569–70; landed property in, 321–24; Napoleon's invasion of, 316, 331; Swedish Pomerania, addition of, 629; and the Wars of Liberation, 617–19. *See also* Germany
Ptolemy II Philadelphus among Scholars Brought to the Library of Alexandria (Camuccini), *652–53*
Puigblanch, Antonio, 289

Quellgeister (Böhme), 443
Quistorp, Johann, 475, 511, 513, 527, 588
Quistorp, Johann Gottfried, *410,* *412,* 444, 459, 460, 513

Raby Castle, the Seat of the Earl of Darlington (Turner), *141–42*
Rackwitz, Freiherr von, 527–28
Ramdohr, Friedrich Wilhelm Basilius von, 366, 572–80, 684 n.41; and Friedrich's *The Tetschen Altarpiece,* opposition to, 572–80
Räuber, Die (Schiller), 327, 494; Friedrich's illustrations for, 539–41, *540*
Reading of the Bulletin of the Grand Army (Boilly), *48–49*
Rede am Napoleonstage des Jahres 1809 (Kosegarten), 588
Reden an die deutsche Nation (Fichte), 318–19, 346–47
Reden an die Religion (Schleiermacher), 349, 591
Reiffenstein, Johann, 572
Reign of Terror, 234, 327, 359
Reimarus family, 389, 391, 393
Reimarus, Johann Albert Heinrich, 432–33, 434, 477
"Reime aus einem Gebetbuch für zwei fromme Kinder" (Arndt), 379–80
Reimer, Friedrich Wilhelm, 563
Repton, Humphrey, 147
Researches about Atmospheric Phaenomena (Forster), 173
Rest on the Flight to Egypt (Runge), 457–59
Rest on the Flight to Egypt, study (Runge), 457–59, *458*
Restoration, 307, 311; English, 161; French, xxiv, 628, 637, 655
Resurrection, The (Dürer), 449–50
Return of the Sons, The (Runge), 446–47
Reventlow, Christian Diltlev, 518
Reynolds, Sir Joshua, 195, 446
Ridley, James, 126
Riesbeck, Baron Kaspar von, 387
Rime of the Ancient Mariner (Coleridge), 99–100
Risorgimento, 654–55
Robertson, George, 121–23, *122*
Robinson, Crabb, 433, 492
Rocky Crag with Caves and Masonry (Friedrich), 524–25
Rojas, Fray Juan Fernández de, 267
Rolf Krage (Ewald), 421
Romanticism, xxvi–xxvii. *See also* German romanticism

Romulus, Conqueror of Acron (Ingres), 67–69, *68*
Rosicrucianism, 491–92
Rousseau, Jean Jacques, 326, 330, 335, 345, 425, 462, 518, 591
Royal Academy, England, 98, 103 109, 111, 125, 132, 134, 139, 152, 156, 158
Royal Academy of Fine Arts, Copenhagen, 419
Royal Economic Society, Spain, 218, 253
Royal Observatory, Spain, 246
Royal Porcelain Factory (Fabrica de la china), Buen Retiro Park, Madrid, 221
Royal Tapestry Works of Santa Bárbara, Spain, 218, 221
Rübezahl folktales, 549–52
Rügen folktales, 552–54
Rügen, island of, 604–5. *See also* Friedrich, Caspar David
Ruisdael, Jakob von, 576
Rumohr, Karl Friedrich, 446, 494
Runenberg, Der (Tieck), 427–29, 543, 544–45, 547, 548–49, 554, 559
Runge, Daniel, 389, 411, 414, 431, 446, 488, 505; correspondence with Philip Otto Runge, 420, 421, 437, 457, 481, 500, 527
Runge, Philip Otto, 320–21, 324, 327, 338, 347, 357, 376, 411, 445, 449, 450–51, 477, 677 nn.1, 11, 14, 18, 678 nn.22, 24, 27, 679 nn.43, 47, 52, 680 n.63; affinities with Friedrich, 511, 512, 514, 522, 527–28, 530, 535, 536, *542,* 565–66; and applied arts, 417–18; arabesques and hieroglyphs in art, 434–35, 449; color symbolism of, 430–32, 434; connection with Darwin, 477–79, *478,* 491; and decorative arts, 418–19, 421, 423–26, *424,* *425,* 470–73; and fairy tales, 546–47; and Flaxman, admiration for, 420–21, 423, 435, *438–* 39, 443, 447, 449, 477, 480; floral and botanical motifs, 416, *425–*26, 434–35, 454, 456, 465, *466,* *467–*68, 471, 475–77, *476,* *481–*88, *483–85,* 487; *Geister* theme, 443, 444, 455, 456, 458, 470, 472, 473, 481, 483, 485–87, 489, 497; Hülsenbeck, Runge and Co. apprenticeship, 417–19; Kosegarten, influence of, 412, 415–16, 566; on landscape painting, 434–36, 454; and Linnaeus,

473, 475–77, *476;* nationalism of, 499–505, *501–4,* 507, 508–9; nature as a self-revelation of God, 414–15, 426, 478; and Ossian, *448–52, 451,* 508; portraits, *460–*63, *461, 465–69, 466–68;* relationship to German idealist philosophy, 426, 430–32, 441–43, 450; Royal Academy of Fine Arts, Copenhagen, education, 419–26; Schelling, influence of, 426, 441, 442, 463, 482–83; and science, *432–*36, 441, 451–52; sojourn in Dresden, 443–46; "source" themes of 1805, 452–54, *453, 457, 458;* and Tieck, 434–35, 436–43, *438,* 446, 452, 454, 456, 457, 470, 480, 483, 497, *542;*
—, works: *Achilles and Skamandros, 437–38; Arion's Sea Journey, 470–71; The Artist's Parents, 466–* 68, *467; The Artist's Parents,* sketch, *466–67; The Birth of Fingal, 448–50; Cornflower, 476–77; The Effect of the Comic and Tragic Masks, 425; Farbenkugel, 430–32, 431; The Fatherland's Fall, 502–3; Fingal with Raised Spear, 450, 463; Head of Meleager, 424; The Hülsenbeck Children, 461–63, 465–66; The Joys of the Hunt, 472–73; Louise Perthes, 468–69; The Mother at the Source, 452–* 54, *453; New Year's Card, 501; Nightingale's Bower, 471, 495; The Nightingale's Lesson, 425, 472; Oscar, 451–52; Ossian, 450–* 51; *Plight of the Fatherland, 503–* 5, *504; Rest on the Flight to Egypt, 457–58; The Return of the Sons, 446–47; Saint Peter on the Waves, 505–9, 507, 566; The Source and the Poet, 452–54, 453, 461; Times of Day (see main entry); Triumph of Amor, 425, 443, 449; Vases antiques copies, 422–* 24; *Vivat 1801, 496–97; We Three, 460–61*
Ruskin, John, 135, 138
Russia, 316, 569, 617–18

Saavedra, Francisco de, 237, 265, 267
Sachsen-Weimar, Herzog Karl August von, 580, 604
Sacred College, 655
Sadak in Search of the Waters of Oblivion (Martin), 123–27
Saint-Ours, Jean-Pierre, *89–90,* 92, 94

Saint Peter on the Waves (Runge), 505–9, *507, 566*
Saint-Pierre, Bernardin de, 93
Salon (Paris), xxv, 20, 26, 27, 32, 35, 38, 42, 49, 57, 60, 70, 72, 73, 210; of 1802, 87–88; of 1810, 207, 300; of 1812, 111, 123, 207
San Francisco de Borja Exorcising an Evil Spirit from an Impenitent Dying Man (Goya), 256–58
Sandby, Paul, 135–36
Saussure, Horace-Bénédict de, 91–92, 117, 128, 173, 180, 518, 661 n.56
Savigny, Friedrich Karl von, 402
Saxe-Weimar, Erzherzog, 611
Scène de Déluge (Girodet), 92–95, *93*
Scenes de la vie bohème (Murger), 436
Schäfers Klagelied (Goethe), 605
Schaffgotsch, Grafs, 610–11
Scharnhorst, Gerhard Johann David von, 323, 333, 429, 494, 571, 603, 609, 618–21
Scheele, Karl Wilhelm, 442
Schelling, Friedrich Wilhelm Joseph, 327, 348, 352, 357, 391, 433, 450, 455, 529, 534, 558, 577, 579, 673 n.26; on Gothic architecture, 622; *Naturphilosophie*, 337–40, 441, 442, 463, 465, 477, 478, 490, 554, 558, 578–79; Runge, influence on, 426, 431, 441, 442, 463, 482–83; Steffens, impact on, 429–30; *System des transzendentalen Idealismus*, 336, 339, 399; *über das Ich*, 358–59
Schildener, Karl, 457, 459, 460, 481, 527
Schiller, Johann Christoph Friedrich von, 327, 335, 374, 389, 425, 494, 539
Schimmelmann, Graf Ernst, 518–19
Schinkel, Karl Friedrich, 186, 384, 398–408, 436, 498–99, 676 n.24; *Cathedral among the Trees, 384,* 404–5; *Evening, 404–5*; Friedrich's visionary landscapes, impact on, 621–22; and German nationalism, 403–8; *Morning, 405*
Schlatter, Anna, 328
Schlegel, August von, 327, 329, 376, 402, 426, 435, 622–23
Schlegel, Friedrich von, 327, 329, 376, 394–96, 402
Schleiermacher, Friedrich, 327,

335, 349, 350, 361, 523, 591–92, 633, 634, 686 n.74
Schloss Kriebstein (Friedrich), *526*
Schön, Theodor von, 323
School of Mines, Dresden, 445, 525
School of Mines, New Spain (Mexico), 215–17
Schröder, Friedrich Ludwig, 495
Schröter, Johann Hieronymus, 376, 631
Schubart, Christian Friedrich Daniel, 363
Schubert, Gotthilf Heinrich von, 339, 433–34, 442, 477, 490, 631–32, 683 nn.16, 29, 687 n.80; and Friedrich, 534–39, *534, 536, 538,* 631–32, 634, 657–58
Science, 14–24, 75, 123–24, 246–47, 338, 415, 455
Seashore with Fisherman (Friedrich), *594*
Seasons, The (Thomson), 116–17, 133, 416
Seats of the Nobility and Gentry in Great Britain and Wales, The (Angus), 138–39
Sebastian Martínez y Perez (Goya), *234*
Second Coalition, the, 49
Second of May 1808 in Puerta del Sol, The (Goya), *296–98*
Seidler, Luise, 323
Self-Portrait (Friedrich), *581, 583*
Seminary of Agriculture, 244
Semler, Christian August, 571, 578
Senatus Consultum, the, 200–210
Sepia, 527
Sepolcri, I (Foscolo), 643
Serfdom, abolition of, 323–26
Seven Years' War, 3, 4, 126, 142, 316, 374, 447, 551
Shakespeare, William, 304
Shipley, William, 417
Sí de las niñas, El (Moratín), 282
Sieveking, Georg Heinrich, 389, 391, 393
Sieveking, Karl, 678 n.37
Sketches and sketching, 183–84, 186–87, 632
Smith, Adam, 239, 254, 324, 337
Smith, John Raphael, 138
Snowstorm: Hannibal and His Army Crossing the Alps (Turner), *111–16,* 662 nn.17, 19
Sociedad Aragonesa, Zaragoza, 219
Société d'encouragement des industries nationales, 21
Society for the Encouragement of

Arts, Manufactures, and Commerce, London, 417
Society of Jesus, Spain, 255
Solander, Daniel, 475
Somerhill, near Turbridge, the Seat of W. F. Woodgate, Esq. (Turner), *156–57*
Sommernacht, Die (Klopstock), 374
Somnium (Kepler), 372–73
Sorrows of Werther (Goethe), 374–75
Source and the Poet, The (Runge), 452–54, *453,* 461
Spain, xxvii, 41, 196, 210–12, 216–17, 229, 232–34, 236–37, 246–247, 254, 270, 277, 319, 343, 638; agricultural reform in, 239–40, 243–45, 280–81; encouragement of industry, trade, and the arts under Carlos III, 219–22; and France, 199–200, 210–12, 232–35, 237, 265, 290–292, 295–300; industry in, 305–7; *Majismo* vs. *Afrancesamiento*, 222–29; receptivity to English culture, 263–64, 271–74
Spalla, Giacomo, 643–46, *644, 645*
Spanish Enlightenment, 270, 276, 278, 280, 282; and educational system, 283–84; and Goya and the Osuna family, 253–62; and witchcraft, 248–53, 288
Spanish Inquisition, 237–38, 240, 246, 255, 257–58, 264, 266, 670 n.51; censorship of, 248–49, 264; denouncement of Jovellanos, 267; under Fernando VII's reign, 311–12; of Logroño, 253, 261, 262, 289; and witchcraft, 249,251–53, 261, 287–90, *288, 289. See also* Witchcraft
Speckter, Johann Michael, 389, 417
Spring (Friedrich), *535–36*
Squillace Riot, 223, 225
Stadtschule of Wolgast, 413–14
Staël, Anne-Louise-Germaine de, 206, 327
Steffens, Henrik, 428, 431, 441, 455, 475, 490–91, 494, 495, 519, 611, 624, 673 n.29, 678 nn.27, 28, 683 n.29; *Beyträge zur innern Naturgeschichte der Erde,* 579–80; *Gebirgs-Sagen,* 549–52; *Geognostisch-Geologische Aufsätze als Vorbereitung zu einer innern Naturgeschichte der Erde,* 429–30, 432, 440; Wars of Liberation, participation in, 338–39, 426, 429, 580

Stein, Freiherr vom, 322–26, 333, 570, 609, 619, 620, 634
Stein-Hardenberg agrarian reforms, 611–12
Steinmeyer, Johann Gottfried, 401
Sternberg, Barol Speck von, 611
Stolberg, Count Friedrich Leopold, 391–92, 446, 448–49
Straw Manikin, The (Goya), 225–26
Struensee, Johann Friedrich, 419, 421
Stubbenkammer (Friedrich), *530*
Stubnitz und Stubbenkammer (Kosegarten), 595
Sturm und Drang, 318, 327, 333–34, 365
Sturm und Drang (Klinger), 328
Sublime, the, 141, 143
Sulzer, Johann Georg, 362
Summer (Friedrich), *536–37*
Sweden, 411, 500, 569. *See also* Pomerania
Swift, Jonathan, 282, 304
Switzerland, 90–91, 128
System des transzendentalen Idealismus (Schelling), 336, 339, 399

Tabley, the Seat of Sir J. F. Leicester, Bart.: Windy Day (Turner), *150–51*
Tabley House (Wilson), 150–52
Talavera potteries, 221
Tales of the Genii: or, the Delightful Lessons of Horam, the Son Of Asmar (Ridley), 128, 663 nn.36–38
Tales of Hoffmann (Hoffmann), 558–60
Talleyrand, Charles-Maurice de, 5, 201, 205
Teatro crítico universal (Feijóo), 249–50
The Tetschen Altarpiece, or *Cross in the Mountains* (Friedrich), 565–80, 586, 592; and geology, 579–80; and *Naturphilosophie*, 577, 579–80; and Ramdohr's opposition to, 572–80; and Tieck's *Franz Sternbalds Wanderungen*, 566–67
Textile industry, 245–46
Thayer, James and Henriette, 400–401
Theater, eighteenth centiury, 259–61
Thévenin, Charles, 42–43
Third of May, 1808, The (Goya), 210–12, *211*, 298–300, 650
Thirty Years' War, 321, 512, 524, 585, 590, 602

Thomson, James, 109–19, 116–17, 133, 193, 377, 414, 416, 518
Three Essays (Gilpin), 147, 149
Thugut, Franz de Paula de, 36
Thunderstorm Brewing behind a Farmhouse in Zealand, A (Juel), *516–17*
Thun-Hohenstein, Graf von, 570–71, 578, 611
Tieck, Ludwig, 326, 327, 329, 333, 357, 364, 368, 385, 391, 394, 395, 445, 478, 495, 542, 559, 592, 613, 615, 679 nn.47, 50; and Friedrich, 539, 543–45, 564, 565, 566–67; *Die Geschichte des Herrn William Lovell*, 334–36; *Der gestiefelte Kater*, 370–71; *Phantasien über die Kunst für Freunde der Kunst*, 371–72; *Die Runenberg*, 427–29; and Runge, 434–35, 436–43, 446, 452, 454, 456, 457, 470, 472, 480, 483, 488, 493, *542*; and Steffens, 548–49; use of moon imagery, 381–83; and Wackenroder, 359–62
Tiepolo, Giovanni Battista, 217–18
Times of Day (Runge), 436, 437, 446, 476–78, 479–91, *481–85*, 487, 502, 566; *Day*, or *Noon*, 485–86; *Evening*, 483–84; floral and botanical motifs, 481–88, *483–85*, *487*; and freemasonry, 491, 495, 496–99, *497*; meaning of, 487, 489–90; *Morning*, 487–91, *497*, 501; *Morning*, drawing, *481–83*; *Night*, 484–85; themes of, 481–83; *Das vaterländischen Museum* designs, thematic parallels to, *502–5*, *504*
Tischbein, Wilhelm, 422–23, 425, 678, n.22
To the Autumnal Moon (Coleridge), 99
Tolsa, Manuel, *215–16*
Tolstoy, Leo, 617
Tom Tower, Christ Church, Oxford (Turner), *140*, 142
Topography, 135–38, *139*, 140–42, *141*, 156–57
Tories, 98, 147, 148, 161, 165, 193, 196
Transactions of the Geological Society, 117–18, 663 n.23
Transcendental idealism (Schelling), 339–40
Traveler above the Fog (Friedrich), 632–34, *633*
Traveler at the Milestone (Friedrich), *542–43*

Treaty of Amiens, 25, 49, 63, 67, 87, 113, 290
Treaty of Basle, 237, 243, 318
Treaty of Campo Formio, 4, 35
Treaty of Fontainebleau, 210
Treaty of Tilsit, 50, 72, 324, 331, 354, 473, 500–501
Triumph of Amor (Runge), 425, 440–41
Triumph of Jupiter-Napoleon, Dominating the World, The (Appiani), 647–48
Trumbull, John, 204
Tudo, Pepita, 293
Turner, Joseph Mallord William, 88, 102–4, 123, 125, 127, 130, 131, 167, 172, 185, 383, 514, 662 nn.11, 12, 663 nn.29, 31, 664 nn.50, 53; and the aesthetics of property, 135–38; and the Battle of Trafalgar, *104–6*, 190; Beckford commissions, *131–35*, *132*; Claude Lorrain, influence of, 131–32; commercial topography, influence on technique, 138–39; composition of, 106, 115, 122, 131–32, 133, 152–53; and the concept of the picturesque, 140–53, *141*, *150*, *152*, *153*; and Constable, 159–60, 162, 185, 189–93; and the Earl of Egremont, 153–56; fascination with Alpine scenery, 118–19; and geology, 117–22, *119*, *120*; innovative style and technique of, 137, 155–59, *156*; and James Thomson, 116–17, 133; moonlit motif, 121–22; patrons, 108–11, 122, 131–35, 139, 149, 154–56, 159;
—works: *Chapter-House, Salisbury*, *140*, 142; *Cockermouth Castle*, *141–42*; *The Fall of an Avalanche in the Grisons*, 116; *The Fifth Plague of Egypt*, 132–35; *Fonthill Abbey at Sunset*, 131–32; *Fonthill House*, 138–39; *Interior of an Iron Foundry*, 119–20; *Limekiln at Coalbrookdale*, 119–22, *120*; *London*, 108–11; *Lowther Castle, Westmoreland, the Seat of the Earl of Lonsdale: Mid-Day*, 152–53; *Petworth, Sussex, the Seat of the Earl of Egremont: Dewey Morning*, 153–55, *156*; *Raby Castle, the Seat of the Earl of Darlington*, 141–42; *Snowstorm: Hannibal and His Army Crossing the Alps*, 111–16, 133, 160, 192, 662 nn.17, 19; *Somerhill, near Tumbridge, the Seat of W. F. Woodgate, Esq.*,

156–57; *Tabley, the Seat of Sir J. F. Leicester, Bart.: Windy Day,* 150–52; *Tom Tower, Christ Church, Oxford,* 140–42

Über die Bedeutung der Farben in der Natur (Steffens), 430
Über das Ich (Schelling), 358–59
Über Mahlerei und Bildhauerarbeit in Rom für Liebhaber des Schönen in der Kunst (Ramdohr), 572
"Über das Verhältnis der bildenden Künste zu der Natur" (Schelling), 340–41
Ultramontane-Jansenist debates, 266–67, 270–71, 276, 290
United States, 27, 114, 229
University of Greifswald, 512–13, 682 n.2
Urquijo, Mariano Luis de, 237–38, 267, 300

Vahl, Martin, 426, 475
Valenciennes, Pierre-Henri de, 185–88, *187,* 400, 531–32, 575
Vallabriga, Doña María Teresa de, 231–32
Vanderlyn, John, *20,* 26–33, *27, 31,* 186
Various Subjects of Landscape, Characteristic of English Scenery (Constable), 164–65
Varnhagen, Rahel Levin, 619, 630
Vases antiques (Hamilton), copies by Runge, *422–24*
Vaterländischen Museum, Das, 392, 501–2
Vaterlandslied (Arndt), 627
Vathek (Beckford), 128–30
Vaudoyer, Léon, 18
Veit, Dorothea, 394
Veit, Philipp, 620
Veláquez, Diego Rodríguez de Silva y, 293
Velde, Willem van der, the younger, 140
Vendôme Column, Paris, xxv, *12,* 59, 657 n.7
Veronese, Paolo, 203
Versuch einer Geschichte der Leibeigenschaft in Pommern und Rüngen (Arndt), 325
Vesuvius, Mount, 91–92
Viejo y la niña, El (Moratín), 259
Vien, Joseph-Marie, 204
View from the Terrace of the Erdmannsdorf Estate (Friedrich), 614–17

View of Arkona with Rising Moon (Friedrich), 532–33
View of Arkona with Rising Moon and Fishnets (Friedrich), 531–32
View of Arkona with Shipwreck (Friedrich), 531–33
View of Arkona with Sunrise (Friedrich), 530–31
View of Dedham (Constable), 177–79
View of Dedham, oil sketch (Constable), *183–84*
View of Hindsgavl (Juel), 516
Villaneuva, Joaquim Lorenzo, 271
Villeneuve, Admiral, 104
Vincent, François-André, 27
Visconti, Gian Galeazzo, 646
Vivat 1801 (Runge), 496–97
Volksbücher, 364
Volta, Alessandro, *16–17,* 64, 66, 338, 442
Volta's Experiment at the Institut (Fragonard), *16–17*
Voltaire [François-Marie Arouet], 276
Voltz, Johann Michael, 89–*90*
Vom dem Fischer und syner Fru (Runge), 546
Vom dem Machandelboom (Runge), 546–47
Vorbildern für Fabrikanten und Handwerker (Schinkel), 399
Voyages dans la basse et la haute Egypte (Denon), 22–24
Vulcanists, 65, 91–93, 117, 123, 125, 427

Waagen, Friedrich Ludwig Heinrich, 446
Wackenroder, Wilhelm, 326, 327, 357, 373, 382, 385, 395, 564, 592; *Herzensergiessungen eines kunstliebender Klosterbruders,* 364–70, 445, 545, 575; and Medieval art, 437, 440; Perthe's publications of, 391, 394; *Phantasien über die Kunst für Freunde der Kunst,* 371–72; and Ramdohr, attack on, 572–73; and Tieck, 359–62, 382
"Waldeinsamkeit," 543–44
Wallraf, Ferdinand, Franz, 396
Wandelaar, Jan, 474–75
War and Peace (Tolstoy), 617
War of 1812, 114
"War of the Roses" (Portuguese War), 290
Ward, James, 162
Wars of Liberation, 323, 327, 355, 408, 465, 617–20, 623, 626, 628,

630; and Arndt's nationalism, 350, 380, 381; and German freemasonry, involvement in, 492, 494; and Körner's poetry, 603, 609; Steffens' participation in, 338–39, 426, 429, 580
Water Carrier, The (Goya), 305-6
Watercolor painting, 135–38, 157. *See also* Turner, Joseph Mallord William
Watteau, Antoine, 228–29
We Three (Runge), 460–61
Wealth of Nations (Smith), 239
Wedding, The (Goya), 227–30
Wedgwood, Josiah, 135, 180, 477
Weigel, Christian Ehrenfried, 475
Weimarer Bilderkonkurrenzen, 437–38
Weimarer Kunstfreunde, 562–63
Weishaupt, Adam, 493
Wellesley, Arthur, 200
Werner, Abraham Gottlob, 65, 91, 93, 118, 427, 445, 554, 556, 579, 580, 608, 683 n.29
Werner, Zacharias, 630–31
West, Benjamin, 25, 26, 88–89, 106–8, *107*
Whigs, the, 147, 165, 195
White, Gilbert, 168–69
Whitehurst, John, 180–82
Wilcke, Samuel Gustav, 415, 475
Wilkie, David, 98
Wilson, Richard, 150–52, 195
Winckel, Therese Emilie Henriette aus dem, 630
Winter (Friedrich), 537–38
Winckelmann, Johann Joachim, 367, 474
Wissenschaftslehre (Fichte), 335, 345
Witchcraft: and Darwin's *The Botanic Garden,* 263–64; exploitation of for political purposes, 255; in Goya's work, *258–62, 259, 261, 287–90;* and the Inquisition, 287–90; and the Spanish Enlightenment, 248–53
Witches in Flight (Goya), *258*
Witches Sabbath, The (Goya), *261–62, 264*
Without You I Would Have Perished (anonymous caricature), *94–95*
Woman with a Raven on a Precipice (Friedrich), 543–44
Woman with Spider's Web between Bare Trees (Friedrich), 542–43
Wordsworth, William, 98, 193–97, 305, 667 n.130
Wounded Cuirassier Leaving the Field of Battle (Géricault), 628–29
Wren, Sir Christopher, 110

Wright, Joseph, of Derby, 71, 121, 180, 307, 383, 421, 526
Wülffing, Johann Friedrich, 417

Young, Arthur, 120–21, 154
Young, Edward, 274, 373–74, 416, *518, 542*

Young Girl Mourning for her Dead Pigeon (Chaudet), *58–59*

Zamora, Antonio de, 259–60, 308
Zauberflöte, Die (Schinkel), *498–99*
Zeitung für die elegante Welt, 573
Zeugung, Die (Oken), 463–64

Zingg, Adrian, *521–22*
Zinzendorf, Graf Nikolaus Ludwig von, 368
Zix, Benjamin, *25*
Zoonomia: or, the Laws of Organic Life (Erasmus Darwin), 272–73, 337